Art of the Ancient World

Art of the

LIBRARY OF ART HISTORY

H. W. Janson, GENERAL EDITOR

H. A. Groenewegen-Frankfort
Bernard Ashmole

Ancient World

PAINTING · POTTERY · SCULPTURE · ARCHITECTURE

from Egypt, Mesopotamia, Crete, Greece, and Rome

Harry N. Abrams, Inc., Publishers

NEW YORK

H. W. J A N S O N *General Editor*

M I L T O N S. F O X *Editor-in-Chief*

Standard Book Number: 8109-0008-4
Library of Congress Catalogue Card Number: 77-113722

Printed and bound in Japan

Editor's Preface

The present book is one of a series. *The Library of Art History* comprises a history of Western art in five volumes, devoted respectively to the Ancient World, the Middle Ages, the Renaissance, the Baroque and Rococo, and the Modern World. The set, it is hoped, will help to bridge a gap of long standing: that between one-volume histories of art and the large body of specialized literature written for professionals. One-volume histories of art, if they are to be books rather than collections of essays, must be—and usually are—the work of a single author. In view of the vast chronological and geographic span of the subject, no one, however conscientious and hard-working, can hope to write on every phase of it with equal assurance. The specialist, by contrast, as a rule deals only with his particular field of competence and addresses himself to other specialists. *The Library of Art History* fits in between these two extremes; written by leading scholars, it is disigned for all those who are neither beginners nor professional art historians—educated laymen, upper-class undergraduates, and scholars in other fields who do not need to be introduced to the history of art but are looking for an authoritative guide to the present state of knowledge in the major areas of the discipline.

In recent years, such readers have become a large and significant group. Their numbers reflect the extraordinary growth of the history of art in our system of higher education, a growth that began in the 1930s, was arrested by the Second World War and its aftermath, and has been gathering ever greater momentum since the 1950s. Among humanistic disciplines, the history of art is still something of a newcomer, especially in the English-speaking world. Its early development, from Vasari (whose famous *Lives* were first published in 1550) to Winckelmann and Wölfflin, took place on the Continent, and it became a formal subject of study at Continental universities long before it did in England and America. That this imbalance has now been righted—indeed, more than righted—is due in part to the "cultural migration" of scholars and research institutes from Germany, Austria, and Italy thirty years ago. The chief reason, however, is the special appeal of the history of art for modern minds. No other field invites us to roam so widely through historic time and space, none conveys as strong a sense of continuity between past and present, or of kinship within the family of man. Moreover, compared to literature or music, painting and sculpture strike us as far more responsive vessels of individuality; every stroke, every touch records the uniqueness of the maker, no matter how strict the conventions he may have to observe. Style in the visual arts thus becomes an instrument of differentiation that has unmatched subtlety and precision. There is, finally, the problem of meaning in the visual arts, which challenges our sense of the ambiguous. A visual work of art cannot tell its own story unaided. It yields up its message only to persistent inquiry that draws upon all the resources of cultural history, from religion to economics. And this is no less true of the remote past than of the twentieth century—if we are to understand the origins of nonobjective art, for instance, we must be aware of Kandinsky's and Mondrian's profound interest in theosophy. The work of the art historian thus becomes a synthesis illuminating every aspect of human experience. Its wide appeal is hardly surprising in an age characterized by the ever greater specialization and fragmentation of knowledge. *The Library of Art History* was conceived in response to this growing demand.

H. W. Janson

Contents

H. A. Groenewegen-Frankfort

PART ONE

Egypt · Mesopotamia · Crete and Mycenae

Preface

If to attempt the impossible means either a heroic or a frivolous undertaking, then an author planning a short history of ancient Near Eastern art may well feel that he is faced with a similar alternative. For his material is not only vast and varied, it is utterly alien. He may therefore distrust a shortcut to aesthetic appreciation and be convinced that his approach should lie through a jungle of unfamiliar modes of thought, strange forms of experience: a long and difficult road, too long for a short survey. How is he to solve the dilemma?

I have neither solved nor quite evaded it. Convinced as I am that Near Eastern art is difficult of approach, I have on the one hand avoided giving the reader a false sense of snug proximity by overemphasizing familiar features, and on the other insisted on the need to penetrate beyond a mere analysis of form and style. My aim has been to make stylistic idiosyncrasies appear significant. This made it necessary, especially in dealing with religious art, to discuss at some length the dominating concepts and preoccupations of the milieu in which a style evolved. Admittedly these digressions were made at the expense of the already limited space at my disposal. I had to cut down the material to the barest minimum and to concentrate on the three main centers of original creativity, Egypt, Mesopotamia, and Crete, leaving out all peripheral and derivative art.

The reader may feel that I have cheated him out of a full measure of art history. My excuse is that by hinting at the existence of problems which lie beyond the range of facile appreciation I hoped to strike a spark of understanding in the reader that might start him off on a voyage of discovery.

As regards the choice of material, I was tempted not to illustrate several well-known masterpieces which may have become rather hackneyed, but I found that, especially in the case of Egyptian monuments, the gulf between great works of art and mere competent crafts-

manship is so wide that to give prominence to the latter would mean to misrepresent the scope of the former. If anywhere it is here that the warning of a well-known art historian[1] is valid: "It seems to be a lesson of history that the commonplace may be understood as a reduction of the exceptional, but that the exceptional cannot be understood by amplifying the commonplace."

In the order of treatment I have given first place to Egypt because of the wealth and above all the coherence of available material. Here the term "development," so often ambiguous in art history, is justified. In comparison Mesopotamian art appears chaotic, a matter of interrupted growth and spectacular efflorescence, not unlike the country's turbulent history. I have dealt with Crete last of all, not, however, because I consider its art a prelude to the second part of this volume; on the contrary, it is in a sense the most puzzling phenomenon to precede the appearance of Greek art and perhaps the most unlike it.

1

Egypt

THE ARCHAIC PERIOD AND THE OLD KINGDOM

It is a commonplace of Egyptian histories and art histories alike that they require a prefatory note on the Egyptian landscape. Evidently those who have experienced its haunting strangeness believe that here they may find a clue to what is equally strange in its monuments.

There is some truth in this and it is undeniable that no one who has lived south of Cairo for any length of time can escape from the spell of the country's unique configuration. Upper Egypt is entirely dominated by two coordinates, south-north, east west, and the simplicity of this structure owes its compelling quality, I believe, to the fact that it is pregnant with meaning: it embodies the antithesis of life and death. The south-north flowing river means life in terms of human existence: a narrow strip of cultivation reaches as far as, but no farther than, the river's silt deposit. On either side, in east and west, a horizontal line of cliffs irrevocably marks the boundaries of life, for beyond lies desert, lies death. Conversely it is

here in the realms of the rising and setting sun that the daily renewal of cosmic life takes place. Egyptian landscape has a symbolic significance that is inescapable, its grand monotony is final like a very simple truth. It is also undramatic, as is the rhythm of its seasons. No devastating storms occur, no flood disasters threaten, and at the time when in neighboring countries a merciless sun beats down on living creatures, the Nile majestically rises with its promise of renewed fertility. Death in life and life in death is the keynote of this landscape. But having said this I want to make it clear that I do not mean it as a glib "explanation" of the very obscure, very complex question of the Egyptian's attitude toward the problem of life and death. Nor is it merely meant to conjure up the mood which so easily responds to the clichés of Egyptian art history, the "static," the "timeless" quality of this art. Such epithets if used as catchwords may cover up rather than elucidate a host of problems.

We shall, however, do well to realize that the

description I have given applies only to Upper (southern) Egypt and that the Delta has and no doubt had a totally different character. This is important because Egypt's long history began with its unification. Kings of Upper Egypt conquered the northern region, and after that time the country was called the Two Lands; apparently, during the earlier dynasties, it was ruled from a region close to the meeting point of North and South. It is tempting to assume that the difference between the austere Nile valley and the featureless swampy Delta must have been reflected in their cultural remains. Unfortunately the Delta is, archaeologically speaking, an unknown quantity in the very period when Egyptian civilization in all its aspects begins to emerge. And though imaginative scholars have tried hard to fill the Delta vacuum with theories about its influence on Egyptian culture, these have remained so far purely speculative.[2]

Since I intend to devote all available space to mature Egyptian art, I shall not deal with the relics of successive prehistoric village cultures

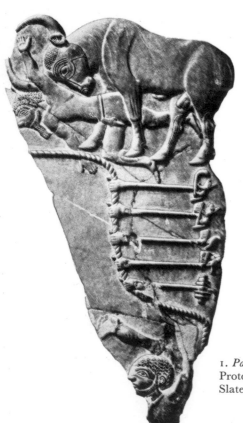

1. *Palette* (fragment), probably from Abydos.
Protodynastic, c. 4000–3200 B.C.
Slate, height 10 1/4″. The Louvre, Paris

and can refer only briefly to the so-called Protodynastic period, that fascinating, relatively short span of time, when in a dramatic upsurge of cultural creativity new forms of art appeared, architecture assumed monumental dimensions, and writing was invented, when in short a distinct and unmistakably Egyptian civilization emerged.[3] Where art is concerned we might sum up the change as follows: the prehistoric craftsman when decorating his utensils readily submitted to stylistic tradition. Animal and human motifs, even where the latter might have a religious significance, were subordinated to design. The Protodynastic artist was a highly individual creator. In the realm of plastic figures he boldly experimented and the figurative content in relief sculpture became increasingly independent of decorative function. We find for the first time pictorial statements which clearly reflect new political and religious preoccupations. Originality is the key word of this period, an originality which is by no means impaired by the fact that in its early stages there is more than a hint of influence from outside.[4] I shall limit myself to a brief outline of the development of tomb architecture, which forms a prelude to later funerary monuments, and show in a few examples of relief and sculpture in the round both the richness in experiment during the period and the trend toward a more formal discipline.

To begin with the reliefs, most important among the Protodynastic remains are large ornamental slate palettes which were found in the precincts of a temple. (In a small form such palettes were used in daily life for the pulverizing of malachite, the basis for eye paint.) The large votive palettes, carved in relief, can be roughly arranged in a time sequence, the earlier examples being decorated with animal designs while the later ones attempt some form of narrative. In these we can follow significant

2. *Macehead of King "Scorpion"* (drawing), from Hierakonpolis. Late Protodynastic, c. 3250 B.C. Limestone, height 9 1/2". Ashmolean Museum, Oxford

changes in the representation of the chief personage: the king of Egypt makes his earliest appearance. He is first depicted in the symbolical form of a lion or a bull (fig. 1) trampling on a human enemy, and there can be no doubt that both here and in a fragment of a gruesome battle scene a historic event has been commemorated. The allegorical but lively and dramatic statement of victory—note the cruel imprint of the bull's hoof on the man's soft calf muscle—marks an important innovation, for it shows that a single military event was considered to be of lasting importance and was pictorially rescued from oblivion.[5] We shall see that such commemorative scenes, which modern man is apt to take for granted, were by no means a universal concern of early artists in the Near East and that in fact they almost completely vanished from Egyptian art for reasons which we shall discuss later on, and only emerged on a grand scale in the late New Kingdom.

We find a different kind of commemoration on a large sculptured macehead, presumably of slightly later date, which depicts a named ruler: King "Scorpion" (fig. 2). Here the king appears in human form, presiding over a ceremony which, in all probability, inaugurated the opening of a new canal. Both the savagery and the chaotic grouping of the earlier scenes have disappeared. We see the king wielding a large hoe in what might be called the earliest attempt at a coherent landscape setting: a winding river or canal, trees in a wattle enclo-

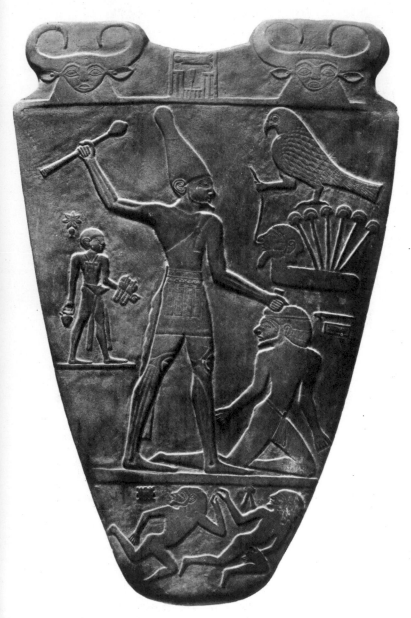

sure, two urgent figures hurrying to the scene
The effort to combine action and setting gives
to the former a curious "actuality" which is all
the more remarkable because nothing similar
was attempted for centuries to come. A pro-
found change in the concept of kingship and its
expression in art must have taken place between
the reign of King Scorpion and that of Narmer,
by tradition the first Egyptian Pharaoh and the
unifier of the Two Lands. The famous Narmer
palette clearly reveals this (fig. 3). Here the
king's image is utterly removed from the realm
of actuality. The bare groundline on which he
stands precludes the suggestion of a definite
locality, the formalized gesture lacks physical
brutality, while the sprawling figures at the
bottom of the palette make a poor remnant of
former battle scenes. In fact what we have here
is not a scene at all but a pictographic formula,
a timeless statement in the strict sense of the
word, namely: Pharaoh is conqueror. As such
it was to prove an extremely long-lived one,
because it expressed to perfection the super-
human character of the king's supremacy,
which from now onward began to dominate
what we might call the "theology" of kingship.
We shall return to this later.

The remains of Protodynastic sculpture in

3. *Palette of King Narmer*, from Hierakonpolis.
Dynasty I, c. 3200 B.C. Slate, height 25 1/4"
Egyptian Museum, Cairo

4. *Statuette of a King*, from Abydos.
Late Protodynastic–Dynasty I, c. 3200 B.C.
Ivory, height 3 3/8". British Museum, London

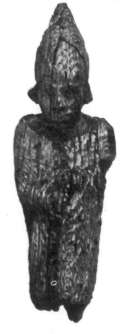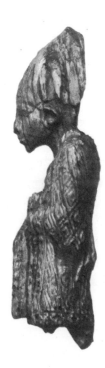

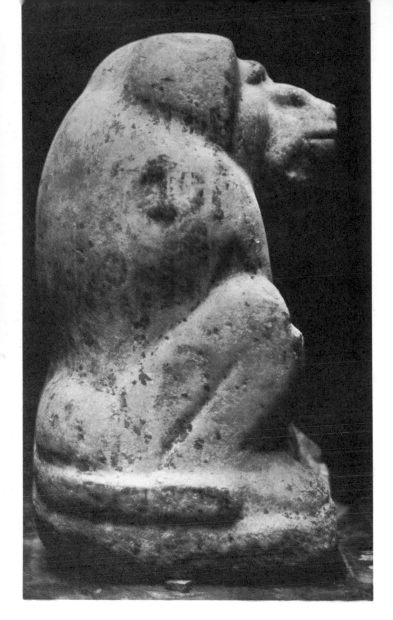
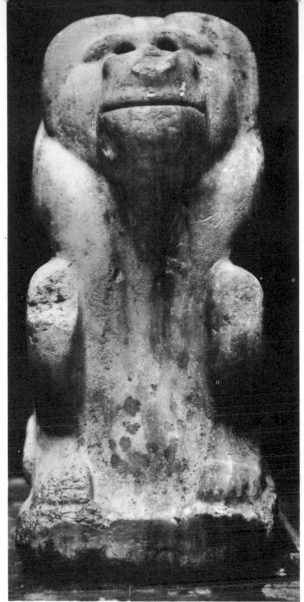

5. *Baboon with Hieroglyph of King Narmer.* Dynasty I, c. 3200 B.C. Alabaster, height 20 1/2″. State Museums, Berlin

the round are extraordinarily varied in style, ranging from a subtle rendering of the human form in ivory carvings to rigid formalization in stone figures. Since the bulk of the material is undated I have chosen only one "naturalistic" example, the striding figure of a king, wrapped in a patterned cloak (fig. 4). The curious posture with hunched shoulders and head thrust forward appears highly individual, as do the large loose mouth and wide protruding ears. It would be hard to find a more striking

contrast than between this exquisitely human and dynamic portrayal of royalty and the formal ideals which were to prevail in Old Kingdom statues of the Pharaoh. We possess one alabaster carving which bears the name of Narmer—the terse compact baboon (fig. 5). It is less severely self-contained than later examples which avoid the rather ugly downward thrust of the arms. But it is undeniable that this gesture gives the animal a peculiar fierceness which was lost later. Similarly the snarl of the

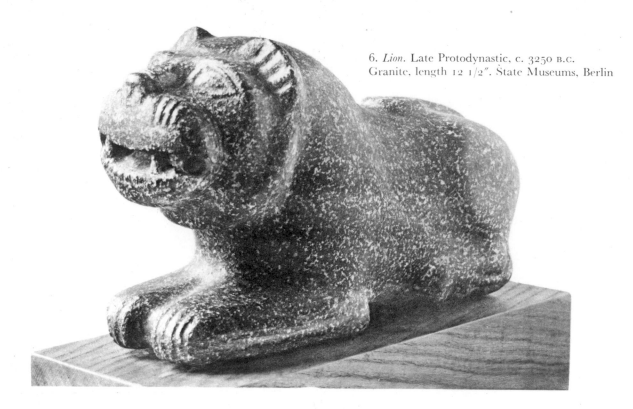

6. *Lion*. Late Protodynastic, c. 3250 B.C. Granite, length 12 1/2". State Museums, Berlin

wonderful granite lion (fig. 6) was never repeated in later leonine figures, which were dignified rather than terrifying.

The next royal statue of importance, which, like the objects we have mentioned so far, was found in the precincts of a temple, not in a tomb, is the slate figure of King Khasekhem (fig. 7). This brings us close to the end of the Second and the beginning of the Third Dynasty—that is, to the Old Kingdom. Technically it is an astonishing achievement, while stylistically it appears self-assured. The attitude chosen—a seated figure in repose—has plastic articulation; the plain cloak reveals corporeality without making it obtrusive, so that the emphasis is on the detailed treatment of the head, now sadly damaged. Nevertheless the round-shouldered, almost slouching, posture and the awkward gesture of the left fist pushed into the bend of the right arm make the work appear hybrid in character, both stiff and relaxed, lively and constrained.

As regards architecture, the Early Dynastic period saw the development of a monumental form of tomb. The earliest royal tombs in Upper Egypt consisted of a simple tumulus, a flat-topped rectangular hillock with a retaining wall of unbaked brick on the outside of which a stele marked the place of offering. This was succeeded in a few instances by more elaborate structures of the same shape but with recessed walls which, though mainly solid, contained tombshafts and passages (fig. 8). Recent excavations at Saqqara, near the apex of the Delta, have, however, revealed similar structures with even more complex interiors which proved to be contemporary with the early royal tombs at Abydos, so that it appears as if Upper Egyptian rulers, though buried at Saqqara, built cenotaphs in the land of their origin.[6]

The size and complexity of the Saqqara tombs is certainly startling; we even find one which consists of superimposed receding mastabas. Their development appears a rapid crescendo which rises to a dramatic climax in King Zoser's stepped pyramid (figs. 9–11). It

20

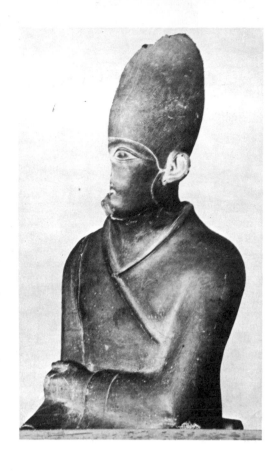

is right and proper that the man who conceived
and executed this astounding project, the vizier
Imhotep, should have been remembered for
millennia as a great magician. He was, by any
standard.

It should be realized that the entire work
was carried out in stone, which had so far been

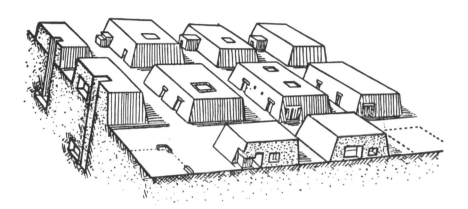

8. Group of Mastabas. *Reconstruction drawing* (after A. Badawy)

9. Funerary District of King Zoser, Saqqara. Dynasty III, c. 2750 B.C. *Partial view*

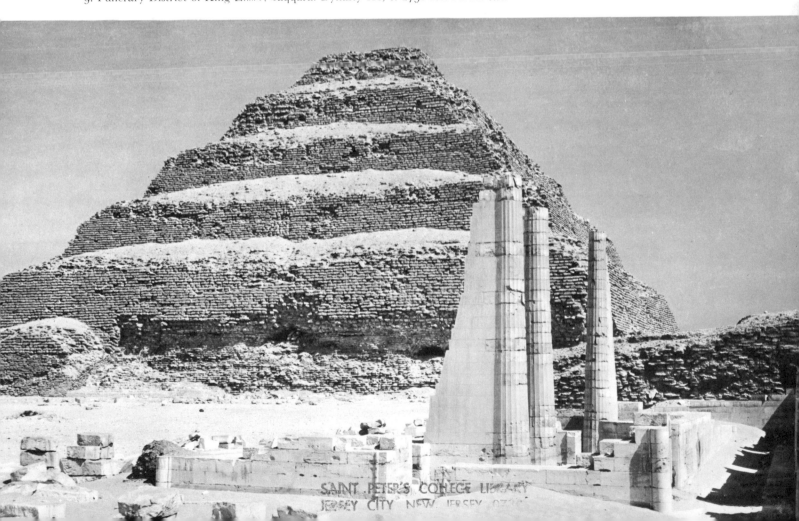

only occasionally and sparingly used; and that the pyramid itself was only part of a vast building complex within an enclosure wall (figs. 10, 11). In fact the soaring tumulus which marked the king's grave had grouped about it, in effigy, all those buildings in which the royal power had functioned during the king's lifetime. On the north side of the pyramid, in a small serdab[7] built up against it, was placed the statue of the king (figs. 12, 13), not as a monument to past glory, for it was entirely hidden except for two openings at eye level, but as a lasting presence.

There is no doubt that this statue, placed so near the actual tomb yet linked with the space where ritual would be enacted before its eyes, did not represent the king in his lifetime, but as living after death. As such it no doubt differed from other figures, probably standing, of which a few tantalizing fragments have been found in different parts of the building, but we can compare it with the votive, not funerary, statue of Khasekhem (fig. 7). The latter's low-backed seat has become a nobly proportioned throne; the gesture of the clenched fist has been abandoned, the dead king's arm and hand merely rest in his cloak. It must be admitted that the concept of the dead as "living," even if it is alien to us, has been superbly expressed.

The harsh cubic structure of the body with its emaciated limbs suggest an immobility deeper than repose. The face framed by the vertical strands of an elaborate wig that is partly covered by the royal headcloth may well have been even more fearsome when the now cavernous sockets still held their eyeballs (fig. 13). The ugly features, the heavy mouth, powerful to the point of brutality, are strikingly individual, and yet the figure as a whole is utterly remote, estranged from actuality. There is no question here of transfiguration, of an idealized human form, nor of a mere juxtaposition of living face and lifeless body; life and death are indissolubly correlated. This harmony of incompatibles was to remain the hallmark of all Egyptian funerary statues, which should for this very reason always be seen *as a whole*. To concentrate on the lifelikeness of the face alone, as is so often done, means to miss their significance, their paradoxical, alien character. It is true that this harmony was only achieved in the great masterpieces, that its balance rested on a razor's edge, for there was always the threat of

10. Funerary District of King Zoser, Saqqara. Dynasty III, c. 2750 B.C. *Model*

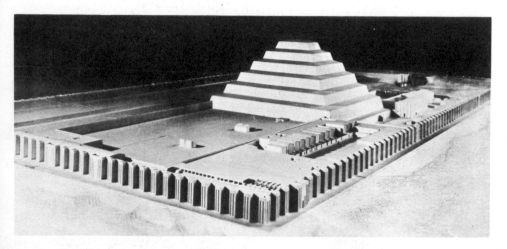

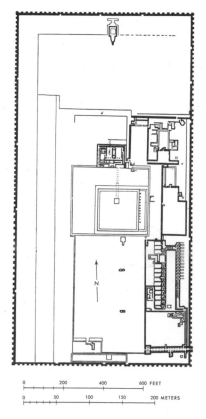

11. Funerary District of King Zoser, Saqqara. Dynasty III, c. 2750 B.C. *Plan* (M. Hirmer after J. P. Lauer)

its sliding off into trivial realism on the one hand, or dull lifelessness on the other. Again I would like to quote the scholar I mentioned earlier, because he has pointed out that in the history of art so often "an adventurous proposition sinks to a platitude and . . . genius is engulfed by complacency and inertia."[8] That this soon occurred in the Old Kingdom we shall see later. First, however, we might try to fathom in terms of religious concepts what was the meaning of this first great "adventurous proposition," of kingship thus portrayed.

Let me first make it clear that I shall concentrate on kingship as a socioreligious creed, not on the actualities of pharaonic rule, for it is essential that we should probe its meaning and not merely reject its apparent absurdities.[9] We should not forget that an uncomprehending outsider might treat Christianity and its bloodstained history in much the same way.

The comparison is not meant to be entirely ironical, for in both cases the outsider would be faced with and baffled by an all-important paradox. This is, in the case of Egypt, not the dogma of an incarnate God but the concept that the king was divine: in other words, the earthly and the transcendent realm interpenetrated in the person of the king in such a way that the maintenance of order in society by the king had divine support, and that conversely he shared in the responsibility for cosmic order and the renewal of life. This religious paradox carried with it the conviction that regal power could not be considered as entirely dependent on the accidental span of a king's life but needed periodic renewal: in a jubilee, the so-called Heb-Sed festival, the king passed through ritual death and was reborn. Nor could the crisis of his actual decease mean the end of his power; this was emphatically denied in the assertion of his having attained a new and unchanging form of life.

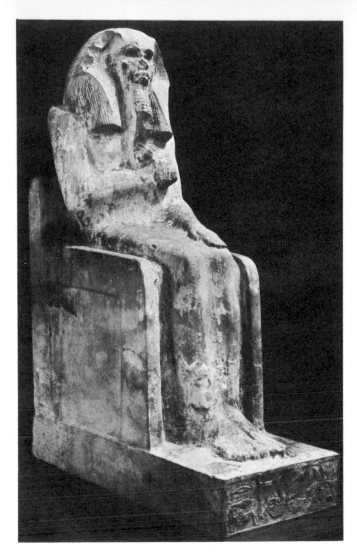

12. *King Zoser*, from Saqqara. Dynasty III, c. 2750 B.C. Limestone, height 55″. Egyptian Museum, Cairo

13. *King Zoser* (upper portion of statue in fig. 12)

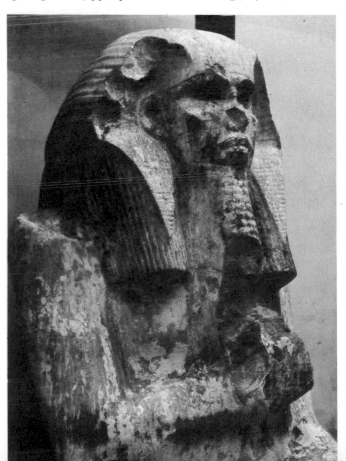

It is well known that similar concepts of kingship prevailed on African soil and survive to this day. What should be realized, however, is that in the case of Egypt a highly gifted, intelligent people was faced with the necessity of making a rather primitive tribal creed compatible with a large and increasingly complex state, at a time when religious speculation had probably already reached great metaphysical depth. We do not know precisely what social conditions, what religious convictions, were encountered when the kings of Upper Egypt, where African affinities were no doubt strongest, subdued the North. All the available evidence points to at least two very early and important religious centers: Heliopolis, with its sun worship, and Memphis, where a remarkably mature form of abstract speculation had its origin.[10] Whatever the impact, the outcome of this encounter was no longer a tribal creed backed up by force and shrewd politics, but a theology of kingship based on the grand conception of divine powers being immanent in nature and the state alike. The king, so it was explicitly stated, was the transmitter and the

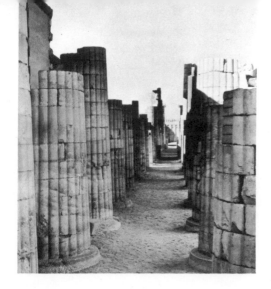

15. Columnar Entrance Hall, Funerary District of King Zoser, Saqqara. Dynasty III, c. 2750 B.C.

guarantor of divine order, of *maat*, a word that has both cosmic and social connotations, though it is often translated as justice or truth.

In attempting to sum up complex religious ideas in a few phrases we can do no more than bring essentials into focus, but this at least enables us to see the complex layout of Zoser's monument in the right perspective: there can be no doubt that it signifies the transcendent character of regal power. This phrase, however, seems to shrivel into insignificance when we are confronted with the actual building and realize the stupendous effort it must have entailed.[11] The enclosure wall alone measured more than a mile around, while the central pyramid (fig. 9), built over an initially planned smaller mastaba, rose to 204 feet and has a rectangular base of 411 by 358 feet. Inside it a tombshaft led to the sarcophagus chamber, and after the burial it was closed with a granite prop weighing six tons. Other passages led to subterranean chambers which were lined with blue-green tiles, undoubtedly imitating matted reeds and representing a hallowed archaic structure of wooden poles and mats that had already occurred in early pictograms and was long to function as a holy shrine. Here in a setting that suggests a false door were found three panels in

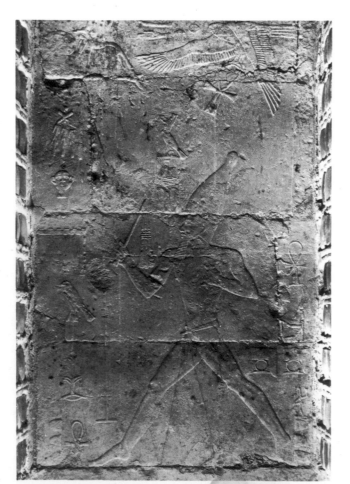

14. *King Zoser Performing the "Dance of Offering."* Dynasty III, c. 2750 B.C. Limestone relief. South Tomb, Funerary District of King Zoser, Saqqara

relief representing Zoser;[12] paradoxically, it is close to the reality of death that we see the king in action, not in defiant or self-assertive but in devout action, visiting holy shrines and performing the "dance of offering" (fig. 14). He appears a youthful, resilient figure, whose profile, with heavy jowl, strikingly resembles that of the statue in the serdab (figs. 12, 13).

The enclosure furthermore contained a temple—or perhaps a palace—on the north side of the pyramid, extensive magazines in the west, and in the southeast the unobtrusive entrance to the whole, which led into an imposing colonnade consisting of rows of engaged ribbed columns. North of this entrance we find the strange dummy buildings, mostly filled with rubble, which represent a Heb-Sed hall with a double row of shrines, and other unidentified buildings. Throughout the entire complex the columns and façades meticulously imitate in stone the wood, palm ribs, mats, papyrus, or bricks of which the originals were made. We even find petrified half-open doors! Among the rich harvest of new architectural forms scholars were amazed to find the nearest prototypes of Doric columns, though "engaged" rather than freestanding, at 2700 B.C., and some blamed the Egyptians for not adhering to these fine proportions (fig. 15), but indulging in a variety of frail and untectonic-looking columnar forms of vegetable origin (fig. 16). Such critics missed the point, because these chapels and offices were intended to be translations into stone of the slight buildings of perishable material that were put up *ad hoc* for various royal functions in different parts of the country. In other words the adjuncts of royal power, or in the case of the Heb-Sed hall, of the renewal of power, were here made permanent.

Are we then justified in accepting the commonplace that all that the Pharaoh—or for that matter any of his subjects—ever aimed at was to continue after death the activities of his lifetime, and that life's appurtenances were

16. Papyrus Half-Columns, East Façade of North Palace, Funerary District of King Zoser, Saqqara. Dynasty III, c. 2750 B.C.

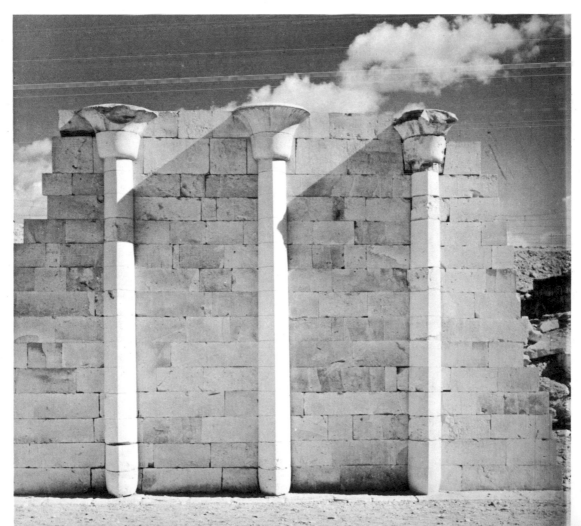

needed for the magic to bring this about? If this were so, Zoser's monument would be no more than a monstrous outgrowth of primitive magic. We shall deal with this problem later in connection with the private tombs, but we should note here that several of the so-called Pyramid Texts, an admittedly confused and often contradictory mass of religious hymns, ritual incantations, and magic spells which were recorded on the walls of the pyramids at the end of the Old Kingdom, have been dated to Zoser's reign on philological grounds. There is not a single one that suggests the late Pharaoh flitting among dummy buildings in order to exercise his ghostly royal prerogatives. On the contrary, the poetic images of the hymns generally invoke the king as indeed a transcendent being, flying to the sky, being welcomed by the gods, crossing the water to reach the Elysian fields. But why then, one may ask, this weight of stone, marking and surrounding his earthly remains?

We saw that the theology of kingship emphasizes the intimate bond between divine and earthly rulers. Since, however, the hallmark of cosmic order is its eternal, unchanging character, permanence on earth must have appeared to partake of the numinous, and *to make permanent* could become a religious act. The Egyptian equivalent of the Christian idea of eternity, or the Hindu ideal of timelessness, was life everlasting. And in so far as life was not merely considered a pleasurable state of being but—especially in the case of the Pharaoh—a manifestation of the divine, this was more than a childish wish, it was a religious paradox.

We may concede that in Zoser's building project an element of defiant ostentation probably played a part, that the ritual enacted around the pyramid was tainted with primitive magic,[13] that the effort to challenge time and to compel it to submit to size and durability was a tragic illusion, but unless we see the monument in its speculative context we cannot do justice to its form. This is all the more regrettable because the step pyramid inaugurates an era of still greater achievement, in which its monumental purpose was clarified and even more nobly expressed: the era of the great pyramid builders.

There still exist three gigantic structures[14] which mark the transition from Zoser's pyramid to the greatest and most perfect examples, the pyramids built by Cheops, Chephren, and Mycerinus at Giza. When finally Cheops built his stupendous monument on the rock plateau at Giza, the change was not merely one from trial and error to crystalline perfection; Zoser's structure of superimposed receding mastabas still appears earth-bound, that of Cheops with its once-gleaming polished sides belongs equally to the realm of light.

I shall omit a detailed description of the Giza pyramids, since the facts of their size, the problems of their construction, the miraculous precision of their execution are outside the

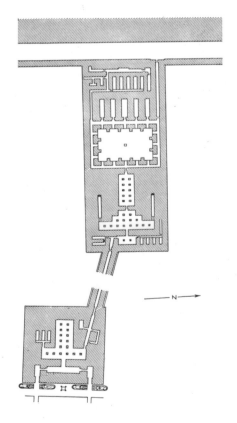

17. Valley Temple (below) and
Mortuary Temple (above) of King Chephren, Giza.
Dynasty IV, c. 2600 B.C. *Plan*

26

scope of this book and are moreover fairly common knowledge.[15] It is the change in the architectural plan as a whole, apparently already inaugurated by Snefru, which we have to consider. Little is left of the actual temples belonging to Cheops' monument, but in the case of Chephren at least one temple has been largely preserved and enough remains of the rest to warrant an authentic reconstruction (fig. 17). Compared with Zoser's monument the change is striking indeed. Gone are the centralized layout, the vast enclosure wall, the petrified adjuncts of power or the renewal of power, gone the serdab built up against the pyramid with the image of the dead monarch, hidden but watchful. We find instead an emphasis on processional movement, starting from a valley temple built near the edge of the Nile's floodwater and leading along a covered causeway to a mortuary temple situated at the foot of the pyramid but outside the wall which surrounds it. Here the movement comes to a halt in a small shrine where a niche, which must have contained a stele or perhaps a false door, points toward the final mystery, the triumphant assertion of the royal tomb.

Where this change reflects a shift in religious emphasis and ritual procedure, its precise significance is beyond recall. What concerns us here is that in conceiving this gradual approach toward the threshold of eternal life, architects created entirely new, not imitative, forms in which to express the dominant religious ideas of their time. The valley temple may have outwardly resembled a huge granite mastaba with sloping sides and two plain entrance doors. But the T-shaped hall which it contains, with its wonderfully proportioned, harmoniously spaced square pillars, is an original concept (fig. 18). It is uncompromisingly austere with walls, pillars, and architraves of polished granite, a floor of alabaster. But this very austerity emphasizes the numinous quality of stone as a symbol of eternity.

18. Hall of Pillars, Valley Temple of King Chephren, Giza. Dynasty IV, c. 2600 B.C.

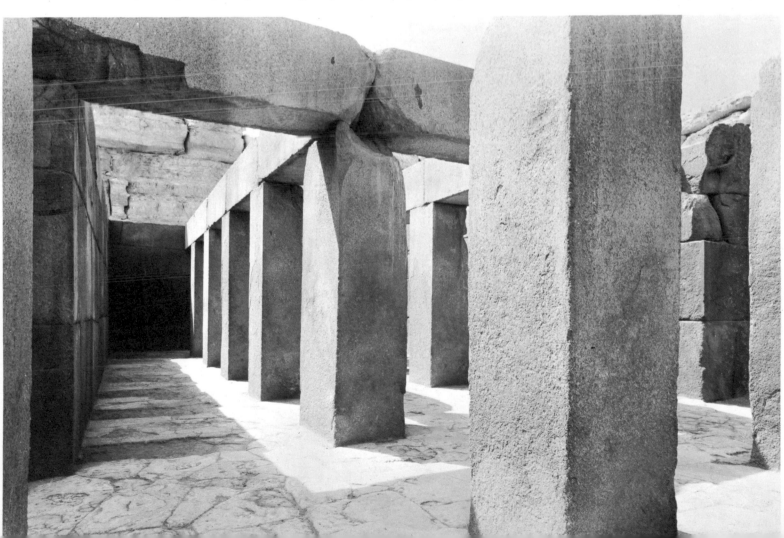

A number of seated statues, twenty-three in all, were placed against the granite wall and lit from above by oblique slits in the roof. This numerical increase hints at a more abstract concept of royal power, for an array of almost identical images, which may each have had a function in ritual, could hardly bear the full weight of the king's individuality, as did, for instance, Zoser's statue in its brooding isolation. These statues, carved in diorite, basalt, limestone, and alabaster, apparently all differed slightly, though they may well have aimed at the same type of stylization. One superb example is given in figure 19. Here we do not find a balance between the portrayal of a living person and a lifeless form, but a barely individual, idealized head that is in complete harmony with the utter tranquillity of the body, a firm, not an emaciated, body with a hint of concentrated power in the closed right fist. The

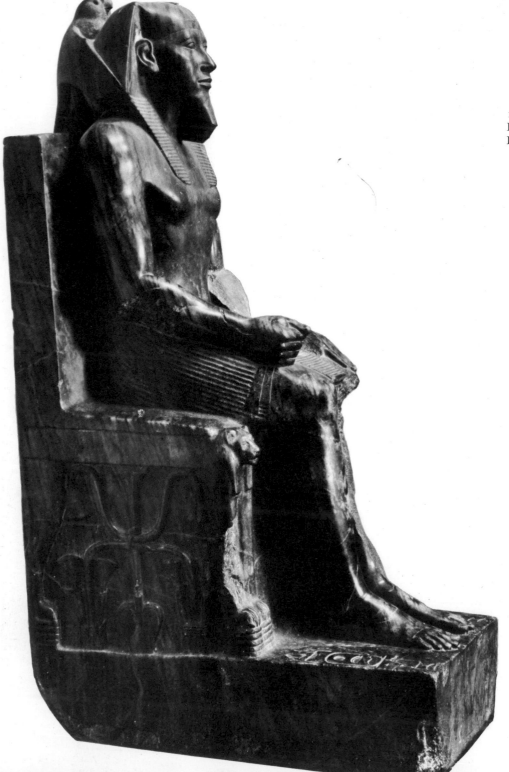

19. *King Chephren*, from his Valley Temple, Giza. Dynasty IV, c. 2600 B.C. Diorite, height 66 1/8". Egyptian Museum, Cairo

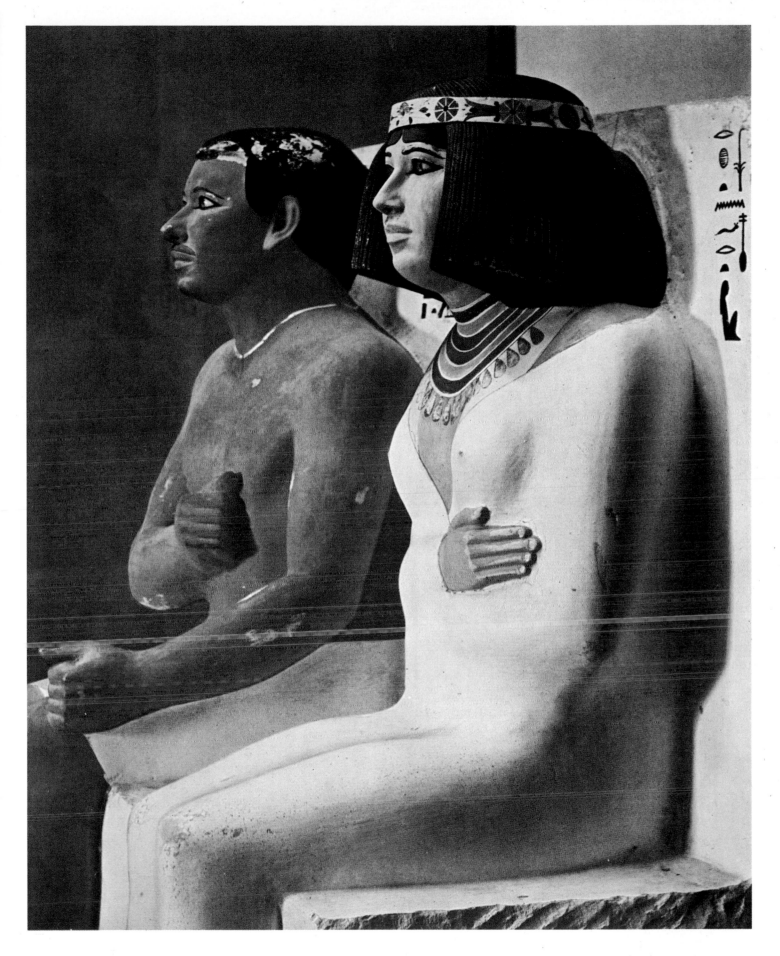

Colorplate 1. *Prince Rahotep and His Wife Nofret*, from the Tomb of Rahotep, Medum.
Dynasty IV, c. 2660 B.C. Painted limestone, height 47 1/4″. Egyptian Museum, Cairo

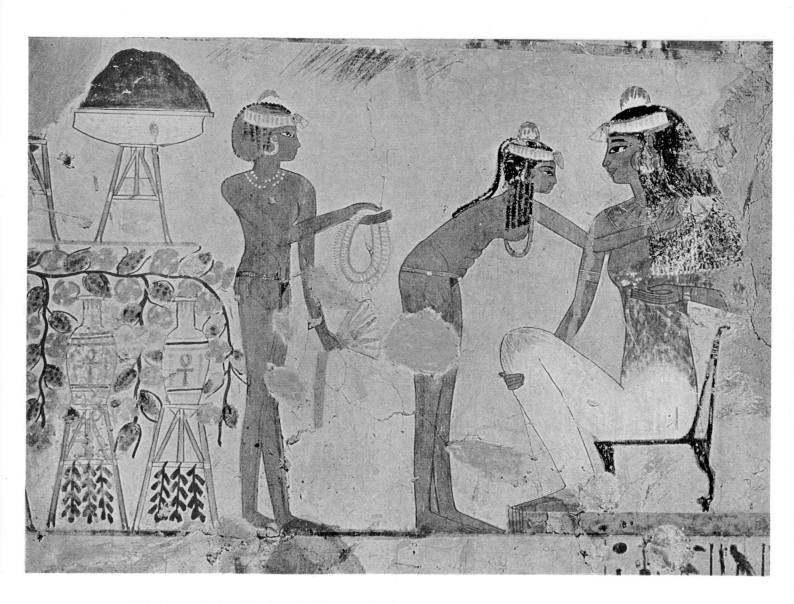

Colorplate 2. *Lady and Serving Girls.* Dynasty XVIII, c. 1420 B.C.
Wall painting (detail). Tomb of Djeser-ka-re-seneb, Thebes

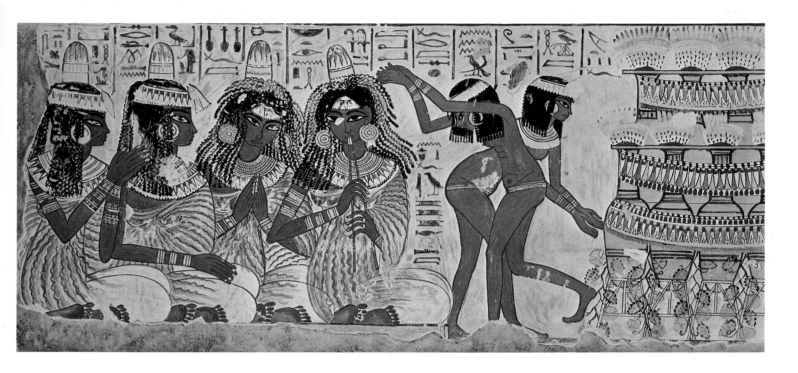

Colorplate 3. *Musicians and Dancers*. Dynasty XVIII, c. 1420 B.C. Wall painting (detail).
Tomb of Nakht, Thebes (tempera copy by N. de Garis Davies in The Oriental Institute, University of Chicago)

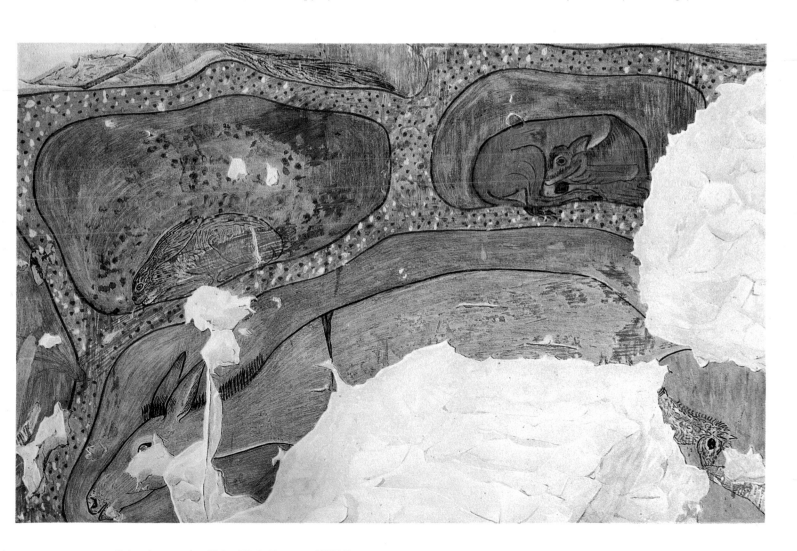

Colorplate 4. *Ass Giving Birth*. Dynasty XVIII, c. 1425 B.C. Wall painting (detail).
Tomb of Kenamun, Thebes (tempera copy by N. de Garis Davies in The Oriental Institute, University of Chicago)

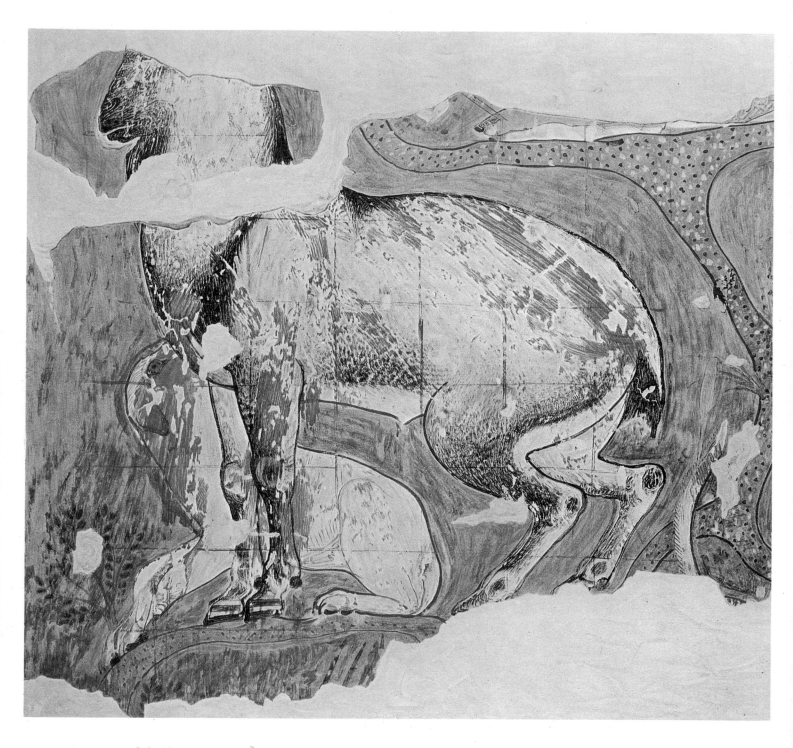

Colorplate 5. *Ibex and Hunting Dog*. Dynasty XVIII, c. 1425 B.C. Wall painting (detail).
Tomb of Kenamun, Thebes (tempera copy by N. de Garis Davies in The Oriental Institute, University of Chicago)

surpassing serenity of the face, enfolded by the protective wings of Horus, the divine hawk, appears otherworldly and yet of this world. The paradox of divine kingship is here expressed in transfigured majesty.

It is possible that the long covered causeway leading up to the mortuary temple was not entirely unadorned. A few fragments of very fine limestone relief suggest that the walls of both Cheops' and Chephren's causeways were decorated with the figures of tribute-bearing minor deities, such as commonly occur in the Fifth Dynasty royal monuments. But Chephren's mortuary temple was in all probability as austere as his valley temple. A remarkable feature of this rather complex building is an open courtyard, linked by doorways with a surrounding passage which on the east side gives access to five deep niches.[16] Inside the courtyard large statues were apparently placed at intervals around the periphery. The very cautious architect responsible for the excavation[17] found reason to assume that they were royal figures in the form of Osiris, an upright mummylike swathed figure with crossed arms. If this assumption is correct, these figures would be the first known appearance of the god Osiris, or rather of the king as Osiris; and since this god was to play such an important part in art and religion we have, for a moment, to consider the problems involved.

The central fact, which cannot be over-emphasized, is that at some time during the Old Kingdom the Pharaoh became identified with Osiris after his death; in other words, Osiris *was* the dead king, not, as he became in later times, the king of the dead. The emblems of Osiris, the crook and the flail, appear to have been borrowed from an Eastern Delta god, Andjeti, who may, for all we know, have resembled the type of "dying" god that occurred in different forms in the Near East, a fertility

god whose seasonable death was bewailed, whose resurrection was celebrated with joy. In the case of such a resemblance it would be quite natural for the figures of a divine, though mortal, king and of a "dying" god to coalesce—and for the king, as Osiris, to gradually acquire, as in fact he did, all the characteristics of a chthonic, or underworld, fertility god.

It may appear strange that the chthonic as well as the heavenly aspects of the king's divine powers were allowed to exist side by side, not only in the hymns and the ritual of the Pyramid Texts but throughout Chephren's funerary monument: in the mortuary temple the king was apparently embodied in Osiride figures; in the valley temple the heavenly falcon Horus was his protector; and outside, the immense lion-bodied figure of Chephren as sphinx, carved out of the living rock, faced the rising sun. The reason is that all phenomena bearing on the renewal of life could be not only religiously apprehended but focused on the king: the river in flood, the earth's fecundity, the rising sun, the never-setting circumpolar stars.

It seems undeniable that conceptually and artistically the work of Chephren's reign marks a climax, for though the architectural layout of the pyramid complex provided a scheme which was more or less adhered to throughout the Old Kingdom, the statues of Mycerinus, his successor, already reveal a subtle decline. Not a disintegration of form, for these statues, singly, in pairs or triads, are taut and vigorous and show a new interest in anatomical detail. In fact they suffer from an excess of vigor, an overemphasis on physical well-being. It is not the rather charming plainness of the man, his bulbous nose, fleshy cheeks, protruding eyes (which must delight the hunters for realism in Egyptian art), that make these statues unimpressive, even a trifle common; it is the fact that they do not suggest any metaphysical

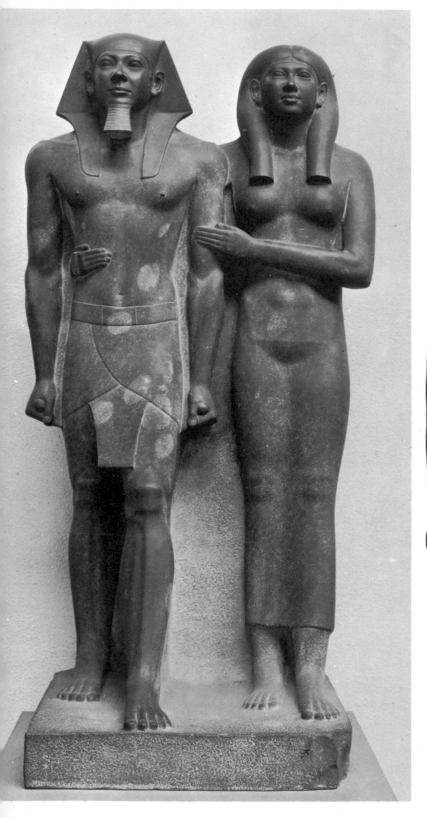

20. *Mycerinus and His Queen Khamerernebty,*
from the Valley Temple of Mycerinus, Giza.
Dynasty IV, c. 2570 B.C. Slate with traces of paint, height 56 7/8".
Museum of Fine Arts, Boston

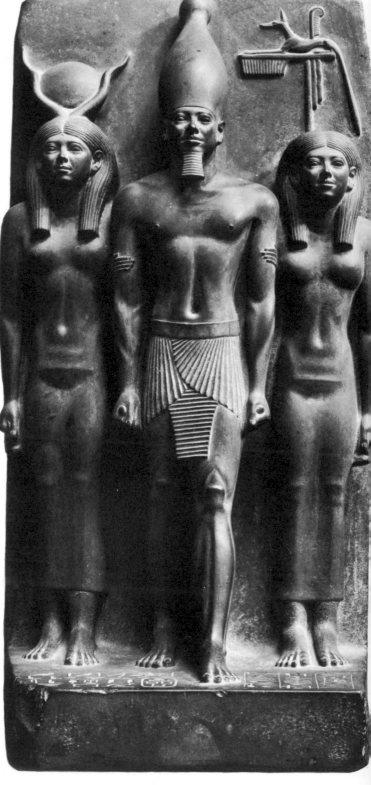

21. *Mycerinus, Hathor, and Local Deity,*
from the Valley Temple of Mycerinus, Giza.
Dynasty IV, c. 2570 B.C. Green slate, height 37 3/8".
Egyptian Museum, Cairo

awareness. The paradox of life in death, the ideal of a monumental form of life, appear forgotten or ignored in favor of a blatant vitality (fig. 20). The result is that the rigid pose, so meaningful in the earlier statues, does not appear an artistic necessity, the plastic expression of a conceptual paradox, but an alien constraint imposed on muscular vigor. Nor is this rigidity alleviated by the upright stance and quasi-striding position of the leg, which may have been copied from reliefs; it merely makes the protecting gesture of the goddesses in the triad of figure 21 slightly absurd, as if they had to keep their charge in check. Here we might point out that while Mycerinus is frequently shown in conjunction with his wife or protecting deities, the latter are, except for their attributes, indistinguishable from the former in appearance and gesture. The goddesses seem well-intentioned females, not awesome presences, the king appears self-assertive rather than reverent.

It is probably inevitable that as the king's stature approximated that of the gods, the latter, since they lacked his concrete individuality, should become a mere formula. This is particularly clear in the unrelieved dullness of those reliefs of the Fifth and Sixth Dynasties where a goddess suckles a king, or divinities bring him their life-sustaining gifts. It must be admitted that Egyptian artists, who could create a human image *sub specie aeternitatis*, failed throughout to conjure up the fearsome qualities of divine power. Their gods remain lifeless clichés. A comparison with an early Sumerian example will make this clear. The god Abu (fig. 104) with his immense all-seeing eyes suggests the *mysterium tremendum*, the awesome secret of divine power and wisdom. The Egyptian artists on the other hand never showed awareness of the gods' complete "otherness." Even the so-called animal gods, where they

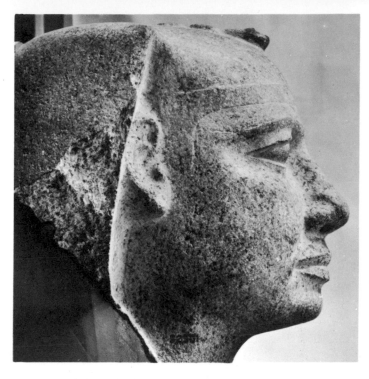

22. *Head of King Userkaf*, from his Pyramid Temple, Saqqara. Dynasty V, c. 2560 B.C. Aswan granite, height 26 1/2". Egyptian Museum, Cairo

appear in the reliefs, are not inscrutable monstrosities; an animal's head mechanically joined to a human body turns these composite figures into mere pictograms, indicating which god was meant to be represented. Apparently the concept of the king as link between the temporal and the transcendent barred the way to more dramatic forms of religious experience and expression. The emphasis on divine protection, then, does not add a new dimension to the all-too-human portrayal of Mycerinus, and we perceive a sliding off from that precarious balance which we noted earlier, in the direction of "realism." Unfortunately we cannot follow the development of royal portraiture in the Fifth and Sixth Dynasties because only one magnificent colossal head, that of Userkaf, has been found (fig. 22). Here the size may have demanded a broad and simple treatment, the result of which is majestic and remote. The absence of royal statues in the Fifth Dynasty is, however, compensated for by a wealth of scenes in relief which proclaim the king's power and

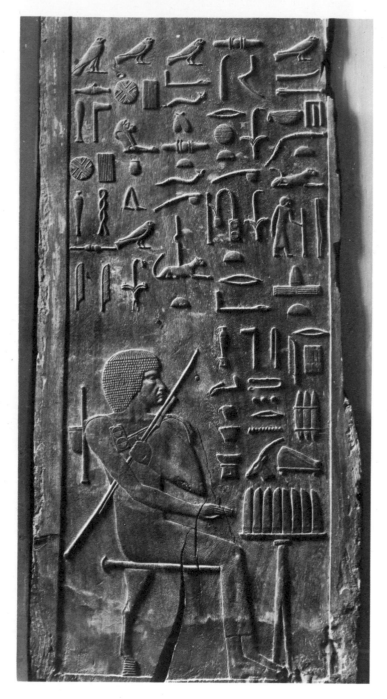

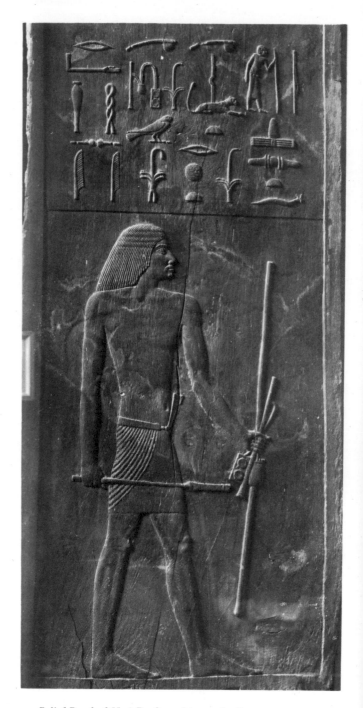

23. *Relief Panel of Hesi-Re*, from his tomb, Saqqara.
Dynasty III, c. 2750 B.C. Wood, height 45″.
Egyptian Museum, Cairo

24. *Relief Panel of Hesi-Re*, from his tomb, Saqqara.
Dynasty III, c. 2750 B.C. Wood, height 45″.
Egyptian Museum, Cairo

glory. We shall deal with these later and in connection with the private tombs to which we must now turn.

The first dated tomb of a nonroyal personage is that of Hesi-Re, who was a contemporary of Zoser, at Saqqara. Its layout is unusual for it has a long passage with false doors on one side, each of which contained a wooden panel with the figure of the owner in low relief (figs. 23, 24), while on the opposite side was an elaborate display, in painting, of worldly goods, complete with lists of food and clothing. The carving of

the reliefs is as delicate as that in the blue chambers of his master Zoser's pyramid. Unlike Zoser, however, Hesi-Re is not depicted in action but merely as alive after death: a thin, austere, elongated figure with a deeply furrowed face, inactive, although when seated he stretches his hand toward the offering table. The pose of the standing figure does not represent a stride; both here and in later examples it is a device to give maximum clarity to the three-dimensional human figure when it has to be rendered on a flat surface. For the same reason the shoulder region is frontal, though the hips are not, and the eye is not foreshortened in the profile face. The transition from torso to hips is extremely subtle—note the left nipple in profile, the navel in half profile—and the resulting pattern is so satisfying that one accepts the identical feet almost as a decorative necessity. In fact we find for the first time here and in the reliefs of Zoser the classical canon for the design of the human figure, which was used for millennia to come. Before blaming the Egyptians, however, for their stubborn adherence to tradition it might be worth considering its advantages, apart from clarity, balance, and the fact that its curious flatness leaves the surface of the wall intact: the spectator cannot ignore the wall by moving in imagination around the figure. Its main advantage was, as I have pointed out elsewhere,[18] that this type of composite, "paratactic" rendering is particularly apt when either the living dead or transcendent beings are depicted. Such figures are not functionally related to the spectator's viewpoint; they appear to exist in an alien world remote from any consideration of space and time.

As regards the layout of the tomb, the placing of the reliefs in the center of false doors undoubtedly suggests the desire for contact between the worlds of the living and of the dead, which always haunted the Egyptians' imagination. Does this mean that in life he envisaged the prospect of posthumous gluttony and comfort, which the rendering of food and chattels would bring magically within his reach? The noble austerity of the figure seems to belie this thought, and though admittedly nothing is thereby proved or disproved, we might give Hesi-Re the benefit of the doubt—especially since many modern funerary practices could be explained in equally derogatory terms. It should be remembered that this tomb lay in the shadow of the pyramid complex where the king's power and glory were, so it was hoped, made permanent on earth. Inevitably the king must have drawn toward himself the main body of religious speculation on life after death. But the belief that his actual existence—his body, his power, his wealth—could and should be eternalized by preservation or in effigy, must have suffused ancient practices with a new significance, especially in the case of those who were closely linked with the king, such as his kinsmen and high officials. Man could not emulate a transcendent existence in the hereafter, but he could attain the numinous quality of eternity by perpetuating his individuality which was, like the king's person, inseparable from status, function, and wealth.[19]

It is tempting for modern man, used as he is to the concept of a disembodied soul, to dismiss this desire for perpetuity as "materialistic" and primitive. We shall see later that although these terms apply up to a point, they are irrelevant: greed and fear alone do not inspire great art. We have to probe beyond the obvious into this strange desire to render the dead as "living" but not time-bound.

We do not possess a statue of Hesi-Re, nor do we know if a number of rather squat, ungainly hard-stone figures which are generally termed "early," belong to this period. Since none was found *in situ*, we do not even know if they were

funerary or votive figures. The first known nonroyal funerary statues, dated to the reign of Snefru, are those of Prince Rahotep and his wife Nofret (fig. 25, colorplate 1). They appear a bold new venture. The modeling of the firm young bodies has a monumental simplicity, but the faces are staggeringly lifelike with their cleverly contrived shimmering eyeballs and dark pupils. These two very compelling individuals, the man open-faced, the woman secretive, the essence of femininity, seem to defy the very thought of death. And yet they also appear to lack potential movement, the essence of organic life. Their frozen immobility seems somehow final; it is as if they are caught in a geometric framework, bound by the unyielding verticals and horizontals of the stone from which they are only partly freed. The stone is left, uncom-

25. *Prince Rahotep and His Wife Nofret*, from the Tomb of Rahotep, Medum (see colorplate 1). Dynasty IV, c. 2660 B.C. Painted limestone, height 47 1/4". Egyptian Museum, Cairo

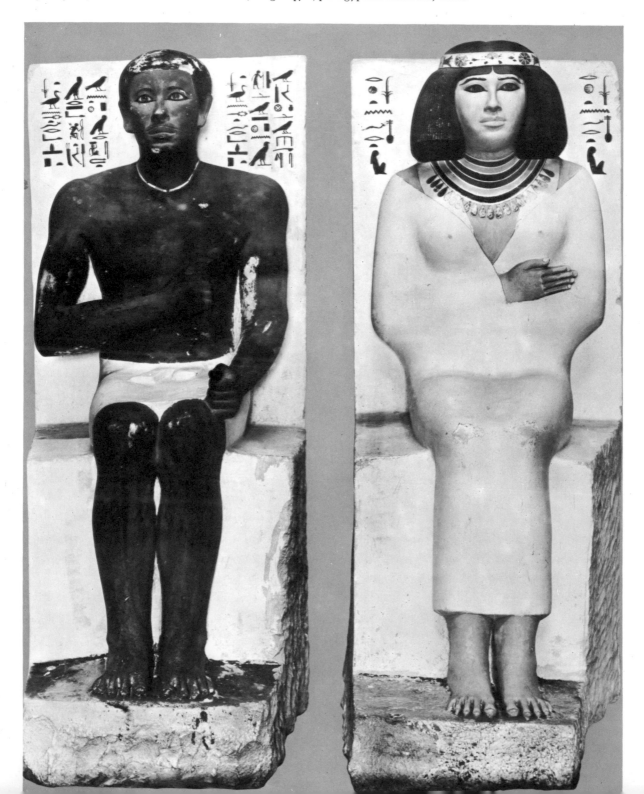

promisingly, for what it is, with no attempt at imitating a chair or throne. Here the function of the proverbial "cubism" of Egyptian art becomes apparent: the paradox of life-in-death could only be expressed by not allowing the human form to appear potentially mobile. The organic had to come to terms with the inorganic, if Egyptian art was to fulfill its strange religious purpose and achieve a "timeless" image. Rahotep and his wife are in this respect as convincing as Zoser's statue, but their youth, character, and charm have been immortalized with a delicacy and restraint which reveals a deep and reverent love of life. It is worth noting that in Rahotep's tomb as in that of his contemporary, Atet, this same attitude to life was expressed in yet another way; wealth as part of man's status was not given first place, but the pleasurable aspects of existence: the first scenes of daily life make their appearance. We shall deal with these presently but first consider the private statues of the Fourth and Fifth Dynasties, which were buried in the mastaba's serdab, completely hidden from view.

To those who may become depressed by the quantity of mediocre Old Kingdom sculpture in which genius was either "engulfed by complacency or inertia" or went astray along the bypaths of common realism, the freshness and daring of the early masterpieces seem almost miraculous, for each presents a different formal solution to the problem of a timeless image, each a different vision of human values.

In the statue of Hemiunu (fig. 26), the vizier of Cheops, for example, the torso has been entirely freed from the stone, but not even the soft modeling of its ample flesh can disguise the rigidity of the pose, which is as harshly angular as the cubic seat. It is remarkable that the emphasis on the abnormally fat chest and the rolls of flesh has not lapsed into the kind of realism that would make the body's immobility

26. *Hemiunu, Vizier of Cheops*, from the Western Cemetery, Giza. Dynasty IV, c. 2650 B.C. Limestone, height including base 61 1/2". Roemer-Pelizaeus Museum, Hildesheim

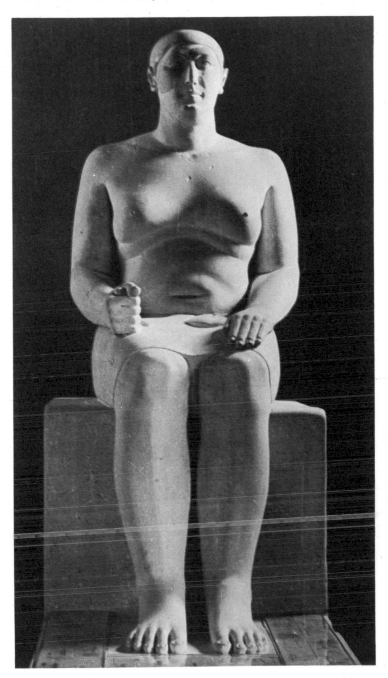

appear due to the lethargy of a very fat man; for there is no sagging in the upright posture. Heaviness harmonizes naturally with inorganic immobility and perhaps that is why the strange body and the remarkably intelligent face, with

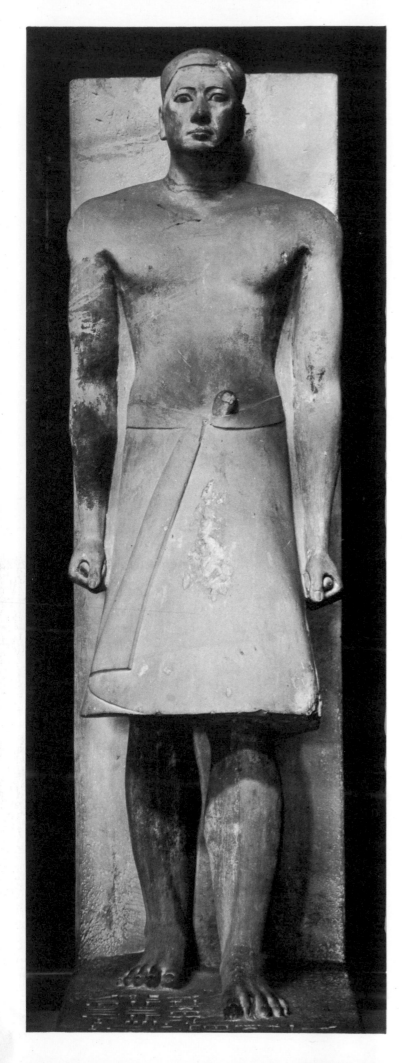

its fine aquiline nose and small firm mouth, share the same surpassing dignity and self-assurance.

Two magnificent statues of Ranofer (figs. 27, 28), almost certainly by different artists, show yet another approach to the problem of the timeless image. The figures are not freed from their angular slabs, nor does the stance with one leg forward—again probably copied from reliefs—suggest a striding movement. The limbs are, as always in Egyptian art, heavy and inert; they epitomize the immobility of the entire posture, so that the left leg appears a diagonal prop. In figure 28 the head is enfolded by the winglike spread of a deeply undercut wig, which leaves the wide brow exposed. The modeling of the face in broad smooth planes is subtle, most sensitive around the finely chiseled mouth (fig. 29). It is a noble, a serene, face that harmonizes with the treatment of the body. For this treatment is neither vigorous nor relaxed, it is an idealized pattern. The torso repeats in inversion the outline of the wig, the formalized loincloth makes a perfect transition to the lifeless limbs.

The contrast with figure 27 is very striking. The head without its protective wig seems strangely exposed, equally noble in the slightly harsher modeling but more vulnerable and with a touch of defiance. It is emphatically not a serene face and it has, like the torso, an air of suppressed vitality. The slight restlessness of the entire upper body is enhanced by the bold sweep of the stiff kilt. Its jutting lower edge, though repeating the horizontals of base and background slab, does not unify the figure, but severs the lower from the upper part and makes the legs appear even more incongruously clumsy.

It must be admitted that there are not many examples of this quality in Old Kingdom art, few that express so deep a faith in the lasting

27. *Ranofer, High Priest of Memphis,* from his tomb, Saqqara. Dynasty V, c. 2560 B.C. Limestone, height 72 7/8″. Egyptian Museum, Cairo

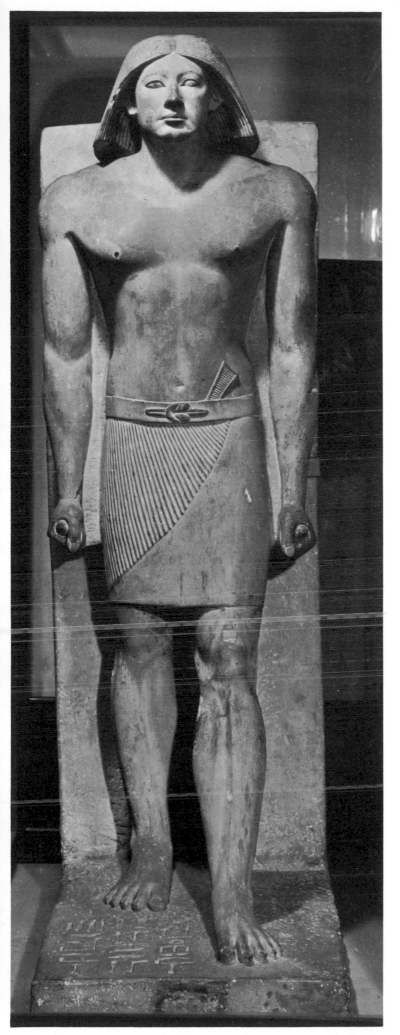

significance and value of individual man. This art was perilously poised between the ephemeral and the changeless. It is therefore not surprising that we find on the one hand the countless stiff, cliché figures, singly or in pairs, with or without offspring, with confident plump faces that monotonously proclaim a dull faith in dull perpetuity; and on the other hand figures so strikingly individual and alive that they appear a wholly secular "genre." We shall ignore the former and likewise the well-known, artless servant figures whose function was purely magical; as their number increased in the late Old Kingdom they often tempted craftsmen to playful experiment.[20]

More interesting artistically is the short-lived fashion of placing a so-called reserve head in the sarcophagus chamber. This custom, introduced at Giza during the Fourth Dynasty when serdab and chapel were usually sacrificed

left: 28. Ranofer, High Priest of Memphis, from his tomb, Saqqara. Limestone with traces of paint, height 70 7/8". Dynasty V, c. 2560 B.C. Egyptian Museum, Cairo

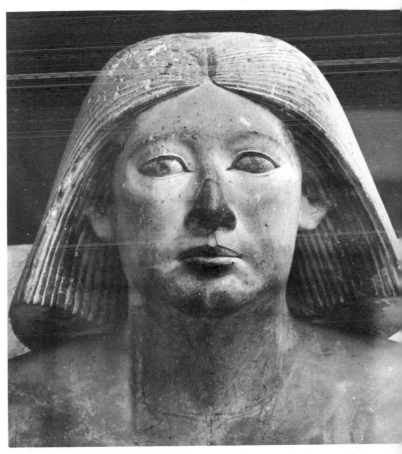

29. *Head of Ranofer* (portion of statue in fig. 28)

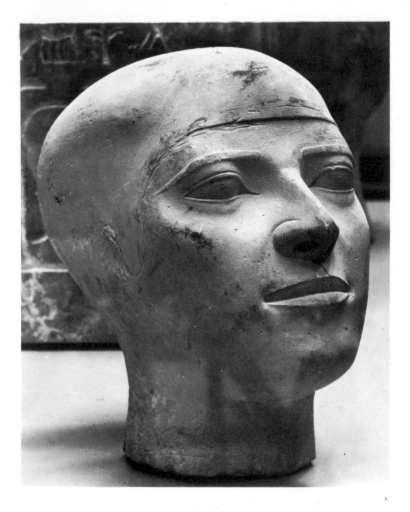

30. *Reserve Head of a Prince*,
from the Royal Cemetery, Giza.
Dynasty IV, c. 2600 B.C.
Limestone, height c. 9″.
Egyptian Museum, Cairo

31. *Bust of Ankh-haf*,
from his tomb, Giza.
Dynasty IV, c. 2635 B.C.
Limestone with thin plaster coating,
painted, height 22 7/8″.
Museum of Fine Arts, Boston

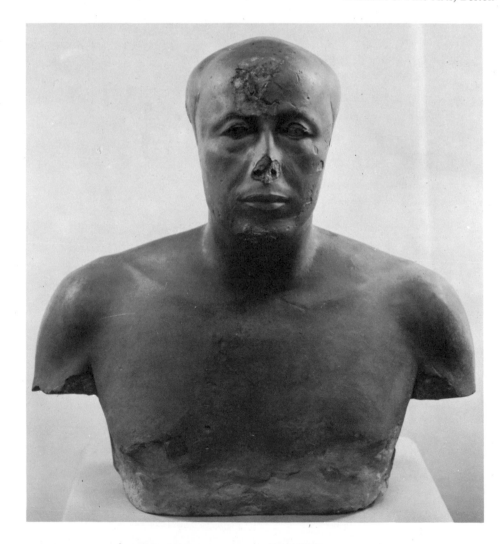

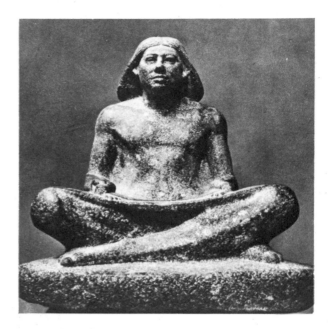

33. *Seated Scribe*, from Saqqara.
Dynasty V, 2565–2420 B.C.
Granite, height 18 7/8".
Egyptian Museum, Cairo

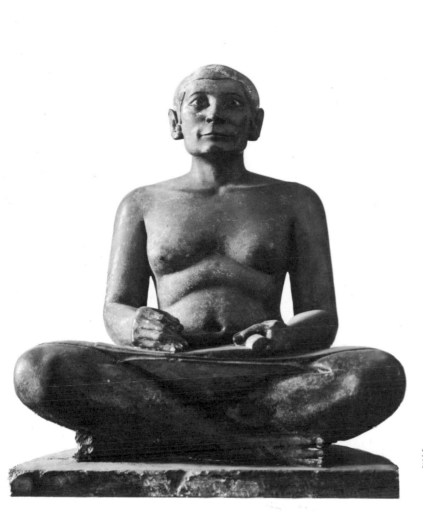

32. *Seated Scribe*, from Saqqara. Dynasty V, c. 2560 B.C.
Painted limestone, height 20 7/8". The Louvre, Paris

to the austere uniformity of solid mastabas, must have fostered a realistic trend since the artist could concentrate on likeness alone. The carving, however, is at this period still bold and very simple (fig. 30). Only one entire bust has been found, namely the extremely competent and convincing portrait of Ankh-haf (fig. 31), son-in-law of Cheops, a rather worried-looking elderly man with puffy eyes and a weak mouth. In this defiantly realistic head, the emphasis is entirely on the symptoms of aging, that is of decay, which makes it appear a freak among contemporary work. Its realism, however, was prophetic of a new trend in Fifth Dynasty sculpture.

The astonishingly alert scribe of figure 32, with arms carved loose from the body and hands ready for action, epitomizes the change. Compared with earlier examples its technical virtuosity stands out; but the more abstract pyramidal composition of figure 33, for instance, which seems to justify the diagonal sweep of the overlarge legs and the resilient curve of the papyrus roll, has in its remoteness from actuality a surpassing dignity.

The most remarkable of the realistic statues

of the Fifth Dynasty is the so-called "village sheikh" (fig. 34), because it deliberately sets out to achieve, not partial, but complete life-likeness and almost succeeds. Gone is the essential immobility of the living dead, the tension between the organic and the inorganic, and with it the dignity of a "timeless" image has vanished too. This is an excellent portrait of a comfortably fat old man, with a loosely tied apron swinging about his legs—which from the point of view of realism are the weakest part. The upright posture is that of a man who has to balance a very heavy stomach and, though the clumsy legs and unresilient feet hark back

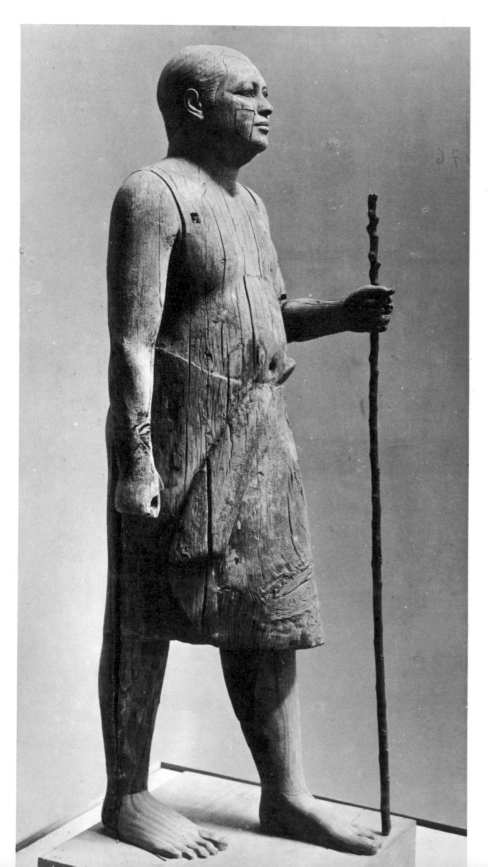

34. *Ka-Aper* (*Sheikh el Beled*), from Saqqara.
Dynasty V, c. 2550 B.C.
Wood, height 43 1/4".
Egyptian Museum, Cairo

to earlier prototypes, this figure appears potentially mobile and almost suggests a stride. It does not underrate the originality or the virtuosity of the artist if one reluctantly admits that here stylistic decay has truly set in. For the exclusive emphasis on individual, transient life means, within the scope of Egyptian art, a loss of metaphysical significance and the road to triviality.

The Egyptians themselves must have been well aware of this; following a period of decline in the early Sixth Dynasty and of complete decadence in the late Sixth Dynasty and the First Intermediate Period, art began to flourish again and the old ideals were then revived and superbly expressed in the statues of the early Middle Kingdom.[21]

As indicated earlier, the Old Kingdom mastabas were hybrid in character and subject to change. Those of the Fourth Dynasty, arranged in a severe rectangle at the foot of the pyramid, were essentially of the solid tumulus type. In the Fifth Dynasty cruciform passages and chapels were introduced, their walls covered with scenes in delicate low relief. We can only hint here at a possible connection between this development and wider political and religious changes in the new dynasty. The worship of the sun god Re—and no doubt the priesthood of Heliopolis—had become an important factor. A new emphasis on the lighter side of existence may have affected not only the tombs but even the royal funerary temples, where lotus, palm, and papyrus columns in rose granite, rising from a black basalt floor as from fertile soil, suggest petrified vegetation (fig. 35).

However this may be, the reliefs in the private tombs, the well-known "scenes of daily life," should be judged on their own merit. It may seem perverse to emphasize their problematical character instead of simply and delightedly

grasping the unique opportunity they offer— for here we find ourselves face to face with common Egyptians absorbed in common pursuits, here we can watch the antics of man and beast, of sailors, butchers, cowherds and craftsmen, of dogs and donkeys, cattle and birds.[22] The precision, the delicacy of the rendering give us an astonishing sense of proximity, until we realize with something of a shock that this lively throng was never meant to see the light, that it was intended to be a hidden, funereal life. Then we know again that the Egyptian, so charmingly familiar when at work or at play, is a unique phenomenon in history and a deeply puzzling one at that.

There is first of all the astonishing secularity

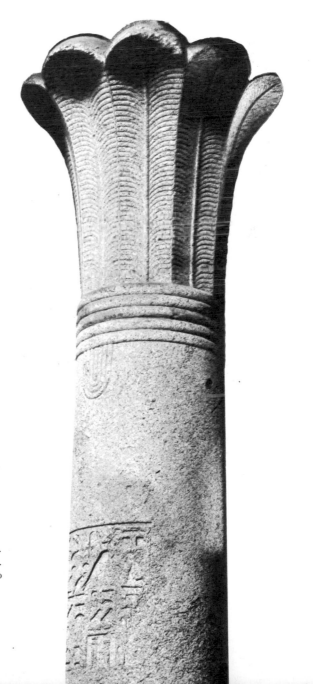

35. Pillar with Palm Capital, from the Temple of Sahure, Abusir. Dynasty V, c. 2545 B.C. Aswan granite, height of capital 78 3/4″.
Egyptian Museum, Cairo

of the tombs to be considered, for no god was ever represented, though the divine king was invoked in inscriptions as the ultimate source of all offerings. It is as if the ancient Egyptians, in the face of death, assessed the value of human existence and affirmed it in these homely scenes. In fact hardly ever in their long history did they in word or image reject the trivialities of ephemeral life. Is this another proof of their incurable naïveté and their materialism? Were these scenes—the explanation lies again ready at hand—purely magical in intention? We might suspend our judgment for a moment and study the form and content of the reliefs somewhat more closely.

The general layout usually consists of a large figure of the tomb owner facing the scenes, which are arranged in horizontal strips (fig. 36). The owner is most often depicted as inactive and not directly connected with the scenes so that generally speaking the immobility of the living dead is maintained here also.[23] The inscription which usually accompanies the figure confirms this, for it simply states that the dead man "sees" or "watches." If for a moment we accept a situation in which the world of the living and the dead are confronted, then it would be hard to find a word that expresses more subtly its human implications, for it conveys both man's longing and his resignation: the watcher shares but he does not participate.

Another fact should be noted here: the scenes in the private tombs depict only typical occurrences and never refer to single events. The owner may boast in inscriptions of his career or his exploits, but the scenes he contemplates after death do not evoke his past life. In fact the word "scene" with its dramatic connotation is perhaps a misnomer, for what we find are pictographic conceits, such as harvesting, cattle raising, game provision, fishing, etc. Even when the action is at its liveliest it is neverthe-

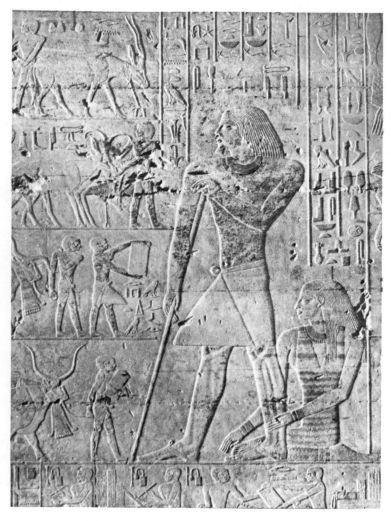

36. *Ti and His Wife Neferhotpes.*
Dynasty V, c. 2420 B.C. Painted limestone relief (detail).
South wall, offering chamber, Tomb of Ti, Saqqara

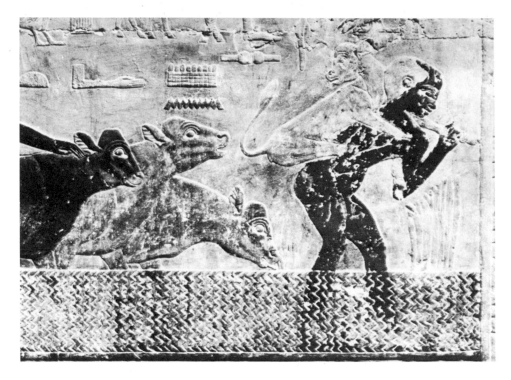

37. *Cattle Fording a Stream.*
Dynasty V, c. 2420 B.C. Painted limestone relief (detail).
North wall, offering chamber, Tomb of Ti, Saqqara

.ess typical, for care of cattle entails the fording of streams (fig. 37), and boatmen will fight (fig. 38)! There is of course no denying that nearly all the scenes have a bearing on food production and that this links them with ancient magical practices. One may concede that some magical purpose persisted without accepting this as proof of the Egyptians' gross materialism and primitive attitude toward the hereafter. When the Egyptians apparently refuse to accept the crises of death as final, when the dead appear to cling to life and the living to strive for permanence in death, this may also mean that theirs was a different attitude toward the very phenomena of life. Where, as in Egypt, the divine is not believed to be wholly transcendent, all that pertains to life may be considered a manifestation of the divine. Therefore, when we find that the typical, the timeless, activities by which life is sustained or increased were made permanent in the "house of eternity"— as the tomb was called— where they would be a

38. *Boatmen Fighting.* Dynasty V, c. 2450 B.C. Painted limestone relief (portion). East wall, Tomb of Ptah-sekhem-ankh, Saqqara

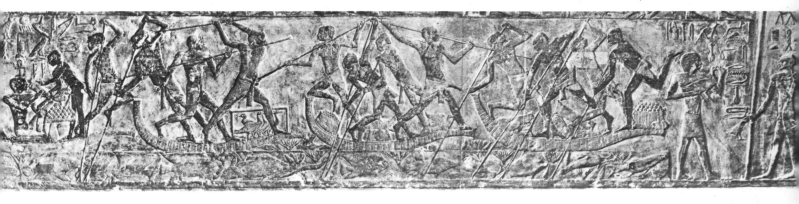

potent presence and a source of joy to the dead, then we may recognize in this not only an outgrowth of primitive magic but also a religious act of devotion.

We might allow the reliefs with their wonderful observation of humans and animals in action (figs. 39, 40), their humor, their gaiety, to speak for themselves, were it not that they present one puzzling feature: in the case of human figures the artists obstinately clung to the paratactic rendering which we analyzed in the reliefs of Hesi-Re. This and the strict adherence of the figures to a groundline preclude any attempt at rendering illusionary depth, and where figures are depicted in action this may lead to the most extraordinary contortions. The problem of spatial representation in Egypt is too complex for a brief discussion, but it should be remembered that no appeal to the imagination of a spectator was ever intended: the purpose of the scenes was to provide for the dead a permanent presence of the facets of daily life, clearly stated as typical occurrences. A paratactic rendering, which emphasizes tactile values at the expense of imaginary depth and fixes, as it were, the images to the wall surface, served this purpose to perfection. In fact this art appears deliberately, and quite logically, to shun every possible appeal, spatial as well as emotional, to the imagination; it is, for all its lively air, sober and undramatic.

This being so, we may well ask how the king was depicted in the reliefs of the Fifth Dynasty funerary temples. For surely the very concept of a divine king was, if anything, extravagant. Here again we must admire the logical consistency with which the theme was handled, though we may deplore the constraint it imposed on the artist. Since the divine and the temporal interpenetrated in the person of the king, both aspects of his power are shown. The king is seen on a par with the gods, as the focus

of their good will, accepting their support when they lead his bound captives or bring him life-sustaining gifts: he is also seen reciprocating with offerings. Now the king, as the divine head of state, was *ex officio* the conqueror of his enemies, the source of all bounty for his subjects. He must therefore reveal his power in acts, but whether he holds a bunch of captives in the time-honored formalized gesture or presides over a scene in which the gold of honor is distributed among his courtiers, the rendering is abstract and lifeless. It must be admitted that although the religious paradox of divine kingship had been superbly expressed in monumental architecture and in single plastic figures, it severely limited the scope of pictorial art. For this dogma, with its ideal of static perfection, robbed religious scenes of tension and climax, robbed secular victory of its dramatic implications. In fact the religious scenes in the Old Kingdom inaugurate an endless stream of bland robot figures repeating the same formal gestures on the walls of temples and royal tombs alike, and it needed a revolutionary change in the very concept of kingship—in the Eighteenth Dynasty—to bring actuality within the range of royal reliefs.

There is only one type of scene which gave the artists full scope for their peculiar gift of detached, yet loving observation of natural form and movement: the hunting scenes in which the king, actually shooting, takes part.[24] Here the problem of paratactic rendering barely arose, for a profile outline will give the essentials of animal form and a groundline may act quite naturally as skyline so that the wild creatures appear *as seen*. In one instance not even the pretext of a royal hunt is given for dwelling on the beauty of animal life, and purely "idyllic" scenes of nature occur: namely, in the sun sanctuary built by Ne-User-Re. This unique building, the only one in the Old

39. *Donkeys Threshing Grain*, relief from Saqqara. Dynasty V, 2565–2420 B.C.
Limestone, length 17 1/2″. Rijksmuseum van Oudheden, Leiden

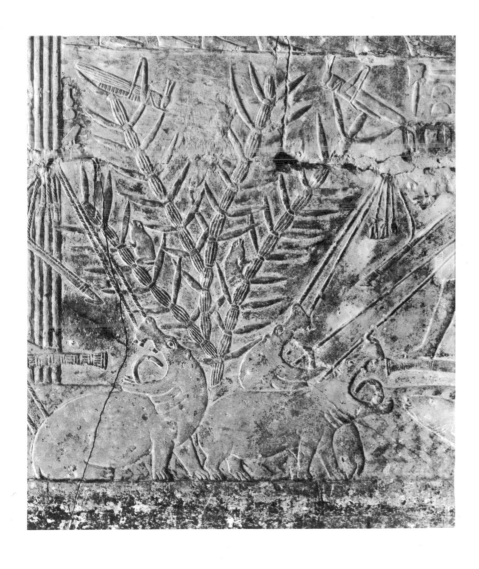

40. *Harpooning Hippopotami.*
Dynasty VI, c. 2410 B.C.
Painted limestone relief (detail).
North wall, entrance chamber,
Tomb of Mereruka, Saqqara

Kingdom to vie in importance with neighboring royal monuments, had an open courtyard with a raised platform on which stood an obelisk. In the passage leading toward it, reliefs were found which so far are unparalleled: large symbolical figures representing the seasons headed various scenes of nature—man reaping the gifts of the life-giving sun god, and beasts and plants—in a setting which, however simple, we are justified in calling pure landscape. That wild creatures could be depicted not as subservient to man and his greed, not even as sacrificial victims, but as proclaiming the sun god's glory by their very existence, is a moving tribute to an often forgotten aspect of Egyptian religion.

THE MIDDLE KINGDOM

The end of the Old Kingdom begins to show the symptoms of political, economic, and artistic decay which almost invariably follow high peaks of achievement. In the next period, the so-called First Intermediate Period, these symptoms increase. There is evidence of feudalism as a disruptive force, of local barons usurping royal prerogatives, evidence of increasing poverty and its correlate, a decline of the visual arts. A literary document of slightly later date refers to this period as one of unalleviated distress.

It is possible that an author of the early Middle Kingdom who had experienced the revival of centralized pharaonic power was inclined—or even commanded—to overemphasize the contrast between conditions in his own lifetime and those of the preceding period. On the other hand, it should be realized that the suffering alluded to may well have been experienced on a deeper level than merely that of economic hardship and political confusion. In a strictly hierarchic state, social order and well-being have an aura of sanctity, and in the case of Egypt, both were anchored in the Pharaoh's perfection as king and god. The religious ideal of a transcendent order manifest in state and cosmos alike may seem to us a mere illusion, but to the Egyptians it pervaded their entire view of life. As such, it was no doubt peculiarly vulnerable, for it could remain unshaken only as long as pharaonic power remained inviolable and its centralized bureaucracy functioned. Subversion and the threat of chaos must have undermined the very meaning of life for those to whom the permanent and the divine were practically synonymous.

It is this aspect of the First Intermediate Period which is of particular interest, for it proves again that a disruption of existing order, for all the suffering it entails, may mean the agony of a new birth. Here the evidence of literary documents is unmistakable; it points to a new maturity of thought and depth of experience, a new probing, searching spirit. The enigma of death and the ephemeral joys of living were boldly contrasted—not, as in the Old Kingdom tombs, approximated.[25] Harpers' songs, one of which has been dated to the Eleventh Dynasty, have been preserved in which man is therefore urged to snatch at

fleeting pleasures; but we also possess a strange dialogue between a man and his soul in which a bitter loathing of the iniquities of life is made more poignant by a lyrical praise of death.[26] It is as if a prevailing mood of brooding introspection must have recoiled from the affirmation of life's eternal values. Instead, the god Osiris, the god who died and yet lived, became, as king and judge of the dead, the new focus of religious hope. We know this from the inscriptions on modest steles, usually put up in Abydos, that is, near the god's legendary grave. In these inscriptions common man became vocal for the first time in history and expressed a new awareness of moral values in the prospect of posthumous judgment. It is true that magic held pace with fear of the unknown: portions of the royal Pyramid Texts, taken from their speculative context, begin to appear on coffins as magic spells.

When, after a protracted struggle, pharaonic power, which had been made a mockery in fact though never as a creed, became again a dominant factor in the life of a reunited nation, a deep change had occurred: the theology of kingship might survive, the sacred rites be again performed, but the myth of the king's static perfection was shattered. It could never again be forgotten that acts of valor, acts of statesmanship, were needed to bring about the blessed bond between the temporal and the divine on which justice, order, and well-being were founded. The great Middle Kingdom rulers emerged in the eyes of their subjects as gods, no doubt, but also as distinct characters, solitary human beings. It is significant that the praise of individual kings was sung in hymns which emphasized his responsibility toward his subjects. This would have been unthinkable in the Old Kingdom.

We shall see presently how this change was expressed in the royal statues, but first I want to deal briefly with the paintings and reliefs in the tombs of those feudal lords who remained powerful even during the reign of the first great kings. Their tombs link up with a new development of the late Old Kingdom, for it was then that provincial administrators began to cut their tombs locally, in the cliff face above the valley. Such tombs soon developed into a form of subterranean architecture with porticoes and pillared halls. Their entrance was open to the light of day, in contrast to the nearly hidden intimacy of the mastabas. This fact in itself may have tempted artists to take the spectator into account, for already in the late Old Kingdom a scene occurs which has no place in the old scheme at all: a battle and siege are depicted. A similar intention to commemorate specific events explains the introduction of several new themes in the rock tombs of Beni Hasan and Sheikh Said. Formally speaking, however, tradition is upheld both in relief and in the bold but rather shoddy painting which appears as its cheaper substitute.[27] Only in one tomb at Meir,[28] where the reliefs are as delicate as those of the Fifth Dynasty, do we find a different type of appeal to the spectator: in a hunting scene, which depicts the owner in the act of shooting, a lively group of hippopotami is rendered in almost pure perspective, that is as seen from a definite point of view. Whatever the latent possibilities of this new form of realism, its development was cut short. Rock tombs were discontinued when the power of the feudal lords was broken, and relief survived only on the steles, which were artistically unassuming though several show a finely balanced design.

One rather odd innovation in early Middle Kingdom tombs should be mentioned here: some of the scenes of daily life appear in a new guise, dislodged as it were from their place on the walls: elaborate groups of small wooden

figures in the round were buried with the dead. In these the magical intention of the wall scenes, so beautifully subdued within the earlier concept of the "watching" dead, is revealed in a crude and childish form. If the shock of social upheaval produced, as we saw, a trend toward greater spirituality, the reverse was also true and magic began to run riot in a plethora of dainty toys, fully rigged ships, soldiers, a rural estate with cattle and herds complete with a pavilion for the master, all of which denote a realistic concept of the hereafter too shallow and naïve to produce anything beyond a rather charming puerility. For truly great Middle Kingdom art we must turn to the royal monuments.

The first of these was undoubtedly the funerary temple of Mentuhotep III of the Eleventh Dynasty, at Deir el Bahari, which is a structure of an astonishing originality (fig. 41). Its setting already means a new departure,

for it was built against the towering western cliffs. A ramp led to a colonnaded terrace, in the center of which a small pyramid, surmounting the tombshaft, formed its architectural climax. Behind the terrace was a pillared hall. The contrast with Giza is very striking. The smooth cube of granite masonry which contained Chephren's valley temple had two rather small entrance porches, and the long covered passage leading from it to the mortuary temple lacked all communication with the outer world. Mentuhotep's temple appears in comparison not only more centrally organized, but open to the world; and as if to emphasize a new relationship between king and subjects, two seated statues of Mentuhotep were placed outside the temple, looking across the Nile

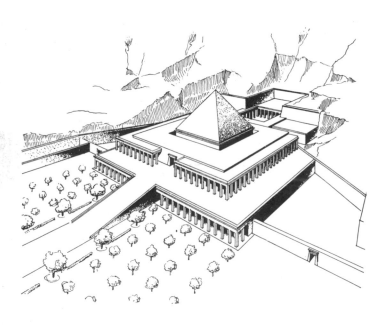

41. Funerary Temple of Mentuhotep III, Deir el Bahari. Dynasty XI, c. 2000 b.c. *Reconstruction* (after Koepf)

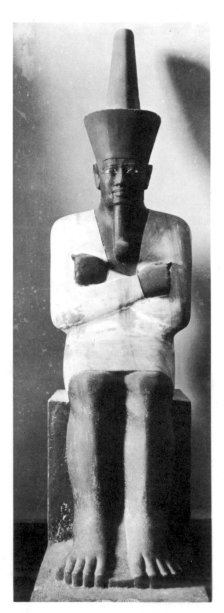

42. *Mentuhotep III*, from his Funerary Temple, Deir el Bahari. Dynasty XI, c. 2000 b.c. Painted sandstone, height 72″. Egyptian Museum, Cairo

52

valley toward the world of the living. These statues, badly damaged now, probably closely resembled the one in figure 42. It shows no trace of the disintegration of form that is so characteristic of the late Old Kingdom. Rigidly cubic and austere, it has a harsh formal discipline that is, however, far from being lifeless.

Unfortunately there is little left of the architecture of the Twelfth Dynasty monarchs, who moved their capital northward again and built their large brick, stone-faced pyramids—for Mentuhotep's terraced plan was abandoned—south of Giza near Lisht. The temples which they dedicated to the gods have been either rebuilt or used as quarries, but it is significant that from the Twelfth Dynasty onward many royal statues, often in the attitude of worship, were placed within them. During the Old Kingdom, the Pharaoh's image had been either a hidden presence or visible to the priests alone. Openly standing under divine protection and, we may presume, in view of worshipers, these Middle Kingdom statues no longer merely embodied transcendent power, they proclaimed it; and though funerary statues continued to be made, it was especially in nonfunerary settings that the paradox of kingship, a divine power functioning through a solitary individual, found a new expression.

The change was slow to appear and never broke the hallowed scheme of utter tranquillity adopted for the living dead. Among the earlier examples two granite torsos, both found in the Delta, clearly show a new trend. In figure 43 the organic tension of the figure suggests an immensely powerful physique and the face with its enormous eyes is extraordinarily compelling.

Future development, however, did not lie in the direction of emphatic corporeality. Superhuman strength was henceforth symbolically expressed in the many royal sphinxes which became a favorite Middle Kingdom device. These were not monstrous forms in the sense that they embodied a significant disharmony of component parts, like the female sphinxes developed at a later date outside Egypt.[29] Nor were these royal sphinxes mere ideograms in

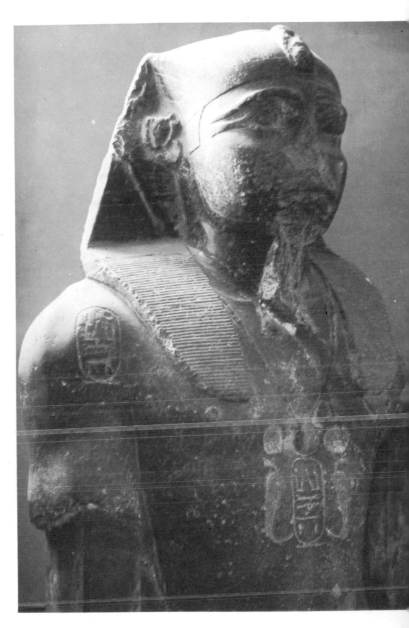

43. *Head and Torso of Sesostris I*, from Alexandria. Dynasty XII, c. 1930 B.C. Black granite. Egyptian Museum, Cairo

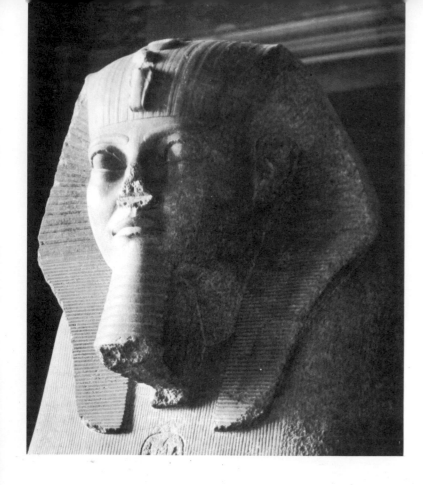

44. *Sphinx of Amenemhat II?* (portion), from Tanis.
Dynasty XII, c. 1895 B.C.
Pink granite, height of whole 81″, length c. 16′.
The Louvre, Paris

45. *Sphinx of Amenemhat III*, from Tanis.
Dynasty XII, c. 1800 B.C.
Black granite, height 39 3/8″, length 72″.
Egyptian Museum, Cairo

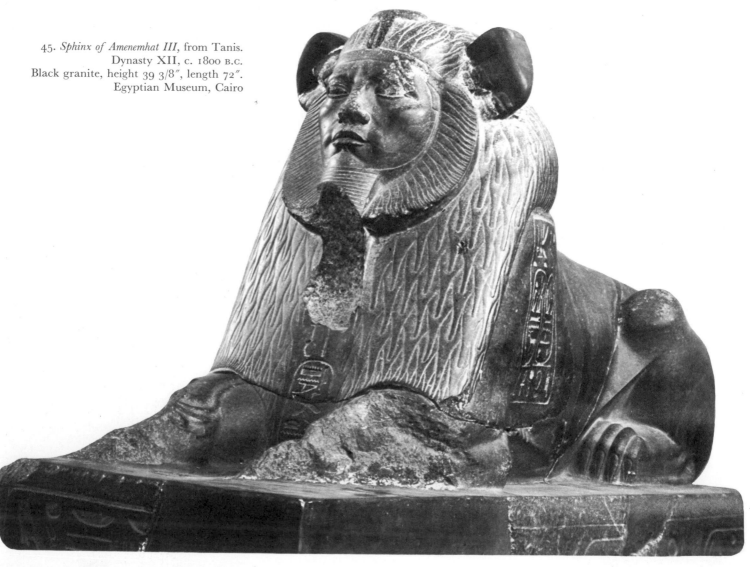

plastic form, like Chephren's sphinx. It is as if the artists, faced with the task of proclaiming to the nation the timeless function of each successive monarch, found a new inspiration in the welding of an individual head to static leonine nobility. In figures 44 and 45 I have chosen two examples, one of the earliest in the period and one of the latest, depicting Amenemhat II (?) and Amenemhat III respectively. Both show the skill with which, instead of disharmony, a superbly convincing unity of form was achieved. In figure 44, the severely formalized mane repeats in a smooth vertical pattern the horizontal pleats of the headcloth. Though it curves away over the shoulder to form an unobtrusive transition to the recumbent body, the head in front view rises quite naturally from its steep sloping surface, as from a stiff garment. The face is utterly serene. In figure 45, on the other hand, the sholder mane entirely envelops head and shoulders with its restless pattern like shimmering metal. Only the face stands out, framed by stylized hair tufts that radiate like flames from a burning center. Stern, brooding, with just a hint of potential cruelty, the head and the leonine form mutually require each other; they are indivisibly one.

But though Middle Kingdom artists chose at times to express the transcendent aspect of royalty in a symbolical form, they also probed its human implications to a depth never reached before or since in Egyptian art. A change occurs suddenly in the reign of Sesostris III. Figure 46 shows a votive statue of the king found at Karnak. The lean-flanked austere body is taut, yet so organically coherent that its immobility appears an act of will; and surpassing will power—power of self-control, and the control of others—is expressed in the astonishingly compelling face (fig. 47). It is a starkly human, an "exposed" face, that hides nothing,

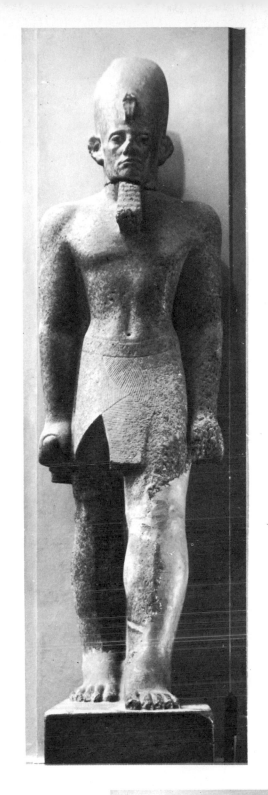

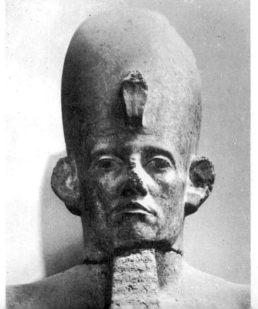

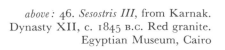

above: 46. *Sesostris III*, from Karnak.
Dynasty XII, c. 1845 B.C. Red granite.
Egyptian Museum, Cairo

47. *Sesostris III* (upper portion of statue in fig. 46)

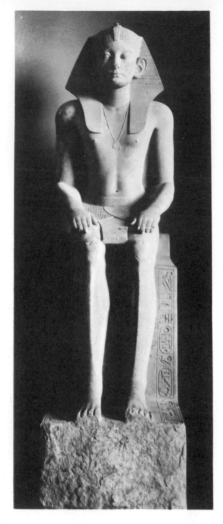

48. *Amenemhat III*, from his Funerary Temple, Hawara.
Dynasty XII, c. 1800 B.C. Yellow limestone, height 63″.
Egyptian Museum, Cairo

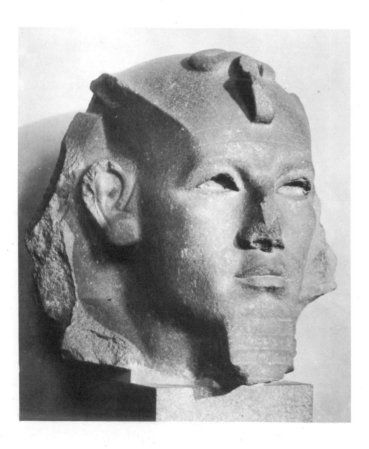

yet reveals nothing in terms of mere personal experience. Its strength and its nobility are those of a dedicated man who has accepted the burden of an immense task. The personal greatness of a single individual is here measured up to a function that transcends human stature. And yet the human aspect of kingship in this great work does not inaugurate a tendency to secularize it. It is true that there are a number of fragmentary "portraits" of Sesostris III which show an increasing weariness, even melancholy. But we have said before that Egyptian sculpture cannot be judged except from the entire figure, and it must remain an unsolved problem if and how this new, poignant hint at frailty was harmonized with an expression of majesty.

The statues of Sesostris III's successor, Amenemhat III, appear gradually to introduce yet another direction: the mystery, the uncanniness, of the king's power predominate over his human qualities. Not, however, in the beginning of his reign. Figure 48 shows how a sensitively human approach could even transform a classical formula. The delicate modeling of the young body is vibrant with life; the face with its large, curiously introvert eyes, sensitive nostrils, and firm mouth and chin, has an air of solemn expectancy, of serious resolve. This gives the traditional rigid pose an entirely new quality of natural stillness, as if the young king were present at a ritual function. A later portrait head of the king shows a kind of wary reserve; and the colossal head of figure 49, alert, severe, with all its strength concentrated in the lower part of the face and around the full mouth, suggests a man who has learned that kingship, no longer self-evident, entails the need to dominate. It is eminently the face of a ruler, not of a god in human form.

In the sphinx already discussed, and in later statues from the Delta, the awesome character

49. *Head of Amenemhat III*, from Bubastis.
Dynasty XII, c. 1800 B.C. Gray granite, height 30″.
British Museum, London

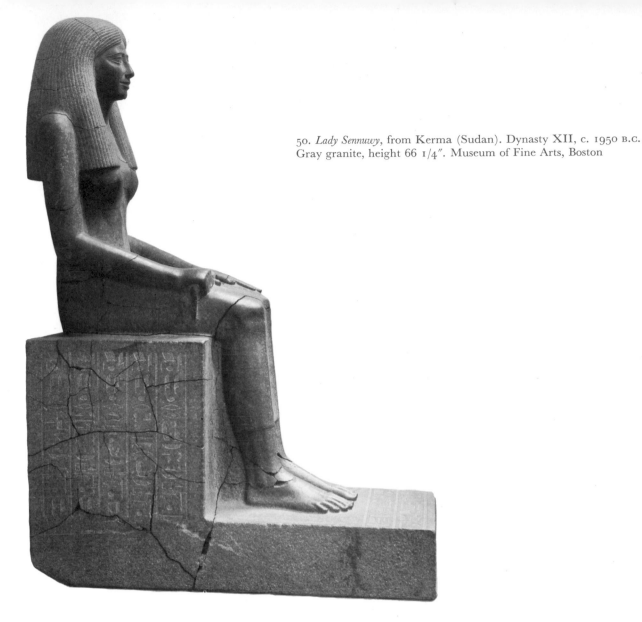

50. *Lady Sennuwy*, from Kerma (Sudan). Dynasty XII, c. 1950 B.C. Gray granite, height 66 1/4″. Museum of Fine Arts, Boston

of royal power predominates. The artists' vision of the king as a solitary human being subsequently fades and vanishes forever.

There exists a striking difference between the royal images we have discussed and the two outstanding female statues of the period, for all emphasis on individuality has there been avoided. In the case of Lady Sennuwy (figs. 50, 51) and of an unknown queen, the beauty of face and form is that of transfigured life. It has entirely lost the earthiness which gives to the best Old Kingdom work its pungent vitality.

A similar change can be observed in most private statues, where it may well express a new religious awareness, a loss of interest in the permanence of physical form. We now find squatting figures entirely wrapped in cloaks, limbs hidden in long stiff garments as if cor-

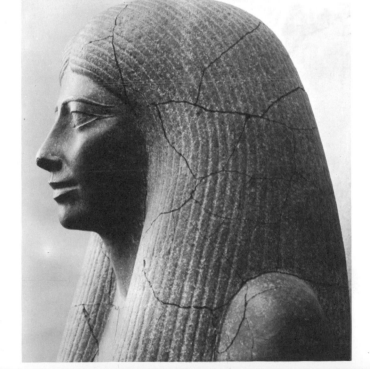

51. *Head of Lady Sennuwy* (portion of statue in fig. 50)

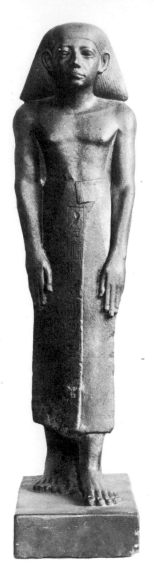

52. *The Priest Amenemhat-ankh.*
Dynasty XII, c. 1840–1795 B.C.
Brown sandstone, height 28 3/8".
The Louvre, Paris

poreality was of less account. The broad heart-shaped faces have a curiously remote expression, they are completely impersonal, although they are never lifeless in the better examples. Votive statues in the attitude of worship appear for the first time, as for instance in figure 52. Here the gesture of the arms and hands extended downward, subtly emphasized by the vertical hem of the garment, is both collected and entirely natural. The rare formal harmony of the figure almost makes one forget that it is far removed in spirit from the Old Kingdom: its inner stillness is devoid of all tension, it is beyond the reach of conflict between life and death. In figure 53, a funerary statue, corporeality has become almost an abstraction, a matter of smooth curving planes and balances. The rhythmic play of diagonals—in which even the edge of the wig takes part—with a basically cubic structure seems akin to musical harmony; it matches the impersonal serenity of the face. Here all clinging to the ephemeral, all trace of magic purpose, have vanished from a new ideal of timelessness.

53. *The Steward Chertihotep.*
Dynasty XII, c. 1850 B.C.
Quartzite, height 29 1/2".
State Museums, Berlin

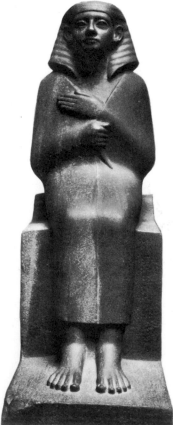

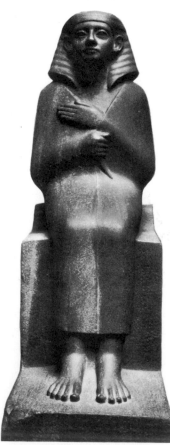

THE NEW KINGDOM

The Early Eighteenth Dynasty

The Middle Kingdom likewise ended in disaster. The Nile valley was overrun by Asiatics[30] and only after centuries of confusion and foreign domination was the country reunited by a dynasty of Theban rulers. These not only expelled the intruders but followed up their victory by a series of conquests in Palestine and Syria, thereby creating a vast empire. With her ascendancy abroad assured, Egypt entered, powerful and wealthy, on yet another period of great achievement.

The change from a relatively parochial political existence to that of a great imperial power deeply affected the entire civilization of the New Kingdom. In art the change may not seem dramatic at first for the ideal of permanence remained valid throughout Egyptian history—barring one short episode, as we shall see—so that the value of traditional forms was generally unquestioned. In fact, one of the fascinations of New Kingdom art is the inner tension between those forms and a new situation, a new attitude to life.

Kingship is a case in point. The Pharaoh again loomed large and the theology of kingship was formally upheld, but an insidious process of secularization had set in. The king's image, for instance, now frequently appeared in the tombs of a class of high officials, who owed their function to an autocratic ruler. In this context the king had thus become primarily the source of administrative power. In royal inscriptions the purely personal often intrudes, and detailed accounts are given of the Pharaoh's courage and physical strength.[31] Conversely we find a new emphasis on the power of the gods, who may give commands to the Pharaoh in oracles and who receive the spoils of his battles. The changed situation appears, in fact, symbolically expressed in the configuration of the royal funerary temples and the divine temples. While the actual royal tombs, burrowed in the cliffs of the Valley of the Kings, became mere hiding places for the dead and their treasures, the funerary temples of successive rulers, strung in a row along the west bank of the Nile, now faced the even greater temple complex across the river, where the powerful priesthood of Amon held sway. Astute theologians had established the unity of the Theban god Amon, the "hidden," the invisible god of the air, with the ancient sun god Re of Heliopolis. Amon-Re's ascendancy made it possible for an increasingly mature metaphysical speculation to focus on the two most universal gods of Egypt's cluttered pantheon.

In one respect New Kingdom rulers were unchanged: their building activity was as formidable as ever. It must be admitted that much of the work they commissioned at a later stage is mainly impressive through sheer size, but it is undeniable that the earliest well-

preserved monument belongs among the great masterpieces of all time. Queen Hatshepsut, the only woman ever to usurp the throne, built her funerary temple at Deir el Bahari, at the foot of the Theban cliffs (fig. 54). The project was undoubtedly due to her vizier Senmut, who had his own image, a small kneeling figure, carved in relief throughout the building. An avenue of royal sphinxes led to three rising colonnaded terraces, connected by ramps. There is no pyramid, no tomb; severely simple square pillars and fluted columns are used throughout, except on the upper terrace where the pillars were faced with Osiride figures of the queen. It is here, next to the queen's main sanctuary, that we find a sanctuary with a stepped altar open to the sky and dedicated to Amon-Re. The middle terrace has two open halls with fine reliefs and, leading off on either side, two chapels dedicated to Hathor and Anubis respectively. The clear exposed plan of the building, the austere rhythm of its crystalline pillars and columns, assert the grandeur of pure form against the amorphous cliff face towering above it. It is a daring imaginative concept, superbly executed.

54. Funerary Temple of Hatshepsut, Deir el Bahari. Dynasty XVIII, c. 1485 B.C. *General view from the east*

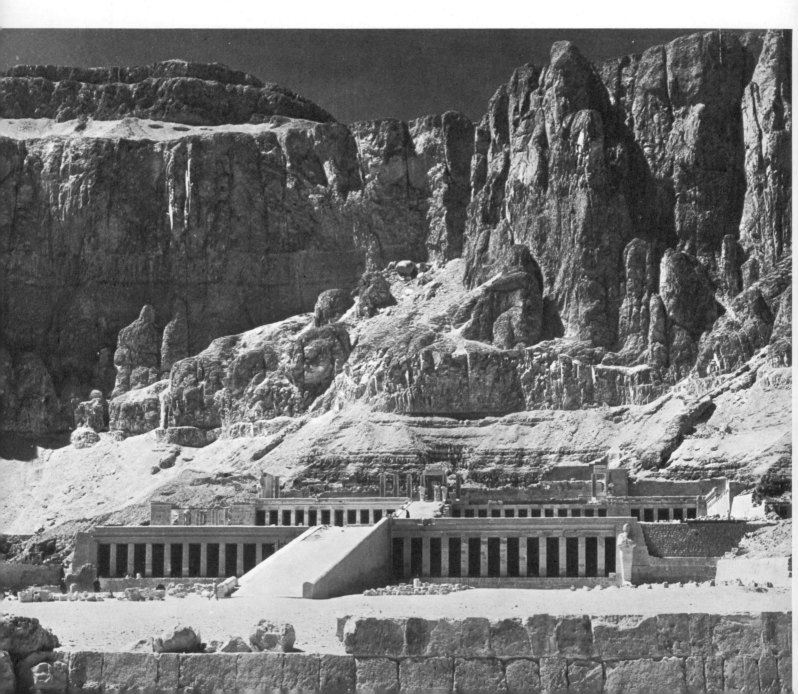

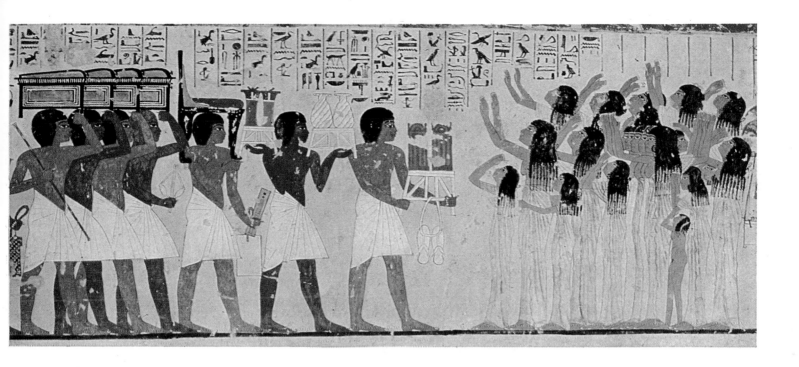

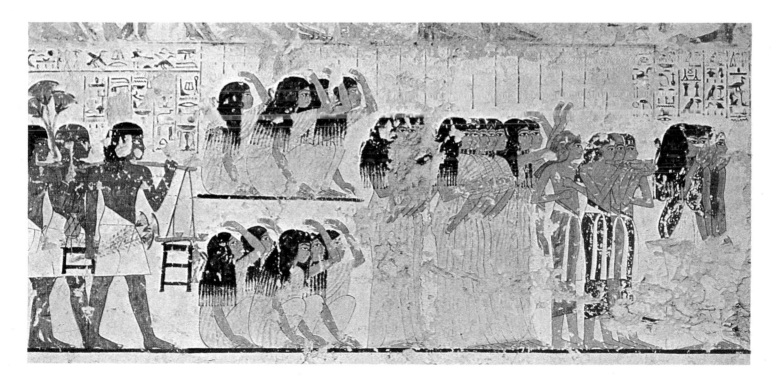

Colorplate 6. *Mourners*. Dynasty XVIII, c. 1400 B.C.
Wall painting (portion). Tomb of Ramose, Thebes

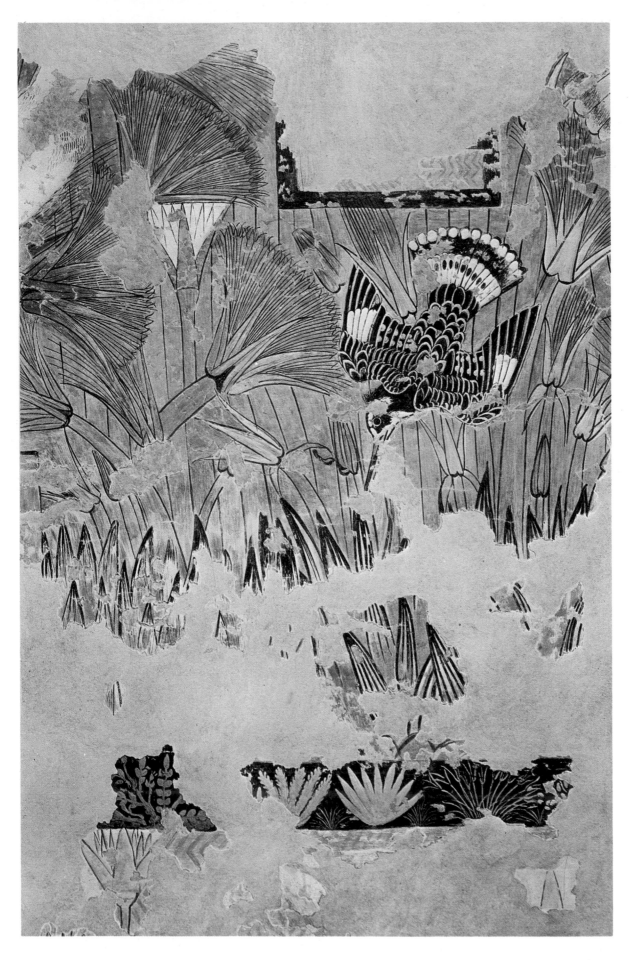

Colorplate 7. *Kingfisher*. Dynasty XVIII (Amarna Period), c. 1372–1355 B.C. Wall painting (detail).
North Palace, Tell el Amarna (watercolor copy by N. de Garis Davies in The Oriental Institute, University of Chicago)

We should note one significant detail here. The reliefs we mentioned above[32] represent, on the one side, the queen's miraculous conception and birth. Since she was a usurper her divine ancestry had to be demonstrated: Amon's fatherhood was discreetly stated in pictorial abstractions. The reliefs in the other hall contain an account of a peaceful expedition to the land of Punt, famous for its incense. The style and workmanship of these scenes resembles the best of Fifth Dynasty royal reliefs, but in spirit they differ completely. The strange inhabitants of this remote country are not depicted as obsequious aliens, awestruck by the Pharaoh's might; they have been observed with humorous detachment (fig. 55) and a lively interest in such details as dwellings, plants, and animals. These innovations are significant; never before had the divinity of the Pharaoh required an explicit justification, nor had the world outside Egypt ever proved interesting for its own sake. We are indeed on the brink of new developments.

Compared with Hatshepsut's funerary temples, those of her successors appear massive and dull. More interesting are the temples they dedicated to the gods. We cannot touch here on the many problems which the ponderous confusion of the Karnak temple complex (fig. 56) offers to historians; they are made even more bewildering by the reconstruction of Middle Kingdom remains.[33] A brief comparison with the layout of Old Kingdom funerary temples, however, may prove illuminating. We saw that the plan of the latter was processional and focused on the pyramid. Generally speaking the New Kingdom temples show a similar absence of centralized plan, though they lack the climax provided by the royal tomb. Instead the processional movement through entrance pylons, open courtyard, and pillared hall toward the cramped dark chapels of the inner

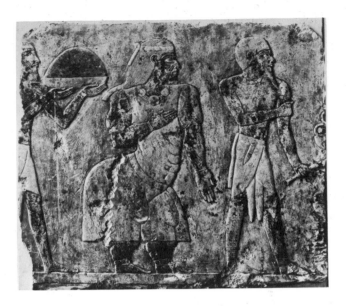

55. *"Fat Queen."* Dynasty XVIII, c. 1485 B.C.
Painted limestone relief (detail). South wall, Punt colonnade,
Funerary Temple of Hatshepsut, Deir el Bahari

56. Temple of Amon, Karnak.
Begun during Middle Kingdom,
large-scale additions made during
Dynasty XVIII. *Plan*

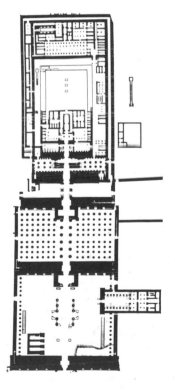

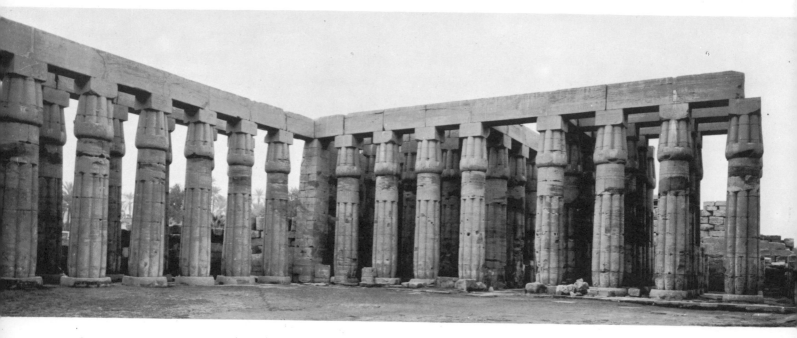

57. Court of Amenhotep III and Entrance Hall to Temple of Amon-Mut-Khonsu, Luxor. Dynasty XVIII, c. 1375 B.C. *View from the north*

sanctuary might be reversed on great occasions, when the sacred bark of the god was displayed to the multitude. The architectural emphasis was therefore laid on the towering entrance pylons which marked the threshold of the god's domain. Their soaring expanse of smooth masonry, slightly receding and with beveled edges, recalls the outside of a mastaba, infinitely enlarged. Barely integrated with the building, impressive through sheer size, these pylons are as forbidding as their function demands.

Apart from these differences, it is clear that the great formal creations of Old Kingdom architecture provided the vocabulary as well as the syntax of New Kingdom temples. Plant columns were reintroduced by Tuthmosis III and his successors, but though the papyrus columns in the Luxor temple (fig. 57) and the colonnade at Karnak are well proportioned, they lack the grace and beauty of their Old Kingdom prototypes. The ideals of massiveness and seclusion, essential to a funerary monument, prevail throughout. Interior space as such

was barely considered and the harmony between space and volume, so superbly maintained in Chephren's pillared hall (fig. 18), was ignored even when the construction of triple-aisled basilicas with a raised central hall offered a grand opportunity for spatial articulation. The dire results of these general trends are clearly seen in the temple architecture of the Nineteenth Dynasty, which I shall therefore briefly mention here.

The famous hypostyle hall at Karnak, built by Ramesses II, seems to have been created for the sole purpose of filling it to capacity with plant columns of monstrous size (fig. 58). Equally depressing is the forest of sagging bloated columns in the temple which his father, Seti I, built at Abydos (fig. 59). It is true that this abstract vegetation may have had a religious significance. It has often been pointed out that since various parts of an Egyptian temple had a cosmic connotation, plant columns reaching to the star-bedecked ceiling may have linked the earthly with the heavenly sphere. This does not redeem them aesthetically, and it

64

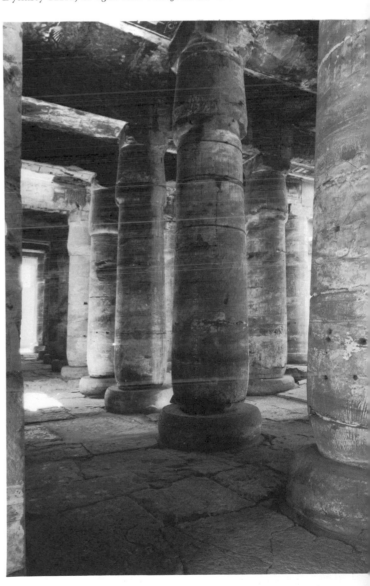

is an ominous sign of approaching decay when size becomes a prime consideration, divorced from the demands of form. Colossal size may be of the essence of a truly great concept, as in the case of the pyramids; it may also impart a mock dignity to what is insignificant or essentially dull. The much overpraised temple of Ramesses II at Abu Simbel is a case in point.

If we now turn to the royal statues of the earlier part of the Eighteenth Dynasty, it must be admitted that not even superb workmanship can hide their decline at the height of Egypt's imperial power. Tradition was upheld in the rigid pose with its framework of verticals and horizontals. The smooth idealized faces still show an appreciation of individuality, as in the

delicate heart-shaped face of Hatshepsut (fig. 60), the alert intelligent head of Tuthmosis III with his bold high-bridged nose (fig. 61). But their expression, whether bland, self-confident, or downright complacent, has a worldly serenity which belies the religious phraseology of the inscriptions. It is as if the undeniable dignity of these figures was due to ancient thought-laden forms which had become stereotypes.

In contrast with the Middle Kingdom, it was not in royal portraiture but in the scenes in the private tombs, whose owners held high office under the empire, that New Kingdom art entered on a new phase, rich in experiment and full of life. It is in a sense surprising that this should be so. The fashion of monumental rock tombs had ceased in the Middle Kingdom when feudal lords lost their power under Sesostris III. The votive steles of private people in the later Middle Kingdom show a new and often a more spiritual approach to the problem of life after death, though popular imagination continued to be preoccupied with ghostly threats and magic countermoves. In the New Kingdom the entire phantasmagoria of the netherworld

was more or less codified in the *Book of the Dead*, and one might expect that thereby the concept of the hereafter was finally divorced from all that life had to offer. This was not so. Amidst the bustle and excitement of the empire, with the opening up of new horizons, the ostentation of a class of wealthy officials, and a pleasure-loving court, the ancient paradox of life's significance in death was reasserted, and scenes of life appeared again in rock-cut tombs. This time, however, we do not find the typical aspects of life, remote from the contingent and the ephemeral, in other words the rustic innocence of Old Kingdom reliefs. We find instead a new emphasis on those rewards of existence which are bound up with purely personal values, with pride of office and a sensuous awareness of beauty. This widened the scope and surreptitiously changed the character of the scenes, for it entailed a movement away from the typical and toward actuality in both form and content.

To begin with content, we can now see the tomb owner, no longer passive, busy with the pursuits of his lifetime: hunting, riding in his

60. *Hatshepsut* (portion of seated statue, partly restored), from Deir el Bahari. Dynasty XVIII, c. 1485 B.C. Limestone, height of statue 77 1/8". The Metropolitan Museum of Art, New York (Rogers Fund and contributions from Edward S. Harkness, 1929)

61. *Head of Tuthmosis III* (portion of a standing statue), from Karnak. Dynasty XVIII, c. 1450 B.C. Slate, height 78 3/4". Egyptian Museum, Cairo

chariot, supervising the bearers of foreign tribute, receiving awards of gold. The old motif of the deceased seated at his offering table blossomed into banqueting scenes where guests were entertained with song and dance. Great interest is shown in depicting locality, not as a mere accessory to typical action such as fishing or hunting, but in order to suggest a definite place, a house, a garden, even a law court. The manner of representing these, by a combination of plan and elevation, is archaic, but subtle changes occur in the rendering of the human figure which tend toward a new form of illusionistic realism. It is as if these figures, though still intended to be a presence for the dead, are now also aimed at the living, and meant to be *seen* by them.

There can be no doubt that a preference for the use of paint was prompted by the new trend and fostered it in turn.[34] So far painting, with very few exceptions, had been used either to enliven relief or as its substitute. Now it came into its own as a means of conjuring up visual rather than tactile values—the transparency of garments, the stains on snow-white linen caused by the melting of greasy perfume cones which guests wore on their wigs. More important still, the swiftness of brush strokes tempted artists to experiment with movement, not as subservient to action, but as significant in itself. They evoked the sinuous grace of young dancers, the delicate gestures of serving girls (colorplate 2). Sometimes such figures are grouped to form an intricate pattern that eschewed the rigors of paratactic rendering (fig. 62). In one instance a girl in three-quarter view from the back (fig. 63) appears almost *as seen*[35] and gains a strange incongruous corporeality in a scene where even overlapping figures lack any suggestion of rounded form. The problem of scenic depth is adumbrated: the full-face flutists (colorplate 3) have an aura of three-

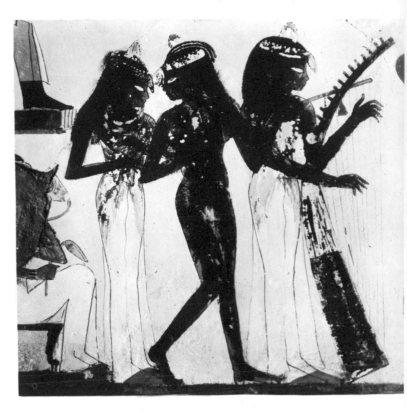

62. *Musicians and Dancer*. Dynasty XVIII, c. 1420 B.C. Wall painting (detail). Tomb of Nakht, Thebes

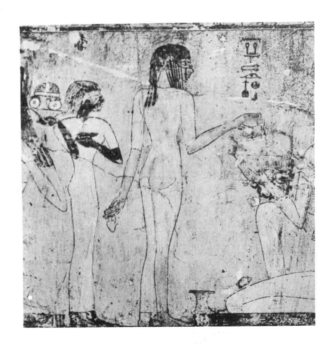

63. *Women Being Entertained*. Dynasty XVIII, c. 1450 B.C. Wall painting (detail). Tomb of Rekhmere, Thebes

64. *Mourners on Funerary Barges.* Dynasty XVIII, c. 1340 B.C. Wall painting, Tomb of Neferhotep, Thebes (tempera copy in The Metropolitan Museum of Art, New York)

dimensionality and the grouping of wailing women often definitely suggests recession (fig. 64).

A most interesting experiment in spatial illusion has been made in a famous hunting scene.[36] Here registers have been discarded altogether; the animals appear on small islands, as it were (colorplate 4), and are quite literally "surrounded" by desert soil, painted in irregular sweeps of stippled red. It is in this setting that a uniquely dramatic scene occurs. The usual incidents of the chase, such as dogs attacking game, fleeing gazelles dropping their young, small animals hiding in holes, had by now become well-worn clichés. In this case the artist has rendered not the typical reactions of fear but a single moment of desperate courage: we see an ibex proudly facing his murderers in the moment of his collapse (colorplate 5).

New Kingdom tomb painting is extraordinarily appealing, not only because it is subtle, varied, and full of surprises, but because we must see in it a vain bid for freedom, an attempt to escape from the formidable logic of an ancient scheme that had lost its original meaning and yet barred the way to an entirely new

65. *Senmut and Princess Nefrure.* Dynasty XVIII, c. 1480 B.C. Black granite, height 39 3/8″. State Museums, Berlin

68

development (colorplate 6). Nothing short of a revolution could break the tyranny of such a deep-rooted tradition. We shall see presently that such a revolutionary movement did in fact occur, but we must first consider the plastic figures of the period preceding this event.

The private statues of the Eighteenth Dynasty also reflect the complexity of the imperial age, its worldly sensuality, its groping for new religious values. It is significant that we can note a clear distinction between funerary and votive statues. The latter, put up in the forecourt of a temple, often show an uneasy combination of human and nonhuman elements: kneeling figures may hold an offering table or a stele. Such statues lose their plastic self-sufficiency in favor of vociferous, if pious, inscriptions. In funerary statues, however, archaic forms may persist; the "cubism" of Middle Kingdom squatting figures is reduced almost to absurdity in the statue of Senmut and the small princess entrusted to his care, although this strangely abstract monument to personal devotion has great formal nobility (fig. 65). We also frequently find the time-honored pose of a scribe, with or without the paraphernalia of his office, but in contrast to the alert Old Kingdom examples the facial expression has become introvert and brooding (figs. 66, 67).

The change in character of the feminine figurines is even more striking, especially if we compare them with the chaste serenity of Middle Kingdom "queenly" statues, which for all their firm and delicate modeling are impersonal, ageless. In the New Kingdom feminine beauty is not seen *sub specie aeternitatis*.

left: 66. *Amenhotep, Son of Hapu.* Dynasty XVIII, c. 1380 B.C. Gray granite, height 56″. Egyptian Museum, Cairo

below: 67. *Horemheb as a Scribe,* probably from Memphis. Dynasty XVIII, c. 1342 B.C. Diorite, height 46″. The Metropolitan Museum of Art, New York (Gift of Mr. and Mrs. Everit Macy, 1923)

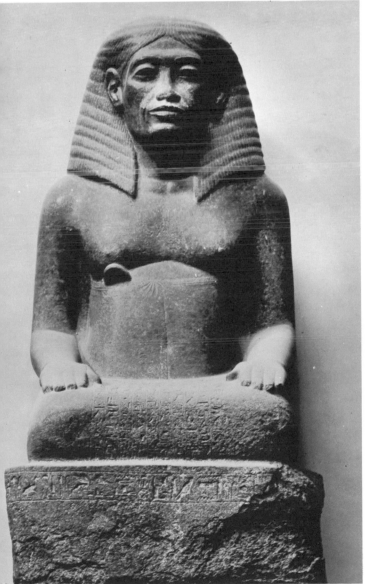

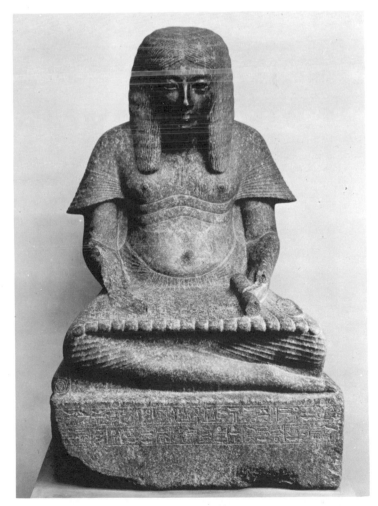

In one instance of the late Eighteenth Dynasty (fig. 68), where the archaic rigidity of the thin body is very marked it has the curious effect of psychologically enhancing the extreme reserve of the taut nervous face. This is, however, an exception, for the artists' main concern was with the ephemeral grace of youth. The modeling of slender girls, elegant in flowing garments, becomes soft and sensuous (fig. 69). The strict frontality, the "immobility" of such figures appear a natural pose and, though intended for the tomb, they are in spirit very close to the delicate frivolity with which carvers shaped the handle of a spoon or mirror in the form of a girl and turned a small nude servant carrying a vase into an unguent pot (fig. 70). Here, outside the realm of funerary art, the proverbial rigidity of Egyptian figures becomes relaxed and the twisted posture, closely observed, is skillfully rendered. It is ironical that those who look

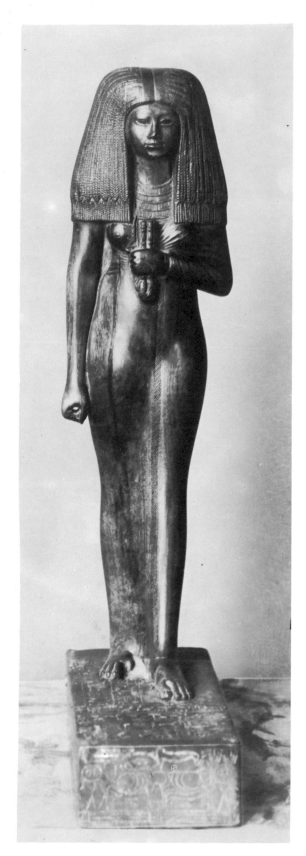

69. *Figurine of Tui*. Late Dynasty XVIII. Wood, height 13 3/8″. The Louvre, Paris

68. *Statue of an Unknown Lady* (fragment). Dynasty XVIII, c. 1400 B.C. Limestone, height 19 3/4″. Archaeological Museum, Florence

70

hopefully for a relaxed form of "naturalism" in Egyptian art will mostly find it in a decadent period or in the small luxuries of a sophisticated age. With one important exception: once and once only an attempt was made to break the bonds of a stern tradition.

The Amarna Revolution

The impetus of imperialistic expansion was suddenly halted and reversed by the strangest episode in Egyptian history, the so-called Amarna revolution, which was inaugurated by a king. The bare facts are too well known to be

70. *Unguent Pot in the Form of a Negro Serving Girl Carrying a Vase.* Late Dynasty XVIII. Wood, height 5 5/8".
Oriental Museum, Duke University, Durham, North Carolina

enlarged upon: the young Amenhotep IV flouted the powerful priesthood of Amon and turned away from an archaic cluttered pantheon to worship one divine principle only, the life-giving sun disk, the Aten. He changed his name to Akhenaten and moved his capital northward to an uninhabited area on the east bank of the Nile, later known as Tell el Amarna. In the spacious new town with its palaces and vast sun temple open to the sky, the king encouraged, in the name of truth, an extreme form of naturalism in art.

It is true that every one of these facts bristles with problems, but there is a temptation to ignore them, especially for those who feel that they have at last reached the oasis of a familiar pictorial idiom. All that was alien and contradictory in earlier figures, all that needed a circuitous approach in order to unravel its meaning, has vanished. What we find is the closest, subtlest, most sensitive approach to living form, especially to the enigma of the human face. Portraiture for its own sake, without ulterior motive, in the shape of busts and masks, makes its first appearance in history. It is understandable that since the heads of funerary statues were often more or less lifelike, the Amarna portraits have been considered a perfectly natural development of the former, showing only greater sophistication and psychological depth. However, this is to underrate the truly revolutionary significance of Amarna art as a whole.

It should be remembered that Akhenaten's rebellion was directed not only against the priesthood of Amon, it struck at the root of popular religion and undermined the theology of kingship. The latter, unchanged through millennia, must have satisfied deep religious needs, because it had linked the function of royalty with both celestial and chthonic powers. Akhenaten monopolized the celestial, ignored

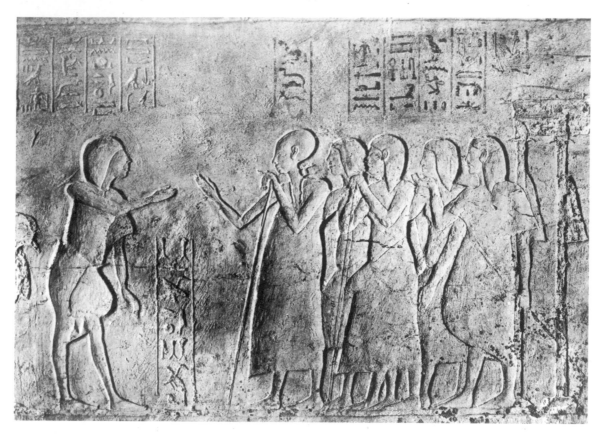

71. *Mahu Reporting to Vizier*. Dynasty XVIII (Amarna Period), c. 1372–1355 B.C.
Limestone relief (portion). Tomb of Mahu, Tell el Amarna

72. *Akhenaten and His Family*, relief from Tell el Amarna.
Dynasty XVIII (Amarna Period), c. 1372–1355 B.C.
Limestone, 12 1/4 × 15 1/4″. State Museums, Berlin

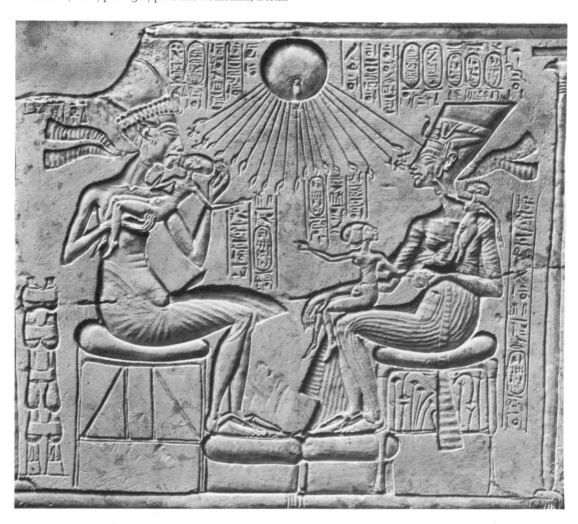

the chthonic aspect of religion; he sang the praise of life, never of life-in-death. He also stripped kingship of its mythical content—that is, not only of its superstitious trappings but of the speculative and emotional values which, through the ages, are preserved in the semi-articulate form of sacred acts. The new king was no longer, as in the coronation rites, the avenging son of his father Osiris, who, resuscitated after death, sanctioned the continuity of his office; he was no longer protected by goddesses acting as his mothers in the same rites, nor did he guarantee in his person the divine dispensation of social justice and order.

At Amarna, Akhenaten, though basking in the glory of the sun disk whose prophet he had become, presided over an isolated artificial community that was not only freed from the burden of tradition but, as it were, from the night side of existence. This of necessity deeply affected the pictorial arts, which had so far been mainly focused on the hereafter and now no longer served the dead. It is true that rock tombs continued to be made, but not one of them was ever used for interment. They appear a mere pretext for the display of secular scenes in which only the image of the king had some religious association, for the king, even if he appeared at times an all-too-human prophet, was intimately linked with the godhead. I cannot give a detailed analysis here of the changes in content and form of these tomb reliefs[37] and of the remains of frescoes that have been found in the palaces. It is true that several lively features can be traced back to the more mundane tombs of the early New Kingdom, but at Amarna these features were not furtive attacks on a rigid scheme; secularization was deliberate and final. Where life was alone glorified, its transient aspects no longer needed to be shirked; they were in fact emphasized. Actuality became a prime concern, even

dramatic narrative occurred, and both entailed an increased interest in local setting and in nontypical events. More important still, the wall surface could be considered as an entire spatial unit for the rendering of coherent scenes. On several occasions the traditional registers were discarded and different events were represented as occurring simultaneously. Individual character was now revealed by idiosyncrasies of movement or gesture; note for instance the difference between the police officer Mahu excitedly telling the story of his exploit and the boredom of the listening courtiers (fig. 71). The king looms large in most of the tombs, but apart from the symbolical cliché of sunrays supporting the life sign and reaching down to his person, secularization here meant humanization; we can see the royal family, even when riding out and visiting the temple, affectionately entwined, and rather cloying family scenes prevail (fig. 72). The royal figures, whether in tombs or on small steles, appear at all times relaxed to the point of spinelessness, and without a trace of formal dignity. All this is new and remarkable for its revolutionary intention rather than its artistic value.

Painting was never used in tombs, only on the walls and the gesso floors of palaces where tantalizing fragments hint at new ventures.[38] Plant and animal life was closely observed as for instance in the delightful marsh scene which ran in a continuous frieze round the walls of a small room and is presumably a rare example of pure landscape without a trace of human activity. The delicate movement of the swaying papyrus in all the stages of its growth, the swooping kingfisher (colorplate 7), are astonishingly vivid. So is the grouping, more or less in depth, of the two baby princesses seated on a cushion at their mother's feet (colorplate 8). Here the figures show traces of shading. Evi-

73. *Portrait Mask of an Old Woman.*
Dynasty XVIII (Amarna Period), c. 1372–1355 B.C.
Plaster, height 10 1/2″. State Museums, Berlin

dently new possibilities were adumbrated, though as far as we can judge were not yet fully exploited. It was in plastic figures that Amarna art truly excelled.

It should be realized that Amarna statuary was not intended for either tomb or temple; it was emphatically a secular form of art. This meant that the old formal constraint, the "tensional harmony" between the individual and the timeless, lost its meaning even if a millennial tradition could not be suddenly discarded. Strict frontality was maintained in full-length figures but it is significant that the interest shifted from figure to portrait head. The king's religious obsession with *maat*, the divine order, in the limited sense of truth must have encouraged artists to explore what is most individual in man, and human faces became the focus of a more intense, a more receptive form of observation. That this opened the road to rather shallow naturalism is shown by a number of plaster masks, in some cases even worked-over casts found in a sculptor's work-

shop. Their main interest lies in the fact that they are faithful records of contemporary faces[39] (fig. 73).

The royal portraits, on the other hand, are inspired works of art. Here the perennial awe of the Pharaoh, felt even in the case of this strange king who insisted on the portrayal of his own physical peculiarities and those of his family, redeemed these portraits from mere realism. It is true that Akhenaten's colossal statues at Karnak, which date from the earliest years of his reign and still represent him in Osiride form, show that artists working by command and on that scale were baffled as well as inspired, and produced hybrid figures of disturbing morbidity.[40] But the finds at Amarna show that the king's ideas bore fruit in that setting. There is a delicacy, almost a reverence, in the approach to the royal sitters and at the same time a psychological penetration that holds a modern spectator spellbound in their

74. *Portrait Bust of Queen Nofretete*, from Tell el Amarna.
Dynasty XVIII (Amarna Period), c. 1372–1355 B.C.
Painted limestone, height 18 7/8″. State Museums, Berlin

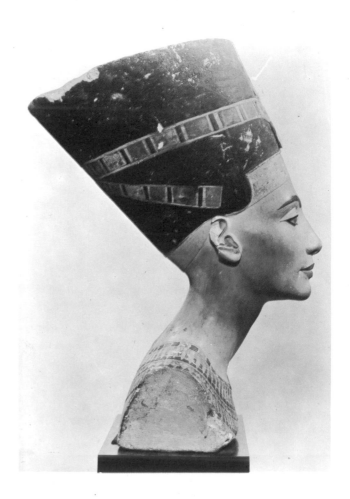

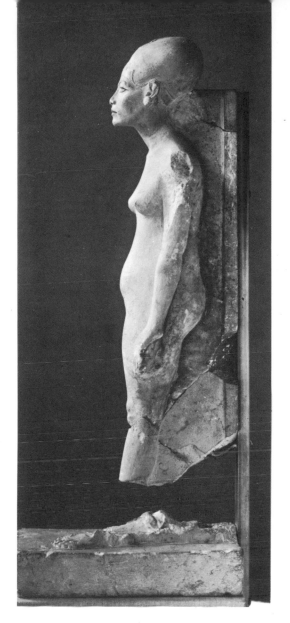

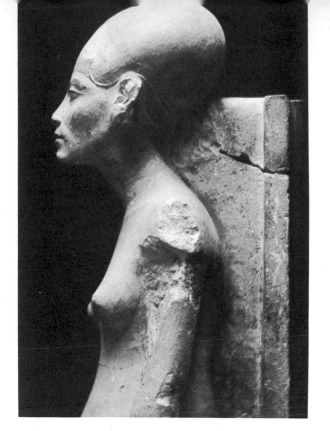

76. *Queen Nofretete* (upper portion of statuette in fig. 75)

75. *Statuette of Queen Nofretete*, from Tell el Amarna. Dynasty XVIII (Amarna Period), c. 1372–1355 B.C. Painted limestone, height 15 3/4″. State Museums, Berlin

presence. Never has queenly beauty, remote and enigmatic, been more subtly evoked than in the busts and heads of Nofretete. In figure 74 it was not realism that shaped the slender neck overlong but the need to balance the backward sweep of the crown. The decay of such beauty was poignantly portrayed in a small full-length statue of the aging queen, with sagging body and hardened features (figs. 75, 76). Akhenaten's face (fig. 77), self-willed, intelligent, slightly decadent, is as haunting as the image

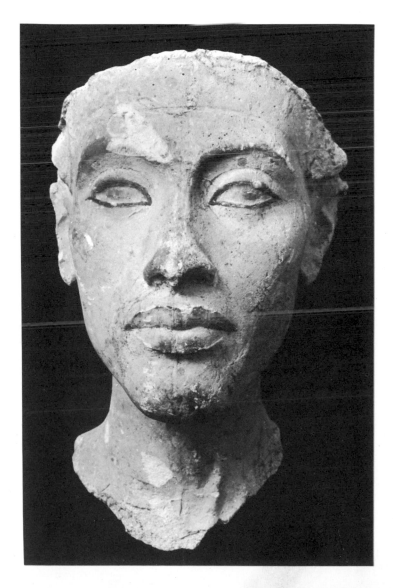

77. *Head of Akhenaten*, from Tell el Amarna. Dynasty XVIII (Amarna Period), c. 1372–1355 B.C. Painted limestone, height 9 7/8″. State Museums, Berlin

that emerges from historical sources. One is grateful to be spared for once the elongated skull and the abnormally fat hips and abdomen—ominous signs of a degenerating disease—which are emphasized in the reliefs and the Karnak colossi. The portrait heads of the young princesses, of which several have been found, all show the same long skull which, like the royal hips, soon became a mannerism in all Amarna figures. Their gentle faces are often enchantingly childish. The small torso of figure 78 renders incipient adolescence with wonderful delicacy.

Amarna art, however, was a hothouse plant: it grew in a setting which was sheltered from the impact of grim political realities, and it ignored the tragic implications of existence. When the town was deserted after the collapse of the religious revolution, apparently little of it survived the following wave of reaction except a few mannerisms and a new sensitivity. No royal family scenes at Amarna approach even remotely the delicate intimacy of the portrayal of the young Tutankhamen and his queen (fig. 79, colorplate 9).

We might also mention here one remarkable piece of sculpture of this period because it appears to hark back to a traditional form: the exquisite funerary statues of the court official Maya and his wife Merit, singly and seated side by side in the time-honored fashion (figs. 80, 81). In the earlier New Kingdom, interest

79. *Tutankhamen and His Queen Ankhesenamen*, from the Tomb of Tutankhamen, Valley of the Kings. Dynasty XVIII, c. 1355–1342 B.C. Lid of wooden chest, inlaid with ivory and other materials, height 12 1/4″. Egyptian Museum, Cairo

78. *Torso of a Princess*, from Tell el Amarna. Dynasty XVIII (Amarna Period), c. 1372–1355 B.C. Quartzite, height 5 7/8″. University College, London

76

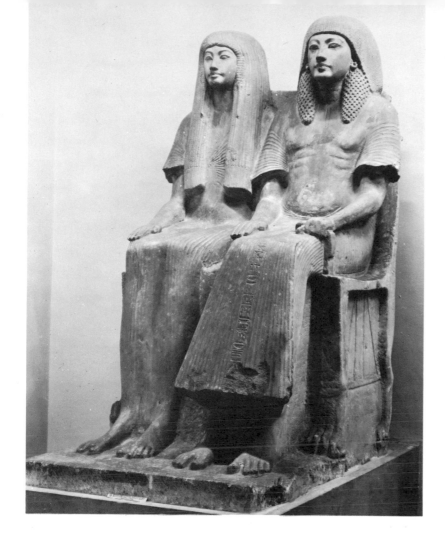

80. *Court Official Maya and His Wife Merit*,
probably from a cemetery near Saqqara.
Dynasty XVIII, c. 1345 B.C.
Limestone, height 60".
Rijksmuseum van Oudheden, Leiden

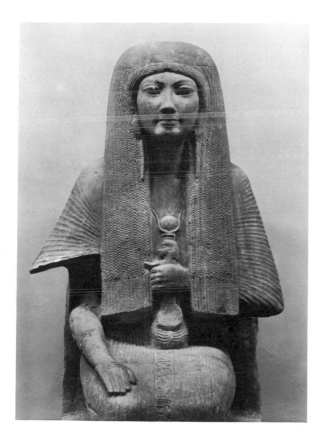

81. *Merit, Wife of Maya*. Dynasty XVIII, c. 1345 B.C.
Limestone, height 63". Rijksmuseum van Oudheden, Leiden

in such groups must have flagged, for those
that exist are of poor quality. Here the model-
ing is subtle and restrained, but the fascination
of these figures also lies in the strange balance
they hold between otherworldly serenity and
mundane "courtoisie." It is as if this refined
and beautiful couple were presiding over a
very solemn festivity.

The Nineteenth Dynasty

And yet the influence of Amarna went deeper
and was more fruitful than appears at first
sight: both its sense of the dramatic in gesture
and expression, and the interest in coherent
scenes and local setting, re-emerged in a form
and a context of which, ironically, the prophet
of Light and Life would hardly have approved.

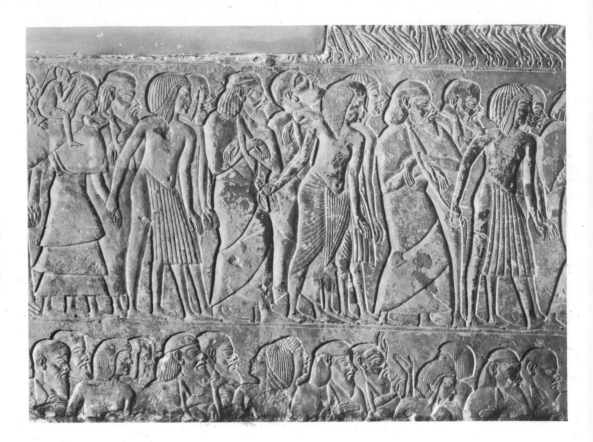

82. *Procession of Prisoners*, relief (portion) from the Tomb of Horemheb, Saqqara. Dynasty XVIII, c. 1345 B.C. Limestone. Rijksmuseum van Oudheden, Leiden

In the tomb of Horemheb (fig. 82), a former general of Akhenaten, who unified the country after his master's death and became the last king of the Eighteenth Dynasty, and in the contemporary tomb of Nefer-renpet (fig. 83), we find scenes of such emotional intensity and individual characterization that one must assume these artists to have been schooled in the Amarna tradition. Here, however, the scenes have nothing of the lightheartedness of

83. *Funerary Procession of Nefer-renpet, High Priest of Memphis*, relief from his tomb, Memphis.
Dynasty XIX, c. 1313 B.C. Limestone, length 51 3/8". State Museums, Berlin

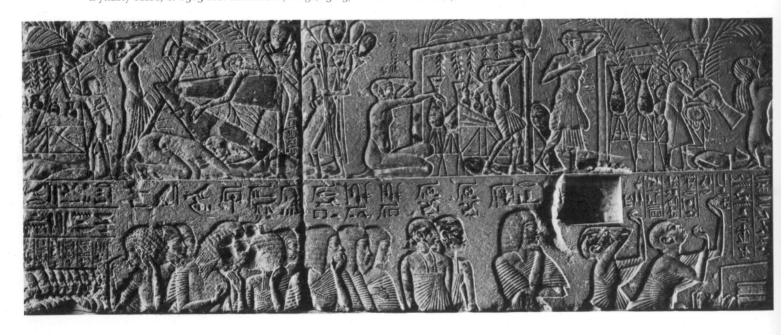

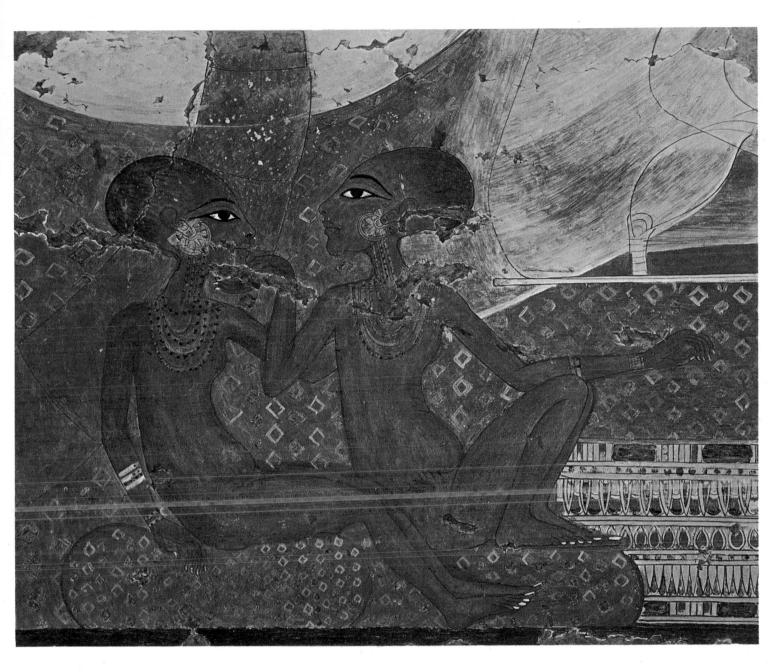

Colorplate 8. *Daughters of Akhenaten*, wall painting (fragment) from the Tomb of Akhenaten, Tell el Amarna. Dynasty XVIII (Amarna Period), c. 1372–1355 B.C. Ashmolean Museum, Oxford (tempera copy by N. de Garis Davies in The Oriental Institute, University of Chicago)

Colorplate 9. Backrest of the Throne of Tutankhamen, from his tomb, Valley of the Kings.
Dynasty XVIII, c. 1355–1342 B.C. Wood covered with gold leaf, inlaid with faience,
glass paste, semiprecious stones, and silver; height of throne 41″. Egyptian Museum, Cairo

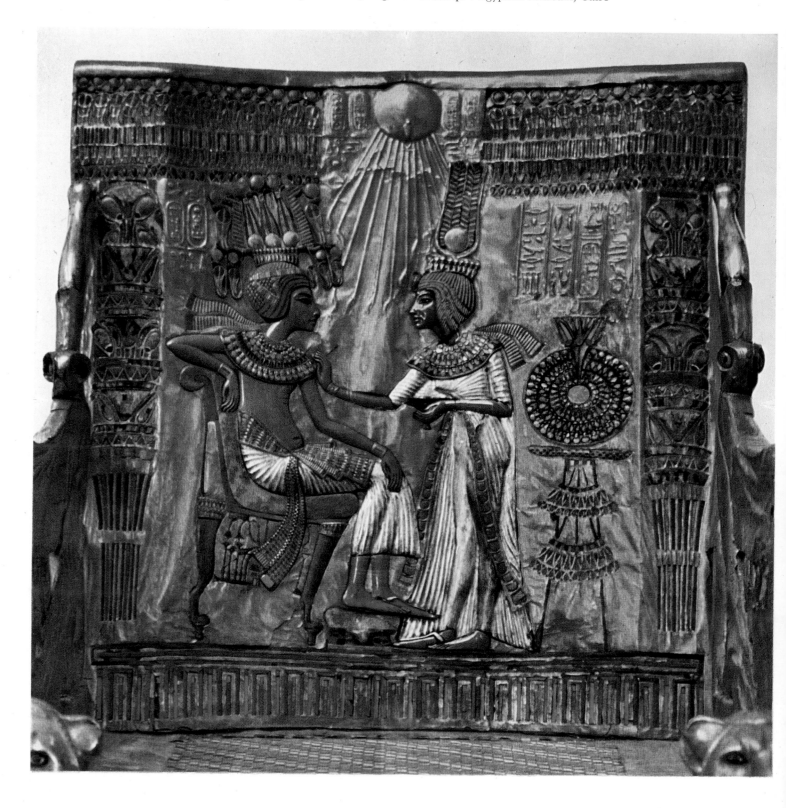

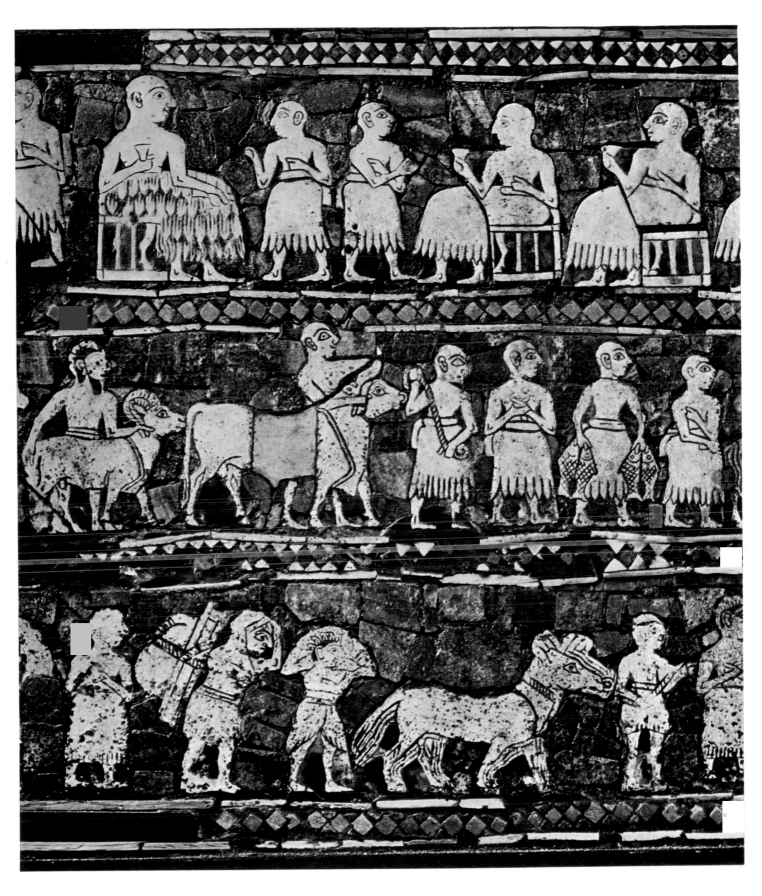

Colorplate 10. "*Standard of Ur, 'Peace Side'*" (portion), from the Royal Cemetery, Ur. Early Dynastic III, c. 2550 B.C. Wood inlaid with shell, limestone, and lapis lazuli, height 8″. British Museum, London

Colorplate 11. "*Standard of Ur,* '*War Side*' " (portion), from the Royal Cemetery, Ur.
Early Dynastic III, c. 2550 B.C. (see colorplate 10)

the Amarna mock tombs; they are frequently tragic. In fact the worldly gaiety of the earlier funerary art was soon lost; in the Nineteenth Dynasty religious scenes, such as that of the goddess Hathor offering life-giving drafts to the dead, begin to predominate. Tomb painting then gradually vanishes.

A more important inheritance from Amarna was the preoccupation with actual instead of typical events; this dominated the great Nineteenth Dynasty battle scenes, those of Seti I and his successors. That these were as revolutionary as some of the Amarna reliefs can be asserted but not proved, because the remains of pre-Amarna royal reliefs are very scanty. One so-called battle scene on the chariot of Tuthmosis IV, however, seems to confirm the impression that before Akhenaten actuality was not the artists' concern when depicting the king. It is in fact an elaborate pictogram of the Pharaoh as *ex officio* victor over his enemies, with some of the paraphernalia of battle thrown in, and is entirely devoid of dramatic tension or coherence in space. In the reliefs of Seti I at Karnak, on the other hand, we have a unique blend of symbol and actuality, of the king's unconquerable might and the grim reality of the battles he fought. For the last time in Egyptian history the paradox of kingship found superb artistic expression. The motif of the royal warrior was infinitely varied, but even where the king is engaged in violent action the outcome is a foregone conclusion; he is not only the dominating but almost the static center of the turmoil. In many cases this is epitomized by the traditional diagonal stance of the royal horse-team, something between a prance and a gallop, between an arrested and a dynamic movement. This gives to violent action and even to pursuit a decorative equipoise, almost a stillness; and though it soon became a mechanical device, even as a transfer pattern

84. *The Capture of Pekanan.*
Dynasty XIX, c. 1300 B.C. Limestone relief (portion).
North exterior wall, Hypostyle Hall, Temple of Amon, Karnak

it is invariably effective. I cannot go into a detailed description of these scenes, nor trace their development and their decay under Ramesses II and III.[41] I can only point to two small episodes which are unthinkable without the stimulus of Amarna. In the siege of the hilltop town the resilient stride of one escaping man and the hopeless collapse of another are highly dramatic (fig. 84). So is the attitude of

85. *Fleeing Shepherd.*
Dynasty XIX, c. 1300 B.C.
Limestone relief (portion).
North exterior wall,
Hypostyle Hall, Temple of Amon,
Karnak

the panic-stricken shepherd who, fleeing, looks back at the towering figure of the king (fig. 85). The Seti reliefs are full of such original details, which under his successors soon became clichés.

It is as sad as it is significant that in the purely religious art of the same period not a trace of inspiration can be found. Seti I was a reactionary who not only deliberately turned away from the cult of light but, as it were, in an opposite direction. His famous temple at Abydos is dedicated to the mysteries of Osiris and in a subterranean cenotaph at the back of the temple the chthonic aspect of divine kingship was reaffirmed. The reliefs in the temple, however, are mainly concerned with ritual and the relationship between king and god, and these are sadly disappointing (fig. 86). They are, for all their exquisite workmanship, utterly lifeless.

With these all too brief references to the art of the Nineteenth Dynasty we have reached the end of our introduction to Egyptian art. As I said before, the study of periods of decline may be both interesting and rewarding. This certainly applies not only to the reigns of Ramesses II and III, but to those periods of Egypt's preternaturally long history when old

forms were artificially rejuvenated in the most deliberate attempt at archaism the world has ever known. Even the old preoccupation with individual man re-emerged spasmodically in purely naturalistic portraiture.[42]

We may nevertheless admit that with the Nineteenth Dynasty the vitality of Egyptian art had spent itself.

86. *Seti I Before Soker, God of Death.*
Dynasty XIX, c. 1300 B.C. Limestone relief (portion).
Northwest wall, Hall of Nefertem and Ptah-Soker,
Temple of Seti I, Abydos

2

Mesopotamia

THE PROTOLITERATE PERIOD (circa 3500–3000 B.C.)

The main fascination of studying Near Eastern art as a whole is that it taxes our imaginative powers to the utmost. Any sense of familiarity which we may, with difficulty, have acquired in one region is shattered when we move to a different scene. The contrast, for example, between Egypt and Mesopotamia is in terms of geography, climate, social structure, and religious life almost complete.

Mesopotamia was a vast fertile plain, a land of circular horizons. It had no natural defenses against invaders from the northern and eastern mountain ranges, none against the nomads from the arid stretches of Syria and Arabia into which it merges. It had temperamental rivers that were invaluable for irrigation, but, especially in ancient times, often destructive. It knew extremes of heat and cold in dramatic transition, torrential rains and violent thunderstorms, the latter almost unknown in Egypt. Its early history, the history of the Sumerian people, evolved around independent city-states and their struggle for supremacy. These city-states, whose main concern was agriculture, had originally a rather simple form of democratic rule, power being vested in a council of elders; the council could, however, if circumstances demanded, appoint a king as temporary ruler. Kingship was therefore generally speaking a military or political expedient, by no means a sacred dogma. The layout of each city, the hub of the city-state, was centered in a temple dedicated to a protective deity, and from this center the city's economy was organized and controlled in a system that has been rightly called a form of "theocratic socialism."[1]

Mesopotamian religion reflects in many ways the violent climatic and political upheavals to which man's efforts were subjected. The ephemeral in human affairs was taken for granted and speculation on the hereafter conspicuously absent. Nor was the unchanging, the eternal, the only hallmark of divinity—in fact, the Sumerian language had no equivalent

for the word *eternal*,[2] which is so frequently, so glibly, used in Egypt. Though cosmic order was recognized in the movement of celestial bodies and in seasonal rhythm, the great cosmic divinities were conceived in terms of passionate wills and immense power. There is in the early texts a remarkably human quality in the behavior of the sky god, storm god, and others, who match their wills and powers and who confer, discuss, and take decisions like a council of state. Theirs was, however, a humanity infinitely enlarged and a wisdom that remained inscrutable. Hence man's deep concern with the divine will, his constant preoccupation with "fate" (a concept unknown in Egypt), his sense of utter dependence—and yet, paradoxically, in his personal and communal relationship with deities a sense of proximity, of intimacy hovering between love and fear.

The reader may find that several features of this brief sketch are vaguely familiar, or at least less utterly alien than is the Egyptian ideal of static rule by a divine king. It is therefore tempting to add a significant comparison. The pyramid, as part of a tomb-and-temple complex, remains to Western eyes one of the strangest concepts in the history of religious architecture. Its Mesopotamian counterpart, the huge ziggurat or temple tower, often almost equivalent in size and roughly in shape, is by no means conceptually alien. Rising steeply above the featureless plain, these sacred mountains built by man, with their slow approach in stages to the temple on the summit, the seat of the divine, have a symbolical appeal that can be experienced simply and directly even today when one visits their sad remains, amorphous hills of crude mud brick.

And yet in the realm of representational art the situation seems reversed. Generally speaking, Mesopotamian art lacks the very features which in Egypt, even if wrongly interpreted, appear familiar to modern spectators: the portrayal of daily life and individual human beings. It is, with very few exceptions, devotional in intention and concerned with ritual and symbol rather than with the phenomena of life, except where these proclaim divine blessings to mankind. If this suggests to the reader a dull kind of formalism, the very opposite is true. The range and variety of Mesopotamian art is astonishing and, though its development is incoherent and the general level of achievement is low, its masterpieces have originality and daring.

Two preliminary observations should be made here. Firstly, the population of Mesopotamia consisted, from roughly the middle of the third millennium onward, of two distinct ethnic strains, Sumerian and Semitic,[3] and even in earlier times it had repeatedly to absorb invaders from the mountain region in the northeast. This may account for sudden changes and inconsistencies in style. Secondly, the only material available for architecture, apart from timber, was mud brick, a severely limiting medium; while stone for sculpture was rare, so rare that the pivot for a door could be considered a worthy present from one local ruler to another. Mesopotamian artists therefore lacked the experience and the tradition of good craftsmanship that sustained mediocre sculptures in Egypt, and all but the very best work may be almost unbelievably incompetent. Metal, on the other hand, was used with great mastery, and earlier than in Egypt.

We began our survey of Egyptian art with the Protodynastic period. In Mesopotamia the "Protoliterate" period (circa 3500–3000 B.C.), so called by archaeologists because it coincides with the invention of writing, shows at a slightly earlier date the same phenomenal eruption of cultural achievement: the development of

cities, the appearance of representational art and of architecture on a large scale. The preceding Al 'Ubaid period with its rather stagnant village culture has no other claim on art history than painted pottery of feeble abstract design. It is, in fact, a debased version of a most remarkable form of decorative art which flourished in the Persian uplands bordering on the plain before the marshland of Mesopotamia proper was habitable. I mention it here because in the painted pottery of prehistoric Susa, Persepolis, and Samarra we find a bold imaginative use of animal form for decorative purposes that seems strangely prophetic of at least one aspect of later Mesopotamian art: the transformation of beasts into patterns.

There exists, however, one important link between the Al 'Ubaid and Protoliterate periods, namely, the development of temple architecture. Already in the late Al 'Ubaid period temples reached a considerable size and show the buttressed walls which are a prelude to the more complex form of recessed building that remained in use from the Protoliterate period up to Hellenistic times. Where building material was of such uncompromising dullness, recessed walls were the obvious means of articulating and enlivening the wall surface, unless color was applied. We shall see presently how this too was done.

At Warka, the Biblical Erech, a temple of the Protoliterate period, probably dedicated to the sky god Anu, has been almost miraculously preserved. Its plan, an oblong cella with a raised altar and an offering table with adjoining hearth, shows intricate recesses both inside and out. Its most spectacular feature, however, is its location on the summit of the first known ziggurat, a man-made irregular mound, buttressed round its base, that rises forty feet above the plain (fig. 87). A stairway led to the

87. The "White Temple" on Its Ziggurat, Uruk (Warka). Protoliterate, c. 3200–3100 B.C. *View from the east*

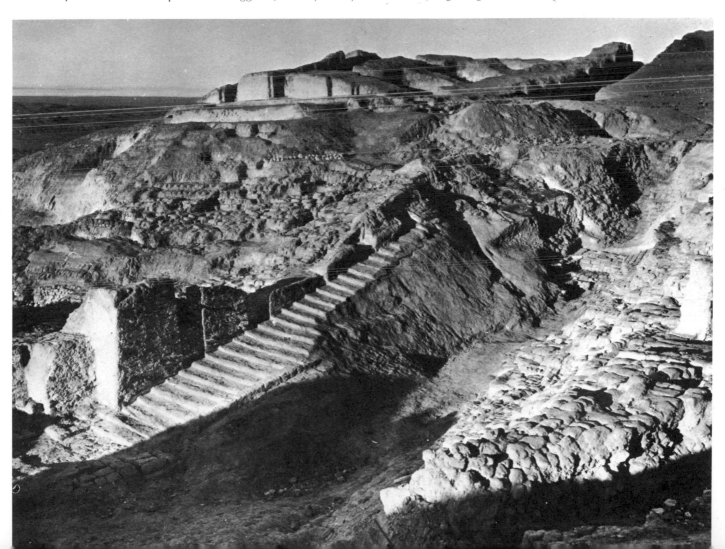

88. Wall fragment, from the court of the E-anna precinct, Uruk (Warka). Protoliterate, c. 3300 B.C. Cone mosaic, length 8' 6". Iraq Museum, Baghdad

platform on which stood the temple, painted a gleaming white, a beacon to mankind, a summons to the god for whose epiphany it was erected. We know from religious texts that mountains had a numinous quality for these dwellers in the plain. A later ziggurat was called "Bond between Heaven and Earth," and this epitomizes both the daring and the humility of an imaginative concept that must have entailed a stupendous communal effort.

A temple built nearby in the plain, and dedicated to the mother goddess, shows the remains of huge brick pillars and engaged columns hardly ever used in later times. A remarkable feature here was the insertion, in an effort to embellish and protect the surface, of innumerable small baked cones set in a soft layer of mud, their blunt ends colored black, red, or buff. These were arranged in simple patterns and formed a durable and gay protective skin (fig. 88). It is not surprising that this method was discontinued after the Protoliterate period, for it must have entailed a staggering amount of labor.

When we turn to the plastic art of the period, we notice that, compared with Egypt, it is strangely anonymous. No carefully identi-

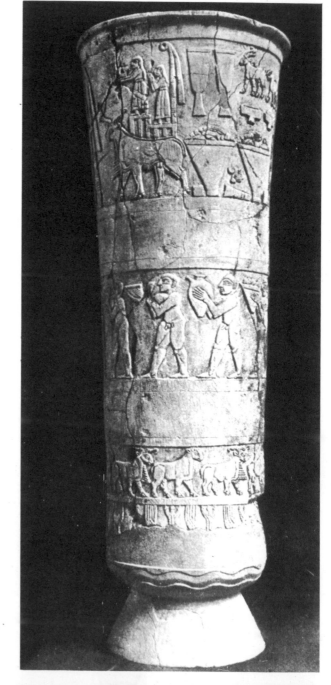

89. Vase with Ritual Scene in Relief, from the E-anna precinct, Uruk (Warka). Protoliterate, c. 3500–3100 B.C. Alabaster, height of body c. 36" (foot largely restored), upper diameter 14 1/8". Iraq Museum, Baghdad

fied kings appear, nor are their acts commemorated. We saw that those early pictorial statements in Egypt had an implicit religious meaning, a tribute to the divine power of the Pharaoh. Early Sumerian art reveals a different religious preoccupation; its main concern is with ritual and the gods, who are either identified by symbol or symbolically represented.

The most impressive ritual scene we possess is depicted on a slender alabaster vase found at Warka (fig. 89). This probably commemorates an important religious event, the sacred marriage of the mother goddess, the source of all life, which was ritually enacted to ensure fertility. The scenes, arranged in horizontal bands, perfectly suit the vase form. In the top register the crowned mother goddess is shown in front of her shrine, indicated by the two coiled bundles of reeds which remained her symbol (fig. 90). She faces a priest who, ritually naked according to the rule in ancient Sumer, offers his tribute. In a lower register a row of similar figures suggests a procession of tribute bearers. Animals and plants in the bottom registers may either represent sacrifice or symbolize the riches of divine blessing (figs. 91, 92). It is interesting to compare these muscular little men, slightly stooping over their large vessels, with Egyptian transfer-patterned tribute bearers in royal reliefs of the Old Kingdom who seem blandly indifferent to the weight they carry. They are utterly static, notwith-

91, 92. *Tribute Bearers, Rams and Ewes, and Plants* (reliefs on vase in fig. 89)

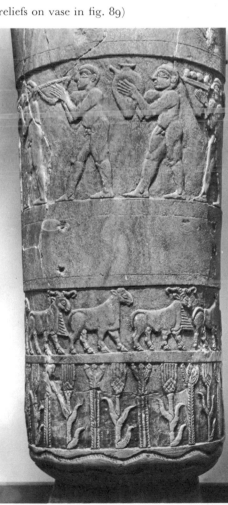

90. *Priest Offering Tribute to the Mother Goddess in front of Her Shrine* (relief on other side of vase in fig. 89)

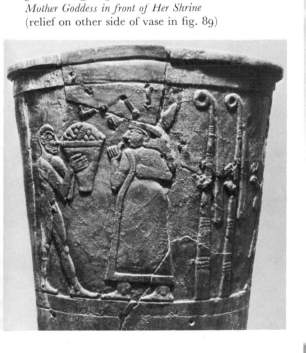

standing their conventional striding posture, and they lack the organic coherence, the dramatic intensity, of the Sumerian priests bent on their task. The artist shows a delightful unconcern with the problem of reducing the human figure to a two-dimensional plane. Though in some cases the shoulder region is awkwardly twisted, most figures appear in almost pure profile and have a convincing corporeality. For better and for worse no strict canon for the outline of the human body was ever evolved in Mesopotamian art. The result is that an actual scene is suggested by the dramatic confrontation of goddess and priest, in contrast with the formal juxtaposition of Egyptian figures engaged in ritual acts.

Figure 93 depicts a stone trough on which the mother goddess is represented symbolically by her shrine from which lambs are emerging: a lively design, though severely decorative in its antithetical grouping. The nearly life-size marble face of figure 94, found at Warka, may be safely assumed to represent her also, although this cannot be proved. It is difficult to imagine the effect which may be conjectured from later examples, of the lapis lazuli eyebrows and eyeballs of shell with lapis lazuli pupils, and of the finely engraved gold sheeting which doubtless covered the flat waves of the hair; but the modeling has great nobility and the mouth is gentle.

It may come as a shock that there is every reason to believe that the leonine monster of figure 95 represents the mother goddess in a terrifying aspect, since her symbol is carved on its shoulder blades. Whatever the function of this particular figure, it seems to point to a streak of ambivalence toward the mother goddess, the source of life and at the same time life's destroyer, for all creatures are "born unto death." We are forcibly reminded of the Gilgamesh epic,[4] recorded more than a thou-

sand years later, in which the Sumerian hero hurls bitter invective at the cruel goddess and suffers her revenge. The hybrid lioness is a horribly convincing creature; as one scholar puts it: "viewed as anthropomorphic the body appears bestial, but if one views it as a lioness it has a ghastly air of misshapen humanity." It has, like the priests on the Warka vase, organic coherence, and the twisted posture gives it a dramatic intensity that sets it worlds apart from the cool clear pictograms of Egyptian divinities.

Since monstrous form plays an important role in Mesopotamian art, a comparison between animal portrayal in the two regions might be instructive. Whatever the origin and the significance of Egyptian animal worship, we find from the Old Kingdom onward a loving but detached observation of animal life in the reliefs, a pictographic use of animal heads on human bodies to denote a god's connection with a particular beast, and in the rare instances of "sacred" animals sculptured in the round, a faithful rendering that is as placid as it is dignified. In Mesopotamia, on the other hand, animals could be apprehended emotionally, as numinous creatures or as having symbolical significance in religious terms, e.g. as embodying transcendent power or wisdom. This may explain the extraordinarily compelling quality of some plastic animal figures, which suggest not the image of a sacred beast but a divine apparition. Various animal forms symbolizing different qualities could also be combined, if a complex religious idea or the different aspects of one particular god had to be pictorially expressed. Even then the result was not a pictographic conceit; religious emotions of fear and awe welded the significant incongruities into a new entity that was neither a symbol nor an attribute, but a monstrous "presence."

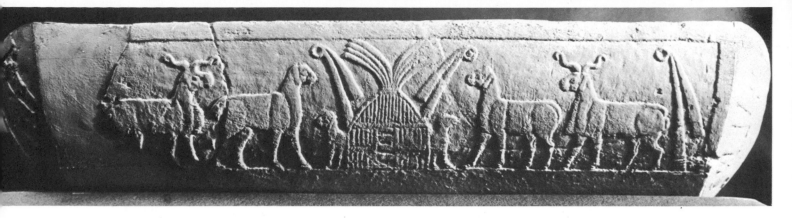

93. *Sacred Lambs Emerging from the Shrine of the Mother Goddess*, trough with relief decoration, probably from Uruk (Warka). Protoliterate, c. 3500–3100 B.C. Gypsum, length 51 1/8″. British Museum, London

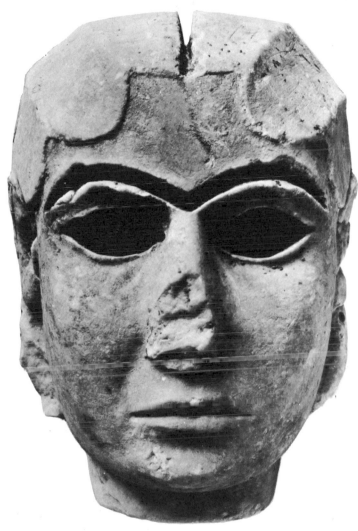

94. *Head of a Woman (Mother Goddess?)*, from Uruk (Warka). Protoliterate, c. 3200–3100 B.C. White marble, height 7 7/8″. Iraq Museum, Baghdad

95. *The Mother Goddess us a Leonine Monster*. Protoliterate, c. 3500–3000 B.C. Crystalline limestone, height 3 1/2″. Brooklyn Museum (Guennol Collection)

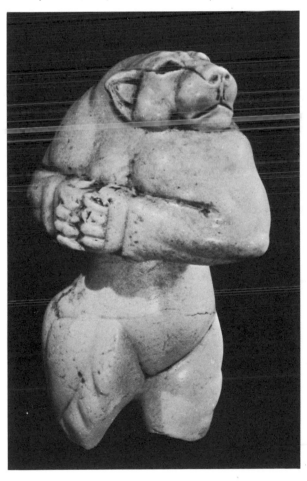

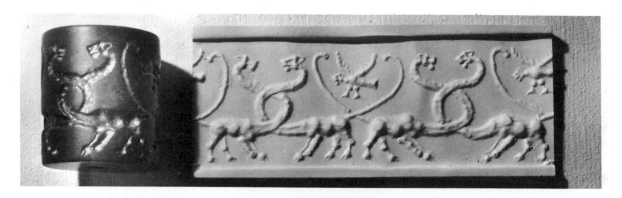

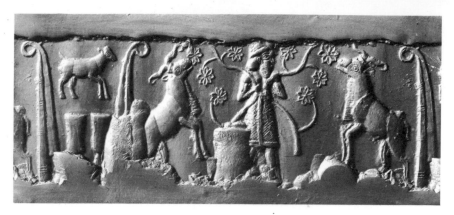

It is interesting to note that Egypt produced only one of these, namely Ta Urt, the helper of women in childbirth. Ta Urt, an impressive upright hippopotamus with crocodile features, combines two creatures of the "watery deep." Both the dignity and the terror of childbirth were expressed in a monstrous entity that remained a valued talisman even in the Amarna period. It obviously fulfilled an emotional need in a highly critical situation.

In Mesopotamian art, monsters abound and the reason for this is to be looked for primarily but not exclusively in a peculiar type of emotional imagination. Artists have been tempted in all times to use monsters, by virtue of their unrealistic character, as a decorative motif and it is significant that already in the protoliterate period several of them have been subordinated to design. The snake-necked lion of figure 96, for example, combines two aspects of fertility: the lioness connected with the mother goddess,

and the intertwined snakes—the later caduceus—which symbolized the male god of fertility. In this case the design appears on a cylinder seal and it was in the art of the seal engravers that monsters were soon to play an important part.

The origin of the cylinder seal is unknown, but if the idea arose from an engraved cylindrical bead rolling over soft clay and producing a patterned strip, its possibilities were soon grasped. In Mesopotamia clay tablets were the only available writing material and since the earliest documents consisted almost entirely of contracts and accounts, their validity would be enhanced if they bore the seal of the parties concerned—a measure that was half practical, half magical. A carved cylinder rolled over the wet surface of the tablet would produce a ribbon design of indefinite length; as it is the *raison d'être* of seals that they should all be different, this practice offered, until writing was incorpo-

rated in the design, a limitless opportunity for inventing suitable patterns. As in all decorative art, however, design and surface are strictly correlated and the Mesopotamian seal cutters were faced with the added problem of producing a continuous strip design on a cramped cylindrical surface. With amazing skill they sometimes produced a coherent scene, but this was considered unsatisfactory and experiments were made with antithetical grouping (fig. 97) or interlaced figures that could be endlessly repeated. At a later period a favorite motif was that of two animals with bodies facing but heads turned back, thereby suggesting a bilateral movement which linked the separate groups as in figure 114. It is clear that monsters were most suitable for different types of unrealistic grouping: in figure 96, for instance, the tails are crossed to form a subsidiary pattern and the result is a satisfying continuous design.

Toward the end of the protoliterate period we find yet another decorative use of animal forms, less subtle and more realistic: bulls and lions carved in the round on stone vases. In connection with these a long-lived mythological motif occurs for the first time: a man of demoniac strength, naked but for his girdle, holding these powerful creatures in his grasp

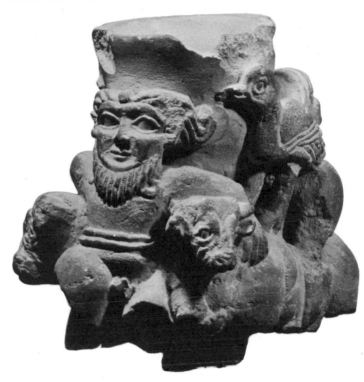

98. *Hero Guarding Cattle*, high relief on a vase, probably from Uruk (Warka). Protoliterate, c. 3100 B.C. Limestone, height 5″. British Museum, London

(fig. 98). The motif of a relentless struggle between human and animal forces was soon to engross the seal engravers of the Early Dynastic period so exclusively that it must have had an almost obsessional appeal.

THE EARLY DYNASTIC PERIOD (circa 3000–2340 B.C.)

With the Early Dynastic period we move into the realm of history, for only then do persons and events emerge from tantalizing anonymity. It is significant that in contrast with Egypt, the earliest named kings appear on modest, poorly carved stone plaques and are not depicted in warlike but in devout acts, making offerings or building a temple. In fact the plaques commemorating such acts are more in the nature of a pledge to the gods than a boastful monument. We possess one record of a secular event in the battle scenes on the stele of King Ean-

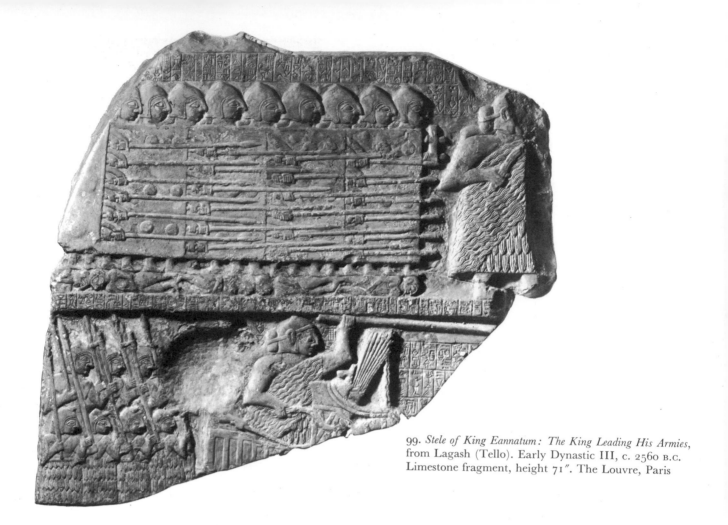

99. *Stele of King Eannatum: The King Leading His Armies,* from Lagash (Tello). Early Dynastic III, c. 2560 B.C. Limestone fragment, height 71″. The Louvre, Paris

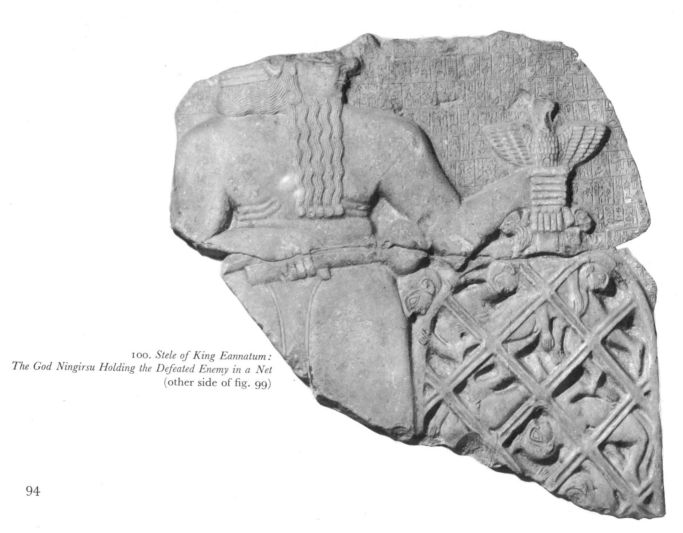

100. *Stele of King Eannatum:*
The God Ningirsu Holding the Defeated Enemy in a Net
(other side of fig. 99)

natum (figs. 99, 100). This stele was, however, erected not only to commemorate a victory over the city of Umma: it was also a boundary stone, inscribed with the contractual settlement between conqueror and conquered. Nor was the king represented as the actual victor. We see him on the reverse side of the stele marching at the head of a solid phalanx of soldiers, who are protected by a wall of shields. In a lower register the king stands in his chariot, hurling his lance, and leads his infantry into battle. The obverse, however, states in symbolical language to whom the victory was due: we see the god Ningirsu holding the net in which he has caught the enemy.

It would be hard to imagine a more convincing expression, both in form and content, of the complete contrast between Egyptian and early Sumerian ideas of kingship. Pharaoh, smiting his enemy in the time-honored gesture, has a calligraphic elegance compared with which both Eannatum and Ningirsu are clumsy, but the formula of an ever-victorious divine king lacks the pungent actuality of this royal leader of men. The god Ningirsu, stolid and massive, appears to emphasize the king's vulnerability.

Eannatum's stele has so far remained an isolated example; in fact, not until Akkadian times do we find another commemorative battle scene. Stone plaques, however, continued to be made. These were usually square with a hole in the center, either to fix them on the temple wall or, if they were put down horizontally, for inserting a banner. They all depict some form of solemn banquet or celebration and sometimes also show the paraphernalia of war, chariots, captives, and the like, so we may assume that they were votive objects dedicated to the god who had granted victory in battle. Since they were neither purely commemorative in intention nor purely religious in representation, they do not seem to have stirred artistic

101. *Banqueting Scene*, votive plaque from Khafaje. Early Dynastic II, c. 2750 B.C. Limestone, height 12 5/8". Iraq Museum, Baghdad

102. *Warrior* and *Prisoner*, inlays of a frieze, from Mari. Early Dynastic III, c. 2500 B.C. Shell, height of figures 4 3/8". The Louvre, Paris

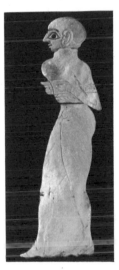

imagination; the rows of little men solemnly feasting, the rows of chariots and captives, are extremely dull (fig. 101). In some instances shell and lapis lazuli inlay, set in bitumen, is used instead of stone relief for such scenes. The resulting scenes, though rather finicky, may be quite charming, as in the case of the "standard" found at Ur (colorplates 10, 11), a trapezoidal object the use of which is uncertain, though it was probably intended for display in the temple. Similar inlays found at Mari[5] are delicately carved and far more varied (fig. 102).

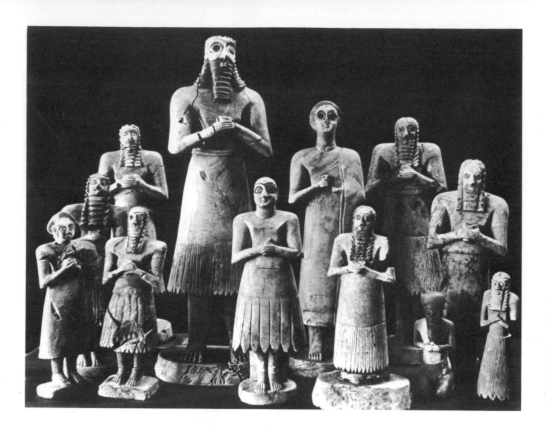

103. *Statuettes of Worshipers and Deities,*
from the Temple of Abu,
Tell Asmar.
Early Dynastic II, c. 2750 B.C.
Gypsum, height of
tallest figure 28 3/8″.
Iraq Museum, Baghdad,
and The Oriental Institute,
University of Chicago

It is not, however, in these hybrid monuments, half secular, half devotional, that the Early Dynastic period revealed its strength.

A rare find at Tell Asmar, a cache of statuettes (fig. 103) reverently buried when an early temple was rebuilt, has thrown light on the earliest sculpture in the round and its religious implications. Here in a narrow and probably rather dark sanctuary the god Abu, identified by his emblem on the base of the statue, and a goddess presumably his spouse must have faced an extraordinarily motley congregation of votive figures which were originally placed, each on a brick base, round the inner walls. It needs an effort of the imagination to penetrate beyond the weirdness of the scene. For divine wisdom and power were embodied and convincingly expressed in the large figure of the god (fig. 104) with its immense staring eyes, while man, in the attitude of worship, exposed himself to an awesome presence. The tense human figures, some of which are almost pathetically incompetent from the point of view of crafts-

104. *Head of Statuette of the God Abu* (see fig. 103), from the Temple of Abu, Tell Asmar.
Early Dynastic II, c. 2750 B.C.
Gypsum, with eyes of shell and black limestone set in bitumen, height of figure 28 3/8″. Iraq Museum, Baghdad

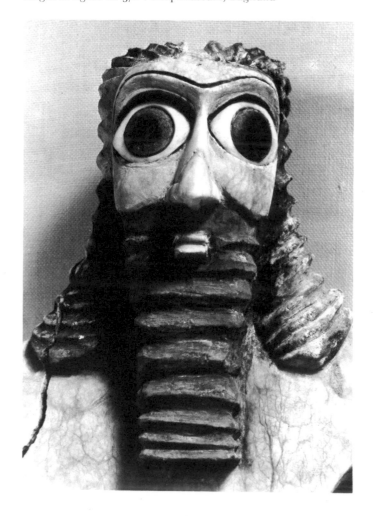

96

manship, show a remarkably deliberate stylization that gives them great dignity. All, except the two female figures, have long skirts that rise cone-shaped above clumsy ankles, harshly angular torsos and wide shoulders. The main emphasis, however, is on the arms, which are carved loose from the body with sharply pointed elbows and raised joined hands. This upward, inward movement of the hands, which epitomizes the spiritual collectedness of prayer, is plastically repeated in the conical skirt. Its circularity intensifies the impression of extreme concentration.

The striking difference between Mesopotamian and Egyptian statuary gains a new meaning here. The "cubism" of the Egyptian, the preference for rounded forms in the Mesopotamian, may well reflect dominant features in the landscape, as has often been stated. But the contrast lies deeper. An Egyptian tomb statue is self-contained, its geometric rigidity,

in transcending the ephemeral, is incompatible with gesture. A Sumerian votive statue represents man as emotionally related to a divine presence; therefore a devout gesture, formally sustained, is of its very essence.

It is interesting to note that whereas most figures in the Tell Asmar group have an almost hunched posture, the shaven-headed priest alone lifts his head in an attitude of moving trust and awe (fig. 105). It is also curious that the two female figures, wrapped in unarticulated cloaks which lack plastic possibilities, are so uninspired and unconvincing. The modeling of the larger figure (fig. 106), who may have represented a type of mother goddess because the remnant of a very small figure is fitted into the base of the statue, is singularly incompetent, and she suggests to modern eyes dull chastity rather than motherhood. The large eyes are not integrated with the face and fail to make it impressive. This is in complete contrast with

105. *Priest* (see fig. 103, foreground center), from the Temple of Abu, Tell Asmar. Early Dynastic II, c. 2750 B.C. Gypsum, with eyes of shell and black limestone set in bitumen, height 16″. The Oriental Institute, University of Chicago

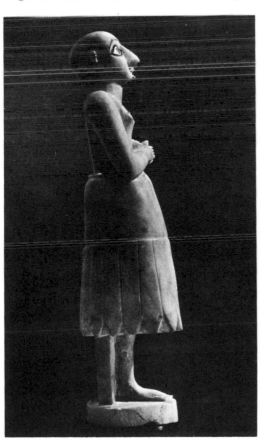

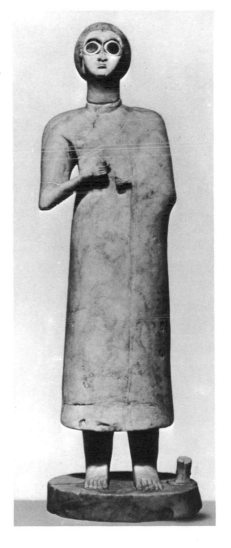

106. *Mother Goddess?* (see fig. 103), from the Temple of Abu, Tell Asmar. Early Dynastic II, c. 2750 B.C. Gypsum, with eyes of shell and black limestone set in bitumen, height 23 1/4″. Iraq Museum, Baghdad

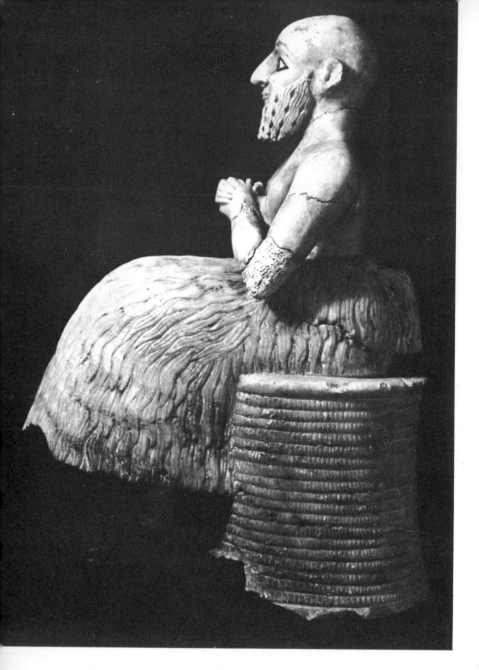

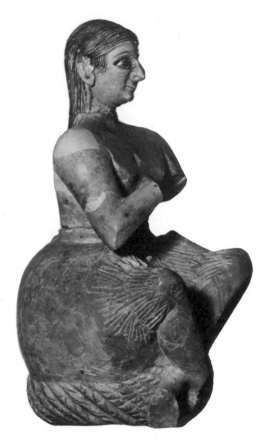

107. *Ibihil, Superintendent of the Temple of Ishtar at Mari*,
from the Temple of Ishtar, Mari.
Early Dynastic III, c. 2500 B.C.
Alabaster, with eyes of shell
and lapis lazuli set in bitumen, height 20 5/8".
The Louvre, Paris

108. *The Singer Urnanshe*,
from the Temple of Ishtar, Mari.
Early Dynastic III, c. 2500 B.C.
Gypsum, with eyes of shell and
lapis lazuli, height 10 1/4".
National Museum, Damascus

the god, for the sweeping curve of his eyebrows, the firm cheeks and fine bold nose enhance the effect of the haunting all-seeing eyes.

The god Abu represents the only Sumerian cult statue discovered so far. The very large copper statues that were probably hammered over a wooden or bituminous core have not survived except as tantalizing fragments. Votive statues of private citizens, on the other hand, increase in number and show a new stylistic trend: rounded forms begin to predominate. Now not only garments but supports and torsos, lips curved in fixed smiles, and evenly raised eyebrows, all appear to submit to a circular trend. This often results in rather dull stodgy forms and an air of well-fed complacency, though occasionally a fine balance of volume is achieved, as in the statue of Ibihil (fig. 107). The main appeal of these statuettes, however, lies, in contrast with Egyptian art, in their undisciplined character (fig. 108). Here the artist's imagination, not constrained by a rigid code, may run riot in a variety of ways: in posture and facial expression, in the treatment

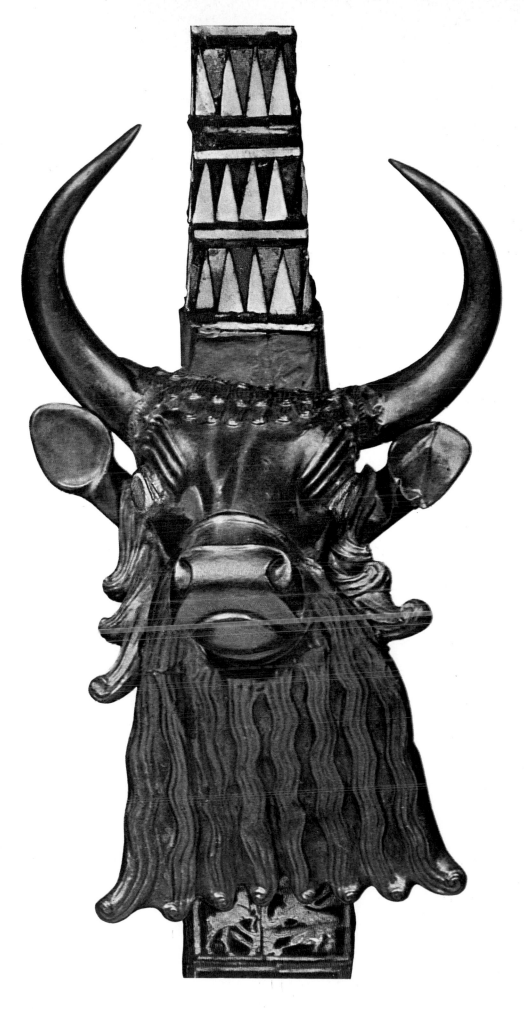

Colorplate 12. *Head of a Bull*, decoration on the front of a lyre, from the Royal Cemetery, Ur.
Early Dynastic III, c. 2550 B.C. Gold and lapis lazuli. Iraq Museum, Baghdad

Colorplate 13. *He-Goat Resting on a Formalized Tree*, from the Royal Cemetery, Ur. Early Dynastic III, c. 2550 B.C. Gold, silver, shell, limestone, and lapis lazuli, height 18″. British Museum, London

of female headgear and coiffure (figs. 109, 110)
—sometimes as the frame of a noble face,
sometimes the very reverse. Nevertheless it
cannot be denied that if the Tell Asmar statues,
with their moving though awkward sincerity,
appear to hold the promise of greater art to
come, this promise was not fulfilled. Once the
confrontation of man and god was taken for
granted, its dramatic implication was lost.
Votive statues of private citizens became trivial
and the custom of putting them up in the
temples died with the period and was never
revived in later times.

It was not in the realm of human but of
animal portrayal that the later phase of Early
Dynastic art produced some rare masterpieces.
In fact at no other time in the history of Meso-
potamian art was it so clear that for the
Sumerians animal perfection, animal power,
animal wisdom both revealed and incorporated
the divine. To give an example, figure 111
shows a small compact carving in serpentine of
a cow, probably representing the goddess of
birth, Nintu, with a false beard tied round her
muzzle to denote her divinity. The small proud
head is twisted toward the center of the recum-

109. *Head of a Woman*,
from Tell Agrab.
Early Dynastic II–III, c. 2600 B.C.
Limestone, height 4 3/4".
Iraq Museum, Baghdad

110. *Head of a Woman*,
from Tell Agrab.
Early Dynastic III, c. 2550 B.C.
Limestone, height 3 1/8".
Iraq Museum, Baghdad

111. *Cow with a False Beard*,
from Khafaje.
Early Dynastic III, c. 2600 B.C.
Serpentine, height 4 1/4".
The Oriental Institute,
University of Chicago

101

bent body with its folded but resilient limbs. The entire figure has a concentrated life that suggests a power far beyond mere animal vitality. Similarly the gold and lapis lazuli bull's head (colorplate 12), also with a false beard, which was fixed to the sounding board of a harp found at Ur, is emphatically not a playful decoration. Powerfully alive, it too has a compelling divine "presence." Its religious meaning is as yet obscure, and this holds good also for the fine panel inlaid with shell in bitumen that decorates the same sounding board (fig. 112). The hero protecting two man-headed bulls, and the animals which seem to perform ritual acts of some kind, may belong to the realm of fable rather than myth but they defy explanation.

One of the finest animal figures in plastic form is the rampant he-goat with forefeet resting on a formalized tree, which was found among the treasures of Ur (colorplate 13). The figure had a wooden core with head and extremities in beaten gold, and a fleece consisting of pieces of lapis lazuli and shell fixed in a layer of bitumen. For all its exquisite workmanship this could never be taken for a mere *objet d'art;* the animal has not only superb dignity but also a weird uncanny power that suggests a super-human not a subhuman being. He is clearly not a mere attribute of the god Tammuz, he is the god's epiphany. We do not possess a single plastic monster of this period that is as convincing as the earlier leonine mother goddess of figure 95, but a large copper panel in high relief depicts the lion-headed eagle Imdugud (fig. 113), who combines the most remote with the most dangerous of creatures. The figure of Imdugud is combined with two stags, which gives the panel an almost heraldic appearance, but Imdugud is as plausible a fantastic creature as the medieval unicorn. Nevertheless this monster was less long-lived than the combina-

112. *Sounding Board of a Harp,* from the Royal Cemetery, Ur. Early Dynastic III, c. 2550 B.C.
Panel, with shell inlay set in bitumen, height c. 13″. University Museum, Philadelphia

tion of man and bull which at this time makes its appearance, both in the round and in glyptic form on engraved stones. It is not the place here to speculate on the reason why the blending of a man with a male herbivore—or for that matter a female and a lion—had such an extraordinary appeal to man's imagination. The man-headed bull, with wings added, survived as a protective demon on the palace gates of the Assyrians. The bull-legged man may well head a long line of mysterious progeny; as a goat-footed faun, he has not lost his appeal to this day.

The Sumerian bull-man has so far remained nameless. In plastic form he does not appear independently but shaped as an object with ritual function, such as a rushlight holder, or an offering stand. It is interesting that the same holds good for the naked hero with triple girdle who, as we saw, already appears in protoliterate times in the act of subduing wild beasts (fig. 98). On cylinder seals both hero and bull-man appear together, often in one group, engaged in a similar struggle, a motif that is repeated in endless variations but for which there is no explanation to be found in myth or lore. It is

clear, however, that their significance, both of the hero and the hybrid creature in whom human and animal potency are welded, lies in the conflict with destructive bestial forces, the forces of death. Both beings were conceived as undefeated in this conflict and their stature was therefore neither quite human nor divine but may well be called intermediate, "daimonic." Before we consider the manner in which seal cutters used this motif for their designs, I would like to point out that although hero and bull-man can by no means be identified with the protagonists of the Gilgamesh epic,[6] the epic may well reflect some qualities which an older imagination imparted to figures that were symbols rather than phantasmata. The emphasis on the innocent animality of Enkidu, the friend of Gilgamesh, and their combined exploits seems to point directly toward the seals; and the central motif of the epic, the tragic reality of death and the vain search for indestructible life, may well show a remote connection with the motif of human and animal potency pitted against feline destruction. The Gilgamesh epic, however, is a mature tragedy, its hero is great in defeat; the imagination of

113. *Imdugud and Two Stags*, from Al 'Ubaid. Early Dynastic III, c. 2550 B.C.
Relief of copper nailed over wooden core, length 94″. British Museum, London

114. Cylinder-seal impression.
Early Dynastic II, c. 2700 B.C.
Height 1 3/8″. Iraq Museum, Baghdad

115. Cylinder-seal impression.
Early Dynastic III, c. 2500 B.C.
Height 1 5/8″. British Museum, London

the seal cutters reflects the wish-bound world of mythical victory.

The reason why the motif had such an extraordinary fascination for Early Dynastic seal cutters must remain speculative, but there is no doubt that its decorative possibilities were soon realized. Rampant beasts and upright humans could either form antithetical groups or, when crossed diagonally, suggest the bilateral movement that was most suitable for linking groups in a continuous design (figs. 114, 115). Quite soon all plausibility of action was sacrificed to intricate linear patterns. It is often barely possible to disentangle the interlocked figures, who appear to have become a mere sport for playful designers, and it was not until the Akkadian period that a new desire for clarity unraveled the design. Bull-man and hero are bodily lifted from the decorative confusion and placed, fighting singly, side by side (fig. 119).

THE AKKADIAN PERIOD (circa 2340–2180 B.C.)

Around 2300 B.C. a shift of power occurred which was of far greater consequence than the ever-changing supremacy of city-states. Sumerian culture, which centered in the South, had stretched uninterruptedly from the Persian Gulf well into Syria, but it is at least probable that the northwestern region was populated by a different race and that a Semitic language was then spoken there, as it has been ever since. It was this Semitic element which began to assert itself politically as well as culturally under the leadership of a few great rulers, of whom Sargon of Akkad was the first. The attempted unification of the country, the concomitant increase in stature of the king, were revolutionary changes. They are the more fascinating because they were reflected in the art of the period. The few relics we possess

show, apart from a superb mastery of form, an originality of concept which ignored and even contradicted Sumerian tradition.

The bronze head of figure 116 and colorplate 14 represents an unidentified Akkadian king. It is the first truly regal portrait to appear in Mesopotamian art and its nobility has never been surpassed. The elaborate coiffure with diadem and chignon is the only traditional feature and dates back to Eannatum. Strikingly original is the curve of the eyebrows with their imperious downward slant; this entirely eliminates the bland, mildly astonished expression of most Sumerian faces, which always have gently rounded eyebrows. The modeling of the face is so firm and delicate, the balance between the formal and the individual so subtle, that one is left wondering what gives it its curiously secular quality. Perhaps only this, that its majesty is self-contained, self-evident; that it does not appear focused on a divine presence, but is aloof, solitary. If the bronze head were the only Akkadian relic known, we would be justified in suspecting a profound change in the significance of kingship. As it happens, the only other great work of art of the period, the

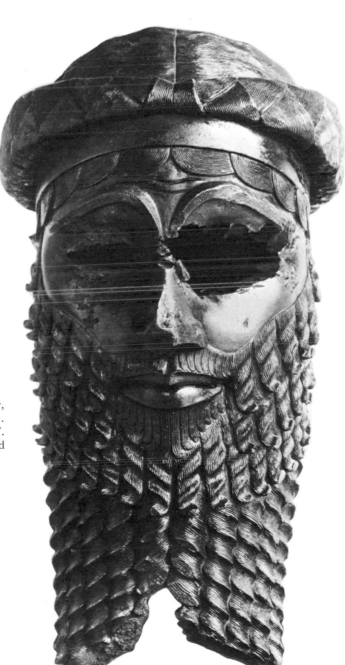

116. *Head of an Akkadian Ruler,*
from Nineveh (Kuyunjik; see colorplate 14).
Akkadian, c. 2340–2180 B.C. Bronze, height 14 3/8″.
Iraq Museum, Baghdad

105

stele of Sargon's grandson Naram Sin, confirms the change and makes it explicit (figs. 117, 118). This stele is the only complete one known so far in Mesopotamian art in which a historic event has been dramatically represented in terms of human achievement alone, without a trace of divine interference. The composition of the battle scene is at once decorative, in that it fits the shape of the stone, and highly dramatic. The upward surge of the conquerors, checked by falling and collapsing figures, is halted by the rigidity of the dour doomed survivors on the right; staring back at the king. The king's posture epitomizes the movement of his soldiers and yet he appears almost immobile at the moment of his triumph, holding the enemy transfixed with fear. His towering figure with horned helmet, a divine prerogative, symbolizes transcendent power, but remains anchored in reality, for the topography of the scene has been taken into account and the relation between the king and his prospective victims has been given astonishing actuality

118. *Stele of King Naram Sin* (detail of fig. 117)

117. *Stele of King Naram Sin*, from Susa.
Akkadian, c. 2280 B.C.
Sandstone, height 78 3/4". The Louvre, Paris

119. *Bull-man and Hero Fighting Beasts*,
cylinder-seal impression, from Tell Asmar.
Akkadian, c. 2340–2180 B.C. Height c. 1″.
Iraq Museum, Baghdad

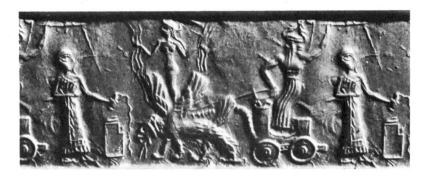

120. *Priest Before Weather Gods*,
cylinder-seal impression.
Akkadian, c. 2340–2180 B.C.
Shell seal, height 1 1/4″.
The Pierpont Morgan Library,
New York

by the tilting of their heads at different angles. The king is thus the dramatic as well as the symbolical and decorative center of the composition and the empty space above him emphasizes his isolation. His aloofness is enhanced, not diminished, by the stellar symbols at the top of the stone. This victory, blessed by the heavenly powers, was yet a solitary achievement.

I have analyzed this remarkable work in some detail because one is almost reluctant to take leave of the last original and daring masterpiece in Mesopotamian art before the Assyrian period. We must, however, briefly deal with glyptic art, because here also a break with tradition occurred. The Akkadian seal cutters turned away from the demands of a continuous design; where they used the old motif of bull-man and hero, which in the hands of Early Dynastic artists had become linear abstractions, they gave them a new lease of plastic life. The result was a hybrid of realism and fantasy, of detailed musculature and improbable, not to say impossible, action, which make these fighters look slightly absurd

(fig. 119). More successful were the truly dramatic subjects of mythology which were tackled with an amazing boldness, considering the cramped surface of small cylinders. For the first and the last time we see Mesopotamian gods in action, the thunder god in his chariot pulled by a dragon (fig. 120), the sun god sailing in his human-prowed boat, and a divine creature, the prototype of Herakles, slaying a seven-headed monster. In short these artists raided the realm of poetry for their subject matter with a daring unequaled in the entire Near East. They also introduced one type of religious scene which did in fact survive the Akkadian period for centuries, if in a rather dull and stereotyped form, the so-called presentation scene (see fig. 129). It depicts the confrontation of god and man in an essentially dramatic form: a divine interceder leading a shrinking human by the hand toward the fearful presence. The simple piety of this scene continued to appeal to later generations for whom the greatest achievement of Akkadian art had become meaningless in a succession of tragic events.

THE NEO-SUMERIAN AND OLD BABYLONIAN PERIODS
(circa 2125–1750 B.C.)

Akkadian rule was overthrown by an invasion of the Guti, tribes from the northeastern mountain ranges. There followed a barbarous interlude that left no trace other than destruction throughout the land. For reasons unknown, the town of Lagash escaped the country's doom, a small island in a sea of devastation. Its ruler, Gudea, believed that the fate of his town had been determined by divine will, and that he was singled out for the special task of serving the gods whose sanctuaries elsewhere were laid waste. Piety was therefore the keynote of his life's work and it was devotion, not monumental pride, that informed the surprising number of his own images, which he put up in the temples. The dedicatory inscriptions of these statues show that they were, in fact, a monumental form of prayer: facing the deity, they explicitly reminded him of good works done and asked for a prolongation of life. It is

122. *Gudea?* (uninscribed statue). Neo-Sumerian, c. 2125–2025 B.C. Dolerite, height 41 3/8″. The Louvre, Paris

121. *Statuette of Gudea* (portion), from Lagash (Tello). Neo-Sumerian, c. 2125–2025 B.C. Diorite, height 29″. British Museum, London

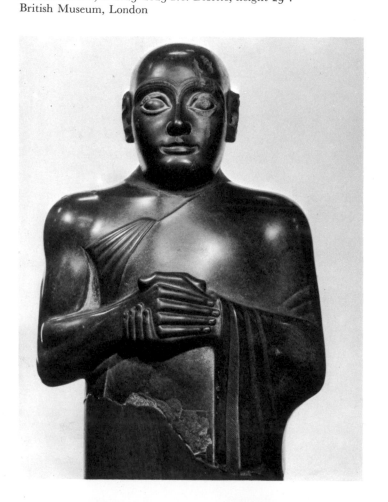

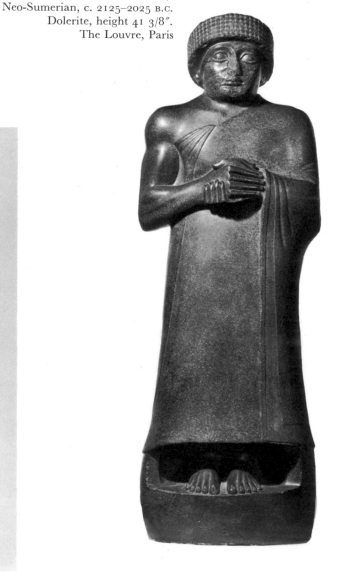

not surprising that such a pious concept of
kingship, if expressed in plastic form, should
recoil from Akkadian secularity and show more
affinity with earlier votive figures. In Gudea's
statues rounded forms prevail (fig. 121). The
faces, often surmounted by a circular woolen
cap like a solid nimbus, are completely formal-
ized, without a trace of individuality (fig. 122);
in fact they are almost identical. The features
do not lack nobility and the carving of the
mouth is particularly subtle; arms and hands
show awareness of muscular and bony structure.
But however skillful the workmanship—for
very hard stone was used throughout—these
figures with their smooth reverent faces suffer
from the flaw of all archaizing art; they lack
the freshness of their prototypes and become in
fact rather dull.

The Guti were finally expelled by the south-
ern states under the leadership of Erech and
Ur, a great but by no means final victory. For
centuries to come the history of Mesopotamia
was of one continuous struggle against foreign
invaders, while internally a seesaw of power
brought first the South and then the North
into prominence. There is no point in giving a
summary of political events, especially since
the period was a barren one for the arts. It is
true that the literary works, which were mostly
recorded shortly after the Akkadian period,
have an emotional depth and a dramatic power
that is unequaled in the ancient world. Even
disasters which must have surpassed in horror
the collapse of the Old Kingdom in Egypt
could be experienced without a trace of self-
centered bitterness, as a divine scourge or an
inscrutable fate. This depth of religious emo-
tion, however, never found expression in the
plastic arts, where devotional clichés predomi-
nate. King Urnammu, like his forebear
Urnanshe, commemorated the building of a
temple on a large stele, but as far as we can

123. Temple of Ishtar, Ishchali. Neo-Sumerian, after c. 2025 B.C.
Reconstruction (by Harold D. Hill)

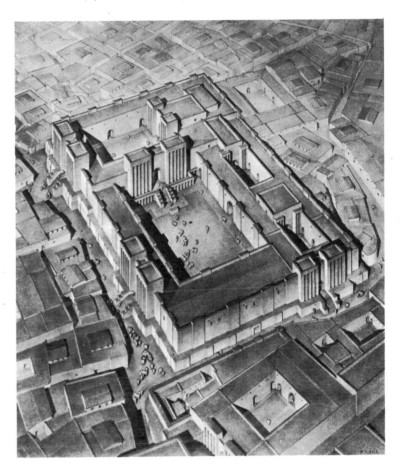

judge from fragmentary remains this entirely
lacks the vigor of Naram Sin's secular monu-
ment.

Urnammu, however, is justly famous for his
architectural achievements; his ziggurat at Ur,
with its triple stairway, is an original concept
and is impressive even in its present dilapidated
state. Throughout the Neo-Sumerian period,
up to the reign of Hammurabi, building
activity was great, and figure 123 shows a
reconstruction of the Ishtar temple at Ishchali,
built after the fall of Ur, which demonstrates
that even mud-brick structures may have

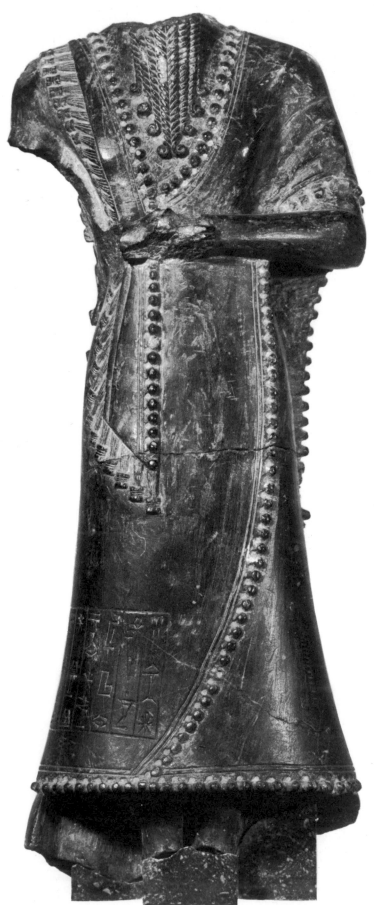

124. *Idu-ilum, Governor of Mari*, from the Palace of Zimrilim, Mari. Neo-Sumerian, c. 2025–1763 B.C. Steatite, height 16 3/8″. The Louvre, Paris

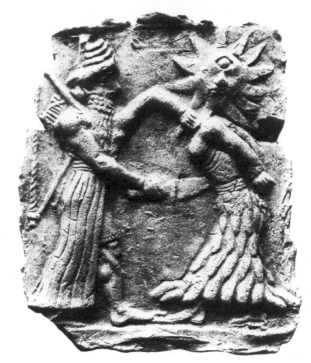

125. *Fiery Cyclops Being Killed by a God*, plaque from Khafaje. Neo-Sumerian, c. 2025–1763 B.C. Terracotta, height c. 4 1/2″. The Oriental Institute, University of Chicago

grandeur. Sculpture in the round, on the other hand, is uninspired: gods and rulers, enveloped in long fringed or tasseled robes, all show the same plastic poverty, though it must be admitted that in many of the statues found at Mari the flowing lines of formalized apparel have been used with great decorative skill (fig. 124). A remarkable contrast exists between the official and the "popular" art of this period, for small unassuming terracotta plaques, with scenes ranging from mythological event (fig. 125) to pure "genre" (figs. 126–28), are extremely lively.[7] Not so the cylinder seals, however; these endlessly repeat the same "presentation" scenes (fig. 129).

When Hammurabi (1792–1750 B.C.) reunified the country under the hegemony of Babylon, and Semitic influence prevailed as in Akkadian times, a new spirit seems to have pervaded at least one monument of the period:

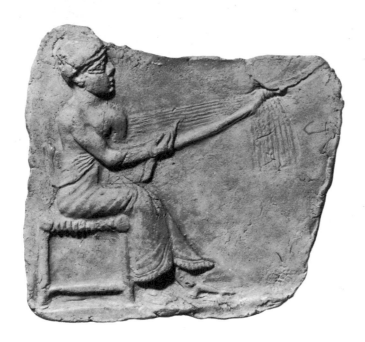

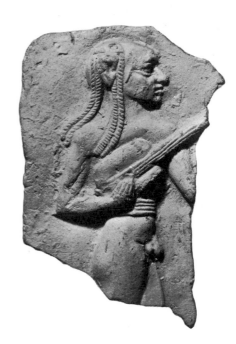

126, 127, 128. *Musicians.*
Neo-Sumerian, c. 2025–1763 B.C.
Terracotta plaques,
height 3 1/2 to 4 3/8″.
The Louvre, Paris

129. *Two Goddesses Presenting a Worshiper
to a God*, cylinder-seal impression.
Neo-Sumerian, c. 2025–1763 B.C.
Green slate seal, height 2 1/8″.
British Museum, London

the granite head of figure 130, which is generally assumed to represent the king. It is admittedly a rather hybrid work, for the round cap, formalized beard, and eyebrows are conventionally Sumerian, but the heavy-lidded, deeply furrowed face has an extraordinary and entirely un-Sumerian virility. The mouth with its jutting lower lip has none of the primness of the faces of Gudea's statues, the eyes with eyeballs deeply undercut and lids slightly contracted are intelligent and alert rather than devout. The short hairs surrounding the mouth are not arranged in decorous curls like the beard, but lightly scratched in, which confirms a tendency towards greater realism. As a work of art it is not entirely successful; it has the restlessness of an unresolved conflict between contrasting styles, but it is remarkably

alive and full of promise, a promise that, again, was never fulfilled.

We have few relics of Hammurabi's reign but it is interesting to note that even a purely conventional theme such as the confrontation of man and god may gain a new life at this time. Hammurabi's famous code of law was inscribed on a large stele at the top of which is depicted the king facing the god Shamash as lord of justice (fig. 131). The imperious gesture of the god, the awed but by no means cringing attitude of the king (who for once is not held by the hand of a divine interceder), have a strange dramatic actuality. Unfortunately the upsurge of new life in stale and weary art forms was short-lived: the invasion of the Kassites, warrior tribes from the Kurdish mountains, meant the end of Hammurabi's dynasty.

130. *Head of a King,*
probably Hammurabi of Babylon, from Susa.
Old Babylonian, c. 1792–1750 B.C.
Black granite, height 5 7/8″.
The Louvre, Paris

131. *Hammurabi, King of Babylon, Before the God Shamash*,
top of stele inscribed with the law code of Hammurabi, from Susa.
Old Babylonian, c. 1792–1750 B.C. Basalt, height of stele 88 5/8″. The Louvre, Paris

THE ASSYRIANS (circa 1350–1000 B.C.)

When we look back on Mesopotamian art since the Akkadian period, it offers the rather depressing spectacle of a sluggish adherence to stylistic habits. In fact, neither of the two short periods of highly original creativity under Semitic rulers altered decisively the general trend toward devout clichés. But four centuries after Hammurabi's death, the miracle of a fresh artistic impulse occurred again, this time in Assyria, well to the north of Babylon. The preceding period was marked by immigrations on a vast scale which originated in Central Asia and made their impact felt as far as the Nile valley. These brought the Hittites into Asia Minor and the Kassites into Mesopotamia, while Indo-European-speaking peoples, the Mitannians, occupied a region stretching from Syria to Kirkuk, in the midst of which Assyria was situated. It was not only a period of ethnic

upheaval, but of disintegration where indigenous art was concerned. Foreign motifs and techniques were adopted by the immigrants and carried to distant parts, there to enrich and confuse native styles. It was a period when Syrian, Aegean, and even Egyptian motifs appeared on Mesopotamian seals.

It is by no means clear how Assyria managed gradually to strengthen her position, which was geographically vulnerable; and it will no doubt remain a mystery why, after a period in which glyptic art had declined into syncretism and mediocrity, the cylinder seals of the Middle Assyrian period should suddenly reveal a breath-taking freshness and originality. For the links between north and south continued to be close. Assyrian scribes still acknowledged Babylon as the cultural center; and temple architecture largely followed the old pattern, though in

132. *Winged Horse Defending Its Foal from a Lion*,
cylinder-seal impression.
Middle Assyrian, c. 1350–1000 B.C. Height 1″.
British Museum, London

133. *Leonine Centaur Fighting a Lion*, cylinder-seal impression.
Middle Assyrian, c. 1350–1000 B.C. Height 1 3/8″.
State Museums, Berlin

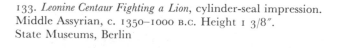

a region where stone was available walls were given revetments of upright stone slabs. There were innovations: ziggurats, now joined to the temple complex, were no longer independent structures and lost the monumental stairways of their prototypes. Glazed tiles were used for the decoration of buildings, the technique of glazing having been transmitted by Syria from Egypt, where it had been in common use for millennia.[8]

Pictorial art reveals more significant changes. The close personal bond between man and god, so characteristic of Mesopotamia, is replaced by a more distant relationship of man with the divine: the god Ashur may appear in the form of two hands emerging from a cloud or, later, in a flaming sun disk. Presentation scenes are conspicuously absent. It was, however, not in relief but in glyptic that a fresh inspiration first revealed itself. The often gloomy, always intensely serious preoccupations of Mesopotamian artists seem to be suddenly swept away and all interest focused on the beauty of animal life and movement. For the first time animals, even when "monstrous," appear perfectly natural, not loaded with religious significance. The wings of the magnificent winged horse defending its foal (fig. 132) do not give it a supernatural air, they seem the projection of a horse-lover's dream of speed and lightness. The leonine centaur (fig. 133) appears no more symbolical than the superb lean huntsman engaged in a similar fight (fig. 134). We seem to have entered a new world in which the grace of a leaping deer, the clumsy waddle of an angry ostrich (fig. 135) have become matters of passionate interest.

This delightful art was short-lived. Soon artistic talent was summoned to perform tasks far removed from the irresponsible freedom of seal designers: the vast new palaces of powerful warrior kings were to be decorated with the record of their exploits.

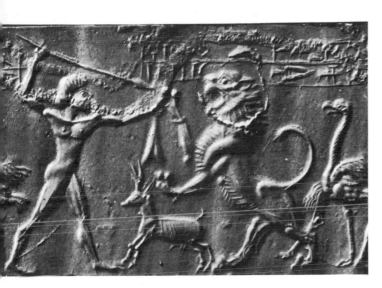

134. *Hunter and Lion*, cylinder-seal impression.
Middle Assyrian, c. 1350–1000 B.C.
Black serpentine seal, height 1 1/2".
British Museum, London

135. *Winged Demon Pursuing Ostriches*,
cylinder-seal impression.
Middle Assyrian, c. 1350–1000 B.C.
Gray marble seal, height 1 1/4".
The Pierpont Morgan Library, New York

136. *Ashurnasirpal II Worshiping the Sacred Tree*, relief (portion) from the Northwest Palace of Ashurnasirpal II, Nimrud (Kalkhu). Late Assyrian, c. 883–860 B.C. Alabaster, height 70″. British Museum, London

LATE ASSYRIAN ART (circa 1000–612 B.C.)

The reliefs of the Late Assyrian palaces present none of the problems which we have encountered so far; they need not be interpreted in terms of implicit religious ideas. They fall clearly into two categories, religious and secular scenes. The former consist mainly of ritual acts in which winged demons and sacred trees play an important part; they are formalized, decorative, and dull (fig. 136). The secular scenes speak for themselves; they depict all aspects of warfare with astonishing virtuosity and a complete absence of religious overtones. No gods take part in them, no kings of superhuman stature lend their fateful nobility to the wholesale destruction of cities, to carnage and

torture which are often depicted with nauseating detail. This art is secular with a vengeance.

It should be realized that Assyria, a small young virile nation, could only meet the constant threat of expansion from peoples in the north, east, and west—the aftermath of a period of migration—by ceaseless warfare and ever-widening incursions into enemy territories. Soon war became the nation's main preoccupation, its favorite pastime. The conquests made by Assyrian kings were never in the nature of a single decisive victory: they were episodes in a recurring struggle and it was as such that they were pictorially recorded on the walls of palaces, to serve as a grim warning to foreign

Colorplate 14. *Head of an Akkadian Ruler*, from Nineveh (Kuyunjik).
Akkadian, c. 2340–2180 B.C. Bronze, height 14 3/8″. Iraq Museum, Baghdad

Colorplate 15. Spouted Jar, Kamareş style, from the Palace of Minos, Knossos.
Middle Minoan II, c. 1800–1700 B.C. Height 9 1/4″. Archaeological Museum, Heraklion

ambassadors. The Assyrian battle reliefs are a historical narrative, the first of its kind in fact.[9] For this reason they lack the static grandeur of earlier "monumental" battle scenes such as the stele of Naram Sin and the Egyptian reliefs of Seti I, in which the actual fighting merely gave dramatic tension to the symbolical statement of the king's invincibility. Assyrian kings on the battlefield were simply great soldiers in action,[10] and the artists who "told their story" could revel in the minor incidents of war and indulge in lively, often irrelevant, detail. From the first appearance of the palace reliefs in the reign of Ashurnasirpal II (883–860 B.C.) until their glorious climax under Ashurbanipal (669–626 B.C.), they lack any trace of metaphysical overtones; they have a freshness and vigor strongly reminiscent of the Middle Assyrian seals, which antedate them by centuries. It is remarkable that in the former we also find a wonderfully subtle observation of animal life: these ruthless fighters must have known and loved horses as no other people did before the Greeks (fig. 137).

The scenes of pitched battles are often so overcrowded that one might lose the thread of the story if its sequences were not so monotonous: assault, destruction, carnage. In fact the only relief from horror is provided by those subsidiary themes in which an artist gave

137. *Head of a Horse Drawing the Royal Chariot*, relief (detail of the *Great Lion Hunt*) from the North Palace of Ashurbanipal, Nineveh (Kuyunjik). Late Assyrian, c. 669–626 B.C. Alabaster. British Museum, London

fugitives at least a chance to escape: the swimmers inflating the skins that may save them and the urgent gesticulating Elamites (fig. 138).

138. *Fugitives Crossing River*, relief (portion) from the south wall, Throne Room B, Northwest Palace of Ashurnasirpal II, Nimrud (Kalkhu). Late Assyrian, c. 883–860 B.C. Alabaster, height c. 39″. British Museum, London

In successive reigns, however, an interesting development took place. The earlier scenes in rather narrow strips, three feet high, clung to the surface and rarely ventured to suggest scenic depth. This changed when the height of the reliefs increased, and artists were tempted to include new subjects: warfare in desert and swamp (fig. 139), assaults on mountain fortresses which entailed the crossing of difficult terrain. Assyrian artists, quite undaunted, tackled problems of topography and the disposition of figures in receding space in a manner that was bold, haphazard, and largely unsuccessful—but nevertheless demands respect.[11] These wild experiments were abandoned,

139. *Sennacherib's Campaigns in the Marshes*, relief (detail) from the Southwest Palace of Sennacherib, Nineveh (Kuyunjik). Late Assyrian, c. 704–681 B.C. Alabaster. British Museum, London

120

140. *Ashurbanipal Warring in the Desert*, relief (portion) from the North Palace of Ashurbanipal, Nineveh (Kuyunjik). Late Assyrian, c. 669–626 B.C. Alabaster, height 46 1/8". British Museum, London

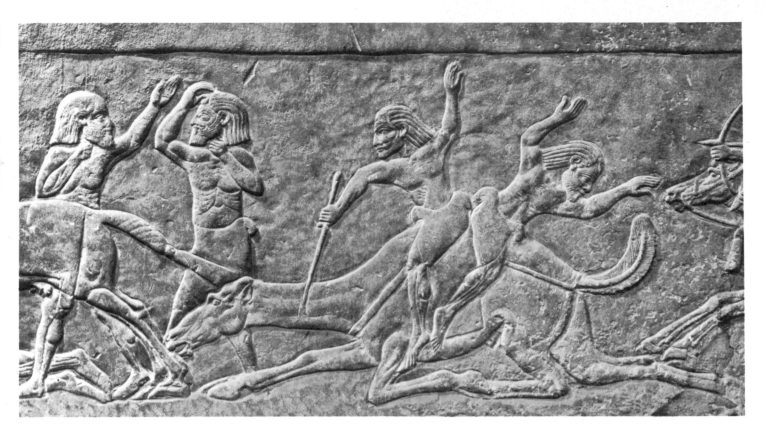

141. *Collapsing Camel* (detail of relief in fig. 140)

however, in the reliefs at Kuyunjik, the palace of Ashurbanipal, where Assyrian art reached its final and most impressive phase. The traditional subjects recur but are handled with far greater subtlety. Note for instance the characterization of the Bedouins fighting naked on camels (fig. 140) and the detail of the collapsing camel in figure 141. In figure 142 the rows of fleeing mountainfolk in conventional registers are surmounted by a "backdrop," half in plan, half in elevation, representing a temple, mountains, trees, and a meandering aqueduct; this backdrop, though unconnected with the figures, clearly suggests the setting of their flight. And yet, for all their artistry, not even these battle scenes ever rose to the level of great art; their episodic narrative lacked a unifying formal concept that might have given it an epic quality, and the display of cruelty never reached tragic depth.

142. *Elamites in Flight*, relief (portion) from the North Palace of Ashurbanipal, Nineveh (Kuyunjik). Late Assyrian, c. 669–626 B.C. Alabaster, height 80 3/4″. British Museum, London

143. *Ashurbanipal Shooting at Lions from His Chariot*, relief
(detail of the *Great Lion Hunt*)
from the North Palace of Ashurbanipal, Nineveh (Kuyunjik).
Late Assyrian, c. 669–626 B.C. Alabaster. British Museum, London

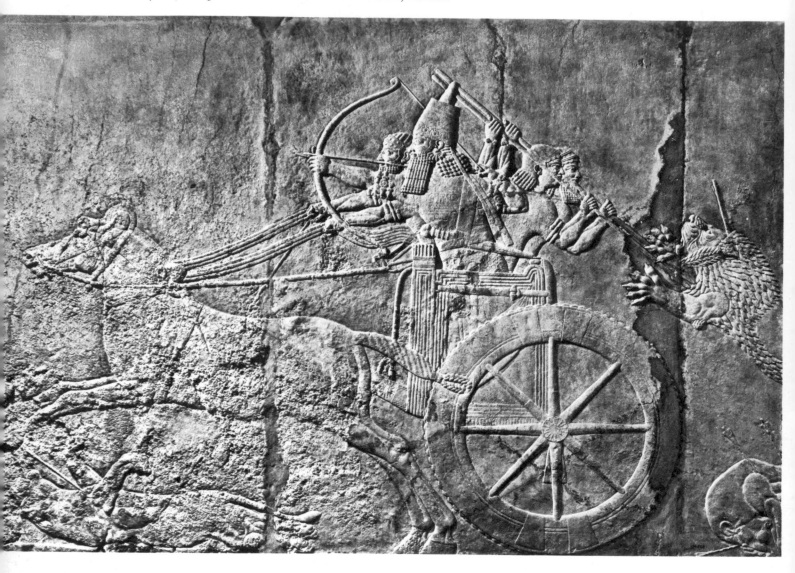

It is therefore a strange paradox that, just before the annihilation of the very people who had so callously brought untold suffering on all mankind within their reach, one great artist among them revealed his humanity in a new approach to animal life, the hunting scenes at Kuyunjik. Scenes of this type already occur in the reliefs of Ashurnasirpal II and persist throughout the period; they usually depict the king exposed to a lion's fierce attack at close quarters. At Kuyunjik a similar scene (fig. 143) is suffused with compassion: we are shown, singly, the death throes of several of these magnificent creatures, their hatred, their broken pride (figs. 144, 145). These images are the more significant because in one small idyllic

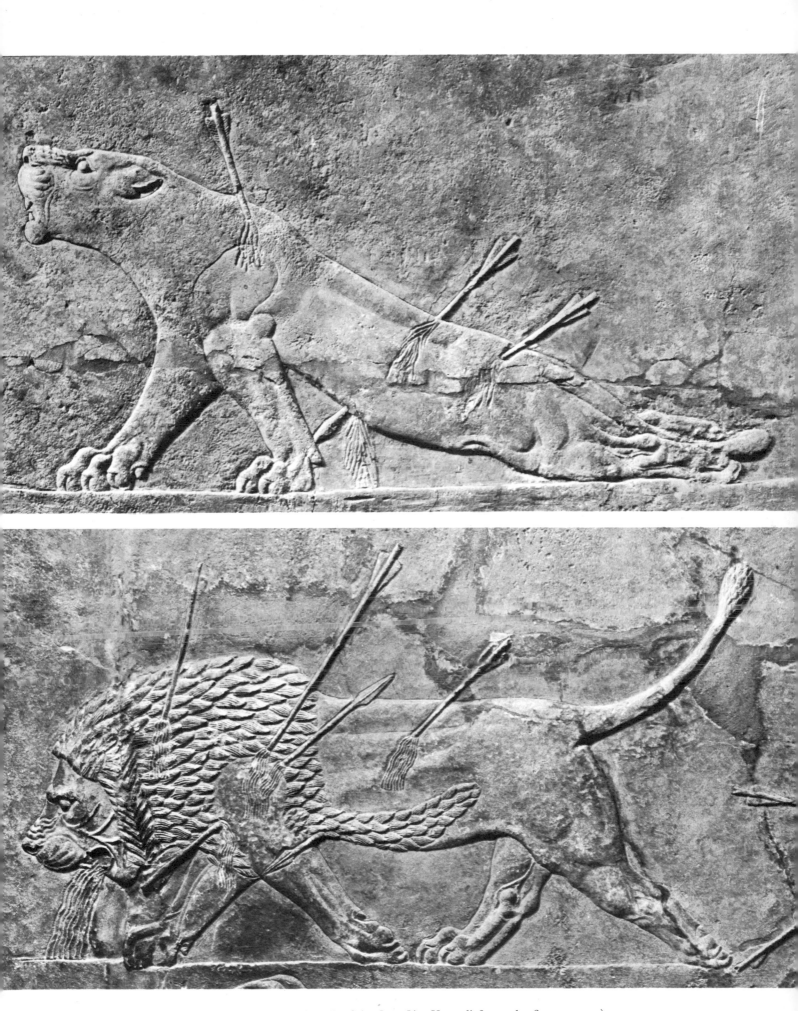

144, 145. *Wounded Lioness* and *Wounded Lion* (details of the *Great Lion Hunt* relief; see also figs. 137, 143)

147. *Wild Asses in Flight*, relief (portion) from the North Palace of Ashurbanipal, Nineveh (Kuyunjik). Late Assyrian, c. 669–626 B.C. Alabaster, height 20 7/8″. British Museum, London

group the artist has shown his awareness of the animal's beauty and superb dignity when at peace (fig. 146). In the scenes of figures 147 and 148—which have been lifted from their context (they are quite unobtrusively placed on the wall)—disaster has overtaken wild asses in flight; and a small herd of gazelles, sensing imminent danger, moves warily away from a man—not shown here—on the right. As if to stress their vulnerability these animals move in an empty undefined space; they are held together by the exquisite rhythm of their grouping. The sensitivity of these poignant scenes is such that the agonized look of the mare at her doomed foal appears an indictment, not a mere record, of man's perennial cruelty.

Those who study the development of the Assyrian reliefs are spared the sad spectacle of decline: it breaks off suddenly when it has reached its climax.

opposite page, top: 146. *Lion and Lioness in the Royal Park*, relief (detail) from the North Palace of Ashurbanipal, Nineveh (Kuyunjik). Late Assyrian, c. 669–626 B.C. Alabaster. British Museum, London

148. *Herd of Fleeing Gazelles*, relief (portion) from the North Palace of Ashurbanipal, Nineveh (Kuyunjik). Late Assyrian, c. 669–626 B.C. Alabaster, height 20 7/8″. British Museum, London

Crete and Mycenae

CRETE

To move from ancient Egypt and Mesopotamia to Crete, the third remarkable center of Near Eastern art, is to enter a world that has an immediate aesthetic appeal and to which every normal historical approach is barred. Here is a highly civilized island community whole original language is unknown[1] and whose written documents, even if the script were completely decipherable, would probably reveal neither the names of kings and gods nor the records of events and religious creeds, for the documents appear to be entirely administrative, contracts or accounts. Cretans not only baffle the historian in his attempt to outline events and personalities, they are also definitely anti-historic in that they show no interest whatever in commemorative statement, pictorial or otherwise. Their artists revel in the beauty of natural forms, in color and movement, but no single memorable act, whether of piety, political wisdom, or military valor, was ever rescued from oblivion.

Fortunately these anonymous Cretans were great seafarers and traders, who exchanged their produce in Egypt and the Levant[2]. This has made it possible to obtain a rough but fairly sound comparative chronology for the most important phases of their silent history. Its span was short: roughly five hundred years after Cretan imports first appear in Egypt, in a Middle Kingdom context, Knossos, Crete's political and cultural center, was destroyed (some time between 1450 and 1400 B.C.). There are, however, indications that before that disaster Crete, as a sea power, had already lost its hegemony to Mycenae, on the Greek mainland. Even then its influence persisted, for the Mycenaeans transmitted many features of Cretan art which they themselves had absorbed.

Now it is clear that since the historical sources that might illuminate political and religious life are almost completely lacking, our approach to Minoan art must differ from the one we adopted previously. In fact I intend to reverse it by

starting with a purely formal analysis and then tentatively to interpret idiosyncrasies of style and subject matter in wider cultural terms.

We shall again pass over the early stages of Cretan art, which in this case persisted far longer than in Egypt and Mesopotamia. Not until around 2000 B.C. can we observe a break from the so-called Early Minoan culture, with its simple decorated pottery, stone vases, and patterned stamp seals, and witness the sudden phenomenal increase in technical skill and inventiveness which marks a true "birth of civilization." The change is inaugurated in the early part of the Middle Minoan period[3] by a highly original type of painted pottery called Kamares ware, after the place where it was first discovered. It was this type of pottery that could immediately be identified as a Cretan import when it was found in a Middle Kingdom Egyptian context. Its colorful gay decoration proves that the Cretans were born painters. Motifs such as unconnected scrolls and arabesques, wavy lines branching out into droplike appendages, dotted rosettes, are sometimes scattered and sometimes skillfully combined on a dark ground. There is no doubt that what links this art with that of the previous period is a preference for sweeping movement in design, already noticeable in earlier patterns. In Kamares ware, however, the often disparate motifs have a curious independence as if they were charged with life. There is a sense of the organic even if no organisms are depicted, a tendency to make lines sprout from hollow curves as if from axils, to make them bend and thicken like leaves or curl like tendrils. There is also an increasing preference for rounded cell-like forms. In some of the finest examples the balance between centrifugal and centripetal movement in the design suggests a living form (colorplates 15, 16).

In this respect Kamares ware was prophetic,

149. Stirrup Jar with Octopus, from Palaikastro. Late Minoan I, c. 1500 B.C. Height 11″. Archaeological Museum, Heraklion

150. Pitcher with Marine Ornament, from Gournia. Late Minoan I, c. 1500 B.C. Height 11″. Archaeological Museum, Marseilles

for in the late Middle Minoan period, after a short decline in the potter's craft when murals seem to absorb the artists' interest, plants and animals appear in profusion on painted vessels, this time in glossy dark paint on a light ground. The choice of motif is clearly determined by its decorative function: we find tall lilies on straight-sided vases, while an octopus spreads its tentacles over a globular one (fig. 149). The small nautiluses that float diagonally round the vase of figure 150 are carefully interspersed

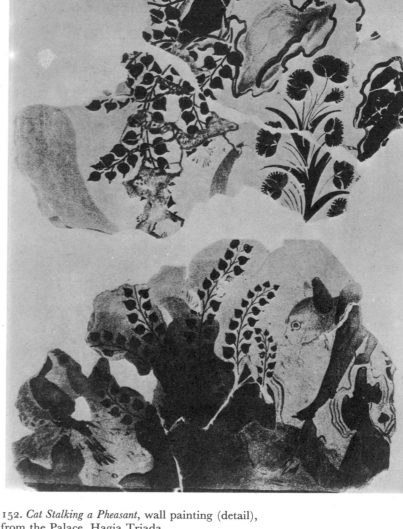

151. *Leaping Deer*, wall painting (detail),
from the Palace, Hagia Triada.
Middle Minoan III–Late Minoan I, c. 1600–1500 B.C.
Archaeological Museum, Heraklion

152. *Cat Stalking a Pheasant*, wall painting (detail),
from the Palace, Hagia Triada.
Middle Minoan III–Late Minoan I, c. 1600–1500 B.C.
Archaeological Museum, Heraklion

with rounded patterns of rocks, to form a coherent web of design. And yet these creatures are not merely subservient to their decorative function, they are not schematized or dissected; singly beautiful, singly alive, each creature plays its part.

We have, however, anticipated; for the startling development of representational art occurred immediately after the Kamares period. It is contemporary with the invention of writing, and also with large-scale building activity such as the labyrinthine maze of the palace at Knossos and the smaller palaces at Phaistos and Hagia Triada, which we shall discuss later.

The new art burst into bloom in murals, glyptic (engraved stones), and relief. Of these the early frescoes, which often ran in an unbroken frieze around the rooms, are perhaps the most astonishing, for here painters evoked with breath-taking virtuosity the capricious charm and beauty of beasts and plants. For the first time in the history of early art, nature appears gloriously self-sufficient. It is clear that for Cretan artists, natural life meant movement—movement in the flying leap of a deer

(fig. 151) or a dolphin, in the stealthy stretch of a cat's paw (fig. 152), in wind-blown flowers with petals dropping, in the writing stems of plants clinging to rocks, even in the rocks themselves, which appear a substance barely solidified. Yet none of these forms is singly, separately important; all are part of a pictorial texture so closely woven that it defies analysis.

It is not surprising that modern spectators have hailed the Minoan artists as naturalistic landscape painters. This is an anachronistic notion, for Minoans often made extremely high-handed use of familiar forms, combining the foliage and blossoms of different plants and altering birds' plumage at will (colorplate 17). Moreover their paintings lack the one requisite for landscape: a concern with receding space. Here not only is depth often ignored, but up and down relationships from the spectator's point of view. We may find that plants and rocks at the top of a fresco point down toward the center, thus "framing" the scene from above, as it were, while the spatial relation between figures and setting below remains quite obscure: we are left in doubt, for instance, where precisely the cat is poised, or where the deer could have taken off from; both seem to float in a world that is almost as unsubstantial as a decorative design. And yet, if these frescoes do not conjure up illusionistic vistas, they are not like ornamental tapestries either, for they suggest authentic movement in an authentic, if unarticulated, setting. Clearly Minoan artists bypassed the problem of organic mobility in relation to static surroundings. Animals and, slightly later, even human beings—note the limp feet of the dancer in figure 153 who does not seem to touch the ground—move in an unresisting medium with the freedom of airborne or subaqueous creatures. In fact a passion for absolute mobility appears to be of the essence of Minoan art, from the earliest ap-

153. *Dancer*, wall painting (portion). Late Minoan I, c. 1500 B.C. Height 43 1/4". Archaeological Museum, Heraklion

pearance of "moving" patterns to the evocation of organic life in nature—frequently aquatic life—and even in the realm of human beings in action. In the latter instance one might expect that the hard fact of the impact of bony structure on unyielding matter could hardly be evaded. And yet this is precisely what Minoan artists seem to aim at, both in the stylization of the human body and in the choice of action depicted. The male body, naked but for the curiously shaped loincloth, with its artificially constricted waist, spidery limbs, and twisted torso, suggests muscular agility rather than bony structure. The women, dressed in wavy flounced skirts and tight bodices with puffed sleeves and a deep décolletage, have a baroque exuberance, a restless flowing contour that remains as vague as it is suggestive (colorplate 18).

Even more significant is the activity of these figures. In the best Minoan work we do not find, as in the Egyptian Old Kingdom, scenes of daily life showing solid earth-bound creatures, whose every movement is functionally

related to the objects they handle, the tasks they perform. Generally speaking, the opposite holds good; for just as the leap of the deer in figure 151 is not motivated by fear—hunting scenes are conspicuously absent in Crete—but simply denotes speed, so human beings in action may have the lightness, the freedom of movement that seems to belong to the world of play rather than to serious effort. The movement of the figures is also unpurposeful; it does not aim beyond its own fulfillment, whether it shows the gentle swaying of dancing women or

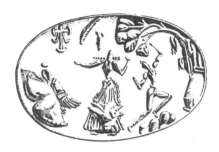

154. *Scene of Worship* (drawing), engraved gem

the arcobatic leap, by boys and girls alike, across the length of a swiftly moving bull whose horns are used as levers. In dancing and bull sport, the self-willed world of play seems to mock the ponderous angularity of those

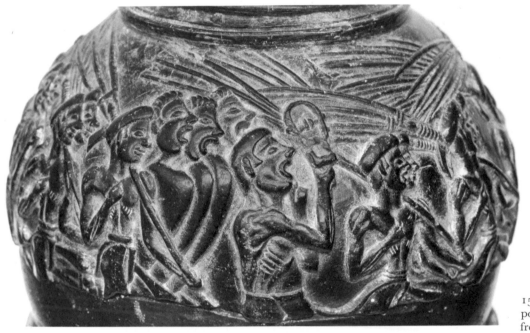

155. *Youths in Ritual Procession*,
portions of the *Harvester Vase*,
from the Palace, Hagia Triada.
Middle Minoan III–Late Minoan I,
c. 1600–1500 B.C.
Black steatite, diameter 4 1/2".
Archaeological Museum, Heraklion

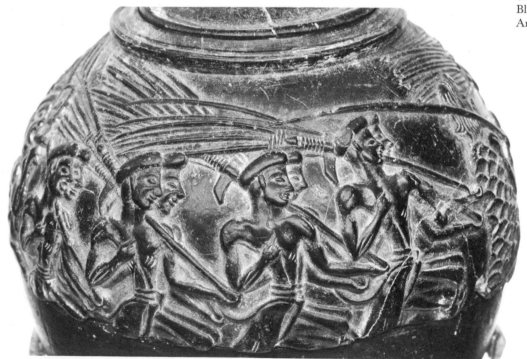

engaged in serious pursuits. We shall see later that in these games more was at stake than mere agility, and I might here point to the passionate contortions of a male figure in what appears to be a scene of worship (fig. 154) and to the *abandon* of the youths marching in a ritual procession (fig. 155) with heads thrown back and knees lifted high. Here movement seems to express a moment of intense, perhaps orgiastic emotion. It is also remarkable that in a few instances the epiphany of a god or goddess is depicted as the air-borne descent of a small figure, in some cases with hair flying upward and feet pointing down.

The examples given here to illustrate the "mobility" of Minoan art have been chosen at random from frescoes, stone seals, and stone vases in relief—an inevitable choice because the vexing problem of dating the fragmentary remains has by no means been solved.[4] It is as yet impossible to trace a coherent development in all the different media within the range of so short a period of prolific bloom. There is something erratic in the way Minoan artists tackled and sometimes solved the most daunting problems—with the confidence of a child prodigy, unaware of the existence of problems—and then never followed up their own exploits. We have already seen that they captured the dynamic surge of massed figures in motion (fig. 155); they even dared—less successfully— to encompass in one scene a vast arena with crowds of spectators. Their sublime indifference to problems of spatial coherence made them resort in this case to the childish trick of sketching the heads of male spectators in a red, of female spectators in a yellow, smear of paint. Only the *grandes dames* seated above the vulgar crowd have been subtly characterized in a number of charming conversation pieces (fig. 156). Even seated figures can be eloquently mobile in Crete.

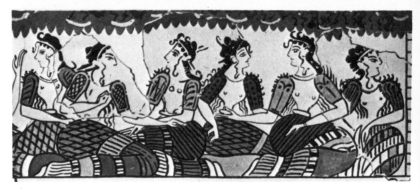

156. *Seated Women*, miniature wall painting (detail), from Knossos. Late Minoan I, c. 1500 B.C. Archaeological Museum, Heraklion

157. *"Priest-King,"* relief from the north end, Corridor of the Processions, Palace of Minos, Knossos. Middle Minoan III–Late Minoan I, c. 1600–1500 B.C. Painted stucco, height 86 5/8″. Museum, Knossos

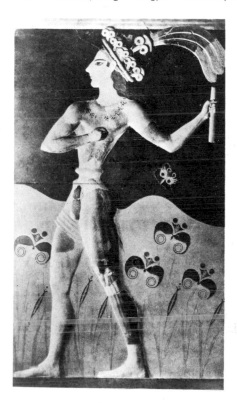

We can, however, detect a certain rigidity, a tendency to mechanical repetition, before the final decline of this short-lived art. It significantly coincides with the introduction of a groundline in frescoes; in a stone vase there are even superimposed registers that contain wrestlers and bull-jumpers in dull repetition. The much restored so-called priest-king in painted relief (fig. 157) still has grace and vigor, but

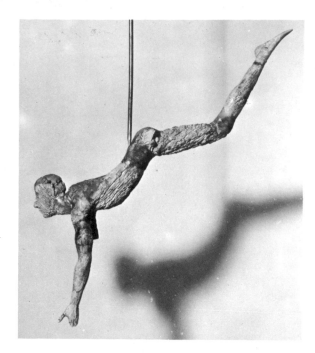

158. *Leaping Youth*, from the Palace of Minos, Knossos. Late Minoan I, c. 1550 B.C. Ivory, length 11 3/4″. Archaeological Museum, Heraklion

the rows of painted tribute bearers in Knossos become increasingly lifeless. Here the large size of the figures may have hampered the

spontaneity and daring that are so evident in the best small-scale work.

The very qualities, however, that were the strength of this art also marked its limitation; for though an emphasis on movement at the expense of structural analysis may in painting foster spontaneity, it must be a serious drawback in plastic art. In the ivory carving of a leaping youth (fig. 158), for instance, the movement is convincing; but, since the structure has been left vague, the youth lacks the vigor and elasticity which the effort must have demanded and he appears in fact rather limp. The faience priestesses (figs. 159, 160),[5] on the other hand, seem rapt in their trancelike rigidity which, whether intentional or not, forms a disturbing contrast to the rococo elegance of their fantastic attire. It must remain uncertain whether they are represented as "possessed" by a reptilian divinity or as wielding magic power. In either case their fixity is unnatural and strangely repellent.

The much admired steatite rhyton in the

right:
159. *Priestess with Snakes,* from the Palace of Minos, Knossos. Middle Minoan III, c. 1700–1600 B.C. Faience, height 13 1/2″. Archaeological Museum, Heraklion

far right:
160. *Priestess with Snakes,* from the Palace of Minos, Knossos. Middle Minoan III, c. 1700–1600 B.C. Faience, height 11 5/8″. Archaeological Museum, Heraklion

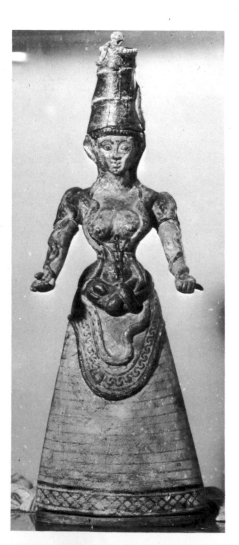

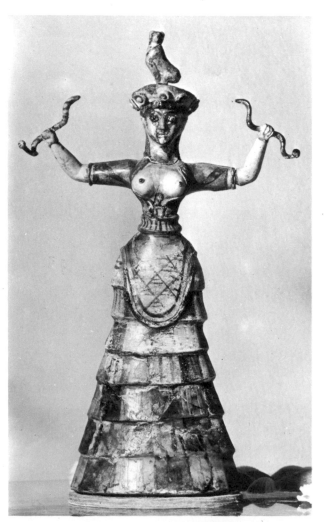

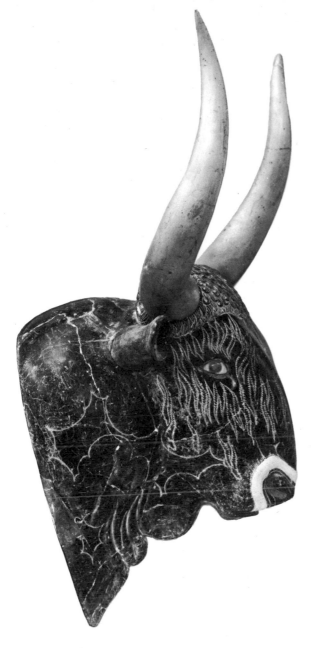

161. Rhyton in the form of a Bull's Head,
from the Little Palace, Knossos.
Late Minoan I, c. 1500 B.C.
Black steatite, inlaid with shell and rock crystal;
height without restored horns 8 1/8".
Archaeological Museum, Heraklion

shape of a bull's head (fig. 161), with its inlays
of shell and rock crystal, is technically a considerable achievement; but the modeling is
soft and insignificant, its smoothness unredeemed by the fussy engraved detail which
is plastically valueless.

Only in a very few instances has the Minoan
genius for depicting movement found a truly
plastic expression, namely in the small bronze
figures of worshipers. Seen in profile the youth
of figure 162, with his torso flung backward,
head slightly bent, and hands lifted in front of
his face, has both tension and poise; he is as

162. *Youth in Attitude of Worship.* Late Minoan I, c. 1550 B.C.
Bronze, height 5 1/2". Rijksmuseum van Oudheden, Leiden

163. *Old Man in Attitude of Worship*, from Tylissos.
Late Minoan I, c. 1550 B.C. Bronze, height 9 7/8″.
Gipsmuseum, University of Berlin

figures could be indulged in, while the cramped, usually circular, space imposed the discipline of composition. Cretan seal cutters were acutely aware of the compositional demands. Single animals in motion rarely "run out of the picture"; each has its head turned back, which gives the movement a circular twist. Sometimes a second figure provides a countermovement to balance the design (figs. 165, 166), but rigid antithetical arrangement is rare and generally betrays Asiatic influence; the grouping of several human figures may be roughly circular or suggest an enclosed space (figs. 154, 167). The main interest of the human scenes,

taut as a bowstring. In this uniquely dynamic attitude of prayer, physical pride and religious awe are held in balance. Nor is pride of bearing the prerogative of youth alone: the elderly obese man of figure 163, upright, collected, reverent, has the same self-confident dignity. This pose is indeed worlds apart from the awe-struck attitude of Mesopotamian devotion. But however vital and original these figures are, the very roughness of their workmanship makes one suspect that they were not highly prized, and they certainly do not inaugurate a significant development. The youth seems almost a translation into plastic form of the figure on a seal where worshiper and goddess are confronted (fig. 164).

In fact Cretan glyptic surpasses plastic art in both achievement and output. In these engraved seals a passionate interest in moving

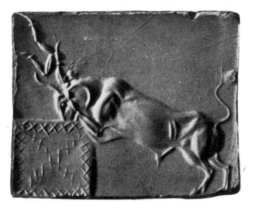

top: 164. *Mountain Goddess and Worshiper*
(drawing), engraved seal

above: 165. *Bull and Bull-Jumper at a Cistern*,
seal impression, from Knossos.
Middle Minoan III, c. 1600 B.C.
Onyx seal, height 7/8″.
Ashmolean Museum, Oxford

left: 166. *Stag and Dog*,
seal impression, from Knossos.
Middle Minoan.
Semiprecious stone, height c. 3/4
Ashmolean Museum, Oxford

Ecstatic Dance of Women (drawing),
gold signet-ring impression,
from a tomb in the vicinity of Knossos.
Late Minoan I, c. 1500 B.C.

Colorplate 16. Interior of a Footed Bowl, Kamares style, from the Old Palace, Phaistos. Middle Minoan II, c. 1800–1700 B.C. Diameter 21 1/4″. Archaeological Museum, Heraklion

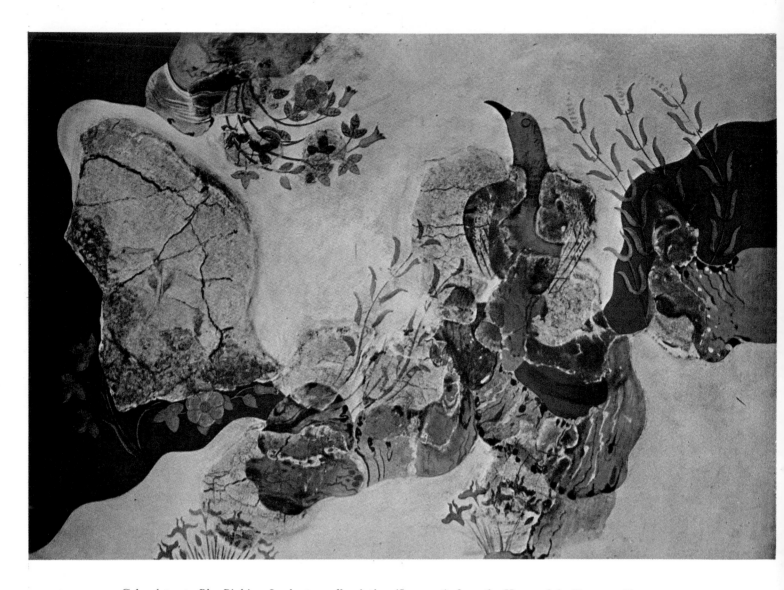

Colorplate 17. *Blue Bird in a Landscape*, wall painting (fragment), from the House of the Frescoes, Knossos. Late Minoan I, c. 1500 B.C. Archaeological Museum, Heraklion

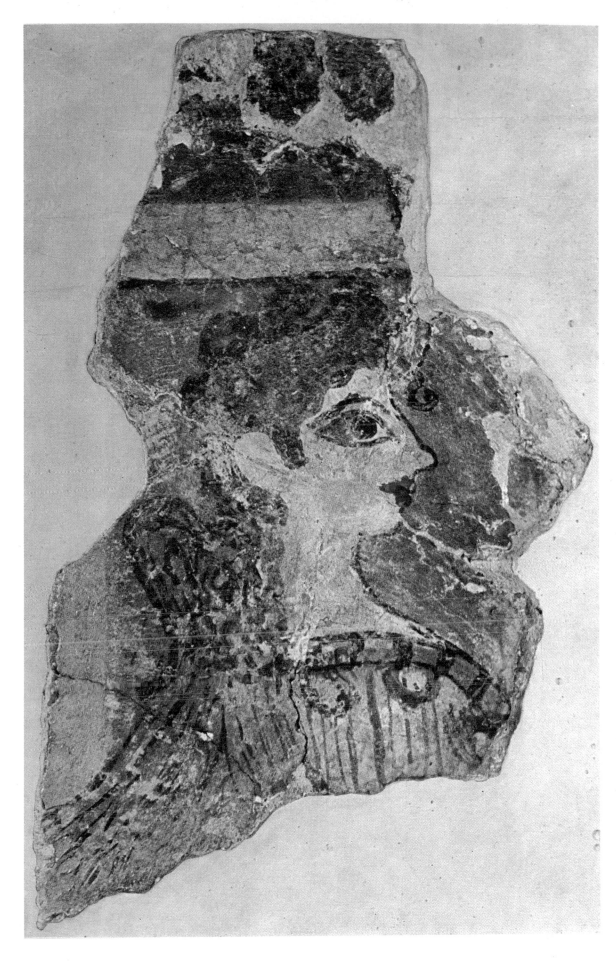

Colorplate 18. *Head of a Woman* ("*La Parisienne*"), wall painting (fragment), from the Palace of Minos, Knossos. Late Minoan I, c. 1500 B.C. Archaeological Museum, Heraklion

Colorplate 19. Dagger Blade with Marine Ornament, from the tholos tomb at Rutsi (near Pylos).
c. 1550–1500 B.C. Bronze inlaid with gold and silver, length 9 1/8″. National Museum, Athens

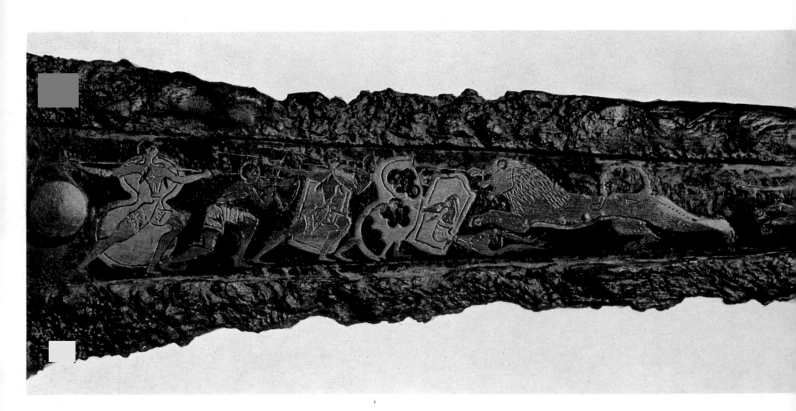

Colorplate 20. Dagger Blade with Lion Hunt (portion), from Grave IV, Citadel of Mycenae.
c. 1550–1500 B.C. Bronze inlaid with gold and silver, length of blade 9 1/2″. National Museum, Athens

however, is iconographic, for here we find a clear indication of religious practice which is all the more valuable since not a single plastic image of god or goddess has been found.

Before we can attempt to interpret the "scenes of worship," as they are generally called, we have to consider the architectural remains, which on this very point are extremely puzzling. Unlike their civilized contemporaries in the Near East, the Minoans built no temples; their places of worship were those which nature itself makes symbolically significant, namely caves and mountaintops, shown by findings of a profusion of small votive objects. In the complex, multistoried palace at Knossos, with its vast open courtyard, frescoed corridors, store-rooms, and sophisticated system of sanitation, only one small unobtrusive sanctuary has been found. Nor does the conglomerate of rooms and stairs show a unifying concept, least of all a focal point such as a throne room or divine image. In both Knossos and Phaistos the most impressive feature is, negatively, the open courtyard, reserved for we know not what purpose and approached by a noble stairway.[6] Attempted reconstructions suggest an architecture that was picturesque, erratic, utilitarian, with attractive details—such as the sturdy pillars which seem to shoulder their burden (fig. 168)—but a complete lack of monumental purpose. Does this emphatic secularity reveal, as has been suggested, a frivolous attitude to life?

It is not easy to find an approach to the religion of the Minoans. The Near East does not offer any clues to its understanding; temples and cult and funerary statues are, as we saw, conspicuously absent; and we do not even find a trace of the solar or astral symbols which abound elsewhere. This latter fact, especially, suggests a remarkable unconcern with the great metaphysical problems of cosmic order

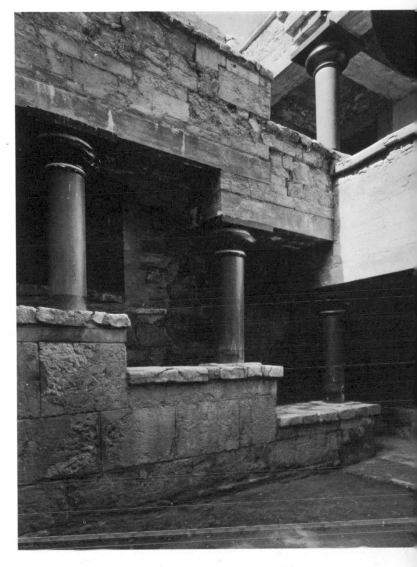

168. Grand Staircase, East Wing, Palace of Minos, Knossos. Middle Minoan III, c. 1600 B.C.

and chaos, time and eternity, divine will and human destiny which stirred the imagination and molded the worship in neighboring lands. If we assume that religious awareness in Crete was mainly focused on the divine source of earthly life, it is curious that we do not even

find a clearly defined image of a mother goddess. Generally speaking the godhead remains as elusive as individual man. In purely Minoan art—we shall later discuss Mycenaean remains —no divinity presides over the "scenes of worship," the small air-borne figures being more in the nature of a momentary epiphany. If figure 164 appears to be an exception, it should be noticed that the mountain goddess has no attributes and that the stiff antithetical arrangement of the lions—which moreover were not native to Crete—shows strong Near Eastern influence.

Since a comparison with better-known religions yields negative results, we shall instead consider the most original, the most peculiarly Cretan ritual of which we have records in frescoes and glyptic, namely the bull sports. A vague memory of these survived even in Greek legends. The term "sport," however, is a misnomer, for there is no doubt that these were serious games. The occurrence of "horned" altars in Crete shows that the bull, the most terrifying embodiment of potency, was sacred; and there is moreover evidence that the touching of horns was widely practiced in fertility rites elsewhere.[7] The bold and graceful leap over a running—not a charging—bull,[8] by using the dreaded horns as levers, is no doubt linked with ancient magical rites; it also transcends them. For here the challenge of a dangerous trial is freely accepted and the supreme effort it entailed is an aim in itself. In the same way, the Olympic games surpass in significance the more ancient rites out of which they developed, rites that were magically to foster the victory of life in nature at a critical moment. In bull-jumping and ritual contests the human agent may enact the perennial conflict between life and death, potency and decline; but the action itself, with its emphasis on physical pride and fearlessness, has passed

beyond the realm of magic compulsion. It has become not only the counterfeit of divine power but its manifestation in the form of youth and beauty. If then we see a communal festive rite in the bull-jumping, performed in the open air amidst a crowd of spectators, it should be noticed that the emphasis was exclusively on the intensification of life. We do not even know if or when the bull was sacrificed.[9] The rite, therefore, entirely lacks the tragic implications that "popular" religious festivals have elsewhere in the Near East. These, likewise rooted in ancient fertility rites, centered in the concept of a dying god whose loss was bewailed by the multitudes, whose rebirth or return was greeted with joy.

The conflict between life and death, the most haunting of man's perplexities, cannot have left the Minoans unmoved, but their response to it must have differed greatly from that in neighboring lands. In Crete not only a ritual intensification of life was aimed at but, in religious terms, the mystic union with the divine source of life. The scenes of worship suggest that this union was experienced dynamically in sacred dances. Whether their climax was the touching of the sacred tree (fig. 154)—a ubiquitous symbol of life—or a vision of the godhead, we cannot say. We are, whether through a historical accident or not, dealing with a wordless religion.

The importance of these scenes lies for us in the light it throws on the unique character of Cretan art, the artists' joyous awareness of a god-given, not a man-made, world, the miracle of living creatures, the ineffable grace of their movement. It may even explain why this art, which so suddenly sprang into bloom, soon withered and in a sense never developed: it bypassed the great, the bitter problem of human achievement and human fate, it ignored the enigma of man himself.

MYCENAE

We have so far dealt with Minoan culture as if, apart from trading contacts, it existed in complete isolation. We were forced to do this in order to give a coherent picture of what is distinctly and exclusively Minoan. Historically, however, the situation was far more complex, especially where the relation between Crete and Mycenae is concerned. For a long time it was believed that Mycenae had been under Cretan domination, almost as if it were the colonial outpost of a seafaring nation. This has proved to be a misconception and although the cultural and political relationship between these rival powers remains obscure and the historical causes of the rise of the one, the decline of the other, are beyond our grasp, it is clear that Mycenae had a cultural individuality of its own and that its remains must be dealt with on their own merit.

This individuality is already evident in the earliest remains of importance, namely the royal shaft graves, which date from the sixteenth century B.C. They were originally situated outside the citadel, but when Mycenae was enlarged in the middle of the fourteenth century B.C. the royal burials were turned into a sacred enclosure, surrounded by a ring of upright stone slabs with a place for offering in the center. The graves, which were excavated in 1876 by Schliemann, the father of archaeology, have yielded an astonishing number of gold objects, ornaments, goblets, cups, and even human masks, rhytons in gold and silver, seals and gems, as well as superbly decorated daggers and swords.[10] There can be no doubt that many of the finest pieces were imported from Crete, while some were imitations of Cretan prototypes. Others, however, merely show traces of Minoan influence or are of purely Mycenaean workmanship. We find, for instance, funerary steles—for which no parallel exists in Crete—roughly carved in relief with war and hunting scenes, and such un-Minoan subjects also predominate on seals and gems. In glyptic the human figures are Cretan in style, with spidery limbs and constricted waist, but the fierce man-to-man combat (fig. 169) and the equally fierce encounters between hunter and lion (fig. 170) have a deadly seriousness, a

169. *Two Warriors in Combat* (drawing), seal from Mycenae. c. 1500 B.C. Height 1/2″. National Museum, Athens

170. *Hunter Fighting Lion* (drawing), seal from Mycenae. c. 1500 B.C. Height c. 5/8″. National Museum, Athens

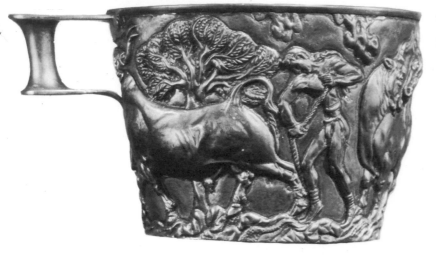

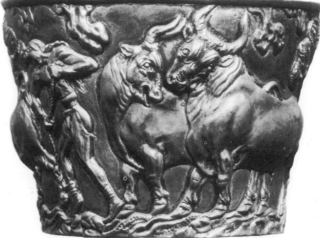

171. *Vaphio Cup I*, from a tholos tomb near Vaphio, Laconia. c. 1500 B.C.
Gold, upper diameter 4 1/4″. National Museum, Athens

heroic quality, which is far removed in spirit from the pugilistic games and bull sports in Crete. If the carvers of these wonderfully dramatic scenes were Minoans, they may have been inspired by the demands of more virile rulers for new kinds of subject matter. It is not surprising that the Mycenaean warrior kings greatly valued their swords and daggers and although both types of weapons are found at an earlier date in Crete, none can compare with the Mycenaean examples. The ornamentation of the daggers, especially, shows a superb craftsmanship. They were encrusted with patterns and even scenes in multicolored alloys, the figures being hammered into the blade and then engraved, the details picked out in niello. Here again the design shows unmistakable Minoan influence, especially where, incongruously, marine motifs were used (colorplate 19), but this process, as well as a subject like the lion hunt (colorplate 20), was unknown in Crete. In fact art on the mainland frequently has this ambiguity, that style and subject point to different origins.

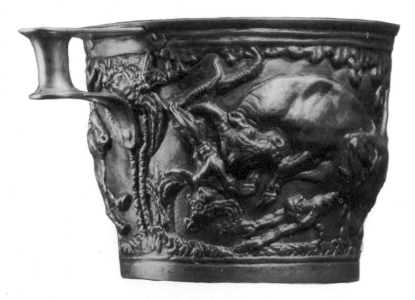

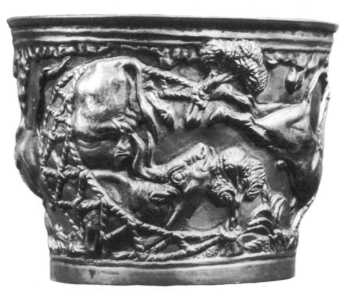

172. *Vaphio Cup II*, from a tholos tomb near Vaphio, Laconia. c. 1500 B.C.
Gold, upper diameter 4 1/4″. National Museum, Athens

This ambiguity is particularly striking during the fifteenth century B.C., when the wealth and power of Knossos was at its height and Cretan influence was strongest on the mainland. I shall give only two examples, both works of outstanding quality. The famous gold cups found at Vaphio in Peloponnesus (figs. 171, 172) are at first sight convincingly Minoan, but the subject is not ritual bull sport; it is the secular pastime of catching bulls, on one cup by peaceful means—the bull is lured by a cow—on the other by more violent methods. One bull is caught in a net, another charges and tosses a youth who grabs the ear—not, significantly, the horns—while his comrade falls lengthwise in a posture that does not even suggest a failed somersault. If the artist was Cretan, Minoan genius has here surpassed itself. Not only the shape and movement of the animals but their mood and character—note the joyous excitement of the bovine couple, the

violence of the charging bull—have been wonderfully conveyed. The modeling is firm and clear, the landscape setting unusually articulated with here and there a suggestion of receding space. Only the figure of the youth twisted round the horns is structurally obscure, but that is precisely how he would appear to the observer of such a breath-taking event.

The second masterpiece is the exquisite ivory carving of two women and a small boy, found near a sanctuary in the Mycenaean citadel (fig. 173). Here a subtle and complex relationship has been expressed in terms of plastic movement alone, a type of mobility which suggests Baroque art in so far as not only limbs and posture are involved but also billowing garments. The emotional bond between these figures, though clearly expressed in the affectionate gesture of what appears to be the elder toward the younger woman and of the latter toward the child, is intensified by the diagonal

173. *Three Deities*, from Mycenae. c. 1500 B.C. Ivory, height 3″. National Museum, Athens

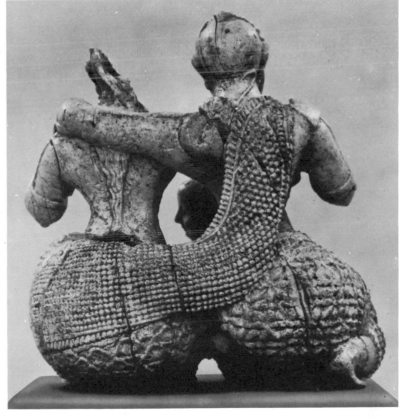

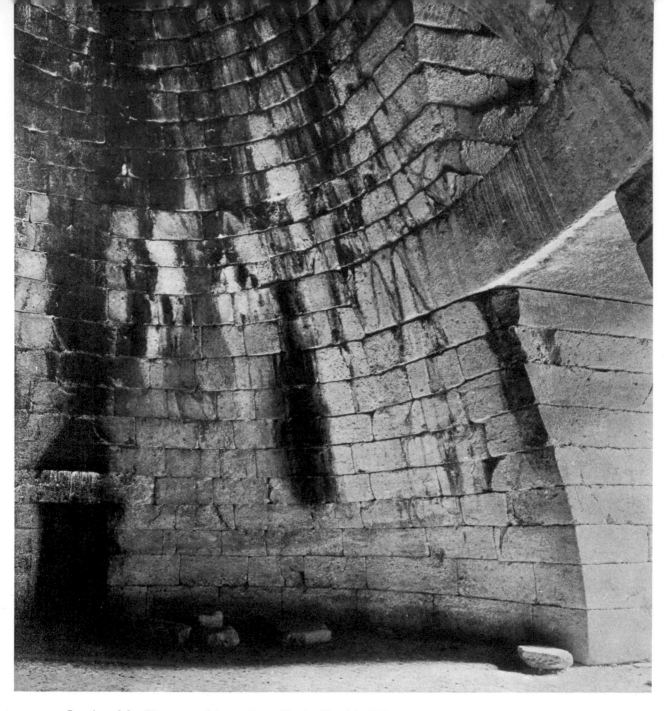

174. Interior of the "Treasury of Atreus," outside the Citadel of Mycenae. c. 1330 B.C. Interior height 42′ 8″.

sweep of a shawl linking the two women. In front view this diagonal is repeated in the opposite direction by the movement of the boy, who stands at the knees of the elder woman and leans toward the other. The almost excessive curves of the traditional flounced skirts, and the elder woman's foot bent for action, give a curious resilience and energy to the squatting postures and counterbalance the effect of weak boneless arms and generously molded but soft, unmuscular torsos. No plastic figure so far found in Crete matches the consummate skill of this small work, which epitomizes both the strength and the weakness of

Minoan art. Again the question arises if here also it was a Mycenaean subject which inspired a great Cretan artist. There can be little doubt that this "trinity" represents the two goddesses who appear under different names but are best known as mother and daughter, Demeter and Persephone, with the young god known at Eleusis as Iakchos.[11] As long as the vexing problem of the difference between Minoan and Mycenaean religion remains unsolved, we can say no more than that in Crete no image occurs of the two goddesses and that the mother-child relation has, so far as we know, never there been depicted.

It remains to consider the architecture of the mainland and in this case the divergence between Minoan Crete and Mycenae is no longer tantalizingly obscure: there exists a striking contrast in technique, function, and general plan between the buildings of the two regions.[12] The palaces at Knossos and Phaistos were lightly built and show a remarkable unconcern with warlike contingencies; they were in fact quite defenseless. The mainland architects, on the other hand, excelled in massive stone construction. Mycenae, as it stands today with the well-known lion gate forming the entrance through cyclopean walls, shows the masons' formidable skill, as does the roughly contemporary citadel at Tiryns with its steeply vaulted passages, constructed with large blocks on the cantilever principle. The plan of the palaces inside these strongholds also differs completely from those in Crete. Their architectural focal point was not a vast courtyard but a *megaron*, the translation into a monumental form of the primeval northern homestead with its central hearth and access through a single doorway. The axial approach to it, from a medium-sized courtyard through a columned porch and vestibule, reveals a desire for logical planning that is all the more

impressive because at Mycenae the site was cramped and had in several places to be adapted to the plan by careful leveling. The assertion made long ago that this clarity of design was un-Minoan gained in significance when it could be proved that the Mycenaeans were in fact archaic Greeks.

There exists yet another type of architectural remains which fully confirms the originality and the intellectual power of the mainland architects, namely the large vaulted tombs which are found over a wide area and range in time from the fifteenth to the middle of the fourteenth century B.C. It was a truly impressive concept for a funerary monument, to raise a stony firmament above the dead.

The best-preserved and most famous of these tombs (fig. 174) has been dated to c. 1330 B.C., and therefore may well have been built for the ruler who enlarged the Mycenaean citadel half a century after the destruction of Knossos. It is often wrongly called "the Treasury of Atreus" and is situated outside the Mycenaean bastion. An entrance passage cut into the side of a low hill and faced with massive stone walls leads to a tall doorway surmounted by a "relieving triangle"; inside is a soaring shadowy vault that appears as weightless as the night sky. Technically it is a stupendous achievement; no unsupported vault of this size was ever again attempted before the days of imperial Rome. As a conception of pure form, noble and austere, this wholly Greek creation is the more impressive still.

When the power of the Mycenaean kingdom was swept away by a new wave of Greek invaders, its artistic legacy was entirely lost. In the Greek art which evolved after centuries of confusion, not a trace of its stylistic survival can be found. Only the memory of Mycenaean glory lived on to haunt the imaginations of the greatest poets of all time.

Bernard Ashmole

PART TWO

Greek Art

4

Introduction to Greek Art

The period covered in the remainder of this volume is one of some thirteen centuries, from about 1000 B.C. to about A.D. 300, from the time when the peoples who were to become the classical Greeks had finally settled in the land of Greece, down to the time when Constantine the Great refounded the ancient Greek city of Byzantium as Constantinople and made it the capital of the Eastern Roman Empire.

Within that period we shall survey not only the art of Greece and the art of Rome, but also that of Cyprus and of Etruria. Cyprus, far out on the borders of the Greek world, was at the mercy of any power dominant in the eastern Mediterranean: artistically she was within the periphery of Greece, but on an eccentric orbit, and reflecting Greek styles with varying intensity. The Etruscans had come to Italy from the heart of Asia Minor, probably first in the ninth century B.C. They reached their greatest power about 500 B.C., disputed with Greek colonists the possession of South Italy, and disputed the possession of Central Italy with the rising power of Rome, until they fell before it. They were admirers of Greek art and were also considerable artists themselves, contributing substantially to the subsequent development of Roman art.

Before discussing the actual works of art, a word should be said about the so-called periods of the history of art, and about the nature of the material that is left to us.

PERIODS

In order to make the history of art intelligible it is useful to divide it into chronological periods, and to give them conventional names. In the following chapters the division into

periods and the names used for them are these:

1000–700 B.C.	*Protogeometric and Geometric*
700–600 B.C.	*Orientalizing, and the formation of the Archaic*
600–480 B.C.	*Archaic*
480–450 B.C.	*Early Classical*
450–330 B.C.	*Classical*
330–146 B.C.	*Hellenistic*
146 B.C.–A.D. 330	*Roman (for subdivisions see p. 449)*

It should be remembered, however, that the development of art is normally a continuous process, that the lives of artists may span any divisions we may make, and that the line between periods is rarely clear-cut. Further, although the periods of art history sometimes coincide fairly closely with historical or political events, they sometimes bear little relation to them. For example, the Persian destruction of the Acropolis of Athens in 480 B.C. was significant for the history of art, not only because the statues broken up by the invaders, and found by modern excavators in the debris, can all be dated by these circumstances to the period before the destruction; but also because, by a coincidence, Greek art was at that time just emerging from its Archaic phase, and the final victory over the Persians gave a great impulse to its development. By contrast, the foundation of Constantinople in A.D. 330, the lower limit of our period, has no artistic significance except in so far as the city became the seat of those emperors in whose service Byzantine art developed and flourished. In short, the division into periods is made for convenience only, and is not sacrosanct.

Within the periods, decorated pottery, painting, architecture, and sculpture will be treated in that order: pottery first, because it provides a more continuous and more easily dated record than any other form of art; with the painted pottery will be discussed painting on a larger scale; architecture next, because buildings can sometimes be dated, and those that have sculptural decoration will provide fixed points in the history of sculpture; and finally sculpture, with which will be included, where appropriate, terracottas, small bronzes, and other forms of art such as gems, coins, and jewelry.[1]

DESTRUCTION AND LOSS

Not only has most of Greek art perished, but destruction has fallen unequally on the various kinds of objects, so that unless we can restore in imagination or at least make allowance for what is lost, the general picture will be distorted.

Basketwork and leatherwork are total losses, and in historical times they had little artistic importance. Earlier, however, these materials were much used; vessels made of them had been imitated by potters, and patterns first designed for or suggested by them became part of the heritage of Geometric art.

Next comes woodwork. A few statuettes in wood have survived, a few wooden toilet vessels, and, from the dry climate of Egypt, a few slight pieces of late Greek and Roman furniture. Otherwise, the fine furniture depicted on Greek vases and the fine joinery used in the interior of temples and other buildings has completely gone.

Similarly with textiles. Everyone wore clothes, and few of these were patternless: some were woven, some were embroidered with patterns, and often the patterns were most elaborate, especially when the garment was designed for religious ritual. Yet, of the millions of yards of stuff woven in the thirteen centuries which our period covers, only a few square inches survive, so that we have practically no direct information of what they were like. As indirect evidence we have the painted patterns on the dresses of some Archaic statues, representing woven or embroidered patterns on the original garments; we have many pictures on vases of people wearing patterned dresses; and we have some fragments of Hellenistic sculptured drapery in marble with raised, presumably embroidered designs upon them. These are the poorest substitutes, and it needs a constant effort to recall the loss, not only of the whole range of designs, but of the general effect of color that patterned clothing must have given.

The next greatest loss has been that of painting.[2] Of all the great wall paintings that are described in detail by Pausanias, and of the panel paintings mentioned by him and by Pliny, not a single fragment survives, and there is no way in which we can even approach a conception of their aesthetic value. The only aids to a knowledge of them are these descriptions, and certain remarks by other ancient writers about the aims and achievements of various famous painters, neither of which comes near touching the heart of the matter. Two other aids, namely the pictures on contemporary Greek vases and the paintings from Roman times based on Greek originals, both have grave defects. The painting of pictures on pottery was not considered a major art by the Greeks, and there is no reason to suppose that, excellent draftsmen though some of these pot painters were, they had anything like the ability of the wall painters. Although the subjects and their treatment on vases sometimes obviously owe a good deal to major painting, vase painting was a sufficiently independent

art not to copy the larger paintings meticulously; and even where some attempt at copying is evident, there is likely to be a vast gap between a great master and those who emulate his style in a more modest and less flexible medium.

The survival rate of the vases themselves must be fairly high, since, being made of clay baked at a high temperature, they can only with great difficulty be totally destroyed, although they can be broken; and when broken the clay vases, unlike metal, cannot be converted to other uses. It follows that of all the vases made in antiquity a high proportion must still be in existence somewhere, either above ground in museums, shops, and private houses, or still buried in tombs or the ruins of cities. This survival is extremely fortunate, because the pictures on vases are an inexhaustible source of knowledge on the thoughts, beliefs, ritual, mythology, and daily life of the Athenians, and to some extent of the other Greeks. Great numbers of Greek vases were found in Etruscan tombs in the eighteenth and nineteenth centuries, and an example of what may still lie beneath the soil is the site near Ferrara in Italy, where within the last century thousands of Greek vases have been found in an Etruscan cemetery.

The paintings of Roman date are more treacherous. Some, we can be fairly sure, were intended to be copies of Greek originals, but there is no certain way of detecting alien elements, whether introduced deliberately or through the unconscious intrusion of the copyist's own style.

With sculpture the case is different again. An enormous proportion, certainly in the region of 99 percent, of all original Greek sculpture on a large scale, in every kind of material, has been destroyed, and we are left with a very few undoubted originals, of varying quality and in a more or less fragmentary state. The vast bulk of the statues which fill our museums are not originals but ancient copies, made mostly in Roman times, mostly for Roman patrons, though mostly by Greek craftsmen. What lost originals these statues copy we can sometimes guess because of their correspondence to descriptions of famous statues by ancient writers; but it is often hazardous guesswork. On the other hand, even where we do not know what the originals were, the copies can be fairly assumed to be faithful; the pointing process by which they were made was not radically different from that used in modern times,[3] and the process made it easier for a conscientious worker to copy his original accurately than to introduce innovations. In this they differ from copies of paintings. Copies of statues can be defective, sometimes through the carelessness of the copyist, sometimes through his lack of sensitivity, sometimes through his deliberate attempt to create something new by modifying the old type; but the great run of ancient copies do seem to have been faithful, if one judges from the way in which different copies of the same original tally with one another.

One other most important source for our knowledge of Greek original style in sculpture is the architectural sculpture. This too is often fragmentary, and not always from the hands of leading sculptors, but it can usually be assigned to a particular school of sculpture and it can often be dated. Thus the otherwise somewhat nebulous history of Greek sculpture is lighted at intervals by these steady beacons: for example, the sculptures from the treasury of the Siphnians at Delphi, about 525 B.C.; from the temple at Aegina, about 490; from the temple of Zeus at Olympia, about 460; from the Parthenon at Athens, around 440; from the Mausoleum at Halikarnassos, about 350; from

the Great Altar at Pergamon, about 180. There are other groups of architectural sculpture less important, but none is without value.

Two other classes of sculpture help to fill the gaps, though they are usually not of the highest quality: these are the grave reliefs and the votive reliefs, both preserved in comparatively large numbers.

The bronze statuettes and the terracottas also give some idea of what the larger sculpture was like, but only of its general development. The makers of bronze statuettes do not seem to have been the same people as the makers of full-size bronze or marble statues, and though statuette makers could not ignore works of larger size, they were artists in their own right, often of considerable and sometimes of surpassing ability.[4] Many of their statuettes, whether freestanding dedications, handles of mirrors, or attachments of larger vessels, give us an inkling of the quality, if not the exact form, of the larger statues.

The makers of small terracottas do not rank so high. Although, especially in Archaic times, there are large terracottas modeled by hand that are worthy to be compared with sculpture in bronze or marble, the great bulk of the statuettes are commonplace; and their method of production by molding means not only that new creations were rare, but also that we seldom possess the freshest impressions from any new molds.[5]

The works in metal other than statues and statuettes would chiefly consist of armor, vessels, and furniture, often richly embossed or inlaid; the loss is difficult to estimate, but on many grounds it can be shown to be great. Objects made of metal, having an intrinsic as well as an artistic value, are apt to be melted down, either when they are worn or damaged, or in time of emergency when metal is urgently needed. Many pottery vases are obviously copies of metal shapes, and the pictures on them show people using vessels that must often be of metal. Inscriptions that record treasures stored in temples mention vessels made of various metals; and there are references to such vessels by ancient writers. Finally, there are the scanty remains of these metal objects themselves, mostly vessels and armor, which show a long and continuous development of shapes and technique and a high standard of achievement.

Of coins the survival rate is again impossible to establish, but from the number of coin dies which can be shown to have existed, and from each of which, to judge from their worn condition, many coins must have been struck, it is not unlikely that where we now possess a few dozen specimens of a coin, thousands originally existed.

Intaglios, or engraved gems as they are usually called—the semiprecious stones carved in sunk relief with miniature designs, for use as seals—are on a different footing.[6] Unlike coins, of which hundreds of identical specimens could be struck from a single die, each gem stone was unique: made for one client and normally his personal signet, they can never have existed in vast numbers. It is clear therefore that the loss of engraved gems has not been proportionately so great as that of coins: that it has still been considerable is shown by the survival of many ancient reproductions in glass paste, made mostly in Roman times from original gems of earlier date now lost. One should add that the engravers of coin dies do not normally seem to have been gem engravers also, although their dies were often of equal quality.

Wherever we turn, the losses of ancient works of art are likely to be greater than we can readily conceive: and, finally, one other loss of a different kind must be mentioned, that of color on sculpture.[7]

All Greek sculpture and probably most Roman sculpture was colored. In Archaic times bold reds and blues, with black and yellow, were used, and, where the stone was poor, in sufficient thickness to mask the surface: but when fine marble was quarried in quantity and its qualities were fully appreciated, the color, probably fixed with some such medium as egg, became less obscuring.[8] Its palette also became more naturalistic. From about A.D. 120 onward it became customary to carve the iris and pupil of the eye in such a way as to simulate the reflection of light in them, but in marble statues before that time these details, as well as eyebrows and eyelashes, had been rendered solely in paint: in bronze statues they were inlaid with colored stones, ivory, or glass, the lashes being of bronze. The blank eyes of much sculpture carved since the Renaissance are due to ignorance of this fact. Coloring added much to the appearance of life and animation of a statue without detracting from its sculptural quality, unless, on occasion, the use of a light color in a shadowed part or of a dark color on a lighted part neutralized the emphasis of the modeling.

ANCIENT WRITERS ON ART

In the face of all these losses some help in reconstructing the history of Greek art is given by ancient writers. We have no writings contemporary with its greatest days. But we have quotations from art historians of the Hellenistic period embedded in writings of Roman date by Greek and by Roman authors; these quotations are often alongside much miscellaneous information on artistic matters culled from various sources of unequal value. Of these later authors two are outstanding: the Roman, Pliny the Elder (i.e. the earlier), and the Greek, Pausanias.

Pliny (G. Plinius Secundus) was born in A.D. 23, and died, a victim of his own unquenchable thirst for knowledge, while watching too closely the eruption of Vesuvius in A.D. 79. Although a busy man of affairs, he was in every moment of his spare time the born encyclopedist, and we have amusing sidelights on his methods, both from himself and from his nephew, the younger Pliny. For his *Natural History*, in thirty-six volumes, he claims to have consulted a hundred main authorities and some two thousand other books.[9] History of art finds a place in the *Natural History* because the account of the natural product, metal, is completed by the account of metalworking, and to that a history of bronze sculpture could reasonably be added. Similarly, when Pliny has described different kinds of stone, he appends a short history of sculpture in marble and engraving on gems; and a history of painting is introduced because painters use natural earths and minerals as their media.

Pliny's book is an astounding monument of human industry, but being purely a compilation, with little attempt to distinguish sound from unsound evidence, it has to be used with the utmost caution. Scattered through it are hundreds of quotations from earlier writings of which we shall never know the authors, though some of them may well have been sculptors and painters of the Classical age

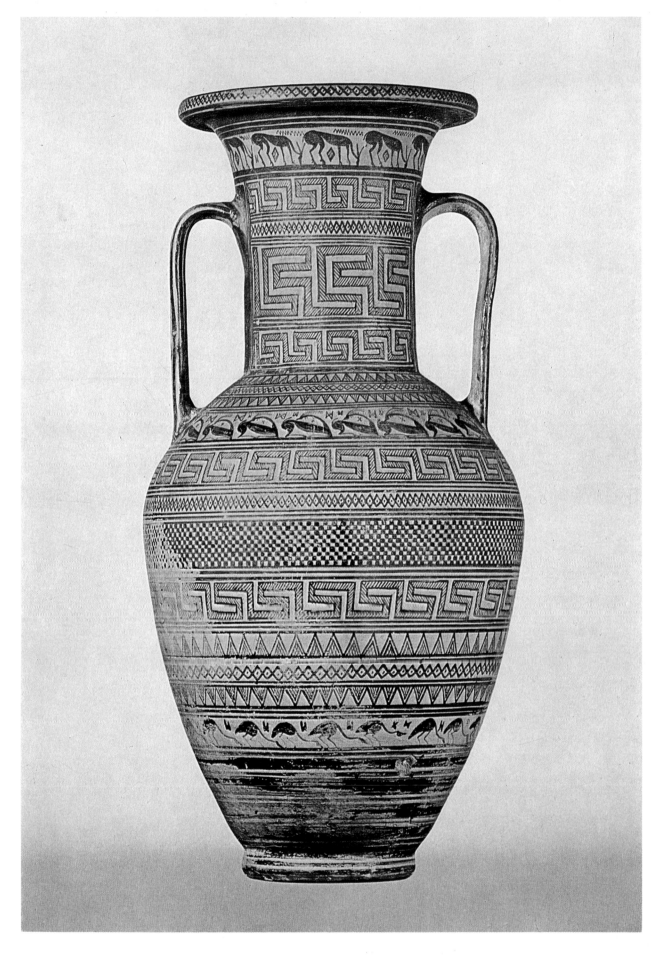

Colorplate 21. Amphora, probably from the Dipylon cemetery, Athens.
Attic Geometric, c. 750 B.C. Height 16 1/8″. Museum Antiker Kleinkunst, Munich

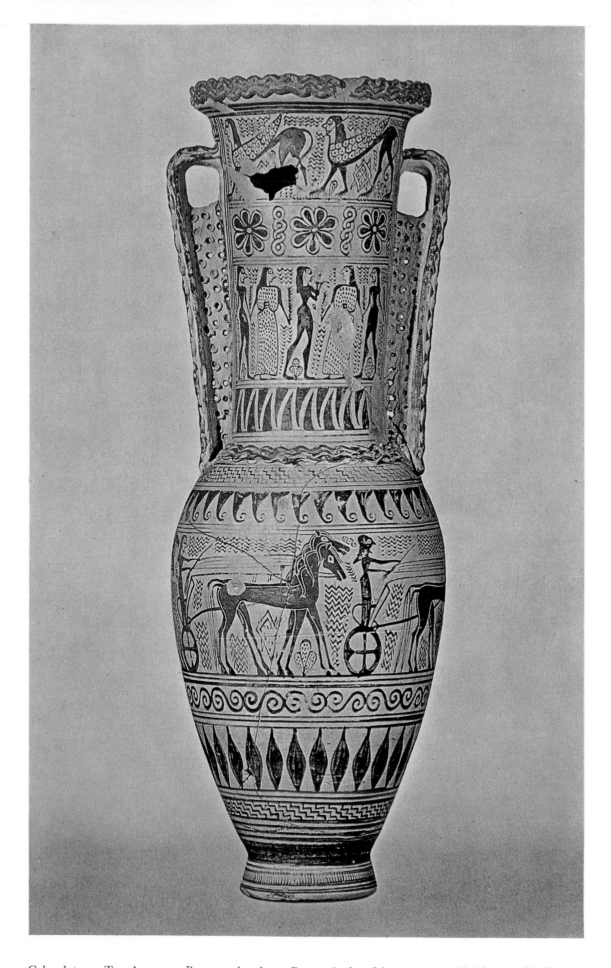

Colorplate 22. THE ANALATOS PAINTER. Amphora. Protoattic, late 8th century B.C. Height 31 7/8″. The Louvre, Paris

itself. It has proved possible to identify some of the material extracted from certain well-known Hellenistic writers, and where, very rarely, we have the text of the earlier authors on which Pliny drew—Aristotle, for instance—we can see his method of using them and how far he understood or misunderstood them; but where the writings are lost we have no way of testing the value of the statements he borrowed, or even whether he transcribed them accurately. Nevertheless his work has been of prime importance in reconstructing the history of Greek art.

The second main source, Pausanias, is a writer whose work differs vastly in both style and form from Pliny's.[10] He was a Greek who lived through the reigns of the Roman emperors Hadrian, Antoninus Pius, and Marcus Aurelius, and was still writing in A.D. 176. His only known work, carefully written in an old-fashioned style modeled on that of the historian Herodotus, has survived complete. It is a *Description of Greece* in ten books: a painstaking, honest account—by an industrious, unimaginative traveler—of Greece as it was in his day; its form is that of a practical guidebook, with emphasis on the antiquities and religious traditions of the country, but with little interest in the scenery or the living inhabitants. Pausanias visited almost all the places he describes,

and consulted local guides, temple records and inscriptions: his artistic judgments are of little value, but he describes or mentions many sculptures and paintings, with a preference for the earlier ones.

There is one other writer, almost contemporary with Pausanias, who, although his remarks on art are rare and casual, occupies a special position, and that is the Syrian satirist, Lucian. His importance is due to the fact that he started life as a sculptor, and when he talks of sculpture he clearly does so with firsthand knowledge and keen judgement. One of his dialogues deals with the not very happy idea of constructing an ideal figure by taking components from various well-known statues and paintings, and he mentions the special beauties of each of these works of art. The scene of another dialogue is laid in a house which is supposed to contain several famous Greek statues, and these are described. Thus we are given clues which may help us to identify, among the copies that have come down to us, those of lost Greek masterpieces.

From the above summary it will be seen that the evidence from ancient writers is of unequal value and difficult to assess; but even so, in the absence of anything better, and because the losses of ancient works of art have been so enormous, we cannot afford to neglect it.

5

The Protogeometric and Geometric Periods (1000–700 B.C.)

The details and even some of the main outlines of the history of the Aegean are still obscure for the period following the collapse of the Mycenaean Empire, but we can be fairly certain that for many years, even centuries, there were tribal movements great and small, wars and forays, and a general lack of security. This is the kind of unsettled life that leaves no written records and no great works of art. Its remains are chiefly of weapons and simple pottery; when the development and distribution of these are better known by further excavation the picture may become less obscure, but it is never likely to be fully clear.

The general racial movements seem to have been southward from the basin of the Danube. These northern invaders, physically vigorous and artistically primitive, using efficient weapons made of iron, seem to have come down into Greece in successive waves; the first drove out the local inhabitants, many of whom fled eastward, and later waves tended to push the earlier waves southward before them. Greek legend spoke of an invasion by the Dorians, and it may well be that the last main invasion from the north did indeed consist of the people who in classical Greek times were called Dorians: these held most of the Peloponnesus, and outside it such important places as Aegina, Rhodes, and Crete. It was this northern stock which gave to Greek art much of its robust and disciplined quality, one of the foundations for the unrivaled achievement of the Classical age. But invaders do not commonly obliterate the earlier inhabitants. They may drive out or kill many or most of the men, but they enslave many, especially the women, and in this way the blood of the conquerors becomes mixed with that of the conquered. Although the results may be imponderable, we can be certain that some inheritance from the Mycenaean inhabitants of Greece, and even from those whom they themselves had supplanted, had its effect on the art of all succeeding periods.

The other main foundation of Classical Greek art is Ionian. The Ionians were tribes who had been driven out of Greece by the northern invaders and had settled on the shores of the Black Sea and on the islands and coastlands of western Asia Minor, where later the Ionian Greek cities of Ephesos, Samos, and Miletos were to arise: their religious and cultural center was on the island of Delos.[1] But Ionians were not confined to the east of the Aegean: in Greece itself the cities of the island of Euboea and, above all, Athens were of Ionian stock. Athens indeed claimed to be the mother city of all the Ionians. Although this claim can be questioned she does seem to have been relatively unharmed by the northern invasions, and thus survived to be the main link of the Ionian cities with mainland Greece. To the Ionian strain in its ancestry, Classical Greek art seems to have owed some of its richness and decorative quality.

In mainland Greece, when the more violent racial movements had died down, we find people settled there who must have gradually been acquiring many of the amenities of a peaceful life, for by about 800 B.C. we have pictures, on their pottery, of their furniture and textiles, chariots and ships. Their art, as we see it in statuettes of bronze and clay, in paintings on pottery and in metal reliefs, has an angularity which has caused it to be called in modern times Geometric; and the period which began about 1000 B.C. and extended to about 700 B.C., although there must have been considerable changes and varieties of style within that time, is called comprehensively the Geometric age.

POTTERY AND VASE PAINTING[2]

Geometric pottery developed from an earlier and simpler pottery called, conventionally, Protogeometric.[3] This in turn had some links with the very late Mycenaean, and it is possible that the technique of its decoration, which generally consists of patterns done in dark glossy slip on a less glossy, lighter ground, had been handed down from Mycenaean times. The potting is excellent, the shapes bold, and the patterns not meager, though satisfying only to a most austere mind (fig. 175). The patterns, intended to be black, would turn out to be brown or even red, according to the amount of carbon that had been locked in the slip: the process by which, at a certain stage in the manufacture, the ground of the vase is cleared of black by the use of an oxydizing fire, leaving the pattern still in black, is the basis of the later, elaborate black-figure and red-figure techniques (see p. 202).

175. Amphora, from the Dipylon cemetery, Athens.
Attic Protogeometric, early 10th century B.C.
Height 16 3/8″. Kerameikos Museum, Athens

176. *Two Warriors* and *Hunting Scene*, vase from Thebes (Boeotia). Boeotian Geometric, c. 700 B.C. Height 5 1/4". British Museum, London

The name Geometric has been given because of the tendency of the artist to reduce all features, whether abstract or natural, to geometric patterns, almost always angular and commonly rectilinear, but with some use of circles. Geometric pottery was made in various centers in the Greek world, and most ot these have now been identified. One of the most prolific and most characteristic was Athens, with Crete a careful and Boeotia a coarse and lively imitator (fig. 176).

Another distinctive kind of Geometric pottery was made in Corinth. The pots are never as large as the Athenian Geometric, nor is the decoration so elaborate, for it often consists only of a series of fine parallel horizontal lines covering the whole surface: but the clay is of the first quality and the pots themselves beautifully made. A specialty was the tiny aryballos (fig. 177), a spherical container into which it is likely that heavy oil-bound perfumes, imported into Corinth from the East, were decanted for re-export; Corinth, with its commanding position on the Isthmus, early became an important center of trade. The aryballoi may well have

been exported empty as well, for they are attractive objects; so too are the small drinking cups of a shape called skyphos, their fabric almost eggshell-thin, their decoration simple but exquisite, which are found on numberless sites of the ancient world (fig. 178). The aryballoi persisted, gradually changing their shape and decoration, for at least two centuries, and became more numerous in the seventh and sixth centuries as Corinthian trade continued to expand.[4]

In Athens, Geometric pots were sometimes of great size, even up to the height of a man, and were not uncommonly used to set up over graves, forming by their austere grandeur a kind of monument. Holes were sometimes pierced in the base, so that drink-offerings could be poured through for the use of the dead below. The painter liked to cover the whole of the vase with his patterns, which were arranged in bands or panels or a combination of the two. There was a wide repertory of patterns: swastika, key pattern, herringbone, running false-spiral, and many others. Some of them had a meaning, for instance as sun symbols, that was derived indirectly from the East, perhaps through the medium of textiles; but it is not certain how far these meanings were known to the Geometric artist. Some pots have inanimate patterns only, and when animals were introduced they too were arranged to form repeating patterns (colorplate 21).

Finally, scenes with human figures appear, and these can be in bands or in panels, according to the subject. The pots used for graves could bear a panel picture (to accommodate this the surrounding patterning was, as it were, pushed aside) in which was represented the dead man laid out on his bier with mourners around him (fig. 179); but the procession of

179. Dipylon Amphora, from the Dipylon cemetery, Athens. Attic Geometric, c. 750 B.C. Height 61″. National Museum, Athens

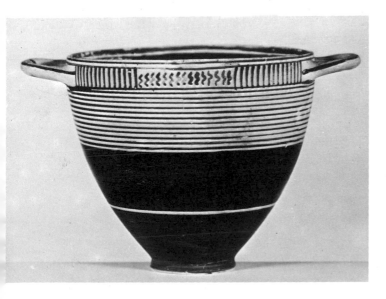

178. Skyphos, from Campania (Italy).
Protocorinthian, c. 700 B.C. Height 3 1/2″.
Museum of Fine Arts, Boston (Francis Bartlett Donation)

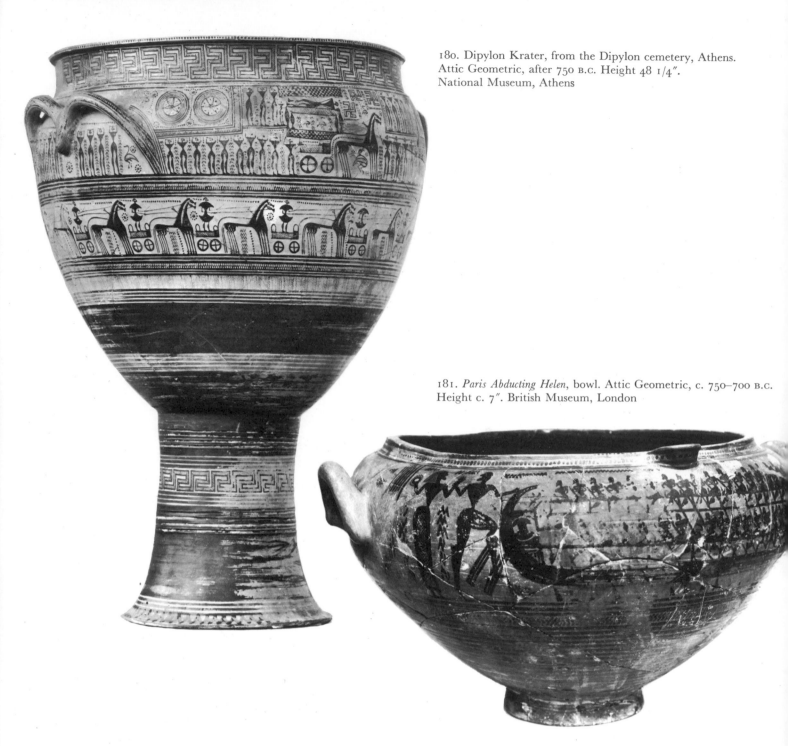

180. Dipylon Krater, from the Dipylon cemetery, Athens. Attic Geometric, after 750 B.C. Height 48 1/4″. National Museum, Athens

181. *Paris Abducting Helen*, bowl. Attic Geometric, c. 750–700 B.C. Height c. 7″. British Museum, London

chariots, which formed part of the funeral, could naturally be shown as a continuous band (fig. 180).

In general, the primitive artist cannot bear to leave any space vacant; thus the areas surrounding the figures were filled with separate ornaments—crosses, swastikas, herringbones,

and so on—which have no connection with the main scene. These are commonly called filling ornaments, and the use of them in this way (which is not confined to Greek art, but is found elsewhere among primitive artists) persisted for at least two hundred years.

If the human figures on these Geometric

vases are examined in detail (fig. 181) it will be found that they have been assembled, as is common also in drawings by children, from a number of memory pictures of the separate parts of the body, and that each part impressed itself on the artist's memory in its most characteristic, which is also usually its broadest, aspect. For instance, a hand will be shown with its fingers spread, legs will be shown in profile, and the eye, even in a profile head, will be shown in its full length, as if seen from the front. But the analogy with children's drawings, though enlightening, is not exact and should not be overstressed. Geometric art is primitive only in a special sense; in its later stages at least it became conventional and sophisticated, having been practiced, not by an untutored child, but by generations of skilled craftsmen.

ARCHITECTURE[5]

We are fortunate in possessing direct evidence for the character of Geometric buildings, in the form of pottery models of temples or houses. One (with fragments of a second) was found at Perachora, a Corinthian settlement on the east shore of the Gulf of Corinth (fig. 182); and another on the site of the temple of Hera at Argos (fig. 183). Both are decorated as if they were pots, so that they can be dated, by comparison with Geometric pottery, to the eighth century B.C.

The model from Perachora represents a building with a porch flanked by pairs of columns, in front of the single central doorway; behind is a single room almost as broad as it is long, ending in an apse (fig. 184, left). The material of the real building was probably rubble or even sun-dried clay (since rounded walls are easy to build with such materials, but difficult with squared blocks), the columns were of wood, and the roof of thatch, perhaps coated with clay. The model from Argos has two single square columns in front and a square end to the room, but is otherwise similar (fig. 184, right). We do not know the size of the buildings represented by these terracotta

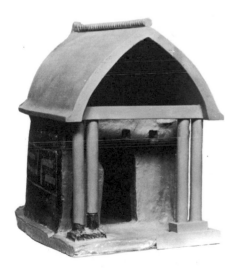

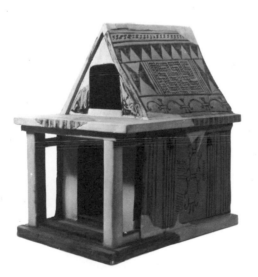

184. Architectural Models from Perachora (left) and the Heraion near Argos (right). *Plans*

182. Architectural Model of a Temple (?), from Perachora. 8th century B.C. Terracotta, length c. 14 1/2″. Ashmolean Museum, Oxford

183. Architectural Model of a Temple (?), from the Heraion near Argos. 8th century B.C. Terracotta, length c. 14 1/2″. Ashmolean Museum, Oxford

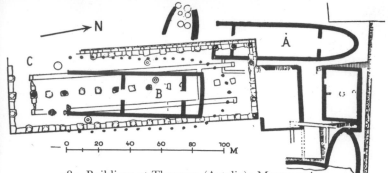

185. Buildings at Thermon (Aetolia): Megaron A, before 1000 B.C.; Megaron B, c. 1000–700 B.C.; Temple of Apollo C, c. 640–630 B.C. *Plans* (after Kawerau)

models, but structural problems suggest that they cannot have been large. That there were comparatively large buildings in this period, and even before, is proved at the site of

Thermon in Aetolia (fig. 185), for there we have the remains of a succession of buildings, one above the other, beginning with one perhaps built before 1000 B.C. which is more than seventy feet long, with a strongly curved apsidal end. This was succeeded about 1000 B.C. by a building of which the end wall is still slightly curved and the range of wooden posts with which it was surrounded strongly curved behind it: this wooden veranda (perhaps a later addition) is in a sense the forerunner of the peripteral colonnades of Classical temples. That building, in its turn, was succeeded by an Archaic temple of normal plan.

SCULPTURE

Geometric sculpture, as we know it today, consists of figures of animals and men, seldom more than a few inches tall, in terracotta and bronze. It is possible that larger figures in terracotta or wood once existed, but no remains of them have been found. The terracottas are often attached to pottery: snakes, for instance, which have a symbolic connection with the dead, are commonly shown twined round the

handles or necks of pots that had a funerary purpose; the handle of a pottery lid could be modeled into the form of a bird, and sometimes a complete four-horse chariot in clay serves the same purpose (fig. 186). An ambitious potter has gone so far in one instance as to model a horse or mule with its load of pots, and wheels were attached to this little masterpiece (fig. 187). Human figures were also modeled in

187. *Horsecart with Load of Amphorae*, from Euboea. Late Geometric, c. 700 B.C. Terracotta, height 9″. National Museum, Athens

186. Pyxis with Quadriga as Lid Handle. Late Geometric, 8th century B.C. Diameter 13″. British Museum, London

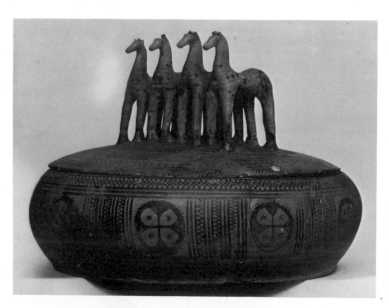

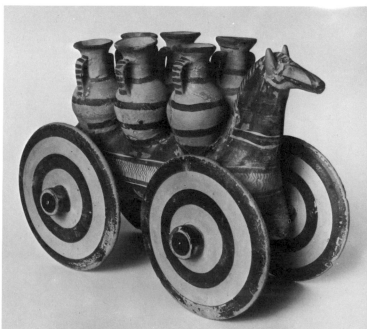

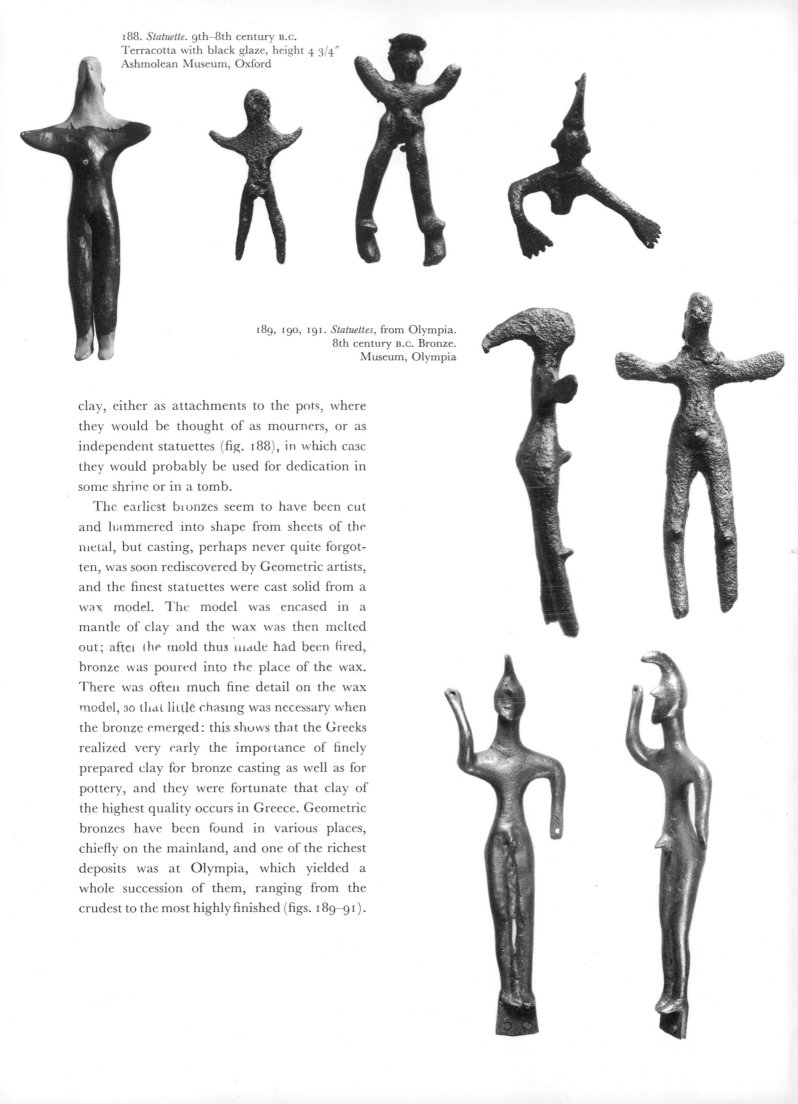

188. *Statuette.* 9th–8th century B.C.
Terracotta with black glaze, height 4 3/4″
Ashmolean Museum, Oxford

189, 190, 191. *Statuettes*, from Olympia.
8th century B.C. Bronze.
Museum, Olympia

clay, either as attachments to the pots, where they would be thought of as mourners, or as independent statuettes (fig. 188), in which case they would probably be used for dedication in some shrine or in a tomb.

The earliest bronzes seem to have been cut and hammered into shape from sheets of the metal, but casting, perhaps never quite forgotten, was soon rediscovered by Geometric artists, and the finest statuettes were cast solid from a wax model. The model was encased in a mantle of clay and the wax was then melted out; after the mold thus made had been fired, bronze was poured into the place of the wax. There was often much fine detail on the wax model, so that little chasing was necessary when the bronze emerged: this shows that the Greeks realized very early the importance of finely prepared clay for bronze casting as well as for pottery, and they were fortunate that clay of the highest quality occurs in Greece. Geometric bronzes have been found in various places, chiefly on the mainland, and one of the richest deposits was at Olympia, which yielded a whole succession of them, ranging from the crudest to the most highly finished (figs. 189–91).

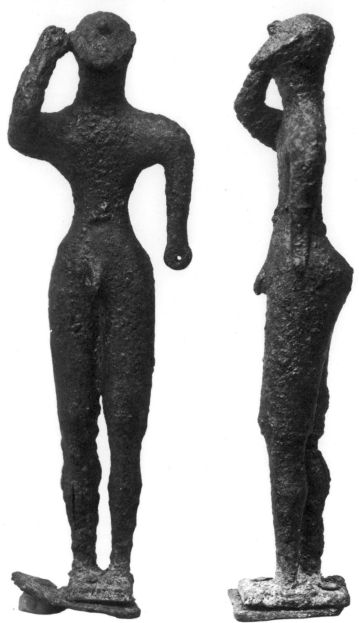

192. *Warrior* (from a large utensil),
perhaps from Olympia.
8th century B.C. Bronze, height 7 3/4".
The Metropolitan Museum of Art,
New York (Fletcher Fund, 1936)

Nowhere can the development of this primitive art be better traced. The favorite subjects here, and it seems elsewhere, were oxen and other animals for dedication as a kind of token sacrifice; but there were also many horses and some men. The horse occupied a position of prestige in Greece, as it does in other parts of the world even today, but at Olympia it was specially honored because of the importance of the chariot race in the Festival: so it is not surprising that some of the bronzes there represent chariot teams and their drivers.

All over Greece the general trend in bronze sculpture was much the same, though not necessarily identical in every particular. We have first of all, before the Geometric style evolved, the truly primitive stage of a flat sheet of metal, giving only a silhouette with no suggestion of a third dimension: it is a human being but there is no hint of individual identity. When we reach the Geometric age the statuette still looks primitive, but in fact has advanced considerably in sense of style, in awareness of the third dimension, and in the portrayal of a particular type of man rather than a generalized human (fig. 192). Man, that most difficult of subjects, looks

more primitive than the animals, and objects in the round more primitive than the low reliefs which, concerned only with flat pattern, are more strongly stylized and have fine decorative quality.

A notable product in this and during the whole Archaic period was the massive bronze tripod; these were commonly given as prizes in the games and dedicated in large numbers in the great sanctuaries, especially Olympia and Delphi. In the Geometric period they normally consisted of three legs, rectangular in section, with broad outer faces ornamented with reliefs (fig. 193): the legs supported a bowl the rim of which was furnished with large, flat, massive ring-handles (fig. 194); and it was to these handles or to the edge of the bowl itself that many of these small bronze figures, both animal and human, were attached.[6] Modern museums contain many Geometric bronzes of which the findspot is unknown, and these are some of the finest: for instance, the man and

194. Ring-handle of a Tripod, from Olympia. c. 700 B.C. Bronze, outer diameter 9 1/4". Museum, Olympia

193. Leg of a Tripod (fragment), from Olympia. c. 700 B.C. Bronze, height 18 3/8". Museum, Olympia

167

196. *Deer Nursing Fawn.* 8th century B.C. Bronze, height 2 1/2". Museum of Fine Arts, Boston

195. *Man and Centaur*, perhaps from Olympia. 8th century B.C. Bronze, height 4 1/2". The Metropolitan Museum of Art, New York (Gift of J. Pierpont Morgan, 1917)

centaur in New York (fig. 195), and the deer and fawn in Boston (fig. 196).

It is remarkable how much feeling there is in many of these apparently primitive figures (fig. 197): the proud carriage of the head in a horse, or its look of coltishness (fig. 198), show that the conventions of this style and the limitations of its technique are no barrier to a sensitive and able artist, and that some of the qualities we admire in fully developed Classical sculpture are already present, if only in embryo.

197. *Statuette of a Youth, Dedicated by Mantiklos to Apollo*, from Thebes (Boeotia). c. 700–650 B.C. Bronze, height 7 7/8". Museum of Fine Arts, Boston (Bartlett Collection)

198. *Horse.* 8th century B.C. Bronze, height 4". Ashmolean Museum, Oxford (Bequest of Sir John D. Beazley)

6

Orientalizing Art and the Formation of the Archaic Style (700–600 B.C.)

Not long before 700 B.C. the mainland of Greece became more closely acquainted with oriental works of art, and their impact can best be detected by the changes which took place in the decoration of Greek pottery. It must have been evident in many other things, especially metal objects and textiles, but the first have largely perished and the second, utterly. One of the means through which the Greek cities were brought into contact with oriental works of art was by the Phoenicians.[1] The Phoenicians were not only enterprising sailors and traders of other people's goods, they were also skilled metalworkers themselves, and capable of producing metalwork of great size. The objects which they took abroad, especially to Cyprus, to Greece, and to the coasts of Italy, were for the most part small: many were little bowls and plates of silver, of bronze, and of gold, chased, embossed, and sometimes inlaid,

with bands of decoration. This decoration often consisted merely of ornamental animals or patterns, but sometimes it showed a scene or told a story. For instance, of two of the bowls that have survived, one depicts the siege of a city, the other a royal party out for a day's hunting. The style of the decoration was usually Egyptian or Assyrianizing, and the drawing commonly not of the highest quality; but one can well understand the attraction that these gay and glittering objects had for the comparatively unsophisticated Greeks.

In addition to this indirect acquaintance with the East, the Greeks had direct contact through their colonies on the coast of Asia Minor and by their establishment of trading posts on the shores of foreign lands; the best known of these is Poseideion in northern Syria, near the modern Alexandretta, which dates back to about 800 B.C.

169

POTTERY AND VASE PAINTING

Although it is customary to date the beginning of the so-called Orientalizing period to about 700 B.C., there are traces of oriental influence in Greek pottery before that date (figs. 199, 200). But about 700 the light from the East became brighter, and for nearly a century it dazzled the Greek artists by its brilliance. This does not mean that the Greeks adopted an oriental outlook; rather they admired and imitated oriental subjects, gradually giving them a more Western character. These subjects were mainly animals, and the lion was a favorite; but it was especially the wondrous monsters, the sphinxes and griffins, that appealed to the simple Greek. A whole new repertory of patterns also arrived: Geometric patterns had been almost entirely rectilinear, but now there appear floral rosettes, plants, tendrils, and a variety of other curvilinear designs. Most of these are based on growing vegetation but not all are easily identifiable, because they had already been stylized by the Eastern artist, and the Greek was not as yet directly imitating the growing plants (see fig. 206).

As was natural, the pottery produced in Eastern Greek workshops took on Eastern characteristics more easily and transformed them less. Melian painters, for example, crowded their pots with patterns through which the people, boldly but insensitively depicted, have to fight their way: to modern eyes the general impression is more oriental than Greek (fig. 201). White-ground wares of the "Wild Goat" style made in Rhodes (fig. 202), Chios, and pro-

199. Amphora. Attic, Late Geometric, c. 700 B.C. Height 24 3/8″. British Museum, London

200. *Lion and Deer* (detail of amphora in fig. 199)

201. *Apollo and the Hyperborean Maidens Greeted by Artemis*, amphora from Melos. East Greek Orientalizing, c. 625 B.C. Height 37 3/8″. National Museum, Athens

202. Oinochoë, "Wild Goat" style, from Rhodes. East Greek Orientalizing, c. 630–620 B.C. Height 12 3/4″. Museum Antiker Kleinkunst, Munich

bably other centers, often reproduce the general shape and scheme of decoration of oriental prototypes in metal, in which a number of friezes, consisting solely of processions of animals, covered almost the whole surface. In the Eastern original these were probably inlaid in another metal, and the imitation in pottery transmutes this effect into something lighter and gayer if less rich, with animals in sharply drawn outline—black on the white surface, embellished with purple and red, and surrounded with floral filling ornaments. By contrast with this ornate kind of pottery, and serving as a warning that not everything in this so-called Orientalizing period orientalized, one group of Cycladic pot painters produced designs of splendid simplicity, defining the anatomy of its animals by a skillful use of light and dark areas and dotted textures (fig. 203).

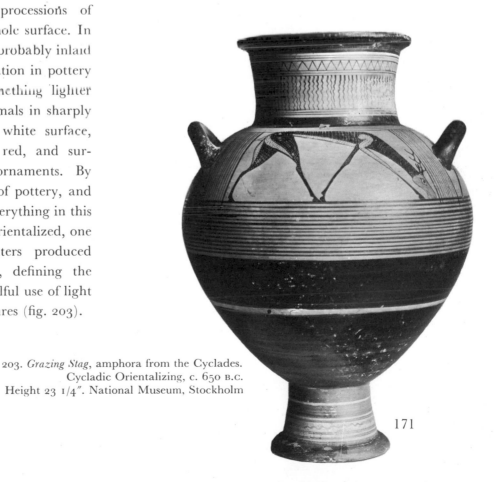

203. *Grazing Stag*, amphora from the Cyclades. Cycladic Orientalizing, c. 650 B.C. Height 23 1/4″. National Museum, Stockholm

171

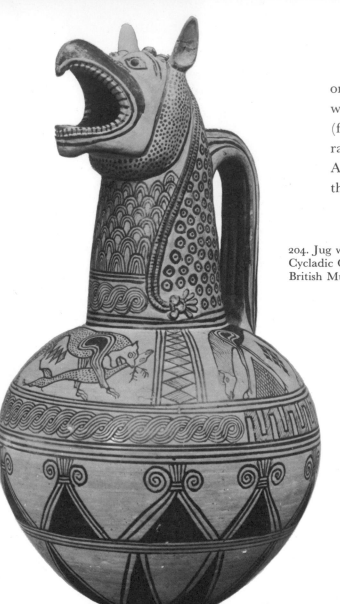

As obvious examples of the borrowing of oriental motifs, we may cite a Cycladic jug which has for its spout a fierce Eastern griffin (figs. 204, 205); a Corinthian jug with an elaborate design of tendrils (fig. 206); and an Athenian jar which has a frieze of sphinxes at the top of the neck (colorplate 22).

204. Jug with Griffin's-Head Spout, from Aegina. Cycladic Orientalizing, c. 700–650 B.C. Height 15 3/8″ British Museum, London

206. Oinochoë.
Protocorinthian, c. 725–700 B.C.
Height 13 1/8″.
National Museum, Naples

205. *Horse,* and *Lion Killing Stag* (details of jug in fig. 204)

Colorplate 23. *The Blinding of Polyphemos*, fragment of a bowl from Argos.
Argive, c. 650 B.C. Height of fragment 10″. Museum, Argos

Colorplate 24. THE MACMILLAN PAINTER. *Hoplites Marching into Battle*
(detail of *The Chigi Vase*; see fig. 213). Protocorinthian, c. 640 B.C. Villa Giulia, Rome

In the next generation more startling things occurred.[2] On an amphora from Eleusis (of gigantic proportions, nearly five feet high) which contained the skeleton of a ten-year-old boy, an early Athenian artist has decorated the ample field with pictures and patterns of an appropriately grandiose character (fig. 207). On the neck he has a vivid scene of the blinding of Polyphemos (fig. 208). Odysseus (originally painted white) with the aid of two companions thrusts the stake into the eye of the Cyclops, who emits a cry as he tries to hold it back with one hand: in his other hand he still has a wine cup, to show what had happened earlier in the story. The main scene below is an ambitious picture of Perseus and the Gorgons, the first of its kind in Greek art: the headless body of Medusa lies full-length (fig. 207), and her sisters chasing Perseus are confronted by his patroness Athena. There was as yet no set pattern for a gorgon, and the painter was obliged to improvise, producing a monster who has nothing human about her head: later the art form evolved into a grotesquely ferocious, round-faced monster, which was current until it was superseded in the Classical period by a different conception, that of sinister beauty. The patterns here are of a wild exuberance, and the filling ornaments—some of them very fanciful—are scattered with a liberal hand: in fact, so much was the artist in love with them that he was not able to resist planting one on the thigh of one of Odysseus' helpers (fig. 208).

207. THE MENELAOS PAINTER. *Perseus and the Gorgons*, amphora from Eleusis. Protoattic, c. 670–650 B.C. Height 55 3/4". Museum, Eleusis

208 *The Blinding of Polyphemos* (detail; neck of Protoattic amphora in fig. 207)

209. *The Combat Between Herakles and Nessos*, amphora. Protoattic, c. 680 B.C.
Height 42 7/8". The Metropolitan Museum of Art, New York (Rogers Fund, 1911)

This same subject was depicted about the same time by an Argive vase painter (colorplate 23): his treatment of it is interestingly different, for he seemed to know of the convention used in Egyptian wall painting of brown bodies outlined in black.

Another Attic amphora with the same exuberant approach but rather less command of the medium is in New York (fig. 209). The centaur Nessos tried to assault Deianeira, the wife of Herakles, after carrying her over a river,

and Herakles slew him. Here Deianeira is not present; instead, a small and lively man, whose identity is a mystery, runs headlong into the picture (fig. 209 right, extreme right).

To turn now from Athenian to Corinthian pottery.[3] After an austere Geometric phase, in which the decoration was largely abstract, Corinthian potters adopted the oriental repertory and quickly transformed it by the disciplined precision of their drawing (fig. 210). Such animals as appear are boldly and finely

drawn and dominate the vessel by their forceful silhouette (fig. 211).

Then, about 640 B.C., there suddenly appears a series of pots painted mainly by one painter, with complicated figure-scenes in exquisite style and elaborate coloring (fig. 212). So sophisticated are they, surpassing in their self-confident mastery even the products of contemporary Athens, and so unusually varied is their palette, that it has been suggested that they are the work, not of ordinary pot painters, but of artists who perfected their art in panel paintings, and who knew something of Egyptian wall painting.

Corinth is described by ancient writers as the greatest center of the art of painting in early times, and it may simply be that the general level of drawing was so high that a talented pot painter could draw like a master. The masterpiece of this same painter is the so-called Chigi jug, a tiny pot only ten-and-a-quarter inches high, yet decorated with no

fewer than three bands of pictures (fig. 213). These are remarkable not only for the fineness of their execution, but also for the complexity of their design which, without having command of true perspective or consistent foreshortening, contrives nevertheless to suggest depth in space by the carefully thought-out overlapping of the figures. Let us examine, for instance, the lion hunt on Mount Ida (fig. 214) in which the companions of Paris indulge while Paris is giving judgment on the goddesses. The lion, based on an Assyrian model (one of the very few traces of oriental influence here), is therefore somewhat conventional. But there are five hunters around the lion: of these, one has fallen to his knees between the animal's forelegs, so that, receding into depth from the front plane, we have first the lion's right foreleg and then the man's right leg and torso; but the lion's upper jaw is on our side of the man's body and his lower jaw is hidden on the far side: then comes the man's left leg, and finally the lion's left foreleg. This is complicated enough, but the third dimension is further suggested in the overlapping of the fallen man's limbs by those of his companions, two of whom are represented on the far side of the lion and partly eclipsed by him—a rare phenomenon in Archaic art, which likes to have its elements clearly displayed side by side: the hunter at the lion's tail spears him on our side and his body is on our side of the tail, but his left arm and leg pass behind the animal's hindquarters.

In the battle scene (colorplate 24) the opposing detachments are engaged, as the reinforcements maneuver, one to the sound of the flute. The line of overlapping shields in echelon suggests depth, and the greater speed of the reinforcements in the rear hints at a wheeling movement. Spatial composition is not impossible in a world where the theory of perspective is still unknown. One last charming scene may

be noticed (fig. 215): it is of a hunter, loaded with animals already taken, their stiffening limbs drawn with extraordinary sensibility; he is crouching behind a bush, holding his eager dog in leash, while a boy who is scouting ahead turns back to signal. Again a remarkable illusion of space is produced by the overlapping limbs of man and dog.[4]

After this we can trace two distinct tendencies in Corinthian pot painting: on the one hand, a

213. THE MACMILLAN PAINTER. *The Chigi Vase*, pitcher from Formello (near Veii, Italy). Protocorinthian, c. 640 B.C. Height 10 1/4". Villa Giulia, Rome

top: 214. *Lion Hunt on Mt. Ida* (detail, other side of *The Chigi Vase*, fig. 213)

above: 215. *Boys Hunting* (detail, *The Chigi Vase*, fig. 213)

continuation of the tradition of fine draftsmanship devoted mainly to figure-scenes; on the other, pots produced in enormous quantities, well made, but decorated with repetitious patterns, mostly of animals. The decoration is arranged in a number of bands, black on a yellowish ground and enriched with liberal touches of purple, the space around them filled with rosettes; the whole thing is often very roughly drawn.

An excellent example of the Corinthian figure style at this time (about 600 B.C.) is a mixing bowl showing in the main frieze Herakles being entertained at the house of Eurytos, king of Oechalia (colorplate 25). To any Greek, the scene was full of dramatic interest: for the story was that when Herakles came to the house of Eurytos, he fell violently in love with Iole, Eurytos' daughter; when her father and brothers forbade him, Herakles threw one

right: 217. *Gorgon* (detail, *The Nessos Vase*, fig. 216)

216. THE NESSOS PAINTER. *The Nessos Vase,*
amphora from the Dipylon cemetery, Athens.
Late Protoattic, c. 625 B.C. Height 48″. National Museum, Athens

brother, Iphitos, from the walls of Tiryns. In the picture Herakles is seated at table on the right, Iole is at the foot of his couch, and her brother Iphitos is behind her, as if expostulating. The color scheme again is interesting, for so much purple is used that the general impression is parti-colored. There is also some use of outline drawing, which serves to remind us that the outline technique, in several ways a more flexible and sensitive medium, went on beside the silhouette technique throughout the whole of the early period of Greek pot painting, and came into its own especially in the white-ground vases and cups of the fifth century. In painting on a larger scale, certainly in wall painting and perhaps also in panel painting, the outline technique must always have predominated.

With this Corinthian pot of the late seventh century may be contrasted the roughly contemporary Athenian amphora in Athens which holds far more promise for the future (fig. 216). The main subject is the same as that of the Eleusis amphora of fifty years before (fig. 207),

Perseus and the Gorgons, but in the interval the formula of the gorgon has crystallized, and these monsters now convey the impression of being real creatures, full of life and vigor (fig. 217). The pot has been badly shattered and now takes its name, the Nessos vase, from the scene on the least broken part, the neck, where there is a panel picture of strikingly compact and forceful design. Herakles is killing the centaur Nessos: with one vast stride he plants his foot in the small of the creature's back, where the human and equine bodies join, and seizes him by the hair; ignoring the centaur's plea for mercy, made by touching his attacker's beard, Herakles is on the point of dispatching him. The figures have their names neatly written beside them; the names harmonize with the neatly drawn filling ornament. Inscriptions are to play an important part in the decoration of many later vases.

ARCHITECTURE

Although we do not know the exact origins or the earliest stages through which the Doric and the Ionic styles developed, it must have been during the seventh century that the seeds of both styles were sown. It was a period of experiment, but apparently of limited experiment. Buildings were mostly small and simple in plan, consisting of a single chamber; if the span was too great there might be internal columns or piers to support the roof. External columns, if there were any at all, were normally limited to those in the porch. The porch was part of temple design mainly because temples resembled the houses of men, and a shelter on the south side was one of the commonest additions to a simple house, as it is in Greece today. This provides a sunny place in the winter, but shade in the summer because the sun is then high overhead. One of the most usual ways to form a porch was to prolong the side walls of the house (antae) forward so that the entrance doorway was in a recess, and to support the roof over this recess with a pair of columns lined up with the antae. This plan had the advantage that the antae gave shelter from the wind: the alternative method was to have a row of columns supporting a simple projection of the roof.

Some of the more interesting examples of architecture in this period are found in outlying places. In the northwest corner of Asia Minor the sites of two temples at Larissa and Neandria have each yielded column-capitals of a distinctive form which, from the name of the district, Aeolis, have been called Aeolic (fig. 218). The

218. Aeolic Capital, from Larissa (Asia Minor).
7th century B.C. Archaeological Museum, Istanbul

219. Temple "A," Prinias (Crete). Late 7th century B.C. *Plan*

At Prinias, in Crete, on the road between Knossos and Phaistos, are the remains of a temple consisting of a single chamber with a very deep eastern porch in front of it. The plan (fig. 219) is reminiscent of the Mycenaean megaron, for the room had two columns in the center flanking a sacrificial pit. The date seems to be late seventh century B.C., and remains of sculpture were found consisting of two seated goddesses in a late Daedalic style (see p. 185), who may have formed supports for the main lintel of the inner doorway. There was also a standing goddess in relief who may have been on the under side of the lintel facing downward, and in addition there was a frieze of horsemen (fig. 220), apparently outside the building. Here the sculptor has been unable to solve the problem of relative scales created by the size of the horses, and his riders are midgets; but the frieze is impressive in its simple way.

The Heraion at Olympia, one of the most important of early temples, was begun about 640 B.C., but since its main features seem to belong to the Archaic period, it will be treated later.[5]

design of these was an old one, for it is found on Assyrian ivories of the ninth century B.C. and elsewhere, and consists essentially of a pair of volutes rising from a central stem, rather in the fashion of a lily. This bears a superficial resemblance to the later Ionic capital but is essentially different, because the Aeolic has emphasis on the central division and the upward spring, whereas the Ionic capital has its two volutes curling downward from each end of a central horizontal element. There were, it is true, experimental forms of the Ionic capital which are more like the Aeolic, but there is no reason to suppose that the final Ionic form was derived directly from it.

220. *Cavalry*, frieze from Temple "A," Prinias (Crete). Late 7th century B.C. Limestone, height 32 3/4″. Archaeological Museum, Heraklion

SCULPTURE[6]

Of Geometric sculpture one could fairly say that some of its qualities foreshadowed those of Classical sculpture, but it would be impossible to demonstrate any direct connection between the two. In the seventh century, on the contrary, we can detect the beginnings of a kind of sculpture which leads without interruption to one of the styles of Archaic Greece. This kind of sculpture is today called Daedalic. The most famous Daedalus was a mythical Cretan, who flew by attaching wings to his body; but the Greeks also had records of a Daedalus who was a sculptor, and who had pupils working as late as the later seventh century B.C. There certainly does seem to have been a sculptor working in Crete about 650 B.C., whether his name was Daedalus or not, who created the distinctive style which archaeologists have agreed to call Daedalic. It has sometimes been held that works in this style were made only in Dorian centers, especially Crete, Rhodes, Laconia, and Corinth, and it is true that large numbers of small terracottas of the kind, mainly heads rather than complete figures, have been found in these places.

But if the style started in Crete it certainly spread widely, and there is no reason to suppose that the artists were always Dorian: a statue in Naxian marble was dedicated on Delos,[7] fragments of another marble statue come from Samos, and gold relief plaques with heads and figures in the same style were found at Ephesos. The findspot is unknown for the most complete figure in this style, but it is of limestone and thought to be of Cretan workmanship (fig. 221): its modern name, "the Lady of Auxerre," arises simply from its having been

221. "*The Lady of Auxerre.*" Daedalic, c. 650 B.C. Limestone, height 25 1/2″. The Louvre, Paris

at one time in the museum at Auxerre in France (it is now in the Louvre). It is worth studying in detail, for although only half the size of life, this is one of the earliest pieces of Greek sculpture known; and to carve a statue, even of this size, in stone is a far more serious undertaking in labor, cost, and technique than to model a small figure in clay or wax.

The statue has been made by cutting in from the four sides of a vertical block of stone, part of which remains to form the base. The front view is the most satisfactory in design and seems to be the dominant view, so that we may suppose the drawings for this to have been set out in considerable detail on the front surface of the block, and the designs for the other sides and the back to have been largely determined by it. The woman, presumably a goddess, is dressed in a heavy garment consisting, like the later Doric peplos, of a rectangle of cloth folded in half, and the selvages sewn together: the wearer stood within the tube thus formed and fastened the upper edge on her shoulders with two pins, one on each side of the neck: but the short cape, which is also worn here, would conceal any fastening there may have been. The waist is tightly encircled by a broad belt, which narrows the diameter of the body and thus helps to suggest the form of the chest above it. Below the belt, the statue is a simple shaft, almost rectangular in section except that the corners are rounded; and the only hint of the existence of separate legs is the projection of the front of the two feet at the lower edge of the dress. The left arm hangs vertical at the side of the body and seems to adhere closely to it, but the right hand is raised and its very long fingers lie in front of the breasts, suggesting that the sculptor was familiar with Near Eastern statuettes of the mother goddess, in which this is a customary gesture. The face, which is of strongly triangular

222. *Hera* (?), from the vicinity of the Temple of Athena, Citadel of Mycenae. Daedalic, c. 630 B.C. Limestone, height 16″. National Museum, Athens

223. *Kouros*. Daedalic, 7th century B.C. Bronze, height 7 3/4″. Museum, Delphi

184

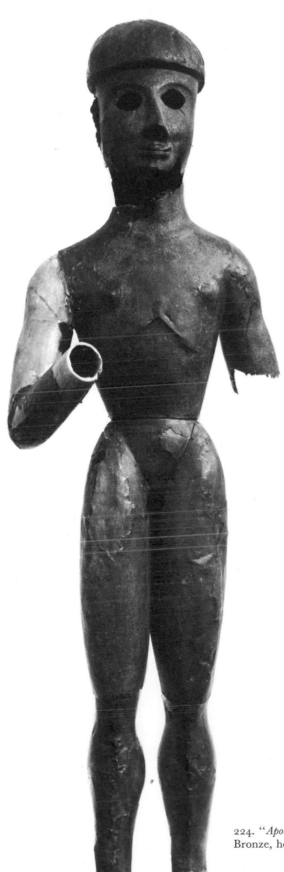

shape, with pointed chin and broad low forehead fringed at the top by a horizontal row of curls, is framed by hair which falls in a heavy mass on the front of the shoulders: this mass consists of four vertical rolls which are divided horizontally eight times. The arrangement is so formal that it suggests a wig, and it does seem to derive, although not slavishly imitated, from the wigs in contemporary Egyptian statues.

There is a fragment of architectural sculpture in Daedalic style from the Peloponnesus which may be part either of a small pediment or of a metope (fig. 222). The subject is perhaps Hera, from a scene of the Hieros Gamos, the sacred marriage of Zeus and Hera on Mount Ida. Although not more than a few inches high, it is a most sensitive piece of carving, especially in the lips and the area round the mouth.

We also possess male figures in Daedalic style: the large ones in marble (on Delos) are very fragmentary, and of the smaller ones in bronze a statuette at Delphi, being cast from a wax model, is rather more free and less distinctive in style than the Lady of Auxerre (fig. 223). The other bronze (fig. 224) is one of a group of three small figures, two female, one male, found in a temple at Dreros in Crete, and probably its cult statues. The females are of Daedalic style, the male less distinctively so: but the technique, known by the Greeks as *sphyrelaton* (hammered), in which sheets of bronze were hammered out into human shape piecemeal and afterwards fastened to wooden cores, is so cumbrous that it is difficult to imagine any great work of art being produced by it. However, the figures from Dreros are interesting because they illustrate a technique which was known from ancient writers to have existed, but it must have been abandoned when its limitations became obvious.

In general, the Daedalic style seems to have sprung from an original mind with a strong

224. "*Apollo*," from Dreros (Crete). Daedalic, 7th century B.C. Bronze, height 25 1/4". Archaeological Museum, Heraklion

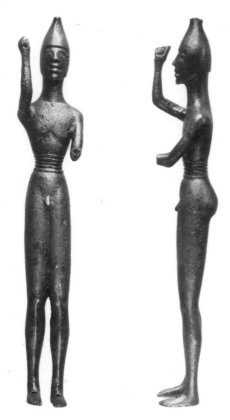

225. *Warrior*, from Olympia. 8th–7th century B.C. Bronze, height 8 1/4″. Museum, Olympia

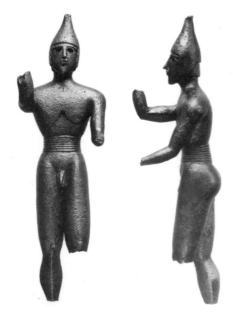

226. *Warrior*, from Olympia. 8th–7th century B.C. Bronze, height 6 7/8″. Museum, Olympia

227. *Head of a Griffin*, tripod protome from Olympia. 7th century B.C. Bronze, height 11″. Museum, Olympia

sense of design and an ability to borrow foreign elements and so to adapt them that they became a consistent part of a new creation.

Whether or not there lived a seventh-century sculptor named Daedalus, there were two sculptors named Dipoinos and Skyllis who were thought in antiquity to have been his pupils: not only are their names recorded by ancient writers, but works made by them survived until the second century A.D., and were seen by Pausanias. Tradition said that Dipoinos and Skyllis migrated from Crete to the Peloponnesus, and it was in the Peloponnesus, at Olympia, that Pausanias saw their work. Moreover, a Peloponnesian work of the next generation, the group of Kleobis and Biton, by a sculptor of Argos, is clearly in the same tradition (see p. 234), and that is why it can be claimed that one of the elements of Classical Greek sculpture is traceable from the mid-seventh century onward.

The Daedalic was not the only style. We can detect others, especially among the small bronzes. Here again Olympia is important, for the finds cover a long and continuous period and comprise dedications from near and far (figs. 225, 226). The general development is

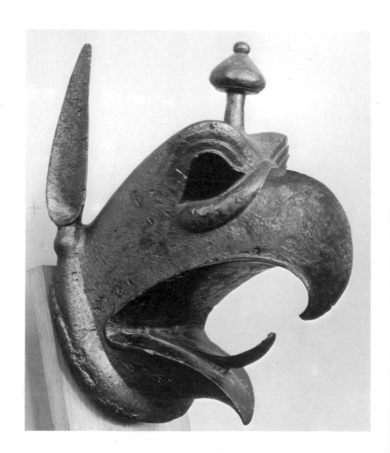

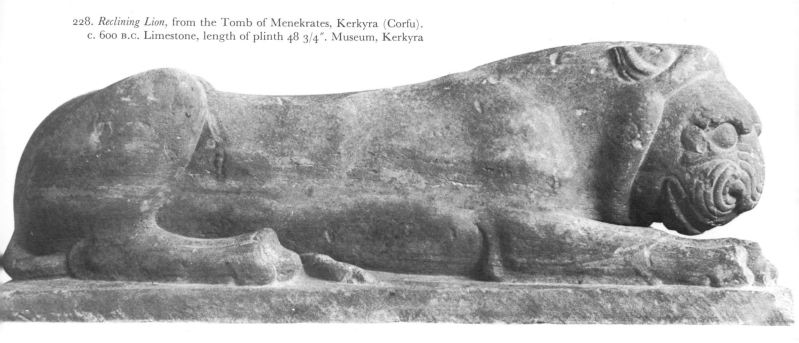

228. *Reclining Lion*, from the Tomb of Menekrates, Kerkyra (Corfu). c. 600 B.C. Limestone, length of plinth 48 3/4″. Museum, Kerkyra

naturally toward a more complete assimilation of the oriental elements, but this can occur early or late in the period, according to the temperament of the borrower.

To see how completely and how satisfyingly Greek artists can transform the oriental subjects they have borrowed, one has only to look at some of the animals, for instance the bronze griffin from Olympia (fig. 227), ornament of one of the great tripods that were a regular dedication there; or at one of the most forceful pieces of early Greek sculpture in existence, the great stone lion which was a monument on a tomb in Kerkyra (Corfu), a colony of Corinth (figs. 228, 229). This comes right at the end of the Orientalizing period, when we know from the slightly later sculptures of the temple at Kerkyra that there must have been at least one first-rate architect and a number of able sculptors at the city's disposal. It is possible that they may have come from the mother city: this is on general grounds quite probable, for Corinth led the Greek world in painting at the time and may well have been pre-eminent in other arts.

Of about the same date as the lion (c. 600

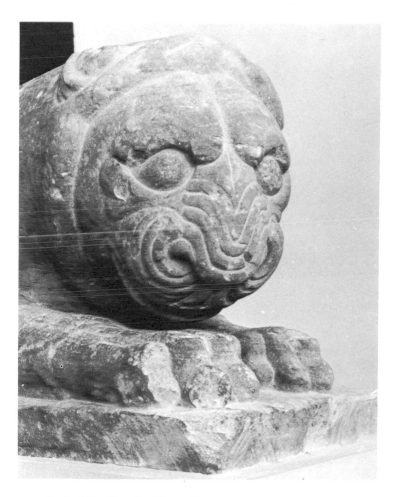

229. *Head of Lion* (detail of fig. 228)

B.C.), and also Peloponnesian, is the large limestone head of Hera found in the Heraion at Olympia (fig. 230). Pausanias says that the statue of Hera was grouped with one of Zeus, and that Zeus was helmeted. They must have been the cult statues in what was then the only large temple on the site, and Zeus must have been regarded primarily as a god of war. Only the head of Hera survives; Pausanias speaks of the figures as "simple," and this head certainly has a more primitive look than, for instance, the lion of Corfu, although it may well be somewhat later in date. The sculptor has been thought to be Laconian, but we do not know enough about sculpture in the seventh century to distinguish this from Corinthian style. In the next century we can begin to discern local styles more clearly.

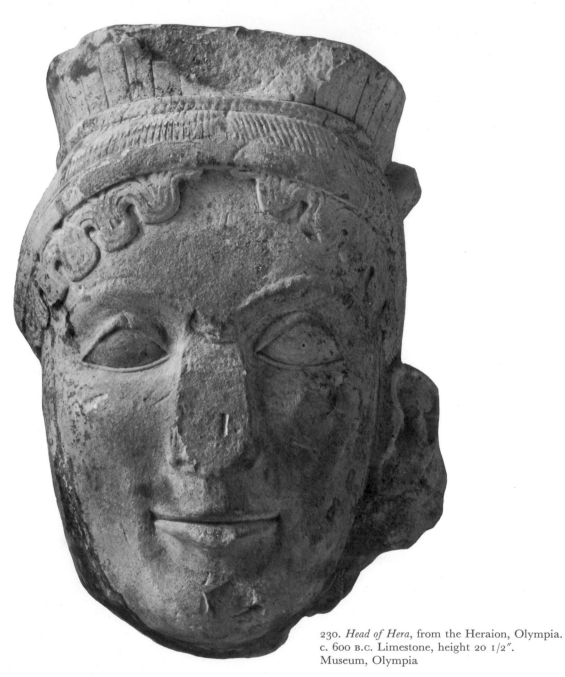

230. *Head of Hera*, from the Heraion, Olympia. c. 600 B.C. Limestone, height 20 1/2″. Museum, Olympia

7

The Archaic Period (600–480 B.C.)

The sixth century was in general one of great prosperity, owing to the increase of trade and wealth and to the growth of stable government. Some Greek cities were ruled by old aristocratic families, some by so-called tyrants, a few by some form of democracy. But clouds were gathering in the east, and the defeat by Persia in 546 B.C. of Croesus, king of Lydia, was an omen of the threat to Greece in the next generation. Croesus had dominated the Ionian cities in Asia Minor, but he had been an admirer of Greece, had consulted its wise men and its oracles, and had dedicated rich offerings in its shrines, while Greece had learned much from Lydia, including the use of coinage. The Ionian cities now became subjects of the more distant and more impersonal empire of Persia, and it was their unsuccessful attempt to throw off this yoke which led directly to an event that overshadowed all else at the time and left its mark on the whole of Greek history and thought, namely the invasion of mainland Greece by the Persians. The final defeat of the Persians at Salamis (480) and Plataea (479) marked the end of the so-called Archaic age of Greece, and inspired many of the achievements of the following generations.

POTTERY AND VASE PAINTING

The Archaic period saw a continued abundant output of colored pottery of many kinds, from the decoration of which the oriental elements adopted in the previous period tended to dis-

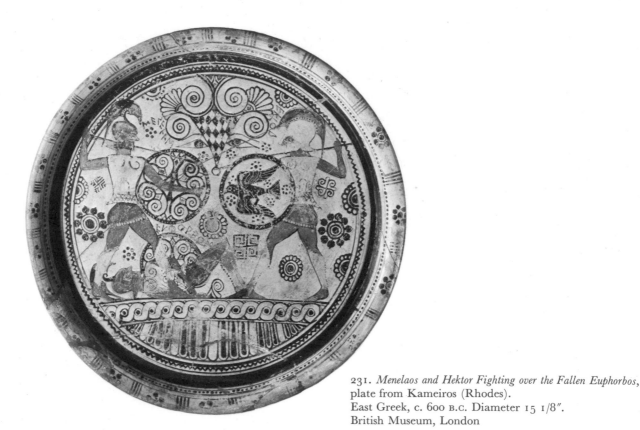

231. *Menelaos and Hektor Fighting over the Fallen Euphorbos,*
plate from Kameiros (Rhodes).
East Greek, c. 600 B.C. Diameter 15 1/8″.
British Museum, London

appear. In general the pots were still gaily variegated in color and pattern, but there was an increasing fondness for scenes with human figures; these gradually took over more and more of the surface, so that the decorative elements were driven into subordinate positions. But the old oriental arrangement of the decoration in a series of bands, which is a natural way to ornament a round vessel, was long in dying, and vestiges of it can still be seen even after the Archaic period. One Eastern Greek plate of about 600 B.C. suddenly appears with a battle scene (fig. 231). It is otherwise unknown for this kind of ware to depict human figures—its preference is for animals—nor can it be said that the result is happy. The inscriptions, which are also the only ones known on this kind of pottery, make clear what the subject is: namely, Menelaos and Hektor fighting over the body of Euphorbos, an incident

described in the *Iliad*.[1] Here the love of filling ornaments has become almost morbid, and they are packed into every available space: the figures as well as the inscriptions appear to have been inserted with difficulty among them. The truth is that the style, which is descended from the "Wild Goat" style (see p. 170), is past its best, and dies out after another generation.[2]

Pottery tended to become less vari-colored as the technique now called black-figure developed, and by about 550 B.C. the whole scheme was becoming more sober and relying for its effect mainly on the contrast between black figures and lighter background, though there were still many touches of white and some of red and purple. The success of black-figure was due largely to the use of incision, the scratching on of details with a sharp point before the pot was fired. In its sharpness and fineness this was superior to the alternative method whereby the

190

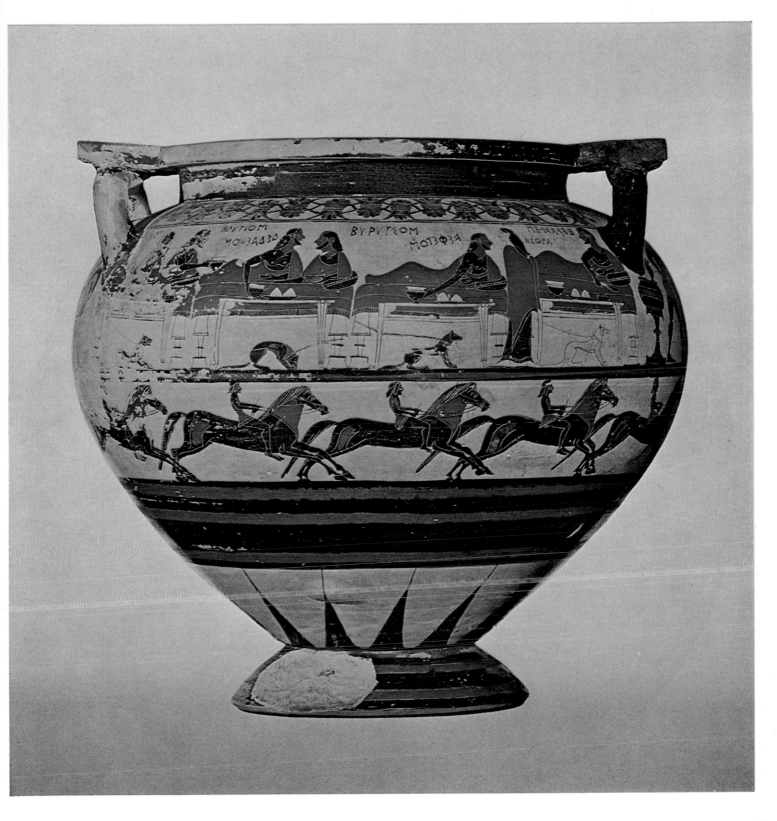

Colorplate 25. *Herakles in the House of Eurytos*, krater from Cerveteri (Italy).
Early Corinthian, c. 600 B.C. Height 18″. The Louvre, Paris

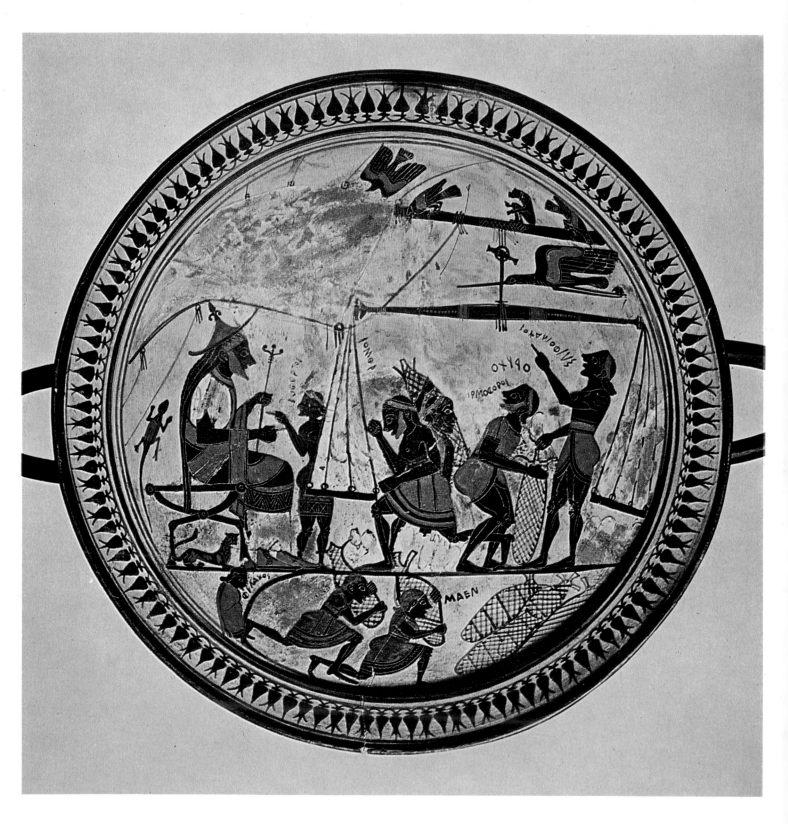

Colorplate 26. THE ARKESILAS PAINTER. *The Arkesilas Cup*, interior of a kylix (see fig. 234) from Vulci (Italy).
Laconian, c. 560 B.C. Diameter with handles 15″. Cabinet des Médailles (Bibliothèque Nationale), Paris

details were "reserved," though a splendidly vigorous drawing by an East Greek painter of about 540 B.C. shows how effective reserving could be (fig. 232). On each side of the pot he has cleared the field of everything but a runner: at first sight the two look the same, but whether by chance or by design, one of the two, the tightly knit resilient sprinter in the right-hand illustration, will obviously outrun his lankier opponent.[3]

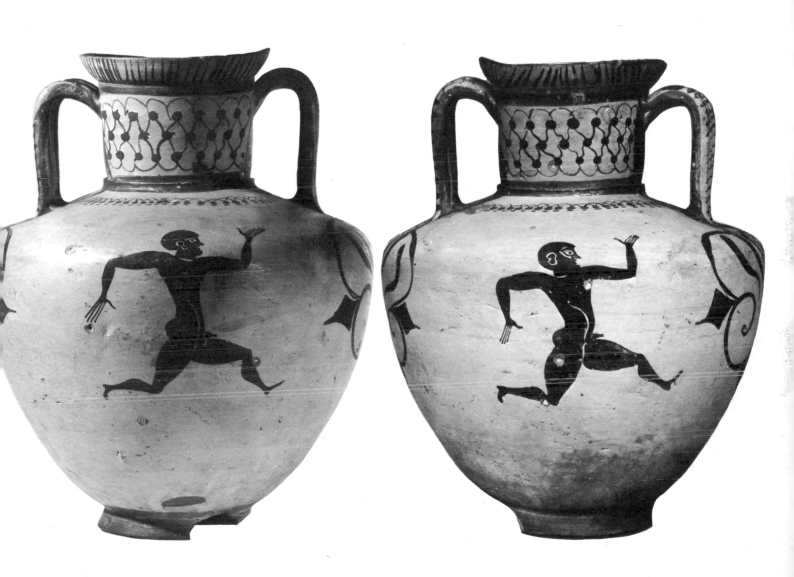

232. THE RUNNING MAN PAINTER. *Two Running Men* (left and right),
"Fikellura" amphora from Kameiros (Rhodes).
East Greek, c. 540 B.C. Height 13 3/8".
British Museum, London

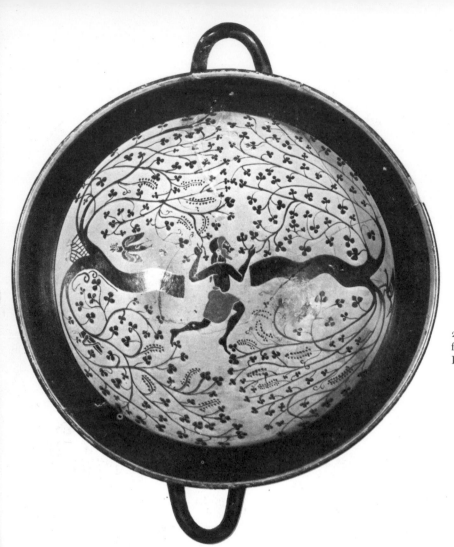

233. *Man Between Two Trees*, interior of a kylix
from Etruria (Italy). East Greek, c. 550 B.C.
Diameter 5 7/8″. The Louvre, Paris

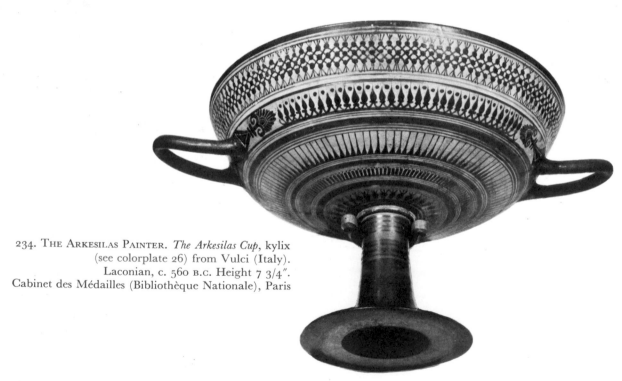

234. The Arkesilas Painter. *The Arkesilas Cup*, kylix
(see colorplate 26) from Vulci (Italy).
Laconian, c. 560 B.C. Height 7 3/4″.
Cabinet des Médailles (Bibliothèque Nationale), Paris

Close to this style is a cup the interior of which is almost entirely covered with the trunks and foliage of two trees: between these stands a bearded man who seems to grasp a branch in each of his hands (fig. 233). In the fork of one of the trees a bird is walking; in the other fork there is a nest containing young birds, and the mother bird flies toward it with

characteristic border of pomegranates (fig. 234). The decoration can consist of animals only, and one of the most charming cups has a circle of tunny fish inside (fig. 235) and a frieze of birds outside. There are also figure-scenes, but these are apt to be carelessly composed and cut off arbitrarily by the circular interior of the cup, as if the scene were being viewed through a

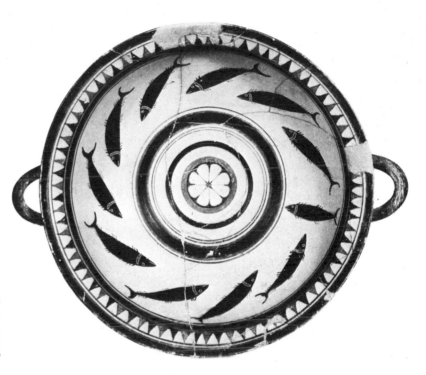

235. *Tunny Fish*, interior of a kylix from Taranto (Italy). Laconian, early 6th century B.C. Diameter without handles 8 1/4". National Museum, Taranto

an insect in her beak. In the branches nearby is a large grasshopper. It is not clear whether this has some special meaning—one might think of Melampus, who could understand the language of the birds—or whether it is simply a picture of country life.

By about 550 B.C., Athenians and Corinthians were the most prolific makers of pottery, but even in mainland Greece they were not the only ones. There was Laconian ware, made in Sparta. This has a white ground, and the surface, especially of the outside of the cups, is often covered with a net pattern ending in a

ship's porthole. However, one of these pictures on the inside of a cup is not only entertaining but informative, for it shows a historical personage, King Arkesilas of Cyrene (colorplate 26). Cyrene was a Laconian colony, and the painter knew of the king (Arkesilas II, about 560 B.C.) and had possibly seen him in his home town. Some commodity is being weighed, perhaps silphium (a medicinal and culinary plant once the staple product of Cyrene) or possibly wool. In general this painter is not good at relative sizes, but he makes up for this and for his somewhat crude draftsmanship by

236. *Quadriga* (left) and *Bulls* (below), "Chalcidian" amphora. c. 550–525 B.C. Height 35 3/8″. Cabinet des Médailles (Bibliothèque Nationale), Paris

the liveliness of the gestures, by the homely touches such as the king arguing with his steward, or the worker in the background knee-deep in the stuff he is packing, and by the copious fauna—bird, beast, and reptile.

Two other black-figure wares should be mentioned: one, the so-called Chalcidian, appeared suddenly and flourished for half a century or so from about 550 B.C.[4] The general appearance of the pots is like the Athenian (see p. 203), but the drawing tends to be juicier (colorplate 27) and there is an extraordinarily

bold use of frontal poses (fig. 236). One of the favorite shapes is an amphora in which the body is egg-shaped (figs. 236 left, 237), and one floral pattern is peculiar to this ware—a border of rosebuds, sharply and sensitively drawn (fig. 238).

The other make of pottery, of about the same date (the generation after 550 B.C.), is found only in the West, indeed only in Etruria and mostly at Caere (Cerveteri), and hence is known as Caeretan. It has a strong Ionian tang and seems to have been produced, perhaps

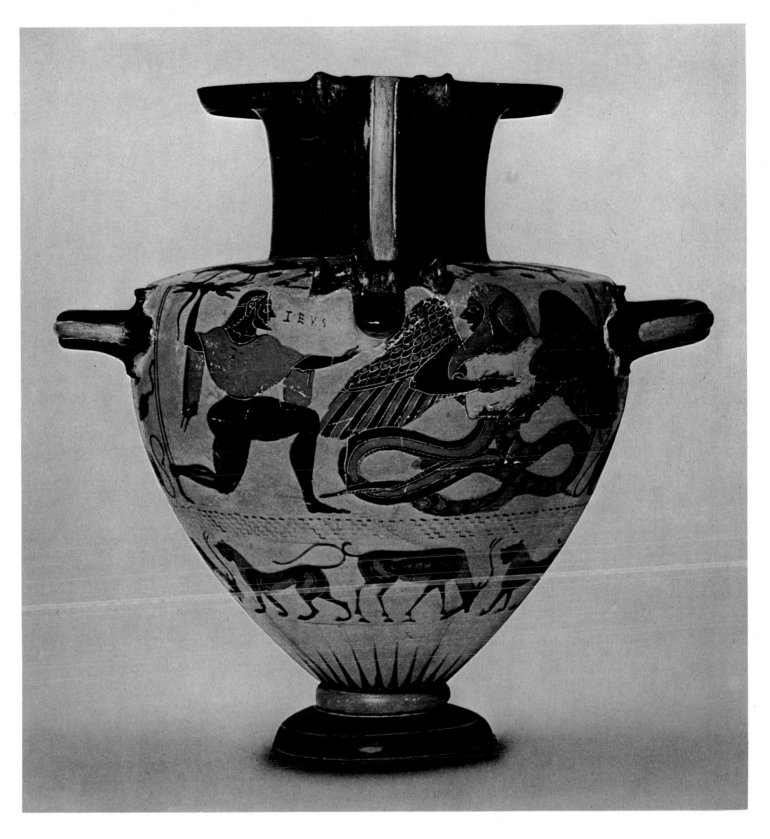

Colorplate 27. THE INSCRIPTION PAINTER. *Zeus Attacking Typhon*, "Chalcidian" hydria from Vulci (Italy). c. 550–530 B.C. Height 19″. Museum Antiker Kleinkunst, Munich

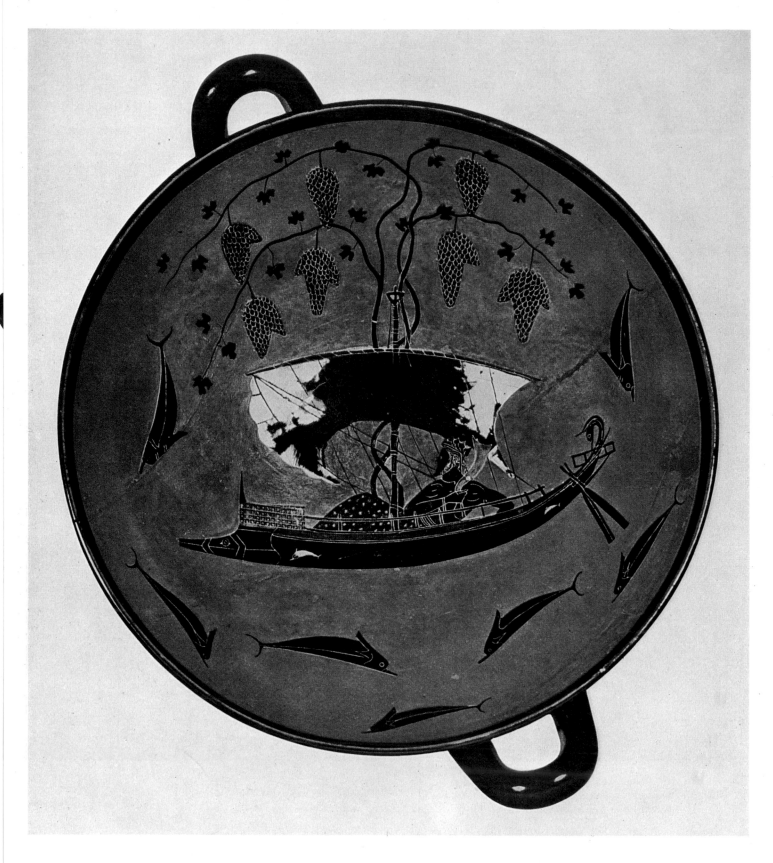

Colorplate 30. EXEKIAS. *Dionysos Crossing the Sea*, interior of a kylix from Vulci (Italy).
Attic, c. 535 B.C. Diameter 4 1/2″. Museum Antiker Kleinkunst, Munich

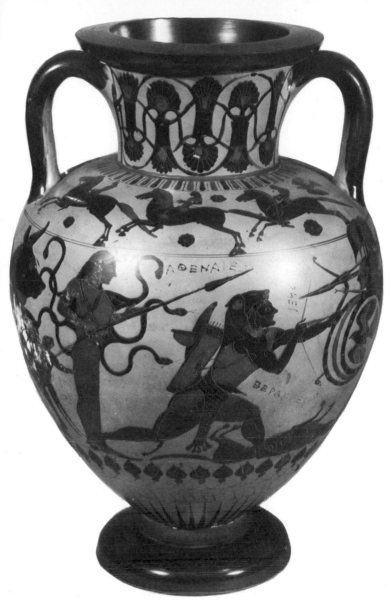

237. *Herakles and Geryon*, "Chalcidian" amphora (other side of amphora in fig. 236)

238. THE INSCRIPTION PAINTER. *Boars*, lid of a "Chalcidian" krater from Vulci (Italy). c. 540 B.C. Diameter 4 1/2". Martin von Wagner Museum, University of Würzburg

with an Etruscan helper or two, by an Ionian immigrant into Etruria. All the pots are three-handled water pots, and they have a highly colored and opulent look: the pots themselves are fat and brown, and details of the black figures are painted in white and red, while the floral borders are bold, varied, and luxuriant (colorplate 28). The painter has a strong sense of humor, but it is humor of a peculiar kind: he relishes especially the "biter bit" situation, as for instance when Herakles slays the Busiri who have been intending to sacrifice him (fig.

239). He also has an eye for nature, and his plants and animals are drawn with love, even if not always with strict attention to the models (fig. 240).

It is time to say a word about how these black figures were produced. The medium of all the painted decoration on a clay vase is itself clay, in a more or less liquid condition and with coloring agents embodied in it. The wash which gave the pot a smooth surface suitable for pictures was of clay, and the figures were painted on this in a thicker solution. When a Greek pot is fired in a kiln from which air is excluded, the iron oxide present in many Greek clays turns black; but when air is admitted it turns again to a lighter color, if it is given time to do so. The figures, being in the thicker solution of clay, turn light more slowly than the rest of the surface, so that if firing stops at the correct moment they remain black. The question of coloring has an important significance: the sixth century opened with a number of decorated vases being made in many places in the Greek world that were competing with one another for export trade; but by about 550 the contest had resolved itself into a straight fight between the Athenian ware and the principal ware of the Peloponnesus—Corinthian—other competitors being gradually eliminated. Here Athens had an immense advantage in the color of her clay; for whereas Corinthian clay, excellent from every other point of view, fired usually to a greenish yellow, Attic clay fired to an attractive rich orange, which was sometimes enhanced by adding to the surface the thinnest possible wash of red. Corinthian orientalizing ware, with its friezes of animals and flowers (fig. 241), was sold far and wide, but in pots decorated with figures the Athenians steadily ousted their rivals, despite such little gems as the Pyrvias aryballos, its team of boy dancers instinct with joy and vigor (fig. 242).

239. *Herakles and the Busiri*, Caeretan hydria from Cerveteri (Italy). c. 520 B.C. Height 17 1/2". Kunsthistorisches Museum, Vienna

240. *Two Eagles with a Hare*, Caeretan hydria (for other side see colorplate 28) from Cerveteri (Italy). c. 525 B.C. Height 17". The Louvre, Paris

Eventually, by about 550, the Athenians were predominant in the richest market of all, that of Etruria, and it is from Etruscan tombs that the bulk of fine Athenian vases come, having been buried with their owners after delighting them in life.

When one looks at the abundance and the quality of Athenian black-figured pottery in the half-century from about 580 to about 530, one can understand its supremacy.[5] The pots are perfectly made, the shapes varied and constantly evolving, the colors bright, the subjects interesting, and the drawing often of surpassing excellence. At the threshold stands Sophilos, and then comes a whole series of great painters and potters.[6] Sophilos is not a painter of the first rank and he is apt to be careless, but the fragment of a bowl by him has an amusing subject (fig. 243): the chariot race at the funeral games of Patroklos, in which we see the grandstand, and the spectators urging on the horses with Mediterranean vehemence.

241. Olpe with Animal Friezes.
Corinthian, c. 625 B.C.
Height 10 7/8″.
Ashmolean Museum, Oxford

242. *The Pyrvias Aryballos*.
Corinthian, c. 580–575 B.C.
Height including lid c. 1 3/4″.
American School of Classical Studies, Athens

243. SOPHILOS. *The Funeral Games of Patroklos*,
fragment of a bowl from Pharsalos.
Attic, c. 580–570 B.C. Height 2″.
National Museum, Athens

244. KLEITIAS (painter) and ERGOTIMOS (potter).
The François Vase, volute krater from Chiusi (Italy).
Attic, c. 570 B.C. Height 26″.
Archaeological Museum, Florence

left: 245. *Lion Felling Bull* (detail,
The François Vase, fig. 244)

below: 246. *The Disembarkation and Dance*
the Liberated Athenian Youths and Maidens
(detail, other side of
The François Vase, fig. 244)

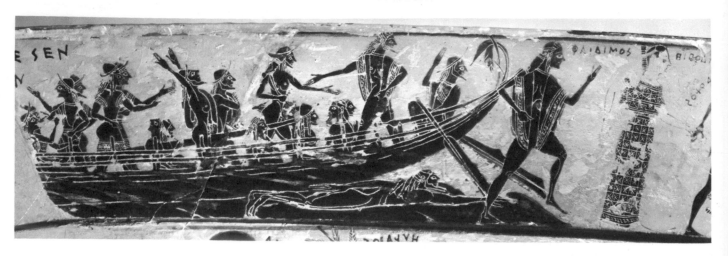

The same subject occurs, with many others, on the François vase, made only a decade or so later (fig. 244). This is a mixing bowl of generous proportions (imitating metal, as do many black-figured vases), and completely covered with decoration. The drawing is tense and precise. The scheme of decoration is somewhat old-fashioned in the number of its friezes, but only one of them has the oriental subject of animals, and even this is far from being a mere procession, since the beasts of prey have turned on the others (fig. 245). Several of the scenes in the main friezes have to do with Peleus and his illustrious son Achilles, others with the Athenian hero Theseus. The lip is decorated on one side with the hunt of the Calydonian boar, in which Peleus took part; on the other with the return of Theseus with the youths and maidens rescued from the Minotaur (fig. 246): the place is Delos, and as they disembark they form up for the dance which Theseus invented and which was danced in Athens for centuries after. Immediately under this is the fight between Lapiths and centaurs at the wedding of Peirithoös, where Theseus was a guest and drove the attackers off; while under the Calydonian boar hunt are the funeral games for the friend of Achilles, Patroklos.

At the level of the main handles is the largest frieze with the wedding of Peleus and Thetis: the procession of gods who attended it is not interrupted by the handles but is thought of as continuing behind them, an analogy to the Doric frieze of the Sikyonian peristyle at Delphi, where the triglyphs do not interrupt the scenes of the metopes but only eclipse them (see p. 252). Next below the main frieze is, on one side of the vase, the return of Hephaistos to Olympus to release Hera from the throne on which he had magically enchained her, on the other side Achilles pursuing Troilos at the fountain house outside the walls of Troy. Finally, lowest of all, the frieze of animals. Not quite finally, because the foot of the vase has a frieze of its own, a miniature frieze with a miniature subject to match it, the battle of the cranes with the pygmies, depicted with a careful attention to the tactics of this kind of warfare, and leaving one in doubt, as much of black-figure painting does, whether the intention is humorous or not. The broad handles (fig. 247) each bear a careful picture of the oriental Artemis, Lady of the Beasts, and, below, the loyal Ajax, always at hand in a crisis, carrying the body of Achilles from the field. Ergotimos was the potter and Kleitias the painter of this monumental work.

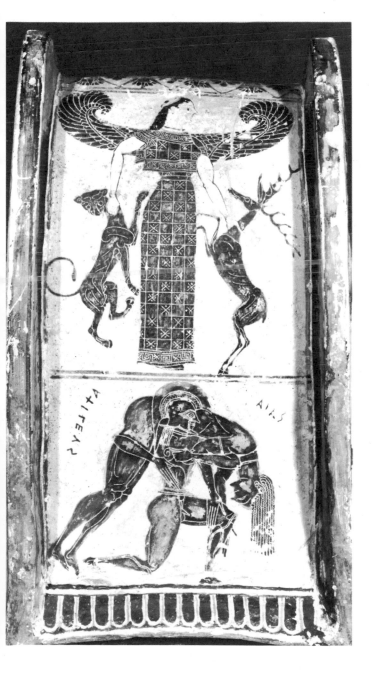

247. *Artemis, Lady of the Beasts (Potnia Theron)* and *Ajax Carrying the Dead Achilles,* handle of *The François Vase* (fig. 244)

205

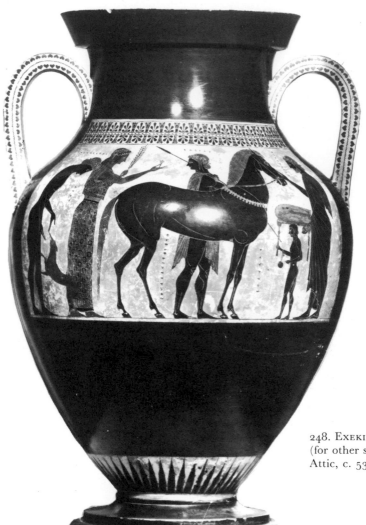

248. EXEKIAS. *Tyndareos, Leda, and Dioscuri*, amphora (for other side see colorplate 29) from Vulci (Italy). Attic, c. 530 B.C. Height 24″. Vatican Museums, Rome

Perhaps the greatest master of black-figure was Exekias, unique in his ability to isolate his figures and to infuse them with emotion, to draw in the largest manner, and to add a wealth of infinitely patient detail without diminishing the effect of either grandeur or feeling. Bound to some extent by Archaic conventions and technique, in other respects he is pure classic. He signs as both potter and painter an amphora now in the Vatican (fig. 248): it is of a shape recently evolved and destined to become popular.[7] On the one side is a domestic scene, not quite an ordinary family. It is that of Tyndareos and his wife Leda, the mother of Helen. With them are their sons the Dioscuri, the Heavenly Twins Castor and Polydeuces (Pollux).

The other side of the vase (colorplate 29) has a scene which recurs on vases so often, in slightly different forms, that there must have been some

famous painting from which they all derive. This picture by Exekias, however, bears all the marks of the painter's own style, and shows no sign of having been copied from another's. The two greatest fighters on the Greek side before Troy, Ajax and Achilles, are playing one of those games invented to while away the long months of a tedious siege. We may suppose the story to have been that the two heroes were so absorbed in their game that the Trojans made a sortie and nearly overwhelmed the Greeks. The heavily embroidered cloaks are unusual, and one cannot help thinking that the painter must have seen some such garment dedicated in a temple, and said to have belonged to some famous hero. On the vase, the almost incredibly minute incised detail on these cloaks is enhanced with touches of color: nowhere is this technique of incision more intricately employed, and yet the largeness of the drawing is in no way spoilt. The inscriptions are as neat and careful as all the rest of the decoration: words issue from the mouths of the players—"Four" from that of Achilles on the left, "Three" from Ajax, who was not often lucky. Vertically behind Ajax runs the so-called love-name "Onetorides is beautiful": the Greeks admired beauty in the young, and painters often inscribed the name of the most popular youth of the day in this formula.

Exekias, for all his sobriety, has a poetic streak. The inside of a cup (colorplate 30) with Dionysus, drinking horn in hand, sailing in a vine-wreathed ship attended by dolphins, has a lyrical quality not easy to parallel.[8]

The Amasis Painter is a different character. His drawing is exquisite but mannered: he has a strong sense for ornamental effect but little for emotion. Yet in this limited medium he can create a new world. His satyrs at the wine press (fig. 249) are not just men with tails and

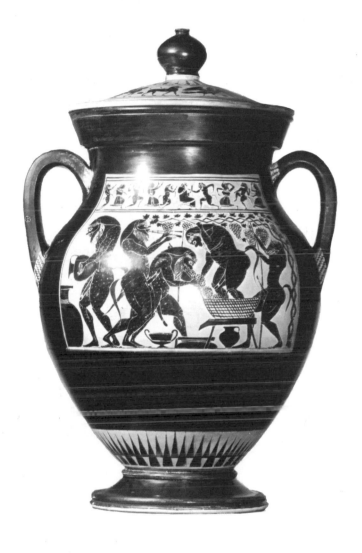

249. THE AMASIS PAINTER. *Satyrs Making Wine*, amphora. Attic, c. 530 B.C. Height 13 5/8". Martin von Wagner Museum, University of Würzburg

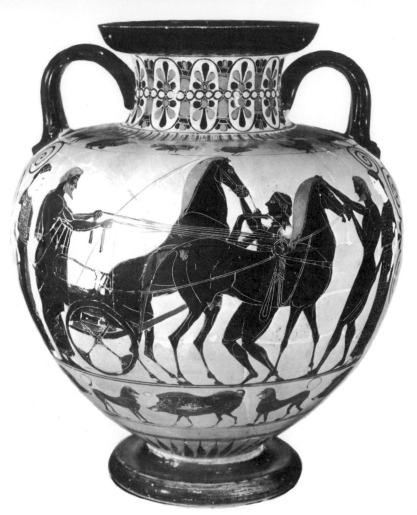

250. EXEKIAS. *Departure of a Warrior*, amphora.
Attic, C. 530 B.C. Height 20 5/8".
Museum of Fine Arts, Boston

251. PSIAX. *An Oriental Between Two Horses*,
amphora (portion) from Vulci (Italy).
Attic, C. 520–510 B.C. Height of whole 14 1/2".
British Museum, London

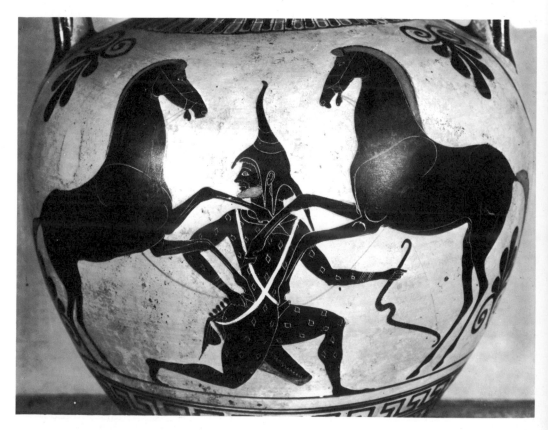

pointed ears, but independent creatures absorbed in their task.

Among black-figure painters the horse is a favorite subject, but it is one among hundreds of subjects, some simple, some complex, which include every aspect of daily life and many scenes from mythology (figs. 250–53).

About 530 B.C. a new technique of vase

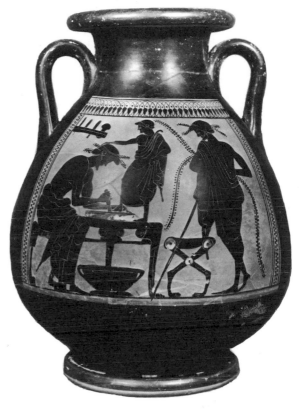

253. THE EUCHARIDES PAINTER. *Cobbler at Work*, pelike. Attic, c. 510 B.C. Height 15 3/4″. Ashmolean Museum, Oxford

252. *Herakles and the Stymphalian Birds*, amphora (portion) from Vulci (Italy). Attic, c. 550 B.C. Height of painting 7 1/4″. British Museum, London

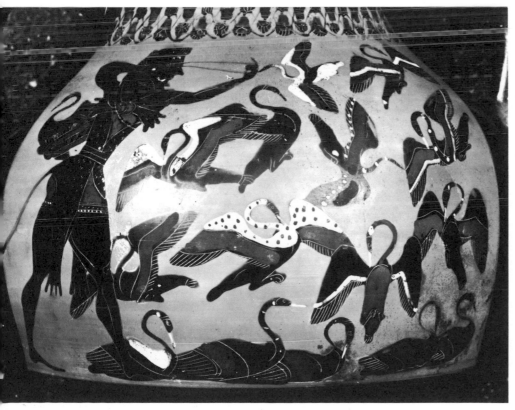

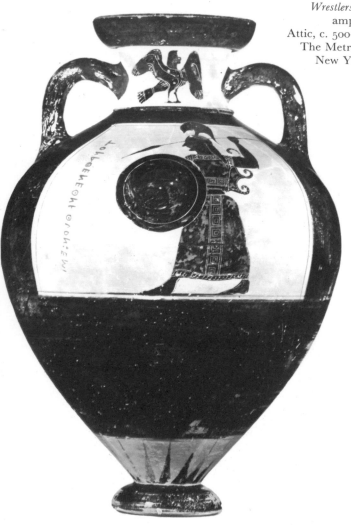

255, 256. THE KLEOPHRADES PAINTER.
Athena (right) and
Wrestlers (far right), Panathenaic
amphora from Vulei (Italy).
Attic, c. 500–490 B.C. Height 24 7/8".
The Metropolitan Museum of Art,
New York (Rogers Fund, 1916)

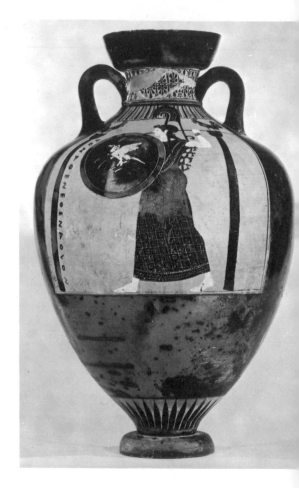

254. *The Burgon Panathenaic Amphora.*
Attic, c. 565 B.C. Height 24". British Museum, London

painting was invented in Athens.[9] Since it is essentially a reversal of black-figure, the invention may have been almost accidental: it is sometimes attributed to the Andokides Painter, who made several pots with black-figure on one side and red-figure on the other. In the old technique the figures were in black silhouette on the red surface of the pot, inner details being indicated by incision and by added color, white, red, and purple. In the new technique, the whole of the pot is black and the figures are "reserved" from the red surface of the pot, the inner markings being by lines painted with the black slip. Fully developed red-figure could express more than black-figure because it had a greater variety of line at its disposal.[10] But it did not immediately supersede black-figure: the two went on side by side for a time. Black-figure never entirely died out, being used for small, cheap pots, such as the little lekythoi dedicated in numbers of tombs, where the figures are often little more than sketches; it was also used, with greater care, on the Panathenaic amphorae, where black-figure was retained on much the same principle that an archaic-looking head of Athena was retained on Athenian coinage (see fig. 518) long after the Archaic style had gone out.

The first Panathenaic amphorae appeared about mid-sixth century, further advertisement for the excellence of Athenian pottery as well as for that of the Athenian oil with which they

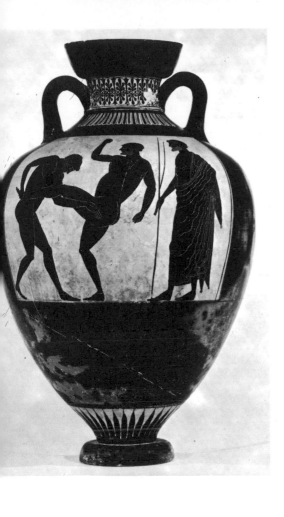

were filled. In shape they are like a kind of storage jar, tapering sharply toward the foot. On one side is always represented Athena, striking with her spear; and on the other a picture of some athletic contest, usually with an inscription "From the Games at Athens." This series continues down to at least the second century B.C.; it tells us much about Greek athletics, and also about the development of style in drawing. In the fourth century magistrates' names were added to the inscription, and this usually enables us to date the pots to a particular year. One of the earliest known of this type (about 565) is called, from its first owner, the Burgon amphora (fig. 254). Later specimens are decorated by painters who otherwise used only the red-figure technique (figs. 255, 256): the shape of the pots becomes more elegant, the Athena taller. This process continues until the pots lose their beauty of shape and the figures of Athena become grotesque in their elongation.

Two leading painters stand out at the beginning of red-figure, Euthymides and Euphronios. Their use of the new medium is instructive. That they were rivals, even if friendly ones, is proved by the triumphant inscription on a pot by Euthymides (fig. 257) which bears a particularly painstaking attempt at foreshortening a reveler who balances precariously on one leg—"Euphronios never did anything like this" —and it is in his efforts at suggesting depth in frontal or three-quarter-view limbs, and at twisting bodies into unusual poses in order to study the lines which make them recede into space, that Euthymides excels. Black-figure painters, especially the Chalcidians, had a number of linear formulae intended to suggest rather than to represent depth in space (for instance, a chariot wheel seen edgeways and resolved into a single vertical stroke: see fig. 236) and the Corinthian painter of the Chigi

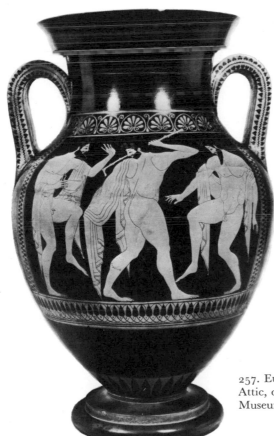

257. EUTHYMIDES. *Revelers*, amphora from Vulci (Italy). Attic, c. 510 B.C. Height 23 5/8". Museum Antiker Kleinkunst, Munich

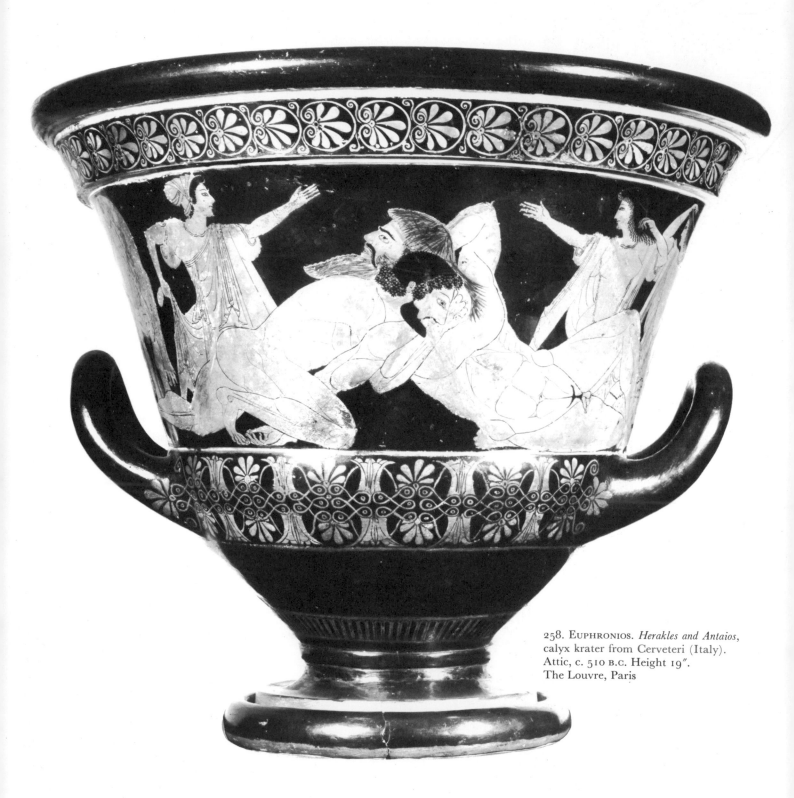

258. EUPHRONIOS. *Herakles and Antaios*,
calyx krater from Cerveteri (Italy).
Attic, c. 510 B.C. Height 19".
The Louvre, Paris

vase, a hundred years earlier, had an elaborate system of overlapping the figures in order to create a similar illusion (see pp. 177–78). Euthymides and other early red-figure painters were concerned with representing rather than merely suggesting depth, despite the handicaps of what is still in effect a silhouette style— that is to say the figures have no line that defines them and suggests their contours, but only a solid black edge; and there is no use of shading to give roundness.

Euphronios has a rather different approach. He is interested in the complexity of the shapes caused by the elaborate musculature of the body, and although he does not neglect its main architecture, he explores the numerous minor features and tries to represent them with appropriate emphasis. His Herakles and Antaios on the large mixing bowl in the Louvre are monumentally composed in a horizontal scheme to fill almost the whole field (figs. 258–60); and the figures in the background, necessarily small because of the narrow picture-band, are mere extras. The hero is trim, and fights silently with mouth shut; the giant is unkempt, with strawy hair and straggling

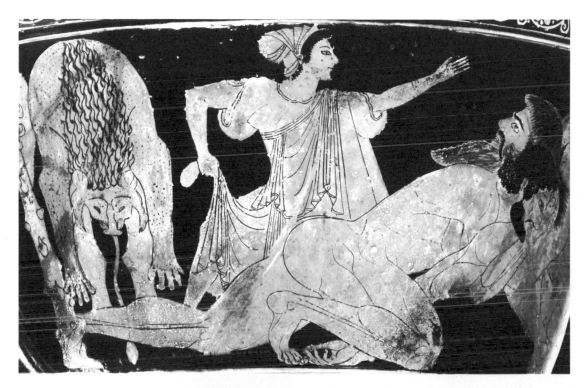

259, 260. *Herakles and Antaios* (details of krater in fig. 258)

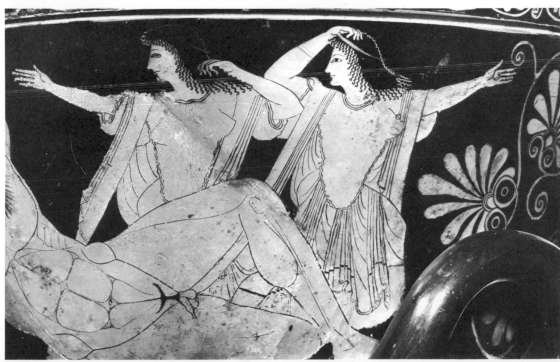

261. EPIKTETOS.
Satyr with a Wineskin,
interior decoration of a kylix.
Attic, c. 520 B.C.
Diameter of whole 7 5/8".
British Museum, London

262. EPIKTETOS.
Barbarian Archer, plate.
Attic, c. 520–510 B.C.
Diameter 7 1/8".
British Museum, London

263. ONESIMOS. *Girl Preparing to Wash*,
interior decoration of a kylix from Chiusi (Italy).
Attic, c. 480 B.C. Diameter of whole 9 1/2".
Musées Royaux d'Art et d'Histoire, Brussels

214

264. THE PANAITIOS PAINTER. *Theseus and Athena Received by Amphitrite*,
interior of a kylix from Cerveteri (Italy).
Attic, c. 500–490 B.C. Diameter 15 3/4". The Louvre, Paris

mustache, his mouth half-open in fear or pain.[11]

Epiktetos, a contemporary who paints mainly cups and plates and usually small ones at that, sees everything with the most delicate eye (figs. 261, 262): his people and horses are elegant, small-boned and light-footed: even his satyrs fail to be gross. He is a master of the circular composition, and many of his are exquisite. But a circular design which it would be impossible to imagine better done is the perfectly balanced composition by Onesimos, on the inside of a cup, of a girl going to wash (fig. 263). Her clothes are rolled up into a ball and balanced on one hand, a cauldron of water is in the other, and a metal basin is in front of her. Very close in style is the Panaitios Painter, who painted the great circular picture on a cup in the Louvre (fig. 264): this tells a more complicated story from mythology, but it is treated with no more nor less care than the domestic scene. Theseus and Minos were traveling to Crete with the Athenian victims for the Minotaur; Minos threw a ring into the sea and dared Theseus to retrieve it, in proof of his divine origin: Theseus plunged in and was taken to the house of his father Poseidon; the cup shows his reception by Amphitrite and her gift of a wreath (now difficult to see).

265. THE KLEOPHRADES PAINTER.
Dionysos with Satyrs and Maenads,
pointed amphora (for details see colorplates 31, 32)
from Vulci (Italy). Attic, c. 500–490 B.C.
Height 22″. Museum Antiker Kleinkunst, Munich

266. THE BERLIN PAINTER. *Herakles Stealing Apollo's Tripod*
(above) and *Apollo* (above right), amphora.
Attic, c. 490 B.C. Height 20 7/8″.
Martin von Wagner Museum, University of Würzburg

Followers of Euthymides and Euphronios, perhaps pupils, are the Kleophrades Painter and the Berlin Painter respectively. An amphora by the Kleophrades Painter shows Dionysos with his train of satyrs and maenads (fig. 265): the painter, by his subtle drawing, and by the full use of his limited palette, has contrived to distinguish among the maenads two different physical types with differing temperaments— the one, with dark curly hair, and seized with the Dionysiac frenzy, has head thrown back, lips parted (colorplate 31): the other, a more Northern type with fair straight hair, is moved too, but by a current that flows deeper and is less turbulent (colorplate 32). For the brunette

the painter has laid on a thick slip, so that it has fired black; for the blonde he has thinned out the slip so that, except for the strokes indicating the texture of the hair, it has fired a golden brown.

The Berlin Painter[12] has a fondness for isolating his figures. Two of his most attractive vases are amphorae of a shape resembling the Panathenaic prize amphorae, but all black, with a single red figure on each side (fig. 266).

216

267. THE BERLIN PAINTER. *Perseus*, amphora.
Attic, c. 490 B.C. Height 21".
Museum Antiker Kleinkunst, Munich

The one shows, on one side, Herakles making off with the tripod, with firm and determined tread; on the other comes Apollo, more lightly built, stepping more delicately. The characters are nicely caught and the idea of their chase round the vase is excellent. Equally delightful is the companion piece, not quite identical in shape (figs. 267, 268). Here it is not easy to decide who is the pursued and who the pursuer. The answer depends on whether the bag

268. *Gorgon* (detail, other side of amphora in fig. 267)

269. THE PAN PAINTER. *The Slaying of Medusa*, stamnos from Capua (Italy).
Attic, c. 490 B.C. Height 13 1/2″. British Museum, London

which Perseus carries on his shoulder is full or empty: if it contains the head of Medusa, then he is being pursued by one of her sisters; but if it is empty, the gorgon on the other side is Medusa herself and Perseus may be regarded as the hunter, though he does not have the confident air that would seem necessary for success.

The theme of the slaying of Medusa is treated by another painter of the same time, the Pan Painter, with an even lighter touch (fig. 269). The deed has been done, the head is in the bag, the body slides to the ground, and Perseus takes to the air followed by his patroness Athena, who daintily holds out a fold of her dress with old-fashioned elegance. This painter, a mannerist, is named from his bell-shaped mixing bowl in Boston, on which Pan springs out upon a hunter. On the other side is Aktaion being attacked by his hounds at the instigation of Artemis (fig. 270): she is tall and elegant, with immensely long legs, head with long straight profile and a long chin; but her mouth is tiny, and so is the head of the fawnskin round her shoulders. The hounds, too, are absurdly thin, with excessively long hind legs and diminutive noses. Aktaion is posed to perfection as he falls: there is something of the ballet in all the movements, both here and in the scene with Medusa.

270. THE PAN PAINTER.
The Death of Aktaion, bell krater.
Attic, c. 480 B.C.
Height 14 5/8".
Museum of Fine Arts, Boston

272. DOURIS.
Jason Being Disgorged by a Dragon,
interior of a kylix.
Attic, c. 480–470 B.C.
Diameter 11 3/4".
Vatican Museums, Rome

271. DOURIS. *Eos and Memnon*, interior decoration of a kylix,
from Santa Maria Capua Vetere (Italy).
Attic, c. 490 B.C. Diameter of whole 10 1/4". The Louvre, Paris

Two prolific painters may fittingly close the period, provided we remember that they may well have gone on working into the next. They differ markedly from one another, the one, Douris, being dry and respectable, the other, the Brygos Painter, wild, vigorous, and daring. Douris has some interesting subjects, for instance Eos, the Dawn, lifting her dead son Memnon from the battlefield of Troy (fig. 271): or Jason being disgorged by a dragon, a story otherwise unknown (fig. 272). The Brygos Painter delights in scenes of reveling, but he is equally at home among athletes (fig. 273), in

273. THE BRYGOS PAINTER. *Athletes*, skyphos.
Attic, c. 480 B.C. Height 5 3/4".
Museum of Fine Arts, Boston

Colorplate 31. KLEOPHRADES. *Ecstatic Maenad* (detail of pointed amphora in fig. 265).
Attic, c. 500–490 B.C. Museum Antiker Kleinkunst, Munich

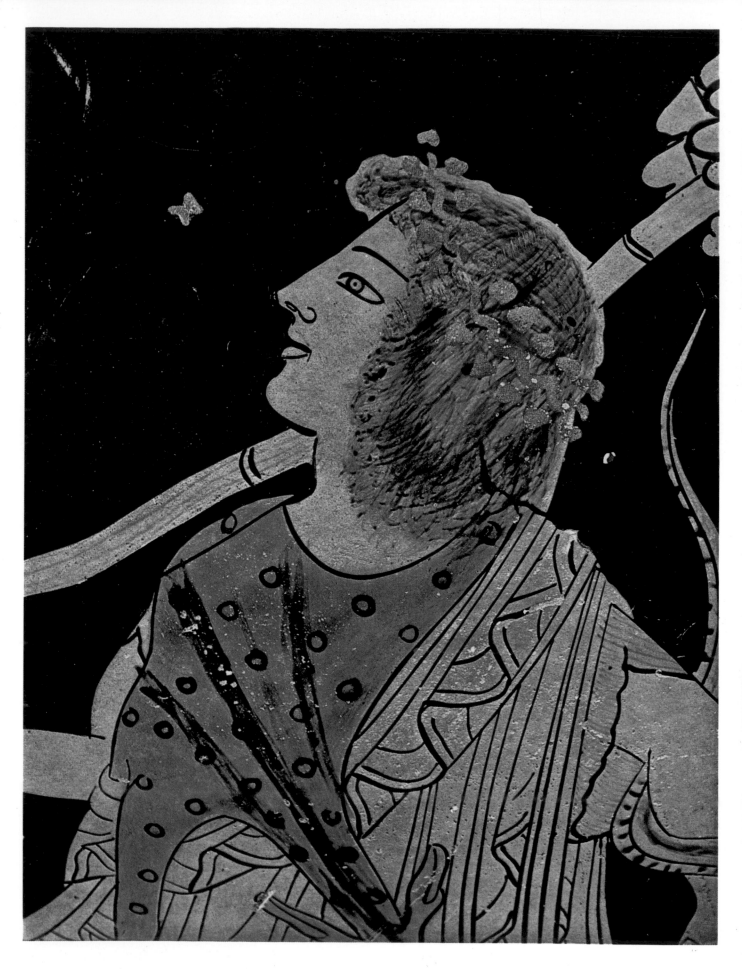

Colorplate 32. Kleophrades. *Rapt Maenad* (detail of pointed amphora in fig. 265).
Attic, c. 500–490 B.C. Museum Antiker Kleinkunst, Munich

274. THE BRYGOS PAINTER.
*Satyrs with Hermes, Hera, and
Herakles*, kylix.
Attic, c. 490 B.C. Diameter 10 3/4".
British Museum, London

scenes that recall satyr-plays (fig. 274), or in
scenes of battle (fig. 275): his sack of Troy—
the violence of its movement, the swinging dress-
es, the expressive gestures, the easy fore-short-
enings, and the limbs overlapping but distinct
—demonstrates his power and originality.

275. THE BRYGOS PAINTER. *The Sack of Troy*,
kylix from Vulci (Italy). Attic, c. 490 B.C.
Diameter 12 3/4". The Louvre, Paris

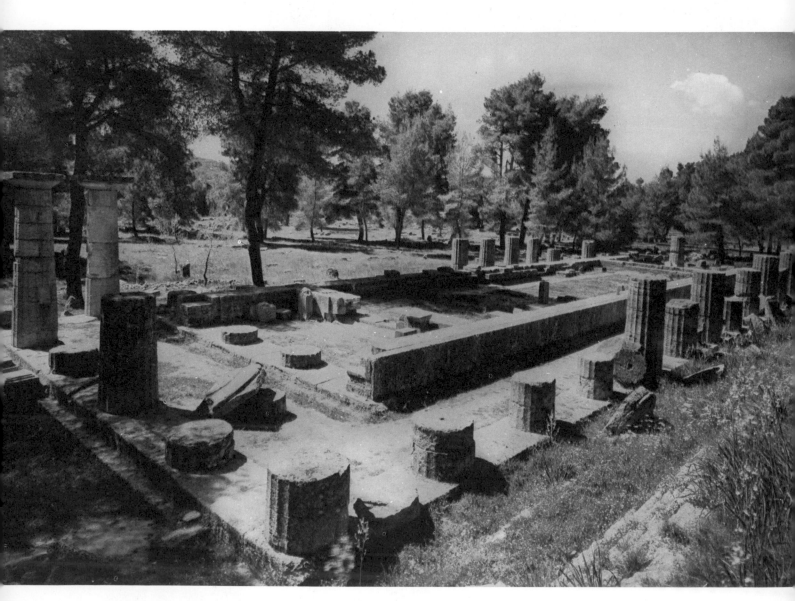

276. Temple of Hera (Heraion), Olympia. c. 600 B.C. *View from the northeast*

ARCHITECTURE

Toward the end of the seventh and during the sixth century B.C. were evolved the two main Orders of Greek architecture, the Ionic and the Doric. These are evidence of a new, systematic way of thinking about architecture, and are the grammar of the language in which architects express themselves.[13] Their most characteristic features are their columns, capitals, and entablature, described below. Both the Ionic and Doric Orders originated in wooden forms, and small buildings continued to be made in wood after many of the temples had been rebuilt in stone. Certain forms in the perfected Orders betray this wooden origin,

although it is difficult to deduce the original construction, except in a general way, from the stone translation: by the end of the Archaic period these forms have little structural justification and are used simply as accents in the design.

A most striking example of the transmutation from wood to stone is the temple of Hera at Olympia (figs. 276, 277). This was built about 600 B.C., the lower part of the walls in rectangular limestone blocks, the upper part in sun-dried brick; the surrounding colonnade was of wood and the superstructure of wood faced with terracotta. As the wooden columns rotted one after another, replacements were made in limestone, without much attempt to copy the first stone example. The result is that not only do the columns vary in style, the profiles of the capitals being those fashionable at the moment of replacement, but strangely enough some of the columns are thinner than others, an economy which may have been disguised to some extent by the coating of stucco with which all were covered. This evidence of the excavated remains is confirmed by Pausanias' remark that one of the columns in the back portico of the temple, when he saw it, was of wood: this was presumably the last survivor.

Wood and the sun-dried brick with which it was often combined are both perishable materials, and throughout the Archaic age such structures were usually protected from the weather by elaborate terracotta sheathing. Not only the roof tiles, but the tile ends, the cornices,

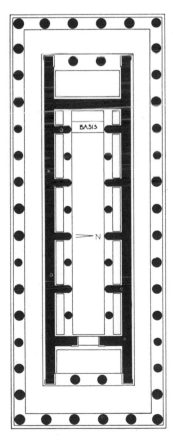

277. Temple of Hera, Olympia. *Plan*

278. *Head of a Goddess*, revetment from necropolis, Fusco (Sicily). c. 500 B.C. Terracotta, height 8 5/8″. National Archaeological Museum, Syracuse

the Doric Order (fig. 279) the columns taper from bottom to top and have twenty flutes of a shallow, subtle curve, which meet each other at a sharp edge. Toward the top of the column shaft are the necking grooves (visible in figure 280), usually three in number, and then, above them, and usually carved in one solid piece, the echinus and abacus. The columns are slightly thickened in a long curve near the middle ("entasis"). Above the columns comes the lintel or architrave ("epistyle," as the Greeks called it; i.e., that which rests on the columns): and then above that the Doric frieze. The Doric frieze consists of alternate triglyphs and metopes. Triglyph means "three-grooved," and triglyphs have in fact two grooves in the middle and two half-grooves at the sides. In origin, these were probably the ends of the ceiling beams cut into a decorative finish; when the fashion for building in stone came in, the form survived simply as a pattern. The metopes were the spaces between the triglyphs. Sometimes they were left open; sometimes they were filled with panels of terracotta, which could be painted, and when stone was used the metopes too would naturally be of stone, which

and various other parts were of molded and colored terracotta (fig. 278).

The two Orders of architecture, as they had evolved by about 500 B.C., were as follows: in

279. The Doric and Ionic Orders.
Schematic drawing

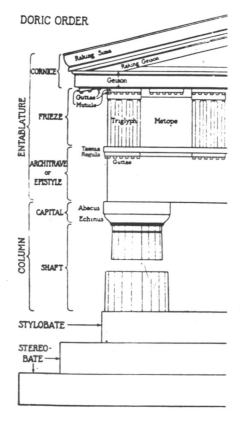

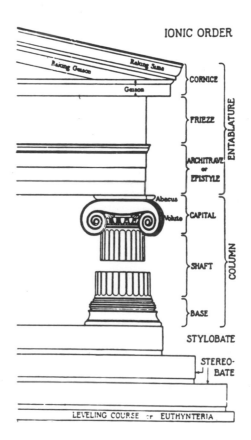

226

was often sculptured. Under each triglyph is a rectangular projection which has small knobs beneath it; these may originally have been wooden pegs joining two sections of a long wooden plank, which lay on top of the architrave, to each other and to the end of the ceiling beam. Above the frieze are a series of projections on the under side of the cornice, one over each triglyph and one over each metope. They too have little knobs on their lower face and look like the ends of planks, which is what they almost certainly were, the ends of the joists of the roof projecting. But it is quite obvious that none of these forms any longer expresses the structure exactly: they are being used as a kind of aesthetic notation which in some places corresponds in a general way with the construction, for example in the columns and architrave, but elsewhere no longer has any structural meaning.

There was an awkward problem connected with the Doric frieze and its alternate triglyphs and metopes (fig. 280). In the fully developed Doric Order the rule was that there should be a triglyph centered over each column and one in the space between, an arrangement which works perfectly well until the corner of the building is reached. If at this point the triglyph is placed above the center of the column, the size of the first metope is narrowed and an awkward strip of metope is left outside the end triglyph (fig. 281A). If, in order to avoid this, the triglyph is moved to the extreme end of the frieze, the first metope is widened (fig. 281B), and the triglyph is no longer over the center of the column. There are other ways of trying to solve this problem, such as shifting the end column outward or inward (fig. 281C) or varying the sizes of the metopes, but no solution is perfect, and the difficulty prejudiced the use of the Doric Order.

The origins of most of the forms of the Ionic

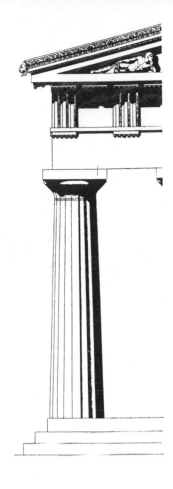

280. Temple of Zeus, Olympia.
470–456 B.C.
Restored elevation of part of the façade

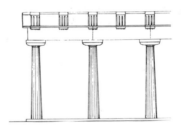

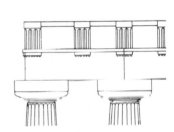

281. Angle Conflict in the Doric Order (after F. Krauss, 1943).

A, *above left*: Triglyphs centered over columns: a portion of the frieze far smaller than the other metopes remains at the end.

B, *above right*: Triglyph at end of frieze: end triglyph is not centered over end column, and first metope is larger than the others.

C, *below*: Triglyph at end of frieze: triglyph is not centered over end column; metopes made of equal size by unequal spacing of the columns

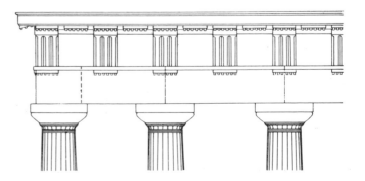

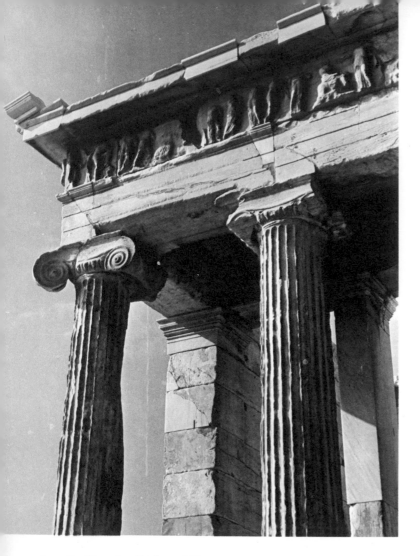

282. Temple of Athena Nike, Acropolis, Athens. 427–424 B.C.
Corner columns and entablature of façade

Order (fig. 279) also seem to be wooden, but this cannot be so clearly demonstrated as with Doric. Ionic columns are usually more slender than Doric; they have twenty-four narrow, deep flutes, which do not meet each other at a sharp angle but have a band of the unfluted shaft between them. Unlike the Doric, the columns have bases. This was partly because of the slenderness of the shafts—it was felt that the load needed spreading at the bottom, just as it was spread at the top of the shaft by the capital; partly because the bottom of slender shafts tends to be damaged and, when made of wood, to be rotted by rain splashing up from the ground. The Ionic capital is in the form

of a long cushion ending in volutes, and it has above it a rudimentary abacus. It is clear that structurally the Ionic capital derived from a bracket, which was flat at front and back— unlike the Doric capital, which is the same on all its four sides; but it was designed, like the Doric, to extend the bearing surface of the top of the columns and to support rather more of the architrave. The architrave itself was some- times flat but sometimes stepped with three overhanging projections: there could be a frieze above this, or the cornice could come directly above the architrave.

A drawback to the Ionic Order, apparently not considered in antiquity so serious as the metope-triglyph problem in the Doric Order, lay in the corner capital. If a colonnade of Ionic columns has to turn a corner, the capital of the corner column will not range with those of the return colonnade because it will offer only the side view of the volute, and not its face, onto that colonnade. The normal solution to this problem was to turn forward the outer volute of the last capital in the front colonnade to an angle of 135 degrees, with similar treat- ment of the capital on its return face (fig. 282). This is a compromise which does not provide a perfect solution on either face, and the problem was not solved until the invention of the Corinthian Order in the Classical period: this Order was in other respects like the Ionic but had a capital which looked equally well from all points of view (see p. 312).

The importance attached to the colonnade, which is nothing but a glorified veranda, may seem strange today, especially to people who live in a northern climate. The colonnade round a temple was chiefly a monumental form of decoration, but it had a practical prototype in the porch which must have been a feature in many Greek houses. In a country where private houses were usually of the most modest

description, and life was lived mostly in the open air, some sort of public meeting place which could give shelter from the sun and rain, and some protection in winter from the cold, was also a necessity. This need was filled by the stoa, usually a simple colonnade with a back wall and a roof over it; and this type of building, not an exciting one to handle from an architect's point of view and almost unknown today, began early and persisted late in Greece. These stoas were often of great size, and were important focal points of communal life. The "Stoa Poikile" (the Painted Stoa) in Athens, adorned with famous pictures by Polygnotos, gave its name to the Stoic school of philosophy; it is perhaps the best known, but others were equally well known in antiquity, and larger in size. The third-century stoa of Antigonos on Delos was four hundred feet long, and the second-century stoa of Attalos in the Agora at Athens, now reconstructed by American scholars on ancient evidence, was a more complex building, including an upper story and ranges of shops. The colonnades of temples no doubt fulfilled some of the functions of the stoa, if less specifically.

The Archaic period was one of great building activity in many parts of the Greek world; the larger buildings were in the Eastern and Western colonies, with the mainland less ostentatious but no less enterprising. The rich cities of Ionia built temples of vast scale, whether under the auspices of a great priesthood, as at Ephesos (where the building of the temple of Artemis was aided by King Croesus of Lydia), or under those of a tyrant like Polykrates of Samos, who rebuilt the shrine of Hera to enormous dimensions[14] and constructed the great harbor mole— still a most impressive monument despite great damage and repair. At Athens, the huge temple now known as the Olympicion, begun by Peisistratos, was evidently intended to rival the temples in Ionia, but with the fall of the Peisistratidai the city had neither the wealth nor sufficient desire to complete it.

The great Ionic temples of the Eastern colonies were equaled in size and magnificence by Doric temples in the West, such as those in Sicily at Selinus, or by one at Akragas, where gigantic statues served as architectural supports, presumably in imitation of Egyptian practice. Few cities could afford to build temples completely of marble, and even wealthy Sicily, far from marble quarries, had to be content with limestone coated with stucco. The Greeks were free from the kind of aesthetic theory that demands the spectator to be shown, by emphasis on the nature of the material or on the stages of manufacture, how and of what the work of art has been composed. They were concerned with the finished surface and with the form it expressed. Since the idea of a column, for instance, is to stress verticality, they thought fit to cover it with a coat of stucco so smooth that the shaft appeared to be monolithic; even in the Parthenon, which is built entirely of marble, every attempt was made to prevent the horizontal joints of the column shafts from showing. They were interested in expressing an ideal form in its integrity and did not allow it to be impaired by undue display of the material. It might indeed be claimed that they were a little insensitive in this respect, for in Archaic sculpture their treatment of form tends to be identical, whether the material is marble or bronze.

But all Greek temples except the smallest were at this time faced with a serious difficulty. It is true that the Greek temple, unlike the Christian church, was not primarily a place of assembly: it was literally the house of the god, and its primary function was to provide a shelter and a setting for his image. Priests and visitors might come into it, singly or in small

groups, but the acts of ritual and the congregation of worshipers usually took place outside, before a large open-air altar. When images were small and only a limited clear space was needed, the structural problems in a temple presented little difficulty: but when they became larger the architect was faced with the problem of providing a spacious hall which the statue could occupy. The Archaic Greeks hardly knew of the arch and always preferred the post-and-lintel form of construction, in which the lack of large timber and ignorance of trussing made it difficult to span a wide space. The only way to do so (when the old megaron plan had passed out of fashion, in which a group of columns in the center of the room supported the roof) was to provide a series of intermediate supports for the timbers. This could be done either by building piers projecting from the side walls, as in the Heraion at Olympia (fig. 277), or by setting a row of piers or columns down the central axis of the room (fig. 283). The first solution narrows the nave but does give an uninterrupted view from end to end. The second solution, which is surprisingly frequent, has the disadvantages that the central door opens, not onto a clear space, but onto the end of a row of columns, and that this row of columns blocks the view of any statue centrally placed at the other end of the room.

The best solution was found about 500 B.C. in a temple at Aegina. Although Archaic temples were numerous, few have survived, partly because many were reconstructed at later periods. The temple of Aphaia at Aegina (fig. 284) is an exception: although not very large it is an outstanding example of late Archaic Doric, and about half of it is preserved. It was of limestone stuccoed, with marble pediments (see p. 258); and it was built, with a slightly different orientation, on the site of an earlier and smaller temple. It differs little, except in size, proportions, and the profiles of its moldings, from the Early Classical temple of Zeus at Olympia, and its architect had already solved this problem of the roof, a solution which was also followed in the Parthenon at Athens. He framed his cult-image with a row of columns on each side, and these rows were surmounted by another row of smaller columns on which the roof rested. By this time marble roof tiles had been invented; but they were both expensive and heavy, and for one of these reasons, perhaps for both, only the lower row of tiles at Aegina was of Parian marble, the others of terracotta.

Both Doric and Ionic buildings were often, though not always, adorned with sculpture, and although there was no fixed rule, certain places for the sculpture had become customary by the end of the Archaic period. To begin at the top of the building, there were acroteria, that is, ornaments perched on the gable at its summit and at each end to break the skyline. In early times these had been abstract ornaments of terracotta, but when they took on animal or human form, it was natural to

283. Temple of Apollo, Thermon.
c. 640–630 B.C. *Plan*

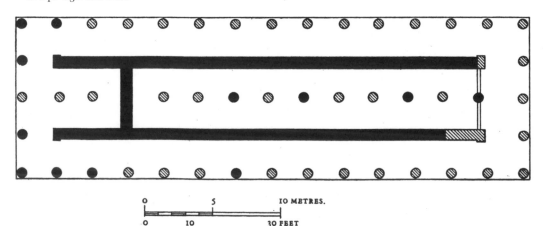

introduce winged figures in this position. There could be sculpture in the pediment, the very low broad triangle at each end of the building formed by the pitch of the roof over the level architrave and frieze below (see fig. 315). A Doric building could have sculptures in the metopes of its frieze (see figs. 320–22); an Ionic building could also have a sculptured frieze, but it differs from the Doric in being a continuous horizontal band, not interrupted by triglyphs (see fig. 282).

There are several problems connected with the setting of sculptures in all of these places. To begin with the pediments: the Archaic designer was at once confronted with the problem of scale. He could put a large figure in the middle and possibly insert another two, almost equally large, on either side of it (this was easier if they were animals lying down); but the rapidly narrowing field of the pediment, caused by the low pitch of the roof, meant that beyond the central group it was almost impossible to insert figures of anything like the same size as the main ones. Archaic artists were not particularly sensitive to such discrepancies of scale because in that favorite subject for early sculptors—the struggle of man against monster—there are no standard sizes: the eye naturally accepts the scale of the human being for its own, and the monster can be of any size you please. But as sculptures became more naturalistic the presence of human beings of widely differing sizes, all taking part in the same action, aroused disquiet.

There was also a problem of scale in the metopes of the Doric frieze. It is possible to devise a number of compositions that will satisfactorily fill a square, or nearly square, frame, but the figures in the compositions, in order to tell at all among the architecture, must be of reasonable size; in other words, two or three is as many as a single metope will ac-

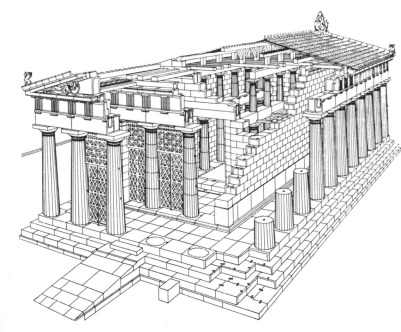

284. Temple of Aphaia, Aegina. c. 490 B.C.
Restored sectional view

commodate. How then to represent a scene with many figures? The Archaic sculptor did it by ignoring the existence of the triglyphs: for example, in the battle of Herakles against the centaurs, on a little Doric building at the mouth of the Sele in South Italy, Herakles, shooting with the bow, has one metope to himself and the remaining ones are occupied by one centaur (or occasionally two), each of whom is seen, despite the intervention of the triglyphs, to be suffering the effects of his action. And on the Sikyonian peristyle at Delphi the same convention reigns (see p. 252)

The Ionic frieze, an uninterrupted band of uniform height usually running round the outside of the building above the architrave, seems to call for a continuous composition. But on the only Archaic Ionic building where the frieze has survived complete, the treasury of the Siphnians at Delphi, there is a separate subject on each side of the building (see p. 254). Not until three quarters of a century later, in the frieze of the Parthenon (an Ionic feature in a Doric building), does a single subject for the first time occupy all four sides.

SCULPTURE

Freestanding Sculpture[15]

Some time around 600 B.C. the Greeks must have become acquainted at firsthand with the immensely impressive sculpture of Egypt. Egypt, unlike Greece, had no supply of white marble suitable for sculpture, but she had fine limestone and several extremely hard stones, including red and black granite, and diorite. The Greeks discovered that on some of the Aegean islands, especially Naxos and Paros, there were marbles which, though hard, could be carved into statues of lifesize and over, by using an iron point and striking it with a wooden mallet. These implements, together with an important innovation of about the mid-sixth century, the claw chisel (which was, in effect, a row of about five or six small points), and the drill used for removing masses of marble or in places where percussion might risk breakage, were the Greek sculptor's main tools. Flat chisels and round-nosed chisels were also used, though sparingly: the iron point, the claw chisel, and a finish with abrasive formed the standard procedure until the middle of the fifth century. From time to time down the centuries the drill was used more extensively, and also the flat and rounded chisels, but the point and the claw remained the chief tools, and they are still used today.

The Greek system in Archaic times was to remove successively layer after layer of the marble from the whole surface of the block until it approached the required shape, and then to refine the ultimate surface with the claw chisel and abrasive.[16] At Athens, where sculpture became plentiful during the sixth century, use was made at first not only of local varieties of limestone but of imported island marble. Grayish strata of marble had been discovered on Mount Hymettus and Mount Pentelicus, each only a few miles from the city, by mid-sixth century; and finally white quarries were discovered on Pentelicus. It was from these that many of the statues and reliefs of the fifth and subsequent centuries were made, including all the sculptures of the Parthenon, and Pentelic marble was used throughout antiquity; but the marble of Paros never lost its prestige, and although it was not found in such large quantities, was always highly esteemed for its translucent quality and its color.

It has become the fashion to admire all Archaic sculpture: but in the Archaic age, just as in any other period, there were sculptors of varying ability. Some were creators, perhaps with a streak of genius; others were artists of high skill but limited originality; and yet others were mere imitators, content to copy the works and the style of others without adding anything new. Nevertheless, Archaic sculpture, because of its patterned quality, even at its least original is rarely without charm. To understand Archaic sculpture, and ancient sculpture in general, it is necessary to rid one's mind of certain modern conceptions. There was not in antiquity the

strong search for originality that characterizes modern art: a sculptor did not think it shameful to copy the work of a contemporary, whether master or rival, giving it to a greater or less degree his own interpretation; it is likely that, as in the Renaissance, a master-sculptor had pupils working under him who helped him execute his commissions and frankly based their style on his.

The general stylistic progression is toward a greater naturalism, and this has led to a belief that more and more lifelike imitation of the human figure was the sculptor's main purpose. In fact, the main problem was the reconciling of the growing knowledge of the forms and mechanism of the body with the demands of sculptural design: for instance, soon after 500 B.C. it was discovered that the "kouros" scheme (satisfactory so long as the effects of movement on the whole skeletal structure were ignored; see p. 271) was no longer able to contain the new knowledge; this led to the introduction of a new type of figure, in which the various parts of the body revealed the effects of an uneven distribution of the weight. In speaking of the advance of knowledge of the forms of the body, the word "anatomical" is misleading, for it suggests that knowledge was gained by dissection. The Greeks did not practice dissection until late in the fourth century, and sculptors were normally content to deduce the workings of the body from what they could observe on its surface. This sometimes led to factual error, but its artistic value is that it does not trick the sculptor into displaying on the surface (as Hellenistic sculpture sometimes does) features which are in fact hidden beneath it, and thus marring the integrity of the presentation.

With these thoughts in mind we may survey the whole Archaic field in the sixth century. Some Greek sculptors learned their craft from Egypt, either by visiting Egypt for the purpose or by inducing Egyptians to come to Greece.[17] Egyptian sculpture was produced by setting out, on the four faces of a rectangular block of stone, detailed drawings of a figure made according to a strict system of proportions. The sculptor cut in from each face in turn, bringing the four faces into relation with one another, the result being a carefully harmonized composition which gained sculptural force from its rectangular origin, but did not always betray it. The Greeks can be shown sometimes to have used the Egyptian scheme of proportions, although they were often not sufficiently practiced to harmonize the four sides of the statue. Also, Greek sculptors were not content to follow the Egyptian stereotype, and they soon began adding new details gained from direct observation of living people. They were, however, content to limit themselves to a comparatively small number of types. Favorites among these were the naked male figure, which we call kouros (young man), and the draped female, which we call kore (young woman). Some other types failed to survive, either because they did not become well enough known or because they were not distinctive enough to become fixed types at all, and none had the popularity of those we have just mentioned; but some of the rarer ones are nevertheless admirable as works of sculpture.

The kouros type is a naked figure, with one leg, usually the left, slightly advanced; the head is upright and faces the front; the weight is exactly distributed between the two feet, the hips and shoulders are level, and both arms are usually close to the sides. If a vertical line is dropped from the middle of the forehead it will divide the body into two equal halves, differing only in the position of the legs and occasionally in that of the arms when one is raised to hold an offering.[18]

Statues of this kind were made in many

places, and as the sixth century progressed the type can be seen to evolve everywhere in much the same way, becoming less massive and more organic as the results of increasingly accurate observation of the living body were steadily incorporated. On the assumption that these changes took place simultaneously in all the places where kouroi were being carved, a classification of the various phases of development has been made, largely based on the advances that are evident in the knowledge of the constituent parts of the body, and approximate dates have been assigned to them.[19]

It is convenient to begin with a work (fig. 285) which by its style is connected with the Daedalic sculpture of the previous century, and

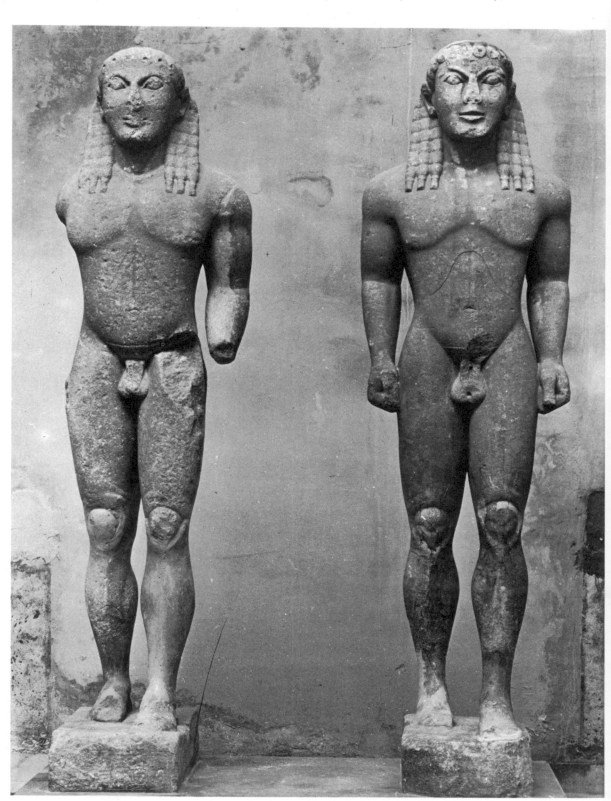

285. *Kleobis and Biton*, from the Sanctuary of Apollo, Delphi. c. 615–600 B.C. Island marble, height of each without base c. 84″. Museum, Delphi

by its sculptor with the tradition that Dipoinos and Skyllis, the pupils of Daedalus, had migrated to the Peloponnesus. For this statue is Peloponnesian, being signed by "- - -medes the Argive." Its interest as a work of art is matched by that of the story of its dedication: it is one of two statues at Delphi, known throughout the ancient world, which portrayed Kleobis and Biton, whom Solon cited when he stood before King Croesus as examples of the highest human happiness. They were young Argives whose mother was a priestess of the goddess Hera, and when, on the occasion of a great festival of the goddess, the oxen which were to draw her wagon from her house to the temple did not arrive from the fields in time, the two sons yoked themselves to the wagon and dragged it a distance of five miles to the temple. Amid the praise of the assembled Argives—the men acclaiming the strength of the youths, and the women their filial devotion—the mother prayed to the goddess that her sons would be granted the highest blessing that men can attain. They lay down in the precinct of the temple and never woke again.

The statues are almost identical, and are of island marble: an inscription on the upper face of the bases briefly recounts the story. The links with Daedalic style (see p. 185) can be seen in the low forehead surmounted by a row of curls, and in the long tubular locks, their horizontal divisions and tapering ends neatly tied, which frame the face. But the hair is less like a wig, the face less schematic, the head more of a piece with the body, and the whole figure instinct with a new feeling of life. Several points may be stressed, because they are characteristic of much Archaic sculpture. One is the boldness of certain elements in the design, contrasted with the timidity of others. The breast and shoulders, the thighs and buttocks are massive, but within the main divisions the modeling varies in its depth and thoroughness: the diaphragm, for instance, is little more than a shallow groove on a flat surface, but the knees are modeled with a care and an approach to truth which suggests that the sculptor, uncertain how the joint worked, was impelled to study it with attention. Then in the head the features, being cut in from the front of the block, tend to lie too much on the front surface of the face, and as a result the cheeks are broad and flat.

In comparison with them a kouros of about the same date is interesting both for its resemblances and its differences. This is the statue in New York, which has been shown to follow closely the Egyptian canon of proportions (fig. 286). It is of Athenian workmanship,

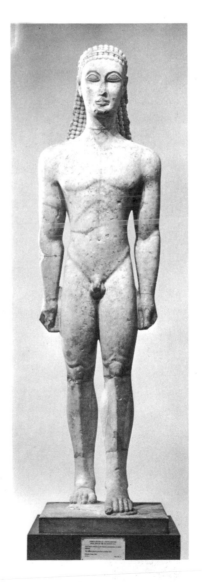

286. *Kouros.* c. 615–600 B.C. Island marble, height with plinth 72 1/2". The Metropolitan Museum of Art, New York (Fletcher Fund, 1932)

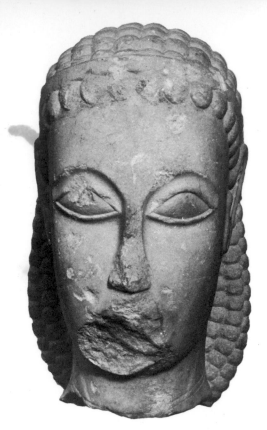

but inferior in quality to the fragments of a closely similar but less well-preserved statue in Athens of which the so-called Dipylon head was part (fig. 287). The New York kouros is more slender than the Delphian twins, and the divisions of the body are less clearly marked, with the result that the modeling looks more consistent and harmonious, although many details are superficial and schematic. The hair,

289. *Kouros (Kroisos?)*, from Anavyssos.
c. 540–520 B.C. Parian marble, height 76 1/4".
National Museum, Athens

287. *The "Dipylon Head."*
c. 610 B.C.
Island marble, height 17 1/4".
National Museum, Athens

288. *Kouros*, from Tenea.
c. 550 B.C. Parian marble, height 60 1/4".
Staatliche Antikensammlungen, Munich

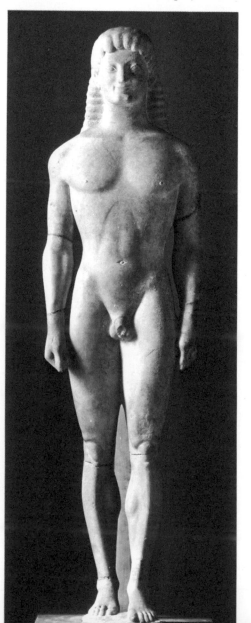

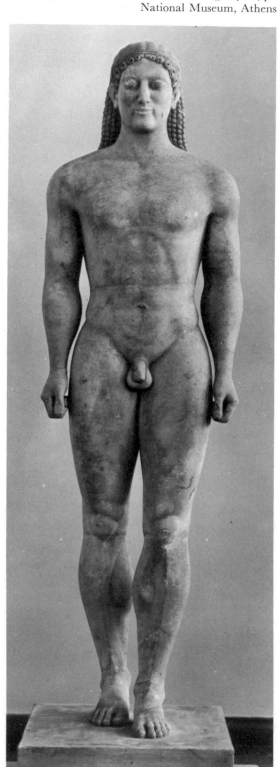

236

instead of framing the face, is swept back and falls in a mane behind: this frees the neck and allows its articulation with the body to be more convincingly suggested.

As time passed sculptors continued to wrestle with the main problems of presenting the naked human body within this formula, but they did not attempt to go outside it for at least a century. The kouros of Tenea (fig. 288) is an example of about 550 B.C., and may be Corinthian. Here the proportions are slenderer, the individual forms are becoming more rounded as the sculptor tries to bring them more closely into relation with one another, and the treatment throughout is more consistent. About a decade later is the kouros from Anavyssos (fig. 289), probably a portrait of one Kroisos, since an inscribed base which probably belongs to the statue mentions Kroisos' death in battle.

A generation later, perhaps about 500 B.C., comes the impressive Aristodikos,[20] carved by an Athenian (fig. 290); and a few years later still, the bronze Piombino Apollo (fig. 291), so called from its findspot in Italy: not only the inlaid silver inscription under its foot, which states in Dorian dialect that it was dedicated as a tithe to Athena, but also its style, suggest a Dorian artist. One thinks of Aegina, of which style we know something from the pedimental sculpture of the temple of Athena Aphaia. Although the Piombino is a boy, younger than

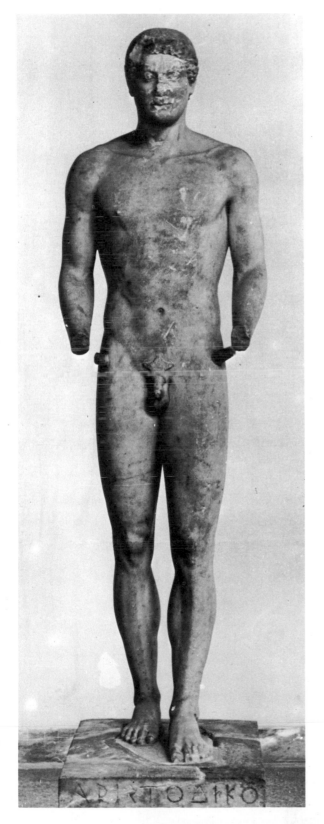

290. *Kouros, Inscribed "of Aristodikos,"* from the Mesogeia, near Mt. Olympos. c. 520–485 B.C. Parian marble, height with base 88″. National Museum, Athens

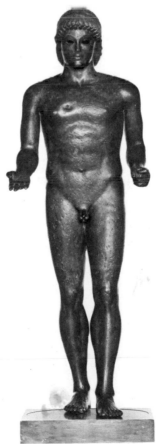

291. *Apollo*, from Piombino (Italy). c. 475–450 B.C. Bronze, height 45″. The Louvre, Paris

292. *Kore* ("*Hera*"),
from the Heraion, Samos.
Early 6th century B.C.
Marble, height 76".
Vathy Museum, Samos

most kouroi, the shoulders are more massive than in earlier statues, for instance that from Tenea. It marks an important advance in that the muscles of the abdomen are carefully studied and integrated as a living part of the torso; but the junction of the torso with the legs in the front view is not yet quite mastered.

The types of kore naturally vary more than the kouroi, because women's clothing has much variety. On the east of the Aegean, notably in Samos,[21] there are traces of an important source of inspiration other than Egyptian, namely Assyrian, in the statue dedicated by Cheramyes to the Samian Hera (fig. 292). The date is early in the sixth century, and it is clearly derived from a sculptural composition more sophisticated than a Greek sculptor of this period would have been able to devise by himself. This statue is most satisfactory sculpturally, largely because of its geometric formality; but Greek sculptors, in the youth of their art, were not in the mood to repeat it unmodified: they quickly began to enliven the scheme, especially by giving movement to the drapery. In real life they must often have seen a woman grasp a fold of her dress and draw it up slightly to one side to make it clear the ground as she stepped forward. This was the action they chose, and it was to have an immense sculptural vogue in the sixth century and even beyond it into the fifth. This motif is particularly associated with Ionia.

Colorplate 33. *Kore*, from the Acropolis, Athens. c. 510–500 B.C. Painted marble, height 22 1/4". Acropolis Museum, Athens

Colorplate 34. *The Triple-Bodied Monster* (portion), from a pediment of the "Old Temple of Athena," Acropolis, Athens. c. 550 B.C. Limestone, height c. 27 3/4″. Acropolis Museum, Athens

293. *The Geneleos Dedication*, from the Heraion, Samos. c. 560–550 B.C.
Marble, height of seated figure 33 1/2″, length of base c. 15′ 4″. Vathy Museum, Samos

The sculptural group known as the dedication by Geneleos on Samos (fig. 293), a long basis on which no less than six statues were set up, conveniently displays three types of female statue together: the standing figure, the less common seated figure, and the rare reclining figure (rare in large sculpture, but less so in small bronzes). The seated figure of the Geneleos group comes very close in type to some of those that flanked the sacred way at Branchidai, near Miletos (for instance, the examples in the British Museum, such as figure 294). But the statues from Branchidai differ from each other widely, not only in details but in their main designs, and one or two (for instance, figure 295) are markedly more Egyptianizing.

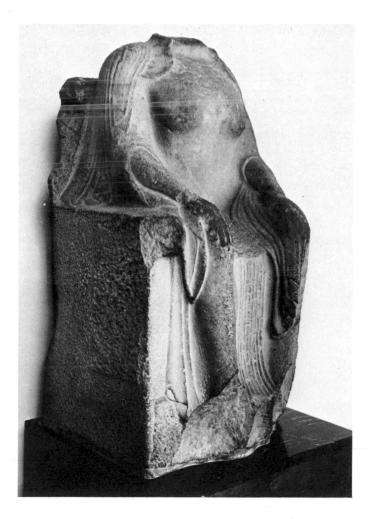

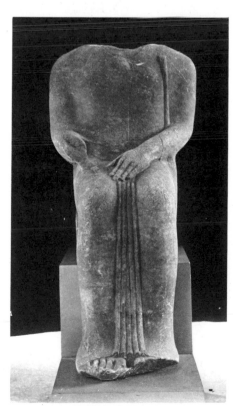

left: 294. *Seated Woman*, from Branchidai (Didyma).
c. 550–525 B.C. Marble, height 68″. British Museum, London

below: 295. *Seated Figure*, from Branchidai (Didyma).
c. 550–525 B.C. Marble, height 45″.
Archaeological Museum, Istanbul

297. *The Peplos Kore*, from the Acropolis, Athens.
c. 530 B.C. Parian marble, height 48″.
Acropolis Museum, Athens

296. *The "Berlin Goddess,"*
from Keratea.
Early 6th century B.C.
Attic marble, height 76″.
State Museums, Berlin

Before discussing the development of the favorite Ionian standing female type it will be convenient to turn aside to look at two unique statues (unique in the sense that no other specimens of the same type are known): both, as it happens, are Athenian, and perhaps symptomatic of the more independent line that Athenian sculptors tended to take. The first of these statues is the so-called Berlin Goddess (fig. 296), found in a country district of Attica, over lifesize and therefore possibly a cult-statue.

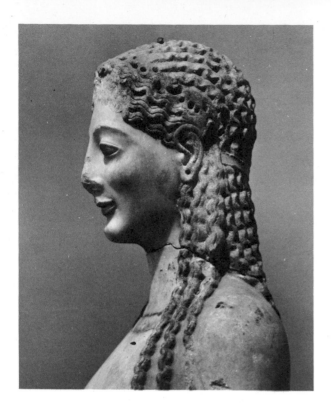

298. *The Peplos Kore* (portion of kore in fig. 297)

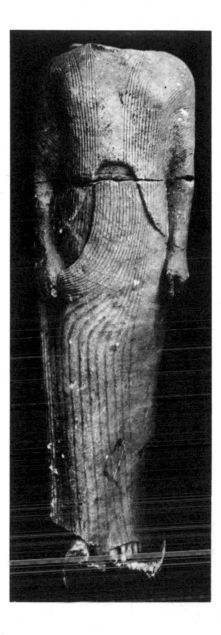

299. *Kore*, from *The Geneleos Dedication* (see fig. 293). Height 63″.

The general style, to judge from the head, is related to that of the Dipylon head, not a weaker brother like the New York kouros, but a coarse and vigorous rustic cousin. This goddess was carved soon after 600 B.C. The second statue must be half a century later. Though it is under lifesize and not a cult-statue—but one of those anonymous korai dedicated to Athena on the Acropolis at Athens—it has a sculptural quality and force to which scale is irrelevant. She is known from her dress as the Peplos Kore (figs. 297, 298), for she wears a heavy peplos over an undergarment which appears only at the ankles. The dress in itself suggests broad simple forms and flattish surfaces, as it does not cling but envelops the body and makes it into a kind of cylinder, greater in diameter above the waist where the peplos is double. Nor is there any movement: the left arm is bent to hold an offering, but that is all. The sculptor treats this simple formula with great subtlety, and similarly he defines the main geometrical forms of the head with clarity and then brings them to life with his crisp, sure, and sensitive modeling.

To return now to the Geneleos group (fig. 293). The standing female figure holds a heavy fold of the lower part of the drapery to one side (fig. 299). The logical working-out of the motif

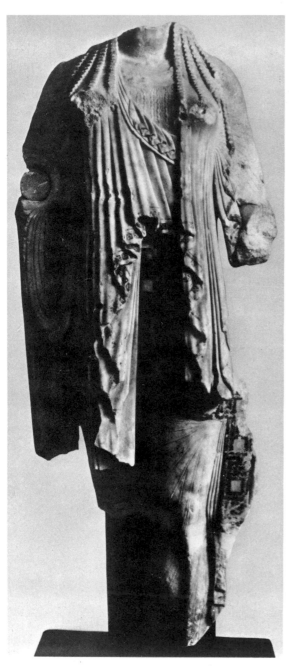

300. *Kore*, from the Acropolis, Athens.
c. 500 B.C. Marble, height 48″. Acropolis Museum, Athens

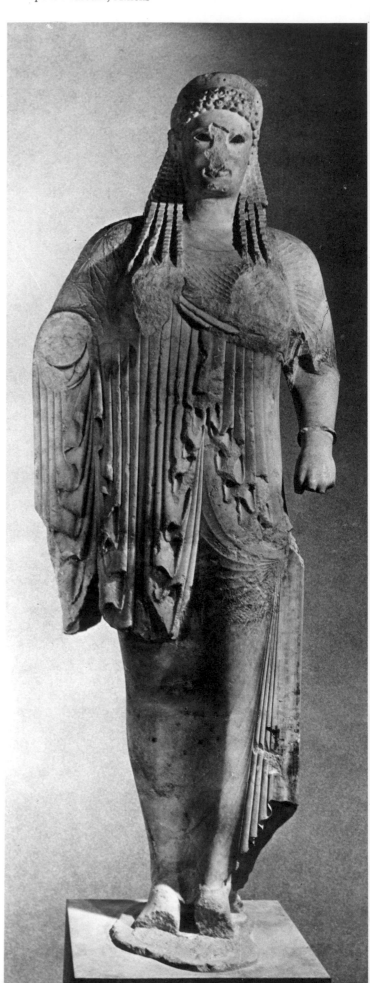

301. ANTENOR. *Kore*, from the Acropolis, Athens.
c. 530–525 B.C. Marble, height 8′ 6″.
Acropolis Museum, Athens

can be seen in later statues from the same
school, until finally the diagonal movement is
fully integrated and this attractive scheme
becomes a general favorite.

It is interesting to see how sculptors from
various places treat this motif. The Archaic
statues on the Acropolis at Athens, which have
been preserved because they were thrown over
by the Persians and subsequently buried, are

244

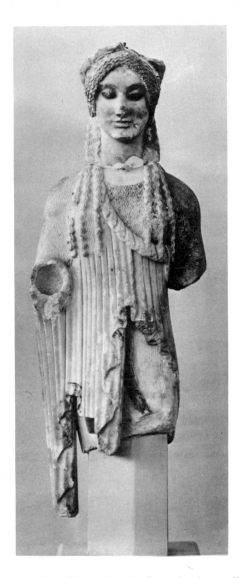

302. *Kore* ("*La delicata*"), from the Acropolis, Athens.
c. 500 B.C. Parian marble, height 36".
Acropolis Museum, Athens

makes the shoulders of his kore (fig. 301), which is far larger than most, square and broad; he tapers it to the feet, and he stresses the vertical elements of the drapery over the upper part of the body and below the left hand, while making little of its transverse movement over the legs.

Toward the end of the Archaic period sculptors were still infusing into this same type new and subtle qualities, as in the kore aptly called "La delicata," with its fragile feminine charm (figs. 302, 303): but right at the end comes a very different kind of creation, perhaps the last kore to be set up on the Acropolis before

303. "*La delicata*" (portion of kore in fig. 302)

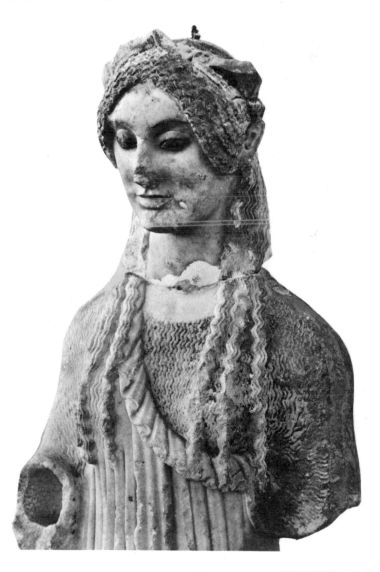

usually held to be a fairly representative collection. It is certainly rich and diverse: the finds comprise works imported from the Islands, from other Ionian centers, and from Boeotia, together with works of pure Athenian style, as well as some which may have been made either by Athenians influenced by alien styles or by immigrants working in Athens. Among the korai of Ionic type from the Acropolis is one by a Cycladic sculptor (fig. 300) who gives his statue a solidity and volume that is equal to that of the reclining figure in the Geneleos group but less crudely indicated. Antenor

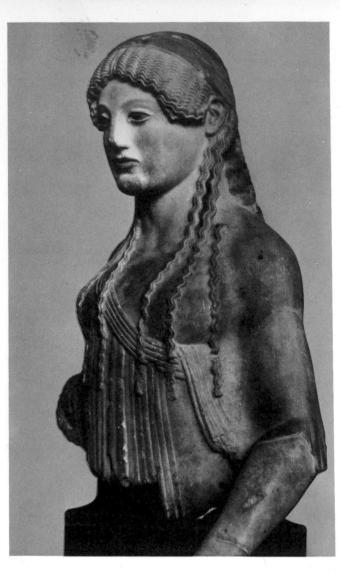

304. *The Euthydikos Kore* (portion), from the Acropolis, Athens. Early 5th century B.C. Marble, height of portion shown 16 1/2". Acropolis Museum, Athens

305. *Aphrodite*, from Rhodes. c. 520 B.C. Terracotta, height 10 1/4". British Museum, London

the Persian destruction (fig. 304). It was dedicated by Euthydikos, of whom otherwise we know nothing. The type is still the same—Ionic dress, and the left hand drawing the lower part to one side—but the spirit is unlike anything we have seen. The sculptor is no longer interested in Archaic drapery for its own sake, although he carves it deftly enough; he is more interested in representing the solidity of the body and explaining its articulation. In the face an analogous change has taken place: Archaic prettiness has vanished, and all the emphasis is on its solid geometry. The expression has changed too, and instead of the bold Archaic smile or the muted smile that succeeded it, there is an uncompromising, almost somber expression.

It is natural to wonder whom these statues represent. The kouros type could appropriately be used for a god, especially Apollo. Or it could be simply an offering that would be likely to please a deity, namely a man in the bloom of youth. It could be set up over a grave as an ideal presentation of the dead, not a portrait statue in the modern sense. Similarly with the kore: it could be used to represent a goddess, but the great bulk of those dedicated on the Acropolis, for example, do not represent either a goddess or a priestess or the dedicator. They are agalmata, objects of delight calculated to please the heart of the goddess as they do those of her human worshipers (colorplate 33). The purpose of these marble sculptures does not greatly differ from that of the terracotta figures

with which many ancient shrines were crowded, but the terracottas, being produced from a limited number of molds, are naturally more monotonous. Besides, molds become worn and lose the fine detail they once possessed. However, especially in places where there was little marble sculpture to outshine them, the artistic merit of the terracottas can be considerable (figs. 305, 306).

One of the finest and most distinctive products of the Archaic period was its small bronzes. These were sometimes freestanding dedications, but were more often attachments to some larger object, as they had been from very early times. Animals were less common than earlier: men and women predominate, and the attitudes are rather more free than in marble sculpture. Both male and female figures were used for the handles of mirrors and water pots, and they could also stand, run, or lie on the rims of larger vessels. There were almost as many types as there are in real life, together with inhabitants from the world of fancy—the wide-eyed Arcadian shepherd (fig. 307), the lively satyr (fig. 308), the genial banqueter (fig. 309), the inscrutable sphinx (fig. 310). These statuettes were produced in many places, for although they demanded high

306. *Aphrodite*, from Rhodes. c. 550 B.C.
Painted terracotta, height 9 1/8″.
British Museum, London

307. *Arcadian Shepherd.*
c. 530 B.C.
Bronze, height 3 3/4″.
State Museums, Berlin

308. *Satyr.* 6th century B.C.
Bronze, height 3 5/8″.
The Louvre, Paris

309. *Banqueter.* Late 6th century B.C.
Bronze, height 2 3/8″. British Museum, London

310. *Sphinx.* c. 550 B.C.
Bronze, height 2 7/8″.
Walters Art Gallery, Baltimore

311. *The Vix Krater.* c. 500 B.C.
Bronze, height 64″, weight c. 440 lbs.
Archaeological Museum, Châtillon-sur-Seine

312, 313, 314. *The Vix Krater* (details)

technical and artistic skill, they did not need a great quantity of material. Corinth, famed for its bronze, was certainly an important center, but, a little unexpectedly, Sparta also was a leader in the art in the sixth century. One of the most magnificent of all Greek bronze vessels, the gigantic krater found in a chieftain's tomb at Vix in France (figs. 311–14), is thought by many to be Laconian rather than Corinthian.

Architectural Sculpture

The Archaic period is rich in architectural sculpture. At the beginning are the limestone pediments from the temple of Artemis at Kerkyra (Corfu), of which the eastern is very fragmentary but the western has survived almost complete (fig. 315). The center of the pediment is dominated by a huge figure of Medusa (fig. 316).[22] On some temples simply the head of Medusa appears, but here is the whole figure—and not Medusa alone, but two large felines, which we may call leopards from the circular spots with which they are adorned. Medusa is one of the old goddesses of the earth, and as such she is Lady of the Beasts (*potnia theron*) like the oriental goddess whom the Greeks found in Asia Minor and identified with Artemis, and who is a favorite subject on vases (see fig. 247) and in statuettes. Two smaller figures appear between her and the leopards, one on each side: they are her offspring, the winged horse Pegasos, and the boy Chrysaor ("golden sword") who sprang from her severed neck when Perseus beheaded her. By a pardonable anachronism the designer has anticipated this catastrophe and shown them already in existence. This group might reasonably have been considered sufficient for the decoration of the pediment, but to fill the available space completely the designer has introduced a number of smaller figures in the angles who seem to have no connection with the main group. On our right the scene is certainly a battle of gods and giants, since the next group is Zeus attacking a giant with his thunderbolt (fig. 317). This is an extreme example of the difficulty of bringing the central figures of a pediment, which must be large in order to fill the ample space in the center, into relation with those in the corners, which must necessarily be small.

An ingenious solution was found by the designer of a pediment for the "Old Temple of

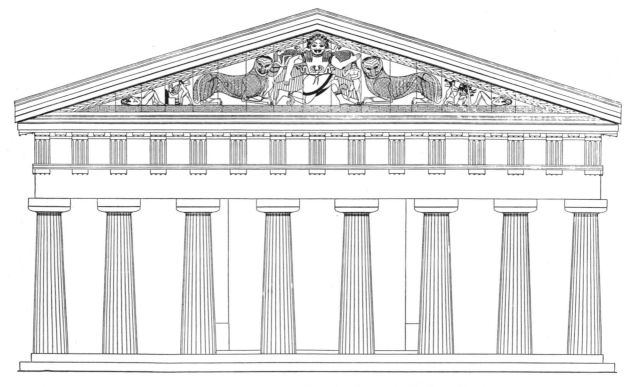

315. Temple of Artemis, Kerkyra (Corfu). Early 6th century B.C.
Reconstruction of the west façade (after G. Rodenwaldt)

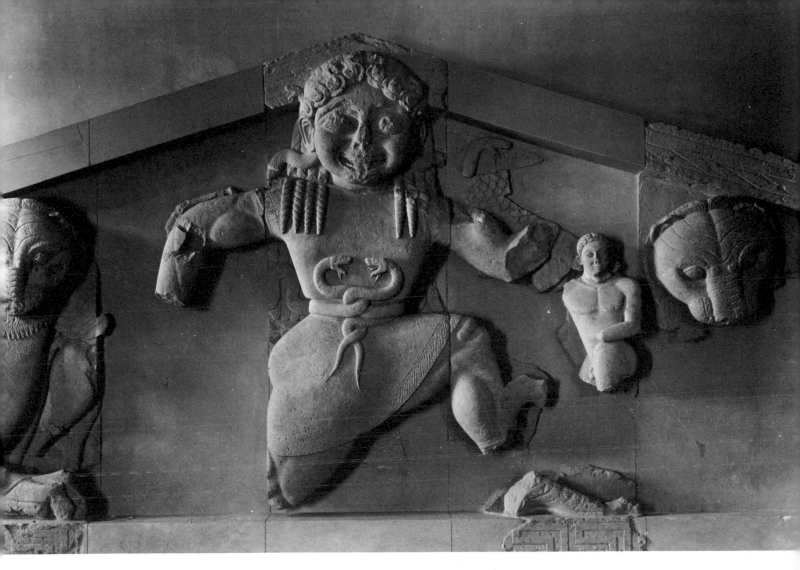

316. *Medusa*, from the west pediment, Temple of Artemis, Kerkyra (Corfu). Early 6th century B.C. Limestone, height of figure 9′ 4″. Museum, Kerkyra

Athena" on the Acropolis at Athens, about 550 B.C. The figures were of limestone and their forms have the boldness of Attic art at the time. The center of the pediment was probably occupied by an old-fashioned orientalizing theme, two lions devouring a bull: but the corners were filled respectively by a group of Herakles struggling with the Triton, and by a monster with three human foreparts and three snaky extremities, the coils of which, like the long fishtail of the Triton, conveniently fill the narrow corners (colorplate 34). Who this creature may be is still uncertain: the snaky extremities suggest a god of the earth, and his expres-

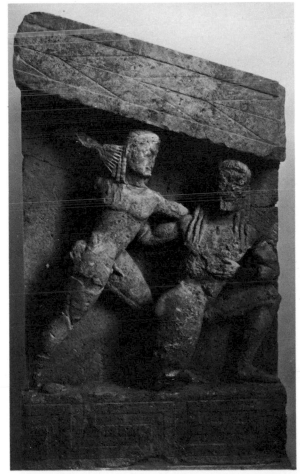

317. *Zeus Attacking a Giant*, from the west pediment, Temple of Artemis, Kerkyra (Corfu). Limestone, height of fragment 8′ 6″.

sions seem to show that he is benevolent (fig. 318). The colors were at one time well preserved, and the youngest of the three heads has a blue beard which has earned him his modern nickname. This pediment is an attractive creation; but a much more imposing one and, because of its more difficult material—island marble—a greater achievement, was that which replaced it about 520 at a rebuilding by Peisistratos. This pediment contained a Gigantomachy, and the designer does seem to have contrived to bring the central figure of Athena into scale with her opponents. Much is missing, but the head of Athena (fig. 319) is tolerably well preserved and shows all the Attic grandeur.

The pediment of Kerkyra must have been by Peloponnesian sculptors, whether Corinthian or not we cannot say.[23] Also Peloponnesian, though a little later in date, are the limestone metopes of the Sikyonian peristyle at Delphi. This building had no walls, but was simply a Doric colonnade supporting a roof under which some trophy, perhaps a racing chariot, was displayed. There was a regular frieze of triglyphs and metopes, and the best-preserved metope is that of the Dioscuri on a cattle raid with the two sons of Aphareus (fig. 320). The leading figure is missing, but in what remains we can see the Dorian feeling for order. The raiders march in quasi-military formation; even the cattle seem to be under discipline, for they are in step, and as they pass us in their

files of three the nearest give a smart "eyes right."

On other metopes of this building the hunt of the Calydonian boar is depicted (fig. 321). The great animal has one metope to itself, and the hunters were shown on others, two or three to each, no regard being paid to the existence of the triglyphs. More remarkable still is the pair of metopes with the ship *Argo* (fig. 322). Its forepart appears on one metope and its stern on another, but the intervening part is not represented at all: it is thought of as continuing behind the triglyph. Two horsemen, the Dioscuri, are on board, and they are shown in frontal view: this to modern eyes extraordinary conception, the frontal horse, and also the frontal chariot, is not uncommon on vases and seems not to have been uncommon in sculpture.

The two greatest temples of the Eastern Greeks were each dedicated to a mother goddess. Of the temple of Hera at Samos no sculptural remains have been found. The other,

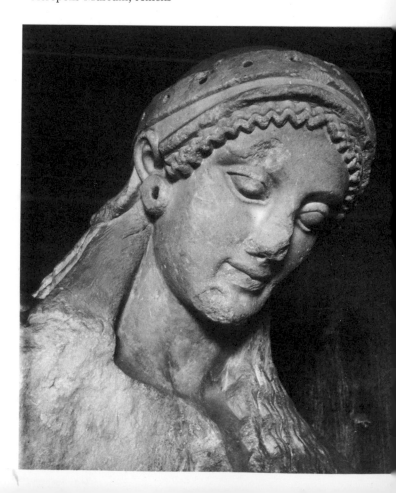

319. *Head of Athena*, portion of a figure from a pediment of the Peisistratid Temple of Athena, Acropolis, Athens. c. 520 B.C. Marble, slightly over lifesize. Acropolis Museum, Athens

318. "*Bluebeard,*" one head of the triple-bodied monster (see colorplate 34) from a pediment of the "Old Temple of Athena," Acropolis, Athens. c. 550 B.C. Limestone, height c. 14". Acropolis Museum, Athens

above left: 320. *The Dioscuri and the Apharetids
Stealing Cattle*, metope from the Sikyonian
Peristyle, Delphi. c. 570 B.C.
Limestone, height 22 7/8″. Museum, Delphi

above right: 321. *The Calydonian Boar*,
metope from the Sikyonian Peristyle, Delphi

left: 322. *The Ship Argo*,
metope from the Sikyonian Peristyle, Delphi

the Ionic temple of Artemis at Ephesos, erected
about 540 B.C., was destroyed by fire two
centuries later, and its remains, excavated
between 1869 and 1874, are extremely frag-
mentary. An exceptional feature of this temple
was the sculptured lower drums of the great
columns of the façade, an oriental idea which
was perpetuated when the temple was rebuilt in
the fourth century B.C. These early drums too
are broken into small pieces, but enough re-
mains to show that they were carved with
lifesize figures, and one or two heads of excep-
tionally high quality and distinctive Eastern
Greek style are preserved (fig. 323).

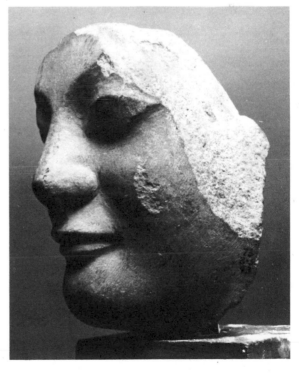

323. *Head*, column-drum fragment
from the Temple of Artemis, Ephesos.
c. 540 B.C. Marble, height 7 1/2″.
British Museum, London

Another famous though much smaller building was the treasury of the Siphnians at Delphi. About 525 B.C. the Siphnians discovered rich mines of gold and silver on their island, and with some of their new wealth decided to erect a treasury at Delphi.[24] It consisted of a single chamber with a portico supported by two korai. A sculptured band ran around all four sides of the building at the top of the walls, and there was a low pediment at each end: the whole was of marble. Although the marble band of sculpture is continuous, the subjects of the frieze on the four sides are not associated with one another. The style is Eastern Greek, though exactly where the sculptors came from is uncertain, perhaps from one of the islands—Samos is possible. The north frieze (figs. 324–27), with its battle of gods and giants, is the most successful as a composition: it is based on a carefully thought-out design, which takes account of what is going on behind the front plane.

The composition is most skillful, the movement being inward from the two ends: but within this frame the waves of attackers and defenders sweep into and pass each other freely, conveying admirably the sway and turmoil of battle. That this free movement in space owes anything to painting is not certain but not unlikely. There are some masterly vignettes: Hera turning to strike somebody who is already down (fig. 324); Hephaistos using his bellows to heat the ammunition (at the extreme left of figure 325); a giant fleeing in terror with his helmet crest and chiton blowing back in the breeze (figs. 325, 327); and, most dramatic of all, the incident which causes his alarm, the two lions of Cybele's chariot remorselessly pulling down and devouring one of his companions (figs. 325, 326). Whether we take into account the limitations of Archaic art or not, the total effect is superb, and there is no wonder that Herodotus refers to this little building as one of the richest in Delphi. The same theme, the attack of the giants on the gods, was handled some three hundred and fifty years later by the sculptors of the Great Altar at Pergamon, on a scale about ten times as large (see figs. 552–55). A comparison of the two makes clear some of the changes that had taken place in the Greek world and the Greek mind in those three-and-a-half centuries.

324. *Hera and Athena Attacking Giants*, north frieze (portion), Siphnian Treasury, Delphi. c. 525 B.C. Parian marble, height of figured relief c. 26″. Museum, Delphi

325. *Battle of the Gods Against the Giants*, north frieze (portion), Siphnian Treasury, Delphi

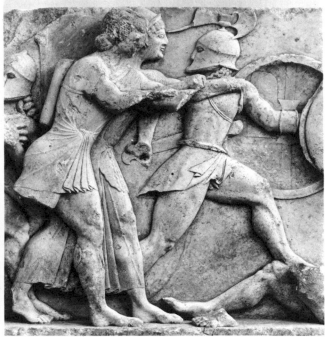

326, 327. *The Lions of Cybele Attacking a Giant*, and *Fleeing Giant* (details, north frieze, Siphnian Treasury, Delphi, fig. 325)

The Siphnian east frieze (figs. 328, 329), though less successful as a composition, is equally interesting. Two scenes are presented together, but one is on Olympos and the other on the plains of Troy: the division comes in the center of the frieze, and since the subjects are so different, the one an assembly, the other a battle, the result lacks harmony. Thetis is appealing to Zeus against the treatment of her son Achilles: this important incident is de-scribed by Homer, but the whole frieze does not correspond exactly to any passage in the *Iliad*, and we cannot identify the combat that is taking place meanwhile before Troy (fig. 329). The arrival of Thetis and her appeal provoke a brisk discussion and some disagreement among the Olympian gods: this is shown by their gestures, and by the way they turn in their seats to touch and talk to one another (fig. 328). The whole effect is one of lively excitement,

328. *Council of the Gods*, left half of east frieze, Siphnian Treasury, Delphi

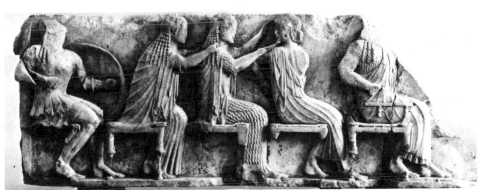

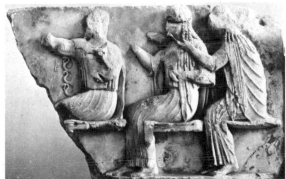

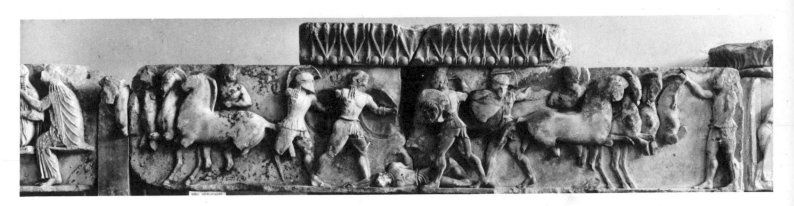

329. *Battle Between the Greeks and the Trojans*, right half of east frieze, Siphnian Treasury, Delphi

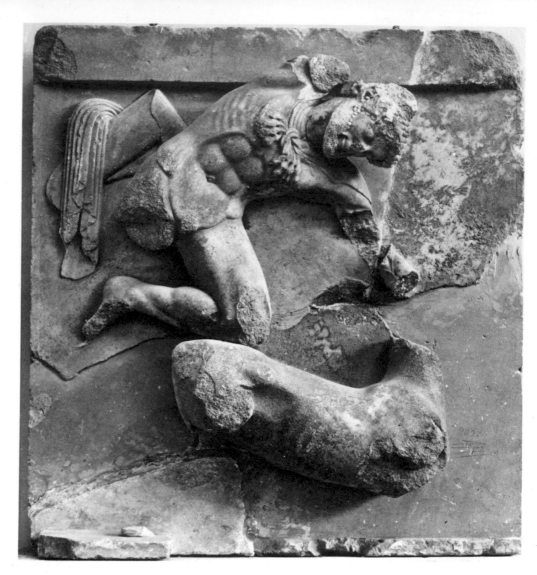

330. *Herakles Slaying the Hind*, metope from the Athenian Treasury, Delphi. c. 500 B.C. Parian marble, height 26 3/8″. Museum, Delphi

331. *Head of Herakles* (detail of metope in fig. 330)

with the various gods cleverly characterized: Ares sits somewhat apart: his only interest is that the war should go on.

Yet another treasury at Delphi was that of the Athenians. This was a Doric building of similar plan to the Siphnian and to most other treasuries, but its portico was supported by Doric columns and not by statues, and its decoration consisted of a pediment and the normal Doric frieze of triglyphs and sculptured metopes (figs. 330, 331). It can be dated to about 500 B.C., and shows Athenian Archaic sculpture in a late phase of great refinement comparable in its linear delicacy with contemporary vase painting.

256

333. *Head of Theseus* (detail of group in fig. 332)

Of about the same date and excellently carved, but not distinctively Attic in style, are the fragmentary remains of a pediment from the temple of Apollo at Eretria.[25] The sculpture that does survive is in a fresh condition: the temple was destroyed in the Persian invasion of 490 B.C., shortly after its erection. Athena, facing the front, was in the center of the pediment, while Theseus was on our right, mounting his chariot, with his arm about the Amazon Antiope who already stood in it (figs. 332, 333). This satisfactory solution of the difficulties of scale in a pediment was achieved by placing a deity of larger, but still not excessively large, size in the center, and it seems to have become the standard practice: the use of horses to form a transition between the central figures and those in the corners also became common.

332. *Theseus Abducting Antiope,* from the west pediment, Temple of Apollo Daphnephoros, Eretria (Euboea). c. 500 B.C. Parian marble, height 43″. Museum, Chalcis (Euboea)

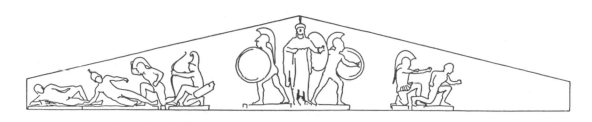

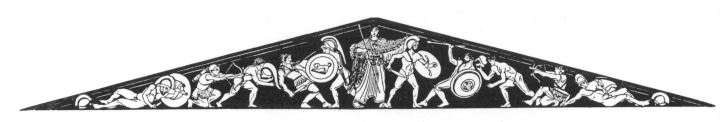

top: 334. Temple of Aphaia, Aegina. *Reconstruction of the west pediment* (after E. Schmidt, 1959)

above: 335. Temple of Aphaia, Aegina. *Reconstruction of the east pediment* (after Furtwängler)

336. *Athena*, from the west pediment,
Temple of Aphaia, Aegina.
c. 510 B.C. Parian marble, height 66″.
Staatliche Antikensammlungen, Munich

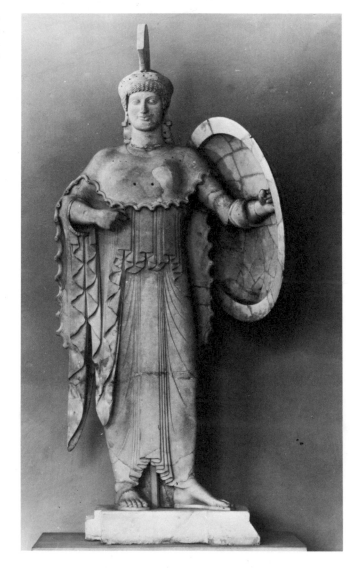

Athena held the central position in the pediments of the temple of Aphaia in Aegina, latest and most fully developed of Archaic temples.[26] Two pediments were carved about 510 B.C., but the eastern one was destroyed in the Persian invasion of 490, and was replaced by the second east pediment probably between 490 and 480. This is, then, about twenty years later than the west, and there are interesting differences between the two (figs. 334, 335). The Athena in the middle of the west pediment (fig. 336) is a rigidly Archaic figure carved with a dry brilliance which may partly derive from the Aeginetan tradition of bronze statuary, for it pays little heed to the nature of the marble. On the other hand, the oriental archer from this same west pediment (fig. 337) is more sensitively carved and has much in common with the later east one. There, the Athena in the center (fig. 338) seems to have been standing not rigidly, but swaying the battle with a gesture of her outstretched arm which foreshadows

338. *Head of Athena*, from the east pediment,
Temple of Aphaia, Aegina.
c. 490–480 B.C. Parian marble, height 12″.
Staatliche Antikensammlungen, Munich

337. *Oriental Archer*, from the west pediment,
Temple of Aphaia, Aegina.
c. 510 B.C. Parian marble, height 41″.
Staatliche Antikensammlungen, Munich

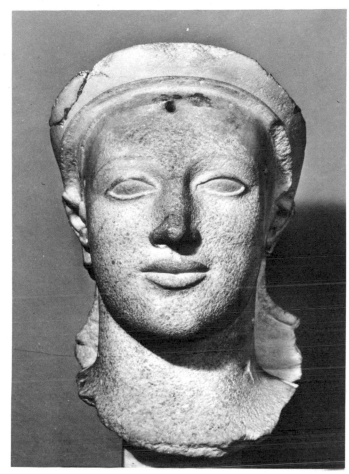

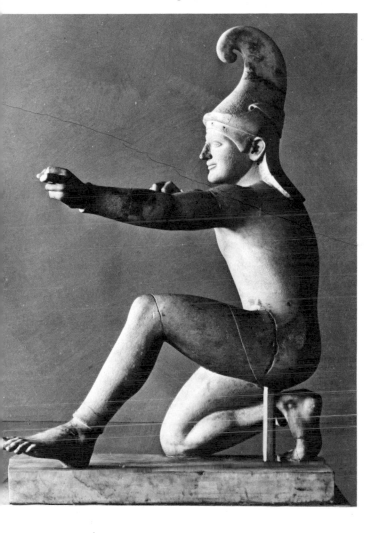

that of Apollo in the west pediment at Olympia.[27] Her head is an exceptionally beautiful piece of carving to which no photograph does justice. In general the figures in the new east pediment from Aegina move more freely than those in the old west pediment, and the greater tension and more elaborate composition of the archer (fig. 339) contrast with the easier,

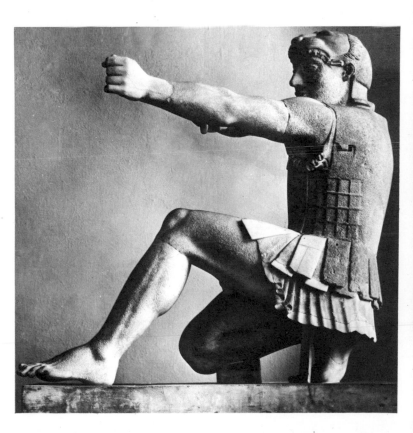

339. *Archer*, from the east pediment,
Temple of Aphaia, Aegina.
c. 490–480 B.C. Parian marble, height 30″.
Staatliche Antikensammlungen, Munich

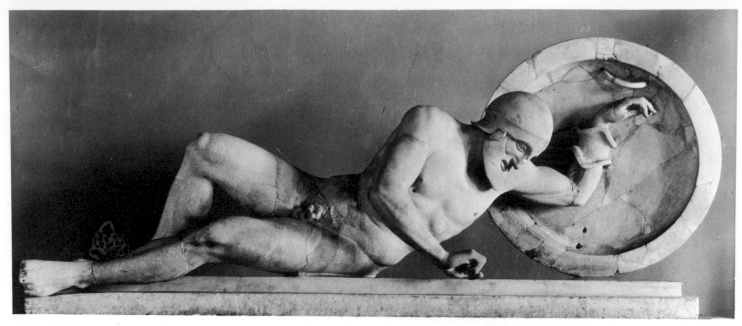

340. *Wounded Warrior*, from the east pediment, Temple of Aphaia, Aegina.
c. 490–480 B.C. Parian marble, height 24″. Staatliche Antikensammlungen, Munich

simpler rhythm of his earlier counterpart (fig. 337); while in the wounded warrior (fig. 340) in the northern corner of the east pediment there is an attempt, unique up to now, to express in the features the distortion of pain. Most striking of all is the head of a dying man (fig. 341), which seems studied direct.

In addition to freestanding statues, and to sculpture in high and low relief for the decoration of buildings, there were also freestanding reliefs. These were mainly used for two purposes, as grave monuments and as votive reliefs. In Attica there is a long series of low reliefs designed for grave monuments, which seem to have developed from a stone slab, either uncarved or with simple decoration. These, with some influence from Egypt, came about 600 B.C. to have the form of a tall flat pilaster surmounted by a capital that supports a sphinx (fig. 342). The pilaster was carved in low relief with a representation of the dead man in profile; but the sphinx, although designed to face the front, was in the round. After being in vogue for a couple of generations and becoming sometimes very large and tall, the sphinx-topped form was superseded by an-

other form, somewhat similar in appearance, but less tall and capped with a palmette. In both types the dead man was shown as if alive, and there was usually some indication of his prowess or of the manner of his death: an athlete holds a discus or a throwing-spear; a man who died in battle is shown in armor (fig. 343). More rarely, two people are represented: one of the largest examples has a brother and

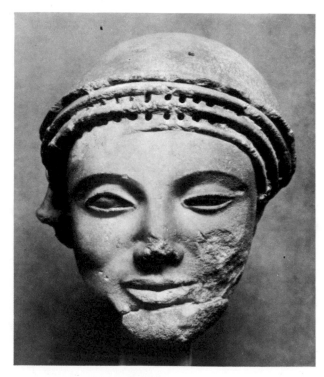

341. *Head of a Dying Warrior*, from the east pediment, Temple of Aphaia, Aegina.
c. 490–480 B.C. Parian marble, height 9 1/8″. Staatliche Antikensammlungen, Munich

260

342. *The Megakles Stele.* c. 540 B.C.
Marble, height of reconstructed fragments 13′ 10 3/4″.
The Metropolitan Museum of Art, New York
(Hewitt Fund, 1911; Rogers Fund, 1921; Munsey
Fund, 1936, 1938; Anonymous Gift, 1951)

343. *Stele of Aristion.* c. 510 B.C.
Pentelic marble, height without base 81″
National Museum, Athens

sister (fig. 342); one of the most moving, a mother and child (fig. 344).[28]

Votive reliefs are less uniform and, in the Archaic period, rarer than the grave reliefs. One of the most interesting is from the Acropolis at Athens (fig. 345): three women, led by a man playing the flutes, are dancing; the last woman holds a boy by the hand. These are probably three nymphs of fertility who had a shrine on the Acropolis, and may be the nymphs who, in legend, were charged with the care of the infant Erichthonios. Votive reliefs were dedicated in the shrines of deities, and they sometimes show the deity alone; but it soon became customary to include the dedicator as well (though on a smaller scale), and this is the common type in the Classical period when votive reliefs were at their most numerous.

344. *Mother and Child Stele.* c. 530 B.C.
Marble, height of fragment 15 1/4". National Museum, Athens

345. *Nymphs*, votive relief from the Acropolis, Athens.
c. 510–500 B.C. Marble, height 15 1/2".
Acropolis Museum, Athens

8

The Early Classical Period (480–450 B.C.)

HISTORICAL INTRODUCTION TO CHAPTERS 8 AND 9

After the final repulse of the Persians in 479 B.C. there came one of those rare and brief periods when the Greeks felt a sense of unity; but this unity was weakened by the memory that some cities had favored the Persians, and by the current rivalry between Athens and Sparta for leadership. Athens hastily rebuilt her shattered walls; and the maritime League of Delos, formed to keep the Persians in check, gradually became a source of Athenian wealth and an instrument of Athenian domination. Between 450 and 430 there was a great concentration of power and artistic ability in Athens under Perikles. But the plague of 430 and the Peloponnesian War—begun the year before—which dragged on to end disastrously in Sicily in 413, and was followed by the decisive defeat at Aegospotami in 405, left Athens powerless and in a condition bordering on anarchy. The next generation saw Sparta dominant, but both it and Athens unscrupulously sought Persian money and aid for use against one another, until Thebes, under Epaminondas, exercised for a decade after 371 B.C. an enlightened but still narrowly Hellenic leadership. About 350 the rise of Macedonia was the presage of one of the most momentous changes in history, brought about by the Eastern campaigns of Alexander the Great.

POTTERY AND PAINTING

Soon after 480 it is possible to feel a slight change in the general temper of Attic vase painting. There is a little less emphasis on action and a little more on character. A

263

skyphos by the Pistoxenos Painter may serve as an example (figs. 346, 347). On one side is a music lesson: a pupil, Iphikles, seen to be docile by his narrow eye, is receiving instruction from his teacher Linos, an unsympathetic character who is bald, has a thinning beard and a glassy eye. Iphikles, the brother of Herakles, was the son of Alkmene and Amphitryon, whereas Herakles was the son of Zeus by the same mother. Herakles himself is on the other side of the cup: he is curly-haired, with widely opened eye; he carries a dangerous toy in the form of a long stick like an arrow, and he is being shepherded along to his lesson by an old Thracian slave. The story was that Herakles fell out with his tutor and brained him with a lyre; and the fatal weapon, a heavy concert instrument, must surely be that which is seen hanging on the wall near Linos.

More profound changes are evident in the vase painting of the next decade or two. Until now the figures have all been on one level, sharing a single groundline; but now on some vases they stand on different levels, with small irregular lines under them suggesting uneven or rocky ground, and here and there is a tuft of herbage. This new kind of arrangement is not a vase painter's invention, and must have been copied from paintings on a flat surface and on a larger scale.

We know that this was the time when large paintings on walls, or on panels fixed to walls, were being commissioned in Athens and elsewhere. A leading painter at Athens was Mikon; but far more famous was Polygnotos, a native of the island of Thasos in the northern Aegean, who was later an Athenian citizen. Pausanias gives us a detailed account of his large paintings in Delphi of the Sack of Troy and of the Underworld. Polygnotos does not seem to have attempted any general scheme of perspective and he did not use shading, but he set the figures at different levels and introduced certain landscape elements such as rocks and trees, pebbles (for the seashore), and cliffs. Pliny says that he painted drapery transparent, mouths open with the teeth visible, and put more expression into the faces. We can deduce from the descriptions that his choice of subjects was rather different from the Archaic: there was less action, and more study of its motives and results.

From these literary accounts we can gain some idea of the subjects, the main composition, and even the details of the subjects, but they convey nothing of his essential achievement: nor do the vases give much help here. From the description by Pausanias one gets the impression of a number of single figures, or very simple groups, set alongside or above one another, with little attempt to unify the picture into a single composition except perhaps by balance. It seems as if the effect lay in the expressiveness of the face or figure of individuals, and the expression of character and emotion: much the same may be said of the contemporary sculptures on the temple of Zeus at Olympia. Polygnotos was also praised for the

346. THE PISTOXENOS PAINTER. *Iphikles and Linos*, skyphos from Cerveteri (Italy). c. 470 B.C. Height 5 3/4". Staatliches Museum, Schwerin

347. *Herakles and Geropso* (other side of skyphos in fig. 346)

348. THE NIOBID PAINTER.
The Rescue of Theseus from Hades (?)
calyx krater from Orvieto.
c. 455–450 B.C. Height 21 1/4″. The Louvre, Paris

below: 349. *Herakles and Heroes*
(detail of calyx krater in fig. 348)

bottom: 350. *Artemis and Apollo Slaying the Niobids*
(other side of calyx krater in fig. 348)

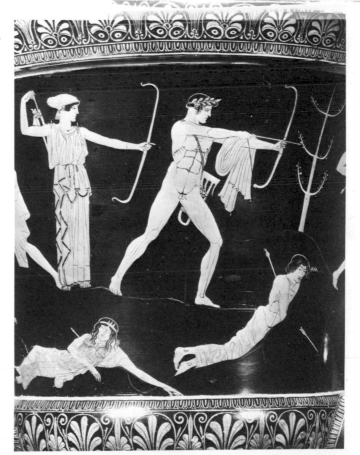

nobility of his figures, and from the vases one can occasionally gain a faint impression of what is implied by this.

The Niobid Painter, so called from one scene on a krater in the Louvre (figs. 348–50), must certainly have had a wall painting in mind: obviously too some of the individual poses are borrowed from the major art. Red-figure does not lend itself readily to landscape, and it is likely that more of this appeared in the wall painting than the starveling tree in front of Apollo on the vase (fig. 350). Rocks and rough ground are lightly sketched: we can see their purpose in a wall painting for suggesting

space and distance, whereas on a vase they run counter to the painter's main intention, which is to decorate a surface.

A new device which certainly comes from wall painting is the concealment of parts of the body by rocky ground. A good example is the son of Niobe who has fallen at the feet of Apollo with an arrow in his back (fig. 350): he lies in a crevice which conceals the whole of one side of the body, part of his left foot, his right forearm, part of his left cheek, and the whole of his left arm except the fingers, which come forward to grip a projection of the rock at the top. The story of the Niobids was well known and it was unnecessary to put the names next to the figures: none in fact is given. But on the other side of the vase there is another scene, also clearly taken from a larger painting and again without names, which has so far baffled the critics (figs. 348, 349). A number of men, mostly armed, are sitting or standing about in a rocky landscape. Two figures are recognizable with certainty, the goddess Athena and Herakles, who wears a wreath but seems from his expression to be sad or anxious.

The same dependence on a major painting is evident as in the scene of the Niobids: in

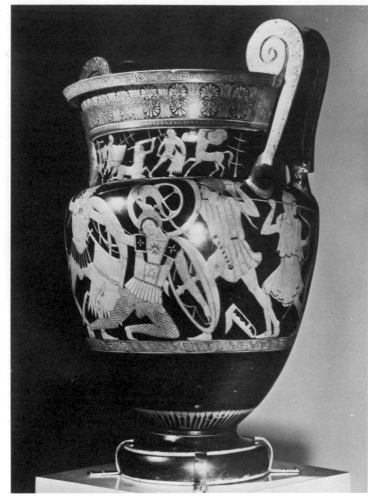

351. THE NIOBID PAINTER. *Amazonomachy* and *Centauromachy*, volute krater from Gela (Sicily). c. 460 B.C. Height 30 5/8″. National Museum, Palermo

particular one may notice the self-conscious attempt, not quite successful, to represent shields in three-quarter view from behind, and the unusual poses and angles of view elsewhere—for instance, in the man seated below Herakles, the foreshortenings of whose limbs and face are again not entirely successful. On other vases the same painter imitates even more closely, and with excessive regard for the details of armor and for the falling weapons (which may have been tolerable in the original but look absurd on the vase), scenes taken from great wall paintings—here possibly a battle of Greeks and Amazons by Mikon (figs. 351, 352)—but the result is lifeless and tedious.

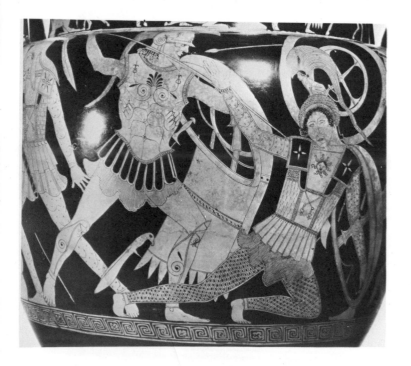

352. *Amazonomachy* (detail of volute krater in fig. 351)

Occasionally the vase painters, though still imitative, succeed in creating a work of art. The large cup with Achilles killing Penthesileia (fig. 353) has a certain pathos, although one cannot help being conscious of the contortions by which it has been attained. Something of the spirit of a greater original survives in the meeting in the Underworld between Odysseus and the ghost of the hapless Elpenor (fig. 354), who fell from the roof of Circe's house and remained unburied when the ship sailed. But in general, the great achievements of wall painting, instead of helping vase painting, do it irreparable injury.

353. THE PENTHESILEIA PAINTER.
Achilles Slaying the Amazon Queen Penthesileia, interior of a kylix from Vulci (Italy).
c. 455 B.C. Diameter 16 7/8″.
Museum Antiker Kleinkunst, Munich

354. THE LYKAON PAINTER. *Odysseus and Hermes with the Ghost of Elpenor in the Underworld*, pelike.
c. 440 B.C. Height 18 5/8″.
Museum of Fine Arts, Boston

ARCHITECTURE

The outstanding building of the Early Classical period was the temple of Zeus at Olympia. It can be dated with certainty because it was built from the spoils of a campaign which took place about 470 B.C., and it was sufficiently complete to have a golden shield fixed to a pediment after the battle of Tanagra in 457. Its architect was Libon, a native of Elis, and it was of purely Doric design, with no Ionic admixture. Its simple plan and carefully disposed sculptural decoration show the Dorian mind at its highest—austere, logical, and majestic (fig. 355). The external decoration, which is discussed below (see pp. 281–87), consisted (apart from the acroteria which broke the skyline at the top and ends of the gables) of two pedi-

355. LIBON. Temple of Zeus, Olympia. 470–456 B.C.
Reconstructed east façade and *cross section at pronaos entrance*

ments; the Doric frieze of triglyphs and metopes, over the external colonnade, was unsculptured, an arrangement which has the merit that two kinds of sculpture of different scale and different height of relief—pediments and metopes—are not juxtaposed, and that the eye is not diverted from the pedimental sculpture. Metopes there were, however: twelve in number, six over each inner portico at front and back, and set between triglyphs in the orthodox way above the Doric columns of the porticoes. They were thus invisible from a distance, but as the visitor reached a certain point on the ramp by which the temple was approached, he found the six metopes of the east end displayed above him; and a similar viewpoint at the back allowed the other six also to be seen as a series.

The sculptures were of Parian marble, but the temple itself was built of coarse conglomerate from a local quarry, covered with a fine stucco made of powdered marble. Except for the sculptures, all that remains today is the main platform on which the temple rested, a number of column-drums and capitals, and some of the entablature.

Two other temples must be almost contemporary with Olympia, and they are better preserved. One is the temple of Hera, once thought to be of Poseidon, at Poseidonia (Paestum), which, although it has lost all its stucco and is now a golden-brown color, con-

356. Temple of Hera II, Paestum. c. 460 B.C. *View from the southeast*

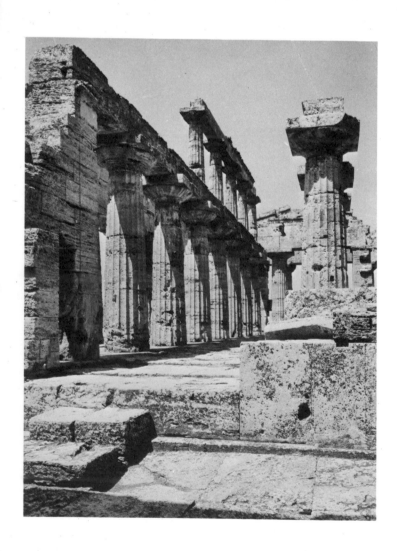

veys more strongly perhaps than any other building the grandeur of Classical Doric (fig. 356). Later buildings may be more refined and have more intellectual content, but the temple at Paestum makes on many people a greater emotional impact. It also preserves, as does the late Archaic temple at Aegina (see p. 230), part of the interior colonnade consisting of two superimposed ranges of columns (fig. 357): this served as a frame and a background for the cult statue, but its main purpose was to support the roof. Seeing the skeleton in this way one can grasp the essential simplicity of most Greek temple plans: it is only when the detail is studied that one realizes the amount of thought that is necessary in the actual construction of a building designed to a modular scheme, in which every part must be correctly related in

357. Temple of Hera II, Paestum. *View of interior*

358. Temple of Athena, Syracuse. c. 480–460 B.C.
View of colonnade, built into wall of later cathedral

position and measurement to every other part.

Equally impressive, though partly for another reason, is the temple of Athena at Syracuse (fig. 358). This has been incorporated in the later cathedral, and although little of it can be seen from outside, the visitor when inside suddenly realizes that most of the temple is there, thinly concealed. The existence of a roof enables him to judge, in a way that is not always easy out of doors, the size and profile of the columns.

Another building of this period was the Heraion at Selinus in Sicily, again built of stuccoed limestone. Its peculiarity is that the metopes are of limestone, but the arms, feet, and faces of the women are of Parian marble (see p. 287): this shows not only that marble was extremely precious here, but that the coat of color cannot have obscured its quality.

SCULPTURE

Freestanding Sculpture

The changes that took place about 480 B.C. and caused the disappearance of the Archaic styles were due to the realization, how consciously reasoned or not we cannot say, of two things: first, that Archaic statues, for all their charm, did not fully correspond to the way in which the human body and its clothing functioned; and, second, that Archaic sculpture showed the human being from outside, shallow, independent, and, if in action, doing rather than feeling—an animal, however splendid. The results of this realization were also therefore twofold. One was the attempt to present the human body as it really was, especially in the way it was poised and in the effect of the uneven distribution of weight (for a man rarely stands for long at attention) on the various limbs and also on the clothing. The second was to make both body and face express some feeling, to give some indication of what was passing in the mind, not only of what was being done by the body. From this it followed that in relief sculpture—and the same is true of pictures on vases—the figures are not always in action; the spectator is left to infer from the expression of the face and the attitude and gestures of the

body what action had been completed, or what was contemplated, and the emotions aroused by them: expectancy, doubt, delight, despair, remorse.

The statue which for us today most clearly illustrates the changes of anatomy and poise is the so-called Kritian Boy (fig. 359), because it is the same apparently simple subject as the

359. *The "Kritian Boy,"* from the Acropolis, Athens. c. 480 B.C. Parian marble, height 33 7/8″. Acropolis Museum, Athens

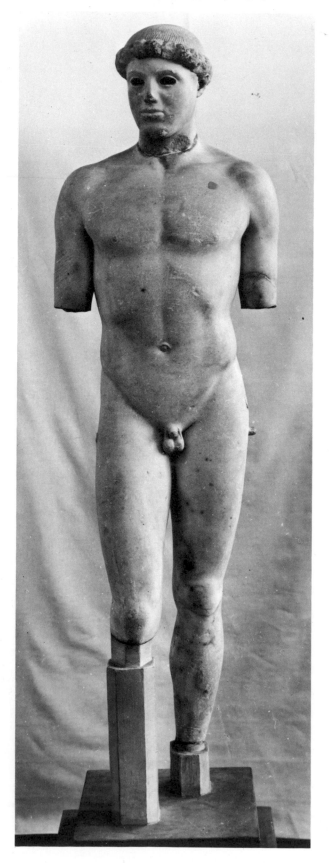
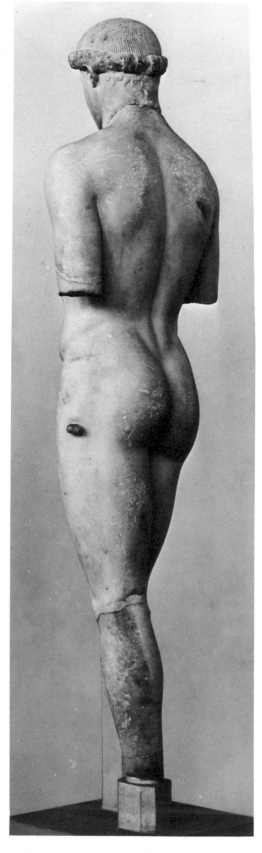

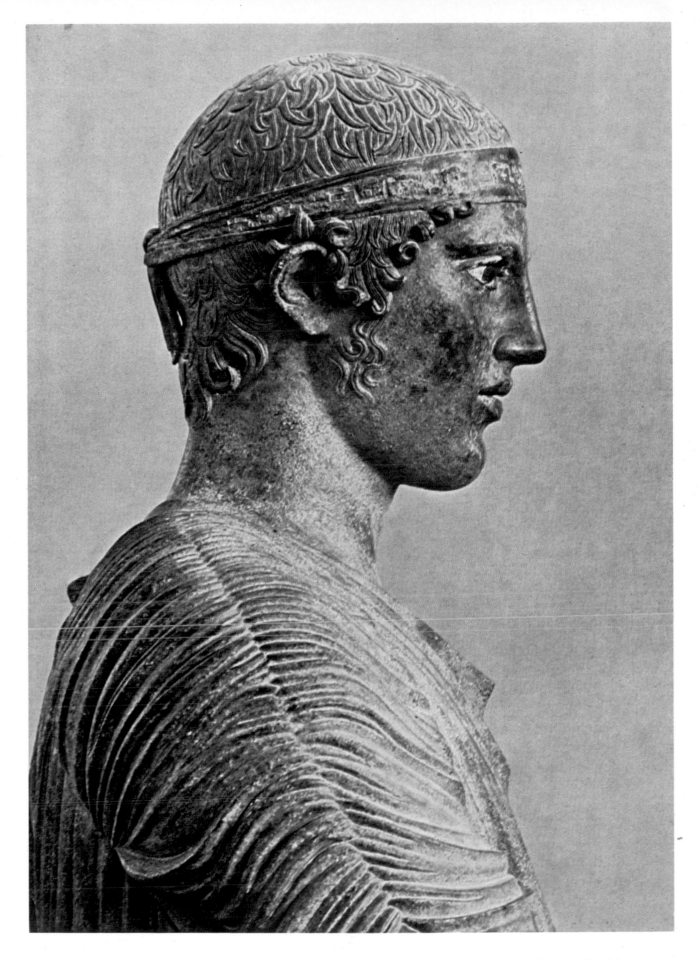

Colorplate 35. *Charioteer* (portion; see fig. 366), from the Sanctuary of Apollo, Delphi. c. 470 B.C. Museum, Delphi

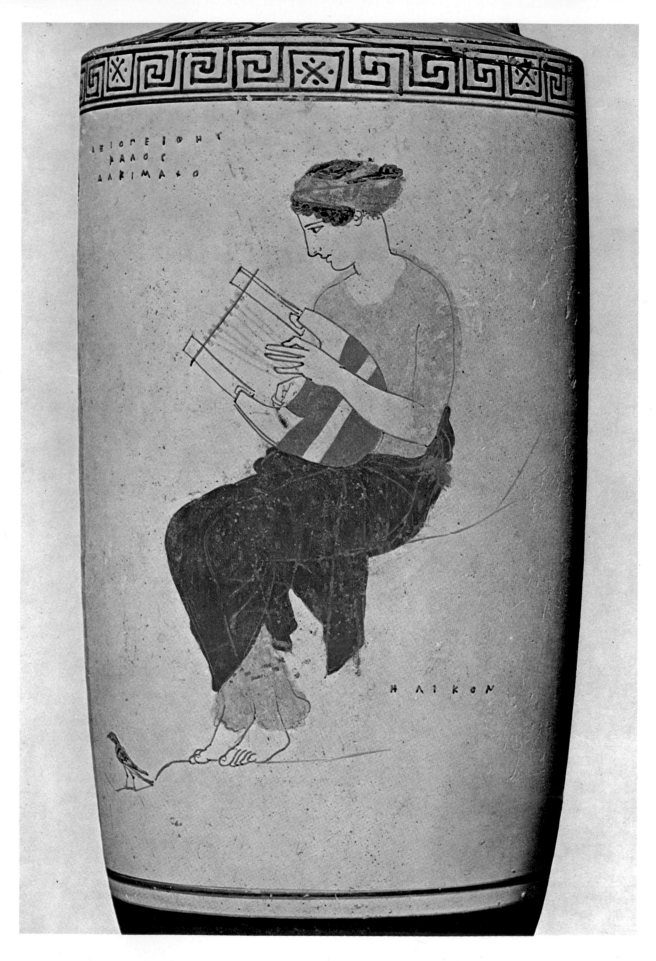

Colorplate 36. THE ACHILLES PAINTER. *Muse on Mount Helikon*, lekythos (portion).
Attic, c. 445 B.C. Height of whole 14 1/2″. Staatliche Antikensammlungen, Munich

kouros, a standing naked male figure (see fig. 290). Its name is modern, having been given because it resembles in style the copies of a lost bronze group by Kritios and Nesiotes of the tyrant slayers Harmodios and Aristogeiton (fig. 360), which was set up in 477 B.C. to commemorate the killing of Hipparchos thirty years before. Whereas the Archaic kouros stood with both shoulders and both hips level and looked straight ahead, the Kritian Boy turns his head to his right so that the shoulders are no longer symmetrical: and, more important for the stance, his left hip is higher than his right. This is not due simply to the sculptor's desire for variety, but is caused by his realizing that the forward movement of one leg, common to all kouroi, should have affected the position of other bones and muscles. He himself has put the main weight of the boy's body on the left leg, thus freeing the right so that it could in life, as it is in the statue, be set in front of the other. It is this movement that causes the left hip to be higher, and this movement cannot occur in isolation: it inevitably affects the position of the buttocks, and it causes changes, less obvious but still definite, in other parts of the body—for instance, the right shoulder is lower than the left, and nearer to the spectator. The amount of thought and study which the sculptor has given to these new problems has led him to make a successful integration of all the parts of the body, and in particular he has succeeded in fitting the torso and its internal organs (the existence of which he suggests by differentiating in his modeling soft parts from hard parts) into the pelvis. The statue is no longer a sculptural formula but an articulated organism. The stance of the Kritian Boy is in its essentials that of the majority of standing figures of the Early Classical period, and holds the field until outrivaled by the innovations of Polykleitos.

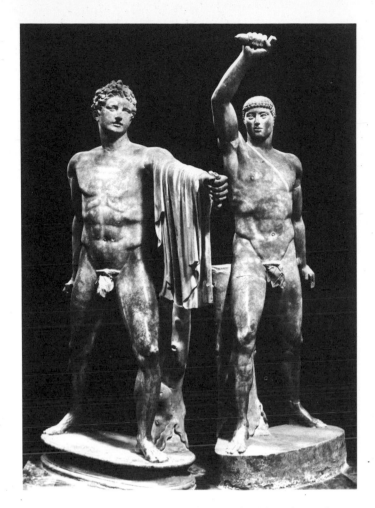

360. Kritios and Nesiotes. *The Tyrannicides Aristogeiton and Harmodios.* Roman copy after a bronze group of 477 B.C. Marble, height 79 7/8". National Museum, Naples

Of the lost bronze group by Kritios and Nesiotes, mentioned above, we have full-sized copies in marble (fig. 360) and tiny reproductions on vases and coins. The older man, Aristogeiton, was protecting Harmodios, who was slashing with his upraised sword; but there is still a doubt how the two figures were set. It was not a closely knit group, nor does it seem to have been quite successful in suggesting one of the most difficult of all themes in sculpture, violent action. But there is a hint that the sculptors were coming to realize that the moment chosen for representation should not be that of the action itself but should be a moment of equilibrium before it.

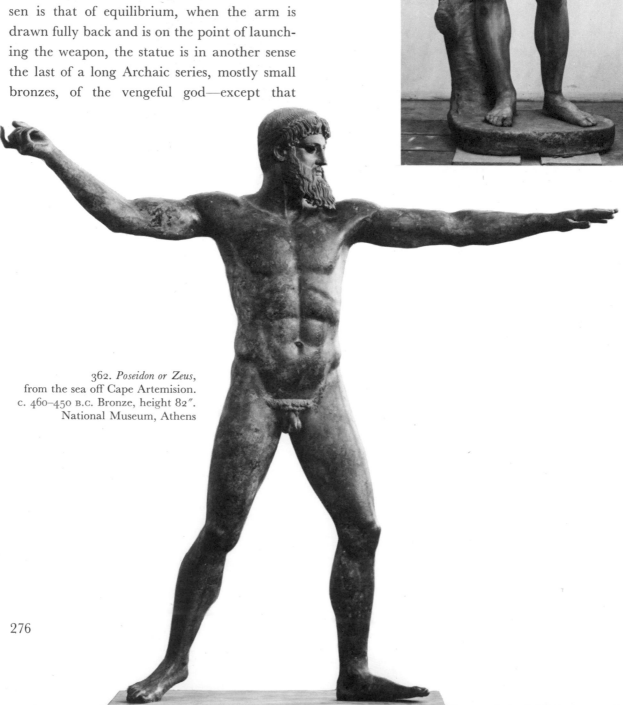

361. *"Choiseul-Gouffier Apollo."*
Roman copy after a bronze original of c. 470–460 B.C.
Marble, height 70 1/2″. British Museum, London

A good example of the new stance is the so-called Choiseul-Gouffier Apollo (fig. 361).[1] This is a well-preserved but rather sketchy copy, whereas a more fragmentary replica in Athens is far more carefully worked. The lost original, a bronze, has been thought to be of a victorious athlete, and there is in fact nothing to distinguish the god, if it be a god, from a human being. This may even be said of another work, an original in bronze (fig. 362) probably by the same sculptor. It was found in the sea off Cape Artemision. Here the subject is certainly a god, either Zeus, if the weapon he was casting was a thunderbolt, or Poseidon, if it was a trident.[2] A stern, majestic figure indeed, but not necessarily divine. Although the moment chosen is that of equilibrium, when the arm is drawn fully back and is on the point of launching the weapon, the statue is in another sense the last of a long Archaic series, mostly small bronzes, of the vengeful god—except that

362. *Poseidon or Zeus,*
from the sea off Cape Artemision.
c. 460–450 B.C. Bronze, height 82″.
National Museum, Athens

276

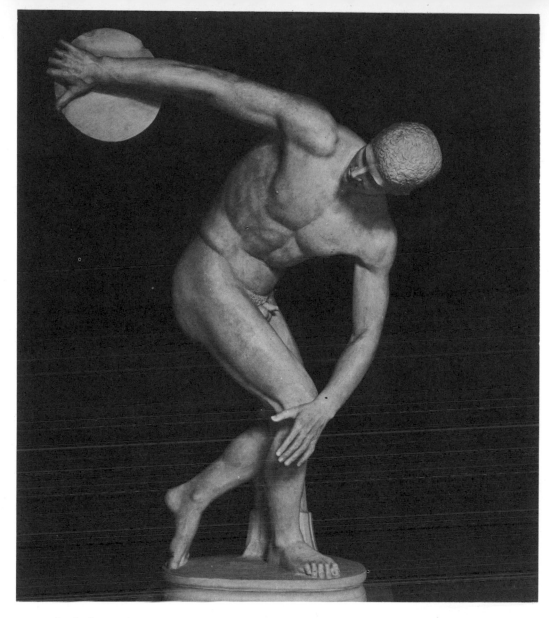

363. MYRON. *Diskobolos.*
Roman copy after a
bronze original of c. 450 B.C.
Marble, height 64 1/2".
Terme Museum, Rome

Archaic artists are not usually so happy in representing the action and show it half completed. Spiritually there is little more to it than that: but if, as some suggest, it represented the god striking at the Persians on behalf of the Greeks, then the subject and the action were appropriate enough. As for composition, one main view was intended, namely that in which the torso is frontal to the spectator and the head almost three quarters, and this provides a fine silhouette. Other views are satisfactory, but this one was evidently the sculptor's chief preoccupation.

In a very famous statue of this same period, the Diskobolos by Myron (fig. 363), again only one main view is intended, that in which the spectator sees the arc formed by the two arms in its fullest extension, cutting the second arc formed by the head, torso, and right thigh. And again the moment of equilibrium is chosen, the fraction of a moment when the pendulum is stationary, the top of the swing. The Diskobolos was certainly a masterpiece, but it was not designed to be primarily what we should call a work of art—no Classical Greek statues were: it was a dedication set up in one of the great athletic centers, Olympia or elsewhere, to commemorate a victory in the Games. Not only is there no emotion shown in the features, no sense of the importance of the occasion, but

there is not even any indication in the face that its owner is engaged in any activity at all. Moreover there is still a touch of the Archaic about some of the details: the hair, for instance, is like a close-fitting cap, and some of the short locks are stylized almost in Archaic fashion; it is even true that the transition between frontal torso and profile legs is not plausible anatomically. It may well be claimed that the statue is none the worse for that, and that it is irrelevant to the statue's sculptural force, but the fact is of interest.

What of the draped statues of this period? Some, known from Roman copies, conform well enough to our general ideas of the Early Classical. There was a fondness for statues wearing the Dorian peplos, because this lent itself to strong generalized forms and bold simple planes. The Hestia Giustiniani (fig.

364),[3] closely related in style to the Choiseul-Gouffier Apollo (fig. 361), is a good example of these "peplos figures," although the dress is not as simple as some because a separate veil is worn. The goddess stands squarely, but her head is sharply turned, which stresses by contrast the vertical strength of the main composition. The design of the upper part of the body is dominated by the folds, few in number but strong in emphasis, created by the projection of the breasts. The lower part of the dress falls in a

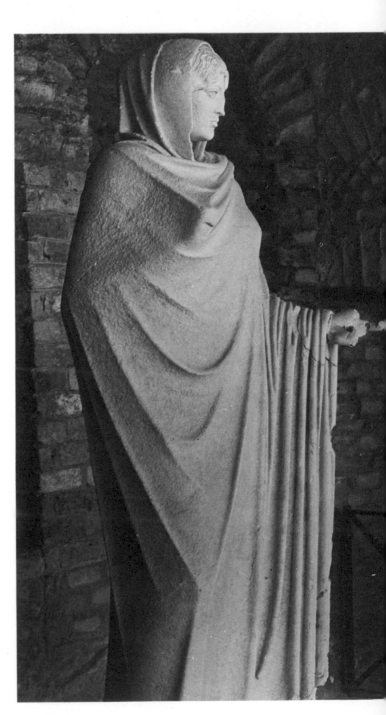

365. *Europa*. Roman copy after an original of c. 470–450 B.C. Marble, height over lifesize. National Museum, Naples

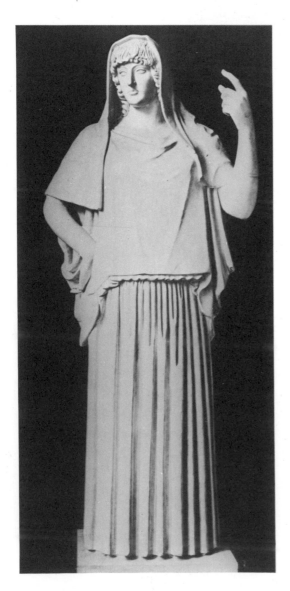

364. "*Hestia Giustiniani*." Roman copy after an original of c. 470 B.C. Marble, height 76″. Museo Torlonia, Rome

number of straight parallel folds defined by deep shadows between: this creates an effect not unlike the fluting of a column, and serves much the same purpose in stressing solidity and verticality. The weight is not in fact evenly distributed between the two legs, but this, though it tells in the design, is not made obvious. In other "peplos figures" the shape of the free leg is allowed to appear and the folds are modified accordingly. This correspondence of form with function—the free leg showing through the drapery, the supporting leg stressed by heavy vertical folds—was much used throughout the fifth century B.C. Dress in this period is not, as in early times, all of a piece with the body, nor is it, as in late Archaic, an entity separate from it: it is still an entity, but it is used to enhance the form and elucidate the action of the body it clothes.

The Dorian peplos was in fashion, but it was not the only wear: another sculptor of this time and of much the same circle has given us a goddess, Europa, the bride of Zeus, wearing the thinner, Ionian dress (fig. 365). But, characteristically, he has covered nearly all of it with a voluminous cloak, which is pulled up to cover the back of the head; the Ionian chiton shows only round the feet. There is great stress again on the verticals, for instance the long fold from the left shoulder to the left foot, and the folds hanging from the left wrist; great breadth of treatment, with no irrelevant details; but within the rocklike mass the pose and stance are made perfectly clear, implicit in every fold.

Another draped figure of the same time but of very different character, which can be dated with confidence to a few years before 470 B.C. because of an inscription by a Sicilian tyrant of Gela on its base, is the bronze Charioteer from Delphi (fig. 366). This is a Greek original, and because of its rarity has perhaps been some-

366. *Charioteer* (see colorplate 35), from the Sanctuary of Apollo, Delphi. c. 470 B.C. Bronze, height 71". Museum, Delphi

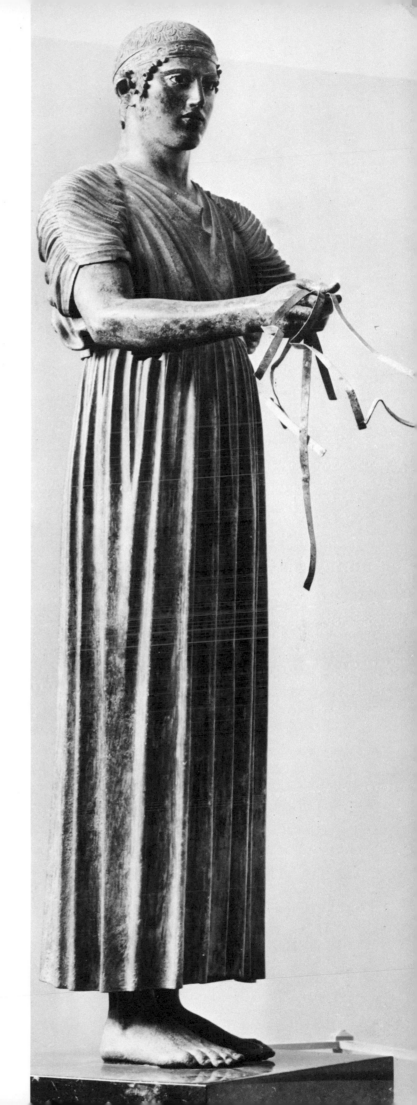

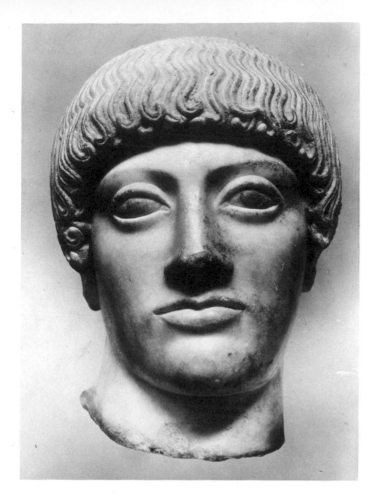

367. *"Fair-haired Boy,"* from the Acropolis, Athens.
c. 480 B.C. Marble, height 9 5/8″. Acropolis Museum, Athens

soldered on, project considerably, but the hair on the crown of the head has no plasticity and is merely a patterned surface of conventional character. The modeling of the face is less sensitive than in many Archaic statues, and were it not for the inset eyes would be almost empty of feeling. This kind of inconsistency is natural at the beginning of the Early Classical period, and does not necessarily impair the statue as a work of art; it may even give the statue a certain piquancy, but the contrasts here are so sharp that they endanger its integrity, making it appear to have been assembled from heterogeneous elements.

The sculptors of the statues just described were all exploiting to a greater or less degree the new discovery that sculpture could show not only the exterior appearance of the body, but

368. *Apollo.* Roman copy after a bronze original of c. 470–460 B.C. Marble, height 77 1/2″. Staatliche Kunstsammlungen, Cassel

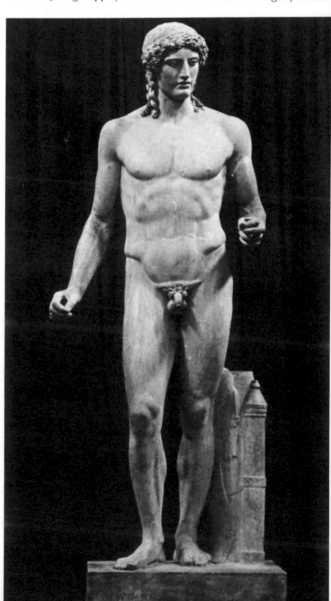

what overrated. The chariot was being led in by a groom, and the charioteer, wearing on his head the ribbon of victory, was standing in it. The dress is long and full, of a type peculiar to charioteers, encircled by a heavy belt above the waist, and gathered on the front of the shoulders and the outside of the upper arms by internal cords: these create a multiplicity of small folds which have been studied and rendered with minute realism. On the chest the folds are broader, and below the belt they fall in strong verticals: all these too are most carefully studied. The hand and the feet are so realistic that they might almost be cast from life. The head is far more formal and varies much from part to part in sculptural intensity (colorplate 35): the loose curls before and behind the ears, which were cast separately and

280

also the way it worked; and some of them also realized that their art was now capable of expressing something of what was going on in the mind. But this is more clearly seen in the "Fair-haired Boy" (fig. 367) from the Acropolis at Athens and in the architectural sculptures of the temple of Zeus at Olympia, with which it has some links of style (see p. 282).

The original of the Cassel Apollo, known from numerous copies in marble (fig. 368) and from reproductions on coins and on a gem, was a bronze set up in Athens. It is in a class apart, for it marks a thoroughgoing attempt to represent a completely ideal superhuman being. The original has been thought to be an early work of Pheidias himself, but by comparison with what we know of other works of his, this is unlikely. Possibly it was the Apollo Alexikakos by Kalamis, a famous sculptor whose style many have tried to identify, but never with success.

Architectural Sculpture

In the sculptures of the temple of Zeus at Olympia, which can be dated between 470 and 456 B.C., Greek sculptors seem first to realize the power and freedom that they have attained to express not only the forms of the human body in all their variety, but also the emotions of the mind. Fragmentary though the sculptures are, and marked here and there by failure to carry out in marble the extremely complicated compositions, they constitute the most powerful, and, partly because of their place in the history of Greek art, the most important body of architectural sculpture that has survived.

But for all their importance, so ignorant are we of the various schools of Greek sculpture that their origin has been much debated. We can be fairly certain what they are not: Attic is unlikely; Eastern Greek highly so; and opinion has veered between Cycladic, North Greek, and Peloponnesian. There cannot be marble sculptors where there is no marble, and the Peloponnesus has few quarries: nor could these great blocks have been worked except by carvers with much experience. Paros had quarries, and did in fact supply the marble of which the sculptures are made: so it is not impossible that it also supplied a number of sculptors. Whether the main designer was among them we cannot say: but whoever he was he succeeded in creating in his team, which must have comprised a great number of sculptors drawn perhaps from many parts of the Greek world, a style which is remarkably homogeneous. There must have been models for the sculpture, perhaps of clay and perhaps of a fairly large size, for it cannot be supposed that works of this complexity were executed without a great deal of preliminary calculation. Who the main sculptor or sculptors were we do not know. Pausanias is of no assistance: he says bluntly that the east pediment was by Paionios, the west by Alkamenes. Paionios, we know for certain, made the statue of Victory set up near the eastern front of the temple (see p. 333), and since he states in the inscription on its base that he also won the competition for the acroteria of the temple, Pausanias may have misunderstood this inscription, or what the local guide told him, and thought of the figures *in* the gable instead of those *on* it. The style of the east pediment has little in common with that of the Victory, even if we suppose that the Victory is thirty years later. Of Alkamenes we know little: one ancient author says that he was an islander, and the clue may lie there; but the evidence for his style is slight and uncertain, and not worth pursuing here. It is better to look at the sculptures for themselves.

Pausanias gives a brief description of both

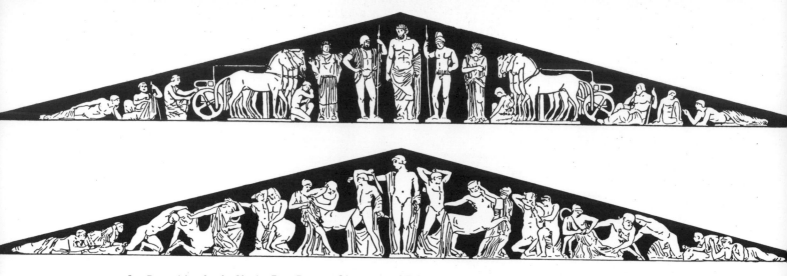

top: 369. *Preparation for the Chariot Race Between Oinomaos and Pelops,*
east pediment, Temple of Zeus, Olympia. 470–456 B.C. *Reconstruction* (after Studniczka)

above: 370. *Battle of the Lapiths Against the Centaurs,*
west pediment, Temple of Zeus, Olympia. 470–456 B.C. *Reconstruction* (after G. Treu)

pediments and metopes. The east pediment represented the preparations for the chariot race between the king of Pisa, Oinomaos, and Pelops, the suitor of his daughter Hippodameia. It had been prophesied that Oinomaos would meet his death at the hands of his son-in-law. He therefore imposed on all suitors a contest in which it seemed inevitable that they would be killed. They raced against him in chariots from Olympia to the Isthmus of Corinth. The suitor started first. Oinomaos waited to sacrifice to Zeus and then pursued the suitor; his horses were immortal and invincible, and when he overtook the man he killed him with his spear. The legend went on that Pelops, knowing the fate of the thirteen previous suitors, bribed the charioteer of Oinomaos to substitute linchpins of wax for those of bronze in the chariot of Oinomaos, who, as a result, was thrown and killed. Pelops then murdered the charioteer Myrtilos, and this deed began the whole train of tragedies which befell his descendants, the Atreidai.

Though tense and fateful, the scene is quiet and almost without movement, except that Pelops' chariot is just wheeling into position (fig. 369). But it must have had for the Greek something of the quality of impending doom which the opening of a tragedy can suggest, and something of that appearance too: for the pediment is not unlike a stage, with the protagonists isolated in the center. The language of gesture and posture meant more to the Greeks than it does to us. They were accustomed in everyday life to use it freely and were therefore prompt to understand it; the conventional clothing of the actors made quick movement inappropriate, so that the gesture and even the stance of the speaker gave deeper or fuller meaning to his words. Thus in all Greek sculpture, where words are lacking, and especially in scenes like those of the pediments at Olympia, it is necessary to study every action and every gesture, and the way the figures are standing, in order to understand the meaning fully.

The four protagonists—Oinomaos with his wife Sterope, and Pelops with his intended bride—are ranged in pairs, one on each side of the central figure, who is Zeus (fig. 371). Pausanias speaks of Zeus as a statue, and this is a possible view, but it is better to think of him

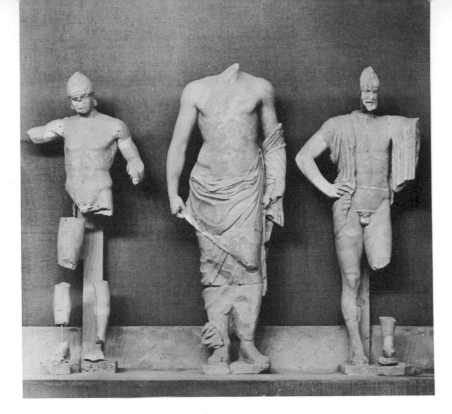

371. *Zeus Between Pelops and Oinomaos,*
from the east pediment, Temple of Zeus, Olympia.
Parian marble, height of center figure 9'.
Museum, Olympia

372. *The Seer Iamos,* from the
east pediment, Temple of Zeus,
Olympia.
Parian marble, height 53 1/2".
Museum, Olympia

as the god himself, unseen by the mortals. The head is missing, but the neck muscles show that it was inclined to his right, thus favoring Pelops: there is irony here, when one remembers the whole of the story. One man foresees the tragedies that are to ensue: he is the family seer of the household of Oinomaos, Iamos, the son of Apollo and founder of a race of seers at Olympia (fig. 372). He is seated on the ground, and his whole attitude is one of foreboding.

The west pediment (fig. 370), where the centaurs, hot with wine, are running amok at the wedding feast of Peirithoös, might be taken at first sight simply for one of those scenes of

373. *Battle of the Lapiths Against the Centaurs*, from the west pediment,
Temple of Zeus, Olympia. Parian marble, maximum height 66 1/8″. Museum, Olympia

violent action in which Archaic sculptors and vase painters delighted. But here there are undertones unknown in Archaic art, and the whole scene is intended to illustrate, not so much the victory of man over monster, as that of the civilized man over the savage (fig. 373); and the action is swayed by the commanding gesture of the central figure, the god Apollo, embodiment of reason and order (fig. 374). In earlier scenes of the kind there is no hint of the underlying emotion, but here the gestures and the expressions excite our sympathy and involve us in the issue.

For the twelve metopes, six over the inner porticoes at each end, the designer most appropriately chose the twelve labors of Herakles. Herakles, the son of Zeus, was the obvious patron for athletes, and he was the legendary founder of the Olympic Games. Some of the metopes follow the traditional compositions; for instance, Eurystheus takes refuge in a storage jar and Herakles deposits the Erymanthian boar on top of him, just as on Archaic

374. *Apollo* (portion), from the west pediment,
Temple of Zeus, Olympia.
Parian marble, original height c. 10′ 3″.
Museum, Olympia

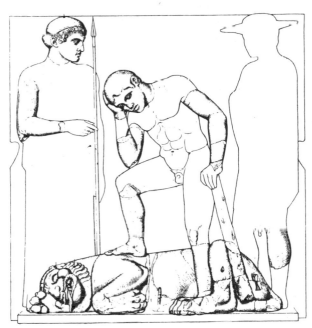

375. *Herakles and the Nemean Lion* (restored drawing),
metope from the Temple of Zeus, Olympia.
470–456 B.C. Parian marble, height 63". Museum, Olympia

376. *Head of Athena* (detail of metope in fig. 375)

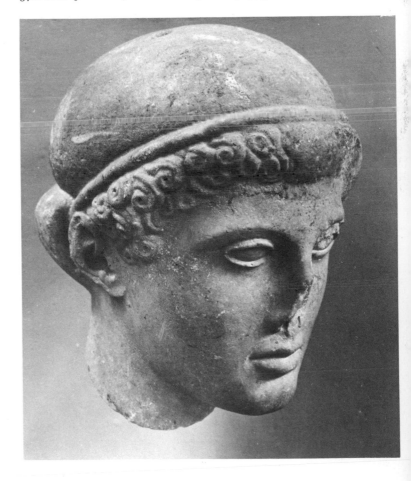

vases; but the labor of the Nemean lion is shown
after its accomplishment, with a weary young
Herakles resting his foot upon the body and his
head upon his hand (fig. 375). This is a new
idea, and one in harmony with the spirit of the
time, which thought not only of the deed but
of what led up to it and what followed it.
Athena stands by him here (fig. 376): she ap-

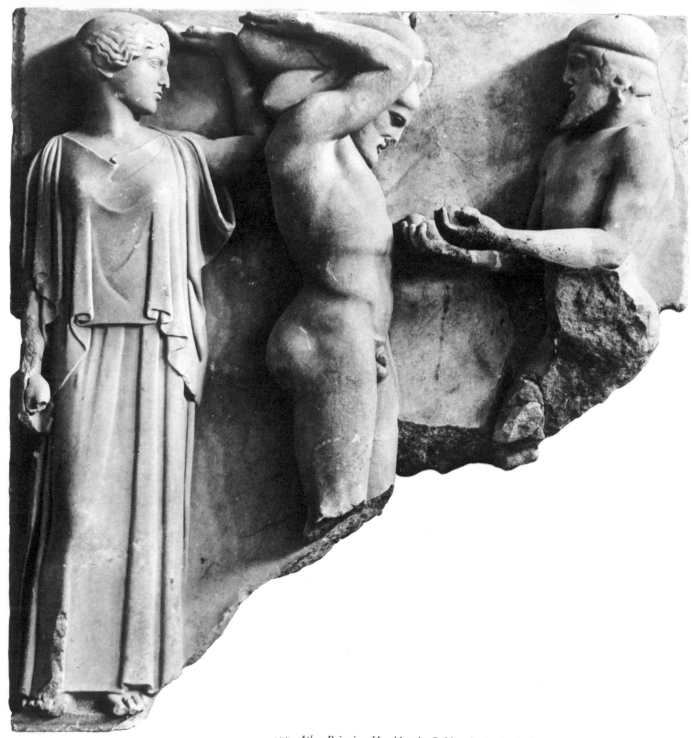

377. *Atlas Bringing Herakles the Golden Apples in the Presence of Athena,*
metope from the Temple of Zeus, Olympia

pears on four of the metopes to encourage and direct him, and since she is the daughter of Zeus it is right that she should be present. In one of them, that of the golden apples, she supports the sky so that he can free himself from its burden and Atlas can resume it (fig. 377).

Two sets of architectural sculptures must be roughly contemporary with those of Olympia. The first is a series of metopes from the Heraion at Selinus in Sicily; the second, a little later, a pedimental group of the Niobids from an unknown temple.

The metopes from Selinus have already been mentioned because of their peculiar construction, the fleshy parts of the female figures being carved in Parian marble and set into the main slabs of the metopes which are of limestone; they are old-fashioned in the sense that the sculptors are still content with Archaic formulae for the drapery, where the sculptors of Olympia would have been far more free and realistic. The metopes may well be the work of local sculptors, since the stocky proportions of the figures are unusual and the style of the faces has something in common with certain Sicilian coins. Some of the scenes, too, are conventional, but those of Aktaion being attacked by his hounds in the presence of Artemis (fig. 378), and that of the sacred marriage of Zeus and Hera, are charged with feeling (fig. 379).

378. *The Death of Aktaion*, metope from the Temple of Hera, Selinus (Sicily). c. 460 B.C. Parian marble and limestone, height 64″. National Museum, Palermo

379. *The Sacred Marriage of Zeus and Hera*, metope from the Temple of Hera, Selinus

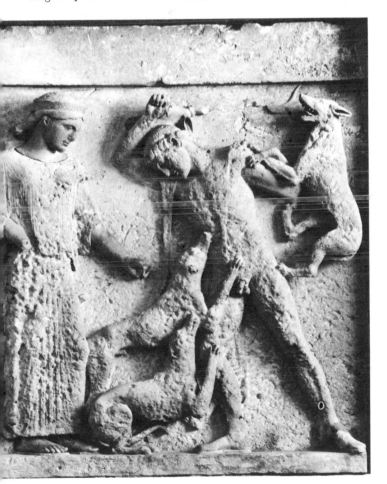

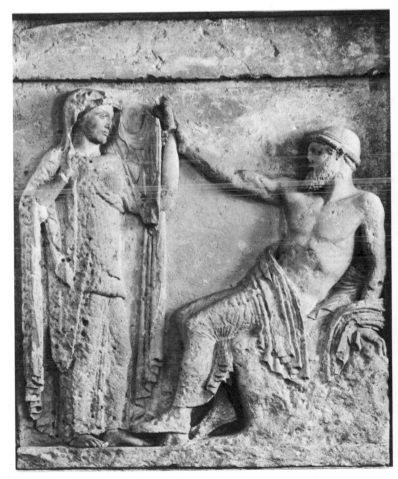

The Niobid (fig. 380) in the Terme Museum in Rome is also most moving, by reason of its simple presentation of the theme and its broad but sensitive modeling.[4] The girl was running, and has been struck in the back by an arrow: she sinks to her knees, her cloak falls from her, and her hands spring convulsively toward the wound. Although evidently designed as part of a larger composition, it composes admirably as an independent figure. The normal view would have been from the front, but an oblique view, which would also have been possible if the figure was in a pediment, shows how carefully studied yet unaffected is the outlining of the exquisite contours of the thigh as the drapery falls on each side of it.

Some of the low reliefs carved at this time are of the highest quality. From Paros, and presumably by a Parian sculptor, comes the girl with her two doves, a grave relief (fig. 381). In the island tradition, but perhaps carved in some Greek colony in South Italy, is the so-

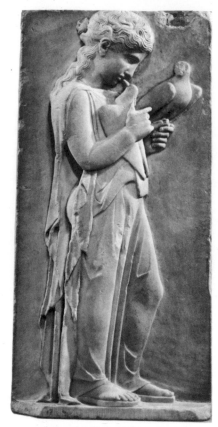

381. *Girl with Doves*, relief from Paros, c. 450 B.C. Marble, height 31 1/2″. The Metropolitan Museum of Art, New York (Fletcher Fund, 1927)

called Ludovisi Throne. It was at one time in the Ludovisi collection and was then believed to be the back and sides of a throne; but this suggestion has long been abandoned: it may be the end of an altar. The front panel is rectangular and has a pointed top; it originally had gable ornaments as if it were a miniature building. Two women, barefoot, stand on pebbly ground and raise a third by each placing a hand under her armpits: with their other hands they hold a garment in front of her (fig. 382). The scene has been variously interpreted. The pebbles certainly suggest water, and the explanation still in favor, though often disputed, is that of Aphrodite rising from the sea and being received by the Horai, somewhat as described in the Homeric Hymn. There are two side panels, at right angles from the central one: the panel on the spectator's left is carved

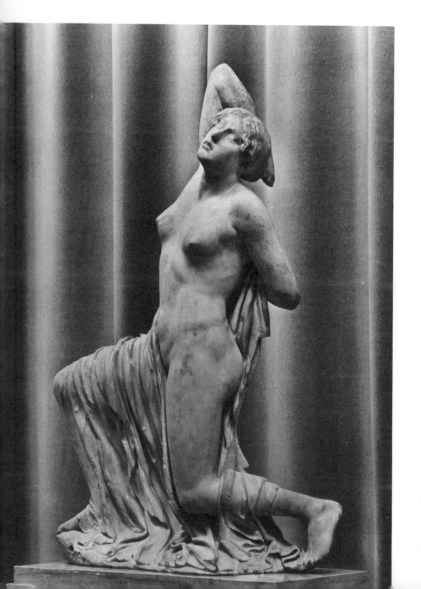

380. *Wounded Niobid.* c. 450 B.C. Parian marble, height 59″. Terme Museum, Rome

with a naked girl sitting on a cushion and playing the flutes (fig. 383); that on the right with a heavily draped woman putting incense on a portable burner (fig. 384). The contrast between nudity and heavy draping must be deliberate: the naked girl is unmarried, the draped woman a bride. Beyond this it is impossible to be specific, but our ignorance of the subject does not detract from its supreme value as a work of art.

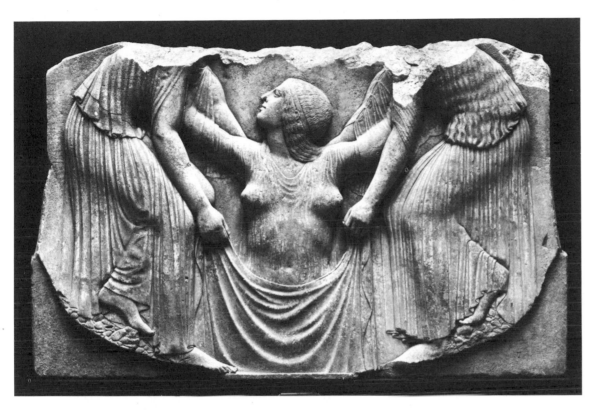

382. *The Birth of Aphrodite*, relief from the "Ludovisi Throne." c. 460–450 B.C. Parian marble, length 56 1/4". Terme Museum, Rome

383. *Flute Player*, relief from the "Ludovisi Throne." c. 460–450 B.C. Parian marble, length 28". Terme Museum, Rome

384. *Bride*, relief from the "Ludovisi Throne." c. 460–450 B.C. Parian marble, length 28". Terme Museum, Rome

The Classical Period (450–330 B.C.)

POTTERY AND PAINTING

The story of Attic vase painting for two or three generations after 450 B.C. is a sorry one. Evidently the painters were discouraged by their failure to imitate the great wall paintings successfully, and disenchanted with their own medium. The quality of the work deteriorates, and it looks as if talented draftsmen drifted away from the craft. There are exceptions, and one at least is a shining one. The Achilles Painter is so named from his red-figured amphora in the Vatican which in front bears a picture of Achilles, alone and motionless (fig. 385). This is a noble figure—one remembers that Polygnotos was said to have made men nobler than they were—pure Classical in feeling and comparable in its strength and calm to the sculptured figures of the frieze of the Parthenon. Equally masterly, and more exquisite, are some of the white lekythoi on which he drew figures in outline. The white lekythos was commonly used as an offering at a tomb, so that the subjects are usually funerary—men or

385. THE ACHILLES PAINTER. *Achilles*, amphora from Vulci (Italy). Attic, c. 445–440 B.C. Height 23 5/8″. Vatican Museums, Rome

Colorplate 37. THE MARSYAS PAINTER. *Peleus Taming Thetis*, pelike from Kameiros (Rhodes). Attic, c. 340–330 B.C. Height 16 3/4″. British Museum, London

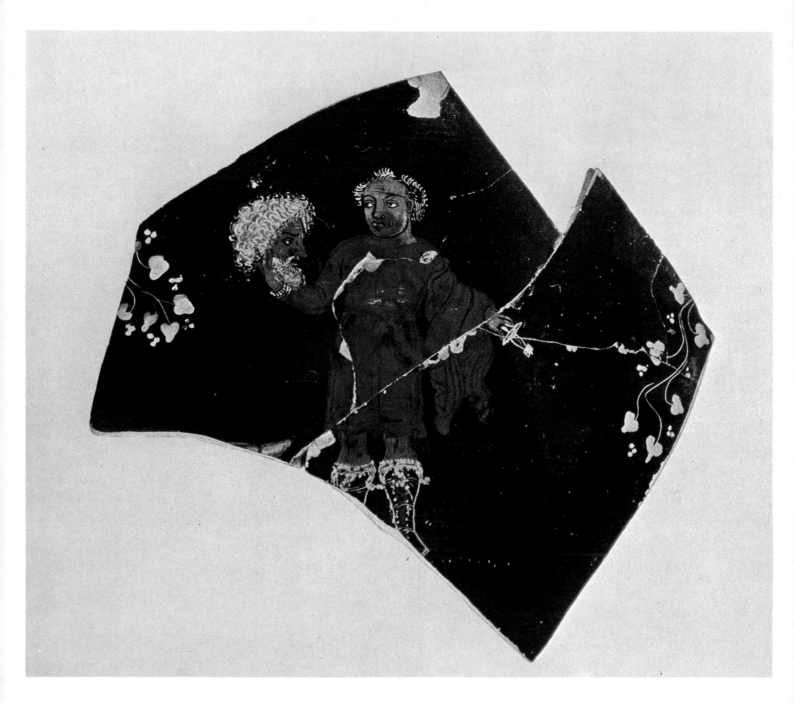

Colorplate 38. *Tragic Actor*, fragment of a krater. South Italian (Tarentine),
c. 350–325 B.C. Height 7 3/8″. Martin von Wagner Museum, University of Würzburg

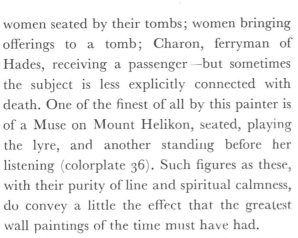

386. The Eretria Painter. *Alkestis in Her Bridal Chamber*, epinetron from Eretria (Euboea). Attic, c. 430–425 B.C. Length 11 1/2″. National Museum, Athens

women seated by their tombs; women bringing offerings to a tomb; Charon, ferryman of Hades, receiving a passenger —but sometimes the subject is less explicitly connected with death. One of the finest of all by this painter is of a Muse on Mount Helikon, seated, playing the lyre, and another standing before her listening (colorplate 36). Such figures as these, with their purity of line and spiritual calmness, do convey a little the effect that the greatest wall paintings of the time must have had.

As the century goes on most of those draftsmen who still worked at vase painting slid off into prettiness or vulgarity, backed up by great technical skill. The Eretria Painter draws beautifully, and his unpretentious subjects, taken largely from the life of women, have great charm (fig. 986). The work of the Meidias Painter (figs. 387, 388), who aims higher, retains a certain greatness of design,

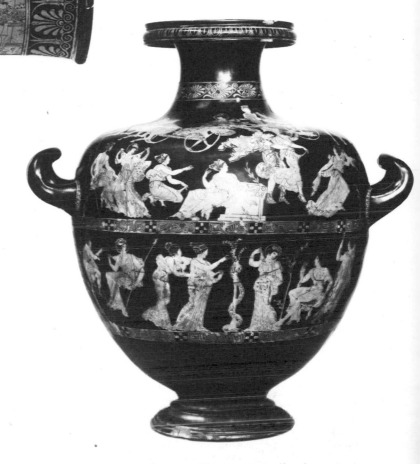

387. The Meidias Painter. *The Rape of the Daughters of Leukippos* (upper frieze) and *Herakles in the Garden of the Hesperides* (lower frieze), hydria. Attic, c. 410 B.C. Height 20 1/2″. British Museum, London

388. *The Rape of the Daughters of Leukippos* (detail of hydria in fig. 387)

293

partly because of his sources of inspiration, among them the figures in the pediments of the Parthenon. His is a world of cloying sweetness, remote alike from the real world and from the ideal world of fifty years before. The decline was incredibly swift, and must have been hastened by political upheavals and by the disasters to Athenian arms.

There is one vase of about 400 B.C. which, though not free from the defects of the time, is one of the most important documents for our knowledge of the Greek theater and the cult of Dionysos. This is the Pronomos vase (fig. 389), so called because it depicts in a prominent position the famous Theban flute player Pronomos: it also shows the complete chorus of a satyr-play (a type of drama closely linked with

tragedy), in addition to several of the leading actors.

There is a revival of Athenian vase-painting about 350 B.C.: it had remained alive but undistinguished in the intervening period. The new "Kerch" style[1] is important partly because it shows what was going on in the lost wall paintings of the time, partly because of the close analogy with contemporary sculpture. The pelike in the British Museum is a characteristic piece in that the sophisticated and much-foreshortened compositions of the figures tend to recede so much into depth as to spoil the surface design of the vase (colorplate 37).[2] There is a whole range of sculptural types on a vase by the same painter found in Kerch itself (fig. 390): the close study of the many small folds in the drapery reminds one of such works as the Demeter of Knidos, which was carved within a few years of it (see p. 355). One suspects that the same statuesque types were appearing in major painting: and it is a fact that sculpture and painting were more closely interrelated in Greece than they have ever been since.

Outside Athens, vase painting takes on new life, especially in the Athenian colony of Thurii, founded in 443 B.C. on the site of Sybaris, in southern Italy. It seems certain that Athenian potters and vase painters were among the colonists, for some of the vases made at this time in South Italy are as Athenian in technique as they are in drawing. Once established in the West, two main schools develop: one at Herakleia, a colony founded jointly ten years later by Thurii and Taras (Tarentum), which had itself been an early colony of Sparta; the other at Taras itself. Both retain in their early products what had been lost in Attica—Classic calm and grandeur. The Carneia Painter's Dionysiac krater (fig. 391), with maenads dancing in front of Dionysos himself, has a masterly touch.

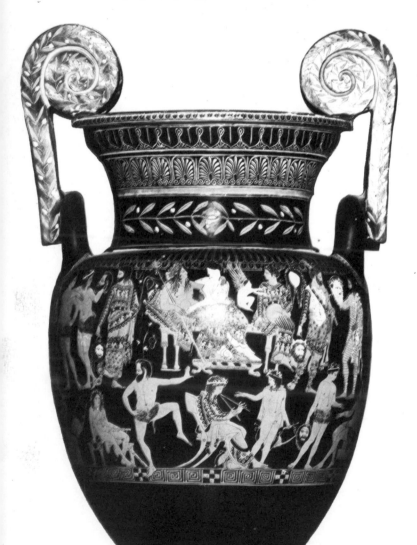

389. THE PRONOMOS PAINTER. *The Pronomos Vase*, volute krater from Ruvo. Attic, c. 400 B.C. Height 29 1/2". National Museum, Naples

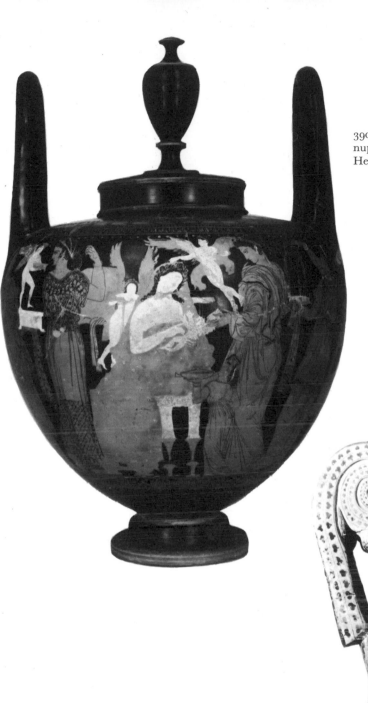

390. THE MARSYAS PAINTER. *Bringing of Gifts to the Bride,* nuptial lebes from Kerch. Attic, c. 350 B.C. Height 18″. The Hermitage, Leningrad

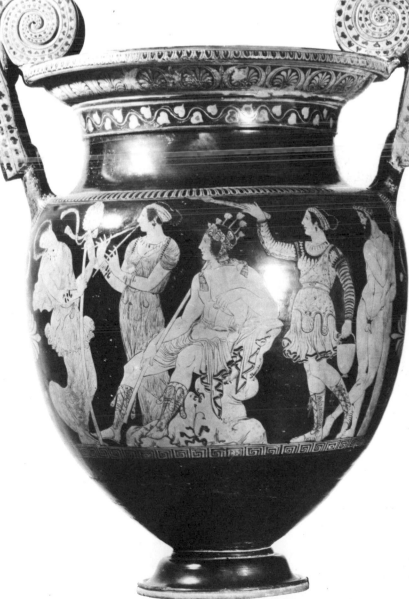

391. THE CARNEIA PAINTER. *Dionysiac Scene,* volute krater from Ceglie del Campo. South Italian, c. 410 B.C. Height 28 1/4″. National Archaeological Museum, Taranto

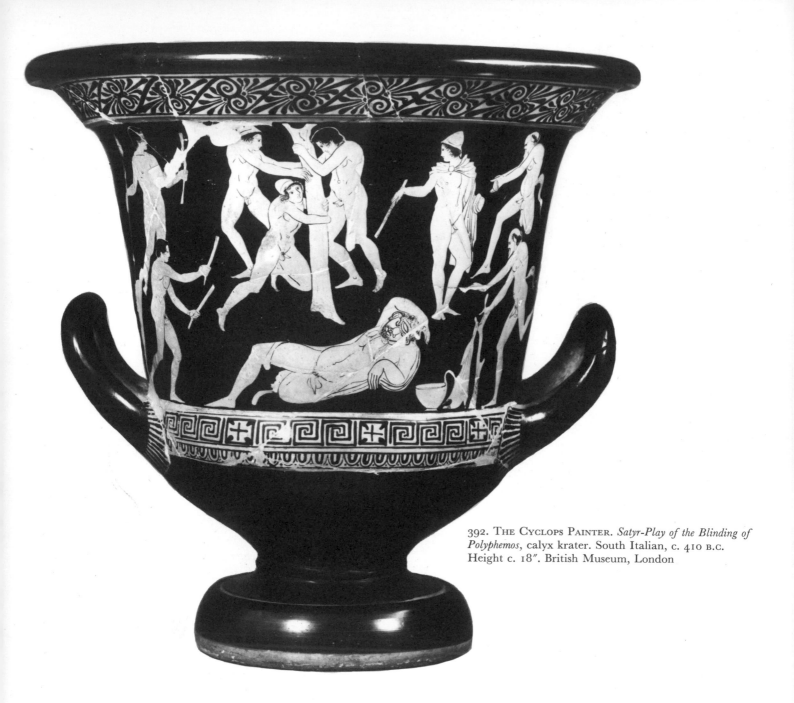

392. THE CYCLOPS PAINTER. *Satyr-Play of the Blinding of Polyphemos*, calyx krater. South Italian, c. 410 B.C. Height c. 18″. British Museum, London

The large krater by the Cyclops Painter in the British Museum (fig. 392), a fine specimen of this classicizing early South Italian style, is based not directly on the story of Odysseus, but on a satyr-play. It may be compared with the same subject on the Attic vase of the seventh century (see p. 175), but the presence here of members of the satyr chorus and other nonentities lessens the dramatic tension. How different is the dainty gesture of this well-groomed Odysseus from the rude vigor of his prototype!

But the real genius of South Italian vase painting lies in farce and parody. The native Phlyax plays often provided a subject (colorplate 38): they show mortals and immortals alike in discreditable but comic situations (fig. 393). Of the parodies, that of Ajax seeking sanctuary at the Palladion and being torn from it by Kassandra is a brilliant example (fig. 394).

296

With these Phlyax vases may be compared a series of comic vases made about the same time in Boeotia, primarily for dedication at the sanctuary of the Kabiri near Thebes. Here again there is a connection with drama: the sanctuary contained a theater, and it is likely that the themes depicted on the pottery were also those of the plays. Black-figure technique, now long outmoded elsewhere, was used, and there was a fondness for the adventures of Odysseus. On one cup (fig. 395) he is shown about to take the drink from Circe, with understandable reluctance; on the front of the same cup he is navigating a choppy sea on a couple of amphorae, before a brisk north wind issuing from the mouth of Boreas himself.

393. ASTEAS. *Zeus and Hermes* (scene from a Phlyax play), bell krater. South Italian, late 4th century B.C. Height 14 1/2″. Vatican Museums, Rome

394. *The Rape of Ajax* (scene from a parody), fragment of a volute krater. South Italian, c. 350–325 B.C. Height of fragment 6 1/4″. Villa Giulia, Rome

395. *Odysseus and Circe* (left) and *Odysseus Crossing the Sea on Amphorae* (right), skyphos from Thebes (Boeotia). Boeotian, late 4th century B.C. Ashmolean Museum, Oxford

297

It is interesting, if somewhat melancholy, to scrutinize what Pliny and other late writers say about painters of this period—melancholy, because all their work has perished; interesting because the remarks do give an occasional clue to what the painters' aims were—and the smaller works of art, such as vases, engraved mirrors, and mosaics, seem now and then to bear them out. But the famous names remain little more than names. Panainos, the brother of Pheidias, painted a picture of the battle of Marathon in which the leaders' heads were "portraits"—a sidelight on the lack of individuality in portraits before this, which to the modern mind is so puzzling. Toward the end of the fifth century come two painters of whose achievements traces may sometimes be detected in the white lekythoi of the period (fig. 396):[3] these were Parrhasios of Ephesos, and Apollodoros of Athens. Pliny says of the former that his "outline expressed the contours of the figure. For the bounding-line should appear to recede and its edge should imply the existence of the parts behind and thus display even what it conceals." This does suggest a conception akin to that of most drawing from the time of the Renaissance down to the present day. Apollodoros was called the "shadow painter," and Plutarch says "Apollodoros was the first to discover the gradation and change of color in shadow." A few years later Zeuxis of Herakleia (probably the town near Taras in South Italy) was thought to have carried further this study of the relationship of lights and shadows. If we knew exactly where to look for it we might find his influence on some of the contemporary vases from South Italy, just as Attic vases of the Kerch style also owe something to the achievements of major painters.

396. *Dead Youth Seated at His Tomb with Mourners*, lekythos from Eretria (Euboea).
Attic, late 5th century B.C. Height 19 1/4".
National Museum, Athens

ARCHITECTURE

About 450 B.C. the arts of sculpture and architecture in Greece attained what is generally agreed to be their highest peak, and although most of the evidence on which that judgment should rest has been destroyed, what still remains does suggest that it is a true one (see p. 263). In Athens, which became the great focus of artistic activity at this time, the outstanding name is that of Pheidias, who, according to Plutarch, supervised the great building schemes initiated by Perikles. This is one of those occasions when history and art are closely interconnected, and the circumstances which favored the creation of a whole series of sculptural and architectural masterpieces are of interest, not only in themselves but also because an ethical problem is involved which exercised contemporary thinkers. The position was this: when the Athenians returned to their city in 479 B.C., after the defeat of the Persians, they found it in ruins. In particular, the monuments on the Acropolis, where a new temple to Athena had been under construction, were burnt and shattered. In common with the other loyal Greek cities, they seem to have sworn a solemn oath not to rebuild the temples that had been destroyed, but to leave the ruins as a memorial of barbarian sacrilege. However, with the Peace of Kallias in 449, Greece came to terms with Persia, and the Athenians seem to have considered that this released them from the understanding; they forthwith planned an elaborate and very costly building program involving in effect the complete remodeling of the Acropolis and important construction elsewhere. How were they to finance the project?

The answer was from the funds of the Delian League. The Delian League was an alliance of Ionians which had been formed just after the defeat of the Persians, in order to protect the Ionian cities on the coast of Asia Minor from renewed attack by Persia. It was a maritime league, and the contribution of the member cities was to be in the form of ships with their crews. But because many of the members were too small to furnish complete ships, their contributions were commuted to a money payment, the funds being kept on Delos, where also the League Council met. Athens supplied the bulk of the defenses, dominated the League Council, and gradually transformed the League into an Athenian Empire, reducing to subjection members who tried to secede. The Council ceased to exist except in name, and in 454 the treasury was moved from Delos to Athens, nominally for reasons of security. Within a few years, under Perikles, it was being used to rebuild Athens in splendor, and it was this diversion of the funds which aroused criticism even in antiquity, the enemies of Perikles complaining that what the cities of Greece had contributed for defense was being used to deck out the city of Athens like a wanton woman. Despite these and even more scurrilous criticisms the work went on, and was nearly approaching completion when the Peloponnesian War broke out in 431.[4]

Anyone standing in front of the Parthenon and looking at it for long will be struck by the

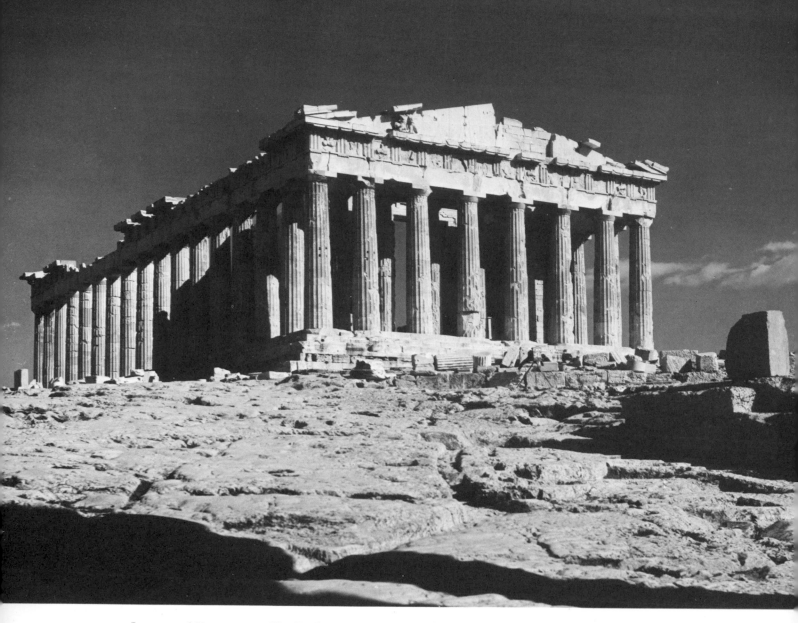

397. Iktinos and Kallikrates. The Parthenon, Acropolis, Athens. 447–432 b.c. *View of west façade and north flank*

feeling of life with which it is pervaded (fig. 397). This is surprising, for nothing could apparently be more uncompromisingly geometric or more lacking in analogies with nature than the post-and-lintel construction—horizontal beams lying on vertical uprights—which is the essential principle of its structure. It seems likely that the architect was conscious of this, and that it was one of the reasons for the system of refinements which he introduced.[5] Some mitigation of the bare geometry had already been provided by generations of predecessors.

From the very beginning, the upright supporting members had rarely been square or cylindrical: they tapered toward the top, and entasis, the slight swelling in the middle to counteract the optical illusion which gave the opposite effect, had been invented before this time; and so possibly had other optical corrections, for some of these refinements were evidently calculated to overcome the effect of optical illusion, and not only to give the building a feeling of resilient growth. It may well be that some of the adjustments were based on a

theoretical system, for we know that artists were concerned at this time with the theory of beauty; and if Polykleitos, the sculptor, could embody a system of proportions in the more difficult medium of statuary, it is not at all unlikely that something analogous was attempted more often than we realize in architecture, one of whose main essentials is satisfactory proportions.

The plan of the Parthenon is interesting, though extremely simple (fig. 398). It consists of two distinct halls, set back to back and not communicating with one another: the one to house the colossal image of the goddess, the other a treasury, which must often have been one of the functions of temples, although it is not often explicitly recognized in the plan. The roof of the smaller hall, the treasury, was probably supported in the fashion of the old Mycenaean megaron by four columns set in a square about the center: the Ionic Order, whose more slender proportions made them suitable for the purpose, was used. It is as if Iktinos, the architect, deprived of any opportunity for innovation in the plan or general form of the building, had devoted all his powers to perfecting a simple traditional entity; and this concentration on a limited problem is not without analogy in other spheres of Greek life and thought. Some of the other refinements he introduced may be mentioned. A long flat platform normally appears to sag toward the middle: here it is therefore constructed in an arched curve, or rather (because no stone of it is actually curved) as part of the bounding-line of an immense polygon. A similar device is used in the entablature; and various parts, including the columns, are tilted forward, backward, or sideways. Columns against the light look thinner than those against a background: the end columns therefore were clustered more thickly, and increased in diameter. The amount of

careful thought, ingenuity, and calculation which has gone into the building may account for another feeling sometimes aroused in anyone who stands before it, namely, that its appeal is not so much emotional as intellectual: the mind perceives instinctively that devices of this kind have been adopted, and tries to detect them all one by one in a mental exercise. Nothing but admiration for such intellectual thoroughness and technical skill can be the result, and possibly the consciousness of what has been done may ultimately deepen the emotional pleasure: but this may be the reason why some people find it more difficult to warm to the Parthenon than they do, for instance, to the slightly earlier temple at Paestum, whose appeal is more direct, less contrived (figs. 356, 357).

398. The Parthenon, Acropolis, Athens. *Plan*

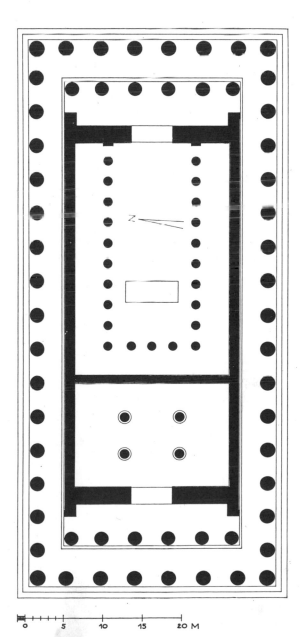

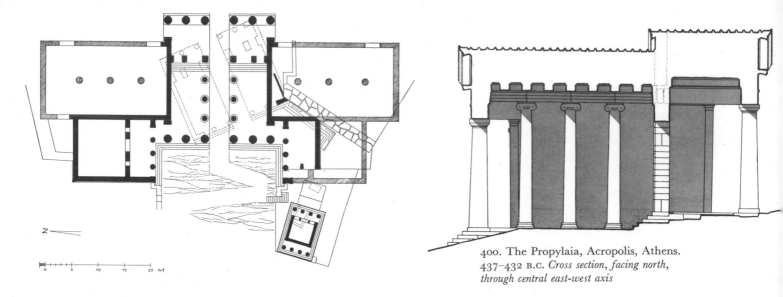

400. The Propylaia, Acropolis, Athens.
437–432 B.C. *Cross section, facing north,
through central east-west axis*

399. Mnesikles' Propylaia (437–432 B.C.)
and the Temple of Athena Nike (427–424 B.C.).
Plan (unexecuted parts of Mnesikles' design
indicated by hatching;
earlier propylaia and archaic shrine
of Athena Nike indicated by broken lines)

401. The Propylaia, Acropolis, Athens.
Partial view of interior, facing east (left)
and *Ionic column of central passage*
(right; compare with fig. 402)

302

The Ionic Order was again used in the interior of the Propylaia, to support a roof at a greater height than Doric columns of tolerable scale could attain. The Propylaia was highly esteemed in antiquity, and despite its unfinished state and extensive mutilation it still excites admiration for the subtle simplicity of its plan (fig. 399), the beauty of its material, and the exquisite design and execution of its detail.[6] The material is Pentelic marble, but courses of dark gray Eleusinian limestone are used to stress certain horizontal features. The function of the building was to provide a monumental entrance to the Acropolis on its steep western approach, with gates for security. It would be natural to solve the problem by providing flights of steps, but the entrances were not only for pedestrians: they had to admit also animals for sacrifice, and for animals steps were impossible. Thus the design had to include a sloping roadway, an entrance on one level on the west, and an exit at a higher level on the east (fig. 400). The architect made the roadway his central axis with the widest entrance, and on each side of it provided two other entrances for pedestrians, who approached them by flights of steps (fig. 401 left) and thus reached the higher level. There were two Doric porticoes, one

facing west (fig. 402) and one at the higher level, with slightly shorter columns, facing east (fig. 403); the change of level in the roof between them was adjusted by the use of the slender Ionic Order in the interior (figs. 400–403). To the left of the entrance of the western portico was a picture gallery (fig. 402): there were to have been two large halls, one on each side of the eastern section of the building, but for reasons at which we can only guess these were never completed (see figs. 399, 403). Thanks to inscriptions we know the dates of these Periklean buildings fairly accurately. The Parthenon was begun in 447 and finished in 432; the main part of the Propylaia was built between 437 and 432: it was never completed.[7]

The Hephaisteion, a temple of Hephaistos and Athena overlooking the Agora at Athens, seems to have been the earliest project in the schemes of Perikles and to have been begun soon after 450. But it was delayed in favor of the buildings on the Acropolis, and its cult statues of bronze, by Alkamenes, were not dedicated until twenty years after the gold-and-ivory Athena Parthenos in the Parthenon. There is little remarkable about its plan, which is a simple Doric building with a single room for the cult statues, and it is not particularly impressive, possibly because of its scale which gives it neither the grandeur of a large building nor the charm of a small one. But the disposition of its sculpture is interesting, for it is concentrated at the ends, and especially at the end nearest the marketplace (fig. 404). On the outside it consisted of a pediment and ten sculptured metopes at the east end; four metopes on the east end of each flank were also sculptured, while the remaining ones, as well as those on the west façade, were plain. Inside the main colonnade, above the walls of the building itself, there was a continuous Ionic frieze over the east porch: this extended outward as far as the columns of the main colonnade; over the back (west) porch was a similar frieze, but it extended only as far as the antae.

A sacred building of unusual plan and of

opposite page, top: 402. The Propylaia, Acropolis, Athens. *View from the southwest, with the adjoining Pinakotheka*

opposite page, bottom: 403. The Propylaia, Acropolis, Athens. *View of east façade*

404. The Hephaisteion, Athens c. 450–430 B.C. *View of upper portion of east façade*

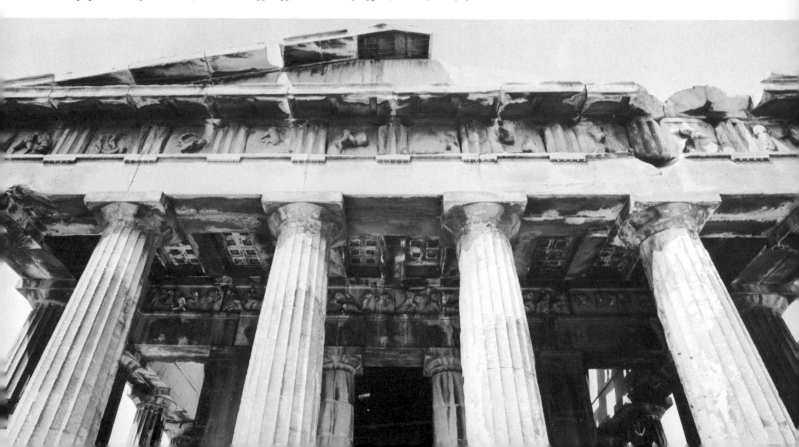

405. The Telesterion, Eleusis. *Plans of successive buildings* (after J. Travlos, 1950).

A. Megaron, 7th century B.C.

B. Peisistratid Telesterion, c. 520 B.C.

C. Telesterion of Kimon's time, c. 460 B.C. (only right half executed).

D. Iktinos' plan (black: confirmed; white: hypothetical).

E. Executed Telesterion, later 5th century B.C. (portico, second half of 4th century B.C., renewed in 2nd century A.D.)

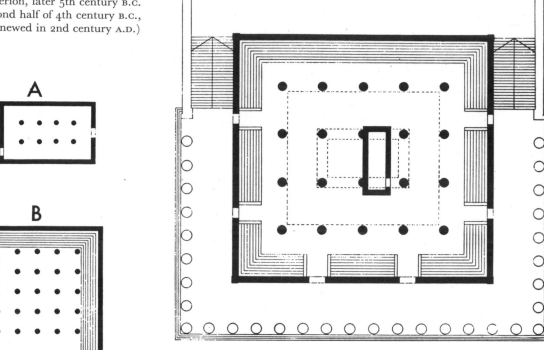

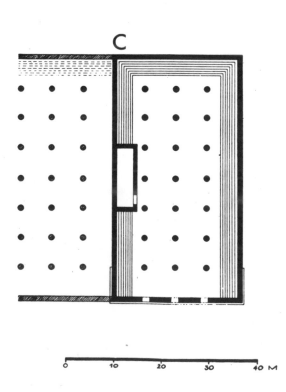

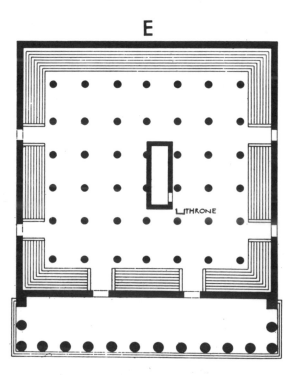

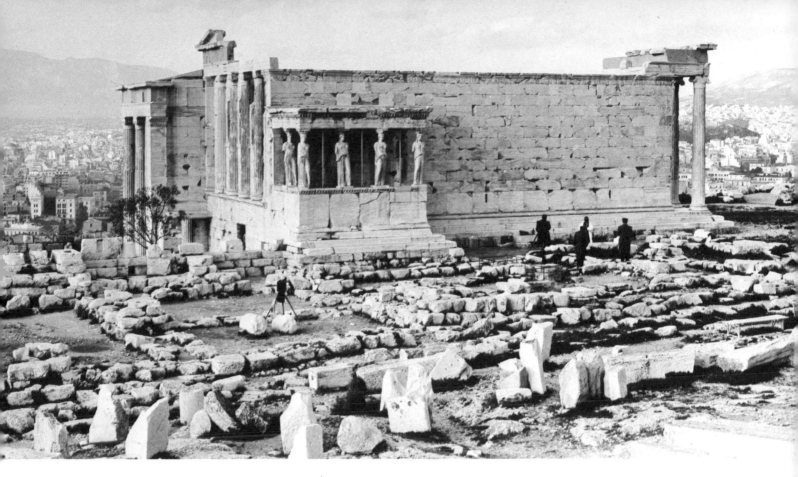

406. The Erechtheion, Acropolis, Athens. 421–406 B.C. *View from the south*

great religious importance was the Telesterion, Hall of the Mysteries at Eleusis, which also came within the Periklean building schemes (fig. 405). This was an ancient shrine, and remains of a seventh-century building still exist. About 520 B.C. this was superseded by a larger building, which seems to have been damaged in the Persian invasion. Then a new scheme, larger still, was started, probably by Kimon, but abandoned about 460 when he fell from power. Finally Perikles revived the Kimonian plan, employing Iktinos, the architect of the Parthenon; but this scheme too remained unfinished at Perikles' death. In all these buildings the essential problem was the same: namely, to provide a covered hall in which a large number of people could witness the performance of sacred drama. They must be able both to see what was going on and to hear what was being said. Without the use of domes or arches, the obstruction caused by the pillars supporting the roof becomes the paramount difficulty, and it is this factor that dominates all the successive plans. In Iktinos' plan the roof seems to have been pyramidal, and the effect of a forest of columns, which the earlier plans utilized and which had Egyptian analogies, was largely avoided. The ritual drama seems to have taken place in the center of the hall, beginning in the light of torches and subsequently in daylight, either by the coming of dawn or by the uncovering of a skylight. The spectators sat or stood on stepped rows of seats around all four walls.

Part of a separate scheme that was initiated later than the Periklean was the rebuilding of the ancient and complicated shrine at the northeastern corner of the Acropolis. This was known as the Erechtheion (fig. 406), and was on the site of the palace of Erechtheus, king of

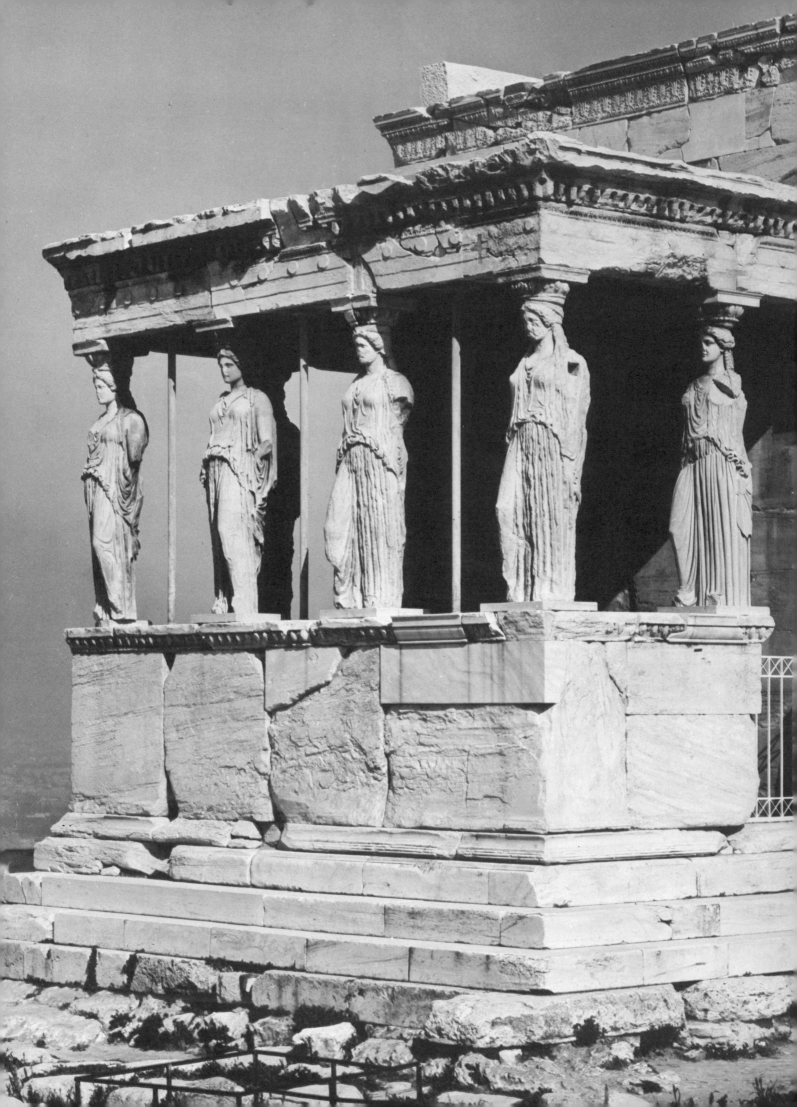

Athens in Mycenaean times. Not only was its ground plan complex, but like the Propylaea it was on different levels, and it had to accommodate such diverse elements as a sacred saltwater tank and a mark in the rock supposed to have been caused by the trident of Poseidon. It cannot be said that the building erected between about 420 and 400 B.C. to fill these needs was entirely satisfactory, but that may well be because it was not completed as the architect had originally intended. It seems to lack balance: the famous Caryatid Porch (fig. 407), placed in that position, it is true because it covered a special shrine, seems to demand a structure of some kind to balance the mass now lying to the east of it. The style was Ionic throughout, and full use was made of the contrast between large surfaces of smooth marble wall and the rich moldings and cornices of this Order (fig. 408). The column capitals, too, lent themselves to much intricate carving (fig. 409), and when all its color was intact the building must have looked as if bejeweled.

opposite page : 407. Caryatid Porch, Erechtheion, Acropolis, Athens. 421–406 B.C.

408. The Erechtheion, Acropolis, Athens.
Portion of southeast wall, moldings, and architrave

409. The Erechtheion, Acropolis, Athens.
Portion of west side of north porch

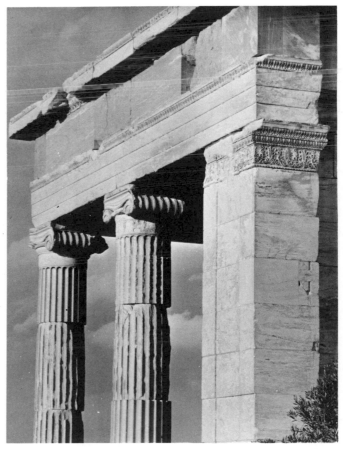

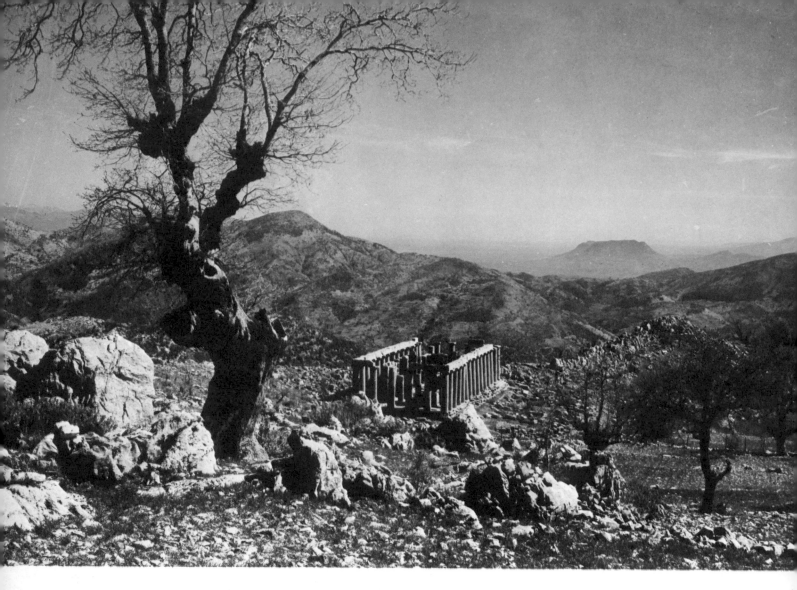

410. Iktinos(?). Temple of Apollo Epikourios, Bassai. c. 420 b.c. *View from the north*

The Doric temple of Apollo at Bassai (Phigaleia), a remote place in the mountains of Arcadia, was also said to have been designed by Iktinos (fig. 410). Though apparently built later than the Parthenon (about 420 b.c.) it embodies few of its "refinements": one reason may have been the enormous cost of such refinements, but equally cogent was the difficulty of executing them in the limestone of which the temple was almost wholly constructed. Some refinements, such as entasis, there were; and others may have been rendered in the stucco with which, as in all limestone

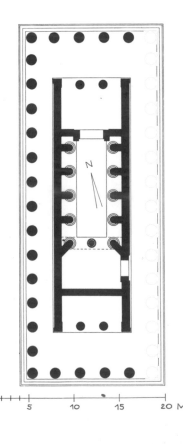

411. Temple of Apollo Epikourios, Bassai. *Plan*

temples, the surface was covered. The temple at Bassai is unique in plan (fig. 411): the long axis, instead of running east and west, runs north and south, and the eastern doorway of the chamber in which the cult statue of Apollo stood opened onto one of the lateral colonnades.

There were two other remarkable features. One was the long room adjoining on the north that of the cult statue: this was surrounded by engaged Ionic columns (fig. 412), the capitals of which, of an unusual form, were of marble: above this colonnade was the frieze, sculptured in high relief with battles of Greeks and Amazons, Lapiths and Centaurs. The second remarkable feature was at its south end, where it gave onto the other room. There was no wall between them, but a single column stood in the center of the opening (figs. 412, 413), and this, instead of having an Ionic capital like the others, had the first known specimen of a

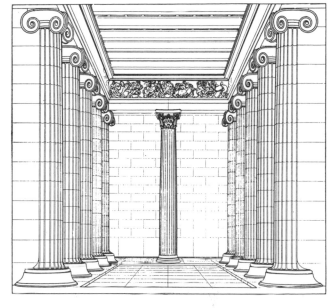

413. Temple of Apollo Epikourios, Bassai.
Reconstructed interior view toward the south
(by F. Krischen, 1938)

412. Temple of Apollo Epikourios, Bassai.
Interior view toward the north, seen from the cult-statue chamber

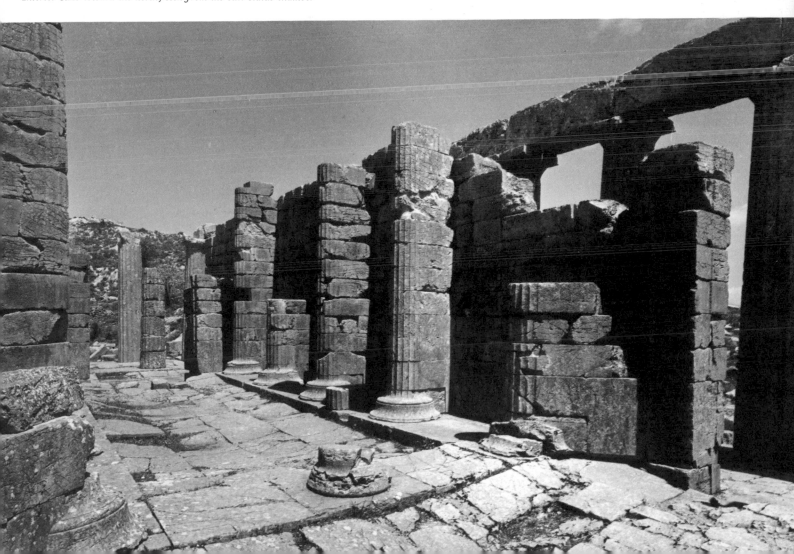

new Order, the Corinthian. This capital is lost, but was drawn before it was destroyed (fig. 414); except that some of the details are painted where they were carved in later examples, it exhibits all the essential elements of a design that has been reproduced thousands of times in antiquity and since. The capital is like an inverted bell, fringed below with a collar of acanthus leaves. Acanthus stems spring out from this collar at four points, and curl upward until they support the abacus with spiral fronds. The enduring popularity of this design is due to the fact that, unlike the Ionic capital, it is omnifacial, and is therefore equally suitable in a range of columns or at the corners. (Its drawback, as many Renaissance and modern archi-

414. Corinthian Capital, from the Temple of Apollo Epikourios, Bassai. c. 420 B.C. (drawing by Haller von Hallerstein)

tects have found, is the shelter it affords for birds.) There is no proof that the Corinthian capital at Bassai was actually the first one made, but it must be a very early specimen: it is possible that the first was of metal, since its invention is credited to Kallimachos, who was an expert metalworker; and its forms suggest and show to advantage in metal. For a century afterward designers experimented with the new invention, and the results range from the almost dainty elegance of those designed by Polykleitos the Younger for the Tholos at Epidauros (fig. 415) to the almost brutal solidity of those

415. POLYKLEITOS THE YOUNGER. Corinthian Capital (above) and Ceiling Coffers (right), from the Tholos, Epidauros. c. 360 B.C.

by Skopas in the temple of Athena Alea at Tegea (fig. 416), another building which combined Doric and Corinthian Orders.

Classical Greek buildings were not always rectangular; there was a class of circular buildings, called tholoi, of which specimens are to be found in several widely separated places. It is not clear what the origin of this form was, and the purpose of some of the specimens is unknown. It may be that the plan perpetuated the form of some primitive round hut. One or two may have been built to cover a sacred hearth: the tholos in the Agora at Athens was an official dining room for chairmen of the committees of the Council (Boule), and an office where some officials were always on duty. Two other tholoi, one at Epidauros and one at Delphi, both of the early fourth century B.C., are of extreme refinement, and the architect of the latter, Theodoros of Phocaea, wrote a book about it. The tholos at Epidauros was built by Polykleitos the Younger in the first half of the fourth century. Its outer colonnade was Doric, its inner one Corinthian, and the capitals of

416. SKOPAS. Corinthian Capital, from the Temple of Athena Alea, Tegea. c. 360 B.C.

these columns and the floral ornament of the coffers of the roof are carved with such delicacy as to suggest some exquisite natural growth (fig. 415 right). Polykleitos was also the architect of the theater at Epidauros whose beauty and fitness for purpose cannot fail to impress even the most casual observer (fig. 417). The

417. POLYKLEITOS THE YOUNGER. Theater, Epidauros. c. 350 B.C. *View from the east*

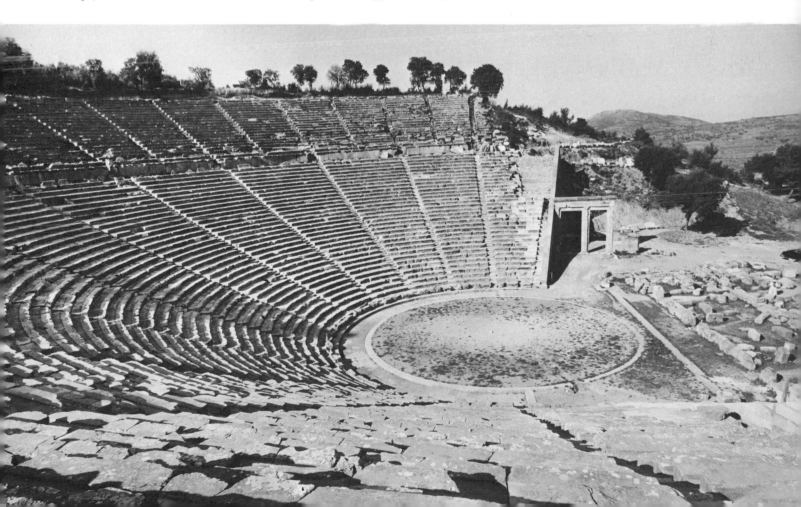

planning of such a building is comparatively straightforward, provided there is no roof: as soon as a roof is needed the great area to be covered presents almost insuperable difficulties in post-and-lintel construction: the invention and free use of arch-and-dome make it, if not easy, at least less difficult.

Another building of unusual form, although it embodied no new architectural principles, was the tomb of Mausolos at Halikarnassos. This was erected by his widow Artemisia for Mausolos, a prince of Caria and a Persian satrap, after his death in 353 B.C. Although we possess a seemingly explicit account by Pliny and numerous references by other ancient writers, and although the site has been excavated, it has proved impossible to restore the building convincingly on paper (fig. 418). We know that it was nearly 150 feet high and that its most striking feature was a pyramidal roof supported by thirty-six columns and surmounted by a chariot; but the exact form and dimensions of the pyramid are still matters of dispute, partly because the figures given by Pliny seem to have been transmitted wrongly, and partly because we do not know whether the thirty-six columns were arranged in a single or a double row. The arrangement in a single row, with nine columns at front and back and eleven on each side, gives a "large" plan; and the arrangement in two rows, with six at front and back, seven on each side, and, in the inner row, four and five respectively, gives a "small" plan. One of these two must be correct, but although the excavations established the height of the columns, and, because of the rigid rules governing Greek architecture, also their spacing, no evidence in favor of one of the two plans was discovered. The reason was that the bulk of the masonry was either burnt for lime or carried away by the Knights of St. John when they built their castle near the site.

SCULPTURE

The Diskobolos of Myron (fig. 363) was revolutionary (see p. 277), and another famous statue by him, the runner Ladas shown in the moment of winning a race, may well, from ancient eulogies, have been equally so: but for some unknown reason no copies of this have survived.

419. MYRON. *Athena*. Roman copy after a bronze origi(group of Athena and Marsyas) of c. 450 Marble, height 68″. Städtische Skulptursammlung, Frankf

Of another work of his, a group, or rather two statues set up in relation to one another, we have several copies. It was dedicated on the Acropolis at Athens, and although its unusual subject suggests that it commemorated some special event, we cannot guess what that was. The group was of Athena and the satyr Marsyas, and the story was an old one: Athena invented the flutes, but seeing in a pool how they distorted her face, flung them away; the satyr Marsyas saw them, picked them up, learned to play them, and challenged Apollo to a contest; Marsyas lost, and was sentenced to be flayed. It is a strange and savage story, originating perhaps in Phrygia, and the terrible climax appealed to Hellenistic sculptors. Myron chose the earlier episode, when the flutes had just been thrown down; the goddess is turning away (fig. 419) and the satyr stealing up to take them (fig. 420).[8] Again a moment of

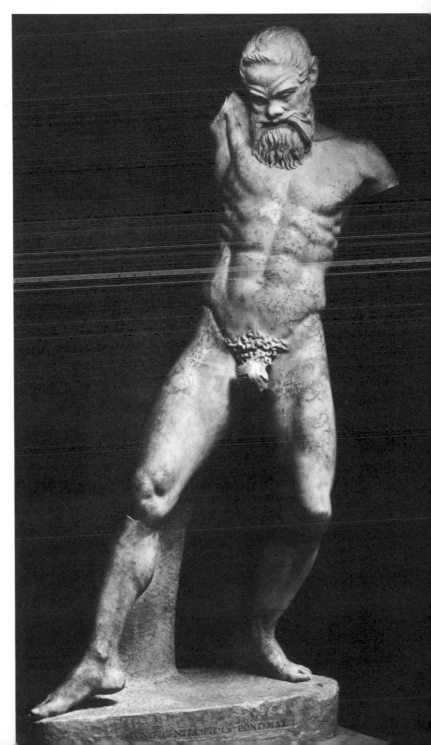

420. MYRON. *Marsyas*. Roman copy after a bronze original (group of Athena and Marsyas) of c. 450 B.C.
Marble, height 62 5/8". Lateran Museum, Rome

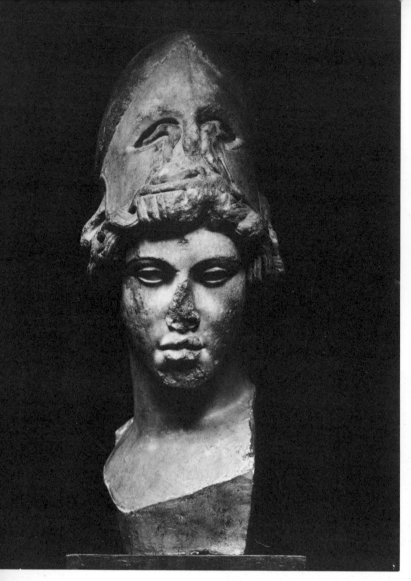

421. MYRON. *Head of Athena.*
Roman copy after a bronze original
(group of Athena and Marsyas) of c. 450 B.C.
Marble, height of head 12 5/8″.
Staatliche Kunstsammlungen, Dresden

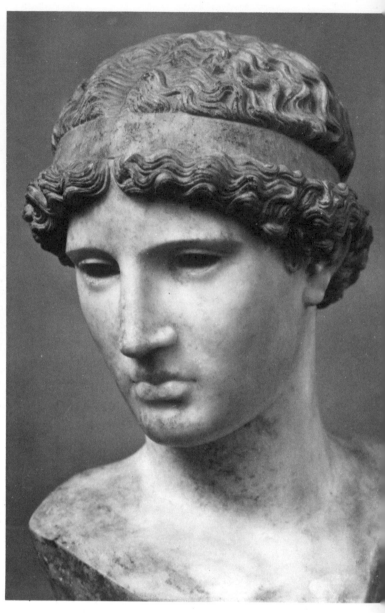

equilibrium, with the goddess poised to retire and the satyr to advance. The group appears on coins, so that we know its general appearance, if not the exact way in which the two figures were placed. The face of Marsyas is masklike and inexpressive, almost grotesque; but the whole concept of Athena is new and sensitive. She is slightly built, little more than a girl, and her face is young and delicate (fig. 421). A new light on Athena, but also a new light on Myron's personality: if we had only the Diskobolos we should never have guessed that

he was capable of this sympathetic study of adolescence.

Almost contemporary with this, and perhaps owing something to it, was one of the most famous statues of the ancient world, the Athena Lemnia of Pheidias. This was a bronze sculp-

316

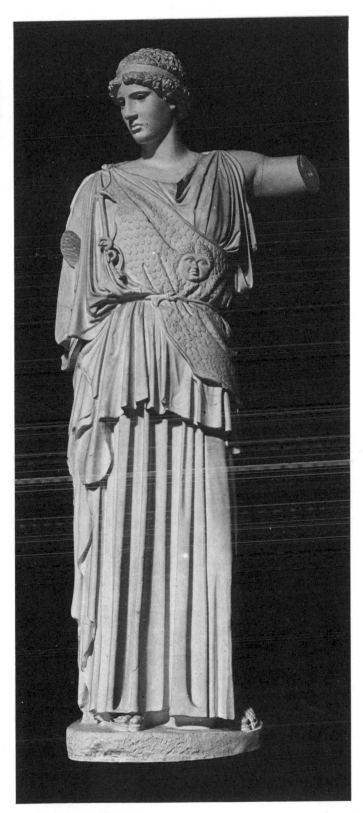

423. PHEIDIAS. *Athena Lemnia.*
Modern composite reconstruction from Roman copies
(Bologna head and Dresden body) after a bronze original of
c. 450 B.C. Marble, height over 72″

ture dedicated on the Acropolis of Athens by the colonists who settled on Lemnos within a year or two of 450 B.C., and so can be accurately dated. A copy has been recognized in the perfectly preserved head at Bologna (fig. 422), and the type of body which goes with it is known from copies in Dresden. The statue thus recomposed is of great beauty (fig. 423); and if a copy can make so deep an impression, we can judge how the original work must have justified the supreme reputation of Pheidias.

He was widely known in antiquity for his colossal statues: the bronze Athena on the Acropolis from the Persian spoils, which can be seen standing there on Athenian coins of Roman date; the gold-and-ivory Parthenos, dedicated in the Parthenon in 438 B.C.; and, most famous of all, the gold-and-ivory Zeus at Olympia, probably created in the years between then and the death of Pheidias in 432. We know a great deal about these, but can form little idea of their essential quality. Pausanias describes both the Parthenos and the Zeus; and we have a number of small copies of the Parthenos, a handsome but rather feeble gem of the first century B.C. showing her head and shoulders, and some full-sized copies in marble of the metal reliefs on her shield. Of the Zeus, a coin of the Roman emperor Hadrian shows a head on one side and a statue on the other, which may reproduce it. Even this is doubtful; but if it were not, the head conveys little and the statue nothing of its grandeur.[9]

It was not only at Athens that sculpture flourished. About 450 B.C., when Myron was producing his Diskobolos and Pheidias his colossal bronze Athena for the Acropolis, both statues famous throughout the ancient world, Polykleitos of Argos created a work which was equally famous and was destined to have a far more profound effect upon subsequent sculpture than either of the others.

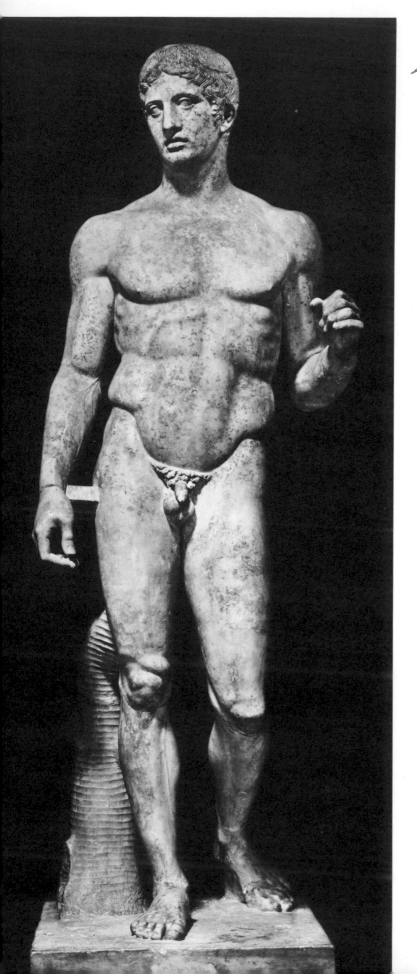

This was the Doryphoros, the spear carrier (fig. 424). Superficially it was a subject simple enough, a youth strolling off or onto an athletic exercise ground, and it was probably commissioned, as were most of Polykleitos' statues, to commemorate a victory in the Games. Critics observed two remarkable things about it: first, the weight of the body rested entirely on one leg and the other was free, so that the youth seemed to be walking, an effect which sculptors had so far not achieved; second, and even more important for its influence on the future, the statue embodied a meticulous system of proportions.[10] A third feature, which ancient critics mentioned only indirectly, was the outstanding rhythmical composition. It is noteworthy that this rhythmical arrangement is designed to be appreciated from the front: there is no attempt at a spiral composition— this took nearly a century more to evolve.

Polykleitos not only created the statue, he wrote a book explaining it. Both the statue and the book were called the "Canon" (the measuring rod), and although no transcript of the book has survived, copies of the statue are numerous. It is natural to wonder what impelled Polykletitos to do this at this particular moment. The idea of working to a scheme of proportions was and is familiar in art—the Greeks had it from their Egyptian teachers many generations before. But we do not know what underlay the Egyptian system, whether it was mainly a convenient technical method of designing a statue and of teaching others to do so, or whether it implied some theory of beauty. With Polykleitos it certainly did the latter. He may have observed the tendency growing in his day—a tendency almost inevitable as technical facility increased—to make sculpture more and more naturalistic. He must have known, as every artist does, that the basis of all art is not mere imitation of nature,

424. POLYKLEITOS. *Doryphoros.*
Roman copy after a bronze original of c. 450–440 B.C.
Marble, height 78″. National Museum, Naples

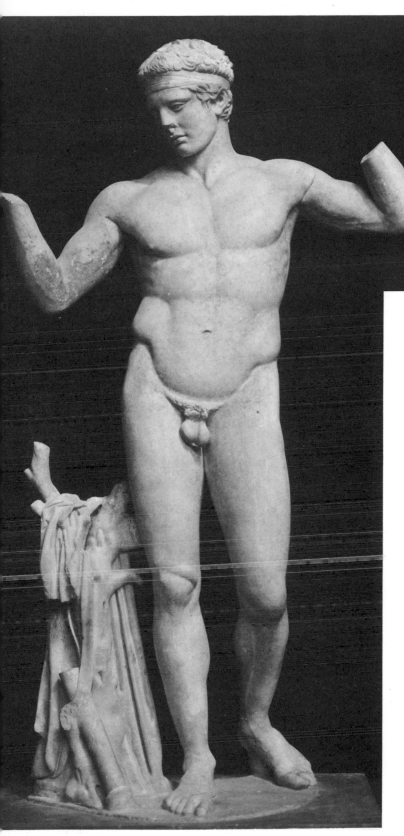

425. POLYKLEITOS. *Diadoumenos*. Roman copy,
from Delos, after a bronze original of c. 440–430 B.C.
Marble, height 73 1/4". National Museum, Athens

but proportions; and being a Greek, with the
characteristic Greek feeling for order and for
the ideal, he may have felt that it was time to
state this in emphatic terms.

Polykleitos also made a bronze Diadoumenos,
a youth binding his hair with the ribbon of
athletic victory: copies show that it must have
been a later work than the Doryphoros, for
there is less emphasis on the divisions of the
body, a rather more flowing surface, and fuller
and less stylized hair (fig. 425). The stance is
different too; the youth is not in the act of
walking but is coming to a halt. Other statues
by Polykleitos, all of bronze, were of boy

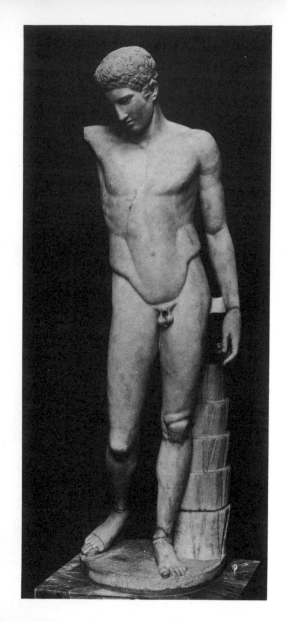

victors in the Games: the Westmacott athlete, in the British Museum (fig. 426), may be a copy of his statue of Kyniskos, victor at Olympia, where its base still is today; the boy looks modestly downward as he places a wreath on his head (fig. 427).

We can trace the style of Polykleitos into the next generation in the statue of a discus thrower preparing to take up his stance for the throw: he has the discus in his left hand and will pass it into his right as he steps forward to throw (fig. 428). This probably copies a bronze by Naukydes, nephew of Polykleitos, who has made some attempt to reproduce the softness of the flesh by using more rounded forms, and has given more interest to the hair by moving the locks over the forehead to one side. The bronze youth from Ephesos (fig. 429), perhaps an

426. POLYKLEITOS. *The Westmacott Athlete.*
Roman copy after a bronze original of c. 440 B.C.
Parian marble, height 59″.
British Museum, London

428. NAUKYDES (attributed). *Diskobolos.*
Roman copy after a bronze original of c. 410 B.C.
Marble, height 46 1/2″. Capitoline Museum, Rome

427. *Head of the Westmacott Athlete*
(detail of statue in fig. 426)

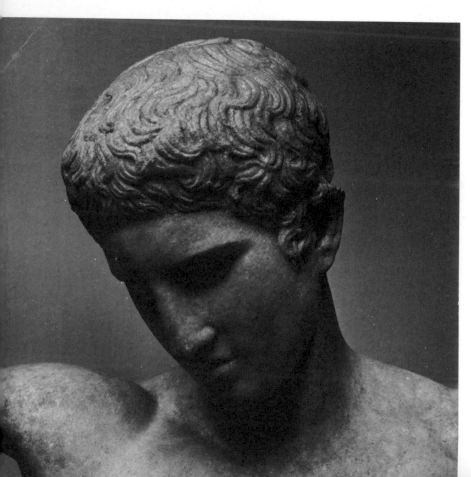

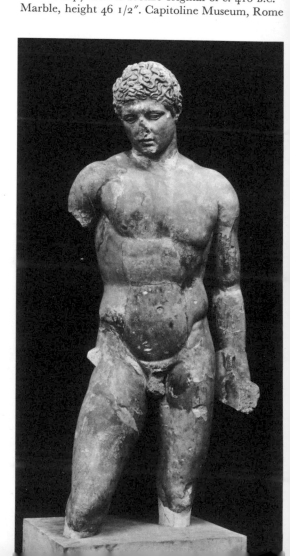

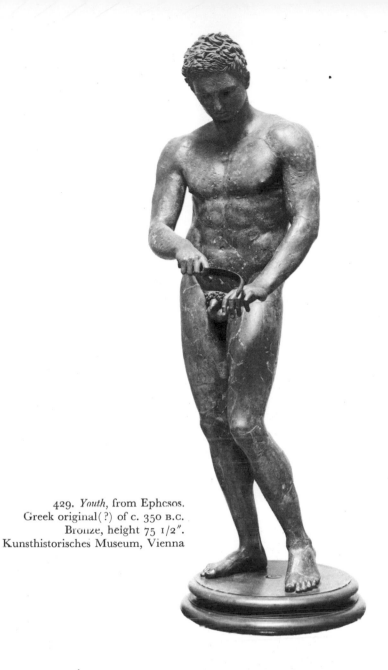

429. *Youth*, from Ephesos.
Greek original(?) of c. 350 B.C.
Bronze, height 75 1/2".
Kunsthistorisches Museum, Vienna

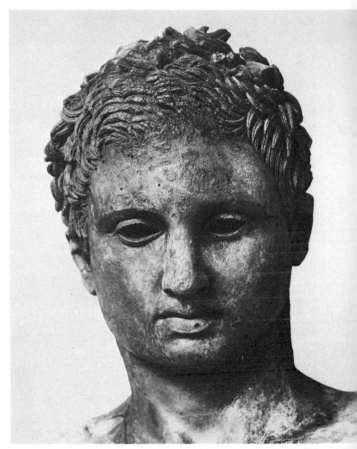

430. *Head of Youth* (portion of statue in fig. 429)

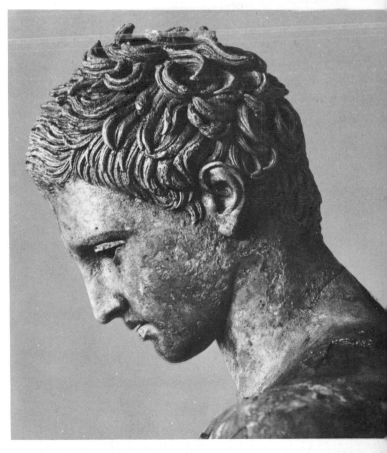

original, is in another manner, but shows similar tendencies and a similar dependence on Polykleitan tradition. Here the body is still more fleshy and the hair in stronger movement, standing up from the surface of the head in a way which suggests that it was tousled and matted after exercise, perhaps a wrestling bout (fig. 430): this would suit the action of the right hand, which is that of scraping off the oil and dust of the palaestra with a strigil.

Pliny preserves the story of a contest between a number of famous sculptors for the statue of an Amazon in bronze, to be dedicated in the temple of Artemis at Ephesos, which was supposed to have been founded by Amazons. There is nothing impossible in the idea of such a competition; it could have taken place in the decade 445–435, and the existence in Roman copies of several types of Amazon, different from one another but sufficiently alike to be contemporary, tends to confirm Pliny's story. Polykleitos was the winner, and the type usually ascribed to him, from its likeness to the Doryphoros, is that in the Capitoline Museum (fig. 431): the Amazon is wounded and the wound is made the motive of the statue, for she is drawing away her dress from it. The Mattei type in the Vatican, of which a more complete replica has been found in Hadrian's Villa, can be reasonably associated with Pheidias because Lucian says that it was pressing down on its spear (fig. 432); and the Berlin type with Kresilas from its resemblance to the portrait of Perikles (fig. 433). Nobility of form and, except perhaps in the Capitoline type, absence of emotion reign throughout: the Classical ideal is dominant and nothing must be allowed to disturb its calm. Art, for better or worse, bore this impress for centuries, and it is felt even today.

Pheidias was the agent of Perikles in all his artistic schemes. Pheidias was a sculptor; and it is therefore natural to see, in the sculptural decoration of the Parthenon, which was their centerpiece, the mind and even the hand of Pheidias. This is a sound inference, but it must be qualified by the consideration that Pheidias was extremely busy on the colossal statue of the Parthenos and other freestanding statues; and even if he had not been, he could not possibly have carved more than a very small fraction of the sculptures of the Parthenon himself.

The sculptural decoration of the Parthenon consisted of the metopes, in very high relief, above the outer colonnade; at each end, a pediment containing figures almost in the round; and inside the outer colonnade, above the exterior walls of the temple itself, a frieze, in very low relief. This arrangement can fairly be criticized: the conflicting scale of metopes and pediments, and their conflicting claims on the spectator's attention, are inherent in any fully decorated Doric temple, and can be

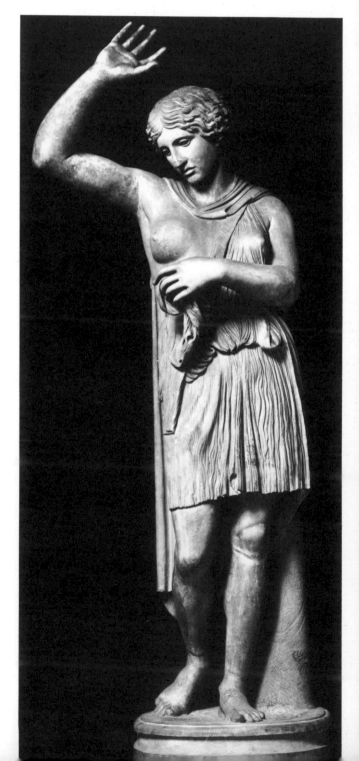

431. POLYKLEITOS (attributed). *Wounded Amazon.*
Roman copy after a bronze original of c. 440–430 B.C.
Marble, height 79 1/2″. Capitoline Museum, Rome

avoided only by leaving the metopes blank, as at Olympia: but the introduction of an Ionic feature, a frieze set in such a way that it can be seen only at a steep angle, seems a wantonly disturbing element. The quantity of sculpture on the building is immense, and its quality is of sustained excellence. Naturally, when so many sculptors of differing antecedents had been brought together, there must have been differences of style and skill, especially at the begin-

ning of the project. These are clearest in the metopes, which were the earliest to be carved, and in the pediments, where strong personalities have left their mark on the separate statues. The frieze was designed as a unity and there the more obvious differences are in the details of execution: but in the western section particularly a sculptor of extraordinary power has occasionally intervened.

Of the ninety-two metopes, most are badly

432. PHEIDIAS (attributed). *Wounded Amazon* (Mattei type). Roman copy after a bronze original of c. 440–430 B.C. Marble, height without plinth 85 7/8″. Villa of Hadrian, Tivoli

433. KRESILAS (attributed). *Wounded Amazon* (Berlin type). Roman copy after a bronze original of c. 440–430 B.C. Pentelic marble, height 74 7/8″. The Metropolitan Museum of Art, New York (Gift of John D. Rockefeller, Jr., 1932)

434. *Centaur Triumphing over a Dead Lapith,*
metope from the south side, the Parthenon, Acropolis, Athens.
c. 440–432 B.C. Pentelic marble, height 56″. British Museum, London

435. *Lapith Fighting a Centaur,*
metope from the south side, the Parthenon

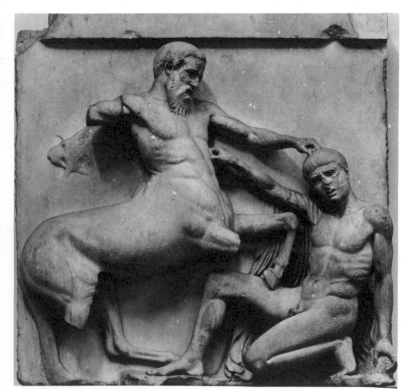

436. *Centaur Attacking a Fallen Lapith,*
metope from the south side, the Parthenon

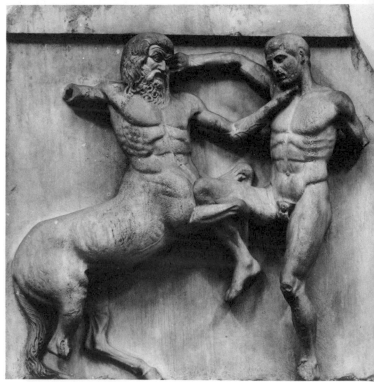

437. *Lapith Fighting a Centaur,*
metope from the south side, the Parthenon

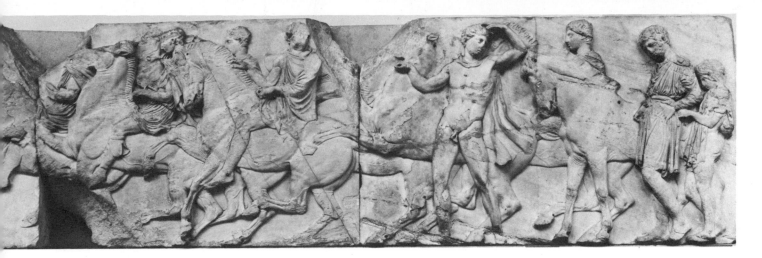

438. *Mounted Procession Followed by Men on Foot*, from the north frieze, the Parthenon, Acropolis, Athens. Completed 432 B.C. Pentelic marble, height 41 3/4″. British Museum, London

defaced; but except in the middle of the long sides, where the damage is greatest, we have a general idea of what they were. On the east was the battle of gods and giants, suitable since the Olympian gods are shown, in the frieze behind, now secure on Olympos; on the west Greeks and Amazons, also suitable, since Amazons were supposed to have attacked the Acropolis. On the north the Sack of Troy was represented, and on the south, at eastern and western ends, the fight between centaurs and Lapiths (figs. 434–37); but on both south and north sides there seem to have been, in the middle, metopes with subjects quite unrelated to the ends, and this to our eyes seems strange. Among the metopes that are reasonably well preserved the two best are those still on the building at the western end of the north and south sides respectively. Some of the others are of excellent design, but some are indifferent in design or faulty in execution: the sculptors seem to have had difficulties with the very high relief, especially in carving projecting arms and legs and centaurs' legs and tails.

The subject of the frieze is the Panathenaic procession. This took place every year, but with greater splendor every fourth year, when a robe, the peplos, specially woven, was ceremonially presented to the goddess Athena and

then draped on her old wooden image in the Erechtheion. As shown on the Parthenon the procession consists of a number of horsemen making ready and then advancing (figs. 438, 439); of chariots in front of them; and in front

439. *Equestrian Group* (detail of the north frieze, the Parthenon). British Museum, London

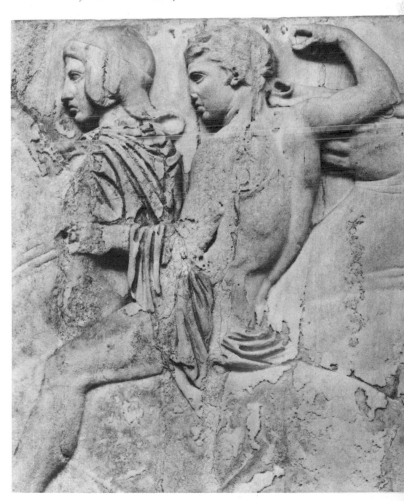

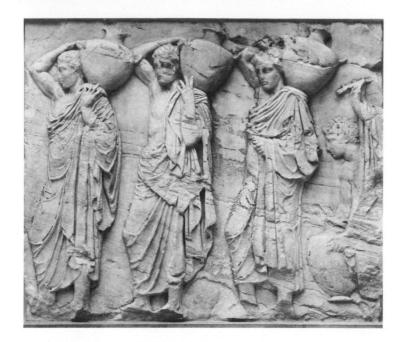

left: 440. *Water Carriers*,
from the north frieze, the Parthenon.
Acropolis Museum, Athens

below: 441. *Girls and Stewards*,
right side (portion)
of the east frieze, the Parthenon.
The Louvre, Paris

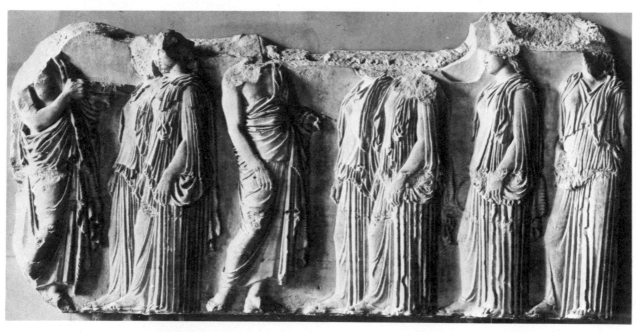

442. *Priest and Attendant Holding
the Peplos*, center portion of
the east frieze, the Parthenon.
British Museum, London

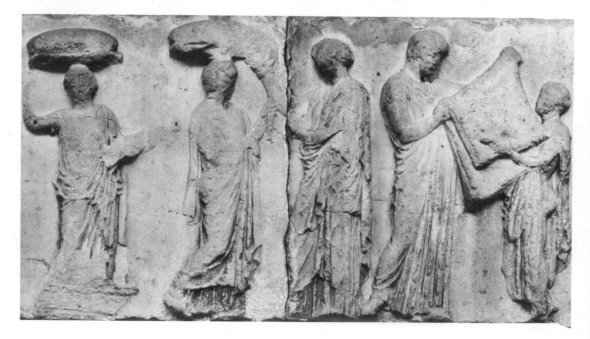

of these various people on foot, carrying objects (fig. 440) and leading victims to be used in the ceremony. At the head of the procession there are a number of women (fig. 441), but all the rest are men.

Although the frieze depicts on all four sides a single subject, it is not continuous; for the procession is in two streams, which start at the southwest corner, one going north, the other east, to arrive at opposite ends of the east front. In the center of the east front a ceremony is being enacted (fig. 442): a man and a boy are handling a large folded cloth which can only be the peplos, but whether it is the old peplos being put away in preparation for the arrival of the new one, or the new one just received, is not clear. On each side of this central ceremony is a group of six gods (figs. 443, 444): they are the twelve Olympians, perhaps on Olympos. Some scholars have thought that this is no ordinary Panathenaic procession, but the first institution of the Panathenaea by Erichthonios, the Attic hero, and thus the prototype of all subsequent processions. In any case the subject is not a Panathenaic procession frozen into marble at a particular moment in its progress:

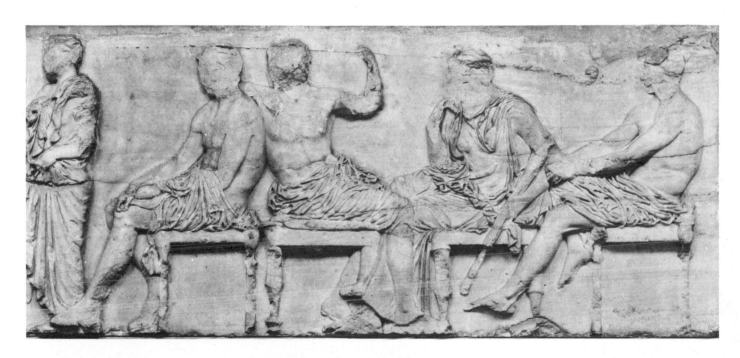

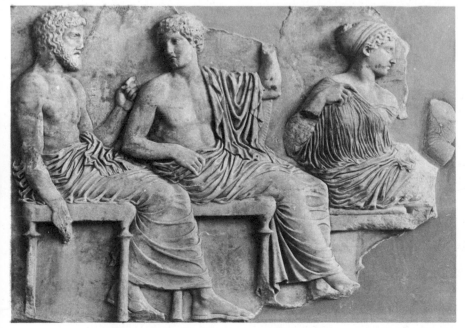

above: 443. *Seated Gods: Hermes, Dionysos, Demeter, and Ares,* left side (portion) of the east frieze, the Parthenon. British Museum, London

left: 444. *Seated Gods: Poseidon, Apollo, and Artemis,* right side (portion) of the east frieze, the Parthenon. Acropolis Museum, Athens

327

rather is it the whole ceremony analyzed, purged of all irrelevancies, and remolded into a new harmony.

There is no unity of time, because events which happened in succession are shown as happening simultaneously: there is no unity of place, because they happen in widely separated places in Athens, and on Olympos as well as in Athens. There is unity, but it is dynamic, not static. In reliefs both before and after this, the so-called continuous style unites a number of successive scenes, which are displayed in one continuous composition, by repeating at intervals an easily recognizable important figure—in Roman reliefs, for instance, the emperor. In the Parthenon, the spectator walking along the frieze from the back to the front himself sup-

plies the unifying factor. He sees, one after the other, all the elements which compose the procession, just as if he were himself taking part. He can share in spirit the preparations, and the gradual speeding-up, and as he moves up the long sides he finds that he is among the horsemen in full career. He then leaves the horses and chariots behind in the lower city and accompanies those on foot who are making their way up onto the Acropolis; and when he arrives there he finds that he is still not too late to be a spectator of the culminating ceremony.

Pausanias ignores metopes and frieze but gives a few words to the pediments: without them we might have been at a loss to identify the subjects. That on the east was the birth of Athena (fig. 445); that on the west her contest

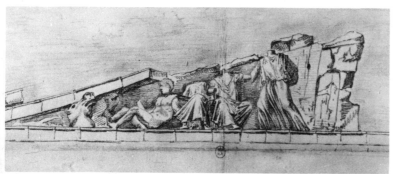 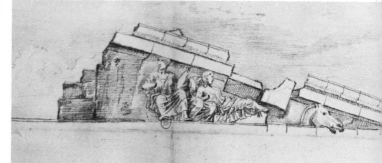

445. *The Birth of Athena*, drawings of the east pediment of the Parthenon by Jacques Carrey. Bibliothèque Nationale, Paris

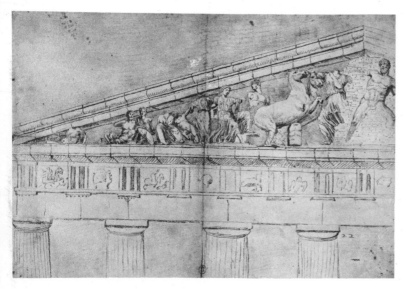

446. *Contest Between Athena and Poseidon*, drawings of the west pediment of the Parthenon by Jacques Carrey. Bibliothèque Nationale, Paris

with Poseidon for the land of Athens (fig. 446). To the classical mind, with its growing sophistication, both of these myths must have seemed somewhat crude; and to the Classical sculptor, with his growing realism, the birth of Athena must have offered a particularly awkward problem. Athena was born from the head of Zeus, which had been cloven by the axe of Hephaistos; and a literal presentation of this, agreeable though it had been to sixth-century vase painters, would in those days, on that scale and in that position, have been little short of laughable. The designer chose the moment after the birth, with Athena, already fully grown, moving away to one side, and Hephaistos, stepping back, on the other; Zeus was seated in profile, not quite in the center (fig. 445).

Similarly in the west pediment there was no longer the rigid vertical of a single divine figure, as at Aegina or Olympia, but a V-shaped composition of Athena and Poseidon, having just produced their gifts (the olive, and the salt spring, symbol of the sea), and leaning back from them (fig. 446).[11] There was in both pediments a rhythm of movement toward and away from the central groups, with figures turning and half-turning one way or the other, but the west pediment seems to have suffered from an excessive number of smaller figures which made it crowded and restless. Two splendid pieces are left, minor figures originally, but well over lifesize: one the river-god from the northern angle, masterly in flowing lines and effortless command of anatomy (fig. 447); and a torso of Iris, messenger of the gods, in quick movement, with her thin tunic pressed against the body in countless folds all expressing

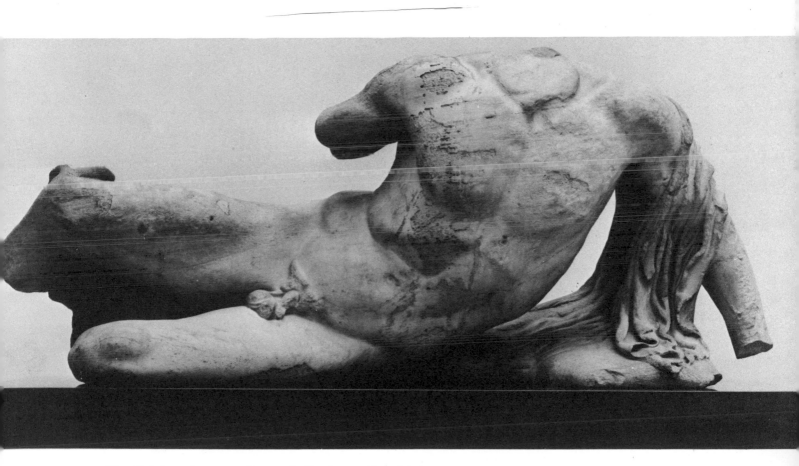

447. *River-God*, from the west pediment, the Parthenon. Completed 432 B.C. Pentelic marble, length 75 1/4″. British Museum, London

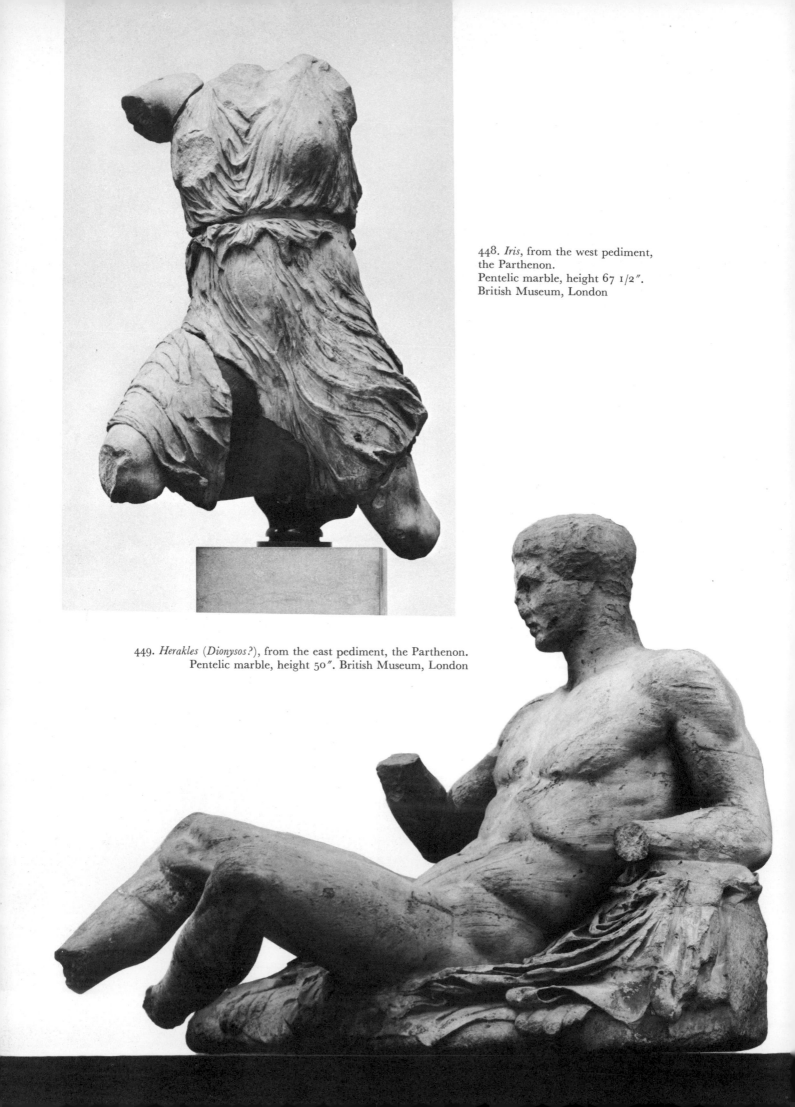

448. *Iris*, from the west pediment,
the Parthenon.
Pentelic marble, height 67 1/2".
British Museum, London

449. *Herakles (Dionysos?)*, from the east pediment, the Parthenon.
Pentelic marble, height 50". British Museum, London

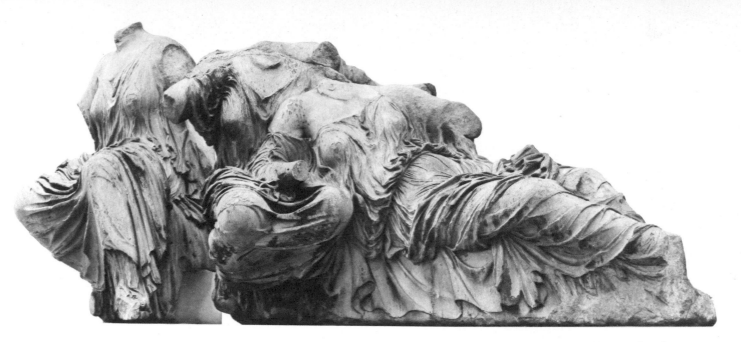

450. *Three Goddesses*, from the east pediment, the Parthenon. Pentelic marble, height 59 5/8". British Museum, London

that movement (fig. 448). The subsidiary figures of the east pediment, despite battering and mutilation, give some idea of the ability of the leading sculptors at this time. At the southern end Helios was rising from the sea in his four-horse chariot, balanced on the northern by Selene, the moon, sinking below the horizon. The great male figure facing Helios, but with back almost turned to the central scene, has been justly admired for the understanding of muscle and movement which it displays and for its harmony of nature with art (fig. 449); it may be Herakles, as representative of the world of mortals, or may be a personification of Mount Olympos, who would thus locate the event in space as the rising sun locates it in time. The two goddesses next to him may be Demeter and Persephone, who, because of their gift of wheat, are the deities most intimate with mankind; and the young girl, perhaps Hebe, cupbearer of Zeus, running away from the center but originally looking back toward it, serves as a link between the central group and those beyond. On the far side of the central gap are three figures, still unidentified, but perhaps the best known of all the sculptures of the Parthe-

non (fig. 450): the one on the left, nearest the center, faces the front but her head was slightly turned as if in awareness of what was going on: the other two seem completely oblivious, one reclining almost at full length in the lap of the second—an almost miraculous study of the thinnest of drapery enveloping bodies that are not by any means insubstantial, with a grace verging on but never declining into weakness. The head of the outer horse from Selene's chariot is also familiar, but that does not diminish its quality: again a perfect blend of art and nature, character and mood (fig. 451).

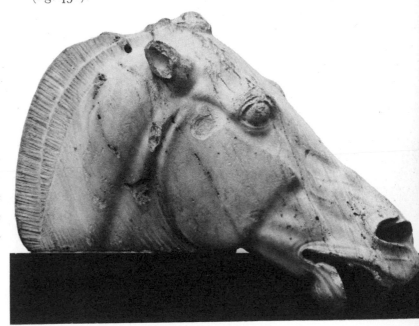

451. *Head of Horse from Selene's Chariot*, from the east pediment, the Parthenon. Pentelic marble, length 33". British Museum, London

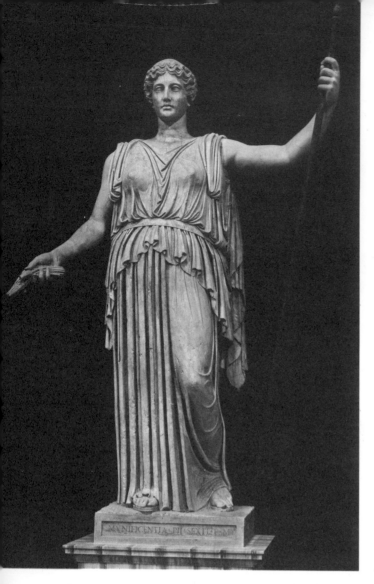

The best-known pupil of Pheidias was Agorakritos, and his colossal marble statue of Nemesis, sometimes ascribed to Pheidias himself, survived in a temple at Rhamnous in Attica throughout antiquity.[12] The so-called Ceres of the Vatican Rotunda may be a copy, but it has been retouched (fig. 452). It must reproduce a statue of the same time and the same scale, however, and it gives an idea of the grandeur of these Pheidian cult images, and also perhaps a hint of the dangers inherent in the Classical ideal. A great truth, inspiring when first discovered, can become a platitude by repetition, and so it is with Classical sculpture when its imitators have nothing new to add. Such an anticlimax can be detected at the end of the fifth century, when the style built up by Pheidias was broken down into brilliant affectation (fig. 453), prettiness, or worse.

But before we consider what happened in the

454. PAIONIOS. *Victory*, from Olympia. c. 420 B.C. Parian marble, height 82". Museum, Olympia

452. *"Ceres."* Contemporary copy (reworked), c. 420 B.C., perhaps of the *Nemesis* by Agorakritos. Marble, height 9′ 8″. Vatican Museums, Rome

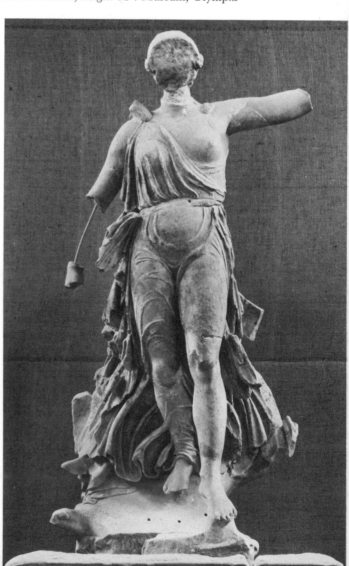

453. *Victory*, acroterion from the Stoa of Zeus, Athens. c. 410–400 B.C. Marble, height with plinth 50 3/4″. Agora Museum, Athens

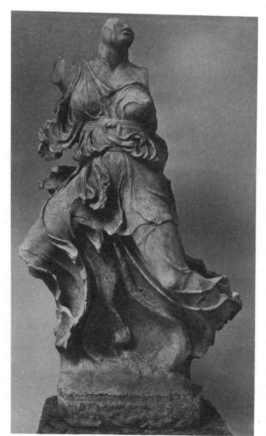

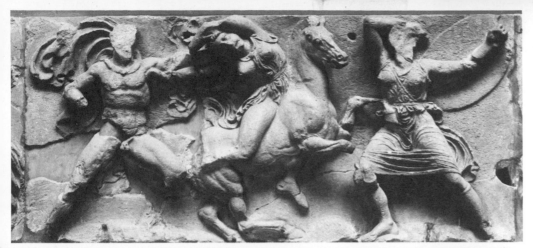

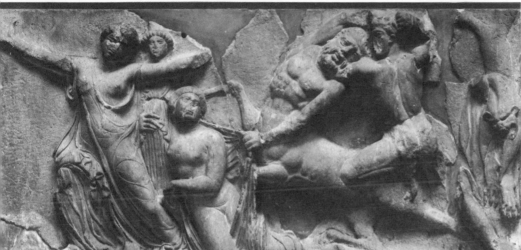

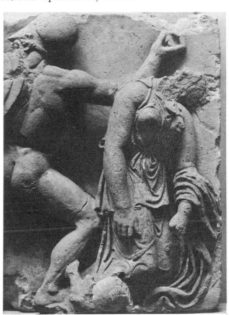

left: 455. *Amazonomachy,* from the cella frieze, Temple of Apollo Epikourios, Bassai. c. 420 B.C. Marble, height 25 1/4″. British Museum, London

below left: 456. *Centauromachy,* from the cella frieze, Temple of Apollo Epikourios, Bassai

below right: 457. *Amazon Collapsing,* from the cella frieze, Temple of Apollo Epikourios, Bassai

fifty years following the death of Pheidias, we must mention two important works of the time just after the Parthenon but in the Peloponnesus— the Nike of Paionios and the frieze from the temple of Apollo at Bassai. Paionios, a native of Mende in Thrace, was commissioned by the Messenians and Naupactians to execute in marble a statue of Victory for Olympia, where it was erected upon a tall column of triangular section (fig. 454).[13] Everything was done to create the illusion of flight: the column was set with an edge toward the spectator, so that its thickness was minimized; the figure had its left foot lightly resting on a projecting piece of marble which would have been masked from the ground by the top edge of the column; the right foot is unsupported, the main weight of the figure being taken by the block of marble from which are carved the drapery behind the figure and, below, the shape of an eagle. The illusion of descending flight is intensified by the dress, apparently pressed against the body by the wind, and by the cloak, held in the left hand and billowing out behind.

At Bassai, the frieze in the temple ran around all four sides of the northern room and bore a battle of Greeks and Amazons (fig. 455) and the fight of Lapiths and centaurs (fig. 456). The arrangement of the slabs is now almost certain: the two subjects, which occupy nearly the same amount of space, were not allotted two complete sides each, but met a little way down each long side. The figures are in very high relief: they overlap each other freely, and there are some bold foreshortenings and difficult subjects, such as the body of an Amazon in the moment of collapse from a standing position (fig. 457). But the carvers have not been

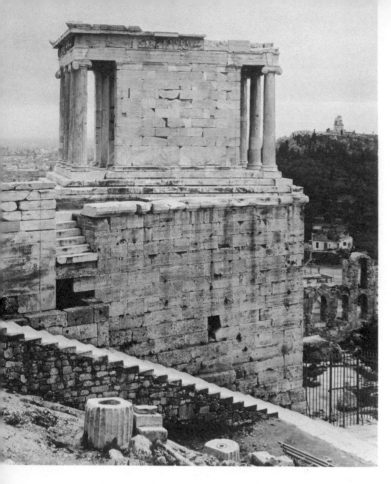

458. Temple of Athena Nike, Acropolis, Athens.
427–424 B.C. *View from the north*

uniformly successful in rendering the fore-shortenings, or in conveying the essence of the subject, in the somewhat intractable marble they were using; and they do not all seem to agree on the amount of foreshortening to be shown, or on how much allowance to make for the angle at which the frieze was to be seen. This suggests that they were copying a design supplied by a major artist and that it was a drawing rather than a model in relief. The proportions are stocky, with the heads rather large; they do not seem to be Attic, nor does the style; but designer and craftsmen are alike unknown.

At the death of Perikles in 429 B.C., Athens was on the threshold of a series of campaigns which dispersed her wealth and decimated her population; there were few commissions until the Erechtheion was begun, probably at the Peace of Nicias in 421, to be interrupted eight years later.

About the same time that the work on the Erechtheion was commissioned, it was decided

459. *Victory Before Athena*, balustrade relief (portion), Temple of Athena Nike, Acropolis, Athens. c. 410 B.C. Pentelic marble, maximum height 37″. Acropolis Museum, Athens

460. *Victory Untying Her Sandal*, balustrade relief (portion), Temple of Athena Nike. Pentelic marble, height 42″. Acropolis Museum, Athens

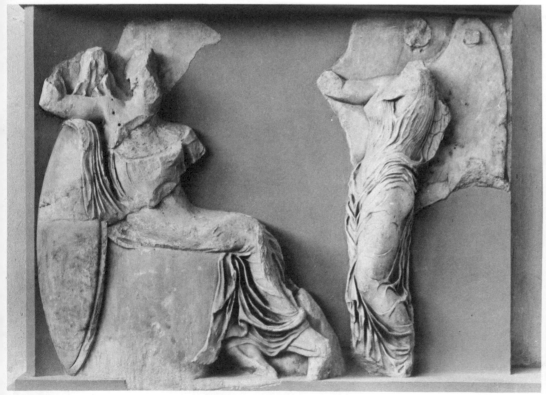

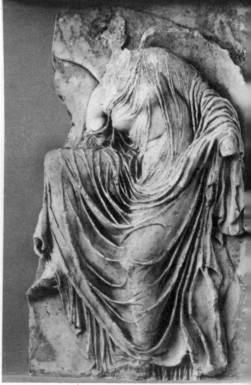

to rail in the dangerous little bastion on which the temple of Athena Nike stood, at the southwest corner of the Acropolis (figs. 399, 458).[14] A marble parapet about three feet high was erected to support the railing; it was smooth on its inner face, but carved on its outer with a frieze of Victories erecting trophies and bringing offerings to their patron goddess, Victory Athena (fig. 459). These sculptors must have included some who had worked fifteen or twenty years before on the Parthenon, or their pupils, for the style is a development from that of the Parthenon in the direction of sweetness and overrefinement, touched with something of the hectic spirit of those days; but it still retains enough of strength and grandeur from the preceding generation to produce reliefs whose brilliance of design and delicacy of execution have never been surpassed (fig. 460). Rhys Carpenter identified six carvers of varying excellence at work on this frieze, and his "Master E" must have been the creator of a statue of Aphrodite of the later fifth century of which the original is lost but which has survived in many copies, the best known being the Aphrodite from Fréjus in the Louvre (fig. 461). Very close in style also, though earlier than the parapet reliefs, is the grave relief from Salamis (fig. 462); and close also, but retaining more

461. MASTER "E." *Aphrodite*, from Fréjus. Roman copy after an original of c. 430–400 B.C. Marble, height 64 5/8″. The Louvre, Paris

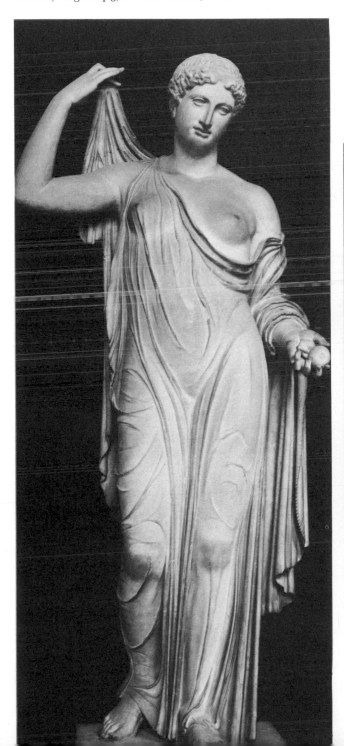

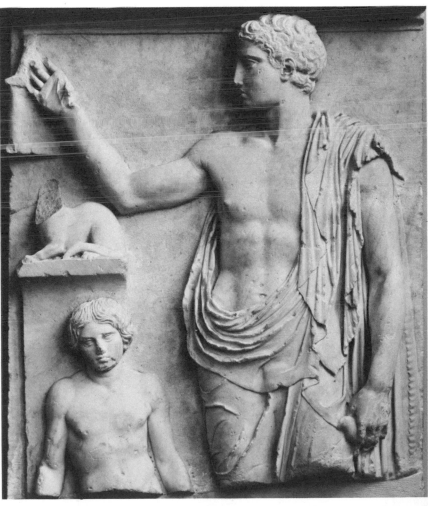

462. *Grave Stele of a Youth*, from Salamis. c. 420 B.C. Pentelic marble, height 28″. National Museum, Athens

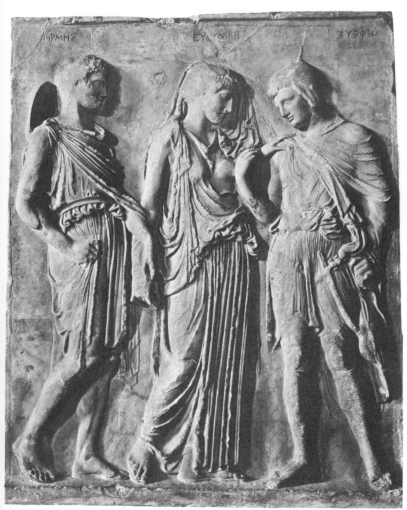

463. *Orpheus and Eurydice*. Neo-Attic copy after a relief of
c. 410 B.C. Pentelic marble, height 46 1/2″.
National Museum, Naples

has survived, and it includes a record of the payments made to sculptors and other craftsmen. This yields important evidence on how such a project was organized: it furnishes a good deal of technical information too, and serves to remind us how much woodwork, especially for ceilings, there was in these marble buildings. The friezes had a background of gray Eleusinian limestone against which the figures, about two feet high, almost in the round and carved separately of white marble, were afterwards fixed. The record shows that the unit here was the single standing figure, for the carving of which the standard payment was sixty drach-

464. *Medea and the Daughters of Pelias*. Neo-Attic copy after a relief of
c. 410 B.C. Pentelic marble, height 42 1/2″. Lateran Museum, Rome

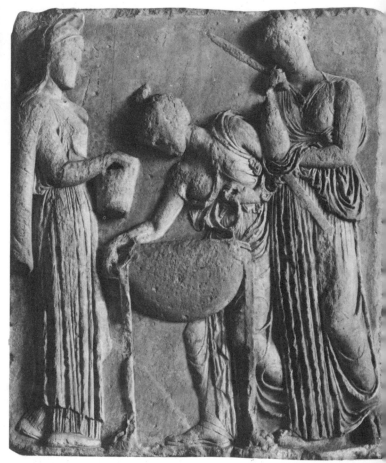

than they do of the calm of the Periklean age, are the reliefs the originals of which Homer Thompson showed may have formed an enclosure round the precinct of the Twelve Gods in the Agora at Athens (figs. 463, 464). Not far off in date, but rather different in style, is the beautiful grave relief of Hegeso (fig. 465).

In 409 B.C., during a temporary respite in the war, a commission was appointed to survey the unfinished Erechtheion and to assess what had so far been done on the building (see p. 308). Much of their report, inscribed on marble,

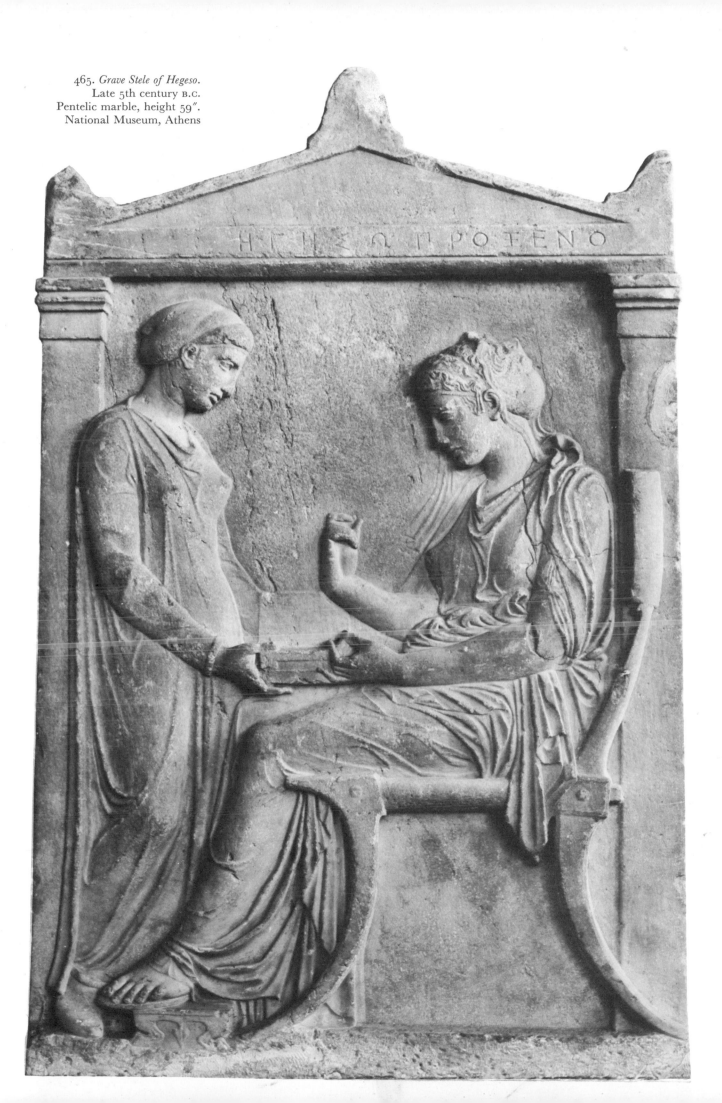

465. *Grave Stele of Hegeso.*
Late 5th century B.C.
Pentelic marble, height 59″.
National Museum, Athens

mas. If anything was added, the payment was proportionately increased: a child cost twenty drachmas, a pillar seven. The commission's report speaks of the blocks that are "above the korai," thus showing that the korai (fig. 466)—the statues of the so-called Caryatid Porch (see fig. 407)—belonged to the period before the project was interrupted.

We have no great sculptures in Athens immediately after the final disaster in Sicily in 413 B.C. and the defeat at Aegospotami in 405. There were no public commissions, and those sculptors who had not perished overseas no doubt accepted such private commissions as there were for grave reliefs and votive reliefs. There is however, a little later, a grave monu-

466. *Kore*, from the Caryatid Porch, Erechtheion, Acropolis, Athens. Before 409 B.C. Pentelic marble, height 91″. British Museum, London

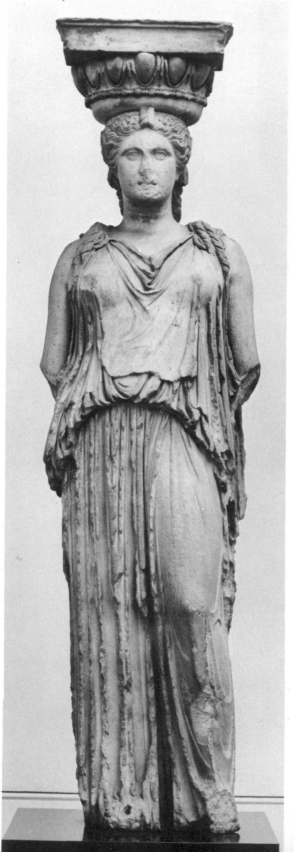

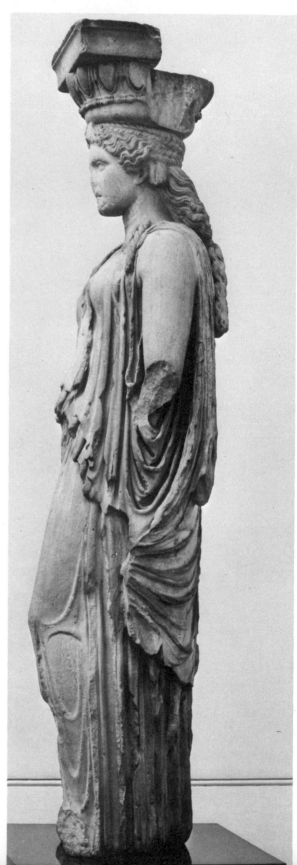

ment to an Athenian knight, Dexileos—an excellent piece of sculpture though no masterpiece—that is important because it can be dated (fig. 467). Dexileos was killed in the battle of Corinth in 394, and the monument, which was a cenotaph in the family grave precinct, must have been carved soon after. The body would have been buried in a public grave with a public monument, and in the Villa Albani in Rome is a relief which, from its more splendid style, may have come from such a public monument of a few years before (fig. 468).[15]

Away from Athens, a comparatively small temple to Asklepios was erected at Epidauros, probably about 375 B.C. It had acroteria and two pediments: all the figures are about half lifesize, the pediments very fragmentary, the

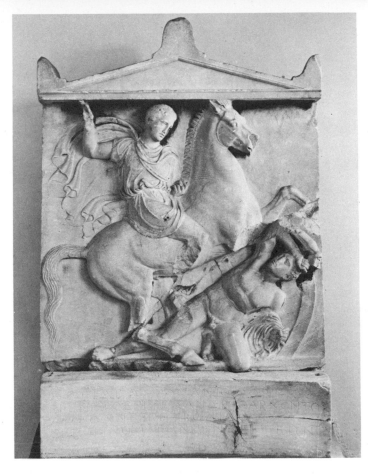

467. *Grave Stele of Dexileos*, from the vicinity of the Dipylon cemetery, Athens. c. 394 B.C. Pentelic marble, height 68″. Kerameikos Museum, Athens

468. *Attic Funerary Monument: Combat.* c. 400–390 B.C. Pentelic marble, height 70″. Villa Albani, Rome

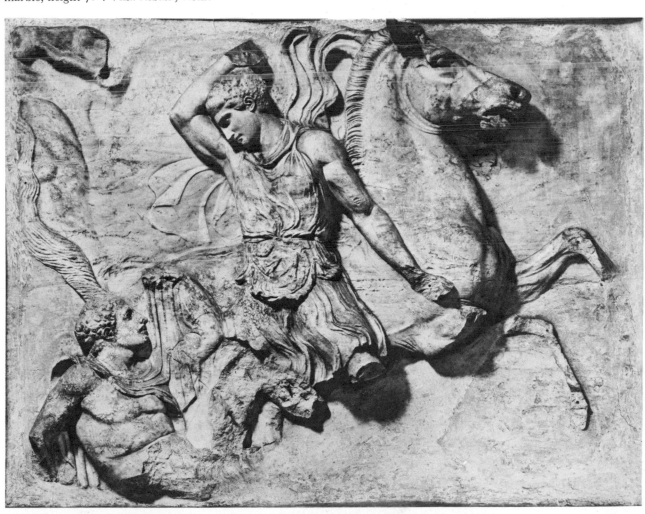

acroteria (fig. 469) less so but much weathered because of their exposed position. We also have a record, inscribed on marble, of most of the payments for these sculptures, and although some details are difficult to interpret, others are fairly certain: Two sculptors, the name of one of whom was Hektoridas, contracted to work the pediments at a cost of 3,010 drachmas per pediment; and Timotheos and another sculptor, whose name began with the syllables Theo- -, supplied between them two sets of acroteria (there would be three figures in each set) at a cost of 2,240 for one and 2,340 (or perhaps 2,420) for the other. This cost presumably included designing and carving the figures, whereas the sculptors of the Erechtheion frieze must have carved from models supplied

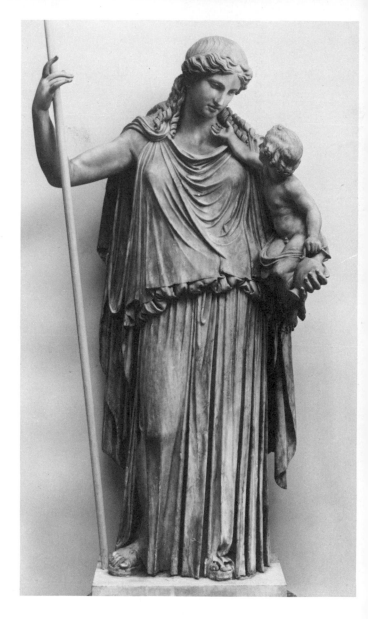

470. KEPHISODOTOS. *Eirene and Ploutos.*
Roman copy after a bronze original
erected on the Areopagus,
Athens, in 372 B.C.(?) Marble, height 83 1/2″.
Staatliche Antikensammlungen, Munich

469. *Nereid on a Seahorse*, acroterion from the Temple of Asklepios,
Epidauros. c. 375 B.C. Marble, height 31 1/2″. National Museum, Athens

to them. It is natural to speculate whether the Timotheos mentioned here was the one who worked on the Mausoleum: there is nothing on the Mausoleum quite like this style, which harks back to the late fifth century, but Timotheos may have been comparatively young in 375, and may have developed more originality as he matured. The figures are carved with skill and feeling; but the formula of clinging drapery is carried to a point at which the clothing disappears altogether where it touches the body, and one feels that this is a technical rather than an artistic triumph.

471. PRAXITELES. *Hermes Holding the Child Dionysos.*
Possibly a Hellenistic or Roman copy of an original of c. 350–340 B.C.
Parian marble, height 84″. Museum, Olympia

With the sculptures of Epidauros this style virtually disappeared. At Athens a new personality was coming to the fore who reacted against the ethereal charm of the Nike temple parapet (figs. 459, 460) and such affectations as the Victory from the stoa of Zeus (fig. 453), and who looked for inspiration to some of the more monumental masterpieces of a century before, for instance the original of the Hestia Giustiniani (see fig. 364, p. 278). This was Kephisodotos. Pliny dates him at 372 B.C. and this may be the date of the dedication of his best-known work, a bronze statue of Eirene (Peace) holding the child Ploutos (Wealth) in her arms, set up on the Areopagus in Athens (fig. 470).[16]

In sculpture the three great names of the fourth century were Praxiteles, Skopas, and Lysippos. Praxiteles was probably the son of Kephisodotos,[17] and his working life probably extended from about 375 to about 330. The work which for many years passed as an original by him, the Hermes at Olympia, is now widely thought to be either a Hellenistic or a Roman version (figs. 471, 472). But it is pos-

472. *Head of Hermes* (detail of statue in fig. 471)

473. PRAXITELES. *Apollo Sauroktonos.*
Roman copy of a bronze original of c. 370 B.C.
Bronze, height 37 1/2". Villa Albani, Rome

material, bronze, made such a bold composition easier, and it was Lysippos who, working exclusively in bronze, was to carry this innovation much further, leading directly to the statue with an all-round view.

The most famous of all the works of Praxiteles was the marble statue of Aphrodite dedicated at Knidos. Reproductions on Roman coins of that city have enabled us to identify copies in marble (fig. 474), but they differ from each other so seriously that it is likely the original was never cast. The goddess was naked—an innovation at this period, though common in primitive times—and was about to step forward, laying aside her drapery over a water pot, these two elements forming the support necessary for a marble figure in such free movement.

About mid-century must come the Hermes with the child Dionysos (fig. 471). Pausanias, visiting Olympia in the second century A.D., says that in the Heraion there was a statue of Hermes with the child Dionysos, and that it was the work (*techne*) of Praxiteles, although he does not say that it was signed or how he knew its authorship. The German excavators in 1877 found a statue with this subject in the place mentioned, and after slight hesitation it was accepted as a Praxitelean original until 1927, when doubts were raised on technical grounds whether it could be a work of the fourth century B.C. It was suggested that the original had been carried off to Rome and that a copy by a Hellenistic sculptor had been substituted. Whatever the truth, the statue, apart from certain mainly technical details (e.g., the very high polish, the form of the puntello between tree trunk and figure, and the unfinished and unsure state of the back), fits well into the work of Praxiteles between 350 and 340, and can be accepted with the reservation that it may be a Hellenistic version and therefore not trustworthy in detail.[18]

sible to form some idea of the changes in sculpture for which he was responsible by arranging in chronological order the various copies which, for one reason or another, can be considered to go back to originals by him. The Apollo Sauroktonos (fig. 473) is reproduced on Roman coins of northern Greece and is accurately described by Pliny. The god is shown as a boy waiting with an arrow to kill a lizard: he leans forward with the weapon poised in his right hand and rests his left elbow on the tree trunk up which the lizard crawls. It seems a trivial subject, and the statue has no great appeal to modern eyes, but it marks a real innovation. There had been leaning statues before but they leaned to one side: the Sauroktonos leans to the front, and so breaks through that imaginary frontal plane which had dominated Greek sculpture so far. The

474. PRAXITELES. *The Aphrodite of Knidos.* Roman copy after a bronze original of c. 350 B.C.
Marble, height 80". Vatican Museums, Rome

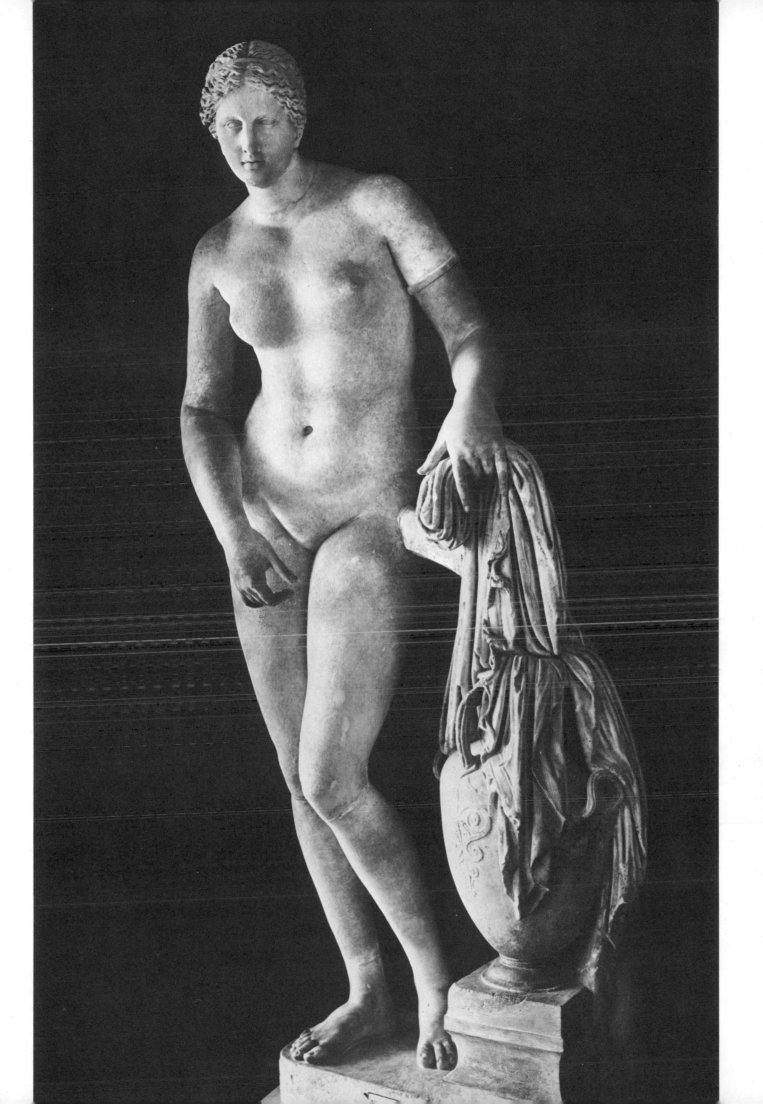

A similar composition is that of the resting satyr (fig. 475), which was immensely popular in Roman times, more than sixty copies being known; but there is no external evidence to connect it with Praxiteles. This new conception of a satyr attempts to show the blend of animal and human in mind as well as body, and is equally distant from the bestial satyrs of Archaic times and from those of the Hellenistic

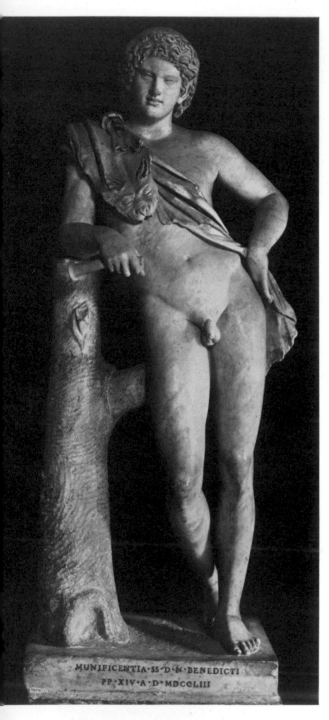

475. PRAXITELES (attributed). *Satyr.*
Roman copy of an original of c. 340 B.C.
Marble, height 67″.
Capitoline Museum, Rome

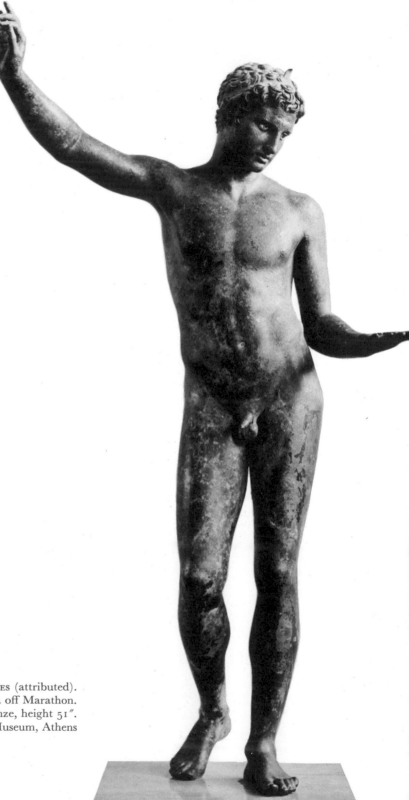

476. PRAXITELES (attributed).
Standing Youth, found in the sea off Marathon.
c. 350–325 B.C. Bronze, height 51″.
National Museum, Athens

age which seem to belong to a carefree world of their own. A bronze youth found in the sea off Marathon was holding some flat object on his left arm, but his action is otherwise unexplained (fig. 476). The statue can be accepted as a late work by Praxiteles or by someone working closely with him: it has something in its pose both of his earlier satyr pouring wine and his Apollo Sauroktonos, but it is not leaning on any support and approaches more nearly to the spiral composition which was evolving under the influence of Lysippos at the end of the Classical period.

Skopas was contemporary with Praxiteles and his son Kephisodotos the Younger, i.e., the middle and later fourth century. For his style the most important criterion is the temple of Athena Alea at Tegea, of which, according to Pausanias, he was the architect. The old temple which it replaced was burnt down in 396 B.C., but the architecture of the new one is judged to be some fifty years later, and this would tally with the style of the sculptures surviving from the pediments. Since the architect was also a great sculptor it is reasonable to suppose that they were executed under his supervision and partly with his own hands. Unfortunately they are very fragmentary, but their style is both original and fairly homogeneous (figs. 477, 478). The main forms are massive, the details bold and tense: the heads are square, the eyes round, set deeply in the head and closely overhung by the brows. The general effect is that of strong emotion, and this corresponds with ancient opinion, which regarded Skopas as the

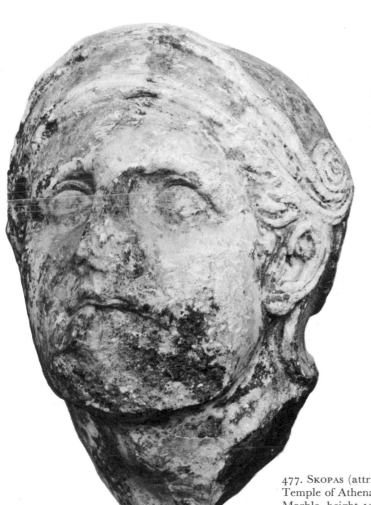

478. SKOPAS (attributed). *Head of a Man*, from a pediment, Temple of Athena Alea, Tegea. c. 350 B.C. Marble, height 7 7/8″. National Museum, Athens

477. SKOPAS (attributed). *Head of a Man*, from a pediment, Temple of Athena Alea, Tegea. c. 350 B.C. Marble, height 12 5/8″. National Museum, Athens

479. *Charioteer*, from a frieze, the Mausoleum, Halikarnassos.
Mid-4th century B.C. Marble, height 25 1/2″. British Museum, London

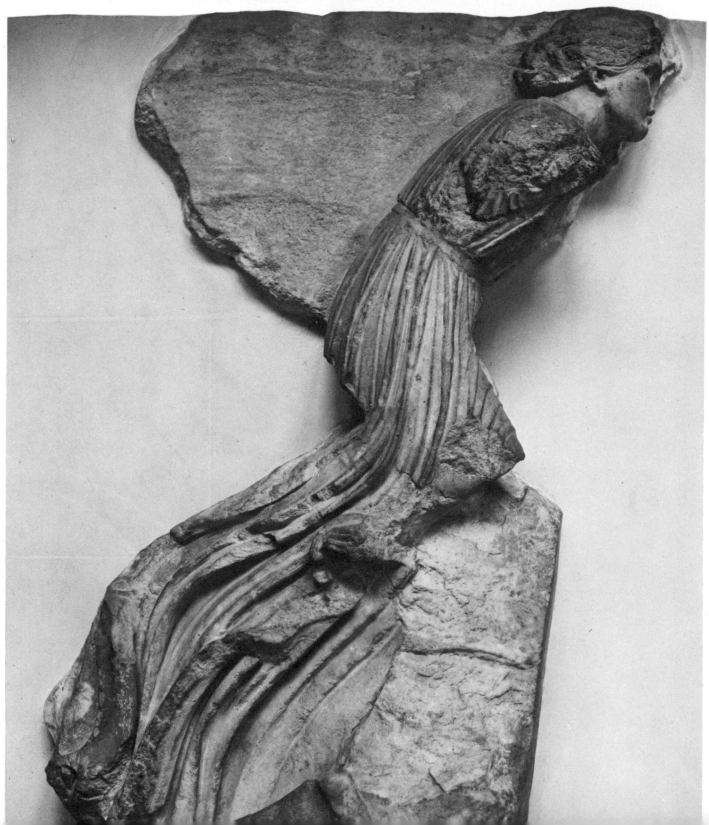

sculptor of passion. Another of his major undertakings gave scope for this talent: it was a group of marine creatures, perhaps carved for a temple of Poseidon in Bithynia but later carried off to Rome and set up in a temple in the Flaminian circus. The subject must have been Thetis bringing to Achilles the arms made by Hephaistos, for both she and her son were present. Nothing of this has survived, but many sea creatures of Hellenistic and Roman date must derive their inspiration from the group, which had a profound effect upon ancient critics, as the enthusiasm of Pliny's description shows.

The third great project on which Skopas was engaged was the Mausoleum at Halikarnassos, about 350 B.C. (see p. 314).[19] Since no slab of any of the friezes has been assigned with certainty either to its position on the structure, as an architectural element, or to a particular side of the building, attribution to individual sculptors must rest upon style alone; and the reasons why this task is difficult will appear.

Of the sculptures in relief on the Mausoleum there are remains of three friezes: a battle of Lapiths and centaurs, a chariot race, and a battle of Greeks and Amazons. Of the first very little is preserved; of the second very small fragments of perhaps twenty chariot teams, with one fine figure of a charioteer (figs. 479, 480); of the third over twenty slabs, many much mutilated, of which the bulk was extracted from the walls of the medieval castle of Bodrum where they had been immured by the Knights of St. John, but three of the best-preserved were excavated from the site of the Mausoleum itself by C. T. Newton. On the strength of Pliny's statement that the four master-sculptors Skopas, Timotheos, Bryaxis, and Leochares were allotted one side of the building each, many attempts have been made to assign certain slabs to certain sculptors. These attempts are misguided in that they ignore the circumstances under which the sculptures must have been carved: we cannot suppose that all the work on any one side was done singlehanded by one sculptor; he must have had assistants who introduced something of their own style as they worked. Differences of style can, it is true, be detected; but more significant are the differences in design (figs. 481–85)—different proportions in the figures, different kinds of grouping, different ways of movement—and these ought to reflect the characters of the four masters, who must have done the main design if nothing else. Most of the work is excellent, and where there is a passage of consistent excellence we may suspect the master's touch (fig. 486): but it is a hazardous business.

480. *Head of Charioteer* (detail of relief in fig. 479)

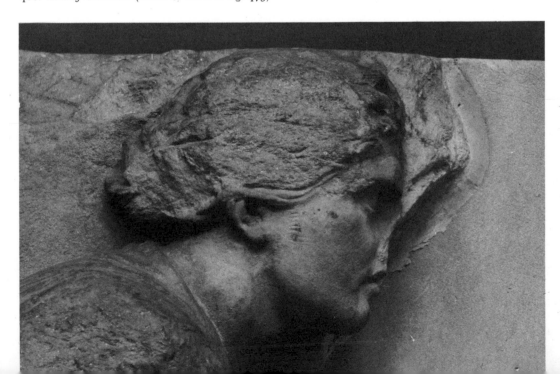

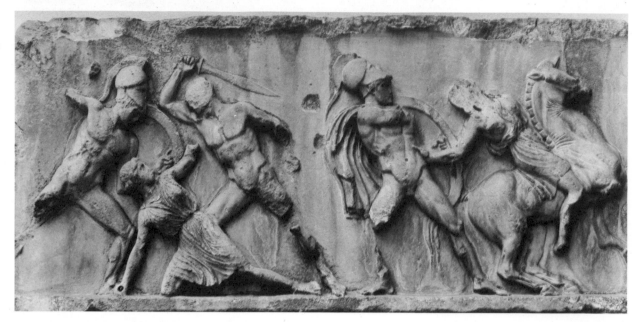

481, 482, 483. *Amazonomachy*, from a frieze, the Mausoleum, Halikarnassos.
Mid-4th century B.C. Marble, height 35″. British Museum, London

484, 485. *Amazonomachy*, from a frieze, the Mausoleum, Halikarnassos

486. *Amazon Riding Backwards*, *Head of Horse*, and *Fighting Amazon* (details of relief in fig. 485)

The sarcophagus from a tomb in Sidon with scenes from the life of Alexander the Great (figs. 487–89) is a generation later than the Mausoleum. When found, much of its color remained, and some can still be seen (colorplate 39): it adds greatly to the life and dramatic tension of the scenes.

In marked contrast to the relief sculptures of the Mausoleum and those on the sarcophagus from Sidon (partly perhaps because of differences of scale and purpose) are the sculptured drums of the temple of Artemis at Ephesos. This was the building replacing the Archaic structure which had been burnt down in 356: the sculptures seem to be of the generation after the fire. The old oriental feature of sculptured lower drums, repeated from the early temple (see p. 253), offered a difficult task to the sculptor because he could no longer be content, as the Archaic sculptor had been, with profile figures in simple procession. He had to make them appear to be moving freely, yet

487. *Battle Between the Greeks and the Persians*, side of the "Alexander Sarcophagus" from Sidon. c. 310 B.C. Painted marble, height of sarcophagus 76 3/4". Archaeological Museum, Istanbul

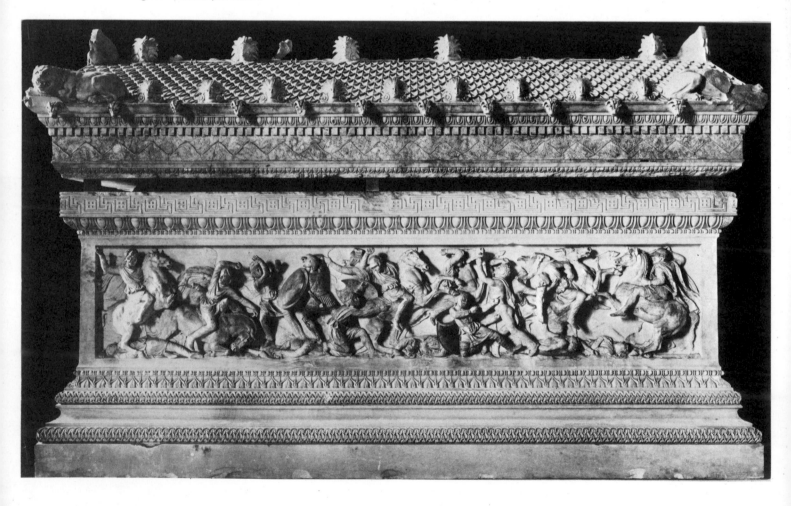

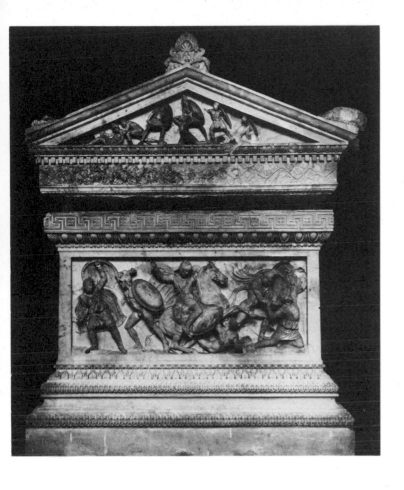

488. *Battle Between the Greeks and the Persians,*
front of the "Alexander Sarcophagus"

489. *Alexander the Great* (left) and *Persian Soldier* (right;
details of the "Alexander Sarcophagus," figs. 487, 488)

could not hope that his foreshortenings, necessary because they were reliefs, would be satisfactory from every viewpoint. In the best-preserved drum, representing the myth of Alkestis or Persephone about to leave the realm of Hades, the sculptor has been remarkably successful (fig. 490). He has not hesitated to use earlier sculptured types—the Hermes, for instance, is based on a figure by Polykleitos; the goddess on the right, holding a wreath, on one by Kephisodotos—and has boldly set some of them in three-quarter, some even in frontal, view; and he has made them stand with their feet on the architectural molding as if they were living, a forecast of the Pergamene Great Altar, where the sculptures writhe up the steps alongside the visitor. The sculptor has created a new personification of Death (visible on the far left), a sleek, winged youth with deeply shadowed eyes and a gentle expression, his one weapon a large sword.

The third major sculptor of the fourth century was Lysippos, whose approach to the art was more nearly that of a modern sculptor. A freestanding statue in bronze is automatically in three dimensions, but this does not mean that the sculptor necessarily makes full use of them; some Greek statues are virtually flat compositions designed for one point of view, while some make a limited use of the third dimension, presenting attractive views from a few other points. Not until the time of Lysippos was a conscious effort made to construct a statue in which every view leads on to another view, enabling the spectator to appreciate to the full that the statue is a creation in space. We can be fairly certain that Lysippos was the great innovator in this respect; but although he was most prolific, only a few certain copies of his statues have survived and the direct evidence for his style is slender. There are two main candidates, one the Agias at Delphi (fig. 491), the other the Apoxyomenos (athlete scraping himself with a strigil) in the Vatican (fig. 492).

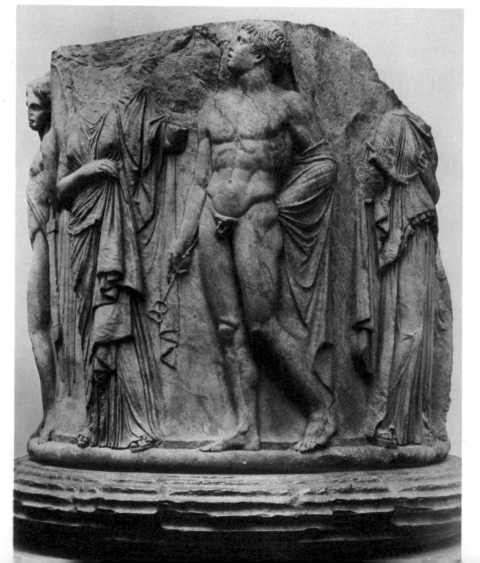

490. *Alkestis* (*or Persephone*) *Leaving Hades*, lower column-drum from the Temple of Artemis, Ephesos. c. 340 B.C. Marble, height 71". British Museum, London

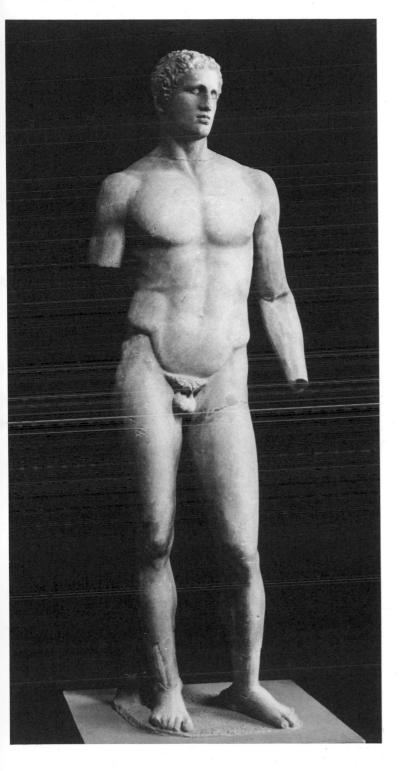

491. LYSIPPOS. *Agias*, from Delphi.
Contemporary(?) copy of a bronze original of c. 334 B.C.
Marble, height 77 1/2″. Museum, Delphi

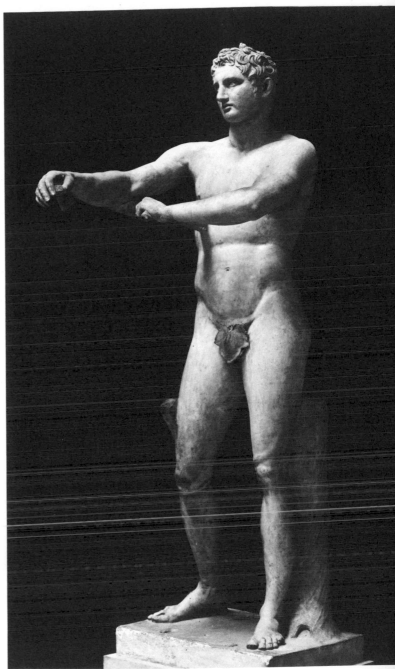

492. LYSIPPOS. *Apoxyomenos*.
Roman copy of a bronze original of c. 310 B.C.
Marble, height 81″. Vatican Museums, Rome

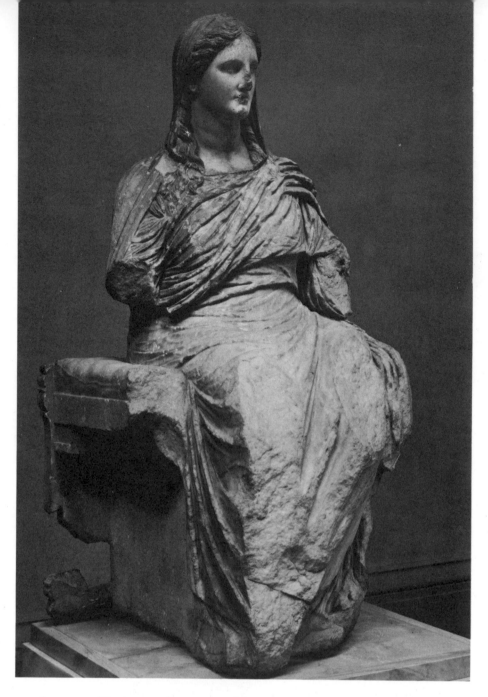

493. LEOCHARES(?). *Demeter of Knidos*. C. 330 B.C. Parian marble, height 60″. British Museum, London

The Agias is part of a set of statues in marble dedicated at Delphi by a Thessalian from Pharsalos, about 334, representing the dedicator and his ancestors. At Pharsalos itself there seems to have been a similar set, and there was certainly a statue of Agias, but in bronze: on its plinth was the name of Lysippos as sculptor. It would seem reasonable to assume that the marble at Delphi was a contemporary copy of the bronze at Pharsalos. The statue was anyhow an imaginary portrait, Agias having died a century before, and if the family had already employed an eminent sculptor for the Pharsalos work they would be unlikely to commission a second to make another, also imaginary: it would be natural to reproduce the Lysippic statue, even though for some reason, probably that of expense, marble had to be used instead

of bronze. The statue of Agias embodies some of the innovations attributed to Lysippos by ancient writers—a new system of proportions as compared with the Polykleitan, the body more tense, the head smaller. If we had nothing else, the Agias would pass for a contemporary copy (not by Lysippos himself but by a marble worker) of the bronze original by Lysippos.

But the Apoxyomenos in the Vatican (fig. 492), a Roman copy of a Greek original, whose claim to represent the style of Lysippos rests on Pliny's statement that the sculptor made a statue of this subject, embodies in an even more obvious way the new features—yet it is not particularly close to the Agias in style. It breaks boldly through the frontal plane with a right arm thrust straight forward, and in general offers a whole succession of satisfactory views: the body is tense, and the man seems ready to spring away in any direction. The head especially is very different from that of Agias, and

it is not a difference that can be explained simply by supposing that they are portraits of different people. It is, however, possible to reconcile the two by assuming either that the Agias is a much earlier work, or that the original of the Apoxyomenos was not the Lysippic statue mentioned by Pliny but was by a pupil treating the same subject. Whatever opinion one holds, the nature of the changes at this time is fairly clear: they herald the greater freedom and variety of the Hellenistic age.

One or two impressive pieces of sculpture come from the end of the Classical period, for instance the Demeter from Knidos by an Attic master, perhaps Leochares (figs. 493, 494). The body is spoilt by breakages, but the head conveys with great subtlety of observation the character of the mother mourning the loss of her daughter; it is tender without the least admixture of weakness: one feels that this could be an implacable goddess, as the legend relates.

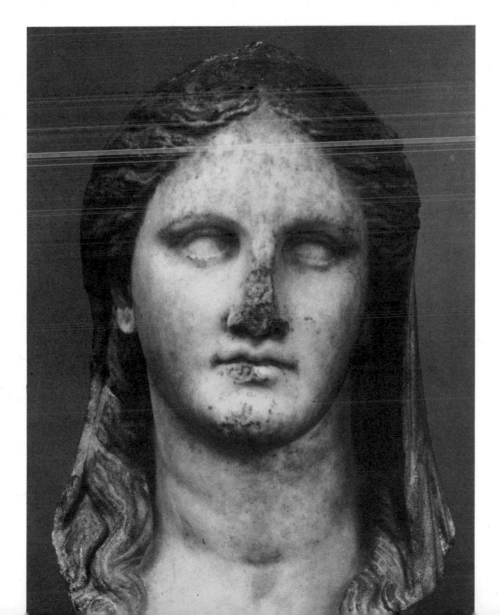

494. *Demeter of Knidos*
(detail of statue in fig. 493)

355

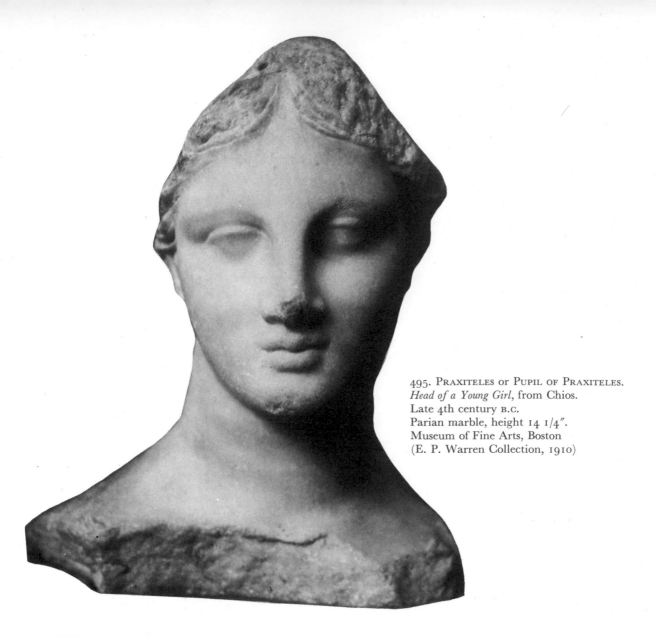

495. PRAXITELES or PUPIL OF PRAXITELES.
Head of a Young Girl, from Chios.
Late 4th century B.C.
Parian marble, height 14 1/4″.
Museum of Fine Arts, Boston
(E. P. Warren Collection, 1910)

Of different character is the head of a young girl from Chios (fig. 495), by Praxiteles or a pupil, an amazing mixture of strong geometric design with minutely observed realistic detail in the lips. The eyes are worked in such a way that the eyelids fade imperceptibly into the adjacent surface, a kind of impressionism which became a trick with Hellenistic sculptors, especially those in Alexandria.

The head from Chios may be a portrait; and a word should be said on portraiture.[20] In Archaic times there was nothing that could be called a portrait in the modern sense, though occasionally one suspects that the sculptor has tried to stress some individual characteristic. The group of the Tyrannicides, Harmodios and Aristogeiton, of which we have copies (see p. 275), was made just after 480 and could conceivably represent individuals, but they are much generalized: this however is a special case because the original group, made thirty years before, had been carried off by the Persians, and the Tyrannicides themselves had long been dead. A few years ago at Ostia a portrait was found inscribed with the name of Themistokles (fig. 496), and this has the same kind of stylization of details such as hair and ears as does the Tyrannicides group,[21] but has

356

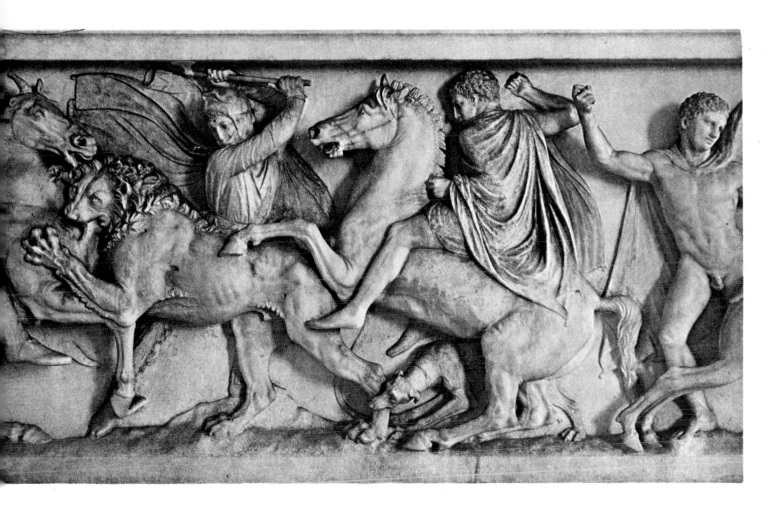

Colorplate 39. *Hunting Scene* (detail of the "Alexander Sarcophagus"; see also figs. 487–89).
c. 310 B.C. Archaeological Museum, Istanbul

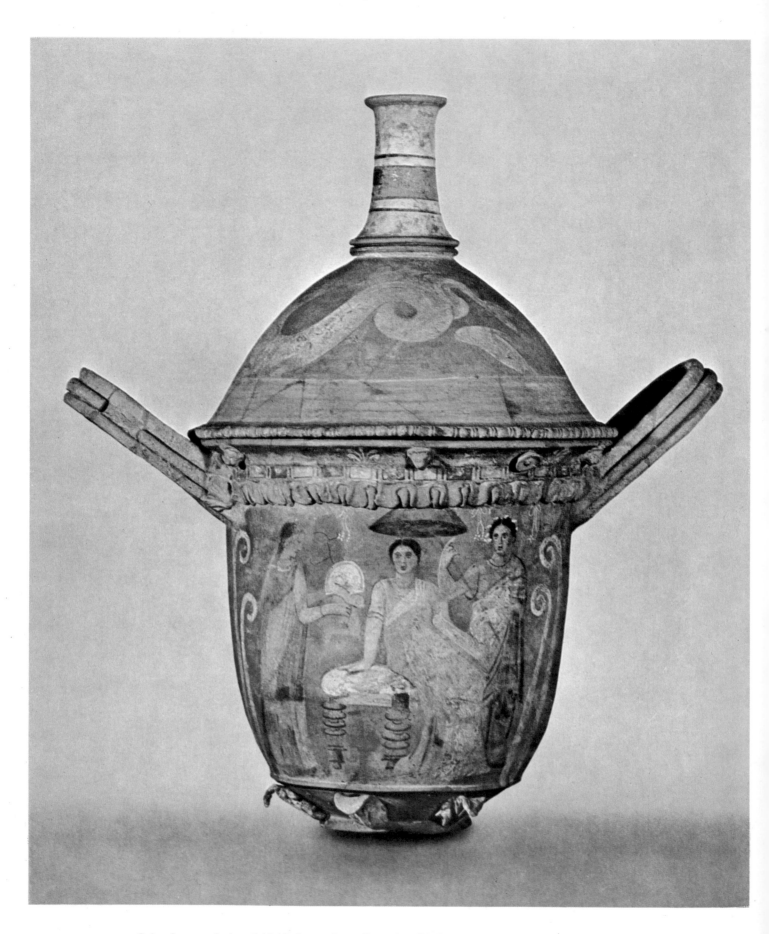

Colorplate 40. *Lady and Maids*, krater from Centuripe (Sicily). 3rd century B.C. Height 22″.
Institute of Classical Archaeology, University, Catania

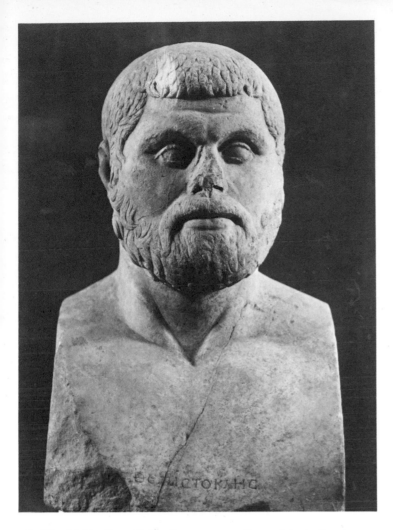

496. *Themistokles*, from Ostia. Roman copy of an original of c. 470 B.C. Marble, about lifesize. Museum, Ostia

strongly individual features. It would not be surprising for a sculptor of this Early Classical period—which was one of experiment, as the sculptures of Olympia show—to have seized on the characteristic features of so forceful a personality as Themistokles; nor is it surprising that the portrait of Perikles (fig. 497), though made later, should be more idealized: everywhere the Classical artist idealizes, and a similar idealization is seen in most of the portraits of the fifth and fourth centuries. But the terms idealistic and realistic are imprecise, and since we have no means of knowing what the sitters looked like, we cannot say how accurately their features were reproduced. Even a so-called realistic portrait, for instance the fourth-century bronze head of a boxer from Olympia (fig. 498), is in fact the result of a process of idealization, for certain features have been stressed and others toned down for the purpose of presenting a kind of ideal.

Only in some portraits from Roman times can one be sure that the sculptor is aiming at an absolutely faithful reproduction of the features (see p. 443): for this the term "veristic" has

497. *Perikles*. Roman copy after an original of c. 440 B.C. Marble, height 23″. British Museum, London

498. *Head of a Boxer*, from Olympia. Late 4th century B.C. Bronze, height 11 3/8″. National Museum, Athens

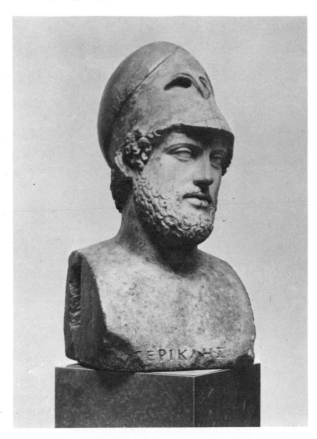

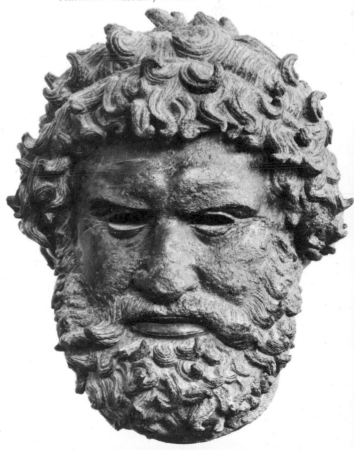

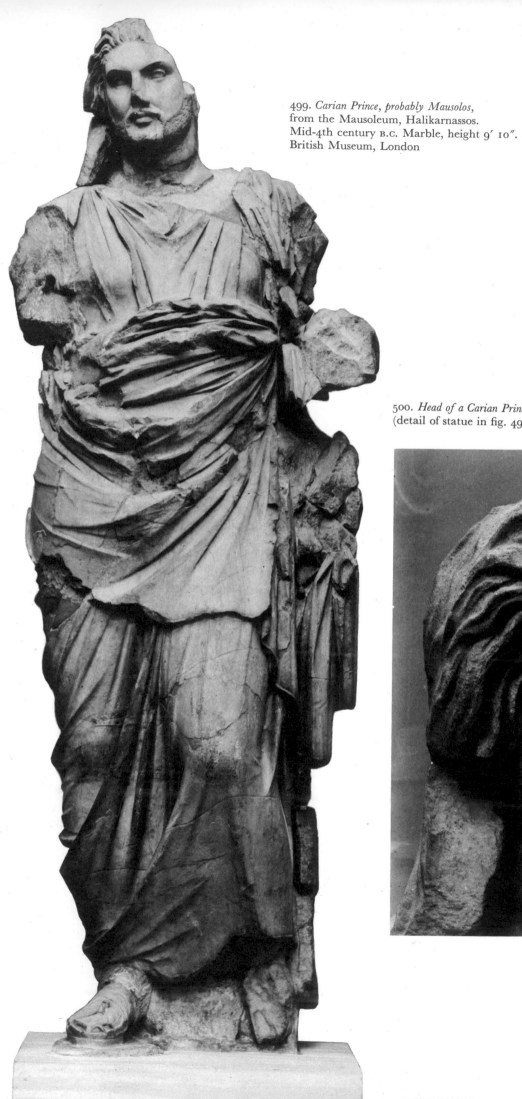

499. *Carian Prince, probably Mausolos,*
from the Mausoleum, Halikarnassos.
Mid-4th century B.C. Marble, height 9′ 10″.
British Museum, London

500. *Head of a Carian Prince*
(detail of statue in fig. 499)

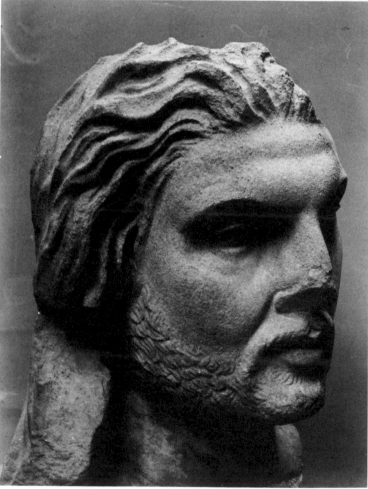

been coined. We have several types of portraits of Socrates, probably all posthumous, but all giving us more or less the characteristic satyr-like features described in Plato; we have the fine portrait of a Carian prince, probably Mausolos (figs. 499, 500); and we have a whole series of portraits of Alexander the Great including those on the coins (figs. 501, 502). It is possible that we should recognize these sitters if we saw them in life, but this does not mean that there has been no idealization. Hellenistic portraits, especially on coins, are sometimes masterpieces of characterization (figs. 503, 504), with unsparing realism where it serves to stress the character which the artist has detected in, or imposed upon, his subject.

Coins, although more utilitarian than other forms of art, are in effect relief sculpture on a

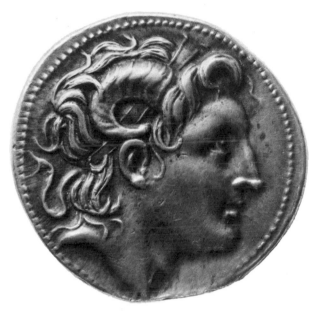

501. *Head of Alexander the Great with Horns of Zeus Amon.*
Silver tetradrachm, obverse (mint of Amphipolis).
306–281 B.C. Diameter c. 1 1/4″.
British Museum, London

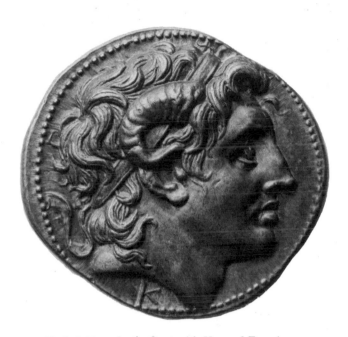

502. *Head of Alexander the Great with Horns of Zeus Amon.*
Silver tetradrachm, obverse (mint of Pergamon).
306–281 B.C. Diameter c. 1 1/4″.
British Museum, London

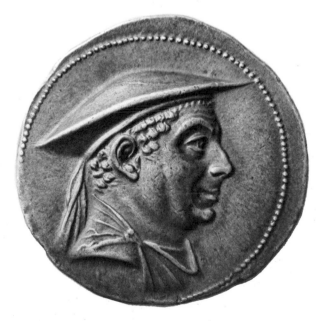

503. *Head of Antimachos I Wearing the Kausia.*
Silver tetradrachm of Bactria, obverse. c. 180 B.C.
Diameter c. 1 1/4″. British Museum, London

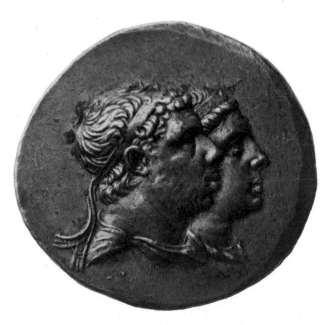

504. *Heads of Mithradates IV and Laodice.*
Silver tetradrachm of Pontus, obverse. 170–150 B.C.
Diameter c. 1 1/2″. Cabinet des Médailles
(Bibliothèque Nationale), Paris

small scale (figs. 505–8), and they offer a challenging field to the designer.[22] Owing to the method of production, which was by hammering the blank between two dies, the designs are apt to be more stereotyped than in other relief sculpture, for the maker of a die tended to copy an existing die and even to use a stamp for impressing the main features of the old design onto the new die. Nevertheless, there are a number of original creations, some of very high quality indeed. Coinage seems to have begun in the late seventh century B.C. in Asia Minor where Lydian neighbors of the Greeks, plentifully supplied with alluvial gold and with a natural alloy of gold and silver known as electrum, were using small lumps of metal stamped with a simple abstract pattern (fig. 509). The next stage of development was to substitute for the abstract pattern a representational one (fig. 510), and after a few experiments the device of the royal signet of Lydia, a lion and a bull, appeared. The idea was taken up quickly and developed by the Greeks, and it was not long before the head of a god or goddess was used on the coins (fig. 511). Thus there originated a device which has been employed continuously ever since, and which still carries with it a special prestige; though in Greek lands it was not until the time of Alexander the Great that a human, as distinct from a divine, head was represented on the coinage.

Excellent coin designs were produced at almost every period here or there in the Greek world, but Sicily was pre-eminent during the fifth century (figs. 512–17). Athens, unfortunately, stereotyped its coinage about 480,

505. *Eagle's Head with Leaf of White Poplar*. Silver stater of Elis, obverse. c. 400 B.C. Diameter c. 7/8″. State Coin Collection, Berlin

506. *Taras Riding a Dolphin*. Silver stater of Taras (Tarentum), reverse. c. 380–345 B.C. Diameter c. 3/4″. Private Collection

507. *Herakles Wrestling with Lion*.
Silver stater of Herakleia (S. Italy), reverse.
c. 350–330 B.C. Diameter c. 7/8″. Private Collection

508. *Europa Seated in a Willow Tree*.
Silver stater of Gortyna (Crete), obverse.
c. 325 B.C. Diameter c. 1 1/4″. British Museum, London

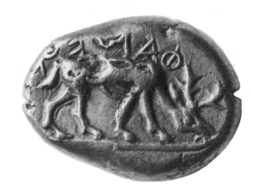

510. *Grazing Stag*. Ionian electrum trite
probably minted at Ephesos, obverse.
c. 600 B.C. British Museum, London

509. *Archaic Coin with Rough Striations* (obverse) *and*
Three Punch Marks (reverse).
Electrum stater, uncertain mint in western Asia Minor.
c. 600 B.C. British Museum, London

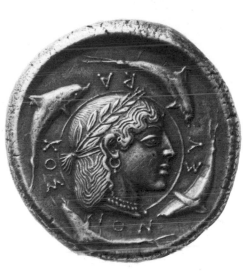

511. *Head of Athena*. Silver tetradrachm of Athens, obverse.
c. 520–510 B.C. Diameter c. 1″. British Museum, London

512. *Head of Arethusa*. Silver decadrachm of Syracuse, reverse.
480–479 B.C. Diameter c. 1 1/4″. British Museum, London

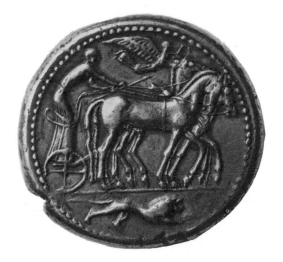

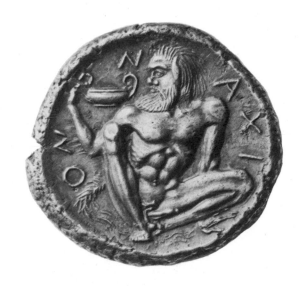

513. *Quadriga with Nike Crowning One Horse*.
Silver decadrachm of Syracuse, obverse.
480–479 B.C. Diameter c. 1 1/4″.
Cabinet des Médailles (Bibliothèque Nationale), Paris

514. *Silenus*. Silver tetradrachm of Naxos (Sicily), reverse.
c. 460 B.C. Diameter c. 1 1/4″. British Museum, London

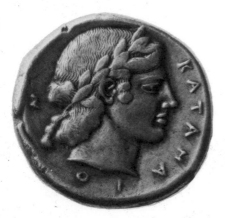

515. *Head of Apollo.*
Silver tetradrachm of
Catana, reverse.
c. 450–440 B.C.
Diameter c. 1″.
Private Collection

using always the same devices (a head of Athena, and an owl; fig. 518) on front and back, and carving the dies always in a late Archaic style which quickly became dry and empty. This is a calamity for us, because Athens, with its outstanding artists in other fields at this very time, might have been expected to produce masterpieces of die engraving; and the new coinage of its colony Thurii, founded in 443, in a superb classical style, shows what Athenian engravers of this generation and the next could do when given the chance (fig. 519).

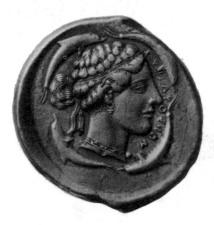

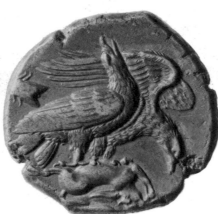

517. *Two Eagles Standing on a Dead Hare.*
Silver tetradrachm of Akragas, reverse.
c. 413–411 B.C. Diameter c. 1 1/4″.
British Museum, London

516. *Head of Arethusa.*
Silver tetradrachm of Syracuse, reverse.
c. 450 B.C.
Diameter c. 1 1/8″.
Private Collection

519. *Head of Athena.*
Silver distater of Thurii, obverse.
c. 375 B.C. Diameter c. 1 1/8″.
State Coin Collection, Berlin

518. *Head of Athena* (obverse) and *Owl* (reverse).
Silver tetradrachm of Athens.
c. 440–430 B.C. Diameter c. 7/8″. Private Collection

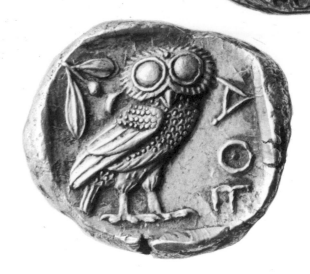

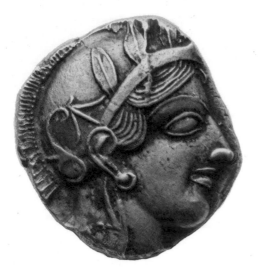

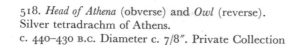

Hellenistic Art (330–146 B.C.)

The loose system of Greek city-states and the classical culture which it had fostered were radically changed by the rise of Macedonia. Macedonia, on the northern fringe of Greece, was ruled by hereditary kings, and was hardly regarded by the Greeks as being part of their own civilization; when the Macedonian king Philip II made plans to unite Greece under his own leadership for an attack on Persia, there was some fierce resistance, especially that led by the Athenian orator Demosthenes. Macedonia became supreme at the battle of Chaeronaea in 338 B.C., and although Philip was assassinated in 336 he was succeeded by his nineteen-year-old son, Alexander the Great, who took up with enthusiasm the scheme for the conquest of Persia. In a series of campaigns, which he mostly directed in person, he conquered, in the three years between 334 and 332, the Persian provinces of Asia Minor, Syria, and Egypt, and in 331 defeated the king of Persia at Arbela, thus gaining control of Persia itself and of Mesopotamia. In the next four years the armies under his command, the vital element of which was the Macedonian phalanx of disciplined spearmen supported on the flanks by daring cavalry, reached the borders of India.

Alexander's political vision was as imaginative as his military leadership: he conceived, and almost succeeded in creating, a vast empire in which Greeks and Persians should be united. But Alexander died in 323 B.C., and there ensued a struggle among his leading generals for the possession of this empire. They were evenly matched, and the empire broke up into three major divisions—Syria, which included some of Asia Minor and of the eastern conquests of Alexander, under Seleukos; Egypt, under Ptolemy; and Macedonia, which included Greece, under Antigonos. In addition there were smaller concentrations of power, notably Rhodes, whose naval strength gave her not only great commercial prosperity but also the task of keeping the seas free of pirates.

Delos was another great trading center; and Athens, which had long yielded political supremacy to others, also enjoyed periods of marked prosperity. Another power was Pergamon, which split off from Syria to become an independent kingdom in 263, and, under the enlightened Attalid dynasty, held off massive invasions of Gauls from the north.

Except for Greece, the Hellenistic monarchies had formed part of the ancient kingdom of Persia; but the new rulers, Macedonian by birth and Greek by education, knew how to exploit their natural resources, and how to levy taxes on this new prosperity. Newly founded cities attracted large numbers of Greeks, and thus the life and culture of these cities became Greek, while the natives in the surrounding country went on much as before, with their old customs and their own language. In Egypt few new cities were founded; but one, Alexandria, became the outstanding center of scholarship and scientific research. In its Museum (shrine of the Muses) was the greatest concentration of the means of knowledge in the ancient world, and the destruction of this center, probably about A.D. 400, was a blow from which we still suffer. Such was the complex empire which eventually passed into the power of Rome.

POTTERY AND PAINTING

In Hellenistic times painted pottery ceased to have its previous importance. It is not easy to judge why this was so, but an increasing use of metal vessels may have been one of the causes, a declining fashion for pictured vases another. Almost the only vases with painted figures belong to a small and short-lived ware of the third century B.C. from Centuripe in Sicily (colorplate 40).[1] The figures are drawn in black outline on a matte-white background and filled in with other colors. They were not made for ordinary use and may have been funerary.

Hellenistic ware with decoration in relief was the forerunner of the most popular pottery of Roman times, *terra sigillata*. There were two Hellenistic kinds, one being Calenian ware, of the third century B.C., a black pottery made by molding from originals of silver. The other was the so-called Megarian bowl, made from the third to the first centuries B.C. (fig. 520). These little clay bowls were made in many places, not directly from metal originals but from independent clay molds: roughly hemispherical in shape, they bear stylized floral designs and sometimes roughly modeled figure-scenes, with a preference for the Homeric story.

Of the work of major painters we know nothing at firsthand, but Pliny and others mention their names and tell what they were thought to have achieved.

Two early Hellenistic painters, Apelles and Protogenes, were especially famous, partly be-

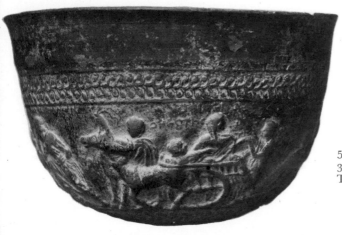

520. *The Arrival of Klytemnestra in Aulis*, Megarian bowl. 3rd century B.C. Height 3 1/4".
The Metropolitan Museum of Art, New York (Fletcher Fund, 1931)

cause both wrote books on painting, partly because they were colorful personalities and rivals, of whom many anecdotes were recorded. Apelles studied how to represent light: in his painting of Alexander the Great with the thunderbolt of Zeus, the apparent brightness of the thunderbolt was increased by darkening the figure of Alexander. To judge from the anecdotes, extreme fineness of drawing and complete naturalistic illusion were what both artists were striving for: but one may be a little cautious of accepting this unreservedly, for it is a matter of common experience that the deceptive copying of nature is one of the easiest things for a layman to appreciate, and is therefore the first thing on which a guide or popular writer comments.

There are many Hellenistic elements in the paintings of Roman date from Pompeii and elsewhere, if only we knew how to disentangle them. Mosaics, too, are occasionally closely copied from painted originals, but this medium inevitably coarsens and distorts effects achieved in another quite different medium. The mosaics of the early Hellenistic age discovered at Pella, the royal Macedonian capital, are splendid objects in themselves (fig. 521, colorplate 41), but cannot, from their very nature, be regarded as masterpieces of the painter's art, even if they are copied from pictures.[2] The mosaic discovered in the House of the Faun at Pompeii is evidently a careful attempt to copy a painting of about the same date (300 B.C.), possibly that by Philoxenos of Eretria, of a battle between Darius and Alexander the Great (colorplate 42). It tells us much about the state of the painter's art at the time, but it would be idle to pretend that the quality of the original has been recaptured. As for the general conception, one's first impression is of a historical picture, a factual battle scene; but the impression quickly fades, and such realistic

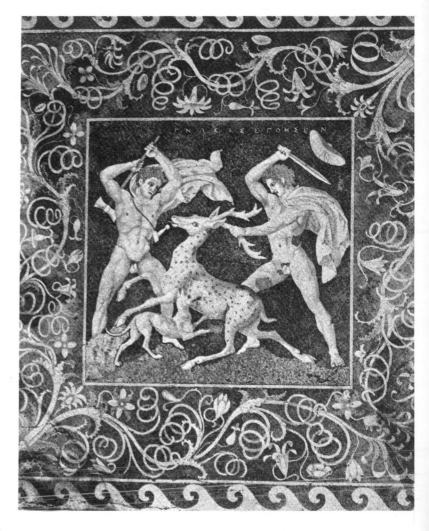

521. *Stag Hunt*, pebble mosaic from Pella. c. 300 B.C. Museum, Pella (Macedonia)

elements as the abandoned weapons and equipment, the lances moving against the sky, even the Persian and Macedonian soldiery, are seen to be present only in token quantities. Interest centers on the two protagonists, Alexander and the king of Persia, and on what they symbolize —the impact of the new Macedon against an age-old empire.[3]

522. *Theseus After Killing the Minotaur,* wall painting from Herculaneum.
Roman copy after an original of the 4th century B.C.
Height 37 3/4". National Museum, Naples

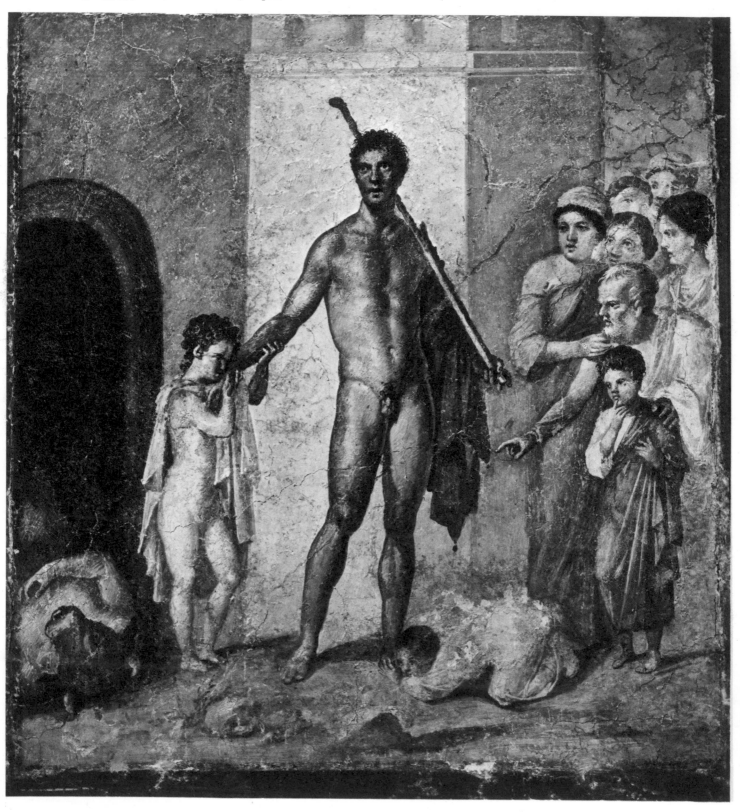

Some of the wall paintings from Roman towns stand in much the same relationship to the originals as does this mosaic: for instance the picture of Theseus just after the killing of the Minotaur, from Herculaneum, which seems to copy an original of the fourth century (fig. 522); that from Pompeii, of Herakles in bondage to Omphale, which copies one of the third century (fig. 523); or that of the finding of Telephos, again from Herculaneum, which goes back to one of the second (fig. 524). But although they are in the same medium as the originals they copy, these paintings of Roman date are less reliable copies than the mosaic is, because they can easily contain later elements of form or color introduced either deliberately or unconsciously by the copyist.

above: 523. Herakles and Omphale,
wall painting from Pompeii.
Roman copy after an original of
the 3rd century B.C.
Height 36″. National Museum, Naples

right: 524. The Finding of Telephos,
wall painting from Herculaneum.
Roman copy after an original of
the 2nd century B.C. Height 67 1/2″.
National Museum, Naples

ARCHITECTURE

As with sculpture, much of the activity of the Hellenistic age in architecture was in the East, in the new kingdoms founded by the successors of Alexander the Great. The tradition there is so continuous from this period onward that it is often difficult to distinguish Hellenistic from Roman work, and many great projects of Hellenistic times were completed or refashioned by the Romans. Of Hellenistic architects Hermogenes is the most important, partly because he was closely studied by the Roman architect Vitruvius, to whom we owe much of our knowledge of ancient architecture.[4]

Hermogenes, according to Vitruvius, invented the pseudodipteral temple. This is not correct: it was known centuries before, but Hermogenes may have theorized about it. In a dipteral temple the central nucleus, usually a chamber for the cult image, is completely surrounded by a double row of columns. The Didymaion near Miletos is an example of this plan (figs. 525–28).[5] It was begun about 300 B.C., but repeatedly delayed, doubtless because of expense, and not completed until Roman Imperial times. The central nucleus was unusual in that instead of a single central chamber there was a courtyard, in the middle of which

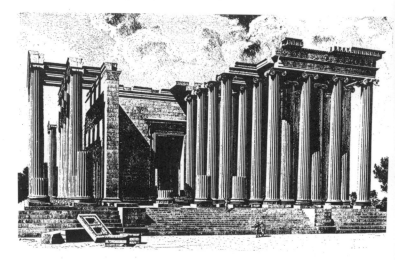

526. Temple of Apollo, Didyma.
Reconstruction: cutaway view of front (east) portion of temple

stood an independent Ionic temple (fig. 528) of small dimensions housing an Archaic statue of Apollo. Oracles were announced from a platform at the main doorway of the temple, the threshold of which was too high for normal access: nearby was a staircase leading to the roof, and two vaulted passages of exquisite masonry leading down to the central court. Apart from these peculiarities the temple had a normal dipteral plan.

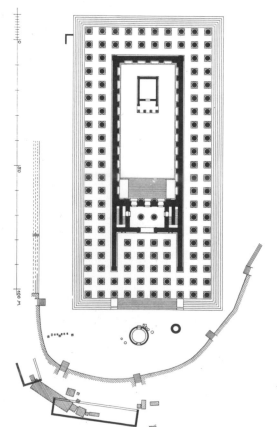

525. Temple of Apollo, Didyma. *Restored plan*

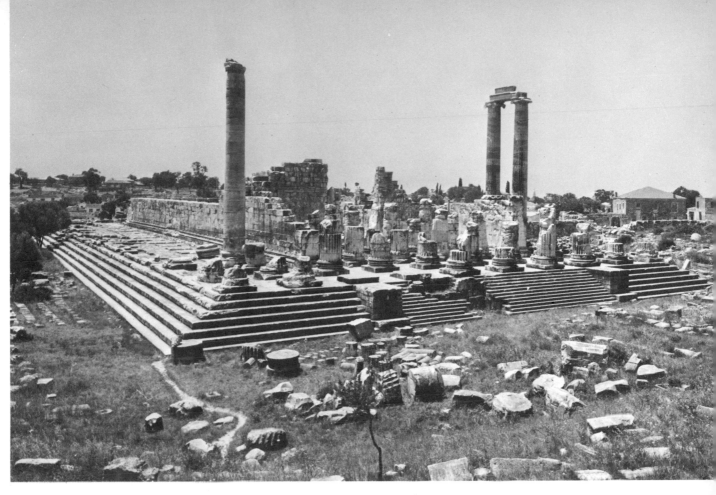

527. Temple of Apollo, Didyma. Begun c. 300 B.C. *View from the east*

528. Temple of Apollo, Didyma. *View toward the east: interior court with foundations of independent Ionic temple*

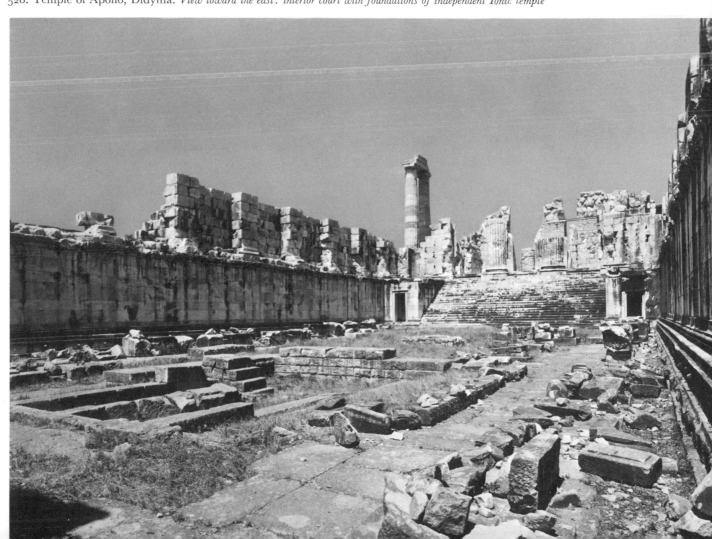

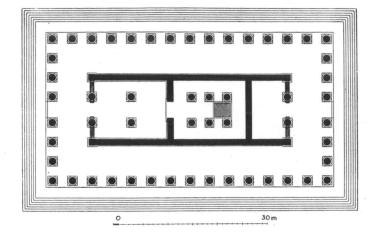

529. HERMOGENES.
Temple of Artemis Leukophryene,
Magnesia on the Maeander.
C. 210 B.C. *Plan*

530. Theater, Priene. *Restoration of earlier and later forms*

The modification of this dipteral plan, later invented by Hermogenes, was to omit entirely the inner row of columns but to leave the spacing between the outer colonnade and the walls of the temple itself as if these columns still existed. One suspects that the immense saving in expense must have been one of the motives for this innovation. Hermogenes demonstrated this pseudodipteral plan in his temple of Artemis Leukophryene at Magnesia (fig. 529) about 210 B.C., overcoming the difficulty of the wide space between the colonnade and the central nucleus by the use of wooden roof beams.

We know little about the palaces that must have been built in Hellenistic times, although we possess a long description of a magnificent banqueting tent erected for Ptolemy Philadelphus. Such other important buildings as the great Bouleuterion at Miletos and the little Ecclesiasterion at Priene show no new principles of construction, and their roofs give the feeling of having been imposed on structures designed for the open air. The theater at Priene (figs. 530, 531) is important because it was built about 300 B.C. in such a way that the main action of the plays must have taken place in front of the stage building: access to its roof was possible but difficult. Nearly two centuries later it was reconstructed in such a way as to suggest that much of the action thereafter took place on the roof, which thus formed a high

stage; and it is therefore one of the crucial buildings in the prolonged discussion on whether and when a raised stage existed in antiquity.

Most Hellenistic buildings are developments from older types, but one has no prototype in Greek architecture. This was the Pharos of Alexandria, built in the early third century B.C. by Sostratos of Knidos for Ptolemy Philadelphus, the Greek king of Egypt. It was a lighthouse, about a hundred feet square at the base and four hundred feet high, probably the tallest lighthouse ever built, and one of the Seven Wonders of the ancient world. It stood

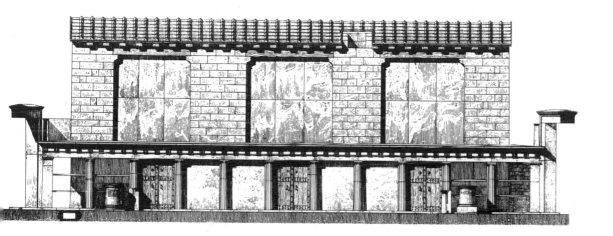

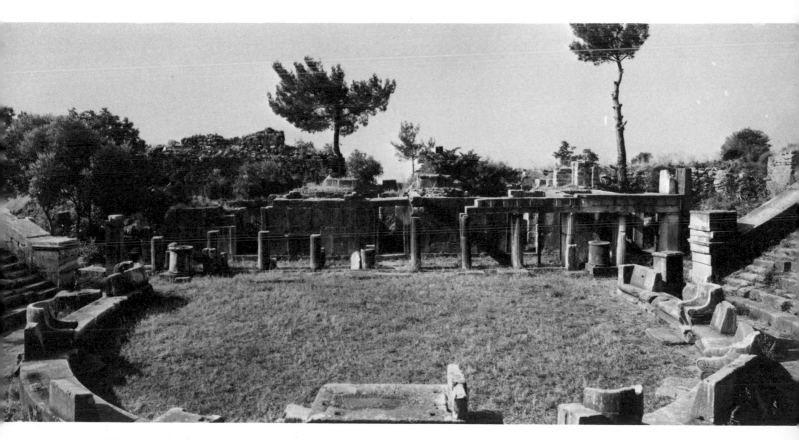

531. Theater, Priene. Begun c. 300 B.C., altered late 2nd century B.C.
View of orchestra and stage building

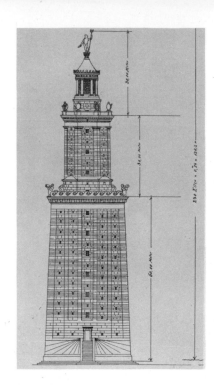

532. The Pharos of Alexandria. Altered form, 5th century A.D. *Geometrical reconstruction* (by M. Lopez Otero) *and elevation* (by A. Thiersch)

complete until it was extensively repaired and reduced in height by the Byzantine emperor Anastasius in the fifth century A.D. (fig. 532). In this modified form, which was a square tower surmounted by an octagonal and above by a cylindrical one, it stood until at least the thirteenth century, and we have detailed accounts of it by medieval Arab writers. Originally it seems to have had four stories, all square in section, but tapering slightly, and each of the upper three was set back from the one below.

SCULPTURE

With the greatly widened sphere of Greek influence in the three centuries following the eastern conquests of Alexander the Great, and with the establishment of many Greek kingdoms overseas, it becomes impossible to trace step by step the history of the development of sculpture as has been done hitherto.[6] There were few closed communities in which a single style was worked upon and brought to perfection: on the contrary, the sculptors knew better than before what was going on in other places, and having no strong local style, but great facility of technique, they were able to imitate and combine the characteristics of other schools and previous periods. Thus it is often as difficult to establish the place where a sculpture was carved as it is to fix its date; this accounts for the widely different dates that have been given even to such well-known statues as the Victory of Samothrace and the Laokoön. There are still occasional local schools whose work it is possible to isolate, although such work is partly made up of alien elements and even carved by sculptors from elsewhere; but in

Colorplate 41. *Lion Hunt*, pebble mosaic from Pella. c. 300 B.C. Height 64 3/8″. Museum, Pella (Macedonia)

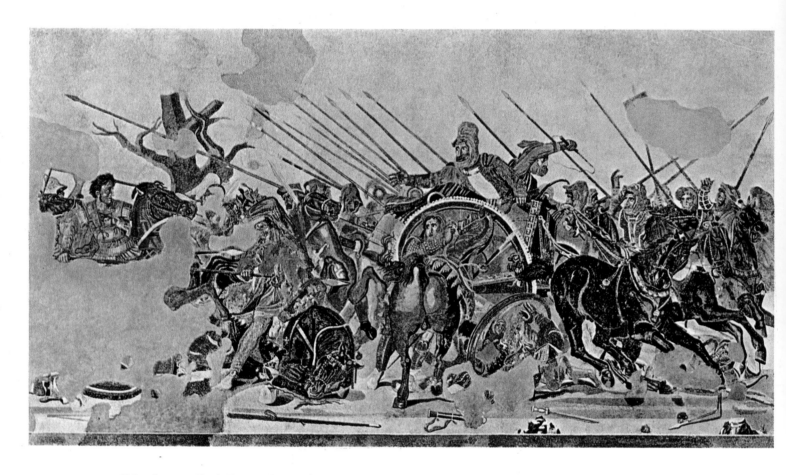

Colorplate 42. *Battle Between Darius and Alexander the Great,* mosaic from the House of the Faun, Pompeii. Roman copy after a Greek painting of c. 300 B.C. Height 10′ 3 1/4″. National Museum, Naples

general we are forced to consider the work of art in isolation, without necessarily knowing its pedigree.

It seems that in Attica in the opening decades of the Hellenistic period, there was a time of stagnation or reaction. It may be that the leading sculptors had gone abroad to carry out commissions in the new Hellenistic kingdoms, leaving behind those who had not enough talent to create new types. Whatever the reason, such major sculptures as we have rely much on the past, and especially on the time of Pheidias, for their inspiration. The seated figure of Dionysos (fig. 533), from the Monument of Thrasyllos, has the broad quiet treatment of the more conservative among the sculptures of the Parthenon; while Chairestratos, in his statue of Themis (fig. 534), translates a type from much the same period into the technique of his own

533. *Dionysos*, from the Monument of Thrasyllos. c. 320 B.C. Marble, height 75″. British Museum, London

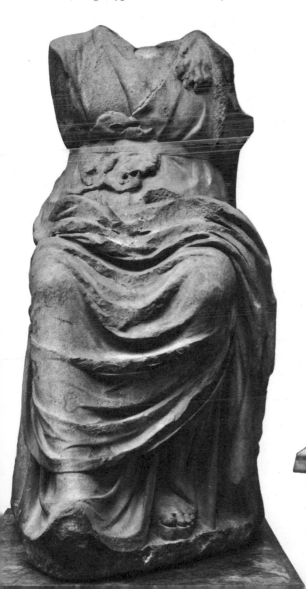

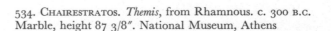

534. CHAIRESTRATOS. *Themis*, from Rhamnous. c. 300 B.C. Marble, height 87 3/8″. National Museum, Athens

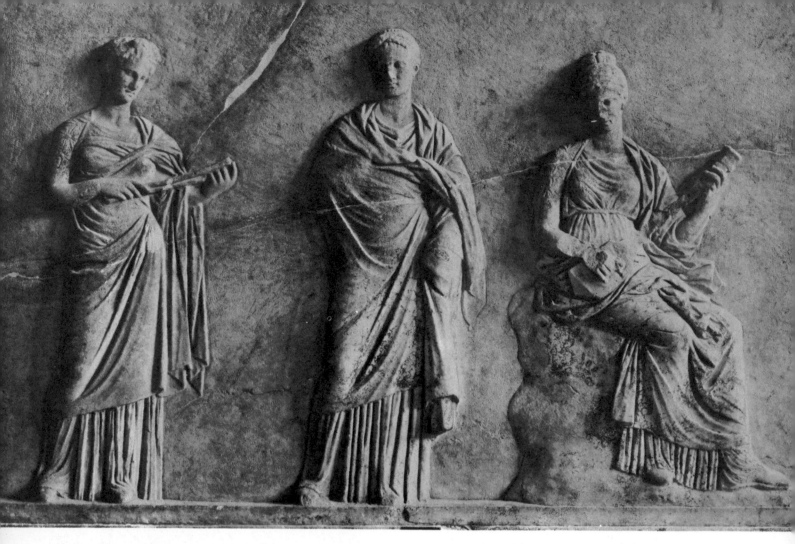

535. PUPILS OF PRAXITELES. *Muses*, panel of a statue base from Mantinea. c. 325 B.C.
Pentelic marble, height 38 1/4″. National Museum, Athens

time. A similar dry and insensitive handling of the drapery is to be seen in the reliefs carved by pupils of Praxiteles for the statue base of a lost group by Praxiteles for Mantinea, but the treatment of the faces shows a finer touch (fig. 535).

About the same time, for it must have been carved before about 315 B.C., when Demetrios of Phaleron introduced a decree which prohibited carved gravestones, is one of the finest and also as it happens one of the largest of all Greek grave reliefs (fig. 536). It came from near the river Ilissos at Athens and represents the dead man seated on a low pillar which stands for his tomb: he is shown as he was in life, with his hunting stick, his small slave (or perhaps a brother), and his hunting dog. An old man looks at him wonderingly. The heads are not portraits in our sense: the scene has a universal application, the mystery of death and the mystery of the death of the young. There are at this time several inferior grave reliefs with much the same scene or with excerpts from it, and it is clear that some famous relief, perhaps this very one, inspired them all. The sculptor is up-to-date, for this young man has the new proportions introduced by Lysippos, and it may be that the excellent study of the dog also owes something to Lysippos, who was famous for his statues of them.

536. *Grave Stele of a Youth*, from near the River Ilissos, Athens. c. 340–330 B.C. Pentelic marble, height 66″. National Museum, Athens

378

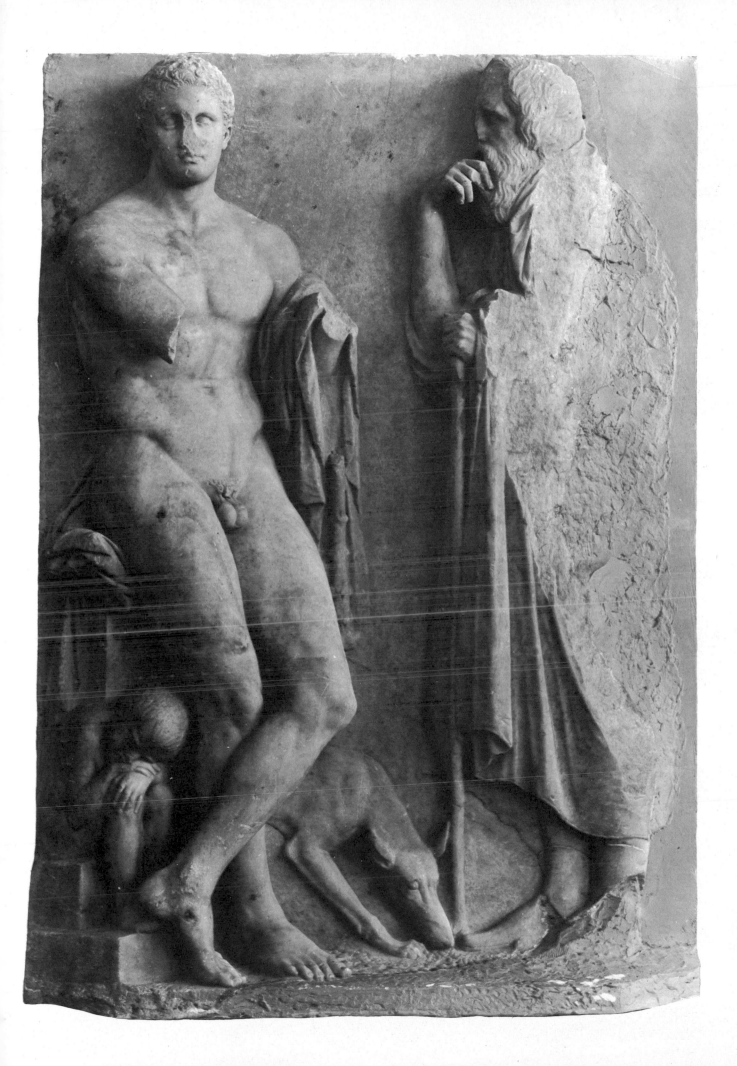

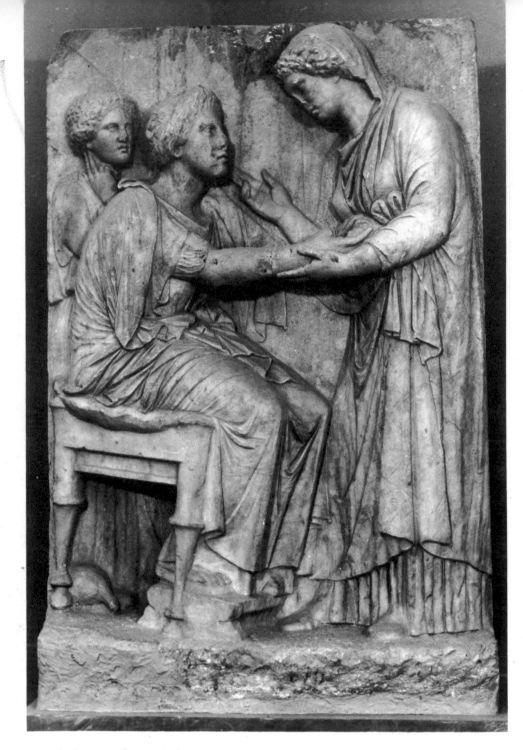

537. *Grave Stele of a Young Woman*. Mid-4th century B.C.
Marble, height 76 3/8″. National Museum, Athens

538. *Tanagra Figurine*.
3rd century B.C.
Terracotta.
British Museum, London

The sculptor of another grave relief may have known the work of Skopas, for his figures show a passion which is not common among Athenian grave monuments: the mother leans down to the daughter with a yearning look and gently disengages her hand for the parting (fig. 537). Athenian sculptors of this class, which is perhaps not the first, are still highly competent and sometimes more than that.

Terracotta statuettes were much in vogue at

the end of the Classical and the beginning of the Hellenistic period. They had always been popular, especially in Archaic times, for dedication in sanctuaries, for they were the cheapest form of votive offering; and the large pits packed with them on many sites show that the excess had to be cleared away from time to time. Now they seem to have been used not only for dedication but also for keeping in the house, so that they were like modern ornaments or souvenirs. The commonest types were draped females in the Praxitelean manner (fig. 538), much like the Muses on the Mantinean base; but there were many other subjects, especially actors (fig. 539). One of the centers of manufacture was Boeotia, and the name of the Boeotian town Tanagra is generally given to such statuettes, although they were made in other places as well.

We possess several fine small Hellenistic bronzes, for instance, the Negro boy-musician (fig. 540) and the dancing woman (fig. 541),

539. *Actor*, from an Athenian grave. 4th century B.C. Terracotta, height 4 1/8". The Metropolitan Museum of Art, New York (Rogers Fund, 1913)

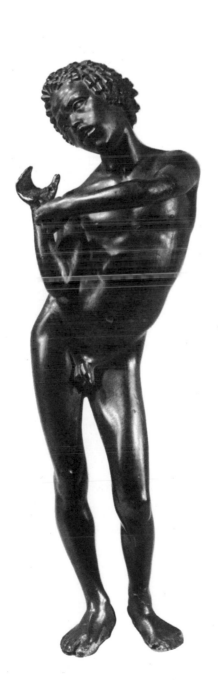

540. *Negro Musician.* 2nd century B.C. Bronze, height 7 7/8". Bibliothèque Nationale, Paris

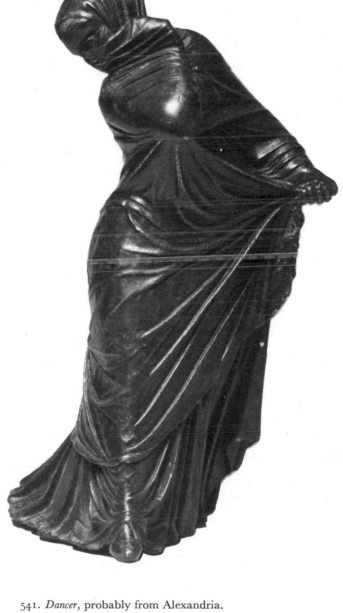

541. *Dancer*, probably from Alexandria. c. 200 B.C. Bronze, height 8 1/8". Collection Walter C. Baker, New York

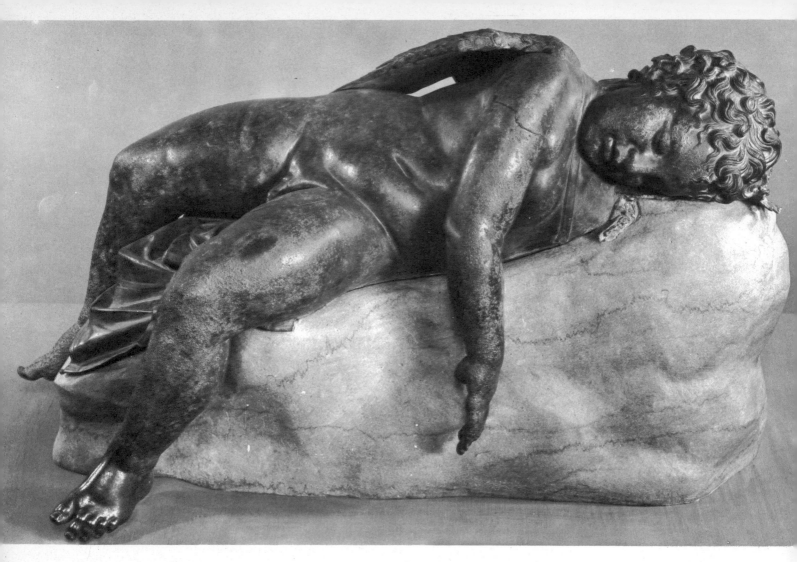

542. *Sleeping Eros*, said to be from Rhodes. c. 250–150 B.C. Bronze, lifesize. The Metropolitan Museum of Art, New York (Rogers Fund, 1943)

while the sleeping Eros (fig. 542) is one of the few full-sized Greek original bronzes that survive, and can fairly rank as a masterpiece.

A bronze statue set up in Athens about 280 B.C. was by Polyeuktos, who may have been an Athenian, though we do not know this for certain. It was a portrait of Demosthenes, who had been driven to his death forty years before for opposing Macedonian aggression. Its base bore a famous epigram: "Had thy strength been equal to thy will, Demosthenes, the war-god of Macedon would never have subdued the Greeks." Numerous copies in marble are known, and we cannot doubt that the original was closely based on his real appearance (fig. 543). The physical handicap from which he is

known to have suffered is shown as an upper jaw too large for the lower, while the somewhat ungainly body and the worn cloak, whether true to fact or not, hint at the patriot who had no thought except for his country's safety.

Outside Attica sculptors were experimenting in two directions, to find new poses and new ways of rendering drapery. Both these trends are evident in the Tyche[7] of Antioch on the Orontes, made about 300 B.C. by Eutychides, a pupil of Lysippos, for the newly founded city. The statue was evidently of great size, and, as often happens when this is so, we have no trustworthy copies: it being impossible to reproduce the original at full scale, resort was made to miniature reproductions modeled freehand,

and one cannot tell how accurate these are. Except for small marble copies which lack the head, e.g., the example in the Vatican, we have to rely on very small bronzes for our knowledge of this statue (fig. 544); but certain points are clear. The sculptor has tried to solve that problem recurrent in a seated statue, namely, that the legs are nearer to the spectator than the upper part of the body, and that the statue inevitably lacks the unified front plane which was one of the major concerns of Greek sculptors. In the past various devices had been tried to overcome this difficulty: in order to bring the torso closer to the front plane, the

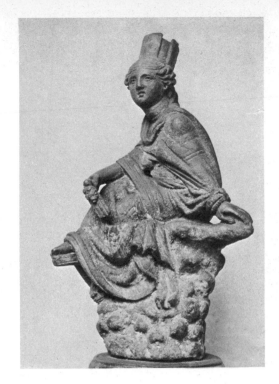

544. *Tyche of Antioch.* Copy after a bronze original by Eutychides of c. 300 B.C. Bronze, height 5 1/2″. Bibliothèque Nationale, Paris

thighs had been made unnaturally short; or the figure had been shown seated, not as a person normally sits, but on the edge of the throne or chair and with the thighs sloping downward. Eutychides ignored these devices. There is no throne: the goddess, like her city, is set on a rock: one leg is crossed over the other and the upper part of the body is bent forward over the legs so that the composition is almost conical. The drapery is used to the same end, being allowed to fall in loose folds over the rock, or being stretched tight by the arms so as to strengthen the main forms of the design. All this is highly artificial: its justification lies in the effect it has had: for the Antioch of Eutychides is the first of that long series of personifications of cities, provinces, and countries which have by now become an integral part of Western thought.

In the search for new effects sculptors began to imitate closely the texture of clothing: there was something of this in the Tyche, but it became more obvious half a century later in such

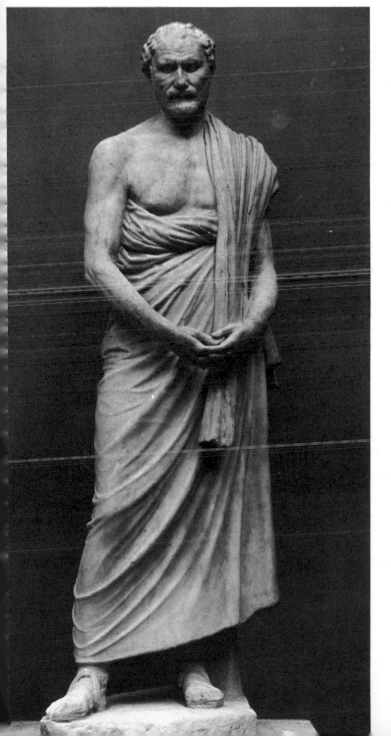

543. *Demosthenes.* Copy after a bronze original by Polyeuktos of c. 280 B.C. Marble, height 79 1/2″. National Museum, Copenhagen

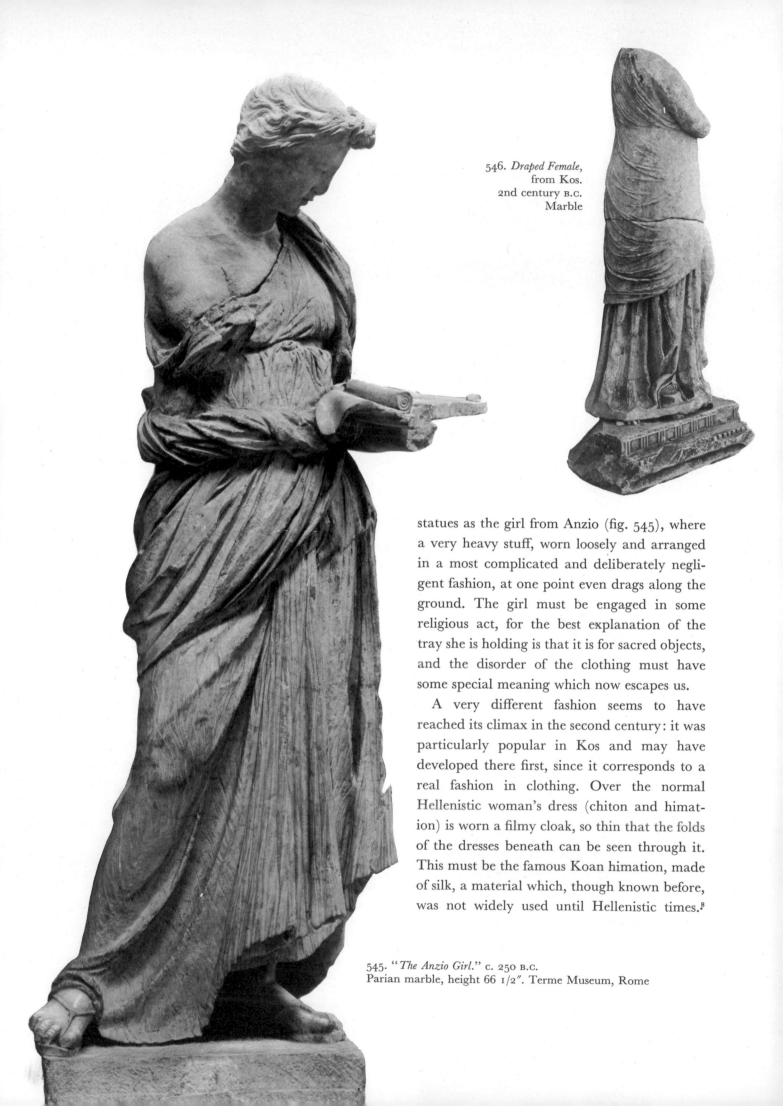

546. *Draped Female*,
from Kos.
2nd century B.C.
Marble

statues as the girl from Anzio (fig. 545), where a very heavy stuff, worn loosely and arranged in a most complicated and deliberately negligent fashion, at one point even drags along the ground. The girl must be engaged in some religious act, for the best explanation of the tray she is holding is that it is for sacred objects, and the disorder of the clothing must have some special meaning which now escapes us.

A very different fashion seems to have reached its climax in the second century: it was particularly popular in Kos and may have developed there first, since it corresponds to a real fashion in clothing. Over the normal Hellenistic woman's dress (chiton and himation) is worn a filmy cloak, so thin that the folds of the dresses beneath can be seen through it. This must be the famous Koan himation, made of silk, a material which, though known before, was not widely used until Hellenistic times.[8]

545. "*The Anzio Girl.*" c. 250 B.C.
Parian marble, height 66 1/2″. Terme Museum, Rome

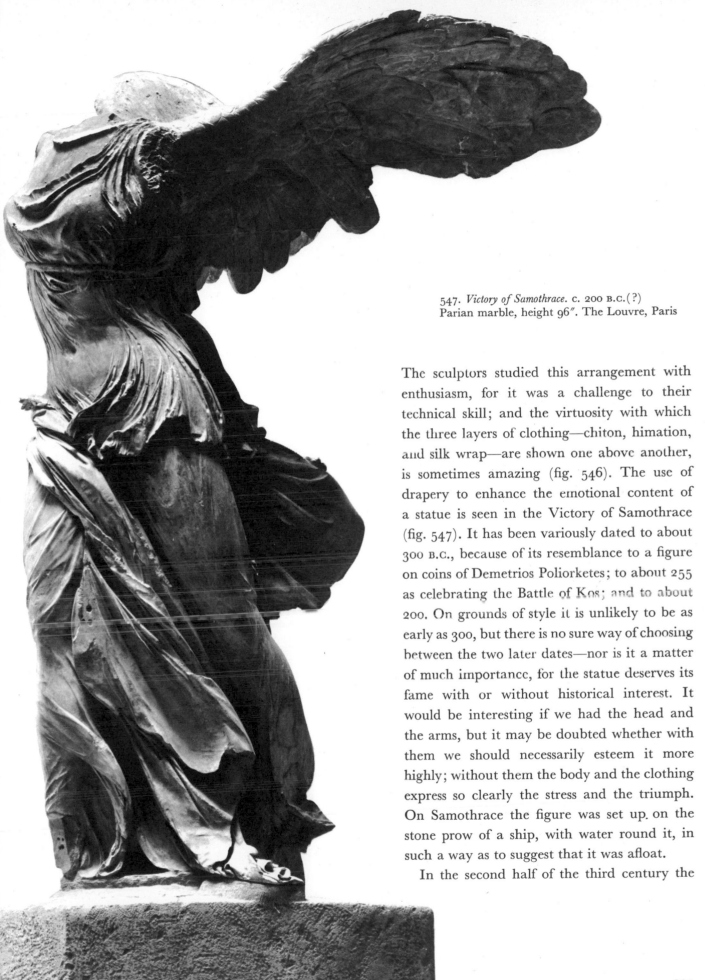

547. *Victory of Samothrace.* C. 200 B.C.(?)
Parian marble, height 96″. The Louvre, Paris

The sculptors studied this arrangement with enthusiasm, for it was a challenge to their technical skill; and the virtuosity with which the three layers of clothing—chiton, himation, and silk wrap—are shown one above another, is sometimes amazing (fig. 546). The use of drapery to enhance the emotional content of a statue is seen in the Victory of Samothrace (fig. 547). It has been variously dated to about 300 B.C., because of its resemblance to a figure on coins of Demetrios Poliorketes; to about 255 as celebrating the Battle of Kos; and to about 200. On grounds of style it is unlikely to be as early as 300, but there is no sure way of choosing between the two later dates—nor is it a matter of much importance, for the statue deserves its fame with or without historical interest. It would be interesting if we had the head and the arms, but it may be doubted whether with them we should necessarily esteem it more highly; without them the body and the clothing express so clearly the stress and the triumph. On Samothrace the figure was set up, on the stone prow of a ship, with water round it, in such a way as to suggest that it was afloat.

In the second half of the third century the

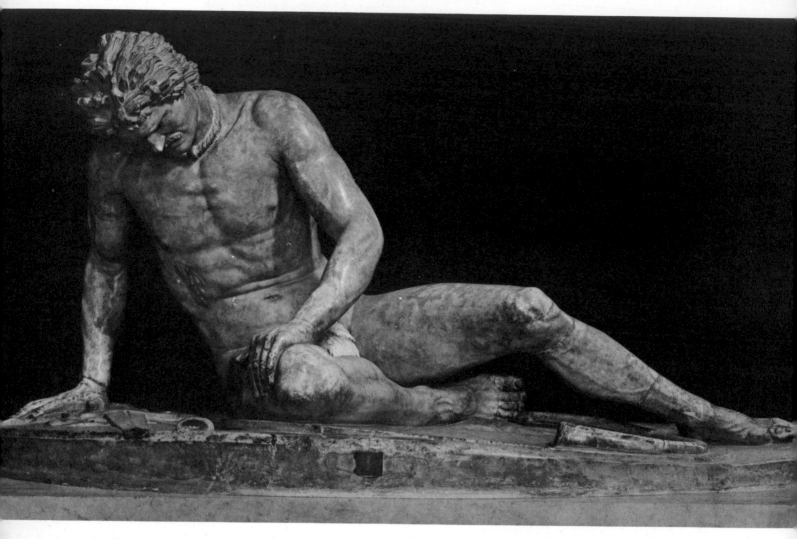

548. *Dying Trumpeter*. Roman copy of a figure from the bronze dedication of Attalos I at Pergamon, c. 230–220 B.C. Marble, height with plinth 36 5/8". Capitoline Museum, Rome

school of sculpture centered on Pergamon came to the fore with a series of statues, perhaps grouped in some way with each other, commemorating victories over the Galatians, who had been a formidable threat to the kingdom of Pergamon under Attalos I. We have only copies in marble: the originals were of bronze. These are noble works of art, reflecting in their integrity the reality of the struggle and the respect of the victors for the vanquished: the bravery, as well as the physical appearance of

their opponents, is studied and depicted with interest and admiration. The best-known figure is the dying trumpeter (fig. 548), and, equally moving in its desperate bravery, the chieftain who, to escape capture, turns the sword on himself after killing his wife (fig. 549). Possibly a symbolic contest between Greeks and Persians also formed part of the dedication, though it is not clear how Persians came to be involved: the head of a dead Persian in the Terme Museum in Rome is of similar style and equal

549. *Gaul Chieftain Killing Himself and His Wife*.
Roman copy of a group from the bronze dedication of Attalos I at Pergamon,
c. 230–220 B.C. Marble, height 83". Terme Museum, Rome

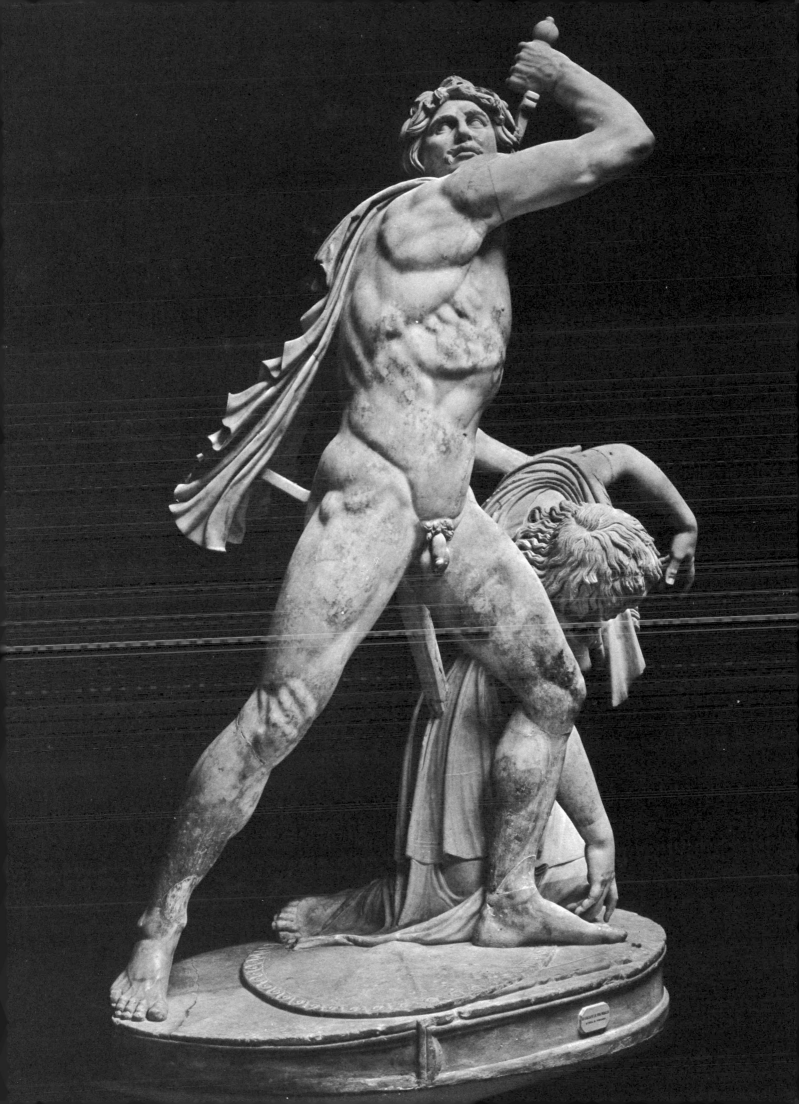

550. *Head of a Dead Persian.* Roman copy of a figure from a victory monument of Attalos I at Pergamon, c. 230–220 B.C. Marble, lifesize. Terme Museum, Rome

and the theatricality of the poses, tend to rob these statues of their effect, and some at least seem to lack the genuine feeling of the earlier dedication.

Eumenes II, who succeeded Attalos, erected a great altar to Zeus at Pergamon itself in the first half of the second century B.C. For sheer skill in carving, for the size of the figures, and for the quantity of sculpture it is unsurpassed— and when one considers the technical knowledge and the thought that must have been devoted to it the result is pitiable (figs. 552–55). It is like a mythological dictionary: all the facts are there, but it is empty of life; and this, since

551. *Dead Gaul.* Roman copy of a figure from the bronze dedication of Attalos I at Athens, c. 200 B.C. Marble, length 54″. Archaeological Museum, Venice

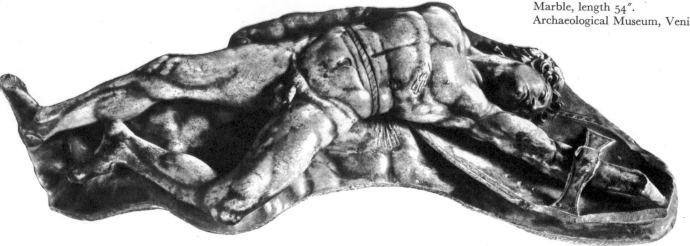

excellence (fig. 550). This dedication was followed by another in which Pergamene sculptors are seen to less advantage: it consisted of a series of bronze statues, slightly under lifesize, which were dedicated on the Acropolis at Athens, probably when Attalos visited it in 200 B.C. Copies in marble of several of them are known: Gauls (fig. 551), Persians, Amazons, and Greeks were all represented. The skill in designing the various figures and in rendering the play of limbs and muscles is very great; but the exaggerated expressions and modeling,

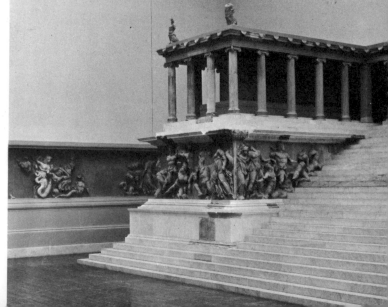

552. Northern Projection of the Great Frieze of the Altar of Zeus, from Pergamon. c. 180 B.C. Marble, height 90″. State Museums, Berlin

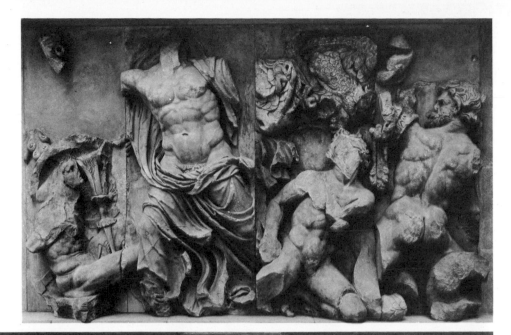

553. *Zeus Fighting Three Giants*, east side (portion) of the Great Frieze, Altar of Zeus

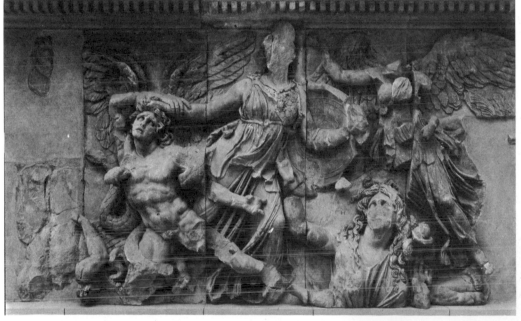

554. *Athena Battling Alkyoneos and Ge*, east side (portion) of the Great Frieze, Altar of Zeus

almost every figure is in violent action, is not a little surprising. Lack of belief is the reason. For artists of the Archaic period, the beings depicted were real; in the Classical period there might have been some suspension of belief, but the scenes had at least a symbolic meaning and were essentially if not literally true. Now even this seems to have evaporated: the events depicted, though with dramatic bravura, have clearly never taken place: the beings have never existed.

555. *Head of the Giant Alkyoneos* (detail of fig. 554)

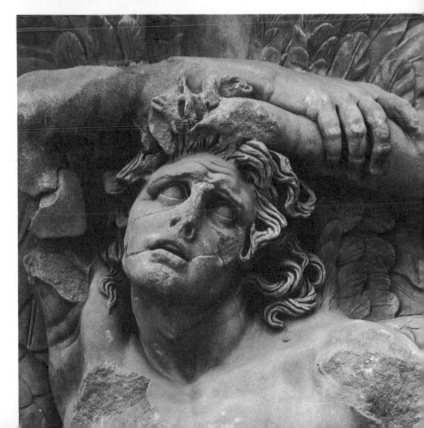

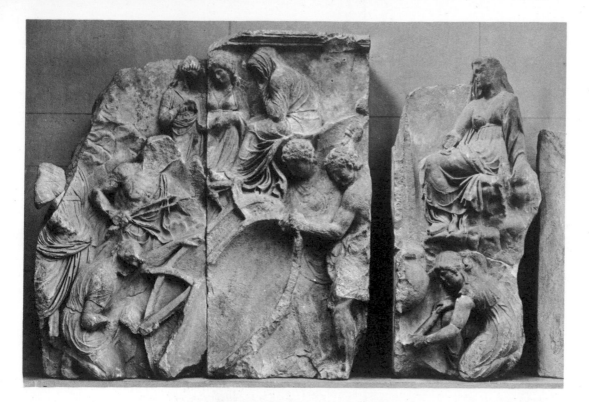

556. *The Building of Auge's Boat*,
Telephos frieze (portion),
Altar of Zeus, Pergamon.
C. 180–150 B.C.
Marble, height 62 1/4″.
State Museums, Berlin

557. Agesandros,
Polydoros, and
Athanadoros of Rhodes.
Laokoön.
Mid-2nd century B.C.
Marble, height 95″.
Vatican Museums, Rome

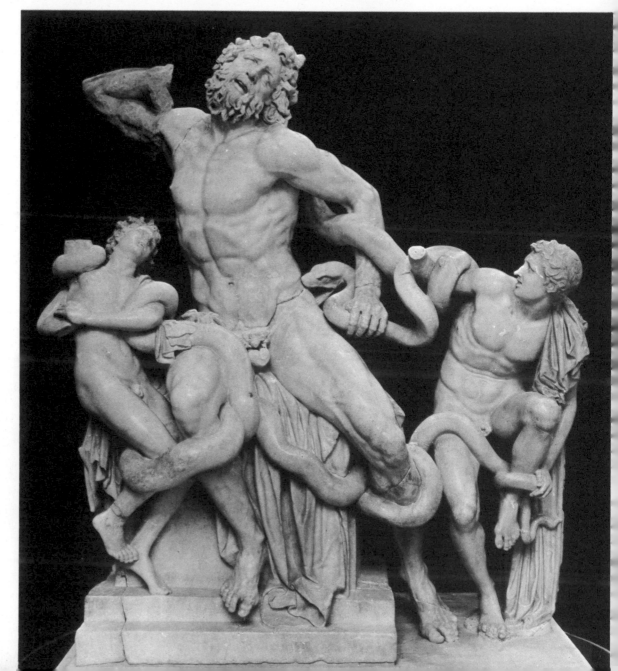

390

The Great Altar must, however, have been an impressive structure, and it has been aptly compared with some of the products of the Italian Baroque. Inside the colonnade which surrounded the altar itself was a hall, the walls of which were also decorated with reliefs (fig. 556). The great frieze on the outside, in the highest possible relief, went on the old system of obscuring the background by massing the figures. Here, on the contrary, the scale of the figures is smaller, the whole conception of relief is different; the frieze, which depicts the story of Telephos, son of Herakles and founder of Pergamon, has many of the qualities of a painting, with its figures at different levels, disposed in space, and with some elements of landscape.

The group of Laokoön and his two sons in the coils of the serpents (fig. 557) used to be dated in the later first century B.C., but its close resemblance to the Pergamene Altar points rather to the middle of the second.[9] True, it was carved by sculptors from Rhodes, but this would merely be one more indication of the free interchange of ideas at this time and of the mobility of sculptors. A set piece in more senses than one, it is isolated from its context and designed to be placed at some focal point for a frontal view. It is an amazing piece of sculpture, but amazing rather than moving, theatrical rather than tragic, a horrifying physical accident rather than a terrible example of the injustice of the gods.

There were other schools of sculpture less progressive than the Pergamene. The Aphrodite of Melos (fig. 558), probably carved about 150 B.C., is a work characteristic of a time and place where invention is flagging and the artist looks back to earlier periods for his models. It may well be called "eclectic" in the sense that the sculptor has taken elements of different kinds, although he has succeeded in blending

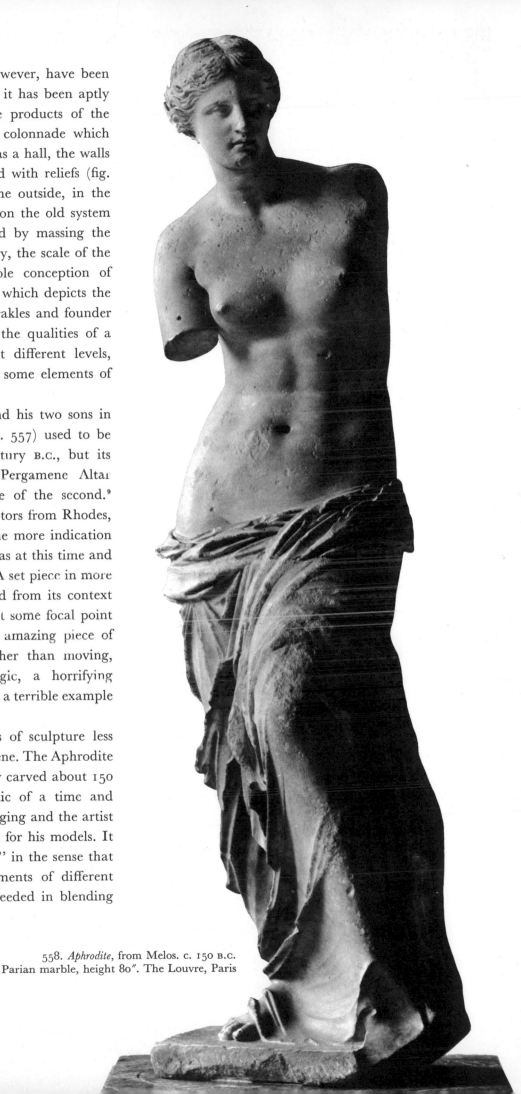

558. *Aphrodite*, from Melos. c. 150 B.C.
Parian marble, height 80″. The Louvre, Paris

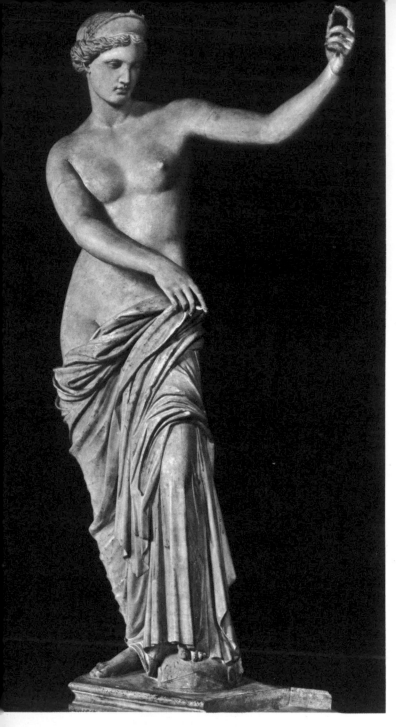

559. *Aphrodite*, from Capua.
Roman copy after an original of the 4th century B.C.
Marble, height 76″. National Museum, Naples

the shield of Ares, and Eros standing in front of her. This must have been made in the fourth century B.C., and it was a statue, or rather a group, intended to be seen from one main point of view; that is, with the torso of the goddess in a three-quarter turn toward the spectator, and her head almost in profile. The designer of the Aphrodite of Melos has taken this as his starting point, but has then radically transformed the composition by raising the head to look forward instead of downward, and by turning it in such a way that the main view of the head and torso is now almost frontal. He has kept the main lines of drapery, but has modified it to bring it into the fashion of his day by emphasizing some of the main folds and eliminating others; and at one point, near the right hip, the cloth is thrust up under the horizontal folds in a realistic way so that a number of short, tightly stretched folds radiate from that place. The modeling of the face and torso, though it betrays later elements—for example there is more swing in the torso—is, in some ways, closer to the fifth century B.C. than to the fourth, and it is the monumental character so attained which is perhaps partly responsible for its popularity in modern times. The changes are worth studying, for they show how an old idea can be freshened up: and it was always characteristic of Greek sculptors that they worked closely upon earlier types, usually those of only the last generation. Whether this classicism is preferable to Pergamene histrionics is a matter of taste.

A similar dependence on the past may be detected in the torso Belvedere (fig. 560), carved perhaps as late as the first century B.C. It is signed by Apollonios the Athenian, son of Nestor, and it has a special importance because of its influence on the artists of the Renaissance and the eighteenth century. The skin upon which the figure sits shows that it is a mytho-

them into a new creation. His main model was certainly the cult statue of a shrine in Corinth, which appears in miniature on Roman coins of the city and in marble copies of Roman date, the best-known being one from Capua (fig. 559). The cult statue was of Aphrodite with

560. APOLLONIOS THE ATHENIAN. *Belvedere Torso*. 1st century B.C.
Marble, height 62 5/8″. Vatican Museums, Rome

logical rather than a contemporary subject. The same Apollonios produced a bronze statue of which the torso is much the same as the Belvedere; but the subject, a boxer (figs. 561, 562), must have been quite different. Such sculptures may have considerable force, but they are rarely creative: they owe such merit as they possess largely to the older works from

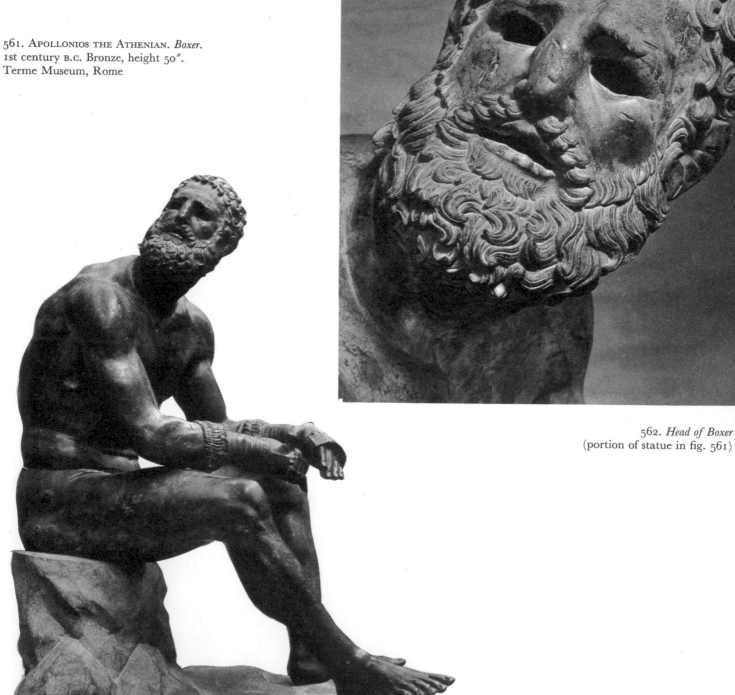

561. APOLLONIOS THE ATHENIAN. *Boxer.*
1st century B.C. Bronze, height 50″.
Terme Museum, Rome

562. *Head of Boxer*
(portion of statue in fig. 561)

which their elements derive. Hence they are apt to be more impressive when they are fragmentary and the lack of harmony among the various parts is not obvious.

It was not only Classical sculpture that was imitated, but also Archaic. Deliberate archaism goes back almost to the time when the Archaic style first passed out of fashion, but it may also occur long afterward. Its causes can be various. The old style may be retained for religious reasons, when for instance it is desired to perpetuate the style of some primitive statue; or for reasons of prestige, as for example in Panathenaic amphorae (see p. 211). Or it may be simply because a sculptor thinks that the past style is better than the present. Thus there is occasional archaizing work throughout Classical and Hellenistic times (fig. 563).[10] These imitations can be accurate copies of Archaic works, and a few such copies, made in Greek times, and more made in Roman times, do exist. More common are creations in an archaistic style, usually of deities in procession (fig. 564), with swallow-tailed drapery, tiptoe gait, and finicky gestures,[11] which reach their greatest popularity under the Romans.

564. *Dionysos and the Seasons.* 1st century A.D. Marble, height 12 5/8″. The Louvre, Paris

563. *Dancer*, from Pergamon. 3rd century B.C. Marble, height 43 1/4″. State Museums, Berlin

Bernard Ashmole

PART THREE

Cyprus · Etruscan Art · Roman Art

11

Cyprus

In the troubled times caused by the invasions of Greece from the north, around 1000 B.C., Cyprus was cut off from the west; but being rich in copper and timber, and in the iron that was now being used increasingly, Cyprus was never out of touch with the coast of Syria and probably not with Egypt. As conditions became more settled in the Aegean, Greek cities and small kingdoms were founded in Cyprus, and outrivaled those of the Phoenicians already established and being established there. The division between the two races, Hellenic and Semitic, persisted throughout historical times. They were sometimes at odds, sometimes living peaceably together: there must have been a certain amount of intermixture, and some of the peculiar qualities of Cypriot art may be due to Eastern blood.

Just after the middle of the eighth century B.C., the Assyrian Empire again started to expand, and conquered first Phoenicia and then Egypt: Cyprus surrendered in 709. The Assyrian domination lasted for about fifty years and was succeeded by that of Egypt. Egypt held sway until 525, when Persia conquered it, annexed Cyprus, and ruled over the whole of the old Assyrian Empire. In the years that followed, communications between Cyprus and Greece were free and they were only interrupted by the collapse of the Ionian Revolt in 499. Cyprus then became the chief supply base for the Persian fleet in its operations against the Greeks in the Aegean. The Greeks, especially Athens, vigorously counterattacked in the twenty years before 450, but in 449, with the death of Kimon at the siege of the Cypriot city of Kition, Athens withdrew her fleets from these waters, and this again cut off the Cypriot Greek cities from mainland Greece. At the end of the fifth century, and through most of the fourth, Greeks and Phoenicians, with Persia as the nominal ruler, struggled for mastery within the island, both physically and culturally. Alexander the Great by his conquests finally

placed it firmly within the Greek world. From then onward it alternated between a Greek Syria and a Greek Egypt, until in 58 B.C. Cyprus was ceded to Rome.[1]

POTTERY AND VASE PAINTING

After an unexciting Geometric phase, the Cypriot style being less inventive than most of those in Greece and independent of them, there developed an orientalizing style of painting which obviously borrowed something from Assyrian models but transformed the spirit of them completely. Its appeal is partly through its strange mixture of the realistic and the formal. Birds and animals are boldly drawn with realistic silhouettes (fig. 565), but when they are grouped the grouping is patternlike, often round an elaborately stylized floral symbol, the Assyrian sacred tree (fig. 566). Occasionally human beings appear, but they are not so successful as the animals, and their charm is that of the primitive (fig. 567). After the disappearance of this style in the early sixth century, there is nothing in Cypriot vase painting that approaches it in interest: there was a large output of pottery, but its decoration

566. *Animals Around a Formalized Sacred Tree*, vase from Larnaka (Cyprus). Mid-7th century B.C. Height 12″. Ashmolean Museum, Oxford

565. *Bird*, oinochoë. c. 750–500 B.C. Height 10″. The Metropolitan Museum of Art, New York (The Cesnola Collection, purchased by subscription, 1874–76)

was of the simplest geometric kind, often merely concentric circles. One curious native form of pot is worth mention: it was made chiefly in the west and northwest of the island, beginning in the sixth century B.C. and persisting until Roman times. It is a jug of which the top is modeled into the shape of a human head, and either the head, or a spout below, serves as the mouth of the jug (fig. 568). A variant, popular in the fifth and fourth centuries, has a complete figure of a woman sitting on the shoulder of the jug and leaning back against the neck: she usually holds a miniature jug herself (fig. 569).

567. *Horse and Rider*, oinochoë. c. 750–500 B.C. Height 12 3/8″.
The Metropolitan Museum of Art, New York
(The Cesnola Collection, purchased by subscription, 1874–76)

568. Jug with Neck Modeled as a Human Head.
c. 500–300 B.C. Height 10 1/2″.
The Metropolitan Museum of Art, New York
(The Cesnola Collection, purchased by
subscription, 1874–76)

569. Polychrome Vase with
Woman and Jug Attached.
c. 400 B.C. Height 15 1/2″.
The Metropolitan Museum of
Art, New York (The Cesnola
Collection, purchased by
subscription, 1874–76)

SCULPTURE

The sculpture too reflects the history of the island. In the eighth century B.C., during the time of Assyrian domination, there are sculptures of stone and also large terracottas which, while evidently made by natives, have strong Assyrian characteristics (fig. 570). It is not easy to say how long this style persisted, but some time after Cyprus fell under Egyptian influence it produced Egyptianizing statues of little interest or artistic value. Then, during the sixth century, when Cyprus was in touch with Archaic Greece, it seemed to be developing something akin to a good Greek Archaic style (figs. 571, 572). Unfortunately, with the collapse of the Ionian Revolt and the subsequent subjection of Cyprus to Persia, it was cut off from Greece, and the impulse died. During the rest of its existence Cyprus reflects,

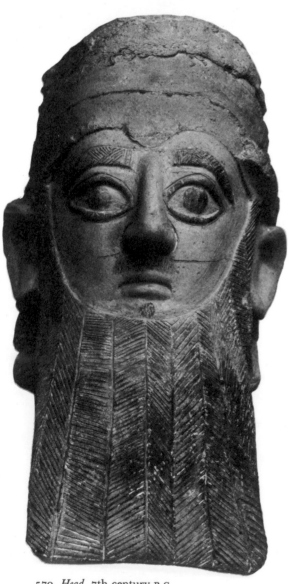

570. *Head.* 7th century B.C.
Terracotta, height 14″.
British Museum, London

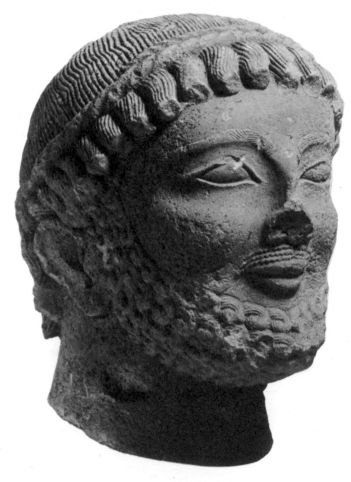

571. *Bearded Head.* 6th century B.C.
Limestone, height 12″. Ashmolean Museum, Oxford

in an uncreative way, the styles of art to which it had access, and after its liberation by Alexander the Great it followed faithfully the changing fashions of Hellenistic sculpture (fig. 573); but being in contact mainly with Syria and Egypt, Cyprus was hardly touched by the great Pergamene movement.

572. *Head of a Bearded Man Wearing a Helmet of Greek Type.*
6th century B.C. Limestone, height 12″.
The Metropolitan Museum of Art, New York
(The Cesnola Collection, purchased by subscription, 1874–76)

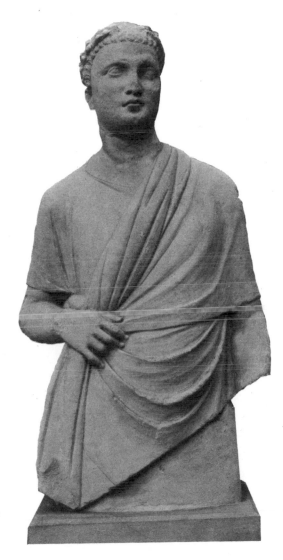

573. *Youth Wearing Wreath.* 3rd century B.C.
Limestone, height 31 1/2″. British Museum, London

12

Etruscan Art

Wherever they came from originally, and whatever elements went into the formation of the Etruscan civilization in Italy,[1] it is certain that from the eighth to the end of the sixth century B.C. the Etruscans were immensely powerful at sea, especially as raiders and pirates. They were not a united nation in the modern sense, nor were they quite like the Greek city-states, but they did consist of a small number of very powerful cities, mostly occupying strong natural positions within a few miles of the western coast of Italy. They sometimes acted in concert and sometimes failed to do so, and this failure finally led to their conquest by Rome. On land the Etruscan Empire reached the summit of its power a little before 500 B.C., when it dominated the whole of Italy as far south as Campania, though the coast of Campania itself continued to be held by Greek and native cities. At this time Rome was under Etruscan domination, its king was Etruscan, and there was a temple of Etruscan type on the Capitoline Hill.

But Etruscan power suffered first a series of sharp reverses and then a steady decline, from which it never recovered. Aristodemos of Cumae repulsed their attack on his city, the oldest Greek colony in South Italy, about 525; and twenty years later he helped the Latin tribes to drive the Etruscans out of Latium: it was then that Rome substituted for the rule of an Etruscan king that of two magistrates, the consuls. In 474 Hieron, the Greek tyrant of Syracuse, defeated the Etruscans in a sea battle off Cumae, and by the end of the fifth century their empire had melted away, its end being sealed with the conquest of Veii by Rome in 396 and with the Gaulish invasion about 390.

Apart from elements of earlier Villanovan culture which they seem to have absorbed, native and foreign elements can both be distinguished in Etruscan art. In the seventh century B.C., the Etruscans, like the Greeks, were strongly affected by oriental influence, and in the sixth they were not only patrons but also imitators of Greek art. But as imitators

they were not slavish: they had a strong and sometimes rather brutal artistic character of their own, with a choice of subject rather different from the Greek. A special talent seems to have been for large terracottas. They also worked local stones, but marble was almost unknown to them, since Italian quarries were not used until Roman times. Their small bronzes are often of high quality, and they were expert goldsmiths. Artistic output and material prosperity roughly coincided with political domination, and the bronzes are particularly plentiful in the later sixth century: but several outstanding pieces were made when the Etruscan Empire was a thing of the past.

POTTERY AND VASE PAINTING[2]

Etruscan art, like the Greek, went through a Geometric phase which seems to have been based on the Geometric art of the earliest Greek colonies in South Italy, especially Cumae. In the seventh century it became strongly orientalizing, but the potters do not seem to have the same command of the foreign elements as do their Greek counterparts.[3]

The Etruscans imitated the Greek black-figure technique, but at about a generation's interval, and their best vases in black-figure were painted around 500 B.C. when in Athens the red-figure technique had virtually displaced it.

The hydriae from Caere have already been mentioned as the work of a Greek settled in Etruria (see p. 196). Another class of vase may also have been started by an Ionian Greek or Greeks, but some of them have a twist which makes one think that natives were gradually taking over: these are the so-called Pontic vases.[4] At their best they are expressive and humorous, and the animal friezes, derived from oriental models, are drawn with an unoriental zest. The best known is perhaps the vase with the judgment of Paris, where Hermes is marshaling the goddesses as they approach the judge (fig. 574): Hera determined, Athena demure, Aphrodite confident.

But in addition to these immigrant artists there are a number of native Etruscan painters of black-figure. One of the best known and most productive is the Micali Painter. Most of

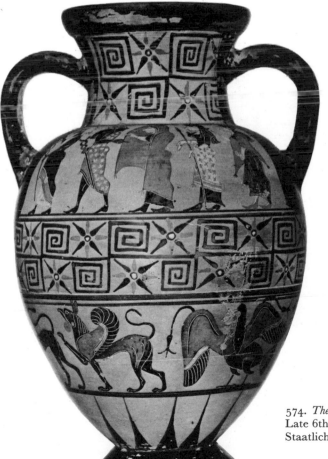

574. *The Judgment of Paris*, "Pontic" amphora from Vulci. Late 6th century B.C. Height 13". Staatliche Antikensammlungen, Munich

405

his pictures are marked by a wild vigor which overshadows the narrative interest: his centaur, in a landscape of trailing herbage, who lashes out with human forelegs at an intruding Pegasos with a freedom made possible only by the possession of another pair of legs, has an abandon which at once distinguishes it from anything in Greece (fig. 575). The winged horse has wings not only on its shoulders but on its legs as well, and on the neck of the pot is a figure winged also on shoulders and legs: there are many wings in Etruscan art.

It was always possible to endow deities or animals with wings for decorative purposes, and this was frequently done in Ionian art of the sixth century B.C.; but among the Etruscans the desire for decorative effect is not the mainspring: they evidently had a whole realm of superhuman beings, male and female, many of them winged, that were not created primarily by artists but were part of general belief. The generic Etruscan name for these female winged beings was Lasa, but like their male counterparts they commonly have individual names as well.

As with black-figure, the red-figure technique was not adopted in Etruria until a generation after it had become fashionable in Athens,

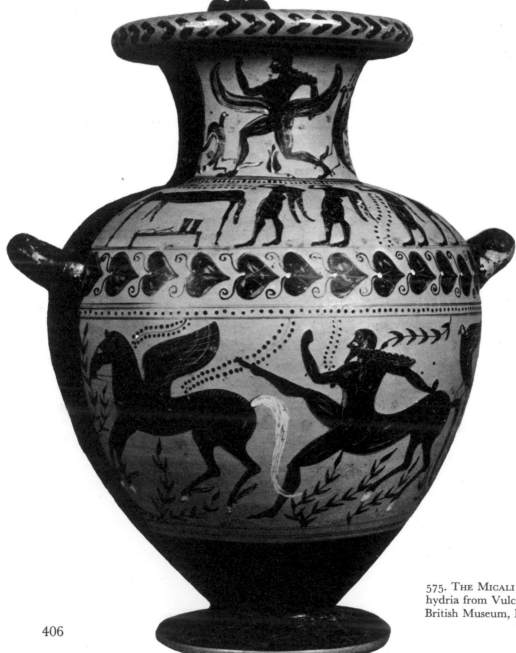

right: 576. *The Rodin Cup.*
c. 450 B.C. (or later). Height 3 3/4".
Rodin Museum, Paris

575. THE MICALI PAINTER. *Centaur and Pegasos,* hydria from Vulci. Late 6th century B.C. Height 16". British Museum, London

although Etruscan painters had used an unsatisfactory method (tried also in Athens and soon abandoned), in which red figures were painted on over the black instead of being reserved from the red ground. One of the earliest Etruscan vases in true red-figure is the Rodin cup in Paris, which directly imitates an Attic cup of about 460 (fig. 576).[5]

Winged figures never lose their popularity, and they abound on a vase which is about a couple of generations later than the Rodin cup. On one side of the vase (fig. 577) a horseman, whose horse turns its head toward the spectator, is being met by a winged boy with wreath and ribbon, tokens of victory: below sits a Lasa on the ground, toying with a flower. On the other side is Apollo: a winged female sits in front of him holding a branch in her hand, below are Pan and a satyr, as if indicating a wild countryside. The Lasa has an ominous look, but there is no clue to the meaning, or to whether she is playing an important part in the scene.

Various groups of Etruscan red-figured vases

577. *Victorious Youth on Horseback*, stamnos from Vulci. c. 410–400 B.C. Height 13 3/4″. British Museum, London

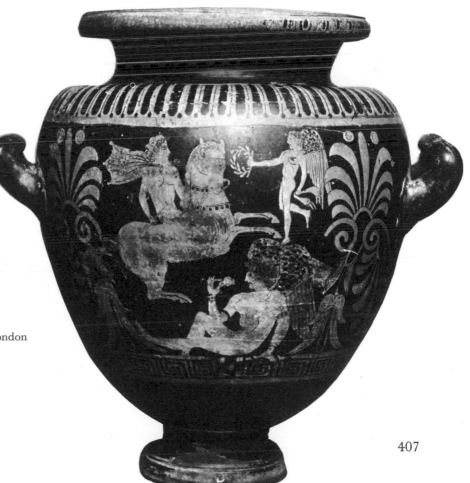

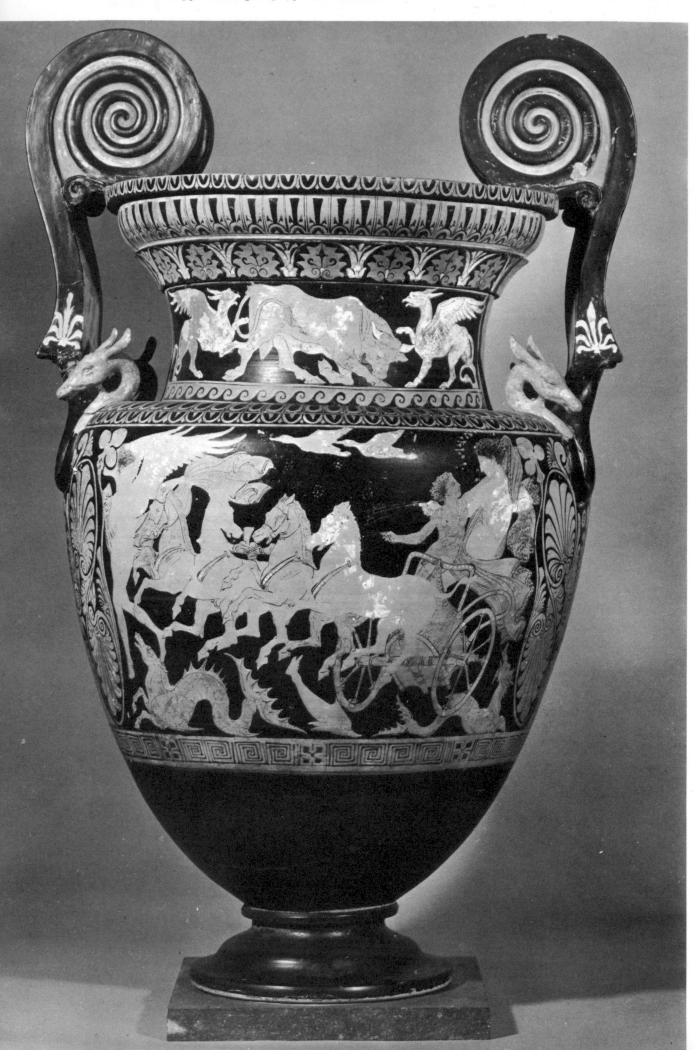

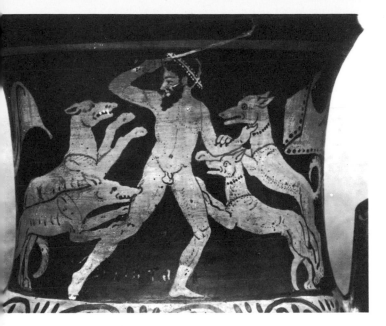

579. *The Death of Aktaion* and *Ajax Committing Suicide*, calyx krater (portions) from Vulci.
c. 410–400 B.C. Height of vase 15 5/8″. British Museum, London

have been assigned to their local places of manufacture; some of the most impressive are those from Falerii, that are called Faliscan. They begin about 400 B.C. and continue for about a century, the earlier ones so close in style to contemporary Athenian work that it has sometimes been thought their making was started by an immigrant Athenian. The masterpiece is a mixing bowl of about 350 (fig. 578): its painter is named from this vase the Aurora Painter, for one side bears a picture of the goddess of the dawn driving her four-horse chariot over the sea, with a young boy, Kephalos or, Tithonos, beside her. The composition is masterly, and not a little of the strong sense of movement is imparted by the accessory figures—the Morning Star who leads the chariot, the pair of flying ducks, and the sea creatures who disport themselves below. The picture on the other side is less idyllic, and almost frightening in its violence (colorplate 43). Peleus seizes Thetis at a fountain. Here everything depends on the protagonists: the accessory figures add little to the power of the central group, which, despite the loss of details, is unrivaled in ancient art for its compactness

and its urgency. It makes the picture of the same subject by a contemporary Athenian painter seem like a theatrical tableau (see colorplate 37).

Finally there are the later phases of Etruscan red-figure, and here too there are scenes strongly Hellenizing yet in their effect quite unlike the Greek. They have a rough, almost rustic tang which is not disagreeable: in two pictures on a vase in the British Museum—concerned, as so many Etruscan pictures are, with death—Aktaion is being attacked by his hounds, Ajax is casting himself upon his sword (fig. 579). The simpler mind shows itself in the exaggeration of important elements in the story, either because they loom large in the mind of the artist or because he feels that, lacking emphasis, they may be overlooked. Thus Aktaion is dwarfed by his pack of truly formidable dogs, utterly unlike the Pan Painter's ratlike creatures which one would think incapable of the deed (see fig. 270). Ajax, noted for his size and courage, is amply sexed, has huge hands and an enormous sword. Contemporary, but rather different in style and feeling, is the well-known vase in the Louvre

580. *Ajax Sacrificing Trojan Captives* and *Odysseus in the Underworld*, calyx krater. Late 5th century B.C. Height 15″. Cabinet des Médailles (Bibliothèque Nationale), Paris

with Ajax sacrificing Trojan captives (fig. 580): it is a theme often repeated, and taken from some great original where the hero was not Ajax, but Achilles. A being who is familiar in wall paintings and on funeral urns stands by: it is Charu, who bears the same name as the ferryman of the Greek river Styx (Charon), but is a very different character. The Etruscan Charu varies somewhat according to the fancy of the individual artist (the name may be generic for death-demon, which would account for variations) but is normally large and hideous, with wings, tusks, and pointed ears; he carries a great hammer, symbolic, one supposes, of the sudden impact of death. Whatever its source, the scene is impressive. More impressive still, and with a macabre feeling foreign to Greek pictures of the subject, is the visit of Odysseus to the Underworld, on the other side of the vase. Here a death-demon marshals the ghosts of the Amazons, wounded, bandaged, and wrapped in their cerements, who are specifically described as ghosts—it is one of the few Etruscan words we know.

WALL PAINTING

Perhaps the most spectacular remains of Etruscan art are the paintings on the walls of tombs, all the more important because nothing comparable has survived in Greece. There must originally have been hundreds of such painted tombs: many survived until modern times, but of these a number were despoiled in the early nineteenth century as soon as they were published, and others have suffered much from decay since then. Those that remain have been repeatedly discussed, and a classification into periods and styles has been made: this can be broadly accepted so long as it is remembered how fragmentary is the evidence on which it rests.

We can, then, recognize an orientalizing

phase during which such paintings as those of the Tomba Campana at Veii were produced (fig. 581). These are comparable to some of the orientalizing Etruscan vases, and show oriental animals—lion and panther—and an oriental monster, the sphinx; but there are also men and a horse, and the date is likely to be well on in the seventh century B.C. if the style corresponds chronologically with those current in Greece at that time. The remains of sixth-century paintings are particularly rich, and Greek, especially Ionian Greek, influence is strong. But, as always, the Etruscan artist makes his own contribution, so that very rarely could any of these paintings be taken for pure Greek. Sometimes they are coarser in drawing, sometimes rougher in finish, but usually they have a new, interesting, and not seldom a stirring inflection. In the Tomba dei Tori there is a scene from Greek mythology, Achilles lying in wait for Troilos outside the walls of Troy (colorplate 44). Achilles is concealed behind the fountain house, which is a solid structure of masonry surmounted by two lions, from the mouth of one of which the water pours into a basin: there are one or two trees of doubtful species, and other miscellaneous vegetation, carelessly drawn. But rough though it is, the scene contrives to be both sinister and ominous. The subject, like that of many of the paintings, is symbolic: Etruscans had a sense of the unexpected attack of death, as is suggested here,

581. *Boy on Horseback* (above) and *Sphinx* (below). 7th century B.C. Wall painting. Tomba Campana, Veii

411

582. *Bull with Human Face.*
6th century B.C.
Wall painting.
Tomba dei Tori, Tarquinia

but they clearly also believed in a life after death. In this same tomb the bulls symbolize generative and therefore regenerative power (fig. 582, colorplate 45), and the elegant sea horses probably refer, as they certainly do in Roman sepulchral imagery later, to the means by which the souls of the dead were transported to the Islands of the Blessed.

It is, however, not always easy to decide whether some of the scenes are from life in this world or from that in the world to come; this is not surprising, for the afterlife seems to have been pictured as one in which present activities and delights persisted. Each set of paintings must be judged separately: where, for instance, a body is shown as laid out on a bier and attended by mourners, it is clearly a scene of the actual funeral. Where, on the other hand, mourners are shown in attitudes of grief on either side of a painted door (fig. 583), the

583. *Mourners Beside a Door.* 6th century B.C. Wall painting. Tomba degli Auguri, Tarquinia

Colorplate 43. THE AURORA PAINTER. *Peleus Taming Thetis*, volute krater (for other side see fig. 578)
from Falerii. Etruscan, c. 340 B.C. Height 23 1/4″. Villa Giulia, Rome

Colorplate 44. *Achilles Waiting to Ambush Troilos.* Etruscan, 6th century B.C.
Wall painting. Tomba dei Tori, Tarquinia

Colorplate 45. *Crouching Bull*. Etruscan, 6th century B.C. Wall painting. Tomba dei Tori, Tarquinia

Colorplate 46. *Ritual Dance*. Etruscan, 6th century B.C. Wall painting. Tomba delle Leonesse, Tarquinia

584. *Two Male Dancers.* c. 470 B.C. Wall painting. Tomba del Triclinio, Tarquinia

door may be considered to be the door of a tomb; but it can also be regarded as a symbol for the door of the other world, and the painted mourners as perpetual symbols of mourning beside it. The doorway looms large in these paintings and is certainly sometimes symbolic, as for instance, on the base of the tomb of Aruns Volumnius (see p. 432).

A common scene is that of banqueting, and here too it is likely to refer to a continuance of earthly pleasures. The banquet is commonly accompanied by dancing, and this may be of a wild and tense character, as in the Tomba delle Leonesse (colorplate 46), or more idyllic, though still of extraordinary life and vigor, as in the complicated postures and bold fore-shortenings of the frieze of dancers in the Tomba del Triclinio (fig. 584, colorplate 47), where they are framed by delicately drawn trees and birds.

585. *Phersu Snaring a Man.* 6th century B.C. Wall painting. Tomba degli Auguri, Tarquinia

Another favorite subject is athletics, which may well be funeral games. There are the orthodox contests, such as wrestling; but there are also other events of a strange character in which a man in mask and tall pointed hat takes part—in one tomb he is labeled Phersu (the word is the Latin *persona* and our *person*), which may have meant "mask." In one scene this being is shown stalking up behind a horseman as if to attack him unawares. In another tomb he holds a rope in which is entangled a man whose head is completely covered so that he cannot see, and who is being savagely bitten by a dog (fig. 585); on another wall of the same tomb Phersu is running away (fig. 586). The scene is enlivened by charming studies of birds (colorplate 48).

As with vases and sculptures, so with the paintings; the successive phases of Greek art are reflected one by one (colorplates 49, 50). But among the surviving monuments of Greek art there is no parallel to the subject on the walls of a tomb in Tarquinia, of fishermen and slingers shooting at birds (fig. 587, colorplate 51). The whole design, with its large areas of sea and sky, and figures on a relatively small scale, with its boats, rocks, flights of birds, and leaping dolphins, is something quite new in European art, and might almost be described as the first European landscape painting.

418

586. *Phersu Running Away.* 6th century B.C.
Wall painting. Tomba degli Auguri, Tarquinia

587. *Hunting and Fishing* (below) and *Banquet* (above).
c. 500 B.C. Wall painting.
Tomb of Hunting and Fishing, Tarquinia

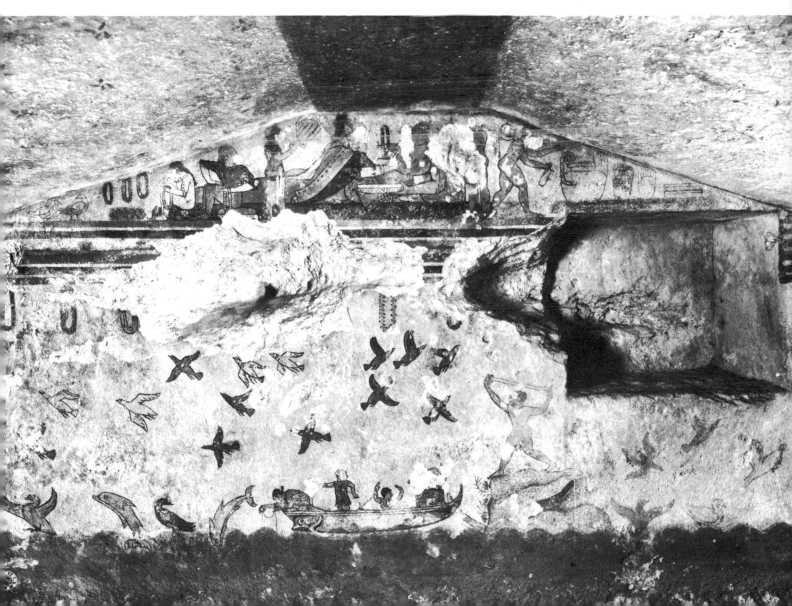

ARCHITECTURE

Etruscan architecture, as we know it today, consists of temples and tombs, although stone cinerary urns and the interiors of some of the tombs carved in soft rock reproduce the houses of the living. The early temples were built largely of wood, and this allows fairly wide spaces to be covered. The Etruscans did not go over to stone construction with the same enthusiasm as the Greeks, nor apparently did they build very large buildings; they were

588. Marzia Gate, Perugia. 3rd or 2nd century B.C.

therefore able to space their columns widely. The remains of their city walls, however, are imposing, with handsome arched gates. The Marzia Gate at Perugia (fig. 588) is an imaginative and striking creation in which three deities and two horses look down as from a loggia, their lower parts concealed by a fictitious balustrade of stone. The arch forming the gateway is still imbedded in a later wall below them.

The characteristic form of temple was a chamber with a deep porch in front, normally built on an elevated platform accessible only from the front, with a flight of steps leading up to it (fig. 589). This form was taken over by the Romans to house the Capitoline Triad of deities, Jupiter, Juno, and Minerva, and it became a regular feature of Roman market places. The breadth of its plan, as described by Vitruvius, was caused by the necessity of accommodating three statues side by side: but there is no reason to suppose that where this necessity did not arise the plan was not narrower.

The most distinctive form of tomb was the tumulus, sometimes walled at its base (fig. 590), and this form too must be the ancestor of the great Roman cylindrical tombs of Augustus, Hadrian, and others.

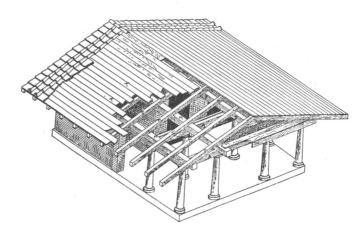

589. Vitruvius' Etruscan Temple.
Reconstruction and *Plan*
(by Wiegand)

590. Circular Tumulus, Cerveteri. 5th century B.C.

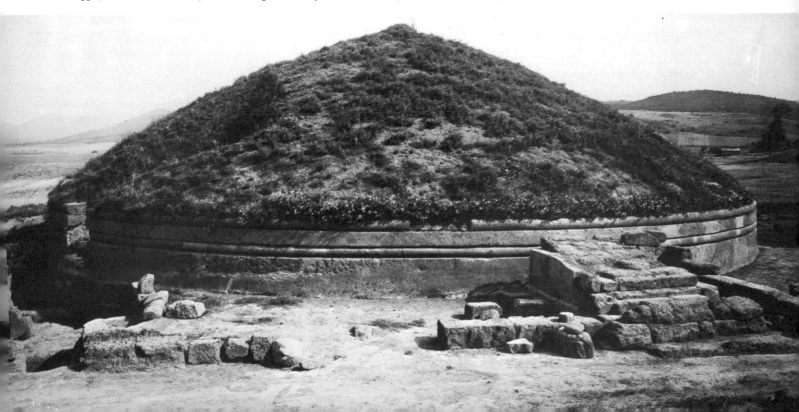

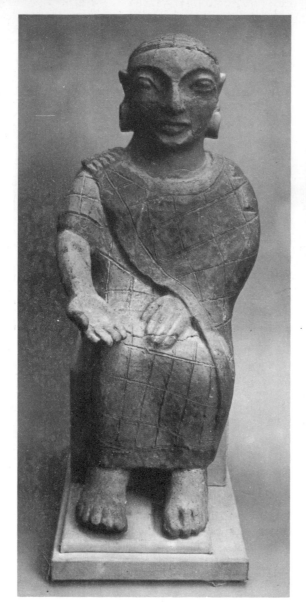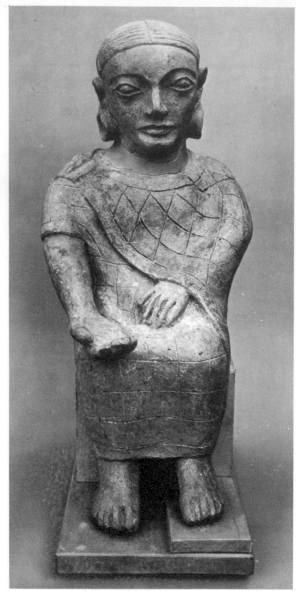

591. *Seated Women*, from Cerveteri. 7th century B.C. Terracotta, height c. 18″. British Museum, London

SCULPTURE

In sculpture, among the earliest heads in the round are those of clay, occasionally of bronze, surmounting "Canopic" urns[6] which contained the ashes of the dead. Some of these heads make an attempt at portraiture: the earliest complete figures are a set of terracottas, a seated man and two women (fig. 591), about eighteen inches high, from a tomb at Cerveteri (Caere). These can be dated to the seventh century B.C. by the clasp on the man's cloak, which imitates in clay a well-known type: an actual brooch of gold of the same type was found in the tomb. About a century later (early sixth century) is the large gypsum statuette from Vulci (figs. 592, 593). This is strongly Peloponnesian in style, somewhat resembling the Delphian Kleobis and Biton (see p. 234). In the same tomb, and possibly of

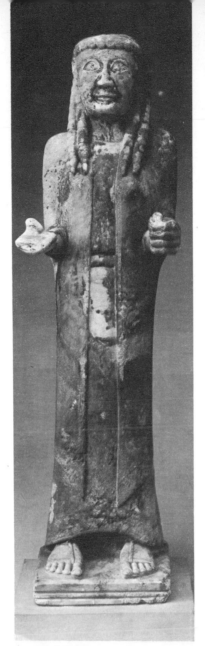

592. *Statuette of a Woman*, from Vulci.
Early 6th century B.C.
Gypsum, height 37 3/8".
British Museum, London

593. *Statuette of a Woman*
(upper portion of
statuette in fig. 592)

about the same date, was the upper part of a large bronze statuette of a woman (fig. 594), made by the *sphyrelaton* process, i.e., a thin sheet hammered into shape, and the details chased upon it. It is not easy to judge this kind of work, but it seems to have a more Eastern flavor than the marble statuette.

As in the other arts, one can see repeated in Etruscan sculpture the various phases through which Greek sculpture passed, but one cannot be certain how much time elapsed before their adoption by the Etruscans.

It is in the later sixth century B.C. that Etruscan terracotta sculpture really comes into its own. The lifesize figures from Veii formed a complete scene of Herakles carrying off the sacred hind and being pursued by Apollo (figs. 595, 596): Hermes was also present. These were not, apparently, from a pediment but from the roof of a building, and they indicate the bold way in which terracotta was handled by the Etruscans (fig. 597). This sprang largely from their common use of extensive terracotta revetments to protect their perishable wooden and brick buildings from the weather. It is natural to connect the statues from Veii with a famous Veientine sculptor named Vulca, who was summoned to Rome to make the terracotta statue of Jupiter for the temple of the Capitoline.

594. *Statuette of a Woman*, from Vulci. Early 6th century B.C. Bronze, height 10 3/4″. British Museum, London

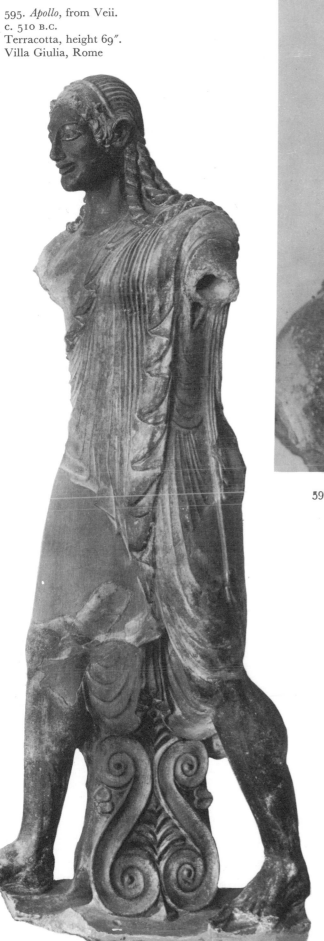

595. *Apollo*, from Veii.
C. 510 B.C.
Terracotta, height 69″.
Villa Giulia, Rome

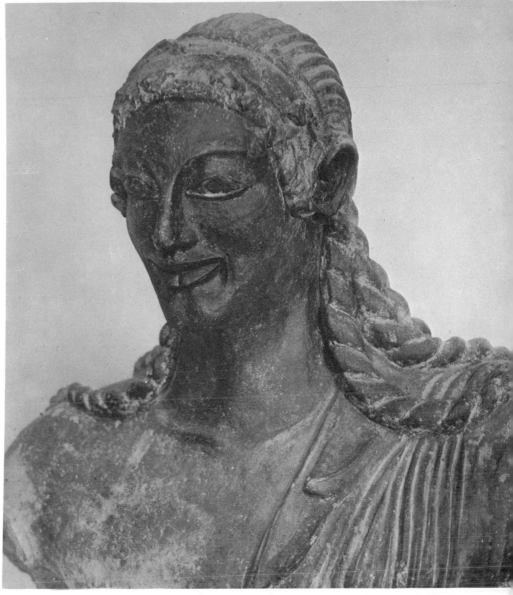

596. *Head of Apollo* (detail of statue in fig. 595)

597. Temple of Apollo, Veii. 6th century B.C.
Reconstruction (after E. Stefani)

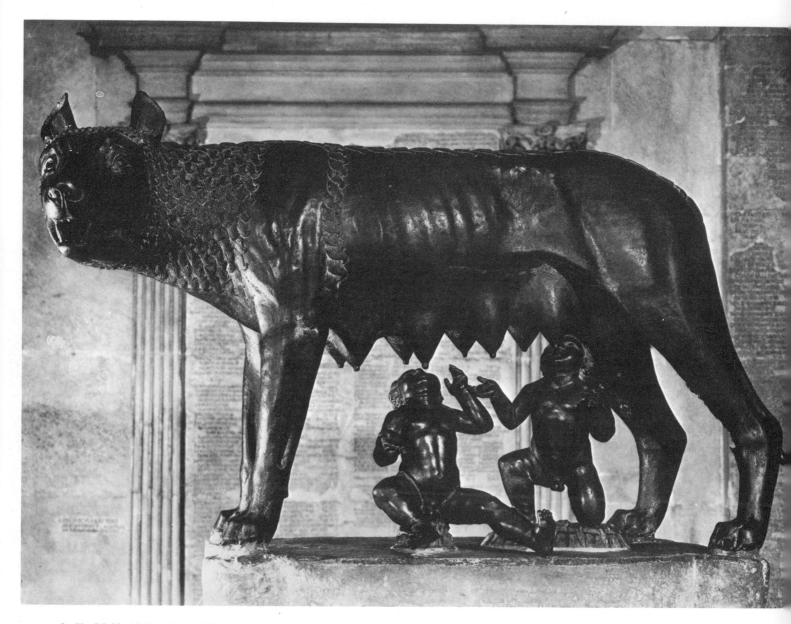

598. *She-Wolf with Romulus and Remus.* c. 500 B.C. (twins added in the 16th century).
Bronze, height 33 1/2". Palazzo dei Conservatori, Rome

The bronze she-wolf (fig. 598) which stood in front of the Lateran Palace in Rome during the Middle Ages (now in the Palazzo dei Conservatori, and accompanied by two sixteenth-century figures of Romulus and Remus) bears some resemblance to the hind of the group from Veii: it must be of about the same date. Claims have been made that it belongs to the same school of sculpture, and that these works are not purely Etruscan but examples of the early Italic art praised by Cato and mentioned by Pliny. Certainly the style is not identical with, for instance, that of the splendid clay sarcophagi from Cerveteri (fig. 599) or with that of architectural terracottas from other sites in Etruria, being rather less accomplished but more powerful than most; but this may mean no more than that there were local styles within the country, whether caused by the blossoming of native as distinct from Etruscan genius one cannot now determine. One has only to compare the gorgoneion antefixes from Veii with those, for instance, from Satricum to see what wide differences there can be.

The art of making bronzes reached its zenith in Etruria about 500 B.C. We do not know how many large bronze statues were produced, but the output of statuettes was very great. Most of their makers were clearly familiar with Greek work but they did not allow this to impair their own creative power (figs. 600–610). To try to detect not only the various local Etruscan styles but also the

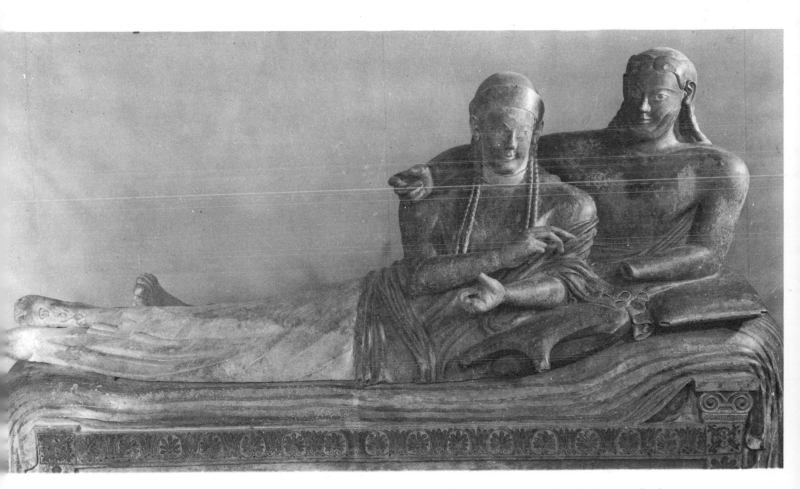

599. *Man and Woman Reclining*, sarcophagus from Cerveteri. c. 550 B.C. Terracotta, height 46″. The Louvre, Paris

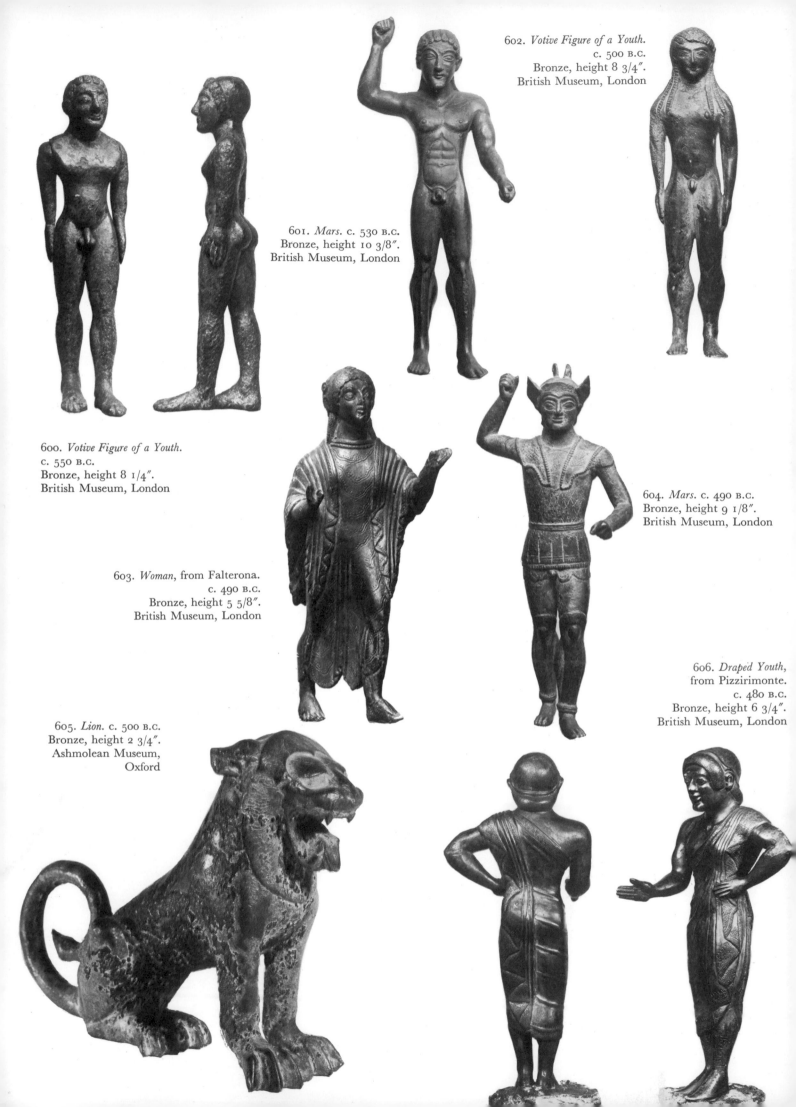

602. *Votive Figure of a Youth.*
c. 500 B.C.
Bronze, height 8 3/4".
British Museum, London

601. *Mars.* c. 530 B.C.
Bronze, height 10 3/8".
British Museum, London

600. *Votive Figure of a Youth.*
c. 550 B.C.
Bronze, height 8 1/4".
British Museum, London

603. *Woman*, from Falterona.
c. 490 B.C.
Bronze, height 5 5/8".
British Museum, London

604. *Mars.* c. 490 B.C.
Bronze, height 9 1/8".
British Museum, London

606. *Draped Youth,*
from Pizzirimonte.
c. 480 B.C.
Bronze, height 6 3/4".
British Museum, London

605. *Lion.* c. 500 B.C.
Bronze, height 2 3/4".
Ashmolean Museum,
Oxford

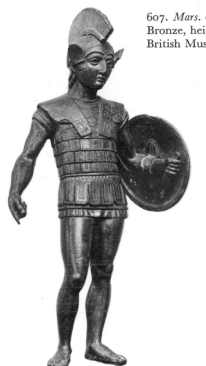

607. *Mars.* c. 450 B.C.
Bronze, height 12 5/8".
British Museum, London

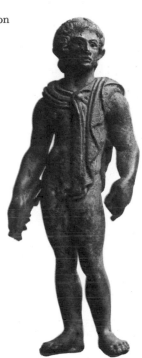

608. *Youth.*
Early 4th century B.C.
Bronze, height 7 5/8".
British Museum, London

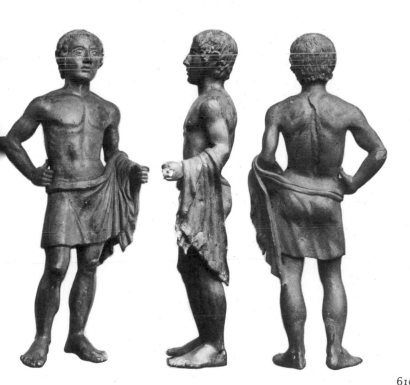

609. *Youth*, from Falterona. c. 350 B.C.
Bronze, height 20". British Museum, London

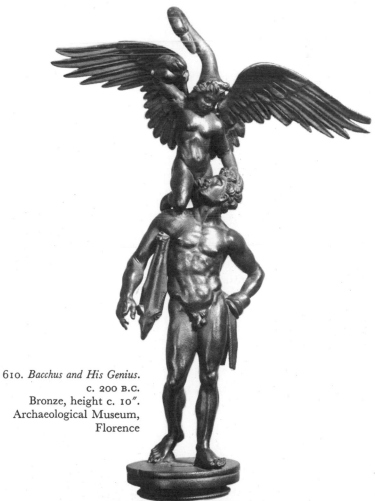

610. *Bacchus and His Genius.*
c. 200 B.C.
Bronze, height c. 10".
Archaeological Museum,
Florence

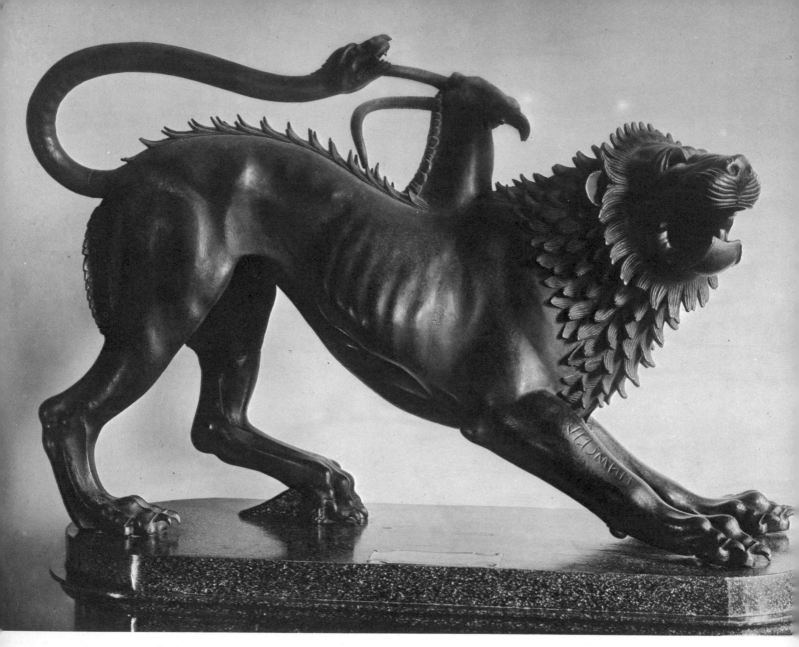

611. *Chimaera*, from Arezzo. 4th century B.C. (partially restored by Benvenuto Cellini). Bronze, height 31 1/2″. Archaeological Museum, Florence

various Greek styles which inspired them is an amusing exercise. There were bronzes, both large and small in scale, before and after the most productive time: the Chimaera from Arezzo is a highly decorative work of the fourth century B.C. (fig. 611), and the orator from Lake Trasimeno (fig. 612), perhaps of the second, foreshadows in its sincerity some of the admirable qualities of Roman sculpture.

After the Archaic period the clay sarcophagi which contained the bodies of the dead continued to be surmounted occasionally by their figures in the round, sometimes of lifesize and sometimes in bold poses. They are often more successful in conception than in execution: a striking example is the young man fallen back upon a couch with his dog beside it, perhaps Adonis, perhaps simply the deceased himself

612. *Orator*, from Sanguineto near Lake Trasimeno. 2nd century B.C. Bronze, height 70 7/8″. Archaeological Museum, Florence

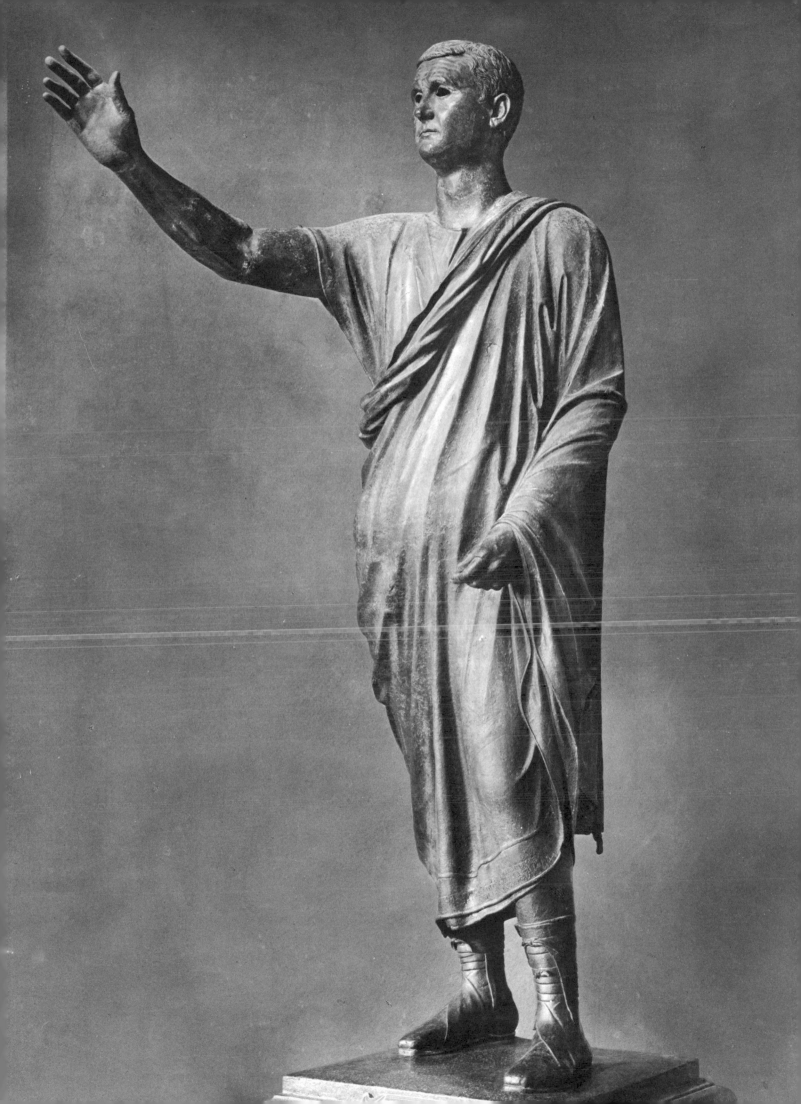

(fig. 613). This type of sarcophagus persisted into and through Roman times, becoming Romanized from the first century B.C. onward.

Even more numerous are the rectangular urns of all sizes for containing the ashes of the dead; the urns are usually made of soft stone, sometimes also surmounted by a figure of the deceased, and almost always adorned with a mythological scene in relief. Battle scenes are common (colorplate 52), and a favorite subject is the fratricidal strife between Eteokles and Polyneikes. All these scenes must have had symbolic meaning, for it is clear from their paintings on the walls of tombs and on vases that the Etruscans thought much about death and the life after death, and had many elaborate beliefs connected with it. A whole range of these urns was found in the tomb of the Volumnii at Perugia; these mostly belong to late Republican times and well illustrate the survival of local Etruscan culture under Roman rule. The most impressive is that of Aruns Volumnius (fig. 614): he is reclining on a couch which forms the casket, and holds a patera in his hand as a symbol of the sepulchral banquet. The couch rests on a high stone base, the cornice of which bears the name of the dead man in bold letters. In the center of the base is a painted archway which originally had four figures painted on it: the arch symbolizes the gateway of the underworld, and the four figures were souls of the dead seen within it. Equally remarkable are the two guardians carved in the round who sit one on each side of the gate: they are winged, have snakes in their hair, and each carried a torch in her hand. These are the Lasas, who play a prominent part in scenes connected with death: others, apparently beneficent, appear on other occasions. It is noteworthy that while the style of the head of the dead man is similar to that of Roman Republican portraits, the heads of the Lasas are in emotional Hellenistic style, not unlike the frieze of the Great Altar at Pergamon.

613. *Sarcophagus of a Youth.* Late 2nd century B.C. Terracotta, height 24 3/4". Vatican Museums, Rome

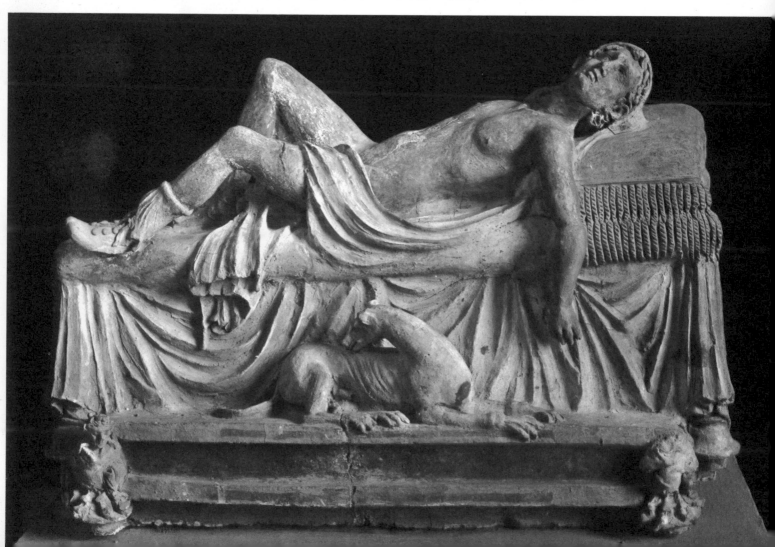

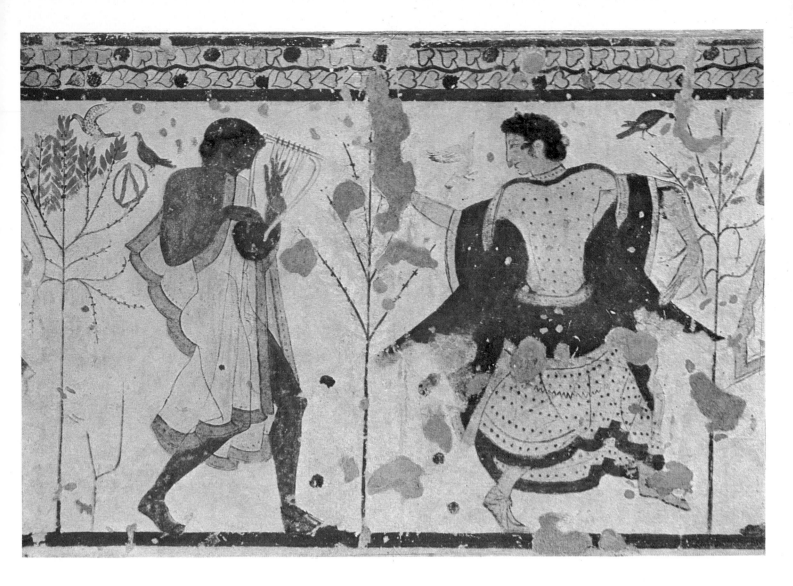

Colorplate 47. *Dancing Woman and Lyre Player*. Etruscan, 5th century B.C.
Wall painting. Tomba del Triclinio, Tarquinia

Colorplate 48. *Hand and Bird*. Etruscan, 6th century B.C. Wall painting (detail).
Tomba degli Auguri, Tarquinia

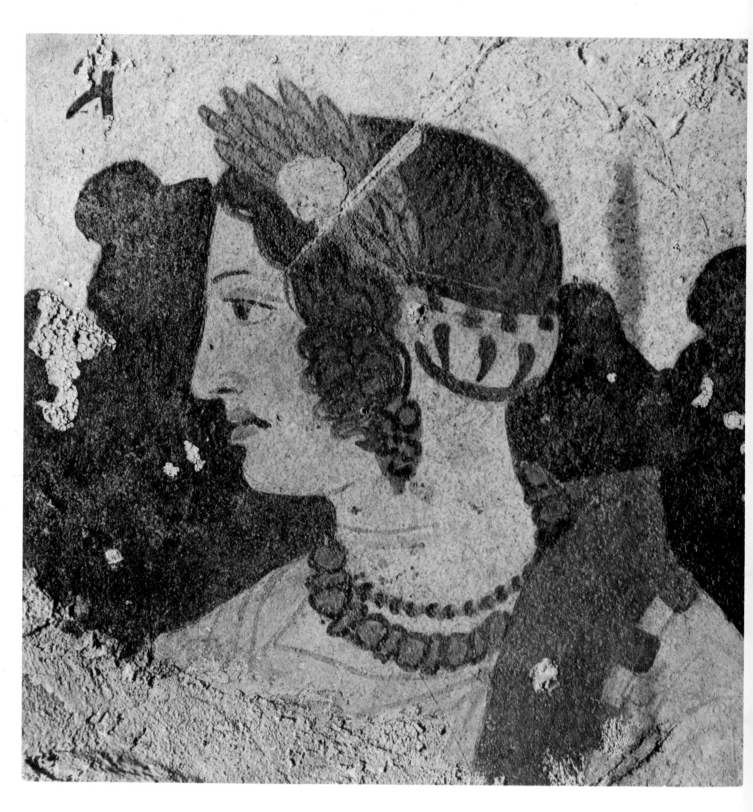

Colorplate 49. *Profile of a Woman*. Etruscan, late 4th century B.C. Wall painting (detail). Tomb of Orcus, Tarquinia

Colorplate 50. *Sacrifice of Trojan Captives*. Etruscan, 1st century B.C. Wall painting. François Tomb, Vulci

Colorplate 51. *Hunting and Fishing*. Etruscan, c. 500 B.C. Wall painting. Tomb of Hunting and Fishing, Tarquinia

Colorplate 52. *Amazons Attacking a Greek*, painting on a sarcophagus from Tarquinia.
Etruscan, 4th century B.C. Archaeological Museum, Florence

13

Roman Art

Throughout the Archaic and Classical periods all Greek sculptors worked with a practical, and usually a religious, purpose in mind. Their statues either represented the deity or were dedicated in his precinct in his honor: statues were also set up as monuments on graves; but the erection of a portrait statue which was not a grave monument could be justified only by its being dedicated to some god or goddess. It is true that, toward the end of the Classical period, the religious aspect became less obvious, but an analogy may show how strong the tradition was: when, for the first time in Greece, the head of a mortal, Alexander the Great, appeared on a coin, it was in the guise of a deity—wearing the horns of Zeus Amon or the lionskin cap of Herakles.[1]

With the breakup of Alexander's empire this tradition of the religious and practical use of art weakened but it did not die, and a work of art was still not primarily a work of art but a dedication fulfilling a purpose.

In the service of Rome, Greek art performed a different function.[2] The Romans were collectors of works of art created by a people whom they admired but had conquered, and whose mythology, however earnestly they tried to assimilate it, remained for the most part a set of alien ideas. Readers of Virgil can see how, for all his sincerity, his Greek mythology, like the Greek literary forms he uses, is a borrowed garment; and readers of Cicero can see how his interest in Greek art is that of a dilettante. Even for the most cultured Romans, works of Greek art were not living forces but museum specimens; for the less cultured, they were trophies whose display brought prestige; for many others they were merely precious objects of trade. Are they not so for us?[3]

But the impact of Greek culture on Rome precedes any wide knowledge of Greek works of art. It seems that about 500 B.C. two Greek artists, Dorians from their names, and therefore perhaps from a Greek colony in South

Italy, were brought to Rome to adorn a newly erected shrine of Ceres, Liber, and Libera— the Greek gods Demeter, Dionysos, and Kore under their Etruscan names. Barely a generation later the worship of the Dioscuri was introduced into Rome, and a generation later again, the cult of Apollo.

The other great formative influence was Etruria.[4] The inroads of the Gauls, who actually occupied Rome in 388 B.C., did much to weaken Etruscan political and military power, but when Veii fell to Rome, Rome herself, which had earlier had Etruscan kings, must already have been thronged with Etruscans, and these included numbers of skilled craftsmen. After the Gallic occupation much rebuilding took place, and the great system of roads was initiated which brought Rome into closer touch with the outside world. In wars which lasted down to about 300 B.C., the Romans overcame the Samnites and gained control of Campania. In 275 they took Taras (Tarentum) and thus the city of Rome became mistress of the whole of Italy. Two years later Ptolemy Philadelphus, the Greek king of Egypt, entered into formal diplomatic relations with Rome. As an index of how far Greek taste was by then established, it was about this time that the sarcophagus of Scipio Barbatus was made (now in the Vatican Museums): it is in the form of an altar with a Doric frieze, and its crowning member ended in Ionic volutes. A century later the Scipio family were known as enlightened admirers of Greek culture.

Capua, the strongly Hellenized city in Campania, was conquered in 212 B.C., and Taras, which had gone over to Hannibal, was retaken. In the second century B.C. Rome began its conquests abroad; it defeated Antiochos the Great of Syria and annexed part of his kingdom, and made a treaty with Egypt in 173. In 146 Greece became a Roman province, and in 133 the kingdom of Pergamon, perhaps the most important center of Hellenistic art, was bequeathed to Rome by its last king, Attalos III.

The fashion for Greek art was stimulated, and even partly created, by the sack of Corinth in 146 B.C. Corinth was one of the wealthiest of the Greek cities, packed with masterpieces, and these poured into Rome for Mummius' triumph. Sulla, in his turn, raided a number of Greek sanctuaries; and many another Roman official used his position to gratify this fashionable taste for the antique. A striking example is Verres, whose spoliation of the Greek cities of Sicily was attacked by Cicero. Some of the Roman emperors, especially Nero, were notorious for their depredations, but some others, notably Hadrian, were genuine admirers of Greek art and assiduously collected both originals and reproductions. There were not enough originals to go around: not everyone could afford to own a Greek masterpiece, the prices for which were inflated by rarity, as are some in the art market of today. Accordingly there arose a demand for copies, and these were produced in enormous numbers by Greek sculptors in several places in the Greek world: they were mostly exported, and used for the decoration of public buildings and private houses and gardens. It was not only to Rome that these were supplied, but to cities all over the Roman Empire, including those of Greece itself. Nor can we suppose that, in the absence of general knowledge of the history of art, the distinction between originals and copies was always clearly understood, or that dealers were interested in making it clear. In addition to accurate copies there were also new compositions, both for statues and reliefs, in Greek style, particularly the Archaic; and these so-called "archaistic" works, often man-

nered and empty, were widely used for decorative purposes.

Distinguished Greek gem engravers worked for Roman clients and produced, in addition to engraved seal stones, those elaborate cameos which utilize the various colored layers of sardonyx to enhance and enliven their design (fig. 615). The same technique was used on

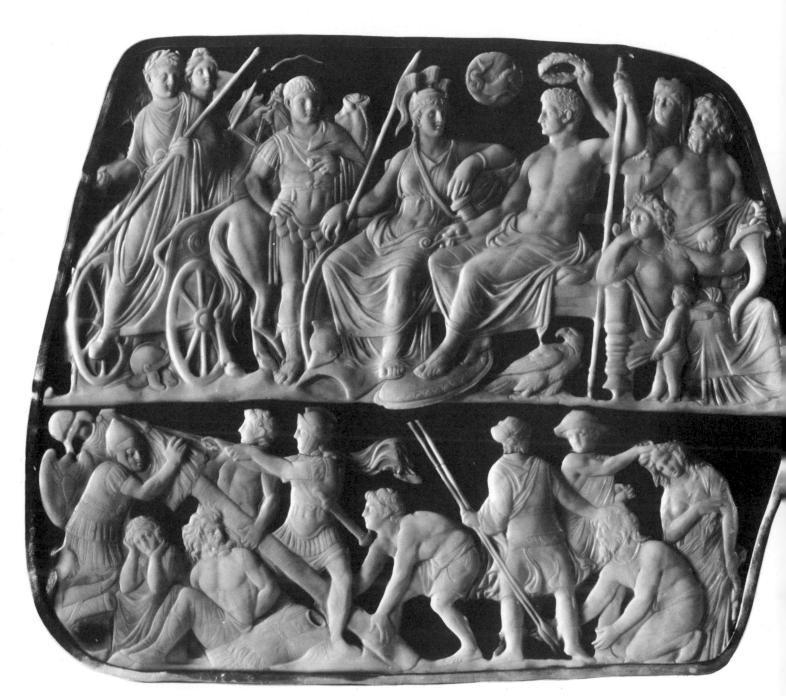

615. *"Gemma Augustea."* c. 10–20 A.D. Onyx, height 7 1/2″. Kunsthistorisches Museum, Vienna

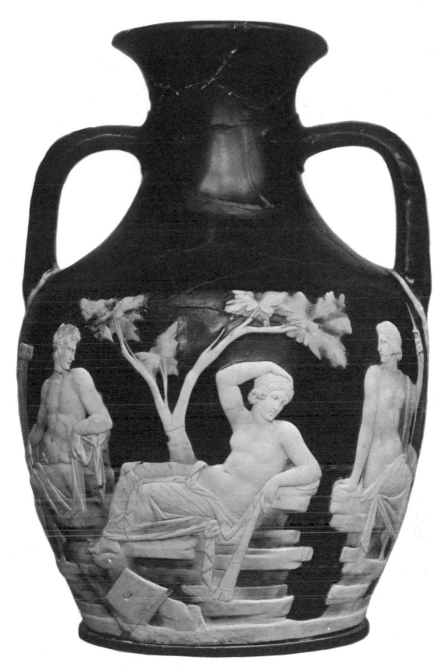

616. *The Portland Vase.*
1st century A.D.
Blue and white glass, height c. 10".
British Museum, London

glass vases that were especially made in several layers of different colors. The Portland Vase (fig. 616) is the most famous example, but it consists of two layers only, white over blue, and the design is cut in the white.

Greek art served Rome in yet another way:

it commemorated in metal Rome's martial and administrative achievements. The Roman coinage, unlike the Greek which rarely refers directly to a historical event, provides a long series of designs, often of high merit and almost certainly by Greek die engravers. These coins

617. *Coin of Nerva.* 97 A.D.
reverse: Postal tax
remitted: post-mules
off-saddled

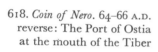

618. *Coin of Nero.* 64–66 A.D.
reverse: The Port of Ostia
at the mouth of the Tiber

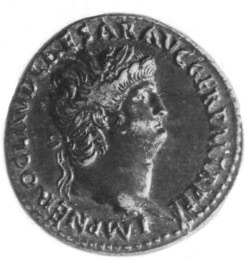

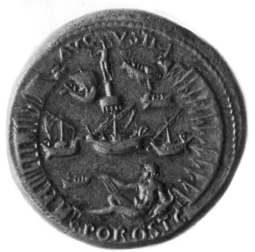

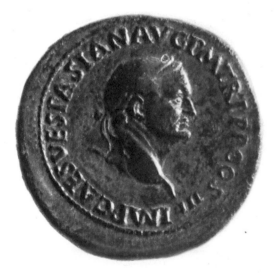

619. *Coin of Titus.*
70 A.D. reverse:
The conquest of Judaea

620. *Coin of Nero.* 64–66 A.D.
reverse: Peace throughout
the world, marked by the
closing of the Temple of Janus

442

form a running commentary on Roman rule: the remission of a postal tax (fig. 617) or the construction of the great harbor at Ostia (fig. 618) have their own commemorative issues not inferior as works of art to those which celebrate the capture of Judaea (fig. 619) or the achievement of peace throughout the world (fig. 620).

Was there then no native Roman art as distinct from the Etruscan and the Greek strains? The answer is that its beginnings seem to have been modest and strictly utilitarian. The Greek historian Polybius, in praising the self-discipline and patriotism of the Romans, describes how, at a funeral, illustrious ancestors were impersonated by living members of the family who in this way were reminded of the achievements of their family.[5] These impersonations were made possible by the custom of taking impressions from the features of the dead and creating from them wax masks which were then colored to the life and carefully preserved in special cupboards in the house. None of these wax masks survives, but many Roman heads in marble seem to reproduce death masks, and it has been suggested that this gave Roman art its realistic character (fig. 621). But this is not quite the right way of looking at it: the making of the masks is simply another manifestation of the practical Roman outlook on everything, which affected their

621. *Portrait of a Man.*
1st century B.C. Marble.
Formerly State Museums, Berlin

622. *The Life History of Orestes: Slaying of Aegisthus and Klytemnestra and Pursuit of Orestes by the Furies* (body of sarcophagus); *Orestes and Pylades in Tauris* (lid). 2nd century A.D. Marble. Lateran Museum, Rome

attitude to art as to other matters. In the art of Rome, even when it is at its most Greek, there is almost always a strong practical element. We have, for instance, processions consisting of real and recognizable people: it seems that an actual procession is being represented as it took place. But the ideal element could not be entirely omitted; almost every Roman historical relief has ideal figures mingling with the real ones, and this often produces a curious feeling of incongruity. There is similar conflict between the ideal and the real in scenes on sarcophagi, a form of art which became especially popular from the second century A.D. onward, coinciding to some extent with an increased use of inhumation rather than cremation, and with more widespread belief in a life after death. The scenes carved on sarcophagi are mostly those of old Greek myths, but they are used with allegorical significance and with reference to a future life (fig. 622). The Nereids and other sea creatures, which are one of the favorite subjects on sarcophagi, were the means by which the souls of the dead were transported to the Islands of the Blessed.

444

Colorplate 53. *Pan and Nymphs*, wall painting from Pompeii.
Third Style, 1st century A.D. National Museum, Naples

Colorplate 56. *The Laestrygonians Hurling Rocks at the Fleet of Odysseus*, wall painting from a house on the Esquiline Hill, Rome. Second Style, 1st century B.C.–early 1st century A.D. Vatican Museums, Rome

PERIODS OF ROMAN ART

Roman art is usually divided into periods named after the emperor or the imperial family of the time. This can be misleading, because a change in art does not necessarily correspond with a change of ruler, and artists may live through more than one reign. On the other hand, in addition to the usual changes of taste and fashion which give a special character to certain periods—sometimes independent of, sometimes enhanced by the taste of the Court—art can be affected by the policy, personality, or success of a ruler. There may be increased prosperity and thus more commissions, public and private; there may be achievements to commemorate, civil or military; an emperor may have no taste for art and so discourage it, or he may be an enthusiastic patron. The following classification is generally used; it is convenient, but must not be regarded as indicating sharp boundaries of style.

Late Republican	First century B.C. to the accession of Augustus
Augustan	Augustus (31 B.C. to 14 A.D.)
Julio-Claudian	Tiberius (14–37 A.D.)
	Caligula (37–41 A.D.)
	Claudius (41–54 A.D.)
	Nero (54–68 A.D.)
Flavian	Vespasian (69–79 A.D.)
	Titus (79–81 A.D.)
	Domitian (81–96 A.D.)
	Nerva (96–98 A.D.)
Trajanic	Trajan (98–117 A.D.)
Hadrianic	Hadrian (117–138 A.D.)
Antonine	Antoninus Pius (138–161 A.D.)
	Marcus Aurelius (161–180 A.D.)
	Commodus (180–192 A.D.)
	Pertinax (193 A.D.)
	Septimius Severus (193–211 A.D.)
	Caracalla (211–217 A.D.)

There is no generally agreed classification of art between the death of Caracalla and the death of Constantine in 337 A.D.

623. Arretine Bowl. c. 30 B.C.–30 A.D. Height 5 1/8".
Museum of Fine Arts, Boston (Henry Lillie Pierce Residuary Fund)

POTTERY

Roman pottery consists mainly of red-gloss wares, which, although they are of great importance for the dating of Roman sites, have little artistic value.[6] There is one exception, Arretine ware, which was made in Arretium, the modern Arezzo, for a couple of generations after about 30 B.C., and was exported from one end of the Roman Empire to the other, being found in places as far apart as Britain and India. Its most characteristic products are bowls ornamented with reliefs (fig. 623). The subjects, in an elegant Greek style, but, like much of Augustan art, eclectic, are commonly a series of banqueters or lovers, figures of the four Seasons, Victories, cupids, dancers, musicians, satyrs, and masks. The source of the designs seems to be metal, and the ware, for all its charm, must have ranked much below silver, which was widely used (fig. 624).[7]

By 30 A.D. Arretine ware was virtually finished: this may have been due partly to the growing use of glass instead of pottery, partly to the competition of Gaulish red-gloss ware, which imitated Arretine but was stouter and more highly polished. The Gaulish potteries were at first in the south near Toulouse, and gradually moved north, following the Roman legions and selling to them and to the new Roman provinces. Their output was enormous, but by the second century A.D. the style becomes much debased. The best pots now are the least classical, those in which the native potter, whether in Gaul or neighboring provinces, has given rein to native fancy and has decorated them freehand with trailed slip (barbotine). Gaulish ware was freely exported, and when exported it was imitated locally, perhaps most successfully in eastern Britain in Castor ware. This is not a red ware, but is made of light-colored clay coated with a slip fired black: hunting scenes are popular, but there is an ambitious vase with gladiators, more interesting for its subject than for its artistic merit (fig. 625).[8]

450

624. Cup, from an inhumation grave at Hoby (southeast Denmark),
c. 100–50 B.C. Silver, height 4 1/4″. National Museum, Copenhagen

625. *The Colchester Vase.* c. 200 A.D. Height 8 1/2″. Colchester and Essex Museum, Essex

WALL PAINTING[9]

In the remains of ancient painting that have come down to us, mainly from Rome itself and from the Campanian towns of Pompeii and Herculaneum that were destroyed in 79 A.D., there are obviously many Greek elements, and the difficulty of distinguishing these and of deciding their relationship to earlier Greek originals has already been mentioned (see p. 367). The Roman elements are almost equally difficult to recognize. It therefore seems best to treat here what is left when the range of pictures obviously inspired by Greek paintings has been eliminated. These remaining paintings may have been produced by Greeks, by Romans, or by one of a number of races: but all were working for clients in a Roman town, and the changes which can be traced in their work as time goes on, although they may be part of a larger movement, may be partly due to local development. In any case, the changes were taking place in what was a Romanized world.

Many years ago the types of wall decoration found in Pompeii and Herculaneum were divided into four styles, on the basis of a passage in Vitruvius; this division, if it is not treated too rigidly, still forms a sensible classification, which leaves aside the question of who painted the larger pictures often incorporated in the decorative schemes (colorplates 53, 54). These styles are as follows: the First Style, of the second century B.C., consisted of polychrome plaster revetments imitating various kinds of marble; this can be highly effective in a grand and simple manner (fig. 626). The Second Style, of the first century B.C. and early first century A.D., seeks to create an illusion of space, especially in small rooms, by painting on the walls architectural and landscape vistas apparently stretching out into the distance (figs. 627, 628). It should be remembered that ancient houses, which, unlike ours, had no

626. *Imitation Marble Revetment.* First Style, 2nd century B.C. Wall painting. House of Sallustio and Cesa, Pompeii

452

627. *Painted Architecture*. Second Style, 1st century B.C.–early 1st century A.D. Wall painting (detail). Villa of the Mysteries, Pompeii

external windows but were built around a courtyard, tended to have rooms that were both small and dark. The Third Style overlaps the Second in the reign of Augustus, and continues until the earthquake of 63 A.D. This has, on limited areas of the walls, small paintings of architecture and stylized plants in a most delicate, almost miniaturist style (fig. 629, colorplate 55). The Fourth Style, from the earthquake of 63 A.D. to the final catastrophe of 79, has fantastic and extremely elaborate

629. *Painted Architecture and "Panel Pictures."* Third Style, 1st half of 1st century A.D. Wall painting. House of M. Lucretius Fronto, Pompeii

628. *Landscape Vistas Framed by Painted Architecture*, wall painting from Boscoreale. Second Style, 1st century B.C.–early 1st century A.D. The Metropolitan Museum of Art, New York

630. *Painted Architecture*, wall painting from Herculaneum. Fourth Style, c. 63–79 A.D. National Museum, Naples

above and right: 631. *"Odyssey Landscapes,"* wall painting from a house on the Esquiline Hill, Rome (see colorplate 56). Second Style, 1st century B.C.–early 1st century A.D. Vatican Museums, Rome

architectural compositions inspired almost entirely by theatrical scenery (fig. 630).

In a house on the Esquiline Hill in Rome, a room was discovered decorated in the Second Style, where the upper part of the wall was painted with a loggia formed of pilasters; these frame a series of scenes from the *Odyssey:* the landscape is panoramic and the pilasters serve to separate the incidents (fig. 631, colorplate 56). Much has been written on this series; it is among the most interesting remains of ancient painting because of the small scale of the figures and of the prominence given to landscape, but it is amusing to notice how convenient, even here, are personifications for localizing a scene. There were artists in Italy who excelled in the painting of natural scenery without such symbolic intrusions: one of the best of them decorated the summer dining room of the

villa at Prima Porta (near Rome) belonging to Livia, the wife of Augustus, with the painting of a garden and an orchard behind it, which completely covered the walls of the room (colorplate 57). There are also delightful still-life pictures, mostly of fruits and other kinds of food, glass and silverware, sometimes flowers (colorplate 58). Another attractive form of wall decoration was that of figures painted on a plain-colored background. These can be single figures, usually painted with a light touch and clever management of foreshortening (colorplate 59), or they can be ambitious compositions: the Villa of the Mysteries, on the outskirts of Pompeii, contains a large room where, within a painted architectural setting, a composition of many figures, moving and seated against a plain scarlet background, extends around all four walls (figs. 632, 633,

632, 633. *Initiation of a Bride into the Dionysiac Mysteries?*
(see colorplate 60). Second Style, 1st century B.C.
Wall painting (portions). Villa of the Mysteries, Pompeii

634. Stucco Ceiling (portion), from the House of the Farnesina, Rome. c. 31 B.C.–14 A.D. Terme Museum, Rome

635. Stucco Vault (portion).
Mid-1st century A.D.
Subterranean Basilica near
Porta Maggiore, Rome

456

636. *Ritual* (detail of vault in fig. 635)

colorplate 60). It dates from the first century B.C. and there has been much discussion of its sources, how far they are Greek, how far Roman: but the frieze has not that obvious dependence on Greek prototypes which most of the pictures forming part of Pompeian decoration suggest. There have also been many attempts at elucidating the subject, the most convincing being that it is the initiation of a bride.

The ceilings and floors of Roman buildings were often decorated, the former with stuccoes, the latter with mosaics. Both stucco and mosaic had been used in Greece, probably more widely than is now realized. Stucco, apart from its use for simple and decorative moldings, which was common at all periods, was also used pictorially, and a house on the Palatine Hill had ceilings adorned with a series of scenes, mostly of Dionysiac initiation and ritual, framed with delicate arabesques, and accompanied by a number of less specifically religious views, with rustic shrines and images, and an occasional votary, which have been aptly called "sacred landscapes" (fig. 634).

The most remarkable series of stuccoes so far known come from the underground chapel found in 1917 near the Porta Maggiore in Rome, where the walls and vaulted roof are completely covered with pure white stucco on which a number of stucco pictures have been modeled: they are of the most varied subjects, but evidently all related to some secret and as yet unidentified religious cult (figs. 635, 636).

Stucco, because it sets quickly, calls for a special technique. Most of the stuccoes we possess are done with a confident, impressionistic touch which suits the medium admirably. There are also some charming unpretentious paintings in much the same manner, which inevitably remind one of Chinese landscapes (fig. 637, colorplate 61). Paintings and stuccoes

637. *"Chinese" Landscape*, wall painting found on the Appian Way, near Rome. 1st century A.D. Villa Albani, Rome

457

638. Wall and ceiling decorated with paintings and stucco reliefs. 1st or 2nd century A.D. Tomba degli Anicii, Rome

639. "*The Unswept Floor*," floor mosaic. 2nd century A.D. Lateran Museum, Rome

were also used in combination with one another on walls and ceilings, not always with very happy effect (fig. 638).

Mosaics also had a Greek ancestry: some Greek examples are known (see p. 367), and a Roman copy is extant of a famous one by Sosos of Pergamon, "The Unswept Floor" littered with the debris of a banquet (fig. 639). But the use of mosaic in Roman times was almost universal. It is a most practical form of flooring, since it is durable, washable, and nonslip, and it can be easily repaired because of the small units of which it is composed. It can be made of humble materials such as clay cubes, if no better are to be had, or of costly stones and glass if rich effects are desired. There are many mosaics with an elaborate color scheme and tesserae so fine that the mosaics resemble painting (figs. 640, 641); but these are not always the most effective: some of the best are

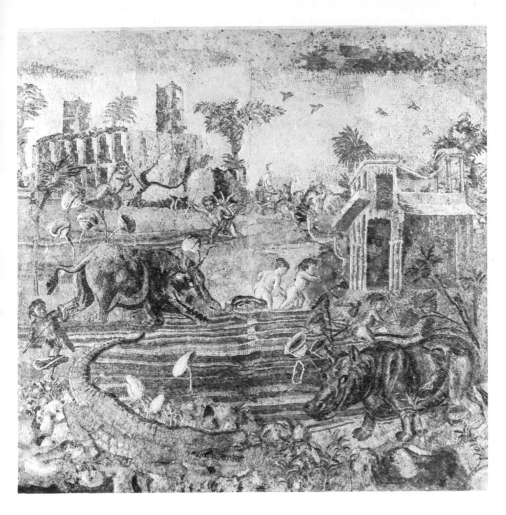

640. *Scene on the River Nile*, floor mosaic.
2nd century A.D.
Terme Museum, Rome

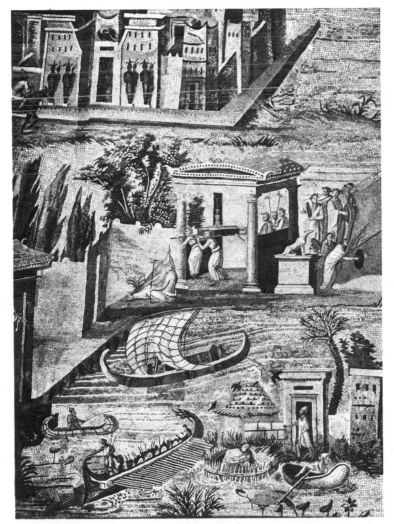

641. *Scene on the River Nile*, floor mosaic,
Palestrina. Probably 2nd century A.D.

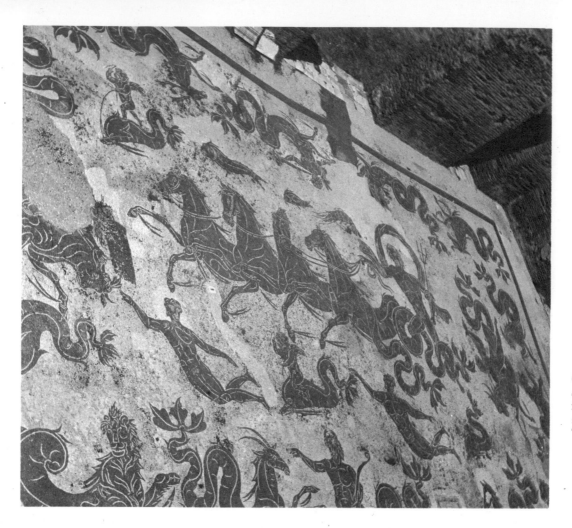

642. *Neptune amid Sea Creatures,* floor mosaic from Ostia. 2nd century A.D. Terme Museum, Rome

643. *"Cave Canem,"* floor mosaic from Pompeii. 1st century A.D. National Museum, Naples

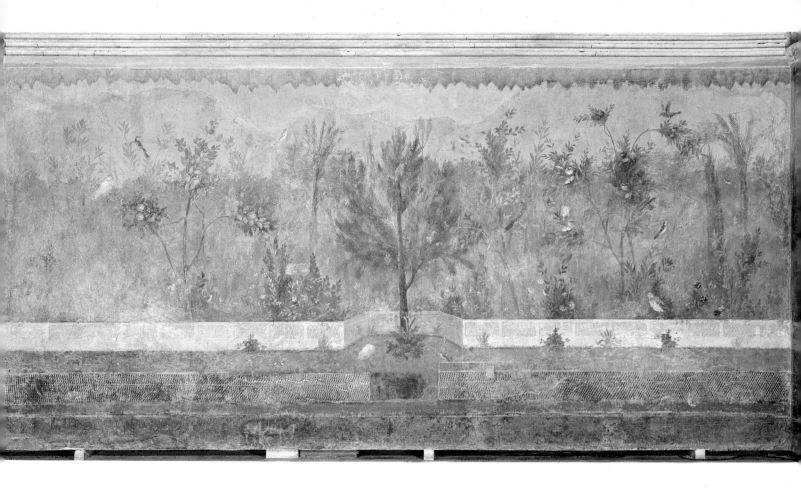

Colorplate 57. *Garden Scene*, wall painting from the Villa of Livia, Prima Porta.
Second Style, late 1st century B.C. Terme Museum, Rome

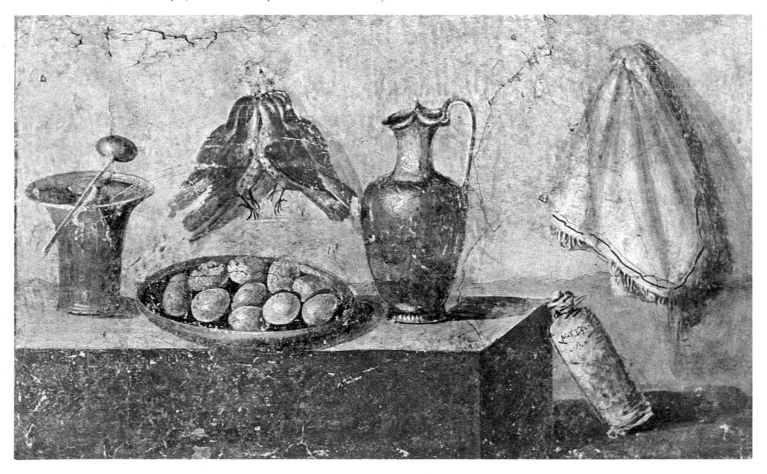

Colorplate 58. *Still Life*, wall painting from the House of Julia Felix, Pompeii.
Second Style, 1st century B.C.–early 1st century A.D. National Museum, Naples

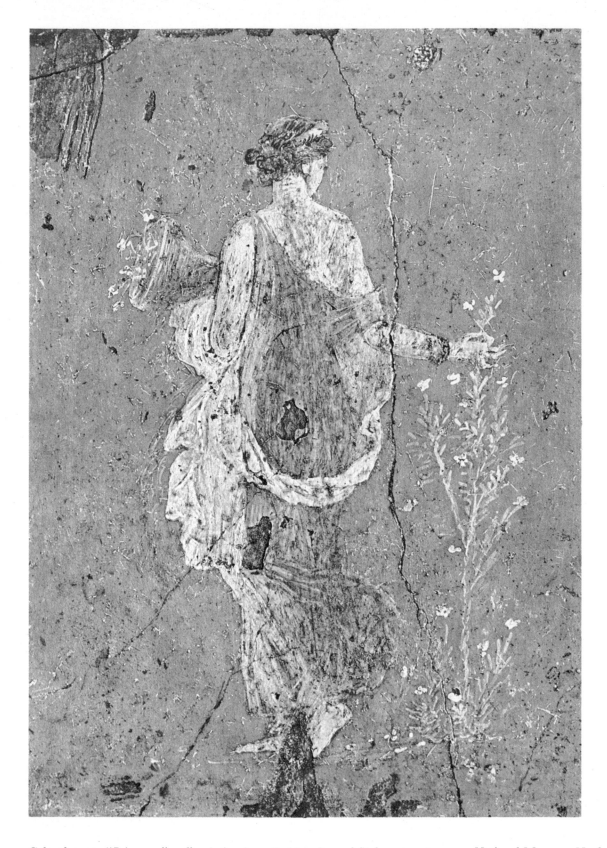

Colorplate 59. "*Primavera*," wall painting from Stabiae. Second Style, 1st century A.D. National Museum, Naples

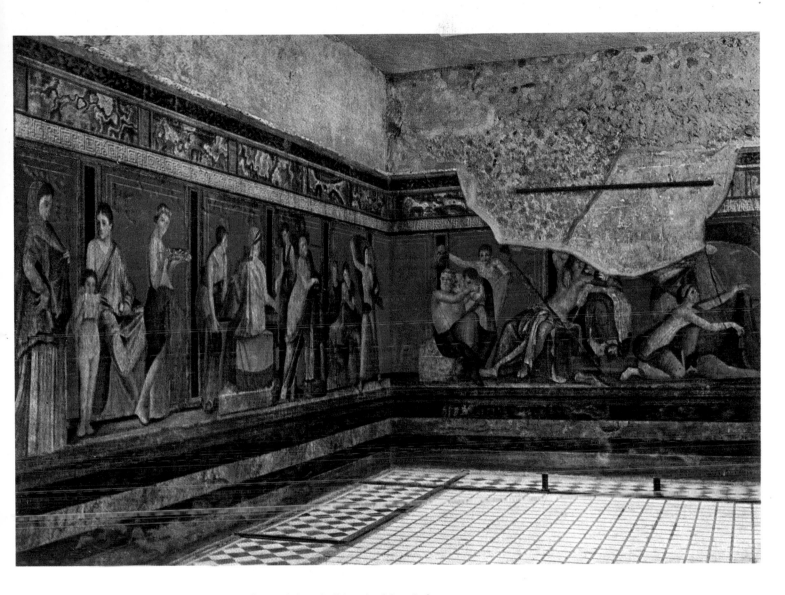

Colorplate 60. *Initiation of a Bride into the Dionysiac Mysteries?*
Second style, 1st century B.C. Wall painting. Villa of the Mysteries, Pompeii

Colorplate 61. *Sacred Landscape*, wall painting from Pompeii. Fourth Style, c. 63–79 A.D. National Museum, Naples

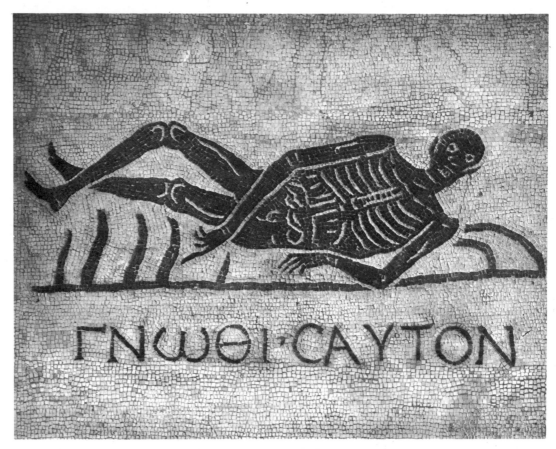

644. *Skeleton*, floor mosaic from Pompeii. 1st century A.D. National Museum, Naples

in a few simple colors or even in black and white (fig. 642). Many plant patterns and abstract and repeating patterns are of the utmost intricacy, and extraordinarily decorative. Every possible subject is used, from elaborate mythological scenes down to the chained mosaic dog in the entrance hall, with the warning "Cave canem" (fig. 643), or the mosaic skeleton inscribed "Know thyself" (fig. 644).

ARCHITECTURE

Roman architects, or Greek and other architects who worked for the Romans, carried on the Greek tradition in temples of conventional plan in stone or marble, often of the Corinthian or the Composite Order, and with much interesting variation of detail. But the genius of the time is most clearly seen in the great theaters and amphitheaters, where superimposed Orders

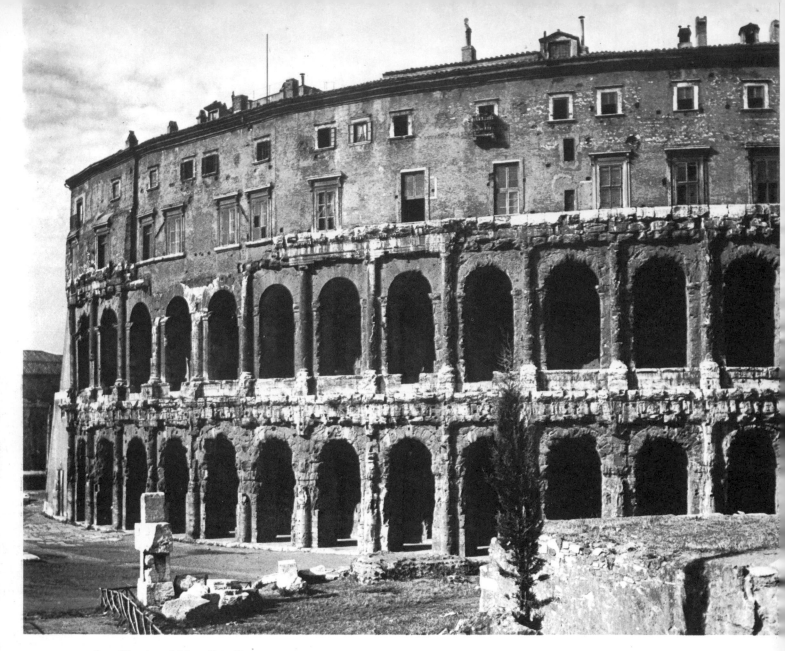

645. Theater of Marcellus, Rome. 23–13 B.C.

are used to perfection (figs. 645, 646): and in the growing use of concrete, which enabled architects to span great spaces. These spaces were needed especially in the immense bath buildings, which played so large a part in Roman life, and in the basilicas where law and business were transacted.

The arch had never found much favor with Classical Greek architects; but it had been known in Etruria as early as the fifth century B.C., and by the second century stone arches were being used by the Romans for bridges and aqueducts. Vaults of small size had long been used by them for domestic buildings, but from the time of Augustus onward an increasing number of barrel vaults and intersecting barrel vaults of large size were built. Just as the true arch and vault succeeded the corbeled arch and vault, which had been known for many hundreds of years, so the true dome, adopted

466

from the East, succeeded the corbeled dome throughout the Roman world. The use of these three features—arch, vault, and dome—which revolutionized architecture, was facilitated by one of the traditional techniques of Roman building, the use of concrete. This had developed from a primitive system of setting rough stones and clay in layers behind a hard facing. The substitution of broken tiles for the stone, and for the clay, of a volcanic earth plentiful in parts of Italy and still freely used today, could produce a concrete wall of great strength. The facing was often of baked brick (which became a Roman specialty), with or without a decorative surface of marble or stucco; but the core was virtually a monolithic mass. This formed an admirable support for vaults and domes, which were themselves usually built of concrete with brick reinforcement and often became monolithic, without lateral thrust. Arches and

646. The Colosseum, Rome. c. 80 A.D.

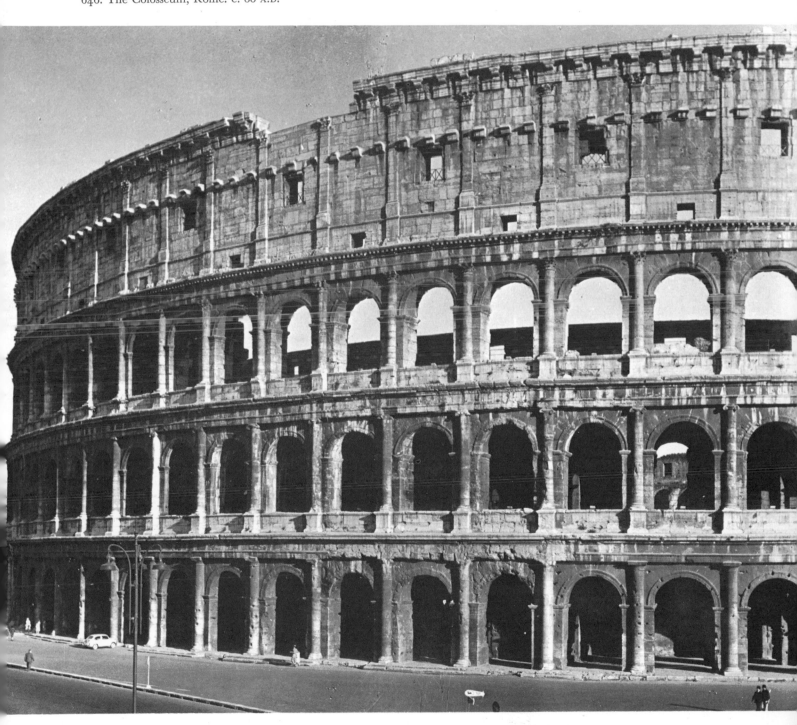

vaults continued to be made in masonry, but in brick and concrete vaster and more daring projects were possible.

The Pantheon, a temple built by Hadrian on the site of an earlier circular piazza, has because of its method of construction in brick and concrete a virtually monolithic dome which exerts no thrust (figs. 647, 648). It is one of the most completely satisfying buildings in the world, both from its form and proportions, and from the majestic simplicity of its lighting by a single circular opening thirty feet across.

647. The Pantheon, Rome. 120–124 A.D.

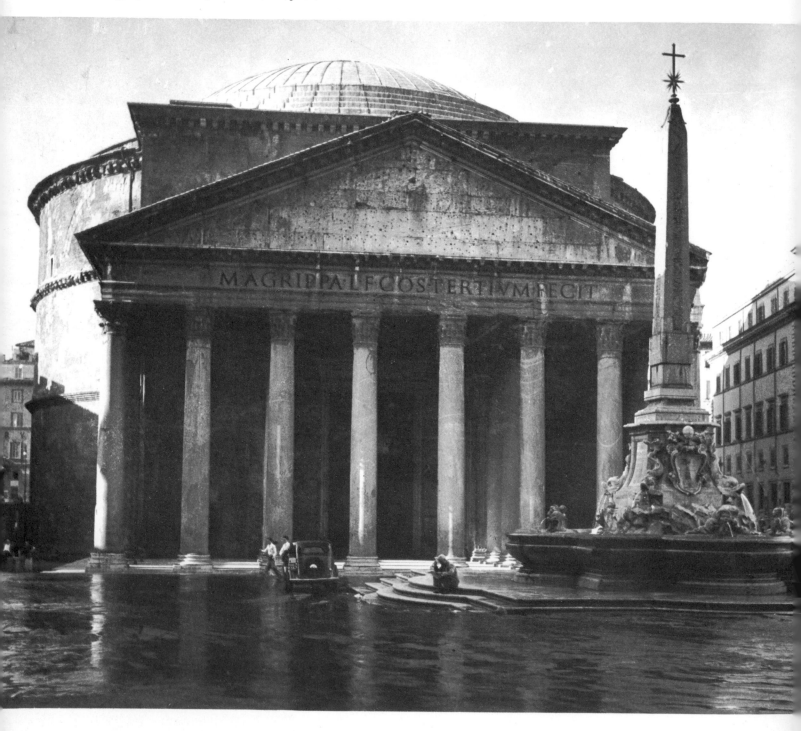

648. The Pantheon, Rome. *View of inter*

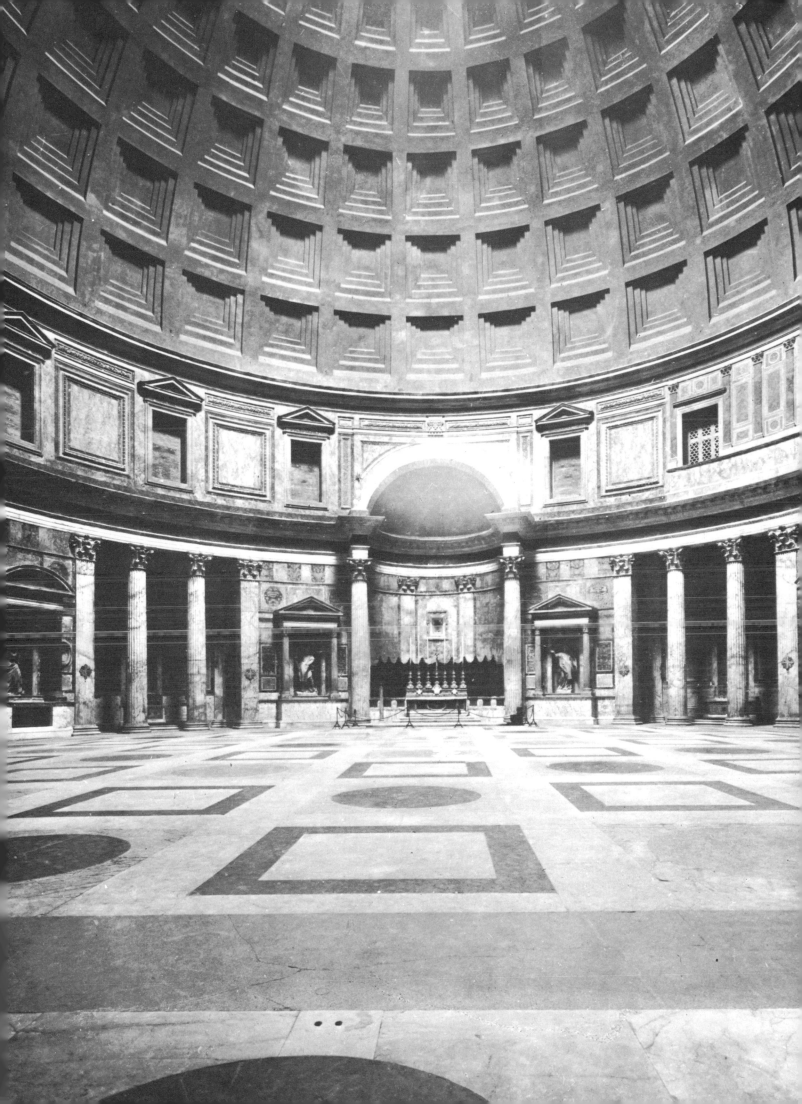

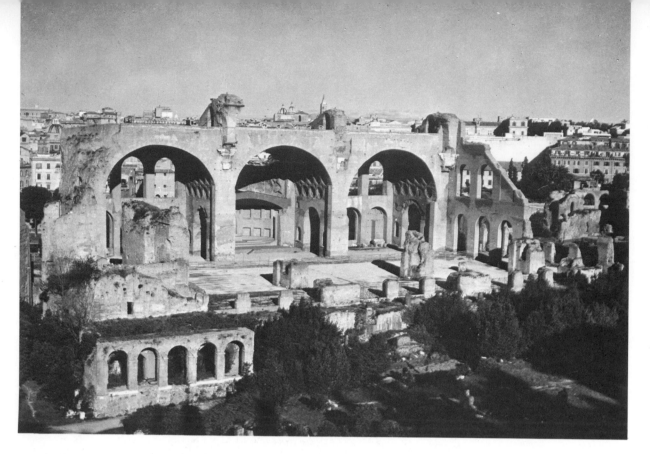

649. Basilica of Maxentius, Rome. 306–313 A.D.

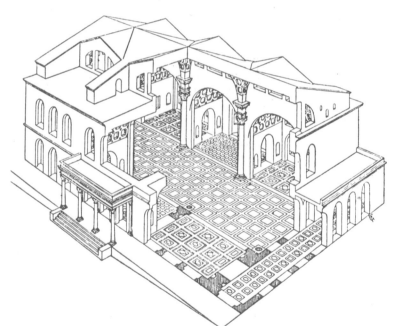

650. Basilica of Maxentius, Rome.
Reconstruction (after Huelsen)

Another building made possible by the use of brick-faced concrete is the basilica of Maxentius (figs. 649, 650). Far less than a third of it now stands, but it is still deeply impressive. It has been said that such structures as aqueducts were regarded by the Romans rather as engineering than as architecture: if that is so the engineer of the Pont du Gard, where aqueduct and road cross the valley of the Gard near Nîmes, created a masterpiece unawares: transparent integrity of design is equaled by beauty of proportions (fig. 651).

right: 652. Villa of Hadrian, Tivoli. 125–135 A.D.
Reconstructed model (by I. Gismondi).
Museo della Civiltà Romana, Rome

470

The elaborate palaces built by Roman emperors, even though mostly destroyed, have exerted a powerful influence on subsequent art since the discovery of their remains from the Renaissance onward: Nero's Golden House, which extended from the Palatine Hill to the Esquiline Hill in Rome, is the outstanding example; but one of the largest, most spectacular and most curious was the villa of Hadrian at Tibur (Tivoli) (fig. 652). It covered an area of at least five square miles, and many of its features were copied from monuments or places which Hadrian had visited on his extensive travels abroad. It was thronged with statues, mainly Greek and Egyptian, some originals, some copies: there was, for instance, a replica of the Caryatid Porch of the Erechtheion at Athens. In this enormous complex the most striking of the features of which we can still form any idea is the Canopus, imitating a place

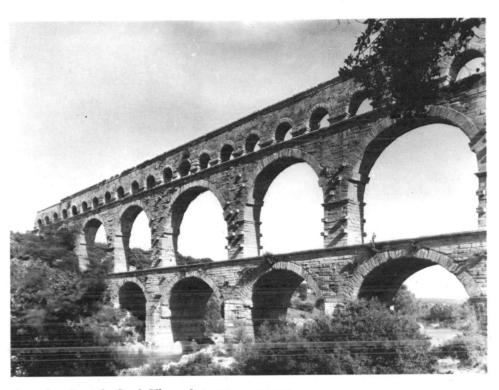

above: 651. Pont du Gard, Nîmes. Late 1st century B.C.

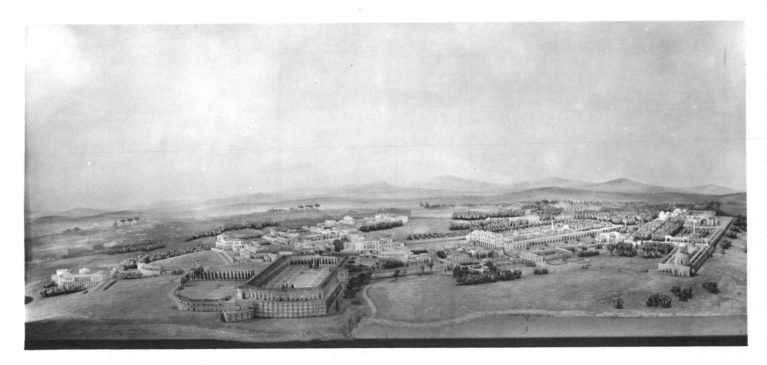

near Alexandria which was part shrine, part pleasure resort, with a canal for boating: Hadrian caused an artificial valley to be dug with a canal in the center, guest rooms along the sides, and a great vaulted niche at the end adorned with statues he had brought from Egypt. Much of the villa still existed in the eighteenth century and drawings were made of it by Piranesi and others.

The largest temple in the world was built at this time at Cyzicus, on the Sea of Marmora, and dedicated to Hadrian as the thirteenth Olympian deity; almost complete in the fifteenth century, all that remains of it today is

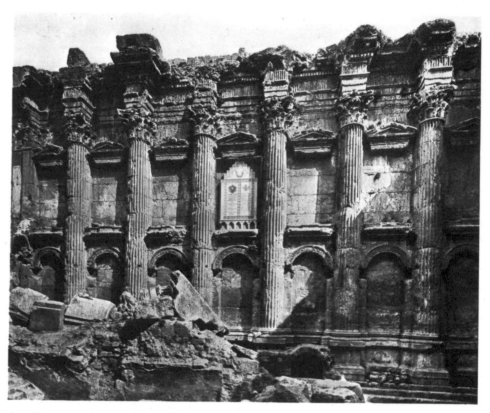

653. Temple of Bacchus, Baalbek (Lebanon). 2nd century A.D. *View of interior*

654. Temple Enclosure, Baalbek (Lebanon). 2nd-3rd century A.D. *Plan and reconstruction drawing*

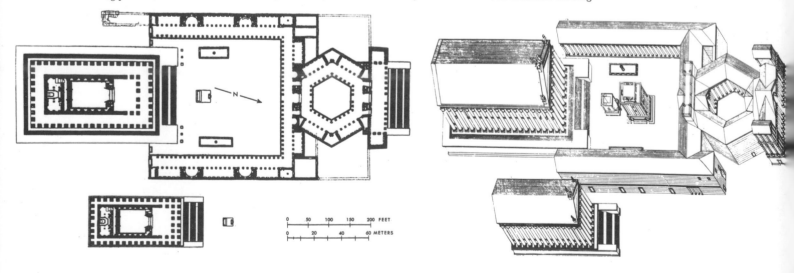

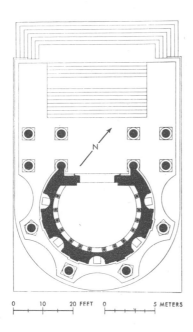

a brushwood-covered mound. In size it out-matched the great temple at Heliopolis (Baal-bek) in Lebanon, whose six remaining columns, from over sixty, are still impressive even to modern eyes (fig. 653). The general layout of Baalbek (fig. 654), begun by Antoninus Pius and completed by Caracalla, is one of the grandest which the ancients have left us, with its immense forecourt and propylaia, its two vast temples of conventional plan, and its unusual little circular temple (figs. 655, 656).

The great monument at the end of our

655. Temple of Venus, Baalbek (Lebanon). 3rd century A.D. *Plan*

656. Temple of Venus, Baalbek (Lebanon). *View from the east*

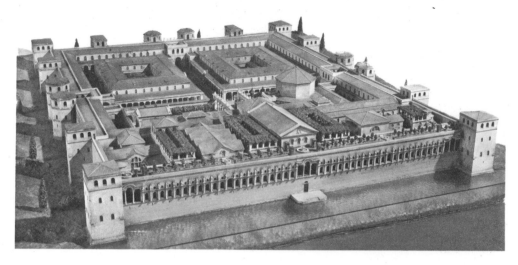

657. Palace of Diocletian, Spalato (Yugoslavia). c. 300 A.D.
Reconstructed model (by E. Hebrard). Museo della Civiltà Romana, Rome

period is the palace of Diocletian at Salona, near Spalato (Split), built just after 300 A.D. (fig. 657). It was a fortress as well as a palace, since it was completely enclosed by walls and towers except along the sea, which bounded one side: today the modern town shelters within it. Great size is the distinguishing feature of most Imperial Roman architecture, and in their treatment of space Roman architects have never been outclassed.

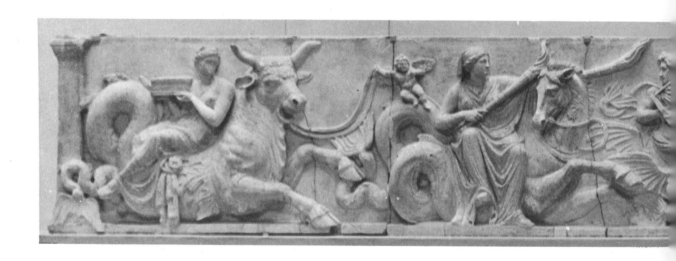

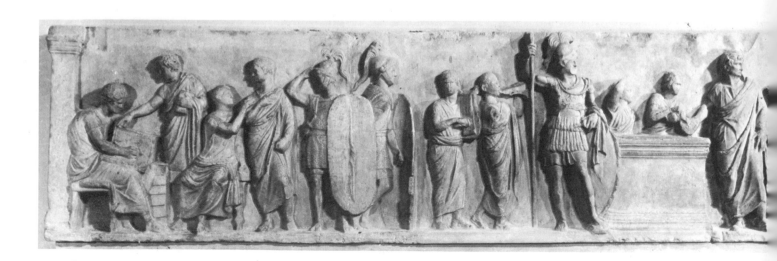

SCULPTURE

An important fixed point in the art of the Late Republic in Rome is afforded by Roman reliefs that are believed to be part of the base made to support a group of sea creatures by the Greek sculptor Skopas; the sculptured group was brought to Rome about 32 B.C. by Domitius Ahenobarbus. Several of the slabs represent a rout of marine deities, Nereids, and sea dragons in an exuberant design of Hellenistic character (fig. 658), but others have a scene of sacrifice which, though it includes figures in heroic postures, represents an actual incident (fig. 659). This insistence on the factual is to become a mark of Roman art: Greek art was so strongly biased in the other direction that even when a monument was set up to commemorate an actual event it is often extremely difficult to conjecture what that event was.

658. *Neptune, Amphitrite, and Marine Creatures,* frieze (portion) from the Altar of Domitius Ahenobarbus, Rome. c. 30 B.C. Marble, height 30 3/4". Staatliche Antikensammlungen, Munich

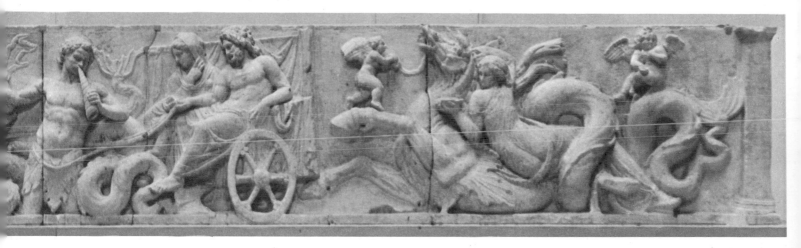

659. *Sacrificial Scene,* frieze from the Altar of Domitius Ahenobarbus, Rome. c. 30 B.C. Marble, height 31 7/8". The Louvre, Paris

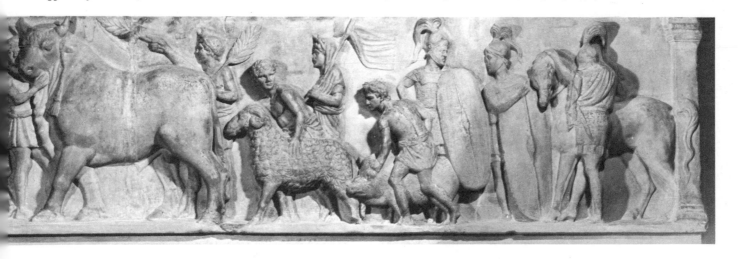

660. *Augustus*. C. 20 B.C.
Marble, height 81 1/2". Terme Museum, Rome

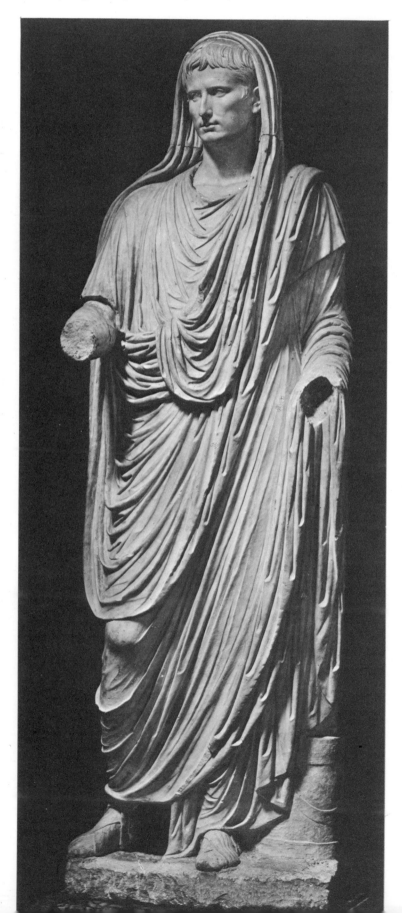

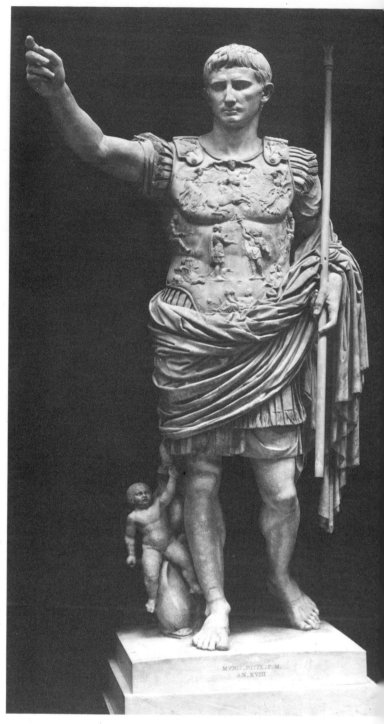

661. *Augustus*, from the Villa of Livia, Prima Porta. C. 20 B.C.
Marble, height 70". Vatican Museums, Rome

Under the first emperor, Augustus, Greek art devoted to the service of Rome generally used not Hellenistic baroque, but a restrained, correct academic style which has been aptly compared to the Empire style of France under Napoleon: classical idioms, art forms, and allegory became an everyday language that could be turned to any purpose needed. We have several statues of Augustus himself in his various capacities—as general, as head of the state religion—and the treatment of these roles is symptomatic of the Roman attitude to art. In the statue showing him in his civil and religious capacity he wears the full toga (fig. 660); this is carved in a commonplace way;

662. *Gaius Caesar*(?) *as Cupid*
(detail of statue in fig. 661)

the head is of far better workmanship and strongly idealizing, very different from Republican family portraits. This head must be by a Greek sculptor, and he must have received fairly precise instructions as to how ideal the Emperor should look. There are variations among the portraits of Augustus, both in sculpture and on the coins, and some look more Greek than others; but after his assumption of supreme power there is not a single one which is not strongly idealizing: only one or two very early coin-portraits give a different impression, of how the man actually looked.

The statue from the villa of his wife Livia at Prima Porta shows Augustus as commander in chief, and may have been a replica from a statue of bronze, or even of some more precious metal, set up in some public position (fig. 661). The Prima Porta statue, like its hypothetical original, is obviously of Greek workmanship. The pose is like that of the Doryphoros of Polykleitos (see p. 318), and one can well imagine that the sculptor, when not commissioned for Roman portraits, was engaged in making copies of Greek statues. Although the pose owes much to Greek art, the action depicted is Roman: the Emperor is shown addressing his troops. And the factual always obtrudes: on the breastplate, among ideal figures including Apollo and Artemis, patron gods of the Augustan house, is a Parthian handing back one of the Roman standards captured in the disaster of Carrhae in 53 B.C. Two other features where ideal and real mingle may be noted: the Emperor, though shown as a general, has bare feet; and the cupid, who rides on a dolphin and acts as the support necessary in a marble figure, is appropriate because Venus was the reputed ancestress of the family—but the cupid looks like a real child and is perhaps Gaius Caesar, the nephew of Augustus (fig. 662).

The remains of a monumental altar found near the Corso Umberto in Rome have long been identified as belonging to the Ara Pacis, the Altar of Peace commissioned by the Senate after the return of Augustus from Spain and Gaul in 13 B.C. and dedicated four years later (fig. 663).[10] The layout consisted of an altar surrounded by a sculptured screen-wall nearly eighteen feet high that formed a small courtyard, roughly square and between thirty and forty feet across. There were two doors, on the east and west sides, so that these sides offered four comparatively short spaces for sculpture, while the uninterrupted north and south sides offered two much longer spaces. The four panels of the east and west were occupied by four legendary or symbolic scenes; the north and south sides by a procession of human beings, not perhaps exactly as it had taken place, but including all those who should have been in the original procession. The choice of the scenes on east and west is interesting. On the east is Mother Earth (fig. 664), with two children, flanked by personifications of Air and Water; the design and the technique are Greek, but the conception of the goddess is more romantic than that of the Greek earth goddess. On the other side of the east doorway there was probably a relief of the goddess Roma. On the west side was Aeneas sacrificing on his first arrival in Italy from Troy (fig. 665), and this was probably balanced on the other side of

663. Ara Pacis, Rome. 13–9 B.C.

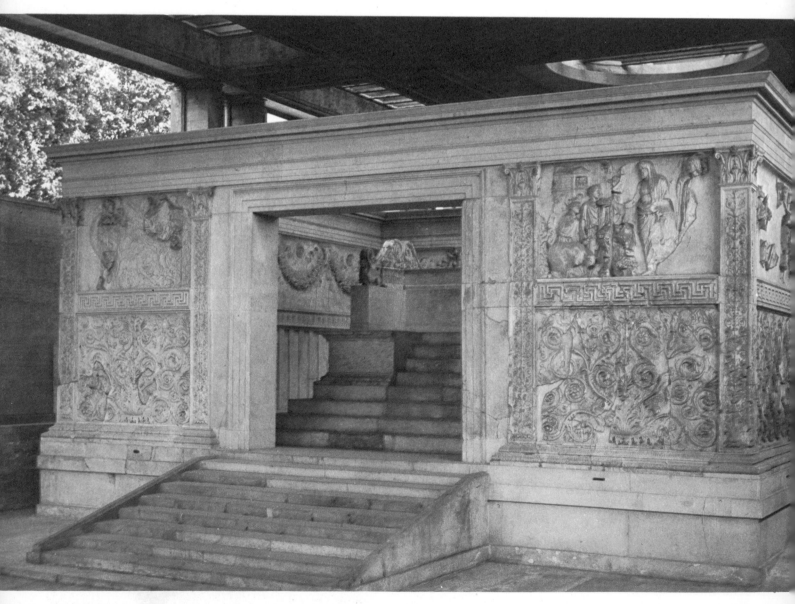

664. *Mother Earth with Air and Water*, relief on the east exterior wall of the Ara Pacis. Marble, height 62″

665. *Aeneas Sacrificing to the Gods*, relief on the west exterior wall of the Ara Pacis

666. *Ceremonial Procession,*
relief on the exterior of
the Ara Pacis

the doorway by a relief of the finding by Faustulus of the wolf suckling the twins Romulus and Remus. The procession on the north and south sides shows a ceremony conducted by Augustus in the presence of his family, most of whom can be recognized (fig. 666): that ceremony may well have been the decreeing of the altar in 13 B.C. The real and the legendary were linked by the two reliefs of the sacrifice of Augustus converging toward the sacrifice of Aeneas at the southwest corner.

It has been suggested that this marble structure reproduces a temporary wooden structure erected when the original sacrifice was made; but it is more likely that the prototypes were Greek. There is, for instance, the much larger altar at Pergamon, and, a closer analogy, the Altar of the Twelve Gods, also known as the Altar of Pity, in the Agora at Athens. In addition to the figure-scenes there was splendid decorative sculpture: on the outside of the enclosure a broad frieze of elaborate acanthus tendrils with other flowers intertwined (fig. 667), and at intervals the swan, the bird of Apollo, whose cult was dear to Augustus; on the inside, a frieze of garlands hanging from ox skulls (fig. 668). The art of the early Empire is conspicuous for the beauty of

667. *Floral Ornament*, relief on the exterior of the Ara Pacis. Height 76 3/4"

668. *Garland*, relief decoration on the interior of the Ara Pacis

669. Altar with Bucranium and Plane-Tree Branches. Late 1st century B.C. Terme Museum, Rome

its floral ornament: in addition to the Ara Pacis we have the "plane-tree altar" in the Terme Museum (fig. 669). The tradition persists in the "rose pillar" from the tomb of the Haterii, which is of Flavian date (fig. 670).

The triumphal arch of stone (fig. 671), a Roman specialty, preserved in permanent form the temporary arches erected for the returning victor as he entered the city. The scenes on the internal faces of the arch of Titus record in permanent form the actual triumphal procession, with the addition of certain ideal figures (fig. 672): the victorious Emperor rides in his

670. "*Rose Pillar*," from the Tomb of the Haterii, Rome. c. 120 A.D. Marble, height 57 3/8". Lateran Museum, Rome

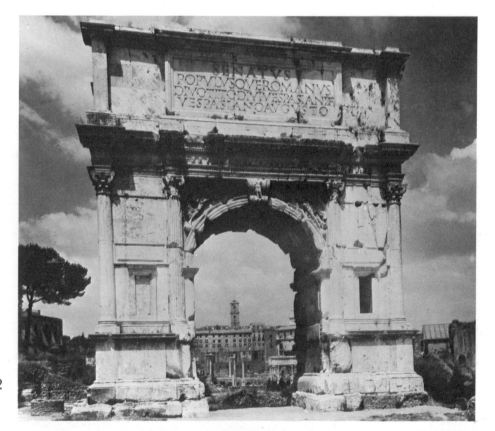

671. Arch of Titus, Forum Romanum, Rome. 81 A.D.

chariot, but his horses are led by the goddess Roma herself; about the chariot is a group of actual persons in Roman dress, but among them is a figure of the Genius of the Roman People in Greek dress, such as would not have been worn in the streets of Rome. On the other side—a record of unique historical and artistic importance—are the spoils brought from the temple at Jerusalem (fig. 673), prominent among them the table of the shewbread and the seven-branched candlestick. Since the arch was a passageway the spectator normally saw the reliefs at an angle as he approached them; and the designer, perhaps partly because of this, has given the scenes an oblique direction. This is in contrast to the frieze of the Parthenon, five hundred years before, or even to the Ara Pacis, fifty years before, where the processions

672. *The Triumph of Titus*, relief on the Arch of Titus, Rome. Marble, height 79"

673. *The Spoils from Jerusalem*, relief on the Arch of Titus, Rome

674. *Domitian Greeted by Vespasian*,
"Cancelleria reliefs" (portion).
Late 1st century A.D.
Marble, height 82 5/8".
Vatican Museums, Rome

675. *Domitian Leaving for War*, "Cancelleria reliefs" (portion)

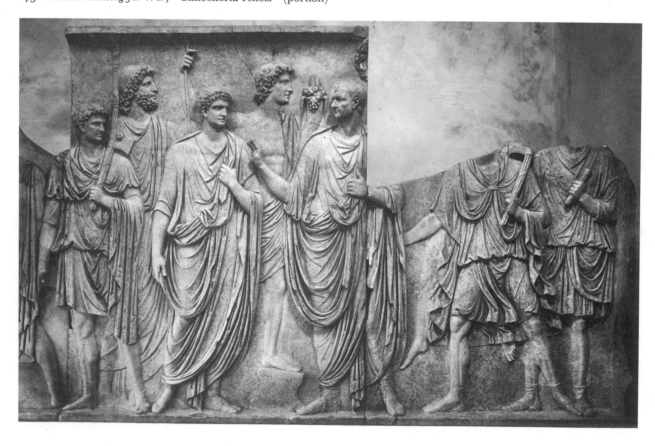

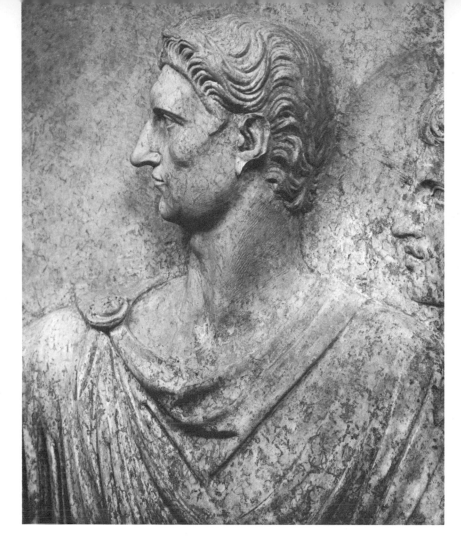

676. *Head of Nerva*
(detail of recut head of
Domitian in fig. 674)

move in profile, though some of the figures
turn to the front. The oblique direction gives
the feeling that air is circulating around the
processions, that they are in space rather than
set against a background.

Far less advanced in this respect, though not
distant in date, are the two friezes, of great
historical interest, discovered in Rome between
1937 and 1939.[11] They belong probably to the
triumphal arch erected by Domitian in the
Campus Martius which is mentioned by the
poet Martial, but they had been taken down
in antiquity and stored away, perhaps in a
stonemason's yard. On one frieze Domitian is
being greeted by Vespasian with friendly ap-
proval (fig. 674); on the other Domitian is
setting out to war (fig. 675). It is a strange

scene: he is being led by Minerva and Mars,
and he is urged and supported, with a hand
under his elbow, by the goddess Roma. It has
been suggested that this is not simply a depar-
ture for some particular campaign, but is
intended to show in a general way what had
been doubted by contemporary critics, Domi-
tian's unwillingness to engage in unnecessary
warfare; that he would fight only when urged
on by the gods and supported by the Roman
state. After his death Domitian's memory was
officially obliterated, and a most interesting
feature of this frieze is that the face here has
been recut to make it into a portrait of his
successor, the emperor Nerva (fig. 676). Other-
wise the work is naïve in its symbolism, and
frigid in its classicizing style and composition.

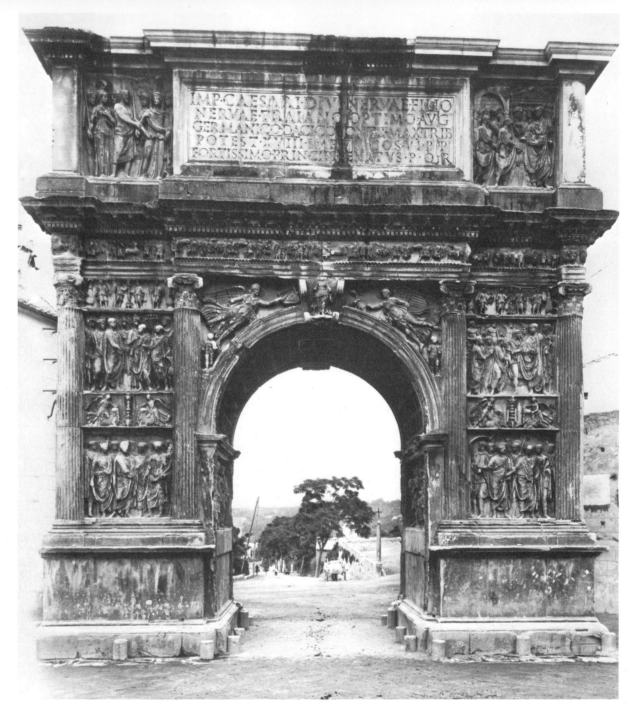

677. Arch of Trajan, Beneventum. Begun 114 A.D.

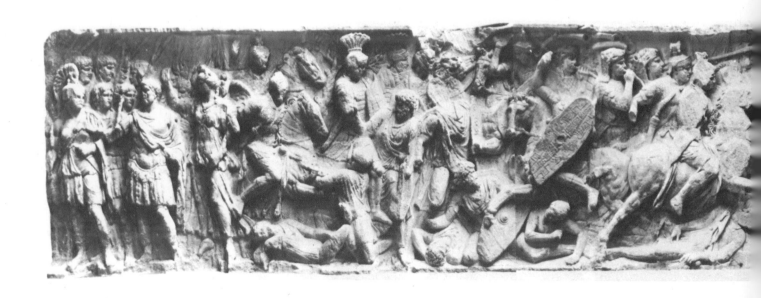

The reign of Trajan has left rich remains of architectural sculpture. His arch at Beneventum (fig. 677), finished by Hadrian, bears many interesting historical and symbolic scenes, and shows how skillfully the awkward juxtaposition of human figures, gods, and symbolical personages could be managed by designers and craftsmen who were working in a good Hellenistic tradition (fig. 678). Even finer, though more damaged, are the four panels, fragments of a longer frieze, that were removed in antiquity from an earlier building, perhaps the temple of Trajan and Plotina, and re-used in the arch of Constantine (fig. 679).[12] The scenes have a generalized character: for instance the battle scenes do not seem to represent historical battles, but are an idealistic compression of Trajan's campaigns and a glorification of his leadership, possibly with a reference to his deification. These are masterly: row upon row of figures, in crowded scenes, are represented with the ease of a painting and without the slightest confusion or artificiality. They must be the work of a Hellenistic artist who has been inspired by a splendid Roman subject: perhaps it was Apollodorus of Damascus, who carried out many of Trajan's building schemes, notably his Forum.

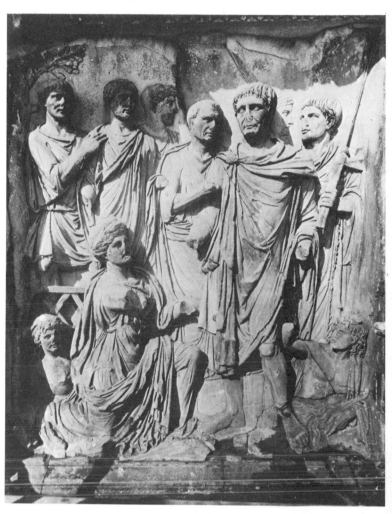

678. *Mesopotamia and Her Rivers Before Trajan,* relief on the Arch of Trajan, Beneventum

679. Cast of Trajanic Frieze Reused on the Arch of Constantine, Rome. Early 2nd century A.D.

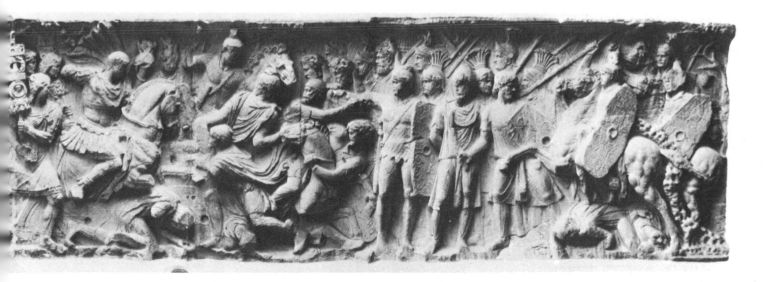

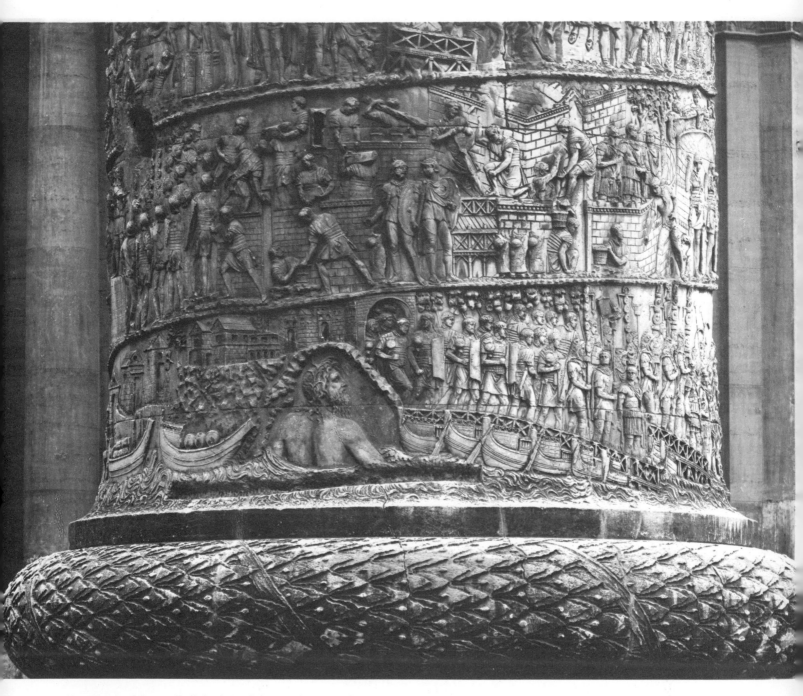

680. Base and Lower Reliefs of the Column of Trajan, Rome. 113–117 A.D.

The Forum of Trajan contained one of the most famous of all Roman monuments, Trajan's Column (fig. 680).[13] A tall column with a spiral of relief sculptures arranged in such a way that most of them could hardly be seen, it is even more wasteful of talent than the frieze of the Parthenon (see pp. 322f.); but it served as a victorious dedication, a permanent record of historical events, and a tomb. The origin of the spirally decorated column is thought to have been the scroll of a papyrus book, and the two most complete examples we have, those of Trajan and of Marcus Aurelius, tell in book-like sequence the story of their campaigns.[14] The column of Trajan, about a hundred feet high and nearly twelve feet in diameter, was built in 113 A.D. of Parian marble: it was carved after being built, and was brilliantly colored. It shows the principal events in Trajan's campaigns against the Dacians, between 101 and 106. A.D. The reliefs are in the form of a band on which the composition is continuous: one scene passes into another without interruption, and the changes of place and time are indicated by the recurrence at intervals of the same prominent personages, especially the Emperor himself. Apart from their historical interest, the reliefs on the column furnish the most detailed information on the dress, armor, weapons, equipment, organization, and methods of a Roman army in the field (figs. 681, 682).

When we consider Hadrian's artistic enthusiasm we may wonder that the sculptural remains from his reign are not more noteworthy. The reason may be that his classicizing taste inhibited the natural development of a Hellenistic art which was taking place under Trajan, and caused a reaction to an old-fashioned and less viable style. There is no lack of sculpture: carved sarcophagi and copies of Greek statues were produced in great numbers, and Hadrian's Villa at Tibur has furnished many of the sculpture galleries of Europe. But there is a deterioration of quality; and this decline, coupled with a general lessening of artistic activity, marks the subsequent reign of Antoninus Pius. The decline continued under Marcus Aurelius; the base of the column erected by him and his adoptive brother, Lucius Verus, as a memorial to Antoninus Pius after his death in 161 A.D. shows how nearly ridiculous Classical symbolism can become. The column was erected in the Campus Martius,

681, 682. Reliefs on the Column of Trajan, Rome

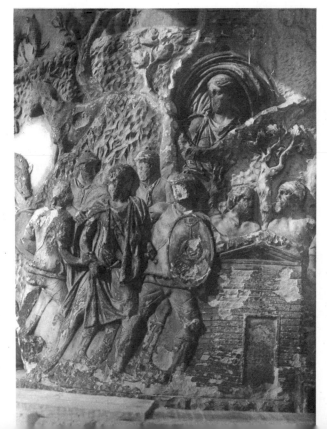

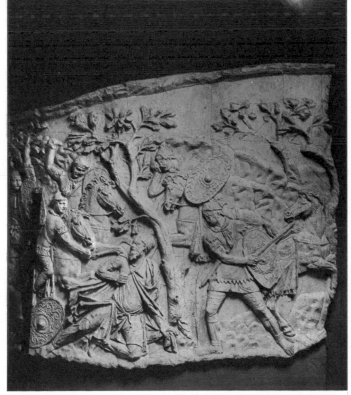

where the cremation of Antoninus Pius had taken place, and one side of the base shows the deification and heavenward ascent of Antoninus and his wife Faustina (fig. 683). The Campus Martius is personified by a figure holding the obelisk which Augustus had set there to serve as a sundial; and the two imperial personages, saluted by the goddess Roma and accompanied by two eagles, are being conveyed upward by a gigantic winged figure, Aion (Eternity), a character borrowed from the religion of Mithras, who holds in his hand a globe encircled by a serpent. These personifications and symbols have not been welded into a whole but assembled piecemeal like so many theatrical properties; the artist did not even trouble to suggest any organic connection between Aion's wings and his body, and introduced a piece of drapery which would make such a connection

difficult or even impossible. The other side of the base, where there is no symbolism, is even less successful (fig. 684). The designer chose, or was given, the almost impossible subject of the "decursio," maneuvers of mounted knights which took place at the deification of the Emperor, and he has depicted it in childish fashion. It is only fair to add that both reliefs have been much restored and reworked, but without altering their essential character. One wonders what a great Trajanic sculptor would have made of these subjects.

The column of Marcus Aurelius himself is an imitation of that of Trajan; it is of the same size, and also illustrates a series of military campaigns. The workmanship is coarse, but subject and composition are often interesting.[15] The personification of Jupiter Pluvius, the Rain, as a vast winged being with outstretched

683. *Deification of Antoninus Pius and Faustina,*
relief on the base of the Antoninus Pius memorial column. 161 A.D.
Marble, height of base 97 1/4″ (column not preserved).
Cortile della Pigna, Vatican Museums, Rome

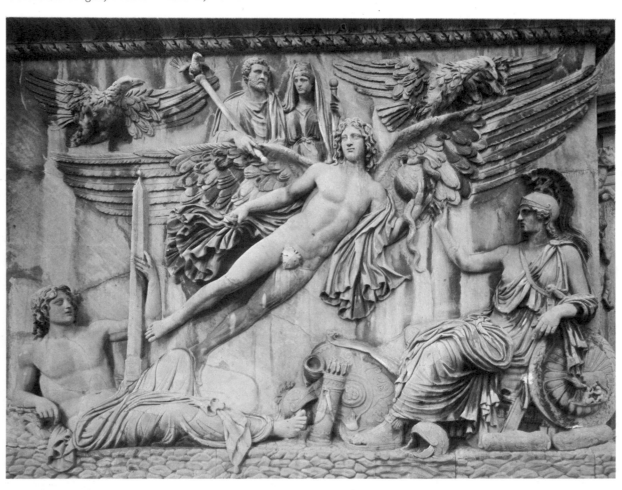

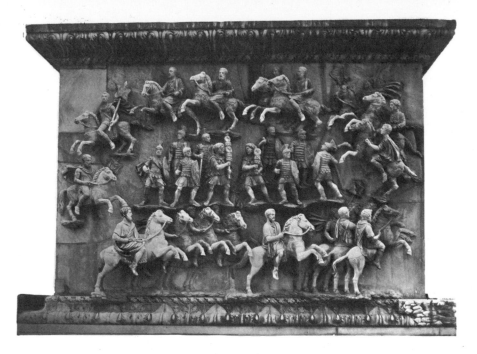

684. *"Decursio,"* relief on the base of the Antoninus Pius memorial column (other side of base in fig. 683)

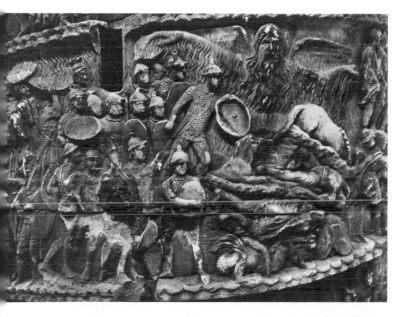

arms from which the water pours, illustrates the convenience of these personifications for a sculptor, who unlike the painter has not the means of depicting the natural phenomena (fig. 685). The ways in which landscape and buildings are represented are often ingenious, and sometimes strikingly like medieval solutions to similar problems (fig. 686).

Under Septimius Severus there was a considerable artistic revival, with new impulses from the Eastern provinces, but on the whole the greatest achievements of the next century are in the field of architecture rather than of sculpture.

In so wide an Empire as that of Rome there were naturally a number of native artists whose work, whether the subject was Roman or not, had a native flavor more or less pronounced—usually less, in the provinces where Classical culture had been longest established. This is a vast field of study, but two or three examples from Gaul and Britain may be cited in order to show how native sculptors borrowed Roman types, and also how they transformed them.

above left: 685. *Miraculous Downpour,* relief on the Column of Marcus Aurelius, Piazza Colonna, Rome. Completed after 180 A.D. Marble, height of frieze 52 1/2"

491

left: 686. *Marcus Aurelius Receiving a Courier,* relief on the Column of Marcus Aurelius, Rome

687. *Cernunnus with Mercury and Apollo.*
1st century A.D. Limestone, height 49 1/4".
Musée Lapidaire, Reims

In Reims is a votive relief of the Celtic god Cernunnus (fig. 687): he is horned like a stag, and seated with produce pouring from a sack on his lap: on one side, on a smaller scale, is Apollo, on the other, Mercury. The design is pure Classical, with a Greek rather than a Roman flavor: the subject is completely native except for the subordinate figures. In the west of Britain from the health resort of Aquae Sulis (Bath) comes a circular relief of a bearded head with waving locks (fig. 688). This, probably the patron sun god himself, used to be called a gorgon; and whether gorgon or not, it is the lineal descendant of the gorgon in the pediment at Corfu (see p. 251). From Cor-

688. *Sun God.* 2nd–3rd century A.D.
Stone, diameter 78". Museum, Bath

stopitum (Corbridge), on Hadrian's Wall, comes a group of a lion with its prey (fig. 689); this subject never failed to please the simple mind, and the same subject appears on an Athenian vase nearly a thousand years before, but it has a far longer ancestry than that (see p. 170).

The Romans are justly praised for their portraiture, and the basis for their distinction in the art must have been the practice of the making of wax masks (see p. 443). Some of these wax masks were evidently copied in marble, for in no other way can the extreme realism of certain marble heads, even down to surface wrinkling of the flesh, be explained (see fig. 621). The original masks must have been of the head only, but in the marble portraits it gradually became customary to add more of the neck and shoulders, and this development of what we now call the portrait bust, which was a Roman invention, was a steady one: its stages can be dated, until by the late second century A.D. the body was included almost down to the waist. Roman portraiture, as was natural in view of its origins and of the impact of various foreign styles and artists upon it, fluctuates between the real and the ideal, the Roman and the Greek—and even the

689. *Lion and Prey.* 2nd–3rd century A.D. Sandstone, height 34″. The Corstopitum, Corbridge

Asiatic; between the classicizing Greek and the more living Hellenistic tradition.

Portraits of emperors form a useful index to these changes, but private portraits do not always conform. After the stark Republican portraits we have the classicism of Augustus (see figs. 660, 661) and then the elegance of Nero, who, in effigy as in fact, becomes grosser as he ages (fig. 690). Vespasian (fig. 691), the

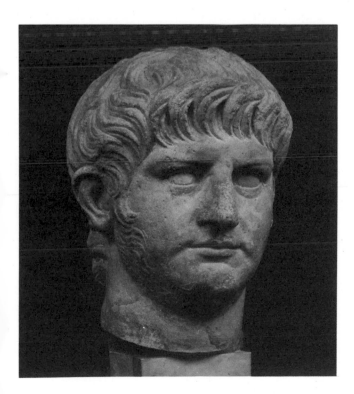

690. *Nero.* Mid-1st century A.D. Marble. Terme Museum, Rome

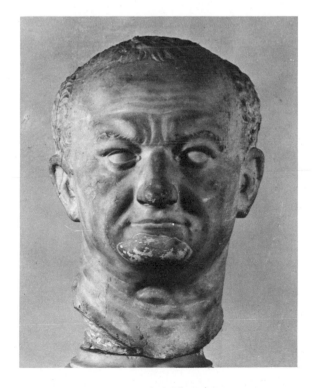

691. *Vespasian.* c. 75 A.D. Marble, height 16″. Terme Museum, Rome

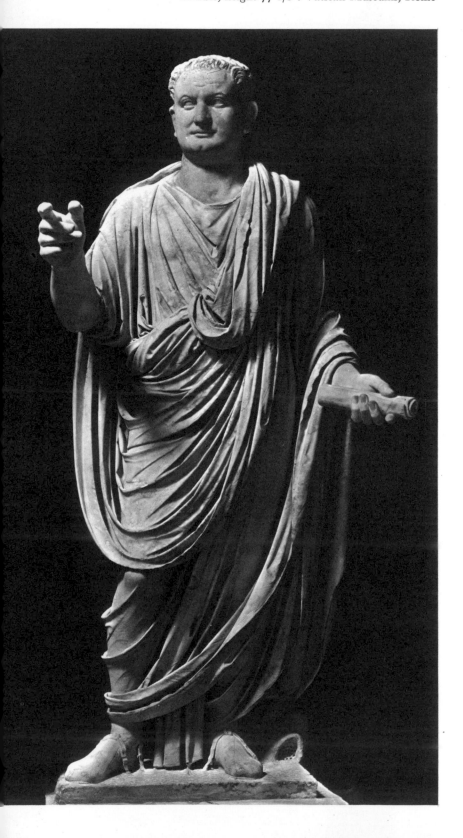

692. *Titus.* c. 80 A.D.
Marble, height 77 1/8″. Vatican Museums, Rome

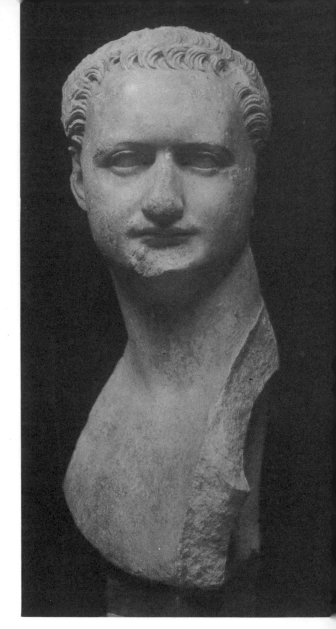

693. *Domitian.* c. 85 A.D.
Marble, height 21 1/4″. Capitoline Museum, Rome

hard-bitten soldier, portrayed with such integrity that you seem to see both the character and the career, is succeeded by the benign Titus (fig. 692) and the well-groomed Domitian (fig. 693). Then comes a return to the sober Roman strain, especially under Trajan (fig. 694). The most marked change takes place late in the reign of Hadrian (fig. 695), and its most obvious symptoms are in the impressionistic rendering of eyes and hair: the eyeballs are carved, usually with a small, kidney-shaped depression to simulate the reflection of light, and the hair begins to be broken up by

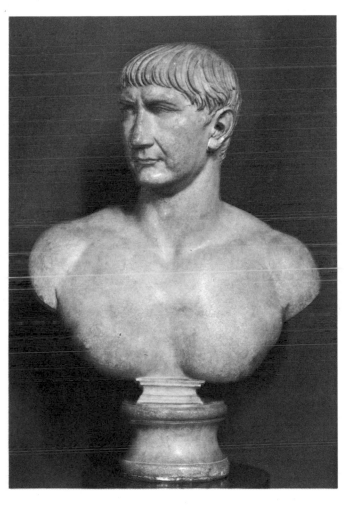

694. *Trajan*. Early 2nd century A.D.
Marble, height of bust 29 1/4". British Museum, London

695. *Hadrian*. 117–138 A.D.
Marble, height 79". British Museum, London

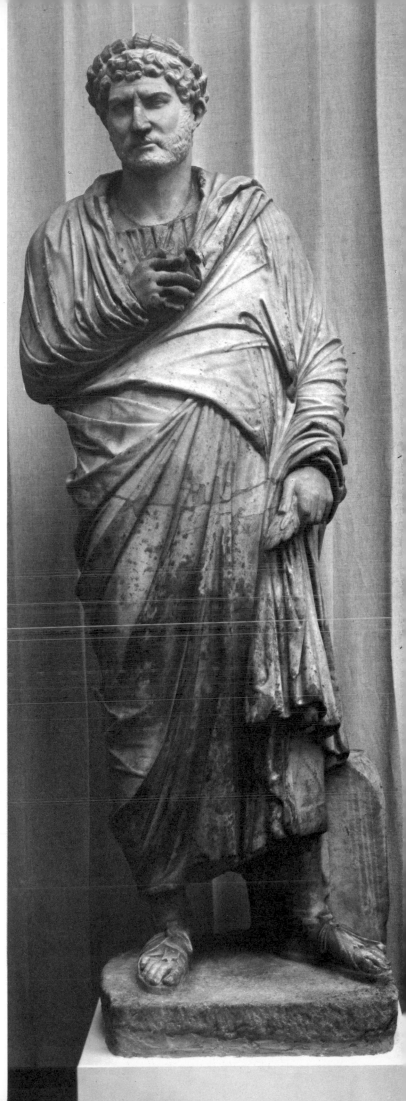

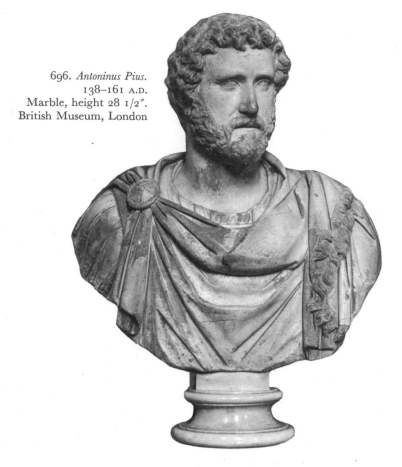

696. *Antoninus Pius.*
138–161 A.D.
Marble, height 28 1/2″.
British Museum, London

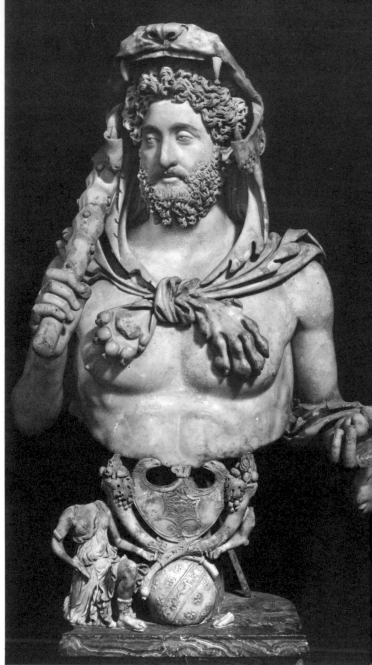

697. *Commodus as Hercules.* 180–183 A.D.
Marble, height 42 1/2″. Palazzo dei Conservatori, Rome

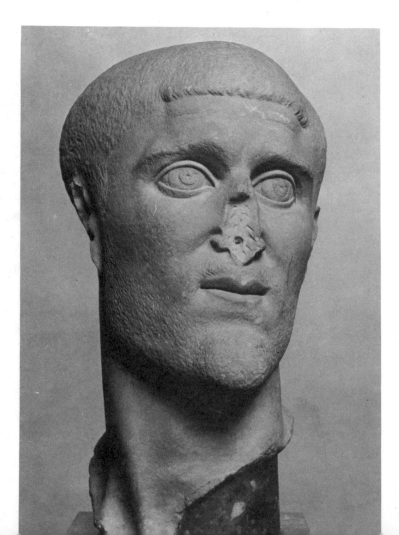

698. *Maximinus the Thracian.* 235–238 A.D.
Marble, height 15″. State Museums, Berlin

drilling. These impressionistic tendencies continue under Antoninus Pius (fig. 696), and reach their climax in the time of Commodus (fig. 697): a coloristic effect is achieved by polishing the surface of the flesh until it is like porcelain, and by honeycombing the hair with extensive drilling, so that the play of light and shadow gives not only the form but even the texture and color contrast of flesh and hair. Real color was added also, and the effect must have been that of a superior waxwork.

This phase continues until about the time of Pupienus (238 A.D.) when there is a sharp reaction, and a number of portraits imposingly plain and massive appeared, like those of Maximinus the Thracian (fig. 698) and Philip the Arabian (fig. 699). Some of the noblest portraits of this time are not of marble, but of gold leaf sealed between layers of glass (fig. 700). In the late third century there is a further change, one of content rather than of technique, with some wistful looking back to the Early Empire. In the portraits of this time we seem to discern the birth of a more compassionate ethic than the pagan, as if the world were ripe for Christianity.

700. *The Family of Vunnerius Keramus.*
c. 250 A.D.; set into a cross, 7th century A.D.
Gold and glass, diameter 2 3/8″. Museo Civico Cristiano, Brescia

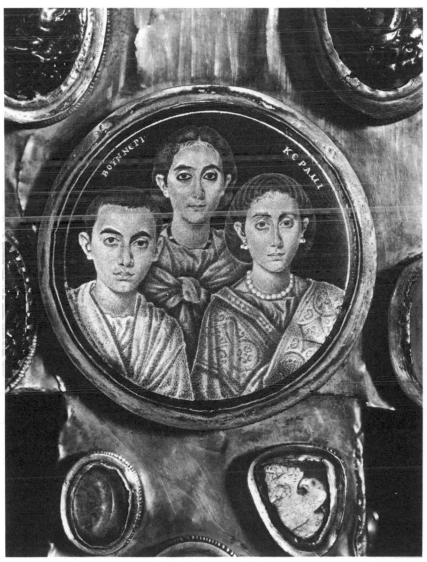

699. *Philip the Arabian.* 244–249 A.D.
Marble, lifesize. Vatican Museums, Rome

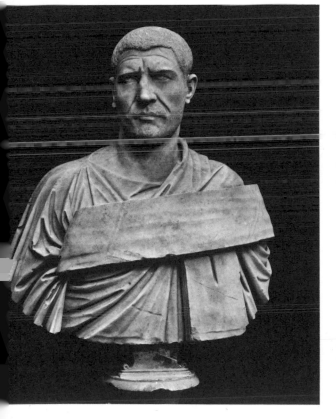

Preface and Chapter 1. EGYPT

1. Edgar Wind, *Pagan Mysteries in the Renaissance*, London, 1958, p. 191.

2. That these theories may nevertheless be well worth considering is shown by Walther Wolf, *Die Kunst Ägyptens*, Stuttgart, 1957, *passim*.

3. On some of the problems raised by this momentous change and on the striking differences between Egypt and Mesopotamia at a comparable stage of development, see Henri Frankfort, *The Birth of Civilization in the Near East*, Bloomington, Ind., 1951.

4. The archaeological evidence of Mesopotamian influence in Egypt toward the end of the fourth millennium is now generally accepted. Only a few chauvinists in the ranks of Egyptologists prefer to doubt its validity.

5. The space-time implications of commemorative art have been dealt with by H. A. Groenewegen-Frankfort, *Arrest and Movement: An Essay on Space and Time in the Representational Art of the Ancient Near East*, London, 1951, pp. 21 ff.

6. Some scholars have suggested that the solid tumulus type of tomb was a southern concept, and that in the Delta the notion prevailed of the tomb as a dwelling for the dead in which the vivifying gifts of the living could be stored. This as yet unsubstantiated hypothesis might help to explain the hybrid character of the flat-topped Old Kingdom tombs, the so-called mastabas (Arabic for bench), which gradually became honeycombed with chapels and storerooms and in one case even contained a lavatory!

On the development of Old Kingdom tombs see George A. Reisner, *A History of the Giza Necropolis*, Oxford, 1942. On the Saqqara tombs see Walter B. Emery, *Great Tombs of the First Dynasty*, London, 1954.

7. Arabic for cellar, a term generally used for a closed statue-room.

8. E. Wind, *op. cit.* (note 1 above), p. 190.

9. See H. Frankfort, *Kingship and the Gods*, Chicago, 1948.

10. The Memphite theology has been discussed in H. Frankfort, *ibid.*, pp. 71, 76, 129, and in John A. Wilson, *The Burden of Egypt*, Chicago, 1951, pp. 56, 58–60.

11. A comprehensive survey of Zoser's monument is given in I. E. S. Edwards, *The*

Pyramids of Egypt, London, 1947, pp. 45 ff. For a full publication see Étienne Drioton and Jean-Philippe Lauer, *Les Monuments de Zoser*, Cairo, 1939; and J.-P. Lauer, *Histoire monumentale des pyramides d'Égypte, vol. I: Les pyramides a degrés (3e dynastie)*, Institut français d'archéologie orientale, Bibliothèque d'études, vol. 39, Cairo, 1962.

12. The same arrangement of subterranean tiled rooms occurs in the so-called Southern Tomb, a grave and sanctuary built up against the southern enclosure wall. This was presumably intended for the king's *ka*, that is, for his personified life force, or, according to others, for the separately buried viscera that were removed from the body before it was wrapped in linen and covered with resin in order to preserve it.

13. The nagging fear that life in the hereafter might continue to depend on food haunted the Egyptians for many centuries.

14. The so-called "bent" pyramid, attributed to Huni, Zoser's successor, appears a failed project, for after a true pyramidal start it was finished off with a flattened angle of elevation. (For a full publication of this monument see M. Zakaria Goneim, *Horus Sekhem-khet. The Unfinished Step Pyramid at Saqqara*, I, Service des antiquités de l'Égypte, Excavations at Saqqara, Cairo, 1967.) Huni's son Snefru reverted to a stepped pyramid at Medum, which he later attempted to make smooth-sided by casing it in. However, this project was abandoned and he later built a true pyramid at Dahshur, the elevation of which was precisely that of the top of Huni's.

15. For facts, plans, and literature on the subject see I. E. S. Edwards, *op. cit.* (note 11 above).

16. Since the different aspects of the king's supernatural power were at a later date expressed in the five names and titles he officially held, the niches may each have contained a royal statue inscribed with one of these.

17. Uvo Hoelscher, *Das Grabdenkmal des Koenigs Chephren*, Leipzig, 1912.

18. H. A. Groenewegen-Frankfort, *op. cit.* (note 5 above), p. 38.

19. That the desire for identity to last beyond the grave was exceptionally strong in Egypt is proved by the fact that in the tombs of courtiers, belonging to the earliest dynasties, small steles bearing their names have been found at Abydos. This practice is unknown elsewhere in the ancient Near East.

20. See W. Wolf, *op. cit.* (note 2 above), p. 38.

21. It must be admitted that opinions may vary on the question when and in what way decline set in, nor can it be denied that the Sixth Dynasty produced quite remarkable monuments, both in plastic and in relief. I must, however, through lack of space refer the reader to more voluminous art histories such as William Stevenson Smith, *The Art and Architecture of Ancient Egypt*, Baltimore, 1958, and W. Wolf, *op. cit.* (note 2 above).

22. The finest reliefs from Fifth Dynasty tombs have been published by Georg Steindorff, *Das Grab des Ti*, Leipzig, 1913, and Norman de Garis Davies, *The Mastaba of Ptahhetep and Akhethetep*, London, 1900; the most interesting tomb of the Sixth Dynasty is that published by Prentice Duell, *The Mastaba of Mereruka*, Chicago, 1938.

23. Although the passivity of the tomb owner was generally maintained, small changes occur in the later Old Kingdom tombs, which may be due to influence from the royal reliefs (see p. 48). These exceptions have been discussed in H. A. Groenewegen-Frankfort, *op. cit.* (note 5 above), pp. 31 ff.

24. See Ludwig Borchardt, *Das Grabdenkmal des Konigs Ne-User-Re*, Leipzig, 1907, and *Das Grabdenkmal des Königs Sahure*, Leipzig, 1910–13.

25. In a text of this period, quoted by R. T. Rundle Clark, *Myth and Symbol in Ancient Egypt*, London, 1959, pp. 139–40, Osiris says to the creator god Atum: "O Atum! What is this desert place into which I have come? It has no water, it has no air, it is depth unfathomable, it is black as the blackest night. I wander helplessly herein. One cannot live here in peace of heart, nor may the longing of love be satisfied herein." To which Atum replies: "You may live in peace of heart. I have provided illumination in place of water and air, and satisfaction and quiet in the place of bread and beer."

26. See Adolph Erman, *The Literature of the Ancient Egyptians*, tr. by A. M. Blackman, Oxford, 1937.

27. The technique and character of Old and Middle Kingdom painting have been exhaustively dealt with by W. S. Smith, *op. cit.* (note 21 above).

28. Aylward M. Blackman, *The Rock Tombs of Meir*, London, 1914.

29. Especially the full-bosomed type of Levantine origin, which appealed to Greek artists and survived in the West. In the sphinxes of Queen Hatshepsut as Pharaoh (see p. 60), as also in one attributed to the wife of Hatshepsut's successor Tuthmosis III, the head was simply joined to a lion's body. We may assume that this was also the case in the one instance where a superb head of a queen of the Middle Kingdom, now in Boston, appears to have formed part of a sphinx. Generally speaking, however, the Egyptian sphinx represented the Pharaoh and is therefore male.

30. On the migration of peoples throughout the Near East in this period see p. 114.

31. See J. A. Wilson, *op. cit.* (note 10 above), pp. 195 ff.

32. For illustrations see W. Wolf, *op. cit.* (note 2 above), pls. 449–51.

33. A good survey of both the funerary and the divine temples of the Eighteenth and Nineteenth Dynasties is given by Earl Baldwin Smith, *Egyptian Architecture as Cultural Expression*, New York, 1938.

34. Extremely subtle relief also occurs in the New Kingdom, e.g., in the tomb of Ramose; see Kurt Lange and Max Hirmer, *Egypt*, London, 1956.

35. Not quite, though; the shoulders are somewhat twisted and the feet are awkwardly rendered in the traditional manner.

36. See Nina de Garis Davies, *The Tomb of Ken-Amun at Thebes*, New York, 1930.

37. See H. A. Groenewegen-Frankfort, *op. cit.* (note 5 above), pp. 101–12.

38. See H. Frankfort et. al., *The Mural Painting of El-'Amarneh*, London, 1929.

39. W. S. Smith, *op. cit.* (note 21 above), pls. 134–35.

40. Though some of these distorted figures are not unimpressive (see K. Lange and M. Hirmer, *op. cit.* [note 34 above], pls. 176–77), I see no need to claim a special merit for them, or to interpret them in anachronistic terms by calling them "expressionistic," as is often done.

41. For an analysis of the battle scenes of Seti I and his successors see H. A. Groenewegen-Frankfort, *op. cit.* (note 5 above), pp. 114–41.

42. On the art of the later periods see W.S. Smith, *op. cit.* (note 21 above), and W. Wolf, *op. cit.* (note 2 above).

Chapter 2. MESOPOTAMIA

1. On the political structure and the economic organization of the Sumerian city-states, see Thorkild Jacobsen in *The Intellectual Adventure of Ancient Man*, Chicago, 1946, ch. IV; also Henri Frankfort, *The Birth of Civilization in the Near East*, Bloomington, Ind., 1951, ch. II.

2. I owe this information to Cyril Gadd, who writes that the Sumerians used a term which literally means: "to (or from) a far distant day," that is, long enduring (or ancient).

3. The problem of the origin and the ethnic affinities of the Sumerian people is still under dispute. Their language, being noninflectional, is not related to either Semitic or Indo-European.

4. See note 6.

5. See André Parrot, *Mari, Documentation Photographique*, Paris, 1952, pls. 64–72.

6. Gilgamesh, the legendary ruler of Uruk, was a king of such terrifying vigor that his subjects begged the gods to create a counterpart in strength with whom he could compete, so that his people might be left in peace. The gods sent Enkidu, a wild hairy man, who roamed with the herds. He was lured from his state of innocence by a harlot, met Gilgamesh in a contest, and became his close friend and companion in a series of dangerous exploits. The goddess Inanna declared her love to Gilgamesh and was scornfully rejected by him on the grounds that she let her lovers die. In anger she sent the "bull of heaven" to destroy both friends but instead they killed the bull. At the goddess' request the god Enhil finally decided to punish the arrogant heroes: Enkidu was struck by a mortal disease and Gilgamesh was left in despair.

He then began his quest for the secret of eternal life, and tragically failed.

For a scholarly translation see Alexander Heidel, *The Gilgamesh Epic and Old Testament Parallels*, Chicago, 1946; for an interesting comment see Gertrude R. Levy, *The Sword from the Rock*, London, 1953, pp. 120 ff.

7. See H. Frankfort, *The Art and Architecture of the Ancient Orient*, Baltimore, 1958, pls. 56, 58B, 59A and c.

8. On the architecture of this period see H. Frankfort, *ibid.*, pp. 73 ff., where the different aspects of Assyrian art are fully dealt with.

9. Though these reliefs have often been compared with and even tentatively derived from the Egyptian battle reliefs of the Nineteenth Dynasty, the essential difference between "monumental" and narrative scenic art cannot be overstressed. The nearest parallel to the Assyrian reliefs are the reliefs on Trajan's Column.

10. It is interesting to note that the ritual functions of the king as mediator between society and the gods, which are emphasized in the texts, have not been depicted. See H. Frankfort, *op. cit.* (note 7 above), pp. 78–88.

11. An analysis of the spatial representation in Assyrian reliefs is given in H. A. Groenewegen-Frankfort, *Arrest and Movement: An Essay on Space and Time in the Representational Art of the Ancient Near East*, London, 1951, pp. 170 ff.

Chapter 3. CRETE AND MYCENAE

1. It is true that since a certain form of linear script, in use after the destruction of Knossos by mainland Greek forces, has been deciphered, it could be proved that the Greek language was in common use in Crete at that time. The art and civilization with which we are concerned, however, antecedes these eventful changes.

2. On the complex problem of Aegean imports and their influence on Egyptian art in the Middle and New Kingdom, see Helene J. Kantor, *The Aegean and the Orient in the Second Millennium B.C.*, Bloomington, Ind., 1947.

3. The division of Cretan remains in Early, Middle, and Late Minoan, for the convenience of archaeologists, does not clearly mark the main phases of cultural development.

4. On the problems of dating see John D. Pendlebury, *The Archaeology of Crete*, London, 1939.

5. These figures are often called goddesses. There exists, however, no iconographical evidence to support this view, and much to contradict it.

6. See Spyridon Marinatos, and Max Hirmer, *Crete and Mycenae*, New York, 1960.

7. See Gertrude R. Levy, *The Gate of Horn*, London, 1947, p. 229.

8. See Arthur Evans, *The Palace of Minos*, III, London, 1921–35, p. 212.

9. See H. A. Groenewegen-Frankfort, *Arrest and Movement: An Essay on Space and Time in the Representational Art of the Ancient Near East*, London, 1951, p. 209.

10. Published by Georg H. Karo, *Die Schachtgräber von Mykenai*, Munich, 1933.

11. See Alan J. B. Wace, "Mycenae," *Journal of Hellenic Studies*, LIX, 1939.

12. On Mycenaean architecture and the vexing problem of its chronology see Alan J. B. Wace, *Mycenae*, Princeton, 1949, whose dating I have accepted throughout. The fragmentary remains of a painted frieze in the megaron with lively battle scenes, horses and chariots, have been published by Gerhart Rodenwaldt, *Der Fries des Megarons von Mykenai*, Halle, 1921, who emphasizes the contrast between the Mycenaean attempt at pictorial narrative and the older Minoan frescoes.

Chapter 4. INTRODUCTION TO GREEK ART

1. Gisela M. A. Richter, *A Handbook of Greek Art*, London, 1959.

2. Martin Robertson, *Greek Painting*, Geneva, 1959; Mary H. Swindler, *Ancient Painting*, New Haven, Conn., 1929 (a survey of the whole field); Ernst Pfuhl, *Masterpieces of Greek Drawing and Painting*, tr. by John D. Beazley, New York, 1926 (still one of the best studies of the subject).

3. G. M. A. Richter, *Ancient Italy*, Ann Arbor, Mich., 1955, Appendix I, pp. 105–11.

4. Jean Charbonneaux, *Greek Bronzes*, New York, 1962; reviewed by Mogens Gjodesen, "Greek Bronzes: A Review Article," *American Journal of Archaeology*, LXVII, 1963, pp. 333–51. See also Winifred Lamb, *Greek and Roman Bronzes*, London, 1929.

5. R. A. Higgins, *Catalogue of the Terracottas in the Department of Greek and Roman Antiquities, British Museum*, I. London, 1954, pp. 3–7; R. V. Nicholls, "Type, Group and Series: A Reconsideration of Some Coroplastic Fundamentals," *Annual of the British School at Athens*, XLVII, 1952, pp. 217–26.

6. G. M. A. Richter, *Catalogue of Engraved Gems in the Classical Style*, Metropolitan Museum of Art, New York, 1920.

7. Patrick ReutersWärd, *Studien zur Polychromie der Plastik*, Stockholm, 1960; G. M. A. Richter, "Polychromy in Greek Sculpture," *American Journal of Archaeology*, XLVIII, 1944, pp. 321–33.

8. G. M. A. Richter, *op. cit.* (note 1 above).

9. *Ibid.*

10. James G. Frazer, *Pausanias*, London, 1898; William H. S. Jones and Richard E. Wycherley, *Pausanias*, Cambridge, Mass. and London, 1918–35 (text, translation, and commentary).

Chapter 5. THE PROTOGEOMETRIC AND GEOMETRIC PERIODS

1. The best modern account of Greek relations with the East, with a full bibliography, is John Boardman, *The Greeks Overseas*, London, 1964.

2. Robert M. Cook, *Greek Painted Pottery*, Chicago, 1960 (excellent comprehensive survey, with full references); Paolo E. Arias and Max Hirmer, *A History of 1000 Years of Greek Vase Painting*, tr. and rev. by B. B. Shefton, New York, 1961 (finely illustrated).

3. Vincent Desborough, *Protogeometric Pottery*, Oxford, 1952.

4. Humfry G. G. Payne, *Necrocorinthia*, Oxford, 1931 (the best general study of Archaic Corinthian art).

5. There are three excellent handbooks on Greek architecture: Arnold W. Lawrence, *Greek Architecture*, London, 1957; William B. Dinsmoor, *The Architecture of Ancient Greece*, 3rd ed., London, 1950; Donald S. Robertson, *A Handbook of Greek and Roman Architecture*, 2nd ed., Cambridge, 1943.

6. Franz Willemsen, *Dreifusskessel von Olympia, Olympische Forschungen*, III, Berlin, 1957.

Chapter 6. ORIENTALIZING ART AND THE FORMATION OF THE ARCHAIC STYLE

1. Donald B. Harden, *The Phoenicians*, New York, 1962.

2. Eva T. H. Brann, *Late Geometric and Protoattic Pottery*, American School of Classical Studies, Athenian Agora, VIII, Princeton, 1962.

3. It has been agreed among archaeologists to call these early phases of Corinthian and Athenian vase painting Protocorinthian and Protoattic. On the origin of the names see John M. Cook, "Protoattic Pottery," *Annual of the British School at Athens*, XXXV, 1934–35, pp. 165–219; Robert M. Cook, *Greek Painted Pottery*, Chicago, 1960, p. 310.

4. The color scheme is noteworthy. The figure-scenes are on a light buff background: the rest of the vase is black, enriched with purple bands, and also with white floral patterns and a frieze of running dogs, above and below the shoulder picture respectively. In the pictures themselves, black, red, and brown colors are used, and there is much "incision," a technique which may have been suggested by the chasing of bronze, Corinth having been one of the main centers of bronzeworking.

5. Helen E. Searls and William B. Dinsmoor, "The Date of the Olympia Heraeum," *American Journal of Archaeology*, XLIX, 1945, pp. 62–80.

6. Major reference books are: Gisela M. A. Richter, *The Sculpture and Sculptors of the Greeks*,

new ed., New Haven, Conn., 1950 (with many illustrations and references); Reinhard Lullies and Max Hirmer, *Greek Sculpture*, 2nd ed., New York, 1957 (finely illustrated).

7. The statue dedicated by Nicandre to Artemis. It bears a long inscription in the Naxian script; see Lilian H. Jeffrey, *Local Scripts of Archaic Greece*, Oxford, 1961, p. 303, no. 2.

Chapter 7. THE ARCHAIC PERIOD

1. Euphorbos, a Trojan, was the first to wound Patroklos; he was himself killed by Menelaos, but his body was rescued by Hektor.

2. Meanwhile Chios had evolved a special variant of this kind of ware, which we know chiefly from the great quantities of it found at Naucratis, the Greek settlement in Egypt. A favorite shape here was a chalice-like cup, white outside, with figures in outline; black inside, with an intricate stylized floral pattern in white and purple over it. This too comes to an end about 550.

3. Fikellura ware, so named because much of it was found near a modern village of that name in Rhodes: its place of manufacture, perhaps Samos, is still uncertain.

4. Chalcidian ware may have been made at Chalcis in Euboea, an Ionian city, or at the western colony of Chalcis in Rhegium (Italy). None has been found in Greece itself, a fair amount in Italy and Sicily, and some in France and Spain.

5. John D. Beazley, *Attic Black-Figure Vase-Painters*, Oxford, 1956 (the major reference book, unillustrated); by the same author, *Development of Attic Black-Figure*, Berkeley and Los Angeles, 1951 (an authoritative illustrated study).

6. Some of their names are preserved: but many are anonymous, partly because the majority do not sign their names at all, and partly because, of those who do so, it is not always clear who were the potters and who the painters. Sometimes they are the same person: of this we can be certain when a man signs "so-and-so made and painted me." When another signs "so-and-so painted me," we know who the painter was but not whether he was also the potter; and when a man signs "so-and-so made me," we do not know whether he was also the painter. Nor do we know for certain that he made the pot with his own hands, since he may have owned a workshop whose products all bore his name. But even though we do not know their names, the styles of hundreds of painters have been identified, both in black-figure and in the succeeding red-figure technique.

7. At first sight there is no connection between the two subjects, but both are in fact set in the wide context of Zeus's plan to reduce the excessive numbers of mankind by the Trojan War. For this the birth of Helen was an essential preliminary.

8. The cup has technical interest; the red ground of the interior is not the ordinary orange-red, but a more brilliant, less yellow color, the so-called "intentional" or "coral" red, and is the earliest example of it. The white of the sail (added over black, as usual in black-figure) has flaked away.

9. John D. Beazley, *Attic Red-Figure Vase-Painters*, 2nd ed., Oxford, 1963 (the major reference book, unillustrated); Gisela M. A. Richter, *Attic Red-Figured Vases: A Survey*, New Haven, Conn. and London, 1946; Robert M. Cook, *Greek Painted Pottery*, Chicago, 1960.

10. In black-figure the incised line is sharp and wiry; but it cannot vary in thickness or intensity, whereas the line used by the red-figure painter can be made to vary according to the thickness of the slip used for it. When the solution is thick it can be made to stand up from the surface of the vase in a fine ridge: this is the so-called "relief-line," rivaling the incised line in precision, surpassing it in flexibility. The line, under a magnifying glass, can often be seen to have a tiny furrow running along its length: this furrow must have been left by the point or nozzle of a so far unidentified instrument with which the slip was applied. When the slip is thinner it does not stand up from the surface so boldly: it becomes oxidized more easily and fires golden-brown instead of jet black. Thus a painter, drawing the human male body—and this is a favorite subject in painting just as it is in sculpture—has at his disposal two kinds of line of differing intensity, the bold black relief-

line for the major divisions and the paler line for subsidiary details. Other colors, especially purple and white, and occasionally gold, could still be added, but the need for them was less. See Joseph V. Noble, "The Technique of Attic Vase-Painting," *American Journal of Archaeology*, LXIV, 1960, pp. 307–18.

11. The foreshortenings are excellently done, and so are the receding limbs: the giant's right thigh is seen from the front and entirely obscures the lower leg bent behind it, except for the distant toes, which are sketched in. Behind Herakles is his equipment—club, quiver, and lion's skin, the last as if hanging on a tree stump with the hind legs and tail seen clear behind the forelegs; but so enamored was the painter with the beauty of his outlines that he could not bear to insert the stump and spoil them. The skin, therefore, tawny with a wash of thin slip, and daintily spotted, hangs unsupported in space.

12. John D. Beazley, *The Berlin Painter*, Melbourne University Press Occasional Paper No. 6, 1964.

13. For the probable contribution of Corinthian artists to developing the Doric style of architecture see Humfry G. G. Payne, *Necrocorinthia*, Oxford, 1931, p. 250, note 3.

14. Oscar Reuther, *Der Heratempel von Samos*, Berlin, 1957.

15. Gisela M. A. Richter, *Archaic Greek Art Against Its Historical Background*, New York, 1949.

16. Carl Blümel, *Greek Sculptors at Work*, tr. by L. Holland, London, 1955.

17. Kim Levin, "The Male Figure in Egyptian and Greek Sculpture of the Seventh and Sixth Centuries B.C.," *American Journal of Archaeology*, LXVIII, 1964, pp. 13–28.

18. The source of this type is undoubtedly Egypt, where close parallels can be found, except that Egyptian statues wear a loincloth, whereas the Greeks prefer to show men naked.

19. Gisela M. A. Richter assembles and analyzes all the known examples (*Kouroi: Archaic Greek Youths*, London, 1970), and her classification can be broadly accepted, with the proviso that, since we do not know how or how quickly information was transmitted from one center to another, we cannot be certain that some workshops in out-of-the-way places were not lagging far behind the others, either because innovations were slow in reaching them, or, if we assume that the development took place independently at the various centers, because they were slow in making the various discoveries that led to improvement.

20. A penetrating critical study by Christos Karouzos (*Aristodikos*, Stuttgart, 1961) discusses Archaic grave statues and other late Archaic art in Athens.

21. Ernst Buschor, *Altsamische Standbilder*, I–V, Berlin, 1934–61.

22. The head is carved in one piece with the topmost stone of the gable: this is significant, for the head of Medusa was widely used for averting evil, and here it protects that all-important element in the structure, the main roof beam.

23. On early Corinthian sculpture see H. G. G. Payne, *op. cit.* (note 13 above), pp. 232–47.

24. The date is established by Herodotus (III, 57) who tells the story of the conquest of Siphnos by the Samians shortly afterward: this was in 524 B.C.

25. Dietrich von Bothmer, *Amazons in Greek Art*, Oxford, 1957, ch. VIII, pp. 124–26.

26. Aphaia was the ancient Cretan goddess Dictynna or Britomartis. For the question whether she was identified with Athena, who appears so prominently on this temple, see Adolph Furtwängler, *Aegina*, I, pp. 1–9.

27. Little of the figure of Athena is preserved, but the right arm was outstretched under the aegis.

28. The development of form and style in these Attic reliefs has been carefully worked out by Gisela M. A. Richter (*The Archaic Gravestones of Attica*, London, 1961) and it provides a valuable index to the progress of Attic sculpture. Elsewhere fewer grave reliefs have survived, and their evolution is not so clear; but the tall flat type was used in other places and one or two fine specimens are known. An interesting series comes from Laconia, and here the dead are shown enthroned and on such a large scale that it is likely they were regarded as heroized.

Chapter 8. THE EARLY CLASSICAL PERIOD

1. Named for a former owner, Count Choiseul-Gouffier, French ambassador to Turkey at the end of the eighteenth century.

2. The left foot and ankle are bent out of shape, and there is some distortion of the other leg.

3. The name Hestia is arbitrary: the goddess may have been Demeter, since fragments of a torch, emblem of the Underworld, were found with one of the replicas.

4. Enrico Paribeni, *Museo Nazionale Romano: Sculture Greche*, Rome, 1953, no. 4; Wilhelm Kraiker, "Die Niobide im Thermenmuseum," *Römische Mitteilungen*, LI, 1936, pp. 125–44. Two other figures, a dying son and an older daughter, are in Copenhagen.

Chapter 9. THE CLASSICAL PERIOD

1. The style is so called because vases have been found at Kerch in the Crimea, with which Athens then had an active trade.

2. The use of color has the same result, and the contrast between those figures that are colored and those that are simply in the "reserved" red creates disharmony, even where care has been taken, as here, to concentrate the added color in the center of the composition.

3. John D. Beazley, *Attic White Lekythoi*, Oxford, 1938 (short but masterly).

4. A supplement to Vol. X of the periodical *Greece and Rome*, 1963, covers the early history of the site, the building, the sculptures, and the political implications of the whole building scheme. But see now Rhys Carpenter, *The Architects of the Parthenon*, London, 1970.

5. A good discussion of these and their likely causes is in Donald S. Robertson, *A Handbook of Greek and Roman Architecture*, 2nd ed., Cambridge, 1943, pp. 115–18.

6. Jens A. Bundgaard, *Mnesicles: A Greek Architect at Work*, Copenhagen, 1957 (essential for a full understanding of the Greek architect's methods).

7. The process of the building of the Parthenon is described and analyzed by Alison Burford, "The Builders of the Parthenon," Supplement to *Greece and Rome*, X, 1963 (see note 4 above).

8. Rhys Carpenter argues that the satyr is too late in style to be a copy of Myron's statue: see *Memoirs of the American Academy in Rome*, XVIII, 1941, p. 5.

9. That the Athena was made first and the Zeus later is proved by the debris, including ivory chips and clay matrices from the making of a colossal statue, in the traditional "workshop of Pheidias" at Olympia. In the debris were vase fragments which can hardly be earlier than 440 B.C. The Zeus could, of course, have been begun before the Parthenos was finished.

10. Despite many attempts to ascertain it, we still do not know what the system of proportions was, or how it was incorporated in the statue; but we get a hint from the philosopher Chrysippos, who laid down that "beauty consists in the proportion of the parts, of finger to finger and of all the fingers to the palm and wrist, and of these to the forearm, and of the forearm to the upper arm, and of all the parts to each other, as they are set forth in the Canon of Polykleitos."

11. Both these central groups are destroyed: the eastern when the Parthenon was converted into a church in the fifth century A.D.; the western by the Venetians in an attempt to remove it in 1687. This followed the explosion caused when a Venetian shell struck a Turkish gunpowder store and destroyed the interior and much of the long sides of the building, which until then had been almost unharmed. Fortunately there had been, in the suite of the Marquis de Nointel who visited Athens in 1674, a quick and competent draftsman named J. Carrey, who in a fortnight had drawn most of the sculptures: his drawings are of the utmost value.

12. Its fragments were seen by travelers in 1812, and one of them brought back to England a fragment of its head, which was about twice lifesize, its marble disintegrating either from prolonged exposure to the sea air or from burning. It is likely that other fragments were lying near

by, since the place was strewn with sculpture; but if so they have since disappeared, having been used for building material or for making lime.

One splendid fragment of an acroterion has recently been published: Semni Karusu, "Ein Akroter klassischer Zeit," *Athenische Mitteilungen*, LXXVII, 1962, pp. 178–90.

13. The dedicatory inscription has survived, and contains a peculiarity which did not pass unnoticed in antiquity. It states that the Messenians and Naupactians dedicated the statue to Zeus "from [the spoils of] their enemies," and Pausanias was told that it commemorated the part they played at the battle of Sphacteria in 424 when the Spartans were defeated; but that they feared to name the Spartans explicitly. Paionios adds that he won the competition for the acroteria of the temple of Zeus, so that the statue is in a sense also a commemoration of his own victory in the competition.

14. Rhys Carpenter, *The Sculptures of the Nike Temple Parapet*, Cambridge, Mass., 1929.

15. It is characteristic of the Classical age that in neither of these reliefs is the dead man shown as dying or in defeat. He is alive and victorious: the scene symbolizes courage in battle and does not depict any particular incident.

16. The identification has been doubted by Andreas Rumpf, *Archäologie*, II, Berlin, 1906, p. 80.

17. He named one of his own sons Kephisodotos, and it was customary to give a son the name of his grandfather. The dates of his birth and death are unknown: Pliny places him in the hundred and fourth Olympiad (364–361), which may be the date of his most famous statue, the Aphrodite of Knidos.

18. We know that Kephisodotos made a group of the same subject, and both subject and composition recall the bronze group of Eirene with the child Ploutos on her arm, also by Kephisodotos (see pp. 340–41).

19. H. Riemann, "Pytheos," in Pauly, *Realencyclopädie der klassischen Altertumswissenschaft*, ed. Georg Wissowa et. al., XXIV, Stuttgart, 1963, cols. 372–514; Kristian Jeppesen, *Paradeigmata*, Jutland Archaeological Society Publications IV, Copenhagen, 1958.

20. Gisela M. A. Richter, *Greek Portraits: A Study of Their Development*, Brussels, 1955.

21. It is a Roman copy, and these details suggest that it is copied from a contemporary portrait of Themistokles.

22. Barclay V. Head, *Historia Numorum*, 2nd ed., Oxford, 1911 (the major reference book); B. V. Head and George F. Hill, *A Guide to the Principal Coins of the Greeks*, London, 1959 (illustrated survey).

Chapter 10. HELLENISTIC ART

1. Elsewhere decorated pottery can at its best be charming, but it has little artistic importance, for the ornaments are slight and repetitive. There is still a preference for black ware, and the decoration is in white, yellow, and purple on the black surface: wreaths, birds, dramatic masks are favorite subjects. This kind of pottery was made in various places, and it is customary to distinguish the "Gnathia" ware of the Western Colonies from the "West Slope" ware of mainland Greece and Asia Minor.

There is also a light-colored ware with designs in darker color: the commonest shape is a squat pottery bottle called lagynos, and the decorative elements are wreaths, festoons, branches, musical instruments, and other readily recognizable silhouettes, painted in a quick and unpretentious way.

2. Photios Petsas, "Ten Years at Pella," *Archaeology*, XVII, 1964, pp. 74–84.

3. Heinrich Fuhrmann, *Philoxenos von Eretria*, Gottingen, 1931; Andreas Rumpf, "Zum Alexander-Mosaik," *Athenische Mitteilungen*, LXXVII, 1962, pp. 229–41.

4. There is some doubt how much is derived from Hermogenes: see Donald S. Robertson, *A Handbook of Greek and Roman Architecture*, 2nd ed., Cambridge, 1943, p. 157.

5. Theodor Wiegand, *Didyma*, Berlin, 1941–58.

6. The major reference book is Margarete Bieber, *The Sculpture of the Hellenistic Age*, 2nd ed., New York, 1961.

7. The Fortune, or, as we would say, the Patroness of the city.

8. Gisela M. A. Richter, "Silk in Greece," *American Journal of Archaeology*, XXXIII, 1929, pp. 27–33.

9. Gisela M. A. Richter, "The Date of the Laokoön," Appendix to *Three Critical Periods in Greek Sculpture*, Oxford, 1951.

10. Werner Fuchs, "Die Vorbilder des neuattischen Reliefs," *Deutsches archäologisches Institut Jahrbuch*, Ergänzungsheft XX, Berlin, 1959.

11. Christine M. Havelock, "Archaistic Reliefs of the Hellenistic Period," *American Journal of Archaeology*, LXVIII, 1964, pp. 43–58.

Chapter *11.* CYPRUS

1. Excellent sketch of history and antiquities of ancient Cyprus in John L. Myres, *Handbook of the Cesnola Collection of Antiquities from Cyprus*, New York, 1914, p. XXVI.

Chapter *12.* ETRUSCAN ART

1. Axel Boethius et. al., *Etruscan Culture, Land and People*, New York, 1962 (general survey); Massimo Pallottino, *The Etruscans*, London, 1955 (general survey with references); Emeline H. Richardson, *The Etruscans*, Chicago, 1964 (shorter survey).

2. John D. Beazley, *Etruscan Vase Painting*, Oxford, 1947.

3. Ake Akerström, *Der Geometrische Stil in Italien*, Leipzig, 1943.

4. The name, derived from a false attribution, is now purely conventional; Pericle Ducati, *Pontische Vasen*, Berlin, 1932.

5. The Attic cup itself also happens to be preserved: it was imported into Etruria and must have been imitated there, probably in Vulci, soon after its arrival. The argument for this is that the decorative elements are also copied from the model without any trace of modernization: but it may be doubted whether the interior picture, which is completely different from that in the Attic original and has foreshortenings and limbs set behind one another in space, may not conceivably be later, which would lower the date of the whole cup.

6. So called because they imitate Egyptian Canopic jars in which the entrails of the dead were buried.

Chapter *13.* ROMAN ART

1. Hans P. L'Orange, *Apotheosis in Ancient Portraiture*, Oslo, 1947; reviewed by Jocelyn M. C. Toynbee, *Journal of Roman Studies*, XXXVIII, 1948.

2. For the relation between Greek and Roman art, see Gisela M. A. Richter, *Ancient Italy*, Ann Arbor, Mich., 1955, *passim*.

3. A witty discussion of this attitude by Rhys Carpenter in "Observations on Familiar Statuary in Rome," *Memoirs of the American Academy in Rome*, XVIII, 1941, pp. 33–34.

4. The influence of Etruria must have been profound. The Romans believed that their city had been founded on the Etruscan model, and the Etruscan dynasty that ruled Rome must have left a permanent impress. In religious matters the Romans borrowed much from Etruria: many of their deities, though later equated with those of Greece, had in fact come to them through the Etruscans. When contact between Greece and Rome became closer in the second and first centuries B.C., this earlier acquaintance with Greek gods, even if in an Etruscan form, made it easier to assimilate them.

5. Annie N. Zadoks-Jitta, *Ancestral Portraiture in Rome*, Amsterdam, 1932.

6. This type of pottery had forerunners in Hellenistic times, and finds have been made on the Aegean coast of Asia Minor and at Samos of a red-gloss pottery which may be its direct ancestor. This or some predecessor may be the "Samian ware" which Pliny, writing in 77 A.D., mentions as still esteemed for table use. (There are two sources of confusion here: first, the word "Samian" was also used in Roman times to mean simply

"pottery"; second, "Samian" has been used in modern times for any red pottery found on Roman sites.) Modern research has shown that this kind of red gloss is produced by dipping the pot before firing into a solution of clay to which alkali has been added. The alkali causes the finest clay particles to remain suspended in the solution and to adhere all over the pot. When fired in an oxydizing fire a glossy red surface results, the red color, as with the earlier Greek pottery, being caused by the presence of iron. As with early Greek pottery, the same kind of pot can be made to fire black when air is excluded from the kiln. Black ware always had a certain vogue because of its resemblance to metal, but the taste for red ware became dominant in the Roman Empire. R. J. Charleston (*Roman Pottery*, London, 1955) has a good account.

7. The technical process is of interest. A mold was first made on the wheel like a bowl with thick sides. This was impressed on the inside with stamps made of fired clay, bearing designs in relief, and was then fired. The potter then threw a bowl inside the mold, from which it could be extracted after the clay had shrunk in drying. One example is known where the metal original for a stamp still exists, but no complete metal vessel was molded for the purpose, or if it was the impression was cut up to make smaller stamps.

8. Naturally pottery in the local tradition was made in many parts of the Roman Empire: one class is the lead-glazed ware which became the ancestor of medieval lead-glazed pottery. The technique seems to have been invented in Egypt, and in appearance carries on the tradition of "faience" used there from very early times; but in the Roman period there were factories making lead-glazed ware in Syria, South Russia, and elsewhere.

9. Amedeo Maiuri, *Roman Painting*, tr. by Stuart Gilbert, Geneva, 1953.

10. Giuseppe Moretti, *Ara Pacis Augustae*, Rome, 1948. The identification has been doubted by Stefan Weinstock, "Pax and the 'Ara Pacis'," *Journal of Roman Studies*, L, 1960, pp. 44–58: answered by Jocelyn M. C. Toynbee, "The 'Ara Pacis Augustae'," *Journal of Roman Studies*, LI, 1961, pp. 153–56.

11. Filippo Magi, *I Rilievi Flavi del Palazzo della Cancelleria*, Rome, 1945; reviewed by Jocelyn M. C. Toynbee, *Journal of Roman Studies*, XXXVII, 1947, pp. 187–91. Hugh M. Last, "On the Flavian Reliefs from the Palazzo della Cancelleria," *Journal of Roman Studies*, XXXVIII, 1948, pp. 9–14.

12. Massimo Pallottino, *Il grande fregio di Traiano*, Rome, 1938.

13. Karl Lehmann-Hartleben, *Die Trajanssäule*, Berlin and Leipzig, 1926.

14. Giovanni Becatti, *La colonna coclide istoriata*, Rome, 1960.

15. C. Caprino et al., *La colonna di Marco Aurelio*, Rome, 1955.

Selected Bibliography

EGYPT

GENERAL

Alfred, C. *Development of Ancient Egyptian Art from 3200–1315 B.C.* London: Tiranti, 1952.

Baumann, H. *The World of the Pharaohs.* New York: Pantheon, 1960.

Breasted, J. H. *A History of Egypt.* 2nd ed. New York: C. Scribner's Sons, 1924.

Frankfort, H. *Kingship and the Gods.* Chicago: University of Chicago Press, 1948.

Frankfort, H., Groenewegen-Frankfort, H. A., Wilson, J. A., and Jacobsen, T. *Before Philosophy.* Baltimore: Penguin Books, 1949.

Groenewegen-Frankfort, H. A. *Arrest and Movement.* Chicago: Humanities, 1951.

Hayes, W. C. *The Scepter of Egypt.* 2 vols. New York: Harvard University Press, 1953–59.

Lange, K., and Hirmer, M. *Egypt.* London: Phaidon, 1961.

Porter, B., and Moss, R. *Topographical Bibliography of Ancient Egyptian Hieroglyphic Texts, Reliefs, and Paintings.* 7 vols. (vol. 1 rev. 1965). Oxford: Clarendon Press, 1927–52.

Ranke, H. *The Art of Ancient Egypt.* London: Phaidon Press, 1936.

Seele, K., and Steindorff, G. *When Egypt Ruled the East.* Chicago: University of Chicago Press, 1947.

Smith, W. S. *The Art and Architecture of Ancient Egypt.* Pelican History of Art. Baltimore: Penguin Books, 1958.

Wilson, J. A. *The Culture of Ancient Egypt.* Chicago: University of Chicago Press, 1956.

ARCHITECTURE

Badawy, A. *A History of Egyptian Architecture.* Berkeley: University of California Press, 1966.

Clarke, S., and Engelbach, R. *Ancient Egyptian Masonry.* Oxford: Oxford University Press, 1930.

Edwards, I. E. S. *The Pyramids of Egypt.* Baltimore: Penguin Books, 1960.

Fakhry, A. *The Pyramids.* Chicago: University of Chicago Press, 1962.

Reisner, G. A. *The Development of the Egyptian Tomb down to the Accession of Cheops.* Cambridge, Mass.: Harvard University Press, 1936.

Smith, E. B. *Egyptian Architecture as Cultural Expression*. New York: Century House, 1938.

PAINTING AND SCULPTURE

Davies, N. M., and Gardiner, A. H. *Ancient Egyptian Paintings*. Chicago: University of Chicago Press, 1936.

Frankfort, H., ed. *The Mural Painting of El-'Amarneh*. London: Egyptian Exploration Society, 1929.

Iversen, E. *Canon and Proportions in Egyptian Art*. London: Sidgwick & Jackson, 1955.

Mekhitarian, A. *Egyptian Painting*. New York: Skira, 1954.

Smith, W. S. *A History of Egyptian Sculpture and Painting in the Old Kingdom*. 2nd ed. Boston: Museum of Fine Arts, 1949.

Vandier, J. *Manuel d'archéologie égyptienne*. 3 vols. Paris: J. Picard, 1952–58.

MINOR ARTS

Fox, P. *Tutankhamun's Treasure*. London: Oxford University Press, 1951.

Lucas, A. *Ancient Egyptian Materials and Techniques*. 4th ed. London: St. Martins, 1962.

Wallis, H. *Egyptian Ceramic Art*. 2 vols. London: Taylor & Francis, 1898–1900.

MESOPOTAMIA

Andrae, W. *Coloured Ceramics from Ashur*. London: K. Paul, Trench, Trubner, 1925.

Frankfort, H. *The Art and Architecture of the Ancient Orient*. Pelican History of Art. Baltimore: Penguin Books, 1958.

———. *The Birth of Civilization in the Near East*. London: Williams & Norgate, 1951.

Lloyd, S. *The Art of the Ancient Near East*. New York: Praeger, 1961.

Pallis, S. A. *The Antiquity of Iraq*. Copenhagen: Munksgaard, 1956.

Parrot, A. *The Arts of Assyria*. New York: Golden Press, 1961.

———. *Nineveh and Babylon*. London: Thames & Hudson, 1960.

———. *Sumer: The Dawn of Art*. New York: Golden Press, 1961.

Smith, S. *The Early History of Assyria*. London: 1930.

Smith, W. S. *Interconnections in the Ancient Near East*. New Haven: Yale University Press, 1965.

Speiser, E. A. *Mesopotamian Origins*. London: Oxford University Press, 1930.

Strommenger, E., and Hirmer, M. *Five Thousand Years of the Art of Mesopotamia*. New York: Abrams, 1964.

Woolley, C.L. *The Art of the Middle East*. New York: Crown, 1961.

———. *The Development of Sumerian Art*. London: Faber & Faber, 1935.

———. *Ur of the Chaldees*. Baltimore: Penguin Books, 1954.

CRETE AND MYCENAE

Blegen, C. W. et al. *Troy: Excavations Conducted by the University of Cincinnati*. 5 vols. Princeton: Princeton University Press, 1950–58.

Brock, J. R. *Fortesta*. Cambridge: Cambridge University Press, 1957.

Cottrell, L. *The Anvil of Civilization*. New York: Mentor NAL, 1957.

Evans, A. J. *The Palace of Minos*. 4 vols. New York: Macmillan, 1921–35.

Furumark, A. *Mycenaean Pottery. Analysis and Classification*. Stockholm: 1941.

Hall, H. R. *The Civilization of Greece in the Bronze Age*. London: Methuen, 1928.

Kenna, V. E. G. *Cretan Seals*. Oxford: Oxford University Press, 1960.

Marinatos, S., and Hirmer, M. *Crete and Mycenae*. New York: Abrams, 1960.

Mylonas, G. E. *Mycenae and the Mycenaean Age*. Princeton: Princeton University Press, 1966.

Pendlebury, J. D. S. *The Archaeology of Crete*. 2nd ed. London: Methuen, 1955.

———. *A Handbook to the Palace of Minos*. London: Defour, 1954.

Persson, A. W. *Religion of Greece in Prehistoric Times.* Berkeley: University of California Press, 1942.

Platon, N. "Cretan-Mycenaean Art," in *Encyclopedia of World Art*, vol. IV. New York: McGraw-Hill, 1961.

Vermeule, E. *Greece in the Bronze Age.* Chicago: University of Chicago Press, 1964.

GREECE

GENERAL

Beazley, J. D., and Ashmole, B. *Greek Sculpture and Painting to the End of the Hellenistic Period.* Cambridge: Cambridge University Press, 1966 (reprint).

Boardman, J. *The Greeks Overseas.* Baltimore: Penguin Books, 1964.

Bonnard, A. *Greek Civilization.* 3 vols. New York: Macmillan, 1957–62.

Bowra, C. M. *The Greek Experience.* Cleveland: Mentor NAL, 1958.

Carpenter, R. *Greek Art: A Study of the Formal Evolution of Style.* Philadelphia: University of Pennsylvania Press, 1962.

Dunbabin, T. J. *The Western Greeks.* Oxford: Oxford University Press, 1948.

Godolphin, F. R. B., ed. *The Greek Historians: The Complete Unabridged Historical Works of Herodotus, Thucydides, Xenophon, Arrian.* 2 vols. New York: Random House, 1942.

Hamilton, E. *The Greek Way to Western Civilization.* New York: Norton, 1942.

Hammond, N. G. L. *A History of Greece to 322 B.C.* Oxford: Oxford University Press, 1952.

Hege, W., and Rodenwaldt, G. *Olympia.* London: Sidgwick & Jackson, 1936.

Kitto, H. D. F. *The Greeks.* London: Penguin Books, 1951.

Laurie, A. P. *Greek and Roman Methods of Painting.* Cambridge: Cambridge University Press, 1930.

Pfuhl, E. *Masterpieces of Greek Drawing and Painting.* New York: Macmillan, 1955.

Pollitt, J. J. *The Art of Greece.* Englewood Cliffs, N. J.: Prentice-Hall, 1965.

Poulsen, F. *Delphi.* London: Gyldendal, 1920.

Richter, G. M. A. *Archaic Greek Art.* New York: Oxford University Press, 1949.

———. *A Handbook of Greek Art.* 2nd ed. London: Phaidon, 1960.

Robertson, M. *Greek Painting.* Geneva: Skira, 1959.

Rodenwaldt, G. *Acropolis.* Tulsa: University of Oklahoma Press, 1958.

Rose, H. J. *A Handbook of Greek Mythology.* New York: Dutton, 1959.

Schefold, K. *Myth and Legend in Early Greek Art.* New York: Abrams, 1966.

Swindler, M. H. *Ancient Painting.* New Haven: Yale University Press, 1929.

Tarn, W. *Hellenistic Civilization.* 3rd ed. London: Meridian, 1953.

Vermeule, C. C. *Greek, Etruscan, and Roman Art.* Boston: Museum of Fine Arts, 1964.

ARCHITECTURE

Berve, H., Gruben, G., and Hirmer, M. *Greek Temples, Theaters, and Shrines.* New York: Abrams, 1962.

Dinsmoor, W. B. *The Architecture of Ancient Greece.* 3rd ed. London: B. T. Batsford, 1950.

Lawrence, A. W. *Greek Architecture.* Baltimore: Penguin Books, 1957.

Robertson, D. S. *A Handbook of Greek and Roman Architecture.* Cambridge: Cambridge University Press, 1954.

Scranton, R. L. *Greek Architecture.* New York: Braziller, 1962.

SCULPTURE

Adam, S. *The Technique of Greek Sculpture in the Archaic and Classical Periods.* London: Thames & Hudson, 1966.

Ashmole, B., Yalouris, N., and Frantz, A. *Olympia: The Sculptures of the Temple of Zeus.* London: Phaidon, 1967.

Bieber, M. *The Sculpture of the Hellenistic Age.* New York: Columbia University Press, 1961.

Carpenter, R. *Greek Sculpture.* Chicago: University of Chicago Press, 1960.

————. *The Sculptures of the Nike Temple Parapet.* Cambridge, Mass.: Harvard University Press, 1929.

Charbonneaux, J. *Greek Bronzes.* New York: Viking Press, 1962.

Corbett, P. E. *The Sculpture of the Parthenon.* London: Penguin Books, 1959.

Lamb, W. *Greek and Roman Bronzes.* New York: Dial Press, 1929.

Langlotz, E., and Hirmer, M. *Ancient Greek Sculpture of South Italy and Sicily.* New York: Abrams, 1965.

Lawrence, A. W. *Classical Sculpture.* London: Cape, 1929.

Lullies, R., and Hirmer, M. *Greek Sculpture.* 2nd ed. New York: Abrams, 1962.

Payne, H. G. G., and Young, G. M. *Archaic Marble Sculpture from the Acropolis.* London: Cresset, 1950.

Richter, G. M. A., *Korai: Archaic Greek Maidens.* London: Phaidon, 1968.

————. *Kouroi: Archaic Greek Youths.* 3rd ed. London: Phaidon, 1970.

————. *The Portraits of the Greeks.* London: Phaidon, 1965.

————. *The Sculpture and Sculptors of the Greeks.* Rev. ed. New Haven: Yale University Press, 1950.

POTTERY AND VASE PAINTING

Arias, P. E., and Hirmer, M. *A History of 1000 Years of Greek Vase Painting.* New York: Abrams, 1963.

Beazley, J. D. *Attic Black-Figure Vase-Painters.* Oxford: Clarendon Press, 1956.

————. *Attic Red-Figure Vase-Painters.* 3 vols. Oxford: Oxford University Press, 1963.

————. *The Development of Attic Black-Figure.* Berkeley: University of California Press, 1951.

Coldstream, N. J. *Greek Geometric Pottery.* London: Methuen, 1968.

Cook, R. M. *Greek Painted Pottery.* London: Methuen, 1966.

Davison, J. M. *Attic Geometric Workshops.* New Haven: Yale University Press, 1961.

Desborough, V. R. d'A. *Protogeometric Pottery.* Oxford: Oxford University Press, 1952.

Noble, J. V. *The Techniques of Painted Attic Pottery.* New York: Watson, 1965.

Richter, G. M. A. *Attic Red-Figured Vases.* Rev. ed. New Haven: Yale University Press, 1958.

MINOR ARTS

Higgins, R. *Catalogue of Terracottas in the British Museum.* London: Methuen, 1954–59.

————. *Greek and Roman Jewellery.* London: Methuen, 1961.

Kraay, C. M., and Hirmer, M. *Greek Coins.* New York: Abrams, 1966.

Richter, G. M. A. *The Engraved Gems of the Greeks and the Etruscans.* London: Phaidon, 1968.

————. *The Furniture of the Greeks, Etruscans, and Romans.* London: Phaidon, 1966.

Seltman, C. *Greek Coins.* London: Penguin Books, 1960.

Strong, D. E. *Greek and Roman Gold and Silver Plate.* New York: Cornell University Press, 1966.

Webster, T. B. L. *Greek Terracottas.* Harmondsworth: Penguin Books, 1950.

CYPRUS

Karageorghis, V. *Cyprus.* Geneva: 1968.

ETRURIA

GENERAL

Bloch, R. *The Etruscans.* London: Praeger, 1958.

Heurgon, J. *Daily Life of the Etruscans.* New York: Macmillan, 1964.

Pallottino, M. *The Etruscans.* Baltimore: Penguin Books, 1955.

Richter, G. M. A. *Ancient Italy.* Ann Arbor: University of Michigan Press, 1955.

Strong, D. "The Etruscan Problem," in *Vanished Civilizations,* ed. by E. Bacon. New York: McGraw-Hill, 1963.

Whatmough, J. *The Foundations of Modern Italy.* London: St. Martins, 1957.

ART

Beazley, J. D. *Etruscan Vase-Painting.* New York: Oxford University Press, 1923.

Goldscheider, L. *Etruscan Sculpture.* London: Oxford University Press (Phaidon edition), 1941.

Pallottino, M. *Etruscan Painting.* New York: Skira, 1953.

———. "Etrusco-Italic Art," in *Encyclopedia of World Art,* vol. V. New York: McGraw-Hill, 1961.

Pallottino, M. et al. *Art of the Etruscans.* New York: Vanguard, 1955.

Poulsen, F. *Etruscan Tomb Paintings: Their Subjects and Significance.* Oxford: Clarendon Press, 1922.

Riis, P. J. *An Introduction to Etruscan Art.* Copenhagen: Munksgaard, 1953.

———. *Tyrrhenica. An Archaeological Study of the Etruscan Sculpture in the Archaic and Classical Periods.* Copenhagen: Munksgaard, 1941.

Vermeule, C. C. *Greek, Etruscan, and Roman Art.* Boston: Museum of Fine Arts, 1964.

ROME

GENERAL

Bieber, M. *The History of the Greek and Roman Theater.* 2nd ed. Princeton: Princeton University Press, 1961.

Brendel, O. J. "Prolegomena to a Book on Roman Art," in *Memoirs of the American Academy in Rome,* vol. 21, 1953.

Carcopino, J. *Daily Life in Ancient Rome.* New Haven: Yale University Press, 1940.

Davenport, B., ed. *The Portable Roman Reader.* New York: Viking Press, 1951.

Hadas, M. *Hellenistic Culture.* New York: Columbia University Press, 1959.

Hamilton, E. *The Roman Way to Western Civilization.* New York: Norton, 1932.

Hanfmann, G. M. A. *Roman Art.* Greenwich, Conn.: New York Graphic Society, 1964.

L'Orange, H. P. *Art Forms and Civic Life in the Late Roman Empire.* Princeton: Princeton University Press, 1965.

Mau, A. *Pompeii. Its Life and Art.* New York: Macmillan, 1904.

Nash, E. *Pictorial Dictionary of Ancient Rome.* 2 vols. New York: Praeger, 1968.

Poulsen, F. *Roman Culture.* Leiden: Levin, 1950.

Richter, G. M. A. *Ancient Italy.* Ann Arbor: University of Michigan Press, 1955.

Toynbee, J. M. C. *Art in Britain under the Romans.* Oxford: Oxford University Press, 1964.

———. *Art of the Romans.* New York: Praeger, 1965.

———. *The Hadrianic School.* Cambridge: Cambridge University Press, 1934.

Vermeule, C. C. *Greek, Etruscan, and Roman Art.* Boston: Museum of Fine Arts, 1964.

Wickhoff, F. *Roman Art.* London: Heinemann, 1900.

ARCHITECTURE

Anderson, W. J., and Spiers, R. P. (rev. by T. Ashby). *The Architecture of Ancient Rome* (vol. 2 of *The Architecture of Greece and Rome*). New York: C. Scribner's Sons, 1927.

Boethius, A. *The Golden House of Nero.* Ann Arbor: University of Michigan Press, 1960.

Brown, F. *Roman Architecture.* New York: Braziller, 1961.

Plommer, H. *Ancient and Classical Architecture* (vol. 1 of *History of Architectural Development*). London: Longmans, Green, 1956.

Robertson, D. S. *A Handbook of Greek and Roman Architecture.* Cambridge: Cambridge University Press, 1954.

Wheeler, M. *Roman Art and Architecture.* New York: Praeger, 1964.

PAINTING AND SCULPTURE

Gabriel, M. M. *Masters of Campanian Painting.* New York: M. Bittner & Co., 1952.

Hamberg, P. G. *Studies in Roman Imperial Art.* Uppsala: Almquist & Wiksells, 1945.

Lamb, W. *Greek and Roman Bronzes*. New York: Argonaut, 1929.

Laurie, A. P. *Greek and Roman Methods of Painting*. Cambridge: Cambridge University Press, 1930.

Maiuri, A. *Roman Painting*. New York: Skira, 1953.

Pfuhl, E. *Masterpieces of Greek Drawing and Painting*. New York: Argonaut, 1955.

Strong, D. E. *Roman Imperial Sculpture*. London: Tiranti, 1961.

MINOR ARTS

Charleston, R. J. *Roman Pottery*. London: Faber & Faber, 1955.

Mattingly, H. *Handbook of Roman Coins*. London: Methuen, 1967.

Richter, G. M. A. *The Furniture of the Greeks, Etruscans, and Romans*. London: Phaidon, 1966.

Index

Page numbers are in roman type. Figure numbers of black-and-white illustrations are in *italic* type. Colorplates are specifically so designated. Names of artists and architects are in SMALL CAPS. Titles of works are in *italics*.

Amenemhat II, sphinx of 55, *44*

Amenemhat III: sphinx of 55, *45;* statues of 56, *48, 49*

Amenemhat-ankh (priest), votive statue of 58, *52*

Amenhotep III, court of, see Luxor

Amenhotep IV, see Akhenaten

Amenhotep, Son of Hapu 66

Amon, Amon-Re 59, 60, 63, 71; temples of, see Karnak; Luxor

Amphitrite 215; see also *Neptune, Amphitrite, and Marine Creatures*

amphora, amphorae *199;* "Chalcidian" 196; Panathenaic 210–11, 216, 395; shape of 206; see also Dipylon cemetery, Athens, amphorae from

ANALATOS PAINTER, Amphora, colorplate 22

Anastasius 374

Anavyssos, *Kouros* from 237, *289*

Andjeti 33

ANDOKIDES PAINTER 210

animals: in Cypriot vase painting 400; in Egyptian painting 73; in Etruscan painting 411–12; in Greek sculpture 164, 187; in Greek vase painting 170–72, 176–77, 195, 205; in Mesopotamian art 87, 89, 90, 93, 101–2, 115, 119; in Minoan art 127–29, 134; see also birds; bulls; horses; hunting scenes; lions; monsters

Animals Around a Formalized Sacred Tree, vase from Larnaka 400, *566*

Ankh-af, bust of 43, *31*

Antaios, vase painting of 213–15, 504n

ANTENOR 245; *Kore 301*

Antigonos 365; stoa of, Delos, 229

Antimachos I, coin portrait of *503*

Antioch, see *Tyche of Antioch*

Antiochos the Great 439

Antiope 257

Antoninus Pius 473, 489; memorial column, Rome, reliefs 489–90, *683, 684;* portrait of 497, *696*

Anu 87

Anubis 60

"Anzio Girl, The" 384, *545*

APELLES 366–67

Aphaia 504n; temple of, see Aegina

Aphareus 252

Aphrodite, relief sculpture of 288

Aphrodite, statues of: *Aphrodite,* from Capua 392, *559; Aphrodite,* from Fréjus ("Master E") 335, *461; Aphrodite,* from Melos 391–92, *558; Aphrodite,* from Rhodes 305, 306; *Aphrodite of Knidos* (Praxiteles) 342, 506n, *474*

Aphrodite, vase painting of 405

Apollo, architectural sculptures of: *Apollo, Temple of Zeus,* Olympia 259, 284, *374;* see also *Seated Gods* (Parthenon frieze)

Apollo, coin head of *515*

Apollo, cult of 439, 480

Apollo, relief sculpture of 492

Apollo, statues of 237–38, 246, 281, 342, 370, 424; *Apollo,* Cassel 281, *368;* "*Apollo*" from Dreros 185, *224; Apollo,* from Piombino 237–38, *291; Apollo,* from Veii 424, *595, 596; Apollo Alexikakos* (Kalamis) 281; *Apollo Sauroktonos* (Praxiteles) 342,

473; see also *"Choiseul-Gouffier Apollo"*

Apollo, temples of, see Bassai; Didyma; Eretria; Thermon; Veii

Apollo, vase paintings of 217, 265, 407; *Apollo* (The Berlin Painter) 217, *266; Apollo and the Hyperborean Maidens Greeted by Artemis,* amphora from Melos *201*

APOLLODOROS OF ATHENS 298

APOLLODORUS OF DAMASCUS 487

APOLLONIOS THE ATHENIAN 392–95; *Belvedere Torso 560; Boxer 561, 562*

Apoxyomenos (Lysippos) 352, 355, *492*

Aquae Sulis, See Bath

aqueducts 466, 470

Ara Pacis, Rome 478, 508n, *663;* reliefs 478–80, 483, *664–68*

Arcadian Shepherd, bronze statuette 247, *307*

arch, see arch, triumphal; arch-and-dome construction; arched gates

arch, triumphal 482; Arch of Constantine, Rome, reliefs 487, *679;* Arch of Titus, Rome, reliefs 482–85, *671–73;* Arch of Trajan, Beneventum, reliefs 487, *677, 678*

archaism, archaistic style, in Hellenistic and Roman art 395, 439–40

Archaic period (Greek art) 150, 189, 402; architectural sculpture and relief 230–31, 250–62, 271; architecture 225–31; coins 362–64; freestanding sculpture 232–49, 271; pottery and vase painting 189–223, 503n

arch-and-dome construction 314, 466–68

arched gates, Etruscan 421

Archer, pediment, Temple of Aphaia, Aegina 259–60, *339*

Architectural Models, from Perachora and the Heraion near Argos 163–64, *182–84*

architrave, of Greek temple 226, 227, 228

Areopagus, Athens 341

Ares 256, 392; see also *Seated Gods* (Parthenon frieze)

Arezzo, *Chimaera* from 430, *611;* see also Arretine ware

Argo (ship) 252

Argos: architectural model from 163–64, *183, 184;* painted bowl from 176, colorplate 23; Temple of Hera 163

Aristeion, stele of 260, *343*

Aristodemos of Cumae 404

Aristodikos, Kouros of 237, *290*

Aristogeiton, see *Tyrannicides Aristogeiton and Harmodios* (Kritios and Nesiotes)

ARKESILAS PAINTER: *The Arkesilas Cup* 195, 234, colorplate 26

Arretine ware 450, 508n; *Arretine Bowl 623*

Arrival of Klytemnestra in Aulis, Megarian bowl 366, *520*

Artemis, architectural sculptures of 287; see also *Seated Gods* (Parthenon frieze)

Artemis, temples of: see Ephesos; Kerkyra; Magnesia

Artemis, vase paintings of 205, 219, 250; *Artemis and Apollo Slaying the Niobids* (The Niobid Painter) 265–66, *350; Artemis, Lady of the Beasts (Potnia Theron),*

handle of *The François Vase* 205, *247;* see also *Apollo and the Hyperborean Maidens Greeted by Artemis*

Artemisia 314

aryballos, aryballoi 160; *Aryballos,* from Cumae *177;* see also *Macmillan Aryballos* (The Macmillan Painter); *Pyrvias Aryballos*

Ashur 115

Ashurbanipal, palace of, Nineveh (Kuyunjik), reliefs from 119, 121–25, *137, 140–48; Ashurbanipal Shooting at Lions from His Chariot 122, 143; Ashurbanipal Warring in the Desert 122, 140*

Ashurnasirpal II, palace of, Nimrud (Kalkhu), reliefs from 119, 122, *136, 138; Ashurnasirpal II Worshiping a Sacred Tree 136*

Asklepios, temple of, see Epidauros

Ass Giving Birth, wall painting, Thebes 68, colorplate 4

ASTEAS: *Zeus and Hermes* (scene from a Phlyax play) 296, *393*

Assyrian architecture 114–15

Assyrian art, influence of 238, 400, 402

Assyrian Empire 114, 399

Assyrian glyptic art (cylinder seals) 114–15

Assyrian relief sculpture 116–25, 501n

Aten 71

Atet, tomb of 39

Athena, architectural sculptures of 252, 257, 258–59, 285–87, 328–29, 335; *Athena* (west pediment) and *Head of Athena* (east pediment), Temple of Aphaia, Aegina 258–59, 504n, *336, 338; Athena Battling Alkyoneos and Ge,* Altar of Zeus, Pergamon *554;* see also *Hera and Athena Attacking Giants,* Siphnian Treasury, Delphi

Athena, coin heads of 210, 364, *511, 518, 519*

Athena, Panathenaic procession to 325

Athena, statues of 315–17; *Athena and Marsyas* (Myron) 315–16, *419–21; Athena Lemnia* (Pheidias) 316–17, *422, 423; Athena Parthenos* (Pheidias) 305, 317, 322, 505n

Athena, temples of: see Acropolis, Athens; Syracuse; Tegea

Athena, vase paintings of 175, 211, 219, 266, 405; *Athena* (The Kleophrades Painter) 211, *255;* see also *Theseus and Athena Received by Amphitrite* (The Panaitios Painter)

Athenian coins 210, 362–64

Athenian (Attic) pottery and vase painting: Archaic 195, 202–23; Classical 290–94, 298; Early Classical 263–67; Geometric 160, 161–63; Protoattic 172–76, 180–81, 502n

Athenian sculpture, Archaic 242, 245

Athenian Treasury, Delphi 256; metopes *330, 331*

Athens 159, 263, 299, 334, 399 (see also Acropolis; Agora); Areopagus 341; grave relief from 378, *536;* Hephaisteion 305, *404;* Olympieion 229; Painted Stoa 229; Stoa of Zeus, acroterion from 341, *453*

athletics: in Etruscan painting 418; in

List of Credits

The authors and publisher wish to thank the libraries, museums, and private collectors for permitting the reproduction in black-and-white of works in their collections. Photographs have been supplied by the custodians or owners of the works of art except for the following, whose courtesy is gratefully acknowledged.

Agora Excavations, American School of Classical Studies, Athens: 453.

Alinari, Florence (including Anderson and Brogi): 322, 360, 383, 424, 428, 431, 452, 461, 463, 464, 468, 472, 475, 491, 492, 522–24, 548–51, 559, 560, 562, 564, 583–87, 590, 595, 596, 610–14, 629–35, 637–41, 643, 652, 657, 660, 661, 665, 668, 672, 673, 677, 680, 685, 686, 690, 692, 697, 699, 700.

Archives Photographiques, Paris: 69, 130, 131.

Artists Illustrations, Ltd., London: 497.

Bildarchiv Foto Marburg, Marburg/Lahn: 26, 34, 42–49, 53 right, 62, 68, 74, 76, 77, 171, 172, 415 right.

Copyright Deutsches Archaeologisches Institut, Athens: 190, 191, 193, 194, 207, 225, 226, 293, 299, 300, 316, 345.

Copyright Deutsches Archaeologisches Institut, Rome: 364, 365, 394, 678, 681, 682.

Walter Dräyer, Zurich: 582.

Courtesy Duke University, Durham, N.C.: 70.

Cesare Faraglia, Rome: 693.

Foto Maltese, Syracuse (Sicily): 278.

Fototeca Unione, Rome: 557, 588, 598, 627, 642, 645–49, 663, 664, 666, 667, 671, 679.

Paul Frankenstein, Vienna: 429, 430.

Alison Frantz, Athens: 187, 224, 282, 301, 344, 376, 397.

Gabinetto Fotografico Nazionale, Rome: 432, 496, 636, 691.

Gesellschaft für Wissenschaftliches Lichtbild, Munich: 256.

Giraudon, Paris: 52, 311–13, 576, 599, 687.

Copyright Professor Hege, Germany: 276, 403 left, 410.

Friedrich Hewicker, Kaltenkirchen/Holstein: 419.

Hirmer Verlag, Munich: 3, 9, 13–16, 18, 19, 21–25, 27–30, 35–37, 40, 57, 59, 61, 66, 79–82, 86, 88, 90–92, 96, 98–102, 106, 108, 113, 115, 117, 118, 121, 122, 124, 126–29, 136–39, 141, 143–45, 155, 158–61, 168, 173–75, 179, 180, 202, 208, 213–18, 221, 222, 227, 230, 231, 232 left, 233, 234, 238, 240, 243–49, 257–60, 263–65, 271, 272, 275, 277, 281, 285, 288, 289, 291, 292, 297, 298, 302, 303, 320, 324–30, 332, 337, 338, 343, 346–53, 356–59, 362, 366, 371–74, 377–80, 384, 385, 389, 391, 396, 401, 402, 403 right, 404, 406–9, 412, 417, 439–44, 448, 450, 454, 458–60, 462, 465–67, 469, 471, 476–78, 481–85, 498, 501–19, 526, 531, 536, 545, 547, 558, 561, 578.

Clarence Kennedy, Northampton, Mass.: 341, 422.

G. E. Kidder-Smith, New York: 58, 63.

Louis L'Emery, Paris: 307.

Mansell Collection, London: 146–48.

Maraghiannis, Crete: 220.

Courtesy Dr. A. Moortgat: 133.

R. Moscioni, Rome: 669.

Courtesy The Oriental Institute, University of Chicago: 1, 84, 85 (photo Dr. C. Nims), 123.

Courtesy Professor Paul Schazmann: 546.

Sebah & Joaillier, Istanbul: 295, 487–89.

Courtesy the late William Stevenson Smith, Boston: 2, 10, 54.

Soprintendenza alle antichità, Naples: 206.

Soprintendenza alle antichità, Taranto: 235.

Courtesy Dr. Franz Stoedtner, Düsseldorf: 653.

Copyright the Warburg Institute, University of London: 95, 688 (photo Otto Fein).

Line drawings and plans have been reproduced from the following sources.

A. Badawy, *A History of Egyptian Architecture*, I, 1954: 8.

H. Berve, G. Gruben, and M. Hirmer, *Greek Temples, Theaters, and Shrines*, figs. 3, 61, 63, 70, 44, 43: 185, 398, 399, 405, 411, 413.

E. Curtius and F. Adler, *Olympia*, II, 1892: 277, 280, 355; *Olympia*, III, 1897: 375.

W. B. Dinsmoor, *The Architecture of Ancient Greece*: 279.

C. Dugas, *Le Sanctuaire d'Aléa à Tegée*, 1924: 416.

A. Furtwängler, *Aegina*, 1906: 284, 335.

A. von Gerkan, *Das Theater von Priene*, 1921, pls. 31, 33: 530.

G. Karo, *Die Schachtgräber von Mykenai*, p. 177: 169, 170.

H. Knackfuss, *Didyma*, I, 1942: 525, 527.

K. Lange and M. Hirmer, *Egypt*, figs. 10, 14: 17, 41.

A. W. Lawrence, *Greek Architecture*, figs. 47, 50, 51: 184, 219, 283.

R. Lullies and M. Hirmer, *Greek Sculpture*, fig. 11: 418.

K. Michalowski, *Art of Ancient Egypt*, fig. 896: 56

T. Wiegand, *Baalbek*, I, pl. 14: 654; *Baalbek*, II, fig. 130: 655.